Walter Pater's European Imagination

Walter Pater's European Imagination

LENE ØSTERMARK-JOHANSEN

Great Clarendon Street, Oxford, OX2 6DP,
United Kingdom

Oxford University Press is a department of the University of Oxford.
It furthers the University's objective of excellence in research, scholarship,
and education by publishing worldwide. Oxford is a registered trade mark of
Oxford University Press in the UK and in certain other countries

© Lene Østermark-Johansen 2022

The moral rights of the author have been asserted

First Edition published in 2022

Impression: 1

All rights reserved. No part of this publication may be reproduced, stored in
a retrieval system, or transmitted, in any form or by any means, without the
prior permission in writing of Oxford University Press, or as expressly permitted
by law, by licence or under terms agreed with the appropriate reprographics
rights organization. Enquiries concerning reproduction outside the scope of the
above should be sent to the Rights Department, Oxford University Press, at the
address above

You must not circulate this work in any other form
and you must impose this same condition on any acquirer

Published in the United States of America by Oxford University Press
198 Madison Avenue, New York, NY 10016, United States of America

British Library Cataloguing in Publication Data

Data available

Library of Congress Control Number: 2022935470

ISBN 978–0–19–285875–7

DOI: 10.1093/oso/9780192858757.001.0001

Printed and bound in the UK by
TJ Books Limited

Links to third party websites are provided by Oxford in good faith and
for information only. Oxford disclaims any responsibility for the materials
contained in any third party website referenced in this work.

For my friends in England

all Europe in its priceless art and choicer scenery crowded together, seemed to hang just beyond the horizon in his fancy, like some precious stone, with soft shiftings and variations.

Walter Pater, 'An English Poet'

Acknowledgements

According to the Day Books of Brasenose College, Oxford, where Walter Pater was a Fellow his entire adult life, vast quantities of German and French wines were consumed in the Senior Common Room: 'Leoville, Moselle, Giscours, Richebourg, Volnay and St. Julien, Pommard, hock, claret, as well as sherry, port and brandy', the College Archivist informs me. Whether the Paterian palate would have relished the Danish beer which saw the light of day in 1847 will remain unknown, but what is beyond the realm of speculation is the great indebtedness I owe, indirectly to the world's beer drinkers, but very directly to the Danish Carlsberg Foundation. This book would not have come into being, were it not for the one-year fellowship with the Paterian name, *Semper Ardens*, which the Foundation generously awarded me from 2018 to 2019. With the fellowship came a publication grant and a generous travel allowance which enabled me to set up house in Oxford and to follow in Pater's footsteps in France and Italy, pursuing the *genius loci* which plays such an important part in his fiction. I owe the Department of English, Germanic, and Romance Studies at the University of Copenhagen all kinds of thanks for releasing me from my duties, for issuing me with a picture researcher, and for allowing me to run an MA course on literary and visual portraiture. Several ideas aired by students found their way into this book in one way or another.

Much of Pater's fiction revolves around our notions of home and abroad, and I am grateful to the institutions which have housed or assisted me over the years, at home and abroad: to Churchill College, Cambridge, for awarding me a By-fellowship when I began work on my critical edition of Pater's imaginary portraits and to the staff at Cambridge University Library; to St Catherine's College, Oxford, for accepting me for a Christensen Fellowship; to the English Faculty, University of Oxford, in the incarnation of the ever-helpful Christine Bayliss, for repeatedly renewing my status as academic visitor as I kept returning. The significance of Oxford as Pater's place, as a haven of libraries, archives, bookshops, publishers, and people, a centre for international scholars, cannot be underestimated. As I write this from Covid-19 lockdown in Copenhagen, I am all too aware that much knowledge exchange has its roots in personal Oxford encounters, not replaceable by screen presences. I am grateful to the staff of the Bodleian, the Sackler, and the Taylorian Libraries for helping me to piles and piles of books; to Librarian Liz Kay and Archivist Georgina Edwards in Brasenose College, to Archivist Anne Manuel at Somerville College, and Mark Bainbridge, Fellow Librarian and Keeper of the Archives at Worcester College for bringing out rare material, answering queries, and being generally very helpful. Peter Henderson, Archivist at Pater's old school, the King's School, Canterbury, generously took a whole day out of his busy schedule to put the *genius loci* of 'Emerald Uthwart' on my physical and imaginary map. In Copenhagen, the Royal Library filled out the gaps and provided me with a reading room when I needed the stimulus of working on my own in the presence of others.

viii ACKNOWLEDGEMENTS

Walter Pater's European Imagination has been aired repeatedly, primarily to European audiences, but also once to a Transatlantic one when the NAVSA conference in Montréal provided me with an opportunity to voice my ideas in embryonic form. I am grateful to Gesa Steadman for allowing me to present to the 'Writing 1900' research group in Germany, to Xavier Giudicelli and the Societée Française des Études Victoriennes et Édouardiennes to let me address Pater and the Bacchic in the Champagne district, to the International Walter Pater Society for inviting me to give the keynote address at the 2014 conference at the Sorbonne, to The Royal Danish Academy of Sciences and Letters for making me speak about Pater in Danish, to Bénédicte Coste for inviting me to talk about Pater and Montaigne at the Fondation Les Treilles, to Christine Reynier for allowing me to address the École doctorale at the Université Paul Valéry in Montpellier. David Russell invited me to present at Oxford's English Faculty Victorian Graduate seminar, Elizabeth Prettejohn took me North to speak in the Department of the History of Art at the University of York, and Charlotte Ribeyrol made me reflect on the colours of the past in Pater's *Gaston de Latour* at the Ashmolean Museum in Oxford. Hilary Fraser and Susanna Avery-Quash gave me the opportunity to explore one of Pater's favourite portraits, Giovan Battista Moroni's anonymous *Tailor*, at the Nineteenth-Century Women Writers and the Old Masters conference at the National Gallery, while Rebecca Beasley kindly allowed me to speak about Pater and place at the launch of Oxford University Press's *Collected Works of Walter Pater* at the Queen's College, Pater's undergraduate college. I am grateful for all the questions, comments, and ideas which these opportunities to present drafts of this book have generated.

Walter Pater's European Imagination appears alongside the ten volumes of the Oxford *Collected Works of Walter Pater*, and I owe many kinds of thanks, first of all to the two General Editors, Lesley Higgins and David Latham, who have been unfailingly supportive, enthusiastic, and helpful with manuscript transcriptions, references, and many other things, and secondly to the other volume editors—Laurel Brake, Joseph Bristow, Ken Daley, Hilary Fraser, and Matthew Potolsky—who have contributed to lively debates about Pater. In England, friends and colleagues have supported and encouraged this book by answering queries, listening to my ideas and concerns, and sharing my enthusiasm. Outside my Oxford community, I am hugely grateful to Carolyn Burdett, Colin Cruise, Jane Desmarais, Jason Edwards, Hilary Fraser, Michael Hatt, Charles Martindale, Catherine Maxwell, Liz Prettejohn, Vick de Rijke, and Ana Parejo Vadillo. Several of them have housed, wined, and dined me, talking Pater—or not at all. In Oxford, Barrie Bullen and Roma Tearne have been unfailing in their support, whether in the form of references, critical questions, or dinners. Philip Bullock and Stefano Evangelista have been wonderful academic and private hosts and friends, full of good cheer and shrewd observations, and a great support team. Luisa Calè and I have shared many a Thai lunch and Italian coffee, discussing word-and-image relations while gently forcing me to keep my Italian alive. My walks and late-night conversations with Sandra Mayer kept me in touch with biography and the goings on at the Oxford Life-Writing Centre, David Russell deserves singular praise for enthusiastically saying 'I want to read this book!', Kirsten Shepherd-Barr was a lovely Danish host at the most Danish of Oxford colleges and such a wonderfully inspiring colleague and friend, while Tania Batelli-Kneale, the

Cheethams, and the Winchesters are long-standing, constant, and supportive Oxford friends for whenever I return with my entourage of children and bicycles. At Oxford University Press, I am hugely grateful to Jacqueline Norton for believing in this book in the first place, to Karen Raith, Lucy Jeffery, and Jo Spillane for efficiently seeing it through the Press, and to the two anonymous readers who suggested important cuts and additions.

In France I wish I had had more lunches and conversations with Emily Eells and Mark Greengrass; I could learn so much more from their wise and delightful company, and Mark, always inventive, deserves special thanks for suggesting the book's title. Bénédicte Coste took me Sunday walking in the hills north of Montpellier, not far from the setting of Pater's 'Tibalt the Albigense', and Catherine Delyfer generously drove me to Montaigne's Tower for a wonderful day out. Without that trip, parts of Chapter 5 would have looked very different. Aude Haffen drew my attention to Marcel Schwob, a new acquaintance for which I am truly grateful, and Christine Reynier kindly offered me a visiting professorship in Montpellier with space and time for thought and good conversations about Pater and Woolf. Charlotte Ribeyrol has long connected Paris and Oxford and made me think about Pater and colour in new ways.

In Copenhagen, Henry Bainton and Alexander Knopf answered queries about the Angevine empire and Herder, the late Eric Jacobsen was a long-standing friend and mentor, the closest you can come to a modern Renaissance man, while discussions with Andrew Miller, Maria Fabricius Hansen, and Anne-Grete Rovbjerg have been always enjoyable and stimulating. Therese Stougård deserves my warm thanks for finding and securing a large part of the illustrations: I am grateful to her for all her independent thinking, efficiency, and detective skills and for having taken one load off my shoulders. Charles Lock kindly read the entire book in one sitting and corrected my proofs, a Herculean task for which I am profoundly grateful. While friends and colleagues have had to live with me being 'just about to finish the book' for far too long, my closest family, my parents, my sister, and not least my children, have had to endure years of my solitary writing. I am grateful for all their love, support, and respect for me as I struggled and look forward to becoming much better company.

Janus, the Roman god of beginnings and transitions, posing in two-headed form above ancient gates and doors, looks both backward and forward. As I complete this book in January 2021, I do so on an elegiac note, sad at the recent loss of the United Kingdom from the European Union. *Walter Pater's European Imagination* inevitably looks backward, as does my dedication. Yet, as Pater knew, thoughts, ideas, and friendships are not contained by physical, financial, or political borders, and a European imagination persists. If this book can contribute towards pointing out new directions in Pater scholarship, something will have been achieved.

<div align="right">

Lene Østermark-Johansen
Copenhagen
January 2021

</div>

Contents

List of Figures	xiii
List of Abbreviations	xix
Introduction	1
The Imaginary Portrait	6
Foregrounds and Backgrounds	17

I. FOREGROUNDS

1. Type and Individual	29
The Diaphanous Self	39
'The Transmutation of Ideas into Images': Leonardo	49
Francis Galton's Composite Portraits and 'The Child in the House'	61
2. Life-Writing	78
Pater's Brief Lives	87
English Men of Letters and English Poets: The Literary Portrait	94
Marcel Schwob, the Modernists, and the New Biography	104
3. Narrating the Self	114
The Diary Form and Fiction: 'A Prince of Court Painters'	123
The Speaking Portrait	132
The Secret Diary: 'Sebastian van Storck'	143
4. Character and Caricature	158
Character, Tragedy, and Ekphrasis	166
Oxford Characters	177
Caricaturing Mr Rose	197

II. BACKGROUNDS

5. The Poetics of Space: From Rooms to Cathedrals	209
At Home or *Chez Soi*: From 'The Child in the House' to a Visit to Montaigne	213
The Aesthetic Interior: Living Up to One's Blue China	229
From the Reliquary to the Cathedral	244
6. The Poetics of Place: Mapping Pater's Europe	267
The Idea of Europe	274
At Home and Abroad: Travelling with *Murray's Handbook* to France	286
France within Europe	309

xii CONTENTS

7. The Poetics of Time: Pater and History	317
Walter Scott, Walter Pater, and the Collective Memory	325
Jules Michelet: Renaissance, Revolution, and Resurrection	335
Modernity: Youth, *Bildung*, and Maturity	349

| *Bibliography* | 365 |
| *Index* | 387 |

List of Figures

Cover: Jean Cousin, *The Rape of Europa* (*c.*1550), oil on panel, 88 × 140 cm. Château de Blois, Blois. Château royal de Blois/F. Lauginie. i

0.1. Giovan Battista Moroni, *Giovanni Bressani* (1562), oil on canvas, 116.2 × 88.8 cm. National Galleries of Scotland, Edinburgh. Purchased by Private Treaty 1977. 7

0.2. Antonis Mor, *St Sebastian* (*c.*1550), oil on panel, 90 × 73.7 cm. Graves Gallery, Sheffield. Sheffield Museums Trust. 9

0.3. Bartholomeus van der Helst, *The Four Archers of the St Sebastian Guards/ The Governors of the Archers' Civic Guard* (1653), oil on canvas, 183 × 268 cm. Amsterdam Museum, Amsterdam. Photo Amsterdam Museum/Niels den Haan (photo after phase 2 restoration 2019). 11

1.1. W. H. Taunt, *Walter Pater* (late 1860s), photograph, from Thomas Wright, *Life of Walter Pater*, 2 vols (London: Everett & Co., 1907), 1:247. Private collection. Photo © Christoffer Rostvad. 30

1.2. Jules Guggenheim, *Walter Pater* (early 1870s), *carte de visite*, photograph pasted into Emilia Dilke's copy of *Studies in the History of the Renaissance*. Brasenose College, Oxford. With the kind permission of the King's Hall and College of Brasenose, Oxford. 31

1.3. Elliott & Fry, *Walter Pater* (late 1880s), half-plate glass copy. © National Portrait Gallery, London. 32

1.4. Anon., *Clara Pater* (early 1870s), *carte de visite*, photograph. Principal and Fellows of Somerville College, Oxford. 33

1.5. Elliott & Fry, *William Hurrell Mallock* (1870s), bromide print. National Portrait Gallery, London. Historic Collection/Alamy Stock Photo. 34

1.6. Simeon Solomon, *Walter Pater* (1872), pencil on paper, 28.1 × 20.3 cm. Fondazione Horne, Florence. 35

1.7. Jean Delville, *L'école de Platon* (1898), oil on canvas, 260 × 605 cm. Musée d'Orsay, Paris. Photo © RMN-Grand Palais (Musée d'Orsay)/Hervé Lewandowski. 52

1.8. Leonardo da Vinci (?), *Salvator Mundi* (*c.*1500), oil on walnut, 45.4 × 65.6 cm. present whereabouts unknown (August 2021). Wikimedia Commons. 53

1.9. Leonardo da Vinci, *Saint John* (1513), oil on canvas, 69 × 57 cm. Musée du Louvre, Paris. Wikimedia Commons. 54

1.10. Title page of *The Renaissance: Studies in Art and Poetry* (London: Macmillan, 1877) with the Leonardesque head, engraved by Charles Jeens. Book in private collection. Photo © Christoffer Rostvad. 56

xiv LIST OF FIGURES

1.11. Albrecht Dürer, *Melencolia I* (1514), engraving, 23.8 × 18.5 cm.
 Wikimedia Commons. 58

1.12. Julia Margaret Cameron, *Lionel Tennyson* (*c.*1866), albumen print,
 30.9 × 23.8 cm. Scottish National Gallery of Modern Art, Edinburgh.
 Wikimedia Commons. 68

1.13. William H. Mumler, *Mary Todd Lincoln with Abraham Lincoln's 'spirit'* (*c.*1872),
 photograph. Indiana State Museum and Historic Sites, Indianapolis. From the
 Lincoln Financial Foundation Collection. 72

1.14. Francis Galton, *Composite portrait of Eight Men and Women of the Same Family*
 (1881), photograph. University College London. The Galton Papers,
 UCL Library Services, Special Collections. 76

2.1. Anon., Greek relief, 'Tryphon' (fourth century BC–first century AD), pentelic
 marble, 177.5 × 90 × 26.5 cm. British Museum, London. © The Trustees of the
 British Museum. All rights reserved. 92

3.1. Giovan Battista Moroni, *The Tailor* (*c.*1570), oil on canvas, 99.5 × 77 cm.
 © National Gallery, London. 116

3.2. Walter Pater, 'Il Sartore', Houghton bMS Eng. 1150 (22) | fol. 12r. Houghton
 Library, Harvard University. 118

3.3. Jean-Baptiste Pater, *Portrait of Marie-Marguerite Pater* (*c.*1720), oil on canvas,
 79.2 × 62.9 cm. Musée des Beaux-Arts, Valenciennes. Photo © RMN-Grand
 Palais/Michel Urtado. 133

3.4. Rosalba Carriera, *Portrait of Jean-Antoine Watteau* (1721), pastel on paper,
 55 × 43 cm. Museo Civico, Treviso. The Picture Art Collection/Alamy
 Stock Photo. 134

3.5. Jean-Michel Liotard, after Antoine Watteau, *La plus belle des fleurs ne dure
 qu'un matin* (1717–27), etching with some engraving, 19.3 × 15.6 cm.
 © Royal Academy of Arts, London. 135

3.6. Jacob van Oost the Elder, *Portrait of a Boy Aged Eleven* (1650), oil on canvas,
 80.5 × 63 cm. © National Gallery, London. 138

3.7. Emanuel De Witte, *Interior of the Nieuwe Kerk in Delft with the Tomb of William
 the Silent* (1656), oil on canvas, 97 × 80 cm. Palais des Beaux-Arts, Lille.
 Photo (C) RMN-Grand Palais/Philipp Bernard. 142

3.8. Bartholomeus van der Helst (figure) and Ludolf Bakhuizen (naval background),
 Portrait of Johan de Liefde (1668), oil on canvas, 139 × 122 cm. Rijksmuseum,
 Amsterdam. Wikimedia Commons. 143

3.9. Philip de Koninck, *An Extensive Landscape with a Hawking Party* (*c.*1670), oil on
 canvas, 132.5 × 160.5 cm. National Gallery, London. Wikimedia Commons. 148

3.10. Gabriel Metsu, *Woman Reading a Letter* (1664–6), oil on panel, 52.5 × 40.2 cm.
 National Gallery of Ireland, Dublin. Wikimedia Commons. 149

3.11. Jean-Louis Ernest Meissonier, *The Reader in White* (1857), oil on wood,
 21.7 × 15.5 cm. Musée d'Orsay, Paris. Photo © RMN-Grand Palais
 (Musée d'Orsay)/Hervé Lewandowski. 151

LIST OF FIGURES XV

4.1. Title page of Pater's private copy of Charles Dickens, *Great Expectations*, with thirty illustrations by F. A. Fraser (London: Chapman and Hall, n.d.). Private collection, © Daichi Ishikawa. 164

4.2. After Myron, *Discobolus*, Roman copy (*c.* AD 140), marble, 155 cm. Museo Nazionale Palazzo Massimo, Rome. Wikimedia Commons. 170

4.3. Anon., *Apollo Belvedere*, Roman copy after a Greek original of the fifth century BC, marble, 224 cm. Musei Vaticani, Rome. Wikimedia Commons. 176

4.4. William Rothenstein, *Walter Pater* (1894), lithograph from *Oxford Characters Part VI. The William Andrews Clark Memorial Library, University of California, Los Angeles.* 186

4.5. William Rothenstein, *F. W. Bussell* (1894), lithograph from *Oxford Characters Part VI. The William Andrews Clark Memorial Library, University of California, Los Angeles.* 187

4.6. Elliott & Fry, *Max Beerbohm* (*c.*1900), photograph. [Elliott & Fry]/[Conde Nast Collection]/Getty Images. 189

4.7. Max Beerbohm, *Walter Pater by Will Rothenstein* (1894?), pencil, 20.3 cm × 25.4 cm. The William Andrews Clark Memorial Library, University of California, Los Angeles. 190

4.8. Max Beerbohm, *Oxford 1891. Mr. Walter Pater taking his walk through the Meadows* (1926), pencil, ink, and watercolour on paper, 38.1 × 20 cm. Mark Samuels Lasner Collection, University of Delaware Library, Museums, and Press. 192

4.9. C. J. Holmes, *Walter Pater in Oxford 1889* (1889), pen and ink. Brasenose College, Oxford (D.13 in the College Picture Catalogue). Gift of Martin Holmes. With the kind permission of the King's Hall and College of Brasenose, Oxford. 193

4.10. C. J. Holmes, *Walter Pater in London 1890–91* (1891), pen and ink. Brasenose College, Oxford (D.14 in the College Picture Catalogue). Gift of Martin Holmes. With the kind permission of the King's Hall and College of Brasenose, Oxford. 194

4.11. James Hearn ('JCR Spider'), *Marius the Epicurean* (early 1890s), pen and ink. Brasenose College, Oxford (MPP 134 B3 in the College Archive Catalogue). With the kind permission of the King's Hall and College of Brasenose, Oxford. 195

4.12. Edward Burne-Jones, *The Briar Wood* (from the large *Briar Rose* series) (1870–90), oil on canvas, 124.46 × 249 cm. Buscot Park, Faringdon. 201

4.13. Neuschwanstein Castle, Bavaria, Germany (*c.*1890–1905), photochrom print. Library of Congress, Photochrom print collection. Prints and Photographs LC-DIG-ppmsca-00179. 203

5.1. *Pater's Sitting-Room at Brasenose* (*c.*1907), from Thomas Wright, *The Life of Walter Pater*, 2 vols (London: Everett & Co., 1907), 1:227. Private collection. Photo © Christoffer Rostvad. 210

5.2. Henry Wallis, *The Room in which Shakespeare was Born* (1853), oil on board, 29.2 × 41.9 cm. Tate Britain, London. Purchased 1955. Photo © Tate. 214

xvi LIST OF FIGURES

5.3. Francis Bedford, *The Room in which Shakespeare was Born* (1860s), *carte de visite*, National Museums of Scotland. From the Howarth-Loomes Collection. Image © National Museums Scotland. 215

5.4. Henry Wallis, *Staircase in Shakespeare's Birthplace* (1847), watercolour on paper, 33 × 44.5 cm. Courtesy of the Shakespeare Birthplace Trust, Stratford-upon-Avon. © Shakespeare Birthplace Trust. 217

5.5. Henry Wallis and Edwin Landseer, *Shakespeare's House, Stratford-upon-Avon* (1854/67), oil on canvas, 65.5 × 49.5 cm. © Victoria and Albert Museum, London. 218

5.6. Henry Wallis, *Interior of Montaigne's Library* (1856–7), frontispiece to Bayle St. John, *Montaigne the Essayist: A Biography, with Illustrations*, 2 vols (London: Chapman and Hall, 1858), vol. 2. © Widener Library, Harvard University. 228

5.7. George du Maurier, 'Six-Mark Teapot', *Punch, or the London Charivari*, 30 Oct. 1880. Punch Cartoon Library/TopFoto. 231

5.8. Walter Pater, MS page Chapter viii, fol. 1r. Brasenose College Archives, Oxford. With the kind permission of the King's Hall and College of Brasenose, Oxford. 232

5.9. James Hadley, *Aesthetic Teapot* (1882) made by the Royal Worcester Porcelain Company, glazed and enamelled Parian ware, 15.9 × 16.5 × 7.6 cm. Art Institute of Chicago. Wikimedia Commons. 233

5.10. Relic head of St John the Baptist, bone, precious stones and metal. Notre Dame d'Amiens. Photographer: Patrick Müller, 1999. Amiens, Cathedral. © 2021. CMN dist. Scala, Florence. 243

5.11. Frontispiece of Andreas Vesalius, *De corporis humana fabrica* (Basel: Oporini, 1543). Wikimedia Commons. 247

5.12. Frontispiece of Thomas Browne, *Hydriotaphia: Urne-Burial or, a Brief Discourse of the Sepulchrall Urnes Lately Found in Norfolk* (London: Henry Browe, 1658). Private collection. PBA Galleries/Justin Benttinen. 248

5.13. Reliquary of St Germain (nineteenth century), gilt wood, glass, and metal. Cathédrale St Étienne, Auxerre. © JOHN KELLERMAN/Alamy Stock Photo. 251

5.14. Photograph of the body of St Edmund of Abingdon (nineteenth century). Archives of Yonne. Arch. dép. Yonne, 2 Fi 10268. 251

5.15. Girolamo Romanino, *S. Alessandro Altarpiece* (1525), oil on panel. © National Gallery, London. 252

5.16. Girolamo Romanino, *S. Gaudioso* (detail from the *S. Alessandro Altarpiece*) (1525), oil on panel, 74.2 × 65.2 cm. © National Gallery, London. 253

5.17. Titian, *Averoldi Altarpiece/The Resurrection of Christ* (1520–2), oil on panel, 278 × 272 cm. SS Nazaro e Celso, Brescia. Wikimedia Commons. 255

5.18. Reliquaries (among them St Gaudioso), silver, glass, precious stones. SS Nazaro e Celso, Brescia. Photo © Christoffer Rostvad. 256

5.19. Anon., *Venus Victrix* (middle of the first century AD), bronze, 195 cm. Archaeological Park of Brescia Romana—Capitolium. © Archivio Fotografico Musei di Brescia. Fotostudio Rapuzzi. 257

LIST OF FIGURES xvii

6.1. *Dying warrior* from the Temple of Aphaea in Aegina (fifth century BC), marble. Antike am Königsplatz, Munich. Staatliche Antikensammlungen und Glyptothek München. Photograph by Renate Kühling. 277

6.2. *Panorama of the Chartreuse de Montreuil*, late nineteenth-century postcard. Private collection. Photo © Christoffer Rostvad. 300

6.3. *Avenue du monastère. Porte d'entrée*, late nineteenth-century postcard. Private collection. Photo © Christoffer Rostvad. 301

6.4. *Monk in the cloisters of the Chartreuse de Montreuil*, late nineteenth-century postcard. Private collection. Photo © Christoffer Rostvad. 302

6.5. *Two monks in the library of the Chartreuse de Montreuil*, late nineteenth-century postcard. Private collection. Photo © Christoffer Rostvad. 303

6.6. *Solitary monk in the cemetery of the Chartreuse de Montreuil*, late nineteenth-century postcard. Private collection. Photo © Christoffer Rostvad. 303

6.7. *The burial of a Carthusian monk in the Chartreuse de Montreuil*, late nineteenth-century postcard. Private collection. Photo © Christoffer Rostvad. 304

7.1. Antonin Mercié, *Tomb monument to Jules Michelet*, marble. Père Lachaise Cemetery, Paris. Wikimedia Commons. 341

7.2. François Clouet, *Elisabeth of Austria* (1571), oil on panel, 37 × 25 cm. Musée Condé, Chantilly. Wikimedia Commons. 351

7.3. Michel Lasne, *Pierre de Ronsard, Prince des Poëtes* (1585), engraving. Private collection. Photo © Christoffer Rostvad. 354

7.4. Etienne Carjat, *Charles Baudelaire* (c.1863), photograph. Wikimedia Commons. 355

7.5. Giorgione, *The Three Ages of Man* (1500–10), oil on panel, 62 × 77 cm. Palazzo Pitti, Florence. Wikimedia Commons. 357

7.6. Titian, *Allegory of Prudence* (1550), oil on canvas, 75.5 × 68.4 cm. National Gallery, London. Presented by Betty and David Koetser 1966 © National Gallery, London. 358

List of Abbreviations

Bibl. Samuel Wright, *A Bibliography of the Writings of Walter H. Pater* (New York: Garland Publishing, 1975).

CW 3 *Collected Works of Walter Pater: Imaginary Portraits*, ed. Lene Østermark-Johansen (Oxford: Oxford University Press, 2019).

CW 4 *Collected Works of Walter Pater: Gaston de Latour*, ed. Gerald Monsman (Oxford: Oxford University Press, 2019).

CW 8 *Collected Works of Walter Pater: Classical Studies*, ed. Matthew Potolsky (Oxford University Press, 2020).

CW 9 *Collected Works of Walter Pater: Letters*, ed. Robert L. Seiler (Oxford: Oxford University Press, 2022).

CWR *The Complete Works of John Ruskin*, 39 vols, eds E. T. Cook and Alexander Wedderburn (London: George Allen, 1903–12).

DNB *Dictionary of National Biography*.

EVW *The Essays of Virginia Woolf*, ed. Andrew McNeillie, 6 vols (London: Hogarth Press, 1994).

OED *Oxford English Dictionary*.

Ren. Walter Pater, *The Renaissance: Studies in Art and Poetry*, the 1893 text, edited with textual and explanatory notes by Donald L. Hill (London and Berkeley: University of California Press, 1980).

Wright Thomas Wright, *The Life of Walter Pater*, 2 vols (London: Everett & Co., 1907).

Introduction

> Portraiture is a slippery and seductive art; it encourages us to feel that then is now and now is then. It seems to offer factual data while simultaneously inviting a subjective response. It offers—in its finest manifestations—an illusion of timelessness, the impression that we can know people other than ourselves and, especially, those among the unnumbered and voiceless dead.
>
> Marcia Pointon[1]

In her account of the interrelationship between portraiture and viewer Pointon offers a path into an art form which—perhaps more than any other—provokes our awareness of presence and absence, life and death. The affective quality of portraiture, as our face faces another, reminds us of our own mortality, of the eventual silencing of our own voices, as we join 'the unnumbered and voiceless dead'. Portraits force us to face the passing of time, as they invite us to bridge the temporal gulf, narrow or wide, between ourselves and the person depicted. The tension between evanescence and substance, as the portrait offers up an expectation of human presence denied by its very materiality, reminds us that portraiture is always about absence. The moment captured in the portrait is forever gone, and even with the original next to us as we gaze at the image, we are aware of the difference between then and now. The vibrancy of Pointon's playful prose cuts to the core of portraiture as a pictorial genre which addresses the fundamental question of what it means to be human.

This book is about literary portraiture, about the ways in which the literary and the visual meet in Walter Pater's so-called 'imaginary portraits'. Stephen Cheeke has reminded us how 'Pater's work is alive with persons', 'saturated in a manifold theory of personality and persons, of personification, of personed-gods and personed-history, of contending voices and of the conversation with the *logos* in the individual consciousness'.[2] From the essays on Coleridge and Winckelmann of the mid-1860s through his studies of Dionysus and Demeter of the 1870s to his portraits 'Emerald Uthwart' and 'Apollo in Picardy' of the 1890s, Pater's concern is monofocally with the human individual, be it in the form of critical-biographical studies of writers or artists of the past, of mythological figures, or autobiografictional selves. The salient position of the individual in Pater's writings gives prominence to the person and the persona, to character and voice in dialogue with painting, sculpture, poetry, the novel, the short story, biography, myth, and history. The present book may be primarily about Pater's fiction—the eight finished and five unfinished imaginary portraits

[1] Marcia Pointon, *Portrayal and the Search for Identity* (London: Reaktion Books, 2013), 28.
[2] Stephen Cheeke, 'Walter Pater: Personality and Persons', *Victoriographies* 5.3 (2015), 234–50, 245.

Walter Pater's European Imagination. Lene Østermark-Johansen, Oxford University Press. © Lene Østermark-Johansen 2022.
DOI: 10.1093/oso/9780192858757.003.0001

2 WALTER PATER'S EUROPEAN IMAGINATION

together with his one finished and one unfinished novel, *Marius the Epicurean* (1885) and *Gaston de Latour* (1888–94)—yet as anyone working on Pater will know, his criticism and his fiction cross-pollinate one another, and any analysis of one corner of the Paterian *oeuvre* will inevitably involve it all. In 1873 Pater spoke of 'that thick wall of personality through which no real voice has ever pierced on its way to us',[3] yet the Paterian protagonist is always a product of a European culture which manifests itself geographically, artistically, and historically in the self. This study aims to position the Paterian selves within a much larger European framework as studies of the cohesive power of European culture from antiquity to the nineteenth century. Portraiture in Pater's fiction may centre on the self, but the full portrait comprises both historical period and geographical location.[4]

What do I mean by 'Walter Pater's European Imagination'? Does 'European' mean 'relating to Europe', 'inspired by or indebted to Europe', 'residing in Europe', 'rooted in European culture', 'promoting a European world view'? In this book it means all of the above. Pater's fiction is set in Europe and his world view is undeniably Eurocentric. Indeed, the author could most likely be characterized as a 'Europeanist': one stressing the cohesive powers of European culture across national borders and centuries.[5] Nourished on European literature and culture, Pater read Greek, Latin, Italian, German, and French throughout his life and had a daily routine of translating from those foreign languages into English. The flexibility with which he moved from one language to another, at least in writing, testifies to his continued interest in bridging languages and cultures. As anyone who has worked with translation will know, the process involves profound cultural and linguistic knowledge combined with imagination and creativity.

Border crossing is a fundamental aspect of Pater's approach to language, literature, and culture: the introduction of foreign phrases into his English prose was commented upon by his earliest reviewers,[6] and his imaginary portraits are stellar examples of generic border crossing, as Max Saunders pointed out, when he addressed Pater's merging of 'forms traditionally valued for their truth-telling—portraiture, history, essay, biography, autobiography—with the counter-factual energies of fiction, imagination, and myth'.[7] Pater crosses the borders between literature, painting, and sculpture, between forms evolving over time and forms evolving in space, in G. E. Lessing's eighteenth-century distinction.[8] Preoccupied with ideas of communities, he becomes a member of what Matthew Potolsky has called the 'decadent republic of

[3] 'Conclusion' in *Ren.*, 187.

[4] Martine Lambert-Charbonnier stresses the European aspect of Pater's imaginary portraits: 'Walter Pater chérissait l'image d'une culture européenne s'enrichissant au fil du temps, appelée à renaître sous des formes nouvelles à des moments-clés de l'histoire.' *Walter Pater et les 'Portraits Imaginaires': Miroirs de la culture et images de soi* (Paris: L'Harmattan, 2004), 9.

[5] According to the *OED*, the term 'Europeanist' was coined in 1881, at the very same time as Pater was writing his imaginary portraits.

[6] See some of the reviews of *Studies in the History of the Renaissance*, especially that of Henry Morley in *Walter Pater: The Critical Heritage*, ed. R. M. Seiler (London: Routledge & Kegan Paul, 1980), 63–70, 66–7.

[7] Max Saunders, *Self Impression: Life-Writing, Autobiografiction, and the Forms of Modern Literature* (Oxford: Oxford University Press, 2010), 42.

[8] G. E. Lessing, *Laocoön: An Essay on the Limits of Painting and Poetry*, tr. and ed. E. A. McCormick (Baltimore and London: Johns Hopkins University Press, 1984).

letters': 'Essentially internationalist, decadent writing is a form of cultural production that begins with and recurrently thematises the act of literary and artistic border crossing.'[9] At a time when European nation states were consolidating themselves, the 'decadent republic of letters', counting members like Joris-Karl Huysmans, Vernon Lee, Oscar Wilde, and Arthur Symons, were working towards national disintegration, porous borders, hybrid languages, and cosmopolitanism, and Pater's European imagination should been seen in that context. With its Latinate syntax and influx of foreign words and phrases,[10] his style opposed what Pascale Casanova has called the 'Herder effect',[11] the romantic linking of nation and language which helped establish a national canon and legitimize nationhood. More than anyone, Pater was aware of English as an assimilative language, with a long history of absorbing other European languages, as he stated in 'Style' (1888): 'English, for a quarter of a century past, has been assimilating the phraseology of pictorial art; for half a century, the phraseology of the great German metaphysical movement of eighty years ago; in part also the language of mystical theology. . . . For many years to come its enterprise may well lie in the naturalisation of the vocabulary of science.'[12] He recommended the writer to use the furthest corners of the English language: 'Racy Saxon monosyllables, close to us as touch and sight, he will intermix readily with those long, savoursome, Latin words, rich in "second intention." In this late day certainly, no critical process can be conducted reasonably without eclecticism.'[13]

Including Pater among his bards of cosmopolitanism,[14] Stefano Evangelista has recently drawn our attention to the ways in which, when introducing C. L. Shadwell's translation of Dante's *Purgatorio* (1892), he defined his own time as 'sympathetic, eclectic, cosmopolitan, full of curiosity and abounding in the "historic sense".'[15] Pater's juxtaposition of 'eclectic' and 'cosmopolitan' helps explain his position as someone arguing for a much broader outlook on European literature than a purely nationalist one. Dante conveniently serves as one such European writer with a universal appeal across countries and centuries, at once a Florentine and an exile, a citizen of somewhere and of nowhere, continuously on the move. As Evangelista points out, 'For the Greek cynic philosopher Diogenes, who is credited as having coined the term, cosmopolitanism was a category of resistance and non-belonging.'[16] With the privilege of feeling at home everywhere also comes the risk of belonging nowhere, and although Pater's protagonists are always citizens of somewhere ('of Rosenmold', 'in Picardy', 'l'Auxerrois', 'the Albigense'), he was clearly part of what Evangelista calls a 'literary cosmopolitanism', 'a materially embodied set of practices and aesthetic

[9] Matthew Potolsky, *The Decadent Republic of Letters: Taste, Politics, and Cosmopolitan Community from Baudelaire to Beardsley* (Philadelphia: University of Pennsylvania Press, 2013), 2.

[10] See Linda Dowling, *Language and Decadence in the Victorian Fin de Siècle* (Princeton: Princeton University Press, 1986), 110–88.

[11] Pascale Casanova, *The World Republic of Letters*, tr. M. B. Debevoise (Cambridge, MA: Harvard University Press, 2004), 75.

[12] 'Style', *Fortnightly Review* 44 (Dec. 1888), 728–43, 732–3. [13] Ibid., 733.

[14] Stefano Evangelista, *Literary Cosmopolitanism in the English Fin de Siècle: Citizens of Nowhere* (Oxford: Oxford University Press, 2021), 21.

[15] 'Shadwell's Dante', in Walter Pater, *Uncollected Essays* (Portland: Thomas B. Mosher, 1903), 145–61, 147.

[16] Evangelista, 1.

4 WALTER PATER'S EUROPEAN IMAGINATION

encounters' which came about through travels and translations, through Pater's reading, fully up-to-date on the most recent international publications.[17]

If thinking in and with language invited a cosmopolitan approach, so did Pater's concept of the 'movement of the Renaissance'. 'The Renaissance, for Pater, is a transnational community of spirit and taste, populated by individuals who are always literally in motion, always crossing national borders, seeking out new patrons, forming new erotic and intellectual bonds, and selecting among political, religious, artistic, and philosophical traditions.'[18] As Winckelmann moves from Germany to Rome, Leonardo from Rome to France, Joachim du Bellay from France to Rome and back again, Pater's European Renaissance is connected by means of individuals who in their exchange of ideas, artistic styles, and literary fashions tie Europe together into one coherent culture, in spite of regional and national differences and conflicts. Pater's imaginary portraits serve a similar function: Greece, Italy, France, Germany, Holland, and England provide background locations for protagonists in movement, from North to South, across the Channel, from periphery to centre and back again, making us question our own preconceived ideas of place, of centre, and periphery. The following list gives an idea of the chronological and geographical spread of Pater's portraits:

- 'Hippolytus Veiled: A Study from Euripides' (1889): Greece fifth century BC;
- *Marius the Epicurean* (1885): Italy second century AD;
- 'Tibalt the Albigense' (fragment, c.1890): thirteenth-century France;
- 'Denys l'Auxerrois' (1886): thirteenth- to fourteenth-century France;
- 'Apollo in Picardy' (1893): fourteenth-century France;
- 'Gaudioso the Second' (fragment, c.1890): sixteenth-century Italy';
- *Gaston de Latour* (1888–9): sixteenth-century France;
- 'Sebastian van Storck' (1886): seventeenth-century Holland;
- 'A Prince of Court Painters' (1885): eighteenth-century France;
- 'Duke Carl of Rosenmold' (1887): eighteenth-century Germany;
- 'The Child in the House' (1878): nineteenth-century England;
- 'An English Poet' (fragment c.1878): nineteenth-century France and England;
- 'Emerald Uthwart' (1892): early nineteenth-century England;
- 'Thistle' (MS fragment c.1890): nineteenth-century England.

Pater's European imagination is the imagination of a writer who could recreate a Europe of the past, imaginatively positioning himself in medieval France, seventeenth-century Holland, or eighteenth-century Germany, while that Europe was none the less vivid than his recollections of having been a day-boy in the King's School, Canterbury. Pater's protagonists may be versions, splittings of his own self, time travelling into foreign cultures, as argued by Gerald Monsman and Max Saunders.[19] If, as Saunders claimed with more than a verbal nod to Pater, the 1870s to

[17] Ibid., 29. [18] Potolsky, 80.
[19] Gerald Monsman, *Pater's Portraits: Mythic Pattern in the Fiction of Walter Pater* (Baltimore: Johns Hopkins University Press, 1967); *Walter Pater's Art of Autobiography* (New Haven: Yale University Press, 1980).

the 1930s was the period when 'autobiography increasingly aspire[d] to the condition of fiction', then modernism constantly engaged with it dialectically, 'rejecting it in order to assimilate and transform it'.[20] Pater's role as gatekeeper to modernist autobiografiction is crucial and is an argument for a much broader readership for this book than the circles of Pater scholars. Pater hovers as the *eminence grise* over at least a generation of modernist writers, and the significance for twentieth-century literature of his continued toying with the fictitious and authorial self in its many forms deserves renewed attention. When it comes to literary form, to voice, irony, intertextuality, and a questioning of the very concept of the self, Pater is a forerunner of Joyce, Eliot, Pound, Harold Nicolson, Woolf, and although aspects of this legacy have been critically explored,[21] there is more to be said on the matter with a starting point in the imaginary portraits.

Well aware that 'character' is a literary construct and 'self' a philosophical concept, Anna Budziak argued for a merging of the two in her application of Richard Rorty's liberal pragmatism and Richard Shusterman's pragmatic aesthetics to Pater and Wilde's imaginary portraits.[22] By doing so, she captured what she called Pater and Wilde's 'Doppelgänger selves', arguing that their decadent characters are alike: 'restless and dramatically divided between their cerebral and sensuous attributes.'[23] The textually based discursive selfhood of Rorty's pragmatism blends with Shusterman's somaesthetics in Pater and Wilde's fictitious figures, but while capturing some very important aspects of English decadence in her analysis, Budziak leaves out the problematic, yet undeniable, aspect of the authorial self. No genre 'can escape the impress of the autobiographical': the authorial self always leaves his or her imprint on the text.[24] Pater's imaginary portraits are cerebral, textual, somatic, and autobiografictional all at once. His playful use of the autobiographical dimension covers the full range from covert, unconscious, or implicit to the very explicit, as Emerald Uthwart's school days come close to Walter Pater's own.[25] Life-writing may be fundamentally intertextual,[26] and if so, Pater's intertexts are partly his own, but also the plethora of centuries of European art and literature which constitute his imagination and contribute towards the making of the Paterian self.

So, this is also a book about Pater the person; not a biography in the conventional sense of the word,[27] but a study in his readings, his viewings, his working methods,

[20] Saunders, 22.

[21] See Perry Meisel, *The Absent Father: Virginia Woolf and Walter Pater* (New Haven: Yale University Press, 1980); F. C. McGrath, *The Sensible Spirit: Walter Pater and the Modernist Paradigm* (Florida: University Press of Florida, 1986); Lesley Higgins, *The Modernist Cult of Ugliness: Aesthetic and Gender Politics* (New York: Palgrave Macmillan, 2002); Angela Leighton, *On Form: Poetry, Aestheticism, and the Legacy of a Word* (Oxford: Oxford University Press, 2007).

[22] Anna Budziak, *Text, Body and Indeterminacy: Doppelgänger Selves in Pater and Wilde* (Newcastle: Cambridge Scholars Publishing, 2008).

[23] Ibid., vi.

[24] Saunders, 3. See also Laura Marcus, *Auto/Biographical Discourses* (Manchester: Manchester University Press, 1994).

[25] Peter Henderson, 'An Annotated Version of "Emerald Uthwart"' (Canterbury: King's School, 1994).

[26] Saunders, 5.

[27] Very few biographies of Pater exist; the challenge of constructing a life on the basis of a relatively limited body of primary material has resulted in less than a handful of lives. See A. C. Benson, *Walter Pater* (London: Macmillan, 1906); Thomas Wright, *The Life of Walter Pater*, 2 vols (London: Everett & Co., 1907);

6 WALTER PATER'S EUROPEAN IMAGINATION

his circles, the ways in which he became an Oxford character, and the long shadow cast onto his immediate afterlife. Much attention has been paid recently to Pater the philosopher, in constant discourse with ancient, eighteenth-, or nineteenth-century philosophy,[28] and while no one would dispute Pater's status as a great thinker, profoundly indebted to centuries of philosophical thought, we must also, I think, consider him as a body, as an aesthete absorbing the material world through all his senses. The significance of Pater's mouth and Pater's nose has been explored and copiously documented;[29] my own work on Pater and sculpture adds touch to taste and smell in an attempt to arrive at a three-dimensional author.[30] But the Paterian body as a viewing body, a travelling body, perceptive of space and landscape, needs further addressing, and the geographies of his imaginary portraits invite us to do just that. Pater's Europe is both experienced and imagined, both tangible and ethereal. He spent most of his long vacations travelling the Continent, primarily France and Italy, and his encounter with sites of memory, with artworks and architecture, together with his sensitivity to the spirit of place, fed into his portraits and made them sometimes hauntingly evocative. Being an armchair traveller was not enough; Pater's European imagination needed stirring by the physical world.

The Imaginary Portrait

The very notion of an imaginary portrait is inherently paradoxical. 'Imaginary portraits of real people; or portraits of imaginary people?', Saunders asks. 'Either way, they are roughly the auto/biographical equivalent of Magritte's painting "La trahison des images" [The Treachery of Images; 1928–9]of a pipe, captioned "Ceci n'est pas une pipe."'[31] Magritte's surrealist tease challenges the conventional way of decoding signs, our expectation of a correspondence between word and image. What you see is not the real thing but a representation, and either your reading skills or your visual decoding skills fail you in the interplay between word and image. If we free portraiture from referentiality, from likeness, what, then, are we left with? Inevitably we bring our expectations from visual portraiture to our encounter with a literary genre called imaginary portraits and expect to find some representation of the real world. We are invited to consider the problems involved in portrayal which all too easily, as

Michael Levey, *The Case of Walter Pater* (London: Thames and Hudson, 1978); Denis Donoghue, *Walter Pater: Lover of Strange Souls* (New York: A. Knopf, 1995).

[28] See Giles Whiteley, *Aestheticism and the Philosophy of Death: Walter Pater and Post-Hegelianism* (Oxford: Legenda, 2010); Kate Hext, *Walter Pater: Individualism and Aesthetic Philosophy*, Edinburgh Critical Studies in Victorian Culture (Edinburgh: Edinburgh University Press, 2013); Sara Lyons, *A. C. Swinburne and Walter Pater: Victorian Aestheticism, Doubt, and Secularisation* (Cambridge: Legenda, 2015); Section 4 on Philosophy in *Pater the Classicist: Classical Scholarship, Reception, and Aestheticism*, ed. Charles Martindale, Stefano Evangelista, and Elizabeth Prettejohn (Oxford: Oxford University Press, 2017), 259–24; Adam Lee, *The Platonism of Walter Pater: Embodied Equity* (Oxford: Oxford University Press, 2020).

[29] Matthew Kaiser, 'Pater's Mouth', *Journal of Victorian Literature and Culture* 39:1 (March 2011), 47–64; Catherine Maxwell, *Scents and Sensibility: Perfume in Victorian Literary Culture* (Oxford: Oxford University Press, 2017), 117–34.

[30] Lene Østermark-Johansen, *Walter Pater and the Language of Sculpture* (Farnham: Ashgate, 2011).

[31] Saunders, 40.

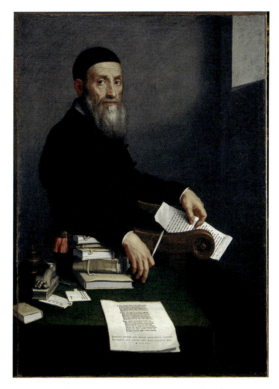

Fig. 0.1. Giovan Battista Moroni, *Giovanni Bressani* (1562), oil on canvas, 116.2 × 88.8 cm. National Galleries of Scotland, Edinburgh. Purchased by Private Treaty 1977.

Marcia Pointon suggests, becomes a betrayal. Is it at all possible to capture the self in writing or in painting?

The term 'imaginary portrait' was not Pater's coinage; it can be traced back to the late eighteenth century.[32] I am intrigued by how it was used in Royal Academy catalogues in the 1870s, shortly before Pater employed the term for the first time in 1878. When Giovan Battista Moroni's portrait of the poet Giovanni Bressani of 1562 (Fig. 0.1) was exhibited in the Royal Academy Winter Exhibition in 1870, it bore the title *Michael Angelo: An Imaginary Portrait. From the Manfrini Gallery, Venice, where it was so called*.[33] The owner of the painting, Baron Meyer de Rothschild, admitted that 'This is a very strange title and has often excited much doubt and curiosity. . . . At all events many critics and literary men will see it in your collection and it will be discussed and perhaps new light will be thrown on the subject.'[34] The imaginary aspect of the title related to the sitter's identity; could the seated scholar really be Michelangelo who by 1562 was an old man, living in Rome, while Moroni was

[32] See 'Critical Introduction' in *CW* 3:4–9.

[33] *Exhibition of the Works of the Old Masters, Associated with a Collection from the Works of Charles Robert Leslie, R. A. and Clarkson Stanfield, R. A.* (London: William Clowes & Sons, 1870), cat. no. 20.

[34] Quoted in Francis Haskell, *The Ephemeral Museum: Old Master Paintings and the Rise of the Art Exhibition* (New Haven and London: Yale University Press, 2000), 75.

8 WALTER PATER'S EUROPEAN IMAGINATION

operating in Bergamo in northern Italy?[35] Although a poet and a learned man, Michelangelo was primarily a sculptor, painter, and architect, and not likely to be depicted as a scholar. Only relatively recently has Moroni's sitter been identified as Bressani.

With his portrait Moroni was resurrecting the dead and implicitly questioning likeness and referentiality. Although depicted pausing momentarily from the act of writing, one arm resting on a pile of books, Bressani had actually died in 1560. Pushed back against a grey wall, he is distanced from the viewer by the table with its many objects, as if to indicate the unbridgeable distance between spectator and sitter, now that the latter has joined the world of shades. By comparison, Moroni's portrait of an anonymous tailor (Plate 3.1) establishes a much closer relationship between sitter and spectator; the table in the foreground is at a different angle, and the scissors and cloth reach out towards us, while the codpiece reminds us of a living and virile sitter who, with his bright colours, stands out against the background. The portrait of Bressani is a speaking picture; Moroni's two inscriptions lend a voice to both artist and sitter, hinting at the posthumous: on the base of the foot-shaped inkstand, we read 'IO: BAP. MORON. / PINXIT QVEM NON VIDIT' [Giovanni Battista Moroni painted him whom he did not see]. Bressani gazes directly at the viewer, and the painter's clever paradox of rendering someone he had never met in real life into such a vivid figure some two years after his death becomes a praise of the artist's skill in bringing the dead back to life, while questioning the very issue of likeness. Moroni based his portrait on a medal of Bressani,[36] so although his assertion of authorship toys with seeing and blindness, presence and absence, the artist did see before he painted, as one artwork led to another. On the bottom of the sheet of paper in the foreground the sitter leaves us a message from beyond the grave: 'CORPORIS EFFIGIEM ISTA QVIDEM BENE PICTA TABELLA / EXPRIMIT, AST ANIMI TOT MEA SCRIPTA MEI. / M. D. LXII.' [This painted picture well depicts the image of my body, but that of my spirit is given by my many writings. 1562]. The separation of body and spirit, which sets in at the moment of death, has taken place, and while life is short, art is long: the physical and spiritual parts of Bressani live on in paint and literature, respectively. A monument to artist and sitter, to painting and writing, the portrait asserts its powers to transcend time, irrespective of likeness.

When the term 'imaginary portrait' again appeared in the Royal Academy catalogues, it was linked to a mythological Swiss figure: in 1875 cat. no. 167, *William Tell: An Imaginary Portrait* was attributed to Hans Holbein (Fig. 0.2).[37] The rather daring Renaissance male nude was cropped just above the genitals, thus leaving the rest of

[35] When the painting was sold in 1977, there was still some uncertainty about the sitter's identity, see *Mentmore. Catalogue of Paintings, Prints and Drawings Sold on Behalf of the Executors of the 6th Earl of Rosebery and his Family*, which will be auctioned by Sotheby Parke Bernet & Co. on Wednesday, 25 May 1977, 5 vols (London: Sotheby's, 1977), iv: 8, lot. 2049, *Portrait of a Scholar*.

[36] See Aimee Ng, Arturo Galassino, and Simone Farrchinetti, *Moroni: The Riches of Renaissance Portraiture* (New York: Scala, 2019), cat. nos. 21 and 22.

[37] *Exhibition of Works by the Old Masters, and by Deceased Masters of the British School, including a Special Selection from the Works of Sir A. W. Callcott, R. A. and D. Maclise*. Winter Exhibition (London: William Clowes & Sons, 1875).

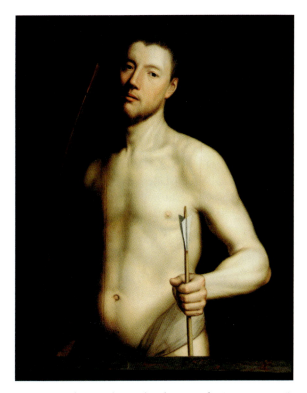

Fig. 0.2. Antonis Mor, *St Sebastian* (*c*.1550), oil on panel, 90 × 73.7 cm. Graves Gallery, Sheffield. Sheffield Museums Trust.

his body to the realm of the imaginary.[38] It provoked critical responses about the identities of sitter and artist, and about the correct use of the term 'imaginary portrait'. One critic declared that '*William Tell* (167) is, indeed, as the Catalogue states, "an imaginary portrait", but it can hardly be a Holbein',[39] and concluded that it looked more like a Saint Sebastian than the Swiss national hero, an identification supported by the *Art Journal* and the *Saturday Review*, where it was referred to as a 'truly "imaginary portrait"'.[40] The true, the real, and the imaginary engage in a strange encounter here, presumably rooted in myth taking material form. Capturing myth in paint was nothing new: history painting abounds in mythological figures, as do allegorical portraits. What stirred the Victorian critics may well have been the sense of the real: this is a real man posing as a mythological figure with some sense of performativity, but also

[38] It remains uncertain when the painting acquired the term 'imaginary portrait'. In John Young, *A Catalogue of the Pictures at Leigh Court, near Bristol; the Seat of Philip John Miles, Esq. M.P. with Etchings from the Whole Collection* (London: Bulmer & Nicol, 1822), it figures as cat. no. 74, '*William Tell* by Holbein'. When the Collection was sold in 1884 it was entitled *William Tell: An Imaginary Portrait* (cat. no. 32). See *Catalogue of the Leigh Court Gallery. The Property of Sir Philip Miles, Bart M.P. will be Sold at Auction by Messrs Christie, Manson & Woods on Saturday 28 June 1884* (London: Christie, Manson & Woods, 1884).

[39] Anon., 'The Royal Academy Winter Exhibition', *Athenaeum*, 2465 (23 Jan. 1875), 128.

[40] Anon., 'The Old Masters at the Royal Academy', *Saturday Review*, 39 (16 Jan. 1875), 82.

10 WALTER PATER'S EUROPEAN IMAGINATION

succumbing to, slipping back into the real. Now identified as a northern European *Saint Sebastian* (*c.*1550) by Antonis Mor, the painting's daring nudity is accounted for by a long tradition. Seductively confrontational in his gaze, part of his face covered in darkness, Mor's Sebastian is real and ideal at the same time. The firm and shapely body, painted with great attention to skin tones, muscle contours, and shadings, is framed by the genital region and the head with its ruddy cheeks and red open mouth, inviting erotic touch. Although much is permissible with reference to the Old Masters, Mor's painting is erotically explicit and an interesting contrast to the many portraits of fully dressed men and women he painted for the Tudor and the Habsburg courts in the mid-sixteenth century.

My reason for dwelling on these instances of the use of 'imaginary portrait' is to draw attention to the fact that the term was already in circulation in the periodical press, in the galleries, and in the exhibition catalogues, provoking thoughts of the real and the ideal, likeness and myth. Although I have no evidence that Pater visited the Winter exhibitions (it is very likely that he did),[41] or that he read the reviews of those particular exhibitions, he was publishing his imaginary portraits to an audience quite possibly familiar with the term and with Old Master portraiture, exhibited not just at the National Gallery, but at many other venues, and provoking debates about the genre. Pater would himself have been a far from disinterested viewer in front of Mor's *Saint Sebastian*; since the Renaissance the saint of archers and reliever of pestilence had been a popular gay icon, to use an anachronistic term, a welcome opportunity for artist and spectator to depict and enjoy the sight of an attractive male nude. In 1886 Pater would choose Sebastian as the name for his Dutch protagonist, in an autobiografictional mode. On the opening page of A. C. Benson's 1906 life of Pater, the author discussed Pater's Dutch ancestry and gave us the following anecdote: 'In a journey through Holland, Walter Pater was much interested in a picture at Amsterdam, by van der Helst, of archers, with a tablet giving the names of the winners in a contest of skill; at the top of the list stands the name Pater.'[42] The painting is van der Helst's 1653 group portrait of *The Four Archers of the St Sebastian Guards* (Fig. 0.3), with four prominent burghers in the foreground (the brewer Albert Dircksz Pater third figure from the left, with a moustache imitated by his English descendant), with two archers in the background and a blackboard with a list of four names, 'D. Pater' at the top and van der Helst's signature at the bottom.[43] In 'Sebastian van Storck', Sebastian's father would fantasize about a portrait painted of his son by van der Helst, a portrait which remains imaginary, as Sebastian refuses to be captured in paint.

Now, what do these loose hints—a nude Sebastian in the Royal Academy, a painting in Amsterdam, and a posthumous anecdote about Pater in search of his ancestry

[41] If Pater did not see the Mor painting in 1875, he had a second chance in 1880 when it was again exhibited with the same title. See *Exhibition of Works by the Old Masters and by Deceased Masters of the British School, including a Special Collection of Works by Holbein and his School*. Winter Exhibition 1880 (London: William Clowes & Sons, 1880), cat. no. 203.

[42] Benson, 1.

[43] See D. C. Meijer, 'The Amsterdam Civic Guard Portraits within and outside the New Rijksmuseum. Pt III. Bartholomeus van der Helst', tr. Tom van der Molen, *Journal of Historians of Netherlandish Art* 6:1 (Winter 2014), 1–24.

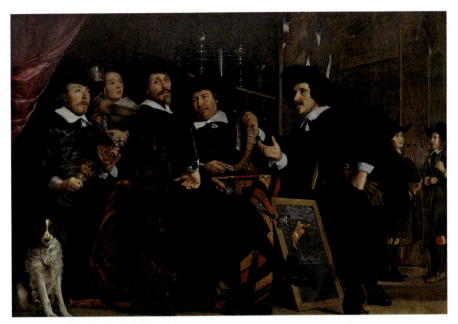

Fig. 0.3. Bartholomeus van der Helst, *The Four Archers of the St Sebastian Guards/The Governors of the Archers' Civic Guard* (1653), oil on canvas, 183 × 268 cm. Amsterdam Museum, Amsterdam. Photo Amsterdam Museum/Niels den Haan (photo after phase 2 restoration 2019).

in the Dutch museums—suggest as trails leading towards 'Sebastian van Storck'? Pater's contemporary, Sherlock Holmes, might well detect an author with a keen eye for visual detail, attracted by young men of his own sex, and with an extraordinary ability to interweave past and present, self and other, at home and abroad, myth and fact. Such a characterization sums up some of the complexities of Pater's imaginary portraits and the many components that went into their making: gallery visits, actual artworks, critical discourse in catalogues and the periodical press, private travel and personal myth, interwoven with European art and literature. Like the language in which he was writing, Pater was by nature inclined towards the accumulative and the assimilative; the Pater manuscripts in the Houghton Library at Harvard suggest that he was working on many different projects at the same time,[44] and as characters were gradually forming themselves in his mind over a long gestation period, the Paterian synthesizer blended ideas, experiences, and impressions into his European portraits. Pater was struggling to define what he meant by an imaginary portrait, as revealed from one of the slips of paper on which he habitually jotted down spontaneous thoughts and ideas:

[44] See Houghton bMS Eng. 1150, Houghton Library, Harvard University.

12 WALTER PATER'S EUROPEAN IMAGINATION

Imaginary: because—
and portraits, because they present,
not an action, a story:
but a character, personality, revealed
especially, in outward
detail.[45]

The blank, elliptical space after 'Imaginary' is telling in itself; sometimes silence speaks more than words. Pater's search for the appropriate terms to capture a shapeless vision assuming form in the imagination, the imago becoming image, proved, at least momentarily, futile. He may well have needed more time and space than allowed by his small slip of paper—the imaginary is not easily defined.[46] His idea of the portrait as something rooted in personality and character could more easily be paraphrased. Readers looking for action and complicated plots in Pater's portraits will be sorely disappointed: compared to the plot-driven fiction which proliferated in mid-Victorian periodicals, the story-line of Pater's portraits is tame. We tend to find the chronicling of a few years in the life of a young man, with a few journeys from one place to another. The great and significant events, usually death, take place suddenly within the very last pages. Pater's note testifies to his deliberate exclusion of action and story, to his engagement with the portrait as something non-narrative. His mentioning of 'character' and 'personality' as synonyms for 'portrait' is intriguing; with one or two exceptions, his protagonists are rarely subjected to a deep exploration of character and could hardly be described as psychological portraits. He most likely intended personality to be rooted in both time and place; the emphasis on 'outward detail' suggests that geographical location, interiors, architectural structures, and historical period all contribute towards the construction of character, something which justifies my division of the latter half of this book into the poetics of space, place, and time.

We must also acknowledge Pater's joy in inventing figures, an aspect of his character often overlooked in scholarly attempts to disentangle his philosophy or trace intertextual references. The accounts by some of Pater's close friends of his imaginary family testify to a much more playful man than the standard image of the reserved Oxford don, author of a philosophical novel set in Antonine Rome, and dense pieces of criticism. The Pateresque resided in a profound delight in the construction of imaginary character, refined over a lengthy period until the imaginary became almost real. A. Mary F. Robinson's recollection of a Christmas visit to the Pater household, neighbours in Earl's Terrace London, allows us a rare glimpse into Paterian privacy.[47] Tiptoeing into the parlour, Robinson interrupted a conversation between the three siblings, Walter, Hester, and Clara, revolving around an aunt, about to arrive with presents. Pater turned to the visitor to include her in the conversation:

[45] Brasenose College Archives, PPI B2/1.

[46] See my discussion of 'imaginary' versus 'imaginative' in the 'Critical Introduction', CW 3:3–5.

[47] For Pater's friendship with Robinson, see Ana Parejo Vadillo, 'The Crownless A. Mary F. Robinson', Studies in Walter Pater and Aestheticism 2 (2016), 71–84.

'We no longer have parents', he told me, 'save our brother the doctor who is always away.[48] And as children we were in that way deprived. That is why we amuse ourselves by inventing a game of ordinary parents. One has a need especially during this season to occasionally strengthen family ties. We are waiting for my aunt, the best of women, with her sister, who is a little harsh! But we love the one like the other; it would cause us great pain were she to pass away. These beings, I must admit, do not exist; they were born of a caprice of our fantasy, and with time became as real as ourselves: a bit of glittering gold, dull silken thread which we know will no longer wrest the fabric of our days.'

Outside the snow falls as softly as the words of Walter Pater. One should not smile at the tranquil peace where the brother and his two sisters employ themselves by 'inventing a family' in this unusual manner. The youngest of these infants was more than forty years old.[49]

Pater's admission that his imaginary aunts were as real as himself is suggestive of his constant toying with fact and fiction to the extent that the death of even an imaginary aunt becomes a possibility. Like the solitary child who invents an imaginary friend, the Paters made up for their collective loneliness by inventing aunts with an edge. There had been parents, even aunts,[50] in their lives, and the figures conjured up that December evening probably owed something to memory and something to wishful thinking. Having recently transferred from Oxford to Kensington, the Paters were peopling a new house with imaginary aunts, long-standing members of the small family, not tied to any architectural structure, as ghosts so often are, but moving with the siblings, as they changed their abode. The atmosphere of the Pater home hovers somewhere between quiet amusement and deep seriousness, and Robinson's vignette gives us a sense of the siblings' shared delight in the invention of character and the construction of a narrative, interlacing the movements of real family events. The portrait of the three orphaned children, middle-aged male and female spinsters, weaving a protective shield of older relatives around their solitary existence, owes as much to Robinson's as to Pater's fondness for blending tale with atmosphere: the soft snow, the subdued voice of the great writer, the end of the year, the elegiac sadness of mid-life without parents and without issue all merge into its own peculiar ghostly Christmas carol of the spirits of Christmas past, present, and future.

Edmund Gosse's more prosaic account of Pater's imaginary aunts and uncles with the silly names confirms Robinson's anecdote: 'One playful fancy, persisted in so long that even close and old friends were deceived by it, was the figment of a group of relations—Uncle Capsicum and Uncle Guava, Aunt Fancy (who fainted when the word 'leg' was mentioned), and Uncle Tart (for whom no acceptable present could

[48] William Pater died in the spring of 1887, and the Paters moved to London in the autumn of 1885, so the anecdote must derive from the Christmas of either 1885 or 1886.

[49] Mary Duclaux, née Robinson, 'Souvenirs de Walter Pater', *La Revue de Paris* 1 (15 Jan. 1925), 339–58. Quoted from R. M. Seiler, ed., *Walter Pater: A Life Remembered* (Calgary: University of Calgary Press, 1987), 63–78, 68.

[50] Pater's father, Richard, had died in 1842, when Walter was only three years old, his mother, Maria, in 1854, when he was fifteen. His Aunt Hester, who brought up the children after their parents' death, had died in December 1862.

14 WALTER PATER'S EUROPEAN IMAGINATION

ever be found). These shadowy personages had been talked about for so many years that at last, I verily believe, Pater had almost persuaded himself of their existence.'[51] In his obituary portrait of Pater, Gosse declared that the imaginary relatives 'were all a part and parcel of his complex and shrouded intellectual life, and therefore not to be forgotten,'[52] giving us a glimpse of a middle-aged writer who never outgrew the need for the imaginary friends most of us abandon in childhood. The child in the Paterian household is never allowed to grow up by his biographer, and Gosse implies a rich imaginative life which connects Pater's private and professional selves in a closeted, secretive existence. The otherwise fact-focused Gosse, stressing his own privileged status as the author's old friend, occasionally lapses into the realm of the anecdotal in order to bring his subject to life, before Pater, like his imaginary relatives, disappears into the shadows of the past.

Imaginary relatives are a kind of splitting of the self into the past; Aunt Guava and Uncle Capsicum, suggestive of the Paterian mouth, of the sweet and the spicy, take us far away from the fogs of December London to the sunny and exotic South. The somaesthetics of the imagination, the body and its sensory impressions, guided the way in which Pater conceived of his fiction. His covering letter to the Editor of *Macmillan's Magazine*, accompanying the first of his imaginary portraits, suggests pictoriality: Pater invited his reader to conceive of his projected series as a gallery, where portraits are at once separate depictions of unique individuals and participants in a narrative sequence, denoting the march of history and generations. Reading and seeing, outer and inner sight, are at the heart of the imaginary portrait:

> Dear Mr. Grove,
>
> I send you by this post a M.S. entitled *The House and the Child*,[53] and I should be pleased if you should like to have it for Macmillans' [sic.] Magazine. It is not, as you may perhaps fancy, the first part of a work of fiction, but is meant to be complete in itself; though the first part of a series, as I hope, with some real kind of sequence in them, and which I should be glad to send to *you*. I call the M.S. a portrait, and mean readers, as they might do on seeing a portrait, to begin speculating—what came of him?
>
> Very truly yours
> W. H. Pater.[54]

The last sentence takes us back to Pointon's seductive and slippery encounter between spectator and portrait, to the viewer's refusal to abide by the painting's finality, and the desire to go beyond the frame and expand the present moment into a past-future tense, leaping into the interstitial space between then and now. We might speculate about the Paterian spectator in the museum. The absence of primary archival

[51] Edmund Gosse, 'Walter Pater: A Portrait', *Contemporary Review* 66 (1894), 795–810, 809.

[52] Ibid., 809.

[53] Subsequently published as 'Imaginary Portraits. I. The Child in the House', *Macmillan's Magazine* 38 (Aug. 1878), 313–21. This title is Pater's first documented use of the term.

[54] Pater to George Grove, 17 Apr. 1878; see *CW* 9 (forthcoming 2022). Of Pater's subsequent portraits, only the unfinished 'An English Poet' also carried the term in the title. See 'Imaginary Portraits 2: An English Poet', *Fortnightly Review* 129 (Apr. 1931), 433–48 (composition date 1878–80).

INTRODUCTION 15

material leaves us with many questions of Pater in the gallery.[55] Where did he go? Was he alone or in the company of friends or sisters? Did he take notes in front of the artworks, memorize images, or buy reproductive prints or photographs? Pater's writings testify to his familiarity with the National Gallery, the South Kensington Museum, the British Museum, the Royal Academy, the Grosvenor Gallery, and major European museums such as the Louvre, the Uffizi, the Brera, the Dresden Gemäldegalerie, and the Munich Glyptothek, together with a range of regional museums and churches in France and Italy. Unlike Henry James, who frequently employed the art gallery as a backdrop for crucial scenes in his fiction,[56] Pater never let his protagonists enter the museum world. His ekphrases of Renaissance paintings, of major sculptural works, imply an encounter between critic and artwork in a museum, but the gallery only enters Pater's writings as a framework for discourses on art late in his career.[57]

Pater fiction contains references to many more portraits than has hitherto been acknowledged. The ekphrastic powers in his art historical essays have been explored, often with a relatively narrow focus on the works of Leonardo, Botticelli, and Giorgione. The vast realm of images that people his fiction has never been examined at any length, nor has the grey-zone area of what James Heffernan calls 'notional ekphrasis', descriptions of imaginary works of art,[58] or the even more slippery hybrid of almost recognizable works. Sometimes Pater's protagonists have their origin in actual portraits or sculptures,[59] in a concern with the interrelationship between artwork and viewer, with the fundamental reciprocity of one self facing another, as the writer problematizes historical notions of the self. The walk-on parts of great thinkers like Marcus Aurelius, Montaigne, Bruno, Spinoza, and Goethe alert us to the fact that the representation of the individual is closely entwined with philosophical notions of

[55] If Pater ever kept a diary or a commonplace book, none has been found so far. His correspondence is notoriously discreet about his movements, both when at home and when abroad.

[56] See Adeline R. Tintner, *The Museum World of Henry James* (Michigan: University of Michigan Press, 1986); Jonah Siegel, *Desire and Excess: The Nineteenth-Century Culture of Art* (Princeton: Princeton University Press, 2000).

[57] In 'The Heroic Age of Greek Art' Pater spoke of 'the grey walls of the Louvre or the British Museum' and of the modern spectator's need to reconstruct a Greek architectural background and a blue sky in order to perceive ancient Greek sculpture correctly. *CW* 8:114.

[58] James A. W. Heffernan, *Museum of Words: The Poetics of Ekphrasis from Homer to Ashbery* (Chicago: Chicago University Press, 1993), 9–22.

[59] Jean-Baptiste Pater's portrait of his sister, Marie-Marguerite, inspired narrative voice and framework of 'A Prince of Court Painters'; the figure in the top-left panel in Romanino's *S. Alessandro Altarpiece* in the National Gallery is described in 'Gaudioso the Second', and Moroni's *Il Tagliapanni*, likewise in the National Gallery, would have provided Pater with a protagonist, had he lived to complete his manuscript. For the two unfinished pieces, see Gerald Monsman, 'Pater's Portraits: The Aesthetic Hero in 1890', *Expositions* 2:1 (2008), 83–102 and MS Houghton 1150 (22). See also Gloria Fossi, 'Le vite antiche di Watteau e il ritratto imaginario di Walter Pater', in *Walter Pater (1839–1894): Le forme della modernità. The Forms of Modernity*, ed. Elisa Bizzotto and Franco Marucci (Milan: Cisalpino, 1996), 81–110 and Lene Østermark-Johansen, ' "This will be a popular picture": Giovanbattista Moroni's Tailor and the Female Gaze', in *Knowing 'as much of art as the cat'? Nineteenth-Century Women Writers on the Old Masters*, ed. Susanna Avery-Quash and Hilary Fraser: special issue of '*19*' 28 (2019), https://doi.org/10.16995/ntn.822 (accessed on 6 Jan. 2021). Allusions to classical sculptures, such as the *Apollo Belvedere* and the *Discobolos*, merge with the *Calf-Bearer* in 'Apollo in Picardy', and sculptural ornament in the Cathedral in Auxerre may have inspired the figure of Denys. See Vernon Lee, 'Dionysus in the Euganean Hills: Walter H. Pater In Memoriam', *Contemporary Review* 120 (1 Jul. 1921), 346–53.

16 WALTER PATER'S EUROPEAN IMAGINATION

the self and theories about the interrelationship between body and soul. Pater's interest in the past makes him question how we represent the self at different moments in history, with the suggestion that the nature of our encounters with such representations reflects our own historical period. Raising issues of a 'period eye', he questions whether we see things differently, depending on our place in history. The interaction between the depicted self and the viewing self contributes towards our understanding of attitudes to the individual over time, and I suggest that we read Pater's imaginary portraits as an idiosyncratic and imaginative history of the European self from antiquity to the nineteenth century.

Readers may be surprised that Pater's only completed novel, *Marius the Epicurean* (1885), is given very little attention in this book, compared with the way in which his unfinished novel, *Gaston de Latour* (1888–94), is foregrounded. There are several reasons for this; one is that there is very little critical literature on *Gaston*, a text which deserves new attention, as it revolves around portraiture, an artistic genre only represented very sparsely in *Marius*. While *Marius* undeniably revolves around the building and development of the self, the novel's philosophical rather than artistic tenor lies slightly outside my framework. It is primarily the painted portrait from the Renaissance onwards which engages Pater as an artistic manifestation of the emergence of the modern self. I suggest that the mature writer intended his second novel to become a comprehensive study of portraiture with France as the meeting point of northern and southern portraiture at a time when the country was torn apart by internal religious wars. 'An age great in portrait-painting', is how Pater sums up Renaissance France in *Gaston* where portraits are ubiquitous and richly contextualized.[60] We have scenes in private portrait galleries and collections, descriptions of actual portraits, and Pater's perception of the self becomes gradually more material, even tangible. In his character drawing we see an increasingly strong presence of the face and the body; his portraits of the three historical figures (Ronsard, Montaigne, and Bruno) encountered by the young Gaston, engage with physiognomical description in a manner not hitherto seen. The interplay between the atmospheric and the material, between what Pater's Bruno would call 'shadow and substance', becomes increasingly complex, while the exploration of serial as opposed to individualized portraiture continues to be of major interest. Emblematic of so many of the aspects of portraiture which had fascinated Pater since the 1860s, *Gaston* reveals a mature author writing back at himself, returning to terms, phrases, ideas which he had employed in his early writing and which would have echoed in the minds of his readers in the 1890s, had the novel been completed.

Pater's theory that the Renaissance began and ended in France, framed by his essays on French medieval romance and Joachim du Bellay, may well have led him to the composition of *Gaston* as an exploration of the decadence of Valois culture: 'It was the reign of the Italians just then, over a doubly refined, though somewhat morbid, somewhat ash-coloured, Italy in France, more Italian still.'[61] The cultural, political, and military exchanges between France and Italy are at the heart of Pater's last book which became an opportunity to revisit his first. Pater's Leonardo essay had

[60] *CW* 4:125. [61] *CW* 4:110.

INTRODUCTION 17

ended with the artist expiring in the arms of François Ier. Our awareness of the major Leonardo paintings as part of the Royal French collection, lodged in the Louvre where they were studied by the nineteenth-century French decadents, is an integral part of our reading of the essay.[62] A long line runs from Leonardo's special type of beauty and his *Mona Lisa* to *Gaston de Latour* and its female protagonist, Marguerite de Navarre. *Gaston* began its life as a serial, with five consecutive instalments published in *Macmillan's Magazine* from June to October 1888, and then—presumably because the notoriously perfectionist author could not keep up the pace—the publication ground to a halt.[63] Pater's library borrowings reveal that he continued working on the novel until his death,[64] when some seven other chapters in manuscript form were found, left in different stages of completion. The volume which appeared posthumously in 1896 under the title *Gaston de Latour* consisted only of the previously published texts, to which had been added one manuscript chapter.[65] Not until Monsman's 1995 edition of the novel were all thirteen chapters published consecutively as a fragment of a much larger project which would most likely have consisted of twenty-four chapters, subdivided into four books of six chapters each.[66] We must regret that Pater did not finish *Gaston*; the fragment contains some of his most powerful writing, showing us an author with a full grasp of the English language, with a new and forceful style which elaborately interweaves foreground and background, historical events and individual character, public and private.

Foregrounds and Backgrounds

When Pater's volume of four imaginary portraits was published in 1887,[67] there was considerable disagreement among his contemporaries. One critic commented that 'These four points in the history of culture are all interesting, with fine backgrounds of color and of thought, and such as one would call "subjects made to his hand", were it not that Pater in a sense always creates his subject',[68] while another declared: 'These "portraits" have no background. There is not even a curtain between them and the infinite dreariness of space, without hope and without religion.'[69] Whatever Pater

[62] See J. B. Bullen, *The Myth of the Renaissance in Nineteenth-Century Writing* (Oxford: Oxford University Press, 1994), 273–98 for the French influence on Pater.

[63] A separate chapter on Giordano Bruno was published in the *Fortnightly Review* in August 1889. It was reworked into a book chapter entitled 'The Lower Pantheism'. See Samuel Wright, *A Bibliography of the Writings of Walter H. Pater* (New York: Garland Publishing, 1975), 37–8 and the textual introduction to *CW* 4.

[64] B. A. Inman, *Walter Pater and his Reading, 1874–1877: With a Bibliography of his Library Borrowings, 1878–1894* (New York: Garland Press, 1990), 473–84.

[65] See Wright, *A Bibliography*, 104–8.

[66] *Gaston de Latour: The Revised Text*, ed. G. Monsman (Greensboro: ELT Press, 1995).

[67] Walter Pater, *Imaginary Portraits* (London: Macmillan, 1887).

[68] G. E. Woodberry, Unsigned review, *Nation* 45 (28 Jul. 1887), 78–79. Quoted from Seiler 1980, 172–5, 173.

[69] E. C. Price, Unsigned review, *Spectator* 60 (16 Jul. 1887), 966–7. Quoted from Seiler 1980, 167–72, 171.

may have felt about the lack of critical consensus,[70] the textual weft and warp of foreground and background of the imaginary portraits constitute an intricate web in which one is inconceivable without the other. This division into foregrounds and backgrounds structures my book as one way of systematizing far too much material and far too many ideas. The first four chapters approach the construction of the foreground figure through a range of different prisms: the tension between type and individual, life-writing, voice, and character. The foreground chapters progress more or less chronologically, each singling out one or two portraits for analysis, often in dialogue with Pater's essays or reviews, demonstrating the cross-pollination between fiction and essays. Pater's treatment of identical issues within different literary formats reflects his own experiments with voices, modes, and print media, as the essays often appeared in other periodicals than the portraits. The last three chapters situate Pater's figures in space, place, and time. The chronicling of the self through a series of case studies of young men at significant moments of European history needed a careful selection of architectural and geographical locations, as well as of historical moments. The last half of the book addresses those Paterian backgrounds in order to stress Pater's vision of the cultural and historical cohesion of Europe.

The first chapter traces the origins of Pater's continued oscillation between the specific and the generic; only when we embrace this ambiguity do we grasp the complexity of his protagonists. It explores Pater's experiments with selves and genres in the period from 1864 to 1878, from the undergraduate society essay, to the art historical essay, to the first imaginary portrait. It also contextualizes Pater's portraits by examining the opposite journey, from individual to type, in Francis Galton's so-called composite portraits, invented during the 1870s and 1880s. Both Galton and Pater were interested in the transferral of mental images onto material form. The emergence of Pater's portraits alongside the birth of psychoanalysis and Galton's experiments with memory, mental images, and composite portraiture, needs addressing, and the study of the individual versus the type seems a productive way of doing so. Through his own photographic portraits Pater engaged with self as other in a way which prepared him for the imaginary portraits, aware of some of the elegiac aspects of photography as actively promoting nostalgia. Slicing out a brief moment of people's lives, photography freezes youth in art, as do the imaginary portraits, ostensibly in dialogue with painting, but perhaps also with an awareness of the new transparent medium. In his 'Diaphaneitè' essay of 1864 Pater began his pursuit of the ideal type, which would continue for some thirty years as the material and the tactile became increasingly present. Pater's diaphanous hero is attractive both for what he is in himself and for the ways in which he reflects his surroundings. 'Diaphaneitè' is a character study of a type, devoid of physiognomy and physicality, a study of a person without narrative, without background, without social relations—the very features which Pater would later add to his portraits.

[70] Oscar Wilde's 'Preface' springs to mind: '*Diversity of opinion about a work of art shows that the work is new, complex, and vital. / When critics disagree, the artist is in accord with himself.*' 'Preface' to *The Picture of Dorian Gray* (1891) in *The Complete Works of Oscar Wilde, The Picture of Dorian Gray. The 1890 and 1891 Texts*, ed. Joseph Bristow (Oxford: Oxford University Press, 2005), 3:168.

I subsequently discuss Leonardo as Pater's case study of one such transparent hero, displaying a unique transparency of vision, mind, memory, and technique which captures Leonardo's obsession with optics, rocks, crystals, mirrors, and the *sfumato* technique. Leonardo's concern with optics and mirrors casts a long shadow across the centuries, with interventions by Vasari, Pater, and Freud, all investing themselves in the enigmatic genius conjured up in biography, art critical essay, and psychoanalytic study. The mediated self, concerned with androgyny, male procreation, and splittings into recognizable types may have originated in Renaissance Florence, but it had a *fin-de-siècle* appeal which became a mark of modernity. As constructed images intended to correspond to an abstract mental image of different human types, Galton's composite portraits challenged contemporary conceptions of photography as mimetic. Galton saw the composites as a mental image made manifest in physical form, emanations on the photographic glass plate of types stored in the mind of someone with particular visionary powers. Like Pater, he was challenging conventional notions of likeness, while aiming at an elusive type, at a face representing 'no man in particular'. For the nineteenth-century biometrist, the portrait of a type was not a contradiction in terms, and at a profound level, the composites question the stability and individuality of the modern self.

Chapter 2 deals with Pater and life-writing. One of its overarching ideas is that Pater's imaginary portraits were precursors of 'the New Biography', defined and discussed by the modernists in rebellion against the Victorian two-volume biography. The chapter is framed by Virginia Woolf and her father Leslie Stephen, general editor of the *DNB* (*Dictionary of National Biography*), to whom Pater gave a presentation copy of the *Imaginary Portraits*. The book became of formative influence on Woolf's own writing, with *Orlando* (1927) as the ultimate Paterian imaginary portrait. I argue that the *Imaginary Portraits* constitute a set of alternative lives: international in scope, ranging from a mythological figure in medieval France to an anti-hero in eighteenth-century Germany, Pater's slim volume poses a counter discourse to the patriotic monument of the *DNB*. Pater was himself a great reader of the lives of others, keenly aware of biographies as constructions reflecting the biographer as much as the biographee. He employed aspects of life writing from his first essays to the unfinished chapters of *Gaston*, and, as Laurel Brake points out, in *The Renaissance*, 'the "real lives" were sketched imaginatively, as characters in a narrative; and in the fiction, the imaginary lives are historicized and documented.'[71] *The Renaissance* and the portraits thus form a complementary pair, imparting a textual afterlife to the departed with an almost transcendental, spiritualist aspect. The conflation of commemoration and resurrection links biography to the obituary, raising such questions as what it takes to sum up someone's life? In his fiction Pater toys with the format of the brief life, or the obituary, in the final summing up the protagonist's life which concludes most of the portraits.

Focusing on 'An English Poet', the chapter explores Pater's merging of life-writing with the literary portrait, in dialogue with Sainte-Beuve's *portraits littéraires*. The interest in the origin of talent, which characterizes so many of Sainte-Beuve's

[71] Laurel Brake, *Walter Pater*, Writers and their Work (Plymouth: Northcote House, 1994), 45.

20 WALTER PATER'S EUROPEAN IMAGINATION

portraits, has a parallel in Pater's poet. Born in France, of Anglo-French origin, his *Bildung*, guided by his reading of English literature, results in a transnational poet whose life is foregrounded at the expense of the works. Pater invited the reader to contemplate the interrelationship between language, style, and literature arising out of an interplay with landscape, spirit of place, and national character. The chapter explores Pater's experiment with the portrait as literary criticism in the context of Macmillan's 'English Men of Letters' series. Editor John Morley's view that it took one man of letters to write the life of another resulted in volumes of compressed biography mixed with literary criticism, composed by some of the leading writers of the day. Pater's alternative lives find their place in the context of the *DNB* and the 'English Men of Letters' as studies in the brief, uneventful lives of people with little impact on history, while questioning what a life is and who is entitled to having their lives written and published.

The final section deals with some of the heirs to Pater's imaginary portraits.[72] With their Greek, Roman, Italian, French, and English subjects, Marcel Schwob's *Vies imaginaires* (1894–6) spanned a similar historical and geographical range. Schwob and Pater's lives revolved around strange and sudden deaths, reflecting the authors' keen awareness of their power to cut lives and narratives short. For modernist life-writing Pater became an influential presence: Lytton Strachey's *Eminent Victorians* (1918), Harold Nicolson, *Some People* (1927), and Woolf's *Orlando* (1927). Nicolson's 'method of writing about people and about himself as though they were at once real and imaginary' was praised by Woolf;[73] his self-conscious toying with degrees of authorial presence, with humour and irony as distancing weapons, has similarities with Pater. In Woolf's *Orlando* the protagonist is as much a reader as a poet, and a continued engagement with literature is an essential component of her exploration of *Bildung*. Her imaginary portrait becomes a piece of criticism, a catalogue of influence; Pater's presentation copy resides in the background as perhaps one of the most important of them all.

Chapter 3 explores Pater's work with literary form and voice with the aim of demonstrating how he was perfectly capable of constructing narrative, drama, and fictitious personalities, reflecting his own fondness for voice, wit, and parody. An examination of some of his working methods on the basis of manuscript drafts for unfinished portraits reveals Pater's deliberate use of narrative frame, with reference to techniques employed by other European nineteenth-century writers. His interest in literary hoaxes and publications which toy with the writer's authority reflects his approaches to narrativity. The chapter revolves around the diary format as a narrative and literary device in 'A Prince of Court Painters' and 'Sebastian van Storck'. With their French and Dutch settings, these two complementary portraits explore Pater's own European ancestry and employ a number of real and imaginary paintings as plot devices, chronicling the rise of the modern self in the seventeenth and eighteenth centuries.

[72] See Elisa Bizzotto, 'The Imaginary Portrait: Pater's Contribution to a Literary Genre', in *Walter Pater: Transparencies of Desire*, ed. Laurel Brake, Lesley Higgins, and Carolyn Williams (Greensboro: ELT Press, 2002), 213–23.

[73] 'The New Biography' in *EVW* 4:473–80, 475–6.

INTRODUCTION 21

Redefining the epistolary genre, Pater added layers of nineteenth-century interiority in a process of deformation which selected certain aspects of the diary novel, while suppressing others. The fictional diary exists in the interface between manuscript and print, private and public: on the page it imitates the entry in an actual diary, set apart with place and date, sometimes reflecting by its length, its space on the page, whether the particular day was an eventful one or not. A serial autobiography, with the plotlessness of a lived life, the diary can only be turned into a plot if edited into form and structure. As the chapter traces Pater's version of the female complaint in 'A Prince of Court Painters', it also discusses interiority as a feature of modernity and the act of writing as in itself an addictive one, related to the 'talking cure' of psychoanalysis.

Fascinated by what he called the renunciant type,[74] Pater was much inspired by Étienne Pivert de Senancour's novel *Obermann* (1804),[75] and by the Swiss philosopher Henri-Fréderic Amiel's *journal intime*.[76] Pater's Sebastian constitutes a fictitious counterpart to these two popular nineteenth-century texts. His journal is both symptom and cause of mental illness, a fetishistic addiction where the boundaries between self and diary are erased as an instance of 'pathographesis', the sustained writing out of bodily and mental pathology.[77] Like the 'wave of publications of the personal, private diaries of near contemporaries, of recently deceased figures of the immediate past' which flooded the French market at the *fin de siècle* to counterbalance the naturalist novel,[78] 'Sebastian van Storck' taps into a new fashion for self-centred, introspective *intimistes* who convey their rich interior worlds to the modern reader. While Pater bridges seventeenth-century France and Holland with nineteenth-century Switzerland and England, he ties together European mind, thought, and writing, questioning the beginnings of modernity.

Chapter 4 originates in my own sense of a problematic detachment from most of Pater's characters. His interest in the pictorial and the artificial makes for a new kind of protagonist with a surface existence whose actions are rarely explained in relational terms. As readers our expectations are teased by Pater's anti-heroes who seldom aim at the 'life-like'. As Paul Ricoeur pointed out, 'stories are recounted, life is lived', thus addressing the intersections between the world of the text and the world of the reader, the insides and the outsides of a text, with the awareness that it is the reader who must complete the story, bringing to it referentiality, communicability, and self-understanding.[79] And yet, how much referentiality can we bring to Pater's silent characters, deprived of dialogue, conventionally one of the chief literary devices for conveying character? Several of his protagonists are mythological figures; can such figures ever become characters? Is Pater not deliberately suggesting a

[74] 'Amiel's "Journal Intime"', *Guardian* (17 March 1886), in *Essays from the Guardian*, 19–37, 24.

[75] Étienne Pivert de Senancour, *Obermann*, with a Biographical and Critical Introduction by Arthur Edward Waite (London: P. Wellby, 1903).

[76] *The Journal Intime of Henri-Frédéric Amiel*, tr. and intr. Mrs Humphry Ward, 2 vols (London: Macmillan, 1885).

[77] See George S. Rousseau and Caroline Warman, 'Writing as Pathology, Poison or Cure: Henri-Frédéric Amiel's *Journal Intime*', *Studies in Gender and Sexuality* 3:3 (2002), 229–62.

[78] Lorna Martens, *The Diary Novel* (Cambridge: Cambridge University Press, 1985), 115–16.

[79] Paul Ricoeur, 'Life in Quest of Narrative', in *On Paul Ricoeur: Narrative and Interpretation*, ed. David Wood (London and New York: Routledge, 1991), 20–33, 25.

22 WALTER PATER'S EUROPEAN IMAGINATION

non-realist universe by entitling his fiction 'imaginary portraits', questioning the very concept of likeness and suggesting the dreamlike, the allegorical, the mythological? The chapter may raise more questions than it answers and does not result in a neat definition of how Pater conceives of or constructs character. It adopts a prismatic approach, first by stressing the parallels between the portraits and tragedy, placing Pater in dialogue with Euripides and Philostratus. Secondly it ponders the connection between Pater having himself become a parodic character in novels by W. H. Mallock, Vernon Lee, Mary Ward, and Oscar Wilde, and his taking up the genre of the portrait. The fluid boundaries between character and caricature are explored with the underlying argument that some of Pater's own emotional detachment from his characters, often expressed through ironizing narrators, derives from his need to respond to the criticism of his style, person, and ideas.

Most of Pater's portraits end with the early death of the protagonist. As Pater aestheticizes classical tragedy, he recreates Euripides' *Bacchae* in 'Denys l'Auxerrois' and rewrites his fragmentary Hippolytus play. Philostratus' *Imagines* serve as likely intertexts for some of Pater's mythological portraits, as they employ the ekphrastic form of the short prose narrative in a transformation of the plots and characters of Greek tragedy into brief descriptions of paintings. In making use of this pictorial device, both Pater and Philostratus exploit narrative frames, while dwelling on the image of the handsome youth, slain too early. Pater's fascination with the Second Sophistic period pervades *Marius the Epicurean*, and some of the sophisticated rhetorical devices of Philostratus which break frames and create effects of hyper-realism find their way into Pater's portraits.

The second part of the chapter deals with the Theophrastan character study and makes the unlikely journey from Theophrastus to Max Beerbohm.[80] The Theophrastan *Characters* form counterparts to Philostratus' *Imagines*: a short, isolated form, centring on the human individual, arranged in a sequence which may be rearranged, just like the portraits in a picture gallery. The chapter makes a case study of William Rothenstein's *Oxford Characters* (1896) which includes a portrait of Pater and Pater's character sketch of Frederick Bussell.[81] *Oxford Characters* addresses the essence of Oxford life, implicitly asking what an Oxford character is. The Paterian educator becomes a recognizable type who speaks Pateresque and holds aesthetic ideals, most of which can be traced back to misreadings of *The Renaissance*. As a subversive form, parody dissolves boundaries between one author and another while questioning our ideas about the integrity of personality and artistic product. What Pater in his essay on Lamb called 'the *Montaignesque* element in literature' dealt with the duplicity of being both self and other in one's writing,[82] and with the narrator himself as a character in 'Duke Carl of Rosenmold', Pater constructed a witty and fitting riposte to Mallock's *New Republic* (1876), in which he had himself been parodied.[83]

[80] J. W. Smeed, *The Theophrastan 'Character': The History of a Literary Genre* (Oxford: Clarendon Press, 1985).

[81] William Rothenstein and Frederick York Powell, *Oxford Characters: Twenty-Four Lithographs by Will Rothenstein, with Text by F. York Powell, and Others* (London: John Lane, 1896).

[82] 'Charles Lamb: The Character of the Humourist', *Fortnightly Review* 24 (1 Oct. 1878), 466–74, 471–2.

[83] W. H. Mallock, *The New Republic: Culture, Faith and Philosophy in an English Country House*, intr. John Lucas (Leicester: Leicester University Press, 1975).

Chapter 5 revolves around what Gaston Bachelard called 'the poetics of space'.[84] For Pater, architectural space constitutes a balance between the material and the immaterial, between bricks and mortar, dreams and memories. I am interested in these embodied spaces as sites of memory and belonging, on a private and personal level, and on the grander scale of collective and national memory. The chapter examines the physical and emotional life of the Paterian self in dialogue with architectural space, from the tiny house of the reliquary to the vast open spaces of the Gothic cathedral. Whether as home to dislodged human remains, shifted about through history as saints' relics often are, or as a grand religious edifice, Pater's houses constitute significant shells for the self in which interior and exterior interact. Bachelard's phenomenological topoanalysis plays some part in my discussion of architecture as a container of memories across Pater's writings. The chapter discusses the notion of 'home', central to Pater's circular narratives as a place from which to depart and return, at once womb and tomb. It traverses a range of domestic interiors, from Pater's own at Brasenose College to his criticism of the aesthetic interior in *Gaston* in dialogue with Oscar Wilde, Joris-Karl Huysmans, and Edmond de Goncourt. The empty interior holds a far greater potential for the imaginary than the furnished home; I explore Pater's engagement with literary tourism in *Gaston*'s visit to Montaigne, pondering Pater's imaginary reconstruction of a site which would have been an empty shell if and when he visited in the 1880s. Like Shakespeare's birthplace, the evocative empty space of Montaigne's tower was a site of memory, embodying a sense of absence, while serving as a stimulus to the imagination as loss begets memory and narrative. Although fascinated with urns, sarcophagi, and reliquaries, Pater had a claustrophobic fear of death and burial;[85] the dead are often exhumed or erupt to the surface in his writing. The chapter traces his concern with exhumations and resurrections from 'Denys l'Auxerrois' (1886) over the essay on Thomas Browne (1886), to 'Gaudioso the Second' (1890s). Pater's love of the gothic in all its forms is reflected in his ghoulish obsession with death; the architectural framework of his exhumations resides in that northern European architectural style which Ruskin had promoted so forcefully. In close dialogue with Ruskin, the nature of Pater's gothic almost becomes a character in its own right.[86] Given Pater's use of gothic architecture as the framework for some of his portraits, he also engages with Merimée and Viollet-le-Duc, whose work on the preservation of gothic cathedrals reinstated them as national monuments at a time when, shortly after the defeat in the Franco-Prussian War, French self-esteem was at a low point. The poetics of Pater's space is both national and European, domestic and public, as the journey from Pater's college rooms to the French cathedrals demonstrates.

Chapter 6 explores the interrelationship between person and place in Pater's portraits. As Aristotle pointed out, any kind of movement or development presupposes

[84] Gaston Bachelard, *The Poetics of Space* (1957), intr. Richard Kearney, tr. Maria Jolas, Penguin Classics (New York: Penguin, 2014).

[85] See Jay Fellows, *Tombs, Despoiled and Haunted: 'Under-Textures' and 'After-Thoughts' in Walter Pater*, with a Foreword by J. Hillis Miller (Stanford: Stanford University Press, 1991).

[86] The central chapter of volume 2 of Ruskin's three-volume opus, *The Stones of Venice* (1851–3) was entitled 'The Nature of Gothic' and dealt with the interplay between an architectural style and national and human character.

24 WALTER PATER'S EUROPEAN IMAGINATION

the existence of place, whether physical or metaphorical, from place to place.[87] Plots and portraits require placing, in geographical and physical locations, and Pater was interested in the ways in which place left its imprint on the self. In *Genius Loci: Notes on Places* (1899), Vernon Lee wrote about how places had the power to touch us like living creatures, about the ways in which place becomes person, place personified.[88] The subjectivity of place lies at the heart of most of Pater's portraits, to the extent that we can trace a constant undercurrent of travel writing in them. Pater's places are both real and imaginary, and the chapter considers Pater the traveller alongside a more abstract discussion of his concept of Europe.

Pater perceived western society as essentially a Platonic and Dorian one. His distinction between the Dorian and the Ionic, two opposed influences, becomes geopolitical, philosophical, aesthetic, and historical; his theories of the 'organic unity' of European literature and culture have their roots in an East-West dichotomy which goes back to antiquity. Underlying some of the discussion is the Bakhtinian chronotope, the notion that space, place, and time merge along both vertical and horizontal axes in an intrinsic interconnectedness of temporal and spatial relationships.[89] Pater's Europe is one in which the materiality of history is historically layered and where fragments of the past often erupt to the surface with an immediate impact on the present. As a war-torn territory, the European continent bears the marks of centuries of destruction and rebuilding, of cultural erasure and resurrection.

Holland, Germany, France, and Italy constitute Pater's self-explored Europe; he never ventured further North than Amsterdam or further East than Venice. Much of Pater's Europe is immediately mappable, to the extent that he gives us almost the exact coordinates so that we can go and see for ourselves. The chapter explores some of these specific sites at the same time as it discusses the much broader notion of 'Europe' in Pater's writings. Where did Pater's Europe begin, where did it end? The very idea of Europe questions our notions of North and South, East and West, natural and cultural boundaries, and boundaries defined by peace treaties, as we deal with nations, separate and united, and communities, real and imagined. Pater's portraits tease us into thinking about what Europe actually is: a myth? A territory? A cultural entity? A geopolitical unit? The portraits reveal Pater as an incorrigible transnationalist, bent on tying together cultures across national and geographical boundaries in an assertion of European interdependence.

When Hayden White and Stephen Bann employed the term 'the poetics of time' in their studies of nineteenth-century historiography,[90] they were alluding to the etymology behind 'poesis', to the act of the making or shaping of time. Chapter 7 discusses Pater as one such 'maker of time', forming, rather than finding the past,

[87] Aristotle, *Physics*, 200b21.

[88] Vernon Lee, *Genius Loci: Notes on Places* (London: Grant Richards, 1899).

[89] M. M. Bakhtin, 'Forms of Time and of the Chronotope in the Novel: Notes toward a Historical Poetics' in *The Dialogic Imagination: Four Essays*, tr. Caryl Emerson and Michael Holquist (Austin: University of Texas Press, 1981), 84–258.

[90] See Stephen Bann, *The Clothing of Clio: A Study of the Representation of History in Nineteenth-Century Britain and France* (Cambridge: Cambridge University Press, 1984); Hayden White, *Metahistory: The Historical Imagination in Nineteenth-Century Europe*, Fortieth-Anniversary Edition, with a new preface and a foreword by Michael S. Roth (Baltimore: Johns Hopkins University Press, 2014).

making both past and present his own. It places the imaginary portraits in the contexts of the historical novel, of Pater's dialogue with the French historian Jules Michelet, and the *Bildungsroman* in an attempt to demonstrate the complexity of Pater's argument with the past. The nineteenth-century approximations of literature and history take many forms, and the imaginary portraits constantly toy with our notions of the factual and the fictional. White and Bann drew our attention to the emplotment of history, to the subjective ways in which the historian selects and edits his material into a coherent narrative which has similarities to the working methods of the writer of fiction. Questioning such concepts as the truth and the factual by alluding to the historian's 'imaginative sense of fact', Pater challenged fact-based positivism and claimed history as a literary art. As a writer acutely aware of the meta-discourses involved in writing both history and fiction and deliberately blurring the boundaries between them, Pater took up ideas voiced by Giambattista Vico. His *'verum factum* principle', that 'What is true is precisely what is made', was first formu-lated in 1710,[91] and echoes of it can be traced in Pater's 'Style'. If the true is the made, or if something is true because it is made, the focus is turned to the process, to con-struction. The continuity of history runs like a background against which the por-traits stand out in relief in a favourite Paterian trope, historical time juxtaposed with aesthetic time, the moment frozen in art. The linearity of unbroken time is part of the romantic narrativization of history in a century when history became an aca-demic discipline, when the emerging nation states developed philosophies of history and national histories, when the historical novel came into its own and vied with the *Bildungsroman* about how to chronicle the life and development of the individual in relation to society and major historical events.

Walter Scott was Pater's precursor within the field of historical fiction, concerned with the impact of time upon character, with the broader sweeps of European his-tory, and collective memory. Chapter 7 suggests Pater as the missing link between Scott and Woolf in the difficult discipline of bridging the gulf to the past. The poetics of time may mould history, but the reverse is equally relevant: time moulds people. Ann Rigney's discussion of degrees of fictionality in the context of what she calls 'Romantic Historicism' draws our attention to the blending in historical novels of real and imaginary figures.[92] How can a narrative be historical in parts only, she asks? The Hegelian view of history as a series of conflicts underlies Scott's novels and Pater's portraits. With their interest in the minor figures of history rather than the stars, they explored the impact of war and crises on the individual, drawing upon the reader's awareness of history. Collapsing the boundaries between past and present they forged an alliance between fiction, memory, and identity in a century when Europe was trying to find its feet after the Napoleonic wars and a series of revolutions.

[91] *De antiquissima Italorum sapientia, ex linguae latinae originibus eruenda* ('On the most ancient wisdom of the Italians, unearthed from the origins of the Latin language'), 1.1. Vico's wording is 'Verum et factum reciprocantur seu convertuntur' [The true and the made are convertible into each other].

[92] Ann Rigney, *Imperfect Histories: The Elusive Past and the Legacy of Romantic Historicism* (Ithaca: Cornell University Press, 2001), 5–6.

Pater shared with Jules Michelet an interest in revolutions as a recurrent phenomenon in political and cultural history, going back to the Middle Ages. Pater may not have written explicitly about the French Revolution, but through his reading of Michelet, he made the cataclysmic event an integral part of his own cultural history of Europe. Pater's medieval narratives present us with different rebellions—erotic, religious, social—containing the seeds of both the Renaissance and romanticism in a complex resurrectionist discourse which travels across some seven centuries. For both Pater and Michelet, the living always carry the dead with them, and their stories are inextricably intertwined with those of generations past. Culture is born through revolution, and the birth of the new constantly takes place, Franco Moretti stated. He saw modernity as another kind of revolution in his study of the *Bildungsroman*, a genre which cultivates youth as the most meaningful part of life.[93] The essence of modernity, youth becomes symptomatic of a world which seeks its meaning in the future rather than in the past. Modern existence involves a loss, rather than an achievement, according to Moretti: 'We do not become adults by becoming adults, but by ceasing to be young: the process involves primarily a renunciation.'[94] The young protagonists of Pater's portraits engage in a dialogue with the *Bildungsroman*; they never reach maturity and never experience a loss of youth through age, but are preserved and commemorated in art, beloved by the gods as those who die young. *Ars longa, vita brevis*: on this short day of frost and sun, while all melts under our feet in the era of the anthropocene, the constant interplay in Pater's portraits between then and now invites us to consider what it means to be human, what it means to be European at a time of natural, cultural, and political disruption.

[93] Franco Moretti, *The Way of the World: The Bildungsroman in European Culture*. New edn, tr. Albert Sbragia (London: Verso, 2000).

[94] Ibid., 90.

PART I
FOREGROUNDS

1
Type and Individual

Walter Pater most likely only visited a photographer three times in his life: twice in Oxford, in the studios of the University photographers W. H. Taunt[1] and Jules Guggenheim in the late 1860s and early 1870s (Figs 1.1 and 1.2), and once, after he had moved to Kensington, to be portrayed by the fashionable Elliott & Fry, possibly in celebration of his fiftieth birthday in August 1889 (Fig. 1.3).[2] Compared with the frequency with which most of Pater's contemporaries were photographed, the rarity of his photographic portraits is intriguing. A sequence spanning some fifteen years, chronicling a receding hairline and a filling out of features, the photographs reflect Pater's careful control of his own image. Avoiding the studio backgrounds and props preferred by many of his academic colleagues, he was photographed in head-and-shoulder compositions in three-quarter profile, his gaze suggesting that his thoughts were elsewhere. Seen against a white ground, the Paterian head hovers ethereally in the Guggenheim and the Elliott & Fry photographs; the vague contours of shoulder and arm suggest a body that must be imagined rather than seen.[3] The spruce jacket and collar, and the tightly-bound tie, frame the head with its impressive moustache.

Pater's sister Clara's *carte de visite* (Fig. 1.4), probably taken in the early 1870s, forms a sharp contrast. In this frontal half-length portrait, she wears an elaborately embroidered dress and engages with the camera, while the kitten, bringing the domestic sphere into the photographer's studio, adds life and movement to the image. Not often do family pets feature in Victorian *cartes de visite*; held close to Clara's heart, the cat constitutes a tactile element, enabling a dialogue between human and animal, skin and fur. It is caught in three-quarter profile, not unlike Pater himself, renowned for his feline behaviour and fondness for cats. Unable to keep still during the long exposure, the cat is slightly out of focus. Clara's immobility and the kitten's instinctual need to defy the frozen moment toy with Roland Barthes's distinction between the Real and the Live. Addressing the melancholy of photography itself, as 'that which has been', Barthes pointed out that 'by attesting that the object has been real, the photograph surreptitiously induces belief that it is alive, because of that

[1] The photograph is reprinted in *Wright*, 1:246, with reference to a copy 'lent by the Rev. A. J. Galpin, M.A., Headmaster of the King's School, Canterbury'. My enquiries with Peter Henderson, Archivist at the King's School, have been unfruitful. The portrait was reprinted in Richard Garnett and Edmund Gosse, *English Literature: An Illustrated Record* 4 vols (London: Heinemann, 1903), 4:358 with the caption 'Walter Horatio Pater. From a hitherto unpublished Photograph by W. H. Taunt & Co.' According to the Oxford City Council list of Photographers, Taunt & Co. were only active from 1868 onwards: http://www.pictureoxon.com/Photographers%20-%20list%20of%20Oxford%20photographers.pdf (accessed on 4 August 2021).

[2] See Lawrence Evans, *Letters of Walter Pater*, 102 n. 4. The negative glass plate (undated) of this portrait is now in the National Portrait Gallery: https://www.npg.org.uk/collections/search/person/mp17756/walter-horatio-pater (accessed on 4 Aug. 2021).

[3] Several other Guggenheim portraits have similar compositions.

Walter Pater's European Imagination. Lene Østermark-Johansen, Oxford University Press. © Lene Østermark-Johansen 2022.
DOI: 10.1093/oso/9780192858757.003.0002

Fig. 1.1. W. H. Taunt, *Walter Pater* (late 1860s), photograph, from Thomas Wright, *Life of Walter Pater*, 2 vols (London: Everett & Co., 1907), 1:247. Private collection. Photo © Christoffer Rostvad.

delusion which makes us attribute to Reality an absolutely superior, somehow eternal value; but by shifting this value to the past ("this-has-been"), the photograph suggests that it is already dead.'[4]

As we gaze at the portraits of Pater and his sister, we attempt to bridge a temporal gulf of some 150 years, aware of the siblings as real people, subject to mid-Victorian taste, yet highly individual in their stance towards the photographic medium. In Pater's case, it would seem as if, quite early in life, he settled upon a standard format, a matrix of how he wanted to be represented: distant, aloof, disengaged with the immediate world, yet not so otherworldly that a smart tie and a well-starched collar were immaterial. A discreet man of fashion, with well-trimmed moustache and hair, he emerges from the photographic print with a domed head emitting an aura-like radiance. To Barthes the photograph was 'literally an emanation of the referent': 'From a real body, which was there, proceed radiations which ultimately touch me, who am here; the duration of the transmission is insignificant; the photograph of the missing being, as Sontag says, will touch me like the delayed rays of a star. A sort of umbilical cord links the body of the photographed thing to my gaze: light, though

[4] Roland Barthes, *Camera Lucida*, tr. Richard Howard (London: Vintage Books, 2000), 79.

Fig. 1.2. Jules Guggenheim, *Walter Pater* (early 1870s), *carte de visite*, photograph pasted into Emilia Dilke's copy of *Studies in the History of the Renaissance*. Brasenose College, Oxford. With the kind permission of the King's Hall and College of Brasenose, Oxford.

impalpable, is here a carnal medium, a skin I share with anyone who has been photographed.'[5] Barthes likened photography to the resurrection, an art form leaving no trace of the artist's hand, yet bearing the imprint of the holy face like Veronica's napkin. The Paterian portrait emits a radiance which draws attention to his intellectual and spiritual powers, accentuated by the absence of the body. The three photographs suggest a serial portrait type; as Sontag reminds us, 'Paintings invariably sum up: photographs usually do not. Photographic images are pieces of evidence in an ongoing biography or history. And one photograph, unlike one painting, implies that there will be others.'[6] Thus, perhaps, we are facing the series of 'Pater at thirty', 'Pater at the time of the publication of *The Renaissance*', 'Pater at fifty', etc. His photographic portraits comply with the type of the Victorian gentleman; Elliott & Fry's portrait of William Hurrell Mallock (Fig. 1.5), who satirized Pater so pointedly in the mid-1870s, represents the very same type of moustachioed intellectual, in sharper profile, admittedly, but the type is recognizable.

[5] Ibid., 80–1. [6] Susan Sontag, *On Photography* (London: Penguin, 1979), 166.

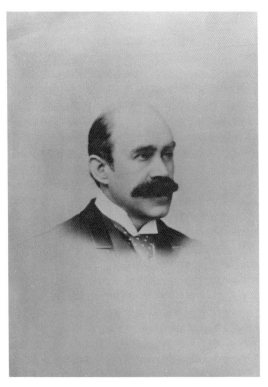

Fig. 1.3. Elliott & Fry, *Walter Pater* (late 1880s), half-plate glass copy. © National Portrait Gallery, London.

Pater avoided the painted portrait altogether; he belonged to the middle classes for whom photography enabled a new type of portraiture, summed up with some scepticism by Søren Kierkegaard in 1854: 'With the daguerreotype everyone will be able to have their portrait taken—formerly it was only the prominent; and at the same time everything is being done to make us all look exactly the same—so that we shall only need one portrait.'[7] Pater belonged to the first generation of people who saw themselves photographically; according to Sontag 'to regard oneself as attractive is, precisely, to judge that one would look good in a photograph.'[8] When Fox Talbot patented the photograph in 1841 under the name of the calotype, he did so with reference to the Greek *kalos*, 'beautiful'; photographing something usually meant conferring a sense of beauty and importance on it.[9] The ability of portrait photography to depict the self as other, to show us ourselves as we never see ourselves, lends estrangement to the medium. Did Pater recognize himself in these portraits, a transparent, evasive, and slightly elusive self? Pater's photographs were material objects to be touched, exchanged, treasured. His letters reveal how he both received portraits of others and gave away portraits of himself,[10] confessing in 1893 to Arthur Waugh

[7] Kierkegaard, quoted in Sontag, 207. [8] Sontag, 85. [9] Ibid., 28.
[10] See *Letters*, ed. Evans, 27, 45, 102, 110, 118, 142.

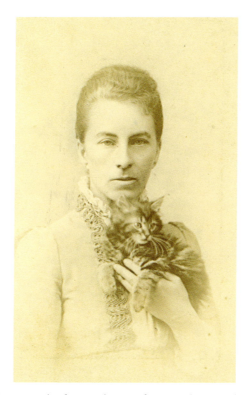

Fig. 1.4. Anon., *Clara Pater* (early 1870s), *carte de visite*, photograph. Principal and Fellows of Somerville College, Oxford.

(father of Evelyn and Alec), 'I never quite like photographs of myself, but send you the latest taken of me.'[11] Pater exchanged photographic portraits with younger admirers and colleagues as tokens of friendship (with Vernon Lee, Oscar Wilde, Arthur Symons, D. S. MacColl, and Arthur Waugh), and must have had a collection of such photographs which, if it has survived, would be an interesting gateway into his more intimate life, a valuable supplement to the letters which tell us so little about the man himself and his affections. Pater's self-consciousness about the photographic medium transpires from MacColl's account of one such exchange of photographs from his Oxford student days in the early 1880s:

> He climbed one day into my tiny room, sat and talked and ruminated, and asked me for my photograph.[12] He nodded over this, and said, with extreme seriousness, 'You ought to be painted by one of your friends—before the wrinkles come.' He was very shy when I asked him for his own photograph in return, and after much hesitation produced an ancient one by Guggenheim. He suffered, I think, from consciousness

[11] Ibid., 142. Evans suggests that this was the Elliott & Fry photograph.
[12] This may well have been Frederick Hollyer's portrait of D. S. MacColl (1884), currently in the Hollyer collection of the Victoria and Albert Museum: http://collections.vam.ac.uk/item/O75503/dugald-maccoll-photograph-hollyer-frederick/ (accessed on 4 Aug. 2021).

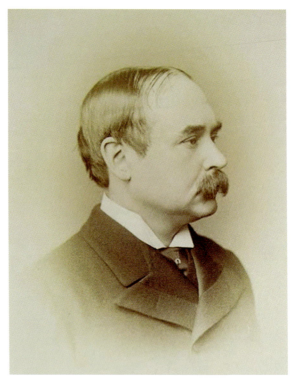

Fig. 1.5. Elliott & Fry, *William Hurrell Mallock* (1870s), bromide print. National Portrait Gallery, London. Historic Collection/Alamy Stock Photo.

of the outer form, the disguise foistered on him by the witch who plays those pranks at birth, and never, I believe, submitted himself to a painter.[13]

Jules Guggenheim ran a photographic studio at 56 High Street, Oxford, between 1863 and 1885, and produced portraits of academics and undergraduates. 'Duplicates may be had at any time', we read on the back of Guggenheim's *cartes de visite*, and we can discern the fate of three such copies of Pater's photograph: apart from the one given to MacColl, which by the early 1880s had become 'an ancient one', another was given to Emilia Pattison. It is pasted into her presentation copy, opposite the title page, of *Studies in the History of the Renaissance*, inscribed to Emilia 'From the Writer'.[14] Along with the inscription, it links author with *oeuvre* and personalizes the copy, which Pattison had further personalized by means of the lavish book binding she commissioned in 1898.

[13] D. S. MacColl, 'A Batch of Memories: 12 Walter Pater', *Week-end Review* (12 Dec. 1931), 759–60, 759.

[14] For a discussion of this copy, now in Brasenose College Library, see Lene Østermark-Johansen, 'The Book Beautiful: Emilia Dilke's Copy of Walter Pater's *Studies in the History of the Renaissance*', *Brasenose College Library and Archives Blog*, 11 June 2015, https://brasenosecollegelibrary.wordpress.com/2015/06/11/the-book-beautiful-emilia-dilkes-copy-of-walter-paters-studies-in-the-history-of-the-renaissance-by-lene-ostermark-johansen/ (accessed on 4 Aug. 2021).

A third copy was, I suspect, given to the painter Simeon Solomon whose pencil portrait of 1872 (Fig. 1.6) is the only one of its kind. Now in the collection of the Museo Horne in Florence, it is accompanied by a small slip in Herbert Horne's hand: 'With the exception of the drawing on stone, done by W^m Rothenstein / about a year before Pater's death; this was the only portrait / for which Pater ever gave a sitting. This I was told by / Pater and his sisters.'[15] The provenance of the drawing is uncertain; a note by Horne dated 24 April 1892 refers to it as being already then in his possession,[16] and another note refers to the existence of an accompanying portrait by Solomon of Pater's close friend and companion, Charles Lancelot Shadwell, commissioned by Pater.[17] The latter portrait has not yet surfaced, but the idea of Pater's commissioning of both portraits is intriguing. Signed and dated 'B.N.C. 1872' (for 'Brasenose College'), Solomon's drawing of Pater bears a strong resemblance to the Guggenheim photograph, although the sitter has been turned slightly towards the

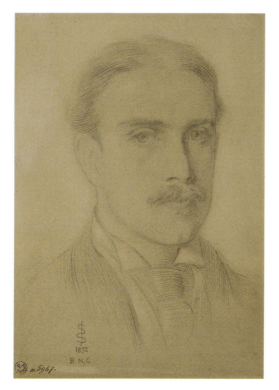

Fig. 1.6. Simeon Solomon, *Walter Pater* (1872), pencil on paper, 28.1 × 20.3 cm. Fondazione Horne, Florence.

[15] See Matilde Casati's catalogue entry for the Solomon drawing in Elisabetta Nardinocchi and Matilde Casati, eds, *L'immagine e lo sguardo: Ritratti e studi di figura da Raffaello a Constable* (Florence: Museo Horne, 2011), 82.
[16] AFH, H.III. 6, *c*.10, Museo Horne, Florence. Ibid., 82.
[17] AFH, H.III. 6, c.9, Museo Horne, Florence. Ibid., 82.

front and issued with the large eyes characteristic of Solomon's faces.[18] According to Colin Cruise, Solomon most probably did draw portraits on the basis of photographs; two portraits in facsimile attributed to him in the National Portrait Gallery of A. C. Swinburne and D. G. Rossetti have close similarities to photographic portraits and are dreamy, hazy reworkings in chalk of the originals.[19] The same might be said for the Pater portrait; the relatively expressionless *carte de visite* has been issued with a soul, a ghostly double of the dandy in the photograph, giving us a new sense of privacy. The fine lines capture a cautious, reticent man, a visual counterpart to Pater's 'continual vanishing away, that strange, perpetual, weaving and unweaving of ourselves'.[20] Faint, delicate, almost transparent, the drawing proliferated at the *fin de siècle*; it appears in Frederick Hollyer's 1904 catalogue of platinotype reproductions as a standard print alongside Titians and Botticellis, testifying to Pater's continued popularity well after his death in 1894.[21]

The purpose of this brief discussion of photographic portraits is to address Pater's approach to the representation of the self, beginning with the self he knew best of all. Unlike other Victorians—Alfred Tennyson and Thomas Carlyle, for example—he did not experiment with the photographic medium in order to explore the self. Pater's choice of the 'safe', typical portrait of the intellectual gentleman as his official face reveals his desire for a mask, only challenged by Solomon's more private portrait, a transparent close-up of a sensitive self. Saunders questioned Pater's ability to write auto/biographically with specific reference to the ephemeral self. Like Carroll's Cheshire Cat, it is there one moment and gone the next: 'Pater is significant for the way he did not write auto/biography. How could he write the *autos*, the self, if that self were a process of dissolution and vanishing?'[22] Pater might well have been keen to avoid any kind of autobiographical veracity. 'According to the Freudian model, the psyche will not let the truth about itself be told; not consciously, anyhow. It will repress, negate, distort, disavow, displace material, leaving the attempt at formal autobiography unreliable, full of gaps and contradictions.'[23] Some of Saunders's conclusions suggest that rather than writing the self directly, Pater projected his self into every one of the protagonists of his imaginary portraits:

> The discourse of individuals and types is crucial to imaginary portraiture. Whereas representational art generally begins from real individuals and idealizes and generalizes from them, to produce a portrait more universally communicable, the imaginary portraitist begins with a type or idealization, and particularizes it by casting it in biographical form. (Indeed, one criticism that can be levelled against

[18] See Solomon's self-portrait and his portraits of Edward Burne-Jones and A. C. Swinburne in Colin Cruise, *Love Revealed: Simeon Solomon and the Pre-Raphaelites* (London: Merrell, 2005), cat. nos. 27, 28, and 29.

[19] Personal communication with Colin Cruise for which I am hugely grateful. The Solomon facsimile of Swinburne is NPG1511. It would seem to be based on *cartes de visite* of the mid-1860s, also in the NPG collection: NPGAX 17804, NPGX12831 &/or NPGX24806. The D. G. Rossetti Solomon 'facsimile' is NPG1510, clearly taken from the Lewis Carroll photograph of 1863 (NPGP29).

[20] *Ren.*, 188.

[21] Frederick Hollyer, *Catalogue of Platinotype Reproductions of Pictures etc., Photographed and Sold by Mr. Hollyer* (London: Frederick Hollyer, 1904), 46.

[22] Saunders, 35. [23] Ibid., 199.

Pater's Imaginary Portraits is that they fail to get away from idealization and generality; are not adequately or convincingly individualized, except as spectres of their author.)[24]

If pre-nineteenth-century portraiture often idealized the portrayed, aiming to please sitter, recipient, and commissioner, the individual often gave in to the type. When we face historical portraits, likeness becomes less significant with time, as the genre—Elizabethan miniature, *Quattrocento* female portrait, rococo male portrait—assumes prominence over the individual. Michelangelo famously declared that he had not aimed at likeness in his figures of the two Dukes, Giuliano and Lorenzo, in the Medici Chapel on the grounds that a thousand years from now no one would know what they looked like anyway. Saunders's suggestion that Pater never arrived at fully individualized character in his portraits resides in a tension between the Paterian self and the self portrayed, between the Pateresque as a style and his fictitious protagonists, none of whom are sufficiently individualized to rise above the type.[25] Like the Leonardesque and the Giorgionesque, the Pateresque is such a powerful expression of the artist in his subject that it cancels out any other form of individuality. As a consequence, the protagonists remain Paterian types rather than individuals.[26] The Pateresque interferes with, indeed, suppresses the creation of rounded characters; the fluctuating self results in the construction of many selves, and the series of imaginary portraits consequently becomes, among many other things, different fragments of the Paterian self. The author who fantasized about imaginary aunts and uncles enjoyed a splitting of the self, reinventing the family bloodline and travelling backwards in time and place in the exploration of what being a young man (and—exceptionally—woman) elsewhere might have been like. That authorial self and its relation to the protagonists of Pater's portraits is a vastly complicated one, and although Saunders's impressive autobiografictional approach is groundbreaking in its analysis of the scope and proliferation of imaginary portraiture from Pater onwards, the complexity of the imaginary portraits seen within Pater's *oeuvre* needs pursuing in greater detail.

This first chapter aims at tracing Pater's interest in the type back to some of his earliest writings of the 1860s, exploring his experiments with selves and genres from the student society essay, to the art historical essay, to the first imaginary portrait. Pater's imaginary portraits came into being at a time when autobiographies abounded, when the desire to judge one's former self as another was everywhere: Anthony Trollope, *An Autobiography* (1883), Ruskin's *Praeterita* (1885–9), and J. A. Symonds's *Memoirs*, posthumously published, to mention just a few examples. Pater was writing himself into a popular genre, fictionalizing it, sometimes to the point of complete transformation. His seminal status as the founding father of modernist autobiografiction partly lies in a quest for the delineation of an inner life which led to a use of fictionalization which subsequently proliferated. The man who coined the portmanteau word 'autobiografiction', Stephen Reynolds, stated in his brief 1906 essay that 'Where the three converging lines—autobiography, fiction, and the essay—meet, at

[24] Ibid., 462. [25] For a variant of this view, see Monsman 1967 and 1980.
[26] Saunders 40–1.

38 WALTER PATER'S EUROPEAN IMAGINATION

that point lies autobiografiction.'[27] He defined autobiografiction as 'a record of real spiritual experiences strung on a credible but more or less fictitious autobiographical narrative', 'any emotion, beautiful thing, work of art, sorrow, religion, or love, which intensifies a man's existence; anything in short that directly touches his soul'.[28] Reynolds wrote about George Gissing, 'Mark Rutherford', and A. C. Benson, but might as well have written about Pater.

Through his photographic portraits Pater engaged with self as other in a way which prepared him for the imaginary portraits. His use of the modern medium testified to his awareness of some of the elegiac aspects of photography as actively promoting nostalgia:

> Photography is an elegiac art, a twilight art. Most subjects photographed are, just by virtue of being photographed, touched with pathos. An ugly or grotesque subject may be moving because it has been dignified by the attention of the photographer. A beautiful subject can be the object of rueful feelings, because it has aged or decayed or no longer exists. All photographs are *memento mori*. To take a photograph is to participate in another person's (or thing's) mortality, vulnerability, mutability. Precisely by slicing out this moment and freezing it, all photographs testify to time's relentless melt.[29]

MacColl's anecdote reflected Pater's awareness of the need to freeze youth in art. In many ways the imaginary portraits do just that, ostensibly in dialogue with painting, but perhaps just as much with a view to the ways in which photography slices out a brief moment of people's lives. Sontag's suggestion that 'A modernist would have to rewrite Pater's dictum that all art aspires to the condition of music. Now all art aspires to the condition of photography'[30] might be applied to the master himself. Perhaps the transparent art of photography, immaterial and material at the same time, is at the heart of Pater's new literary art form, bridging the literary and the visual arts. Barthes may have been right that 'Photography has been, and is still, tormented by the ghost of Painting,'[31] yet the medium was finding its own feet in the late nineteenth century through a series of aesthetic and technical experiments. It both is and is not, characterized by the ethereality of glass and light, imprinting itself on the material world, as type asserting itself through a technique of stamping: calotype, daguerreotype, ambrotype, tintype. Saunders's choice of the term 'self-impression' as the title for his monograph on autobiografiction is appropriate: even a self as elusive as Pater's leaves its imprint in writing.

Sontag addressed the materiality of photographs, giving a new reality to images which went against Plato's derogatory attitude to them as mere shadows. Her suggestion that the powers of photography had de-Platonized our understanding of reality by erasing our ideas of originals and copies made her conclude that 'the force of photographic images comes from their being material entities in their own right, richly informative deposits left in the wake of whatever emitted them, potent means

[27] Stephen Reynolds, 'Autobiografiction', *Speaker*, n.s., 15:66 (1906), 28–30, 28.
[28] Ibid., 28. [29] Sontag, 15. [30] Ibid., 149. [31] Barthes, 30.

for turning the tables on reality—for turning *it* into a shadow. Images are more real than anyone could have supposed.'[32] Pater began his writing with an oscillation between the real and the ideal in his 'Diaphaneitè' essay and pursued the ideal type through some thirty years of writing during which, gradually, the real, the material, the tactile crept in and became increasingly present. This chapter traces the beginnings of that journey, as Pater's type gradually assumed material form in close dialogue with developments in art, science, and photography.

The Diaphanous Self

Any discussion of Pater and portraiture must begin with the earliest prose text we have from his hand: the two-thousand-word essay, 'Diaphaneitè', which he read to the Old Mortality Society, an Oxford undergraduate essay society,[33] in 1864, shortly after he had been elected probationary fellow of Brasenose College.[34] With a total membership of some thirty-five members in the course of its ten-year existence (1856–66), the Old Mortals met in groups of up to a dozen people who read essays on a given subject to one another, followed by a discussion. The Society counted several of Pater's friends: A. C. Swinburne, T. H. Green, Ingram Bywater, J. A. Symonds, and most notably, Shadwell, who would remain a continuous presence in his life. As the travel companion together with whom Pater first encountered Italy in the summer of 1865, Shadwell subsequently became the dedicatee of *Studies in the History of the Renaissance* (1873). After Pater's death he served as literary executor and guardian of the writer's afterlife in close collaboration with Pater's sisters. Taking full control over the unpublished manuscripts, Shadwell edited and issued the three posthumous volumes which have become part of the Pater canon: *Greek Studies: A Series of Essays* (1895), *Miscellaneous Studies: A Series of Essays* (1895), and *Gaston de Latour* (1896). Although Pater probably never intended publication of 'Diaphaneitè', Shadwell included it in *Miscellaneous Studies* 'with some hesitation...as the only specimen known to be preserved of those early essays of Mr. Pater's, by which his literary gifts were first made known to the small circle of his Oxford friends.'[35] We have no manuscript in Pater's hand; it probably passed into Shadwell's possession at some point between 1864 and Pater's death. The textual source of 'Diaphaneitè' is a

[32] Sontag, 180.

[33] For a history of the society, see Gerald Monsman, *Oxford University's Old Mortality Society: A Study in Victorian Romanticism* (Lewiston: Edwin Mellen Press, 1998). Monsman, 9–10, traces the name of Pater's essay society to a concern with death, partly through the figure of Old Mortality, the graveyard caretaker in Walter Scott's novel *Old Mortality* (1816), and partly through a concern with issues of health, according to the Society's minute book: 'After much bethinking themselves as to how the said society should be styled and entitled, the name of "Old Mortality" was suggested as appropriate, from the following weighty consideration: that every member of the aforesaid society was or had lately been in so weak or precarious a condition of bodily health as plainly and manifestly to instance the great frailty and, so to speak, mortality of this our human life and constitution.'

[34] See Gerald Monsman, 'Pater, Hopkins, and Fichte's Ideal Student', *South Atlantic Quarterly* 70 (1971), 365–76.

[35] C. L. Shadwell, 'Preface' to *Miscellaneous Studies: A Series of Essays* (London: Macmillan, 1895), v–vi.

40 WALTER PATER'S EUROPEAN IMAGINATION

fair copy, now at the King's School, Canterbury.[36] Lavishly bound, it consists of nine sheets of writing in Shadwell's hand; the first leaf bears the embossed stamp of Oriel College where Shadwell spent most of his academic life and eventually became Provost.[37] Richard Dellamora compares the bound manuscript with 'the volume of transcriptions of Hopkins's poetry that Robert Bridges made for circulation among a circle of friends, as a work of special significance in a context of male friendships',[38] and it may well have been such a treasured item in the circles of Pater and Shadwell.

Apart from being recipient, keeper, copyist, and editor of 'Diaphaneitè', Shadwell was most likely also its chief addressee when it was read aloud in the Society. Linda Dowling has likened the event to a re-enactment of Plato's *Symposium* in which Pater, who had tutored Shadwell and was his senior by a year, delivered a paean to the notoriously handsome young man.[39] There are several deictic references in the text, which resounds with eighteen occurrences of 'this': 'this character', 'this nature', 'the character we have before us', etc., suggesting the constant pointing towards an individual in the audience exemplifying the type evoked in the essay. The text is at once abstract and personal, and Pater may have had many reasons for not publishing it. 'Diaphaneitè' is a character study of an ideal type, devoid of physiognomy and physicality, a study of a person without narrative, without background, without social relations—the very features which Pater would later add to his imaginary portraits. Seminal to our understanding of the constant oscillation between type and individual in Pater's portraits, 'Diaphaneitè' raises profound issues of the ways in which we approach the self.

Pater's enigmatic title has for decades challenged critics into ingenious attempts at translations and speculations about etymology, grammatical form, and language. Is 'Diaphaneitè' English, French, Latin, or Greek? Did Pater put the wrong diacritical accent on the final 'e'? Did he, indeed, quite know what he was doing?[40] Gerald Monsman concludes, after a long discussion of the Greek meaning of the term, that 'Pater's fanciful creation of this Greek form (not otherwise found in ancient sources) probably was never intended to bear close technical scrutiny'.[41] The translations of Pater's title reflects the controversies: 'the transparent hero',[42] '[You shall] become transparent',[43] 'Shine through!',[44] 'You will cause [something] to appear',[45] 'You will allow [something] to shine through you',[46] 'the quality of being freely pervious to

[36] A detailed description of the MS can be found in B. A. Inman, *Walter Pater's Reading: A Bibliography of his Library Borrowings and Literary References, 1858–1873* (New York: Garland Press, 1981), 74 and Monsman 1998, 102.

[37] See L. R. Price and M. C. Curthoys's entry on Shadwell in the *ODNB*.

[38] Richard Dellamora, *Masculine Desire: The Sexual Politics of Victorian Aestheticism* (Chapel Hill: University of North Carolina Press, 1990), 59.

[39] Linda Dowling, *Hellenism and Homosexuality in Victorian Oxford* (Ithaca and London: Cornell University Press, 1994), 83.

[40] For a survey of the early debate, see John Conlon, 'Walter Pater's "Diaphaneitè"', *English Language Notes* 17 (1980), 195–7.

[41] Monsman 1998, 101.

[42] Carolyn Williams, *Transfigured World: Walter Pater's Aesthetic Historicism* (Ithaca and London: Cornell University Press, 1989), 173.

[43] Anne Varty, 'The Crystal Man: A Study of "Diaphaneitè"', in ed. Laurel Brake and Ian Small, *Pater in the 1990s* (Greensboro: ELT Press, 1991), 205–15, 258, n. 2.

[44] Ibid. [45] Conlon, 196; Monsman 1998, 101. [46] Conlon, 196; Monsman 1998, 101.

light, transparency'.[47] The list testifies to the complexity of Greek, transitive versus intransitive meanings, tempus and mode: are we dealing with a direct address or an abstract concept? is the addressee subject or object? Pater could never have predicted the extensive debate caused by 'Diaphaneitè', but a multiplicity of meanings may well have been intended from the beginning.

In her comprehensive study of Victorian Glassworlds, Isobel Armstrong alerts our attention to some of the inherent antitheses in glass and transparent objects: 'Transparency is something that eliminates itself in the process of vision. It does away with obstruction by not declaring itself as a presence. But the paradox of this self-obliterating state is that we would not call it transparent but for the presence of physical matter, however invisible—its visible invisibility is what is important about transparency. It must be both barrier and medium.'[48] Given Pater's fondness for ambiguities, the inherent paradox of his transparent hero's visible invisibility is perhaps hardly surprising. He is both a physical presence and a gateway to similar ideal presences to come. Armstrong concludes her book with a brief reference to the modernity of Pater's 'Diaphaneitè': 'This is the transparency that exposes contradiction and itself becomes a mediating third term, a prerequisite for change. This "crystal nature" does not bring about change, but creates the conditions for it.'[49] People may not generally think of Pater as an advocate of revolution, but the words 'revolution' and 'revolutionist' recur in the part of his essay which deals with the diaphanous character's perceptive nature:

> It is just this sort of entire transparency of nature that lets through unconsciously all that is really lifegiving in the established order of things; it detects without difficulty all sorts of affinities between its own elements, and the nobler elements in that order. But then its wistfulness and a confidence in perfection it has makes it love the lords of change. What makes revolutionists is either self-pity, or indignation for the sake of others, or a sympathetic perception of the dominant undercurrent of progress in things. The nature before us is revolutionist from the direct sense of personal worth, that χλιδή, that pride of life, which to the Greek was a heavenly grace.[50]

As Armstrong reminds us, 'The real function of a mediating transparency is as much to reflect as to be seen through. Consciousness, doubled as reflection, can achieve *reflective awareness*.'[51] Pater detects such reflective awareness in his diaphanous type, this 'mind of taste lighted up by some spiritual ray within'.[52] The *rayonnement* of his exemplar luminaries—Raphael and Goethe—reflects both ways, from inside and out, and from the world and into the self. The transparent self feeds on and emits light and is thus both medium and barrier. Pater oscillates between the contrasting pairs

[47] Walter Pater, *Studies in the History of the Renaissance*, ed. Matthew Beaumont, Oxford World's Classics (Oxford: Oxford University Press, 2010), 182. Beaumont chooses the *OED* definition of 'diaphaneity'.

[48] Isobel Armstrong, *Victorian Glassworlds: Glass Culture and the Imagination 1830–1880* (Oxford: Oxford University Press, 2008), 11.

[49] Ibid., 368.

[50] *chlidê*: translates as 'personal worth related to physical beauty'. 'Diaphaneitè' quoted from *The Renaissance*, ed. Beaumont, Appendix B, 136–40, 138.

[51] Armstrong, 12. [52] 'Diaphaneitè', 137.

of opacity and transparency, solidity and evanescence, marble and crystal, as qualities inherent in the diaphanous.[53] Many of the entries on 'diaphanous' in the *OED* associate the word with crystal and with the process of crystallization. In his *Life of Goethe* (1855), G. H. Lewes had repeatedly employed the image of crystallization for Goethe's personal and professional development:[54] Goethe was thus 'crystallising slowly; slowly gaining the complete command over himself', while the 'crystallising process which commenced in Weimar was completed in Rome'.[55] Lewes was reflecting the mid-nineteenth-century obsession with glass, crystal, and transparency: with the Crystal Palace of the Great Exhibition (1851) as one of its crowning achievements, Victorian England was undergoing a rapid vitrification in terms of architecture, town planning, manufactured household products, and the applied arts. Such a development left clear traces in the language, and frequently repeated terms like 'crystal clearness', 'purest crystal' reflected the close association of purity, of transcendent transparency with crystal in late Victorian usage.[56] ' "Crystal" is the single defining term of glass culture and nineteenth-century modernism. Crystal is a derivation of rock, a growth of the geological world, product of vapour, minerals, and subterranean action. Quartz is faceted, *prismatic*, its multiple external planes replicating its internal structure. Even when man-made the "tremulous scintillations" of crystal facets, glass against glass, declare crystal's apparent nearness to the natural world of cave and grotto. The status of glass as a congealed liquid and the product of air, as rock crystal is, gave it an affiliation with the natural world.'[57] The crystallization process undergone by Lewes's Goethe is a natural process of refinement, turning an already brilliant and perceptive artist into an even sharper/clearer/purer master of the word.

Lewes was following Carlyle who in his lecture on 'The Hero as Poet' (1840) had celebrated Goethe as Shakespeare's modern counterpart. Carlyle praised Goethe by throwing the German poet's words about Shakespeare back at him: 'His characters are like watches with dial-plates of transparent crystal; they show you the hour like others, and the inward mechanism also is all visible.'[58] What Carlyle called Shakespeare's 'portrait-painting', his 'delineating of men and things' rested on his 'calm creative perspicacity',[59] on his ability to take in the outer world at large in a perceptive and imaginative process of reflection: 'all things imaged in that great soul of his so true and clear, as in a tranquil unfathomable sea!'[60] Only a few years later, in his essay on 'The Poet' (1844), Ralph Waldo Emerson would associate poetic perception with glass: 'As the eyes of Lyncaeus were said to see through the earth, so the poet turns the world to glass and shows us all things.'[61] Absolute knowledge and absolute clarity go together in the nineteenth-century poet's glassworld, and the transparent heroes of Goethe, Carlyle, and Emerson may well be precursors of Pater's

[53] See Varty, and Catherine Maxwell, *Second Sight: The Visionary Imagination in Late Victorian Literature* (Manchester: Manchester University Press, 2008), 74–5.

[54] Varty, 207–8. [55] Lewes, *Life of Goethe*, quoted in Varty, 208.

[56] Ibid., 222. [57] Armstrong, 151.

[58] Thomas Carlyle, 'The Hero as Poet' in *On Heroes, Hero-Worship, and the Heroic in History* (London: Chapman & Hall, 1840), 93–136, 123.

[59] Ibid., 122. [60] Ibid., 121.

[61] Ralph Waldo Emerson, 'The Poet' (1844) in *Selected Essays* (London: Penguin 2003), 270. Whether Emerson recalls Shelley's meditations on Keats in 'Adonais'—'Life, like a dome of many-coloured glass, / Stains the white radiance of Eternity, / Until Death tramples it to fragments'—is mere speculation.

diaphanous man: 'Over and over again the world has been surprised by the heroism, the insight, the passion, of this clear crystal nature.'[62] Goethe appears as the proto-type of the new revolutionary man who will invigorate the centuries to come, while he allows for the presence of the diaphanous even in natures less gifted: 'Perhaps there are flushes of it in all of us; recurring moments of it in every period of life. Certainly this is so with every man of genius. It is a thread of pure white light that one might disentwine from the tumultuary richness of Goethe's nature. It is a natural prophecy of what the next generation will appear, renerved, modified by the ideas of this.'[63] Pater is mixing his images here—flushes, threads, pure white light, nerves—stretching his listeners' imagination. While 'flush' connotes colour and heat, Goethe's 'pure white light' points in the opposite direction. This is the earliest trace of Pater's profound and long-lasting admiration of the German poet: the originality, genius, and successful merging of the classical and the romantic, the South and the North, the old and the new, embodied in Goethe, inspired Pater for the range of his own writings.

Hailed as the 'Ur-portrait' from which the imaginary portraits evolved,[64] 'Diaphaneitè' is a quarry which provides material for much of Pater's *oeuvre*: whole sentences were lifted and inserted into the 'Winckelmann' essay (1867);[65] recurring figures like Raphael, Goethe, Spinoza, and Dante's Beatrice make their first appear-ance here. In his oscillation between the artist, the saint, the thinker, and the trans-parent, aesthetic type, Pater outlines the theory of historical fiction to which he would adhere throughout his life.[66] His imaginary portraits write the history of char-acters whose stories would otherwise remain unwritten, the transparent characters through whom history has an effect, but who leave the centre stage to politicians, kings, and queens. 'Diaphaneitè' is the portrait of 'an elusive type of personality—one who is neither artist, nor saint, nor revolutionary, nor anything else that can be classified.'[67] Alluding to Pater's 'paradoxical project' of 'bringing into visibility the important shaping function of a character who is by definition—by the world's defin-ition—invisible', Carolyn Williams points out how 'the play of visibility and invisibil-ity set in motion by the figure of diaphaneity suggests a critique of conventional historical retrospection. Through the character of Diaphaneitè, Pater considers not only the aesthetic shaping of history-in-the-making but also the retrospectively aes-thetic procedures of history-writing.'[68]

More will be said about the broader perspectives of Pater's historical fiction in Chapter 7, but here let us bear in mind the revolutionary quality of Pater's transpar-ent figure as one that upsets the Carlylean view of history as a series of events shaped by great men. In 'Diaphaneitè' Pater is groping for terms with which to capture the individual. The vagueness and ambiguities of this early text have generated a rich critical literature since the 1980s, and Pater's diaphanous man is as hard to get to grips with as the evanescent shades evoked in the essay. This is a young Pater, making the most of a word: the terms 'type', 'character', and 'nature' are scattered throughout his text with about a dozen occurrences each. Sometimes the words appear

[62] 'Diaphaneitè', 139. [63] Ibid., 139. [64] Monsman, *Pater's Portraits*, 22.
[65] See Francis Roellinger, 'Intimations of Winckelmann in Pater's Diaphaneitè', *English Language Notes* 2 (1965), 277–82.
[66] See Williams, 172–84, 179. [67] Monsman 1998, 100. [68] Williams, 179.

interchangeable, synonymous with one another, sometimes Pater joins them as in 'types of character'. The *OED* is helpful in directing us to the cluster of allusions which Pater may have intended by his repeated use of 'type'. Given that the message of the essay was in part prophetic—especially in its concluding words ('The nature here indicated is alone worthy to be this type. A majority of such would be the regeneration of the world.'[69])—Pater was using 'type' as 'prefiguration' in the theological, typological, sense,[70] predicting a diaphanous type, a precursor of more to come, who might bring about major change. He was also adopting meanings of the word which began to emerge from the 1840s onwards, as science employed 'type' taxonomically in an attempt to systematize the natural world:[71] 'A person or thing that exhibits the characteristic qualities of a class; a representative specimen, a typical example or instance.'[72] In his *Philosophy of the Inductive Sciences* (1840) William Whewell had spoken of type as 'an example of any class, for instance, a species of a genus, which is considered as eminently possessing the characters of the class'.[73] A refinement of this definition is used by Emerson in 1847 about Goethe as 'the type of culture'.[74] This modern Renaissance man, more versatile than most, epitomized nineteenth-century culture at its peak.

While Lewes was exploring the crystallizing process of Goethe's education, he was also chasing what he called 'typical forms' by the seaside in his studies of molluscs and primitive creatures, subjected to his hours at the microscope. Both in his waking hours and in his sleep, the types haunted him: 'The typical forms *took possession of me*. They were ever present in my waking thoughts; they filled my dreams with fantastic images...they teased me as I turned restlessly from side to side at night.'[75] As an amateur user of the microscope—the optical apparatus which rendered the opaque world transparent—Lewes became temporarily obsessed with the fantastic transparent worlds accessed through the optic lens, worlds which seemed to pass almost imperceptibly from broad daylight to the uncontrollable world of dreams. Armstrong points out how 'Popularizers of the microscope developed a thesaurus of transparency unique to lens culture. The microscope seemed to make life itself transparent, to enable the viewer to look *into* and *through* the object, not at it. A vocabulary ranging from the "semi-pellucid" to the "crystal", and an intensified diction of clear and limpid substance, is brought to the scopic experience of the microscope.'[76]

[69] 'Diaphaneitè', 140.

[70] *OED* 1a.: 'A person, object, or event of Old Testament history, prefiguring some person or thing revealed in the new dispensation; correlative to *antitype*.'

[71] The taxonomic meaning of 'type' is completely absent from Samuel Johnson's *Dictionary: A Dictionary of the English Language. To which are prefixed, a History of the Language, and an English Grammar* (London: Knapton, Longman et al., 1755).

[72] *OED* 7.

[73] *OED* 8b.: 'A species or genus which most perfectly exhibits the essential characters of its family or group, and from which the family or group is (usually) named; an individual embodying all the distinctive characteristics of a species, etc. *esp.* the specimen on which the first published description of a species is based.'

[74] *OED* 7b.: 'A person or thing that exemplifies the ideal qualities or characteristics *of* a kind or order; a perfect example or specimen *of* something; a model, pattern, exemplar.'

[75] G. H. Lewes, *Sea-side Studies at Ilfracombe, Tenby, the Scilly Isles, and Jersey* (Edinburgh: Blackwood, 1860), 36.

[76] Armstrong, 329.

The transparent world behind the opaque natural world was opening up new methods of sight, rendering other forms of invisibility visible to the mid-Victorians in search of taxonomic type.

If one looks at the nineteenth-century compound words which include 'type', an oxymoronic tendency seems at work, making us question the delicate balance between the generic and the specific: type-character, type-figure, type-man, type-species, type-specimen. Such words split and are only held together by the hyphen as 'type' pulls towards the generic while 'character', 'figure', 'man', and 'specimen' pull towards the individual and unique. The new coinages are symptomatic of conflicting mid-Victorian tendencies: the drive towards new taxonomies, reminiscent of the eighteenth century, given new impetus by evolutionary theories, while the essentially romantic focus on uniqueness remains powerful throughout the century. Pater's imaginary portraits are caught in this schism between the generic and the individual, and only when we accept that can we approach them as he intended us to. In 'Diaphaneitè' Pater was trying to distinguish different types of character, with the diaphanous one as the finest. This early concern with type would seem to contradict Pater's subsequent warning against the stereotype: 'habit is relative to a stereotyped world, and meantime it is only the roughness of the eye that makes any two persons, things, situations seem alike.'[77] The discerning aesthetic critic, whose work Pater would define in the 'Preface' to *The Renaissance*, was characterized by his refined tastes and delicate perceptive powers, and to such a mind, with such a purity of vision, the individual is unique, as indeed the series of biographies which followed in the book served to testify.

With his focus on 'type', Pater was tapping into contemporary philosophic, aesthetic, and scientific discourses. Throughout his writings he would return to this early interest in the individual as representative of the species, but we might ask whether one can actually make a portrait of a type? This question finds no easy answer and cuts right to the core of portraiture. The tracing, feature by feature ('trait pour trait'), of the looks or character of an individual might seem to exclude the entirely typical. Getting at the individual through the type is one option in such serial portraits as Godfrey Kneller's *Kit-Cat Club portraits* in the National Portrait Gallery (1697–1721), all in the same format representing the same type of Whig MP or writer, or Peter Lely's *Windsor Beauties*, united by their gender, beauty, and experience (in the case of several of them) as mistresses of Charles II. As poses, wigs, or dresses point towards the type, we are also invited to compare and detect individual differences which aim at likeness. Considering the conception, execution, and display of Kneller and Lely's serial portraits, they emerge as both portraits of a type and portraits of individuals. Yet the portrait of the pure type, the visual distillation of the generic, can barely be called a portrait; the genre demands some element of likeness to one particular individual in the real world. Pater's contemporary, Francis Galton, was keen to develop techniques for such a portrait of the type, and the transparencies of photographic glass plates assisted in erasing the individual while getting at the type, as we shall see.

[77] 'Conclusion' in *Ren.*, 189.

46 WALTER PATER'S EUROPEAN IMAGINATION

Pater frequently evoked the sculptural aspect of type, from its Greek meaning of 'impression', something beaten or struck. 'The figure on either side of a coin or medal'; 'A small rectangular block, usually of metal or wood, having on its upper end a raised letter, figure, or other character, for use in printing', and 'A printed character or characters, or an imitation of these'.[78] Pater's diaphanous type procreates by means of impression as it stamps itself on the minds of its followers, just as the schools of Leonardo and Giorgione consisted in a particular form of male procreation, as the master's genius imprinted itself on the minds and art of his disciples. 'Fine' and 'refinement' are words which Pater associates with his diaphanous type, indicative of its delicacy, its sophistication, its continued movement towards a state of perfection. The Paterian process of personal and artistic refinement is essentially a sculptural process, ranging from the immaterial to the material, from the idealizing conception of a piece of sculpture to the last finish: 'For in truth all art does but consist in the removal of surplusage, from the last finish of the gem-engraver blowing away the last particle of invisible dust, back to the earliest divination of the finished work to be, lying somewhere, according to Michelangelo's fancy, in the rough-hewn block of stone'.[79] In Pater's sculptural mind, both 'type' and 'character' are sculptural entities when the etymologies and literal meanings of the words are taken into account. The *OED* definition of 'character' reminds us that its etymology from Greek, Latin, and French all have to do with engraving, with the impressing or imprinting of a hard item onto a softer surface: 'A distinctive mark impressed, engraved, or otherwise made on a surface; a brand, stamp.' Only subsequently, in the seventeenth century, does the word take on the meaning of 'The sum of the moral and mental qualities which distinguish an individual or a people, viewed as a homogeneous whole; a person's or group's individuality deriving from environment, culture, experience, etc.; mental or moral constitution, personality'.[80]

Pater's crystal man exists in an interstitial space. His ideal type progresses from the chthonic, the intangible shades of the Underworld to the luminous spirits of a future aesthetic revolution, from 'those evanescent shades, which fill up the blanks between contrasted types of character' to those 'discontented with society as it is', bent on a future 'regeneration of the world'.[81] Pater's type falls into the blank space between contrasting types of character, he tells us, while directing our attention to the blank space rather than to the oppositions which frame it. One is tempted to draw a parallel to another aspect of Paterian diaphaneity, namely Pater's own blanks. In his carefully handwritten manuscripts, copied out some seven to eight times, we often find blank spaces of varying length, which seem to hold the key to the balance between form and matter in his compositions.[82] As they appear on his pages, they invite questions of surface and depth. Are they blanks, blots, spots or dots, indentations or protrusions, of no importance or of the greatest significance? Are they waiting for the Paterian words to land, so important that by the time Pater left his

[78] *OED* definitions 2b, 9a, and 9c. [79] 'Style', 734. [80] *OED* 'character', definitions 1 and 9a.
[81] 'Diaphaneitè', 140.
[82] For discussions of the Paterian blanks, see Anthony Ward, *Walter Pater: The Idea in Nature* (London: Macgibbon, 1966), 189; Østermark-Johansen 2011, 315–23; *CW* 4:30–4. The manuscript holdings in the Houghton Library at Harvard, MS Houghton 1150, are full of evidence of such blanks.

manuscripts, they had not yet emerged from his imagination? Or are they quantitative units in linear or aural space rather than semantic entities? The Paterian blanks are still awaiting thorough scholarly investigation, but their early visualization in his first essay as images of his diaphanous type is intriguing.

Pater's interest in the colourless, the undefined, and apparently insignificant is a fundamental aspect of his writing. The oscillation between shadow and substance runs from his very earliest text to his discussion of the subject in *Gaston de Latour*, and his type becomes the precursor of several similarly colourless individuals in his fiction. Pater peopled his literary world with diaphanous characters, frequently described by his critics as 'ghosts': young men caught between the desire for fame, substance, and recognition, yet so often drawn back into the state of evanescent shades. When reviewing the 1887 volume, Arthur Symons declared that 'it is quite obvious that neither Watteau, nor Denys, nor Sebastian, nor Duke Carl really lives, in so much as a finger-tip, with actual imaginative life; they are all ghosts, names, puppets of an artist and a philosopher who has evoked and constructed them for a purpose, but has not been able, or has not wished, to endow them with flesh and blood, with the breath of life.'[83] Shadwell may well have proved the most long-lived of the handsome young men in Pater's prose; he died in 1919, and thus outlived the author by some twenty-five years. Most of Pater's protagonists are set on a moribund course from the very beginning of the narratives; the Victorian reader could conclude that the diaphanous type was not one fit for survival. The transparent physiognomy of several of Pater's protagonists (Watteau, Sebastian, the English Poet) reflects the tuberculosis which devours them from within. The aesthetic beauty of the consumptive self provides the Paterian hero with a peculiarly decadent attractiveness. Certain of the imaginary portraits chronicle the history of a pathological type who wastes away, consumed by a passion for art, philosophy, or poetry.[84] Pater's interest in the transparent self predated Wilhelm Röntgen's invention in 1895 of the X-ray, which visualized photographically a diaphanous body through a technique soon to be leading in the diagnosis of tuberculosis. As a disease which usually struck in early youth, consumption caught people at their peak, and Pater's observation, in 'Diaphaneitè', that 'Often the presence of this nature is felt like a sweet aroma in early manhood'[85] would become curiously prophetic for his long line of imaginary portraits which revolve around relatively few youthful years in the lives of his protagonists.

The oscillation between the generic and the specific can be traced throughout the portraits, the earliest of which bear generic titles (child, poet, painter). Pater's protagonists are both representatives of a profession and individuals, placed against a carefully delineated historical and geographical background:

- 'The Child in the House' (1878): the child;
- 'An English Poet' (fragment *c*.1878): the poet;

[83] Arthur Symons, signed review, *Time* (Aug. 1887), n.s. 6, 157–62. Quoted from Seiler 1980, 175–82, 178–9.
[84] See, among many titles on the subject, Susan Sontag's *Illness as Metaphor* (New York: Farrar, Straus, and Giroux, 1978); Katherine Byrne, *Tuberculosis and the Victorian Literary Imagination* (Cambridge: Cambridge University Press, 2011).
[85] 'Diaphaneitè', 139.

- 'A Prince of Court Painters' (1885): the painter;
- 'Sebastian van Storck' (1886): the philosopher;
- 'Duke Carl of Rosenmold' (1887): the collector;
- 'Emerald Uthwart' (1892): the schoolboy/student/soldier;
- 'Gaudioso the Second' (fragment *c.*1890): the bishop;
- 'Tibalt the Albigense' (fragment *c.*1890): the medic;
- 'Il Sartore' (fragment *c.*1892): the tailor.

While there may be little of the Theophrastan physiognomical study about Pater's portraits, most of which are curiously incorporeal, they all spring from his diaphanous 'Ur-portrait', a feature noticed by Pater's colleague Andrew Lang when in 1895 he reviewed *Miscellaneous Studies* in which both 'Diaphaneitè' and 'The Child in the House' appeared:

> The little essay on *diaphanéité* [sic] was, apparently, written when the author was an undergraduate or a very young don, and it is a proof that he became himself very early. Nothing can be more remote in thought and expression from the ordinary heyday of youth. Some of the ideas, like that Platonic one of 'elect souls', recur in the essay on Pascal. If 'The Child in the House' was himself, he must have been his literary self from infancy. He had 'a mystical appetite for sacred things,' a most unusual state of mind, surely; his ideas of ghosts were extremely unlike those which we used to entertain. The essays are like a voice out of another world than ours; a world, I fear, where I should long to do something violently natural—to shout, and throw stones, and disarrange things in general, and talk in a boisterous manner about sporting events. But this reaction (which is deplorable) may be only a proof of the author's success in producing the still, chill, contemplative effect which he desired.[86]

Lang's illustrative contrast between the mannered artfulness of Pater's universe and his own robust liveliness addresses the anti-realist aspects of Pater's writings. Fully aware that neither 'Diaphaneitè' nor 'The Child in the House' aims at mimetic representation, Lang directs our attention to their artificiality, and to their qualities as extensions of the Paterian self. The ethereal and incorporeal, the ghostly and the Platonic, are the qualities he stresses. Writing about an author who had recently joined the realm of the evanescent shades, Lang had every reason to stress the spectral in a colleague, whose writings, precious in their limited output, would seem like the ghostly doubles of his own prolific publications on identical matters such as myth, translation, French Renaissance literature, and Classics. His recognition of the cohesion of the Paterian *oeuvre*, of the child as father of the man, is astute, and while delicately raising the issue of Pater's autobiografictitious selves, Lang most of all pays tribute to a fellow writer whose attitude to the physical, tangible world was so remarkably different from his own.

[86] Andrew Lang, 'Literary Chronicle', *Cosmopolis* 1 (Jan. 1896), 70–87, 77.

'The Transmutation of Ideas into Images': Leonardo

Some five years after 'Diaphaneitè', Pater expanded his study of character, type, and portraiture in 'Notes on Leonardo da Vinci'. First published, with Pater's signature, in the *Fortnightly Review* in 1869,[87] it was subsequently included in *The Renaissance*. The Leonardo essay is seminal in any discussion of Pater and portraiture: here elusive type assumes definite form, as drawings of male and female beauty merge into painting. The imprint of an image on the artist's mind in childhood results in the creation of a mature masterpiece towards the end of his life. The continued presence of the *Mona Lisa* from beginning to end contributes towards making the essay one of the most compelling Pater ever wrote; his constant interweaving of biography, science, myth, art theory, and portraiture accounts for the complexity of his text. Pater's Leonardo is as elusive as his diaphanous type: in constant movement between Florence, Milan, and France, the genius is driven by a Faustian search for a special type of beauty in a strange tension between his own unique brilliance and typified beauty. Based on his reading of Vasari and nineteenth-century French biography, Pater chronicled the life of Leonardo, the constant seeker. A temperamental and irregular worker, experimenting with subjects and techniques, Leonardo is propelled by a quest not unlike Pater's own. 'His problem was the transmutation of ideas into images',[88] we learn. The challenge of turning the inward outward, of shaping ideas into images, sits at the heart of Pater's imaginary portraits. How can we make the invisible visible, how can we depict ideals in writing? Pater asks, as he shows us Leonardo abandoning one project after the other.[89]

Pater's Leonardo is at once artist and scientist. Leonardo's plunge 'into the study of nature' is stressed from the very beginning,[90] and Pater paints a portrait of an artist who exchanges his diaphanous soul for something more complex: 'He learned the art of going deep, of tracking the sources of expression to their subtlest retreats, the power of an intimate presence in the things he handled. He did not at once or entirely desert his art; only he was no longer the cheerful, objective painter, through whose soul, as through clear glass, the bright figures of Florentine life, only made a little mellower and more pensive by the transit, passed on to the white wall.'[91] We have echoes of the glassworlds of Goethe, Emerson, and Carlyle: Pater's young Leonardo creates a realism in his figures which testifies to his own psychological perspicacity and technical brilliance. In his inner battle between art and science, Leonardo is lured deeper and deeper into his scientific labyrinths, eventually to abandon his early clarity of vision and happiness.

Leonardo is Pater's transparent hero, displaying a unique transparency of vision, mind, memory, and technique which captures much of Leonardo's own obsession with optics, rocks, crystals, mirrors, and the *sfumato* technique. As a text which had a profound impact on Sigmund Freud's first biographical study, *Eine Kindheitserinnerung des Leonardo da Vinci* (1910),[92] Pater's Leonardo essay gives us a protagonist whose

[87] 'Notes on Leonardo da Vinci', *Fortnightly Review* 6 (1 Nov. 1869), 494–508.
[88] 'Leonardo da Vinci' in *Ren.*, 88. [89] Ibid., 89. [90] Ibid., 81. [91] Ibid., 81.
[92] The first English translation by A. A. Brill appeared a few years later, *Leonardo da Vinci: A Psychosexual Study of an Infantile Reminiscence* (New York: Moffat, Yard and Company, 1916).

50 WALTER PATER'S EUROPEAN IMAGINATION

childhood memories and early impressionability led directly to his late masterpieces, as the type gradually manifested itself in individual form. Concerned with the impact of childhood experience on the adult artist, possibly spurred on by Vasari's brief discussion of Leonardo's youthful works,[93] Pater merged memory and dream with artistic vision in a manner which illustrated the unique way in which Leonardo transmuted ideas into images: 'Two things were especially confirmed in him, as reflexes of things that had touched his brain in childhood beyond the depth of other impressions—the smiling of women and the motion of great waters.'[94] Pater uses this observation as a structural device for the rest of his essay. In 'The Child in the House' (1878) he would develop an interest in what he called 'brain-building', but already in his concern with Leonardo's plastic infantile brain did he display an understanding of the significance of early impressions for the moulding of character. Pater's proto-Freudianism is clear in this systematic tracing of the female smile throughout his art. As a Freudian screen memory[95]—an apparently less significant recollection which replaces the memory of a repressed and more important event—Leonardo's memory of the female smile runs as a *Leitmotif* through his art. Freud, who would link the female smile and the mouth as an erogenous zone to Leonardo's memory of his mother, found the key to a pervasive feature of the artist's painting in the repressed memory of Leonardo's loss of his mother and declared in a letter to Carl Jung of 17 October 1909: 'The riddle of Leonardo da Vinci's character has suddenly become transparent to me.'[96] By tracing the smile to its roots, Freud would develop his theories of Leonardo's early identification with his mother as the cause of his homosexuality, of his continued fascination with the Madonna-and-child motif, and his scopophilic and investigative drive, while paying tribute to the formative influence of Pater's essay.[97] Pater, however, traces a long line from early visual impression, through artistic copying, to memories, dreams, and visual encounter in his pursuit of the origins of the Leonardesque smile. Andrea del Verrocchio is the source of the smile:

> In that inestimable folio of drawings, once in the possession of Vasari, were certain designs by Verrocchio, faces of such impressive beauty that Leonardo in his boyhood copied them many times. It is hard not to connect with these designs of the elder, by-past master, as with its germinal principle, the unfathomable smile, always with a touch of something sinister in it, which plays over all of Leonardo's work. Besides the picture is a portrait. From childhood we see this image defining itself on the fabric of his dreams; and but for express historical testimony, we might fancy that this was but his ideal lady, embodied and beheld at last. What was the

[93] 'In his youth he made in clay the heads of some women laughing, created through the craft of plaster-casting, as well as the heads of some children, which seemed to have issued forth from the hand of the master [Verrocchio, to whom Leonardo was apprenticed].' 'The Life of Leonardo da Vinci, Florentine Painter and Sculptor' in Giorgio Vasari, *The Lives of the Artists*, tr. Julia Conway Bondanella and Peter Bondanella, Oxford World's Classics (Oxford: Oxford University Press, 1998), 284–98, 285.

[94] *Ren.*, 82.

[95] See Freud's essay 'Screen Memories' (1899) in Sigmund Freud, *The Uncanny*, tr. David McLintock, intr. Hugh Haughton, the Penguin New Freud Library (London: Penguin, 2003), 3–22.

[96] Quoted in Haughton's 'Introduction' to Sigmund Freud, *The Uncanny*, xii.

[97] Freud's Leonardo essay is contained in the New Penguin Freud volume of 'The Uncanny', 45–120. See 56, 63, 66, 74, 79–81, 85–8.

relationship of a living Florentine to this creature of his thought? By what strange affinities had the dream and the person grown up thus apart, and yet so closely together? Present from the first incorporeally in Leonardo's brain, dimly traced in the designs of Verrocchio, she is found present at last in *Il Giocondo's* house.[98]

The term 'impressive beauty' gains new significance, as something which is both a cognitive entity and an artistic process, resulting in new works which, in their turn, can impress themselves on the minds of new spectators and artists. In this ever-ongoing process of looking and creating, Pater's Leonardo becomes a pivotal figure, bridging the fifteenth and the sixteenth centuries, Florence and Milan, the Florentine and the Lombard Schools. Pater is interested in 'The School of Leonardo'—Francesco Melzi and Bernardino Luini—in artistic influence as a peculiarly male form of begetting. Jonah Siegel suggests that our awareness of a school becomes 'not a loss but the possibility of a still greater intimacy with the artist'.[99] Leonardo's transcendental powers prevailed over his pupils who 'acquired his manner so thoroughly, that though the number of Leonardo's authentic works is very small indeed, there is a multitude of other men's pictures through which we undoubtedly see him, and come very near to his genius'.[100] The school is evidence of Leonardo's charismatic personality, and the 'presence of the characteristics of an artist in spite of the absence of any physical work on his part becomes a manifestation of the powers of that artist to make others in his own creative image'.[101] Leonardo's followers thus become his works of art in their own right, clones whose paintings are almost indistinguishable from the master's. Leonardo's particular kind of male procreation results in a new generation of Leonardeschi: transparent, almost, in their erasure of themselves and their ensuing absorption of Leonardo's style. The erotics of teaching and learning, a tradition handed down from Plato, is part of this all-male begetting where impression results in an ongoing process of mirroring, splitting, and erasure. The pupils' selves turn into types in the proximity of Leonardo's domineering genius, with the school itself as testimony to the master's creative power. Jean Delville's monumental *L'école de Platon* (1898) (Fig. 1.7), a decadent spin on Leonardo's *Last Supper*, merges supper with symposium, religious disciples with academic teaching, and the slim, Leonardesque, long-haired ephebes become naked unbearded clones of the master at the centre. Whether this is Plato, Christ, or Leonardo keeping court is, in a sense, less important: the pedagogics of homosociality is conveyed with all its attractive aesthetic intimacy.

Pater began his essay by celebrating Leonardo as 'the painter who has fixed the outward type of Christ for succeeding centuries',[102] most likely thinking of the central figure of the *Last Supper*, whose ephemerality and frail delicacy, literally unfixed on the wall, proved a point of fascination. The apostles are 'ghosts through which you see the wall, faint as the shadows of the leaves upon the wall on autumn afternoons',

[98] *Ren.*, 97–8.
[99] Jonah Siegel: 'Schooling Leonardo: Collaboration, Desire, and the Challenge of Attribution in Pater', in ed. Laurel Brake, Lesley Higgins, and Carolyn Williams: *Walter Pater: Transparencies of Desire* (Greensboro: ELT Press, 2002), 133–50, 134.
[100] *Ren.*, 92. [101] Siegel, 2002, 140. [102] *Ren.*, 77.

Fig. 1.7. Jean Delville, *L'école de Platon* (1898), oil on canvas, 260 × 605 cm. Musée d'Orsay, Paris. Photo © RMN-Grand Palais (Musée d'Orsay)/Hervé Lewandowski.

with Christ as but 'the faintest, the most spectral of them all'.[103] Leonardo's experiments with oil painting, resulting in a new transparency which would appear as almost unmediated painting, left no traces of the artist's hand or brush. Pater may also have been thinking of a painting he had never seen, the recently discovered and much disputed *Salvator Mundi* (Saviour of the World) (Fig. 1.8), known in the nineteenth century through a range of copies.[104] The blurred transparency of the head brings reminiscences of the Holy Face, the so-called *sudarium* with the imprint of the Saviour's face. As Luke Syson points out, in making the invisible visible, the word flesh, Leonardo's 'work becomes a new kind of miracle, founded on God-given talent'. The 'extreme delicacy of his technique in the *Salvador Mundi* conceals any sign of his brushwork. Just as God created Christ as his perfect image and likeness, so Leonardo sought to recreate the perfect icon. Leonardo's art is therefore seen to be just as wonderful as that of the crystal orb, itself unmakeable except by God and Leonardo.'[105]

In his notebooks, Leonardo had observed that the light which passes through 'diaphanous bodies' like glass or crystal, produce 'the same effect as though nothing had intervened between the shaded object and the light that falls upon it'.[106] The orb of rock crystal, emblem of kingship and symbol of the world, which Christ carries in his left hand, plays with our notions of the solid and the evanescent. Perfect in its spherical shape, it is seen to 'both contain and transmit the light of the world'.[107] A piece of divine craftsmanship, it makes the connection between God's creativity and Leonardo's own explicit. Leonardo was playing with a sophisticated kind of

[103] Ibid., 95.

[104] For the controversies, see Ben Lewis, *The Last Leonardo: The Secret Lives of the World's Most Expensive Painting* (New York: Ballantine Books, 2019); Martin Kemp, Robert B. Simon, and Margaret Dallivalle, *Leonardo's Salvator Mundi and the Collecting of Leonardo in the Stuart Courts* (Oxford: Oxford University Press, 2020).

[105] Luke Syson, cat. 91, *Christ as Salvator Mundi* in Luke Syson with Larry Keith, *Leonardo da Vinci: Painter at the Court of Milan* (London: National Gallery, 2011), 300–3, 303.

[106] Quoted in Syson, 303. [107] Ibid.

TYPE AND INDIVIDUAL 53

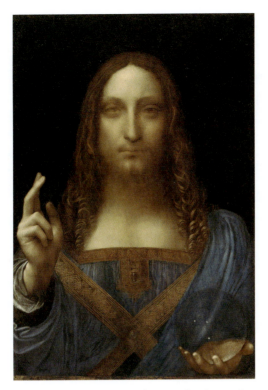

Fig. 1.8. Leonardo da Vinci (?), *Salvator Mundi* (*c*.1500), oil on walnut, 45.4 × 65.6 cm. present whereabouts unknown (August 2021). Wikimedia Commons.

perspective: foreground focus on the blessing right hand and the solid, yet transparent, orb while leaving the head of Christ in a soft focus, thus contributing to an air of mysticism. What Pater would have made of this diaphanous Leonardo—a work contemporary with the *Mona Lisa* and the *St John*—must be relegated to the realm of speculation. But more generally, the veils of *sfumato* and thin layers of paint in Leonardo's paintings give them a transparency which align them with Pater's diaphanous type. His *Saint John* (Fig. 1.9), whose 'delicate brown flesh and woman's hair no one would go out into the wilderness to seek',[108] conflates the type of Christ and Leonardo's smiling women into an alluring androgynous type which Pater saw as the epitome of the Leonardesque.

He found this distillation of the Leonardesque in a small drawing in the Louvre which he discussed in an impressionistic passage, evoking the manner of Swinburne, who only the year previously had published an idiosyncratic account of a visit to the Old Master drawings in Florence.[109] 'Take again another head, still more full of

[108] *Ren.*, 93.
[109] A. C. Swinburne, 'Notes on Designs of the Old Masters at Florence', *Fortnightly Review* 10 (July 1868), 16–40. See also Lene Østermark-Johansen, 'Swinburne's Serpentine Delights: The Aesthetic Critic and the Old Master Drawings in Florence', *Nineteenth-Century Contexts* 24:1 (2002), 49–72; Stefano Evangelista, 'Swinburne's Galleries', *Yearbook of English Studies* 40:1–2 (2010), 160–79.

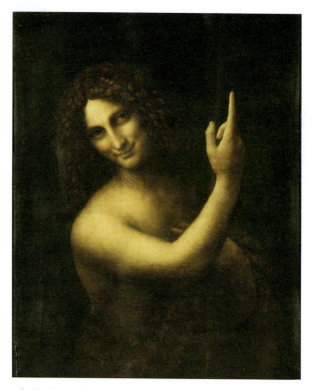

Fig. 1.9. Leonardo da Vinci, *Saint John* (1513), oil on canvas, 69 × 57 cm. Musée du Louvre, Paris. Wikimedia Commons.

sentiment, but of a different kind, a little drawing in red chalk, which every one will remember who has examined at all carefully the drawings by old masters at the Louvre. It is a face of doubtful sex, set in the shadow of its own hair, the cheek-line in high light against it, with something voluptuous and full in the eyelids and the lips.'[110] Although the drawing is catalogued as a 'jeune homme,'[111] Pater turns it into 'a face of doubtful sex' which modulates into a series of female heads, before, at the end of the paragraph, he reverts to a male head 'which Love chooses for its own—the head of a young man, which may well be the likeness of Salaino, beloved of Leonardo for his curled and waving hair—*belli capelli ricci e inanellati*—and afterwards his favourite pupil and servant.'[112] Another name has been added to the 'School of Leonardo', another youth of a similarly androgynous kind.

[110] *Ren.*, 90–1.

[111] In the nineteenth century the drawing was attributed to Leonardo. See Frédéric Reiset, *Notice des dessins, cartons, pastels, miniatures et émaux, exposés dans les salles du Ier étage au Musée impérial du Louvre. Première partie: Ecoles d'Italie, Ecoles Allemande, Flamande et Hollandaise* (Paris: Charles de Mourgues, 1866), where it is described as a 'Jeune homme vu en buste et de trois quarts, tourné vers la droite: sa chevelure est énorme'. The words 'Lionardo 116' are inscribed in the top-hand right corner of the drawing which is now attributed to Giovanni Agostino da Lodi: http://arts-graphiques.louvre.fr/detail/oeuvres/5/3015-Buste-de-jeune-garcon-de-trois-quarts-a-droite (accessed on 4 Aug. 2021).

[112] *Ren.*, 91–2.

Pater famously never illustrated his books. The only visual image which ever appeared in his books was an engraving of this Louvre 'face of doubtful sex, set in the shadow of its own hair'.[113] When the second and revised edition of *The Renaissance* was published in May 1877, the Leonardesque head took up a prominent position on the title page (Fig. 1.10). The signature of the engraver, Charles Henry Jeens, could be seen in the top left-hand corner, and as Pater's correspondence with his publisher, Alexander Macmillan, reveals, the author was very particular about the reproduction of the image.[114] He retained it for the remaining two editions of *The Renaissance* published during his lifetime, in 1888 and 1893. With the insertion of the vignette on the title page, Leonardo became a predominant initial presence in the book. Pater had been keen to have the name of 'Leonardo' inserted under the image and in any promotional material for his revised edition: 'The words of the advertisement might run: "with a vignette after Leonardo da Vinci, engraved by Jeens," and in any gossip on the subject it might be described as being from a favourite drawing by Leonardo da Vinci in the Louvre', he suggested.[115] As the epitome of Pater's Renaissance spirit, the head stares in the direction of reading, inviting the reader to open the book and enter the world of the Renaissance. Pater did not know that the drawing was 'school of' rather than an authentic Leonardo, but even so, as the image appears on the page, it recalls his description of the drawing of Salaino and the discussion of the School of Leonardo. It is Leonardo's special type of beauty which defines Pater's volume, an anonymous individual of doubtful sex, rich in suggestiveness and influence, an imprint, a type, a copy of a drawing, gazing towards the future with a rich potential for 'the regeneration of the world'.[116]

The dynamics in Pater's essay moves towards the *Mona Lisa* as the culmination of Leonardo's career as a painter. 'Besides, the picture is a portrait',[117] he tells us, and belittles the genre: 'That there is much of mere portraiture in the picture is attested by the legend that by artificial means, the presence of mimes and flute-players, that subtle expression was protracted on the face.'[118] Pater may have shared Vernon Lee's scepticism of portraiture, 'a curious bastard of art', sprung from the inartistic 'desire for the mere likeness of a person'.[119] The artist's notion of ideal beauty is opposed to the mimetic aspect of portraiture, Lee claims, and the bastard art of portraiture consequently falls into this interstitial space between the faithfulness to likeness and the aspiration towards beauty.[120] For the musical Leonardo, human character becomes an instrument to be sounded, always with the suggestion that the competent player's

[113] Ibid., 90. See Lene Østermark-Johansen, ' "The Power of an Intimate Presence": Walter Pater's Leonardo Essay (1869) and its Influence at the Fin de Siècle', in ed. Juliana Barone and Susanna Avery-Quash, *Leonardo in Britain: Collections and Historical Reception* (Florence: Leo S. Olschki, 2019), 303–21.

[114] R. M. Seiler, ed., *The Book Beautiful: Walter Pater and the House of Macmillan* (London: Athlone Press, 1999), 74–82.

[115] Walter Pater to Alexander Macmillan, 12 March 1877, Seiler 1999, 79, 82.

[116] 'Diaphaneitè', 140. [117] *Ren.*, 97.

[118] Ibid., 98. Vasari had circulated the anecdote that the sitter's smile was brought forth by musical entertainment. See *Lives of the Artists*, 294.

[119] Vernon Lee, 'The Portrait Art of the Renaissance', *Cornhill Magazine* 47 (May 1883), 564–81, 565.

[120] For Pater's friendship with Vernon Lee, see Laurel Brake, 'Vernon Lee and the Pater Circle', in ed. Catherine Maxwell and Patricia Pulham, *Vernon Lee: Decadence, Ethics, Aesthetics* (Basingstoke: Palgrave, 2006), 40–57; Carolyn Burdett, 'Walter Pater and Vernon Lee', *Studies in Walter Pater and Aestheticism* 2 (2016), 31–42.

THE RENAISSANCE

STUDIES IN ART AND POETRY

BY

WALTER PATER

FELLOW OF BRASENOSE COLLEGE, OXFORD

SECOND EDITION, REVISED

LONDON

MACMILLAN AND CO.

1877

[*All rights reserved*]

Fig. 1.10. Title page of *The Renaissance: Studies in Art and Poetry* (London: Macmillan, 1877) with the Leonardesque head, engraved by Charles Jeens. Book in private collection. Photo © Christoffer Rostvad.

charismatic personality takes over the instrument: 'To take a character as it was, and delicately sound its stops, suited one so curious in observation, curious in invention.'[121] Leonardo's portraits from the court of Ludovico il Moro become symptomatic of an anxious and distorted court culture full of early deaths. The portraits of the Sforzas in the Brera, of Cecilia Galerani, and the so-called *Belle Ferronière* in the Louvre are passed over as commissioned pieces unrelated to the artist's unique pursuit of beauty, not complying with Pater's proto-Freudian narrative.[122]

'Presence' and 'suggestiveness', rather than 'likeness', are key terms. Before evoking the *Mona Lisa* as 'The presence that rose thus so strangely beside the waters', Pater reminds us that one of the chief functions of portraits is to make the absent present: 'Present from the first incorporeal in Leonardo's thought, dimly traced in the designs of Verrocchio, she is found present at last in *Il Giocondo's* house.' The corporeality of the ideal, assuming flesh, becomes an almost religious transformation. Pater instinctively picks up on the austere simplicity of *La Gioconda's* dress, veil, and hair, commented upon by scholars in speculations of hidden religious meanings in a painting which does not resemble the conventional Renaissance female portrait. The merging of dream, person, and childhood memory marks the painting as perhaps Leonardo's greatest success in that transferral of ideas into images. Pater makes a sudden detour to the German Renaissance (Fig. 1.11): 'In suggestiveness, only the *Melancholia* of Dürer is comparable to it; and no crude symbolism disturbs the effect of its subdued and graceful mystery.'[123] Dürer's seated figure is not an immediately obvious counterpart; an allegory, a representation of a state of mind, Dürer's engraving may have a contemplative impenetrability which likens it to the *Mona Lisa*. Certainly, both works have begotten a vast and conflicting secondary literature.[124] The *Melencolia* becomes, according to Joseph Koerner, itself a *Sinnbild* of the spectator, 'designed to generate multiple and contradictory readings, to clue its readers to an endless exegetical labor until, exhausted in the end, they discover their own portrait in Dürer's sleepless, inactive personification of melancholy. Interpreting the engraving itself becomes a detour to self-reflection, just as all the arts and sciences whose tools clutter the print's foreground finally return their practitioners to the state of mind absorbed in itself.'[125] Suggestiveness replaces likeness as the most important quality of the artwork, and the critic's subjective response begets a new work rivalling the original painting. Pater's mock biography, his hyperbolic condensation of this 'embodiment of the old fancy, the symbol of the modern idea' problematized the

[121] *Ren.*, 87–8.

[122] Not all the above-mentioned works are now ascribed to Leonardo, but Pater was less interested in attributions than in the Leonardesque.

[123] *Ren.*, 97.

[124] For the *Mona Lisa*, see Martin Kemp and Giuseppe Pallanti, *Mona Lisa: The People and the Painting* (Oxford: Oxford University Press, 2017); Serge Bramly, *Mona Lisa* (London: Thames & Hudson, 1996); Roy McMullen, *Mona Lisa: The Picture and the Myth* (London: Macmillan, 1976). For Dürer's *Melencolia*, see Peter-Klaus Schuster, *Melencolia I: Dürers Denkbild*, 2 vols (Berlin: Gebr. Mann, 1991); and Erwin Panofsky and Fritz Saxl, *Dürers 'Melencolia I'. Eine Quellen- und typengeschichtliche Untersuchung*, Studien der Bibliothek Warburg 2 (Leipzing and Berlin: B. G. Teubner, 1923) and Raymond Klibansky, Erwin Panofsky, and Fritz Saxl, *Saturn and Melancholy: Studies in the History of Natural Philosophy, Religion, and Art* (London: Nelson, 1964).

[125] Joseph Leo Koerner, *The Moment of Self-Portraiture in German Renaissance Art* (Chicago and London: University of Chicago Press, 1996), 23.

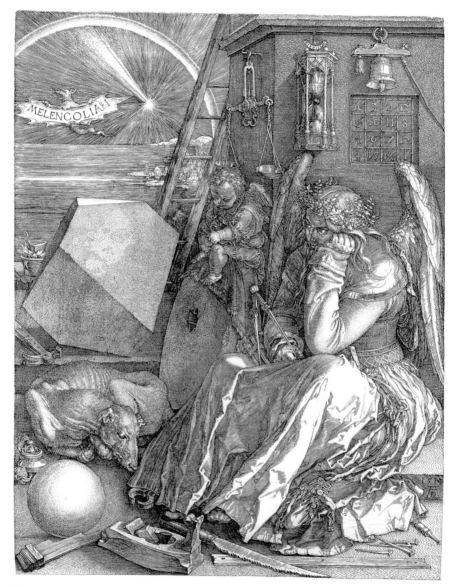

Fig. 1.11. Albrecht Dürer, *Melencolia I* (1514), engraving, 23.8 × 18.5 cm. Wikimedia Commons.

summing up of a life which is one of the constituent elements of portraiture.[126] Lady Lisa's life is more comprehensive than most, as Pater explodes all frames of

[126] See Jonathan Richardson's definition of portraiture in his *Essay on the Art of Criticism* (1719): 'A portrait is a sort of general history of the life of the person it represents, not only to him who is acquainted with it, but to many others, who upon seeing it are frequently told of what is most material concerning them, or their general character at least; the face; and figure is also described and as much of the character

conventional portraiture. Few individuals range from 'the animalism of Greece' to the 'sins of the Borgias,'[127] from paganism to Christianity, from Leda to St Anne. Pater's *Mona Lisa* has a diaphanous transparency which links her to the 'Ur-portrait' and would prove a truly revolutionary type of femininity, if one can go by the impact she has had on subsequent critical literature.

Dürer's Melencolia is embedded in a scientific universe, full of mathematical and geometrical objects, which reflect Dürer's own obsession with science, optics, and perspective. Theories of the seated figure as Dürer's self-portrait have long prevailed, just like the theories that the *Mona Lisa* is really Leonardo's self-portrait. Dürer's scientific bent is related to Leonardo's, and one of the images on which Pater's essay closes is that of the artist as the mad scientist: 'We catch a glimpse of Leonardo again, at Rome in 1514, surrounded by his mirrors and vials and furnaces, making strange toys that seemed alive of wax and quicksilver. The hesitation which had haunted him all through his life, and made him like one under a spell, was upon him now with double force.'[128] The allusion to Goethe's Faust early in the essay makes us aware that the Faustian element has been a driving force in Leonardo's inner struggle between art and science, with science bearing the responsibility for his many unfinished artworks. Pater's repeated allusion to Leonardo's fascination with mirrors alerts our attention to a protagonist bent on seeing the world in distorted or mediated form. Leonardo's glass mind, with a 'taste for what is *bizarre* or *recherché* in landscape; hollow places full of the green shadow of bituminous rocks, ridged reefs of trap-rock which cut the water into quaint sheets of light'[129] gives us rock crystal, with an awareness that transparency comes from rocks. Pater merges the scientist with the artist in his long description of Leonardo's Madonnas of the Rocks as artistic works in which the artist's obsession with the smiling of women and the movement of water blend imperceptibly with his naturalist's explorations into geology and optics.

Freud's 1909 letter to Jung, in which he stated that the riddle of Leonardo's character had suddenly become transparent to him, linked his discovery to a recent encounter: 'Not so long ago I came across his image and likeness (without his genius) in a neurotic,' he told his colleague.[130] The meeting with Leonardo's twentieth-century double would appear to have sparked Freud's desire to explore the pathologization of Leonardo's quest for knowledge. His study of the artist's childhood memories revolves around the tensions between the artist and the scientist, the life-long channelling of erotic desire into the study of painting and the natural world. The tensions were Freud's own; like Leonardo, he was torn between the worlds of art, archaeology, and fiction, and his scientific pursuits into psychoanalysis. He admitted the fluid boundaries between art and science: 'Should my exposition prompt the judgement, even among friends of psychoanalysis and experts in the field, that I have done no more than write a psychoanalytic novel, I would reply that I certainly do not overrate the reliability of my findings. I have yielded, like others, to the fascination of this great and enigmatic figure, in whose nature one senses powerful instinctual passions,

as appears by these, which oftentimes is here seen in a very great degree.' Quoted in Richard Brilliant, *Portraiture* (London: Reaktion Books, 1991), 37.

[127] *Ren.*, 98–9. [128] Ibid., 100. [129] Ibid., 87.

[130] Quoted in Haughton's 'Introduction' to Freud, *The Uncanny*, xxx.

60 WALTER PATER'S EUROPEAN IMAGINATION

which can nevertheless express themselves only in a strangely subdued fashion.'[131] This is the Freud who, as Adam Philips reminds us, was well aware that his early case studies read like short stories or novellas.[132] The analyst's own attraction to and fascination with his 'patient' prevented a fully scientific approach and detachment, and analysis incorporated an element of autobiography in the construction of a coherent narrative. Hugh Haughton went even further and placed Freud in the tradition of Pater's imaginary portraits when he suggested that 'We should think of "Leonardo" rather as a Borgesian fiction about an artist, an exercise in the theory of research, an "imaginary portrait" of a homosexual genius, a speculative experiment in psychoanalytic biography, or a fantastic intervention in the critical literature on Leonardo comparable to Wilde's "Portrait of Mr W. H." in Shakespeare studies. It is also, to some degree, a self-portrait in a convex mirror.'[133] Leonardo's own concern with optics and mirrors cast a long shadow across the sixteenth and nineteenth centuries, right into the twentieth century with interventions by Vasari, Pater, and Freud. The mediated self, concerned with androgyny, male procreation, and the splittings of the self into recognizable types—mere shadows of the great charismatic original—may have originated in Renaissance Florence, but it had a *fin-de-siècle* appeal which reached well into the twentieth century and became a mark of modernity.

The concern with memory, with giving physical form to mental images placed Pater's essay at the forefront of nineteenth-century scientific developments. The child is father of the man: the ageing Leonardo surrounding himself with strange tools and experiments in Rome in 1514 was no different from the young Leonardo gathering toads, lizards, and salamanders in his attempts to create a terrifying Medusan shield as a young boy. Freud observed that in his identification with the Christ child and continued re-enactment of that part in his serial paintings of the Madonna and Child, Leonardo retained something of the child about him even as an adult.[134] The artist who 'fixed the outward type of Christ' could do so better than anyone because the type was himself, not unlike the way in which Dürer made Christ in his own image in his paintings.[135] Pater's essentially romantic interest in the impact of childhood memory on the shaping of the adult man would be explored with an autobiographical twist in 'The Child in the House' (1878), but in terms of his own ability to retain something of the child about him, the accounts of Pater's invented imaginary families are clear testimonies to his cultivation of a childlike persona. Whether that would make him qualify as one of Freud's neurotics is beyond my ability to decide, but certainly Freud's brief essay on 'Family Romances' (1909), with the original German title 'Der Familienroman der Neurotiker', alerts our attention to how normal such imaginary families are and how integral real and imaginary families are to the creation of literary fiction.[136] Undoubtedly, Pater's imaginary portraits owe some

[131] Freud, 'Leonardo' in *The Uncanny*, 103.

[132] See Adam Philips, *Becoming Freud: The Making of a Psychoanalyst* (New Haven and London: Yale University Press, 2014), 6 with reference to *The Complete Psychological Works of Sigmund Freud*, tr. James Strachey, 24 vols (New York: W. W. Norton, 1976), 2:160.

[133] Haughton's 'Introduction' to Freud, *The Uncanny*, xxxix.

[134] Freud, 'Leonardo' in *The Uncanny*, 66, 97. [135] See Koerner, *The Moment of Self-Portraiture*.

[136] Freud's essay on 'Family Romances' can be found in *The Uncanny*, 37–41.

of their being to his own family background, as Haughton suggests in his discussion of Freud's 'Family Romances':

> Freud makes us think about the centrality of the family to the development of both romance and the novel. He also makes us think about our need to displace and replace our parents, revealed by the special currency of stories and foundlings, orphans, bastards and noble lineage. It seems that children, like adults, need the idea of a double life in order to survive the family.... There is always, that is, an imaginary family as well as a real one. The family romance plays out and explores the discrepancies between one and the other, while confirming our 'overestimation of the earliest years of childhood' and the numerous and terrible idealizations of and disappointments with our parents which lie behind most stories of identity.[137]

Pater and Freud traced Leonardo's unique genius back to a unique childhood. More than anyone, perhaps, Leonardo, the bastard son, was blessed with a prodigious talent, and his narrative is that of the extraordinary individual who succumbs to archetypal patterns. His own charismatic personality transcended and interfered with his type of beauty, and although Pater would seem to have been more interested in the type in his Leonardo essay, the all-pervading enigmatic character of the protagonist is what prevails. His flitting, restless genius is in constant pursuit of a home, and it is perhaps not insignificant that when Pater came to deal with the generic child, it was one safely lodged in a house, as if to suggest the need for a three-dimensional framework for the type.

Francis Galton's Composite Portraits and 'The Child in the House'

Before we study that generic child, we must, however, make a detour to Francis Galton's attempts at constructing a portrait of a type. In 1877 Galton began experimenting with portrait photography through new techniques which would engage him well into the twentieth century. Requested by Sir Edmund de Cane, H. M. Inspector of Prisons, to make use of the large national photographic archives of criminals in order to trace the 'criminal type',[138] Galton combined the portraits of a handful of criminals into a single image taken with long exposure and containing in layered form all five portraits, yet blending them into one generic face in which none of the individual images were distinguishable. He developed his own technical apparatus for this process and kept refining it for a series of blended photographs which he termed 'composite portraits'. In taxonomic search of the exterior characteristics, not just of criminals, but also of Jewish boys, tubercular patients, or the typical face of the lawyer, the medic, or ancient emperor, Galton morphed photographs of living human beings, historical portraits, and ancient coins, in pursuit of the typical, rather than

[137] Haughton's 'Introduction' to Freud, *The Uncanny*, xxvi.
[138] Francis Galton, *Memories of my Life* (London: Methuen, 1908), 259.

the individual.[139] By combining the statistical and the photographic, Galton made 'abstract phenomena visible, factual and concrete'.[140] As Lila Lee-Morrison points out, 'One of the more ambitious aspects of Galton's composite portraiture was his use of the photographic medium—a medium grounded in indexical meaning—for the purpose of producing a representation of a face that does not exist in physical reality. Galton's production of the composite utilized the photographic medium to produce a model. The process of repetitive exposure in Galton's composite portraiture transformed the photographic apparatus into a kind of statistical measuring device. The emergence of a perceivable "type" materialized a distinct figure of the imagination on the basis of which it is possible to recognize individual members of the group.'[141]

Galton published his results in a series of articles in specialist journals like *Nature*, the *Journal of the Anthropological Institute*, the *Photographic Journal*, and *Guy's Hospital Reports*, but also in periodicals with a more general readership like the *Nineteenth Century* and the *Fortnightly Review*.[142] He often placed his composite portrait in the centre of a poster, with the constituent individual portraits surrounding it, in illustration of the process by means of which the many had turned into the one. As a result, 'All that is common remains, all that is individual tends to disappear', as Galton proudly phrased it.[143] Although from a scientific and biometric point of view Galton's composite portraits were a failure—he never successfully arrived at a criminal type or a particular kind of physiognomy susceptible to tuberculosis—he continued his experiments for more than two decades, continuously collecting photographs of individuals and running them through his photographic machines, while producing generic portraits of types. The composite portraits should be studied alongside Galton's experiments with mental images, explored in his *Questions on Visualising and Other Allied Faculties* (1880), with eugenics in his *Inquiries into Human Faculty* (1883), and his *Life History Album* (1884), most of them published by Macmillan & Co., who were also Pater's publishers.

We have no evidence that Pater read any of Galton's publications on composite portraiture, attended any of his lectures, or saw exhibitions where the blended images were on display.[144] Yet given the assiduousness with which Galton publicized his ideas and images and their appearance in some of the periodicals that we know Pater read, it seems unlikely that he was wholly unfamiliar with composite portraiture. My inclusion of Galton is more of an associative, contextualizing nature, as one of Pater's contemporaries who took a great personal and professional interest in transparency, mental images, and the layering of images into an oscillation between the generic

[139] There is an extensive account of Galton's experiments in Chapter XII 'Photographic Researches and Portraiture' in vol. 2 of Karl Pearson, *Life, Letters and Labours of Francis Galton*, 4 vols (Cambridge: Cambridge University Press, 1924).

[140] Lila Lee-Morrison, *Portraits of Automated Facial Recognition: On Machinic Ways of Seeing the Face* (Bielefeld: Transcript Verlag, 2019), 89.

[141] Ibid., 95.

[142] A large number of these publications are available at http://galton.org/composite.htm (accessed on 4 Aug. 2021).

[143] Francis Galton, *Inquiries into Human Faculty and its Development* (London: Macmillan, 1883), 230.

[144] Galton's lecture on 'Generic Images' at the Royal Institution in 1879 was illustrated by ten composite portraits (Pearson 2:291); other composites were displayed at the Loan Photographic Exhibition at the Society of Arts in February 1882, Galton, *Inquiries*, 13.

and the specific. Josh Ellenbogen has pointed out how the composite portraits exist in a middle world between high art and science, between photography and painting, and represent something which cannot be found in the actual, physical world.[145] As constructed images intended to correspond to an abstract mental image of the criminal or the tubercular type, they come closer to Platonic, ideal images of 'the criminal', 'the tubercular', and thus challenge the nineteenth-century realist conception of photography as mimetic. Composite portraiture is early photographic manipulation of a kind which modern digital techniques carry to seamless perfection, removing our trust in the image, questioning the very idea of photographic likeness.[146] Although Galton's technique might appear amateurish (with simple line engravings, he illustrated the relatively primitive apparatus he had developed to superimpose portrait upon portrait to arrive at the composite), his use of the photographic medium was highly modern in the ways it refused to abide by the photograph as a fixed image. Galton aimed to use the composites as documentary evidence, and the flux of form becomes impressionistic, transitory, fugitive, as Baudelaire would have it in 'The Painter of Modern Life'. At a profound level, the composites question the stability and individuality of the modern self.

In his many publications on composite portraiture, Galton wrote imaginatively, rather than scientifically, ostensibly for the sake of science, but, one suspects, with a not insignificant degree of aesthetic pleasure. As Benjamin Morgan points out, Victorian scientific ideas were often expressed in narrative and linguistic forms which shared their imaginative orderings and narrative formulations with literature.[147] In his *Inquiries into Human Faculty and its Development*, a book designed to be 'suggestive' rather than encyclopaedic,[148] Galton spoke of the erasure of individual traits: 'The effect of composite portraiture is to bring into evidence all the traits in which there is agreement, and to leave but a ghost of a trace of individual peculiarities. There are so many traits in common in all faces that the composite picture when made from many components is far from being a blur; it has altogether the look of an ideal composition.'[149] The resulting generalized picture, he proudly stated, 'represents no man in particular, but portrays an imaginary figure possessing the average features of any given group of men. These ideal faces have a surprising air of reality. Nobody who glanced at one of them for the first time would doubt its being the likeness of a living person, yet, as I have said, it is no such thing; it is the portrait of a type and not of an individual.'[150]

Notice how Pater's vocabulary recurs in Galton's prose. With adjectives like 'suggestive', 'ideal', and 'imaginary' Galton stepped outside the scientist's vocabulary and into the world of art. Like Pater, he was challenging conventional notions of likeness, while aiming at an elusive type, at a face representing 'no man in particular'. Marcia

[145] Josh Ellenbogen, *Reasoned and Unreasoned Images: The Photography of Bertillon, Galton, and Marey* (University Park: Pennsylvania State University Press, 2012), 7–8.

[146] For Galton as a precursor of modern computer composites, see Suzanne Bailey, 'Francis Galton's Face Project: Morphing the Victorian Human', *Photography and Culture* 5:2 (2012), 189–214.

[147] See Benjamin Morgan, *The Outward Mind: Materialist Aesthetics in Victorian Science and Literature* (Chicago: University of Chicago Press, 2017), 13.

[148] Galton, *Inquiries*, 1. [149] Ibid., 10.

[150] Ibid., 340–1 (extracts from Memoir read at the Anthropological Institute in 1878).

Pointon's 'Portrayal/Betrayal' springs to mind: the face may look real, but it is all art. He is everyman and no man at the same time, a condensation of the features shared by a group of individuals while eliminating all irregularities. Composite portraiture was an aestheticizing process, with the undesired side effect that even the 'criminal type' and the 'tubercular type' were made to look quite attractive, given that, as Galton declared, 'All composites are better looking than their components, because the averaged portrait of many persons is free from the irregularities that variously blemish the looks of each of them.'[151] Galton saw the composites as a kind of mental image made manifest in physical form, as emanations on the photographic glass plate of types which had been stored in the mind of a scientist or artist with particular visionary powers: 'A composite portrait represents the picture that would rise before the mind's eye of a man who had the gift of pictorial imagination in an exalted degree.'[152] Galton's interest in the projection or externalization of internal images, in the fixing of the mental flux in pictorial form, is an intriguing parallel to Pater's exploration of the creative process of one of the greatest Renaissance artists.

Galton continued: 'My argument is, that the generic images that arise before the mind's eye, and the general impressions which are faint and faulty editions of them, are the analogues of these composite pictures which we have the advantage of examining at leisure, and whose peculiarities and character we can investigate, and from which we may draw conclusions that shall throw much light on the nature of certain mental processes which are too mobile and evanescent to be directly dealt with.'[153] Engaging with a composite portrait involved a process of recognition: the spectator would experience a perceptual emergence as the images of criminals, Jews, or tubercular patients would be called forth from memory where they lay already dormant. Lee-Morrison points out how Galton's composites underlie such modern digital processes as automated face recognition (AFR) and Sirovich and Kirby's eigenface technique (1987). Sharing Galton's reductive and statistical way of seeing, the modern techniques aim, by means of algorithms, at identifying the individual on the basis of how he or she deviates from the norm. The type/the composite exists as the 'ghost in the machine' providing the norm against which the individual's deviations can be measured, thus potentially leading to face recognition, in a reverse process from type to individual.[154]

Galton's observations reflected the great empirical project he was undertaking in the 1880s on man's visual imagination. In a series of questionnaires,[155] he inquired into man's ability to visualize human individuals, spaces, landscapes with the object of eliciting 'the degree in which different persons possess the power of seeing images in their mind's eye, and of reviving past sensations.'[156] Some of the questions to be answered were:

[151] Ibid., 343. [152] Ibid., 343. [153] Ibid., 353–4. [154] Lee-Morrison, 99.

[155] Francis Galton, *Questions on Visualising and Other Allied Faculties* (London: Francis Galton, 1880). Some 445 completed questionnaires are preserved in the Galton Archives at University College London, see items 152/1/2/3 in M. Merrington and J. Golden, *A List of the Papers and Correspondence of Sir Francis Galton (1822–1911) held in the Manuscripts Room, The Library, University College, London.* Second impression (London: Galton Laboratory, 1978), 33.

[156] Galton, *Questions on Visualising*, n.p.

6. *Command over images.* —Can you retain a mental picture steadily before the eyes? When you do so, does it grow brighter or dimmer? When the act of retaining it becomes wearisome, in what part of the head or eye-ball is the fatigue felt?

7. *Persons.* —Can you recall with distinctness the features of all near relations and many other persons? Can you at will cause your mental image of any or most of them to sit, stand, or turn slowly round? Can you deliberately seat the image of a well-known person on a chair and see it with enough distinctness to enable you to sketch it leisurely (supposing yourself able to draw)?

8. *Scenery.* —Do you preserve the recollection of scenery with much precision of detail, and do you find pleasure in dwelling on it? Can you easily form mental pictures from the descriptions of scenery that are so frequently met with in novels and books of travel?[157]

Aestheticism and science intersect here in their attempts at capturing, fixing, and tracing human sensations and memories. Mental images and people's abilities to reconstruct them engaged Galton for decades in his desire to understand the interrelationship between the invisible and the visible and the projection of mental images onto the material world. In the 'Preface' of Pater's first book, the author's choice of vocabulary was essentially scientific, as he argued for a systematic, albeit subjective, approach to the relativity of beauty. With verbs such as 'seeing', 'knowing', 'discriminating', 'realising', 'analysing', and 'reducing to its elements', he invited the reader to become an aesthetic critic, capable of seeing 'the object as in itself it really is' (with all its Arnoldian echoes).[158] Pater set up his own questionnaire:

What is this song or picture, this engaging personality presented in life or in a book, to *me*? What effect does it really produce on me? Does it give me pleasure? And if so, what sort or degree of pleasure? How is my nature modified by its presence, and under its influence? The answers to these questions are the original facts with which the æsthetic critic has to do; and, in the study of light, of morals, of number, one must realise such primary data for oneself, or not at all....And the function of the æsthetic critic is to distinguish, to analyse, and separate from its adjuncts, the virtue by which a picture, a landscape, a fair personality in life or in a book, produces this special impression of beauty or pleasure, to indicate what the source of that impression is, and under what conditions it is experienced. His end is reached when he has disengaged that virtue, and noted it, as a chemist notes some natural element, for himself and others.[159]

Pater's insistence on observation and the gathering of data for aesthetic analysis suggests a semi-scientific approach, modified by his subsequent stress on affect and

[157] Ibid.

[158] Cf. Matthew Arnold: 'Of the literature of France and Germany, as of the intellect of Europe in general, the main effort, for now many years, has been a critical effort; the endeavour, in all branches of knowledge, theology, philosophy, history, art, science, to see the object as in itself it really is.' 'On Translating Homer' (1862), *The Complete Prose Works of Matthew Arnold*, ed. Robert H. Super, 11 vols (Ann Arbor: University of Michigan Press, 1960–77), 1:140.

[159] 'Preface', *Ren.*, xix–xxi.

66 WALTER PATER'S EUROPEAN IMAGINATION

emotion as preconditions of Aestheticism. He operates with such volatile concepts as 'pleasure' and 'beauty', yet even Galton had invoked 'pleasure' as a parameter in his questionnaire. Both Galton and Pater are concerned with the interrelationship between the inner and the outer world as a constant flux and reflux of sensations and images at the root of creative and appreciative human activity. Pater's 'Conclusion' continues the scientific tone and begins by examining the physical world, 'that which is without', followed by an analysis of 'the inward world of thought and feeling':

> Let us begin with that which is without—our physical life. Fix upon it one of its more exquisite intervals, the moment, for instance, of delicious recoil from the flood of water in summer heat. What is the whole physical life in that moment but a combination of natural elements to which science gives their names?... Or if we begin with the inward world of thought and feeling, the whirlpool is still more rapid, the flame more eager and devouring. There it is no longer the gradual darkening of the eye, the gradual fading of colour from the wall—movements of the shore-side, where the water flows down indeed, though in apparent rest—but the race of the midstream, a drift of momentary acts of sight and passion and thought.[160]

The epigraph to the 'Conclusion'—'Heraclitus says: All things are in motion and nothing at rest'—controls the imagery of the first two paragraphs,[161] full of the flux of flowing water (reminding us of Leonardo). The aesthetic critic is a recorder of his sensations, no matter whether they are located in the physical or the mental self. Two decades later, in the first chapter of his *Plato and Platonism* (1893), Pater would explicitly link the pre-Socratic philosopher with modern Darwinian theory:

> The entire modern theory of 'development', in all its various phases, proved or unprovable,—what is it but old Heracliteanism awake once more in a new world, and grown to full proportions?
>
> Πάντα χωρεῖ, πάντα ῥεῖ. —It is the burden of Hegel on the one hand, to whom nature, and art, and polity, and philosophy, aye, and religion too, each in its long historic series, are but so many conscious movements in the secular process of the eternal mind; and on the other hand of Darwin and Darwinism, for which 'type' itself properly *is* not but is only always *becoming*.[162]

Plato and Platonism opens with the instability of the individual, as an entity in the natural world as likely to be eroded and undergo mutations as the mountains and the animals. Referencing Hegelian dialectics, Pater situates the modern self in a continuous process of becoming. The type that Galton was trying to fix in his composite portraits, with their idealizing soft contours and blurred focus, could be seen as attempts at transcending the flux of modernity, of returning to the ideal forms of antiquity with the Platonic type as a point of reference, a counterbalance to the realism of the modern world. Galton likened his composites to 'a pencil drawing, where

[160] 'Conclusion', *Ren.*, 186–7.
[161] In Benjamin Jowett's translation, given by Hill, ibid., 451.
[162] 'The Doctrine of Motion', *Plato and Platonism* (London: Macmillan, 1893), 19. Italics are Pater's own.

many attempts have been made to obtain the desired effect: such a drawing is smudged and ineffective; but the artist, under its guidance, draws his final work with clear bold touches, and then he rubs out the smudge. On precisely the same principle the faint but beautifully idealised features of these composites are, I believe, capable of forming the basis of a very high order of artistic work.'[163] The aureole which surrounds many of the composite heads—a blurred zone marking the point where communal traits leave off and individual features lose themselves in the layers of the constituent photographs—contribute towards the air of the ideal, to which Galton repeatedly refers in his writings. The photographer is, in effect, collapsing the boundaries which circumscribe the individual with his blurred halos. Where does one individual stop and another take over?

Ellenbogen draws interesting parallels to the artful and idealizing photographs (1864–75) of Julia Margaret Cameron whose imitation of the poses and expressions in Old Master paintings took Victorian photography into new realms. Her experiments with the soft focus made critics refer to 'that *vaporoso* manner which Mrs Cameron has of late brought to…perfection' and to compare her photographs to the paintings of Leonardo and Luini.[164] A similar enigmatic transparency of the *sfumato* or the *vaporoso* characterizes Galton's composite portraits; he made sure to align the eyes of all the constituent photographs, and no matter how blurred the contours of the heads may be, as beards, ears, and hairstyles varied, the penetrating focal point of all the composite portraits are the eyes, which force us to engage with the image. In Cameron's photographs, some sitters confront the viewer with a direct gaze, while others are caught in contemplation, withdrawn into a state of inner sight, thus turning our thoughts towards mental images and the imagination. Cameron's portrait of Tennyson's son Lionel (Fig. 1.12) gives us just such a child with the suggestion of a rich inner life.

One of the last questions in Galton's questionnaire had addressed the reader's powers of inner vision when a child: 'Do you recollect what your power [sic] of visualizing, &c, were in childhood? Have they varied much within your recollection?'[165] This had its counterpart in a French questionnaire distributed to 123 participants in 1895, 'Enquête sur les premiers souvenirs d'enfance',[166] mentioned by Freud in his 1899 essay 'Screen Memories' ('Deckerinnerungen').[167] With questions such as 'What is the first memory you have of your childhood?', 'Did the remembered event play a significant part in your childhood?', 'Do you remember the event spontaneously, or do you remember it because people have subsequently talked about it?', 'Do you experience memories from your childhood in your dreams, and if so, what are those memories?',[168] the authors of the French questionnaire sought to map the nature and earliest occurrence of childhood memories without prying into the complexities of visualizing, of voluntary and involuntary memories, in the way Freud would do. Asking why the memory suppressed what was significant, but retained what was of

[163] Galton, *Inquiries*, 363. [164] Ellenbogen, 131–8.
[165] Galton, *Questions on Visualising*, n.p.
[166] See V. and C. Henri, 'Enquête sur les premiers souvenirs d'enfance', *L'Année psychologique* 3 (1896), 184–98.
[167] Freud, 'Screen Memories' in *The Uncanny*, 3–22, 4.
[168] See 'Introduction' to *The Uncanny*, xvi.

little consequence,[169] Freud outlined a recurring process of 'conflict, repression, substitution', as a less important event assumed importance and covered up a significant one in people's childhood memories, concluding that 'if a certain childhood experience asserts itself in the memory, this is not because it is golden, but because it has lain beside gold.'[170] Freud was essentially suggesting that all childhood memories were screen memories, proposing that rather than memories *from* childhood, people have memories *of* childhood: 'These show us the first years of our lives not as they were, but as they appeared to us at later periods, when the memories were aroused. At these times of arousal the memories of childhood did not *emerge*, as one is accustomed to saying, but *were formed*, and a number of motives that were far removed from the aim of historical fidelity had a hand in influencing both the formation and the selection of the memories.'[171]

Galton was partly studying childhood recollection, but he was also interested in children's imagination. 'In early life', he observed, 'it seems to be a hard lesson to an imaginative child to distinguish between the real and the visionary world. If the fantasies are habitually laughed at and otherwise discouraged, the child soon acquires

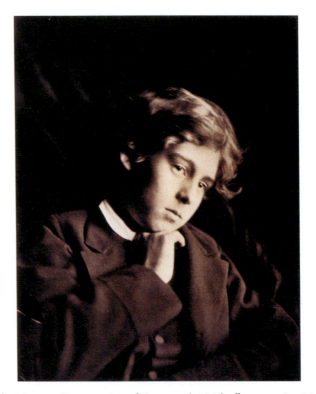

Fig. 1.12. Julia Margaret Cameron, *Lionel Tennyson* (*c.*1866), albumen print, 30.9 × 23.8 cm. Scottish National Gallery of Modern Art, Edinburgh. Wikimedia Commons.

[169] Freud, 'Screen Memories', 6. [170] Ibid., 7. [171] Ibid., 21.

TYPE AND INDIVIDUAL 69

the power of distinguishing them; any incongruity or nonconformity is quickly noted, the visions are found out and discredited, and are no further attended to. In this way the natural tendency to see them is blunted by repression.'[172] Following the romantics by exploring the natural visionary powers of the child, Galton pointed out how children and adult visionaries frequently fell silent from a fear of being laughed at and advocated a release of visionary powers: 'let the tide of opinion change and grow favourable to supernaturalism, then the seers of visions come to the front. The faintly perceived fantasies of ordinary persons become invested by the authority of reverend men with a claim to serious regard; they are consequently attended to and encouraged, and they increase in definition through being habitually dwelt upon.'[173] Galton's exhortation coincides with the foundation in 1882 of the Society for Psychical Research, 'the first learned society of its kind, with the purpose of investigating mesmeric, psychical and "spiritualist" phenomena in a purely scientific spirit.'[174] Rooted in the academic circles of Cambridge, with Professors of moral philosophy and Classics such as Henry Sidgwick and Frederic Myers as some of its early presidents, the Society debated and published extensively on various aspects of parapsychology: mental images, dreams, hallucinations, telepathy, thought-transference, most notably in the early publication *Phantasms of the Living* (1886).[175] In the book, a multitude of personal accounts provided experiences which could not immediately be rationally accounted for, thus challenging Victorian reason with sight, touch, and hearing as sensory inlets into the human mind.

Pater's first imaginary portrait embraced those visionary powers. Encountering a stranger on the allegorical road of life,[176] the adult Florian Deleal is catapulted into a dream-memory and a vision of his childhood, as his mind is triggered by the mentioning of the place of his first home. As name (deliberately kept secret by the author) begets both memory and dream, Pater addresses the representational resources of the dream as it turns thoughts into pictures in a series of striking visual images. The mature man lapses into a season of repeated dreams of his first childhood home, recurrent with an increasing sense of clarity, as he bridges the gulf of some thirty years between his recollecting and his acting self. 'In the house and garden of his dream he saw a child moving,'[177] Pater tells us, almost in exemplary illustration of one of Freud's screen memories, as a sure sign of the edited nature of this recollection:

> [I]n most of the significant and otherwise unimpeachable childhood scenes that one recalls, one sees oneself as a child and knows that one is this child, yet one sees this child as an outside observer would see him. . . . Now, it is clear that this memory

[172] Galton, *Inquiries*, 176–7. Galton's 1883 use of 'repression' in the psychoanalytical sense of 'The action, process, or result of keeping unacceptable thoughts, memories, or desires out of the conscious mind', is early. The *OED* 2c. gives 1909 as the first occurrence in English, as a translation of Freud's *Verdrängung*.
[173] Galton, *Inquiries*, 177.
[174] This is how the Society, still in existence, introduces itself: https://www.spr.ac.uk/about/our-history (accessed on 4 Aug. 2021).
[175] Edmund Gurney, Frederic Myers, and Frank Podmore, *Phantasms of the Living*, 2 vols (London: Trübner & Co., 1886).
[176] The opening of Pater's first portrait is strongly reminiscent of John Bunyan's *Pilgrim's Progress*.
[177] *CW* 3:134.

70 WALTER PATER'S EUROPEAN IMAGINATION

image cannot be a faithful replica of the impression that was received at the time. For the subject was then in the middle of the scene, paying attention not to himself, but to the world outside himself.

Wherever one appears in a memory in this way, as an object among other objects, this confrontation of the acting self with the recollecting self can be taken as proof that the original impression has been edited. It seems as though a memory-trace from childhood had here been translated back into a plastic and visual form at a later date, the date at which the memory was aroused. But no reproduction of the original impression has ever entered our consciousness.[178]

Andrew Lang recognized a youthful Pater in Florian Deleal, but the elegance of Pater's text lies in the delicate way in which Florian both is and is not himself, might or might not be Pater, but might also be an allegory of childhood recollection more broadly. William Buckler discussed this when he suggested that 'The speaker is Florian Deleal speaking of himself as if he were not himself in retrospect and prospect—that is, at a peculiarly illumined moment in time.... Pater is twice removed from his narration: it is the fictive portrait of an imaginary but representative character named Florian Deleal as related by a narrator whose identity is implicit in the peculiarities—facts, interpretations, attitudes, needs—of what he tells. Thus, it fully qualifies, not as verifiable fact, but as self-verifying myth.'[179] Toying with the relationship between the dream-life and the waking life, Pater propels us into the dream-memory for the major part of the narrative, screening, perhaps, the memory of the death of the protagonist's father, only referred to briefly. Death and the ghostly run as constant undercurrents as we travel almost imperceptibly from adult to childhood visions in an exploration of the origin, growth, and maturation of the aesthetic self. Intrigued by Pater's peculiar form of third-person autobiography, Saunders asked, 'is it that for Pater his memories seem like those of another person: that the child about whom he is writing, although it is actually him, doesn't feel like him?'[180] In this confusion between lived and imagined experiences, this estrangement from and defamiliarization with his own memories, Pater's imaginary portraits should perhaps be seen as 'memories raised to a higher power, so that they have the unreality of dreams'.[181]

The original title, 'The House and the Child', had suggested a double portrait, with a balanced juxtaposition of the architectural structure and its inhabitant.[182] This 'foundational account of how material things acquire spiritual resonance' has two protagonists, as Catherine Maxwell points out: the 'child is in the house but the house is also inside the child, and he will carry it with him when he leaves its physical walls and makes his journey into the adult world'.[183] In many respects the house is more of a physical entity, a physiognomy, with a face, an aspect, than the child. At no point are Florian's looks described; he is a mind, a soul, a receptacle of memory and visions

[178] Freud, 'Screen Memories', 20.

[179] William E. Buckler, 'The Poetics of Pater's Prose: "The Child in the House"', *Victorian Poetry* 23:3 (Autumn 1985), 281–8, 285.

[180] Saunders, 53. [181] Ibid., 56.

[182] See Pater's letter to George Grove of 17 April 1878. [183] Maxwell 2008, 78–9.

TYPE AND INDIVIDUAL 71

of the past, triggered by sounds, images, and fragrances. The house, however, travels from the realm of the living to that of the dead: 'The true aspect of the place, especially of the house there in which he had lived as a child' is transformed into the 'half-spiritualised house',[184] to 'the house of thought in which we live',[185] until it is left behind, emptied of its contents and briefly revisited by Florian in search of a pet bird: 'But as he passed in search of it from room to room, lying so pale, with a look of meekness in their denudation, and at last through that little, stripped white room, the aspect of the place touched him like the face of one dead.'[186] Stripped of its habitants, the anthropomorphic house has now assumed the appearance of the 'waxen, resistless faces' which Florian had studied in the Paris *Morgue* and the Alter Südfriedhof in Munich,[187] and his recollection becomes one of painful home-sickness, as he joins the road of life with which the text began. Pater's text revolves around coinages like 'brain-building', 'soul-stuff', and references to notions of the *tabula rasa*,[188] the 'white paper, the smooth wax, of our ingenuous souls'.[189] The process of image formation in the brain, as experiences lodged in the mind contribute towards the development of the self, makes the child father of the man. The power of mental images, imprinted in childhood and called forth by memory and dream, gives the text its strongly visual character. Florian is the only living creature in a text otherwise peopled by the memory of the early dead in their graves and the omnipresent ghosts. As harbingers of death, poltergeists, or *revenants*, they connect the realm of the living with that of the dead:

> For sitting one day in the garden below an open window, he heard people talking, and could not but listen, how, in a sleepless hour, a sick woman had seen one of the dead sitting beside her, come to call her hence; and from the broken talk, evolved with much clearness the notion that not all those dead people had really departed to the churchyard, nor were quite so motionless as they looked, but led a secret, half-fugitive life in their old homes, quite free by night, though sometimes visible in the day, dodging from room to room, with no great goodwill towards those who shared the place with them. All night the figure sat beside him in the reveries of his broken sleep, and was not quite gone in the morning—an odd, irreconcileable new member of the household, making the sweet familiar chambers unfriendly and suspect by its uncertain presence. He could have hated the dead he had pitied so, for being thus. Afterwards he came to think of those poor, home-returning ghosts, which all men have fancied to themselves—the *revenants*—pathetically, as crying, or beating with vain hands at the doors, as the wind came, their cries distinguishable in it as a wilder inner note. But, always making death more unfamiliar still, that old experience would ever, from time to time, return to him; even in the living he sometimes

[184] CW 3:133. [185] CW 3: 139. [186] CW 3: 144. [187] CW 3: 141.

[188] The concept of the *tabula rasa*—that man's mind at birth is a blank or an erased slate, waiting for inscription through experience and sensory impressions, goes back to antiquity, and can be found in Aristotle's *De anima* 412b of the fourth century BC: 'We should not then inquire whether the soul and body are one thing, any more than whether the wax and imprint are.' *De anima (On the Soul)*, tr. Hugh Lawson-Tancred (Harmondsworth: Penguin, 1988), 157. In the Middle Ages Islamic thinkers and Thomas Aquinas returned to Aristotle's idea. Pater may also have in mind the discussion of the concept in John Locke's *Essay Concerning Human Understanding*, first published in 1690: 'let us suppose the mind to be, as we say, white paper, void of all characters, without any ideas.' (Oxford: Oxford University Press, 1975), 105.

[189] CW 3:135.

caught its likeness; at any time or place, in a moment, the faint atmosphere of the chamber of death would be breathed around him, and the image with the bound chin, the quaint smile, the straight, stiff feet, shed itself across the air upon the bright carpet, amid the gayest company, or happiest communing with himself.[190]

A ghostly echo of Catherine's spirit at the window in *Wuthering Heights* merges the dead with the living in a manner which brings Victorian spirit photography to mind (Fig. 1.13). 'Invented' by an accidental double exposure in the 1860s, spirit photography became a nineteenth-century craze. The Boston photographer William Mumler was one of the first to experiment with the effects of double exposure, juxtaposing the images of a living person with a slightly hazier one of a recently dead relative, thus creating haunting images which evoked a sense of the constant presence of the spirit world.[191] Mumler's fraud was eventually exposed, but in England Georgiana

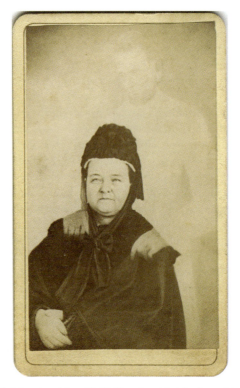

Fig. 1.13. William H. Mumler, *Mary Todd Lincoln with Abraham Lincoln's 'spirit'* (*c.*1872), photograph. Indiana State Museum and Historic Sites, Indianapolis. From the Lincoln Financial Foundation Collection.

[190] *CW* 3:142.
[191] See Louis Kaplan, *The Strange Case of William Mumler, Spirit Photographer* (Minneapolis: University of Minnesota Press, 2008).

TYPE AND INDIVIDUAL 73

Houghton and Fred Hudson were equally successful with their fraudulent spirit photographs. As Louis Kaplan points out, 'The discourse of spirit photography revolves around such paranoid questions as "Are we seeing the truth?" or more complexly, "Can such a truth be seen at all?"'[192] Reminding us that photography is a mechanism as capable of tricking the viewer as any other artistic medium, Kaplan continues, 'There is always the need to expose the black-and-white lies of photography whether we are invested in prescriptive criminal typologies or hysterical bodies of evidence.'[193] Born at the time of combination printing, when also Oscar Rejlander and Henry Peach Robinson employed photography for their elaborate pictorial compositions, spirit photography entered the realm of the imaginary, just like Galton's composites. The spectrality of photography, invoked so powerfully by Barthes, is inherent in the glass plate. Barthes's notion that a ghostly production marks all photographic reproduction is perhaps best recalled in his own paranoid reaction to being exposed to photography:

> The portrait-photograph is a closed field of forces. Four image-repertoires intersect here, oppose and distort each other. In front of the lens, I am at the same time: the one I think I am, the one I want others to think I am, the one the photographer thinks I am, and the one he makes use of to exhibit his art. In other words, a strange action: I do not stop imitating myself, and because of this, each time I am (or let myself be) photographed, I invariably suffer from a sensation of inauthenticity, sometimes of imposture (comparable to certain nightmares). In terms of image-repertoire, the Photograph (the one I intend) represents that very subtle moment when, to tell the truth, I am neither subject not object but a subject who feels he is becoming an object: I then experience a micro-version of death (of parenthesis). I am truly becoming a specter.[194]

The split and frozen self is not unrelated to the revenants haunting Pater's houses. As objectified versions of the self, they remain frozen in their moment of death but retain the right to return at their own free will. Florian searches for the dead in the living; he looks for the likeness of the dead when he studies faces, and the transparency of generations, of hereditary features, determines his gaze. In Pater's portrait, all human characters are diaphanous to some degree, and slightly malevolent ghosts turn into angels, as 'a constant substitution of the typical for the actual' takes place in Florian's thoughts.[195] The Child may be an alternative 'Angel in the House,'[196] but domesticated in a different way.[197] Florian's obsession with death makes him picture to himself what dying would be like, the imaginary portrait taken to its utmost extreme:

[192] Louis Kaplan, 'Where the Paranoid meets the paranormal: Speculations on Spirit Photography', *Art Journal* 62:3 (Fall 2003), 18–29, 19.

[193] Ibid., 22. [194] Barthes, 13–14. [195] *CW* 3:144.

[196] Coventry Patmore's popular poem on wifely duty was created between 1854 and 1862 and had a great influence on mid- and late Victorian ideas of the ideal wife.

[197] Cf. Tamar Katz, '"In the House and Garden of His Dream": Pater's Domestic Subject', *Modern Language Quarterly* (56:2), 1995, 167–88, 186–7.

74 WALTER PATER'S EUROPEAN IMAGINATION

Also, as he felt this pressure upon him of the sensible world, then, as often afterwards, there would come another sort of curious questioning how the last impressions of eye and ear might happen to him, how they would find him—the scent of the last flower, the soft yellowness of the last morning, the last recognition of some object of affection, hand or voice; it could not be but that the latest look of the eyes, before their final closing, would be strangely vivid; one would go with the hot tears, the cry, the touch of the wistful bystander, impressed how deeply on one! or would it be, perhaps, a mere frail retiring of all things, great or little, away from one, into a level distance?[198]

This is a big step from childhood recollections: the prospective final moment, as Florian imagines the letting go of the physical, sensuous world, of the last touch and sounds of the mourners, before the senses give in, an altogether un-childlike vision in a text indebted to Wordsworth's 'Immortality Ode' (1807) and Charles Lamb's 'Blakesmoor in H–shire' (1833). The apparently incongruous juxtaposition of early life and death constitutes an important component in the representation of the child, and with Galton's composite portraits in mind we might think of Pater's 'Child' as a cumulative type, containing both the generic and the specific, the allegorical and the autobiographical, the early and the late romantic within him. While the ghostly presences of romanticism's children reside in the background, Pater's child does not carry death within him as innocently as Wordsworth's children. Pater's essay on Wordsworth appeared in 1874, and 'The Character of the Humourist: Charles Lamb' only two months after 'The Child in the House'; the cross-pollination between Pater's literary essays and his first imaginary portrait can be felt throughout. Pater belongs to the 'School of Wordsworth and Lamb', just as a few years later Vernon Lee would join the same school with 'The Child in the Vatican' (1881), heavily indebted to Pater's first imaginary portrait. The school continued: shortly before he wrote his authorized biography of Pater in 1906, A. C. Benson published his autobiografictional *The Thread of Gold* (1905). Chapter 2, 'The Deserted Shrine. The Manor House', reads like a tribute to Pater where the anthropomorphic house has become protagonist, and the distancing device of the child with the exotic name been abandoned:

> Though the name of the house, though the tale of its dwellers was unknown to me, I felt the appeal of the old associations that must have centred about it. The whole air, that quiet afternoon, seemed full of the calling of forgotten voices, and dead faces looked out from the closed lattices. So near to my heart came the spirit of the ancient house, that, as I mused, I felt as though even I myself had made a part of its past, and as though I were returning from battling with the far-off world to the home of childhood. The house seemed to regard me with a mournful and tender gaze, as though it knew that I loved it, and would fain utter its secrets in a friendly ear. . . . And then I too, like a bird of passage that has alighted for a moment in some sheltered garden-ground, must needs go on my way. But the old house had spoken

[198] *CW* 3:141.

with me, had left its mark upon my spirit. And I know that in weary hours, far hence, I shall remember how it stood, peering out of its tangled groves, gazing at the sunrise and the sunset over the green flats, waiting for what may be, and dreaming of the days that are no more.[199]

Pater's screening—of the child, of the author as child, of the fictitious Florian—has been replaced by a nostalgic first-person narrative. The house, filled with ghosts and memories, has become the elegiac dreamer, eloquent in its recollections. Yet the architectural structure is not intertwined with the soul of the speaker as in Pater's narrative, and instead of the intricate weaving and unweaving of the self, the 'half-spiritualised house', Benson's house is a receptacle of memories rather than visions or epiphanic moments.

In spite of all the ghosts which surround him, Florian's relational self is firmly lodged in a sense of family. Family members have brief walk-on parts, albeit in the hazy form of past recollections: the little sister, scared of spiders, the mother who teaches Florian to read and walks him past the open grave, the aunt who announces the death of his father in India. On the male side the sick brother Lewis, possibly together with the deceased Cecil and Julian, and the children's Latin-reading father, dead off stage. Add to this Florian's awareness of his French ancestry, of descending from Watteau, and we have a sense of a refined family, of which Florian is a sole surviving member. Pater's reviewers noted Florian's delicacy; one spoke of 'this strange, elfish child, described with the same elaboration, the same subtle simplicity, with which we have been used to see Mr. Pater handle a Leonardo picture'.[200] Another was profoundly sceptical of Florian's hypersensitivity and rich imaginative life, and much preferred the socializing process enabled by British boarding schools with their Arnoldian ethos of healthy minds in healthy bodies. Florian's effeminacy and aesthetic sense caused the reviewer to conclude that 'all small boys are not so sensitive to the influences of white curtains and of dainty carvings, still less are all so self-conscious, as Mr. Pater's little lad'.[201]

Pater nowhere announces himself as a eugenicist, but several of his portraits reveal an interest in family frailty, ill health, and sensitivity, often linked to artistic or philosophic temperament. For Galton, the chronicling and documenting of the individual's health throughout life, through weight, height, sickness journal, and photography, became an important aspect of his eugenicist propaganda. His *Life History Album*, published by Macmillan in 1884, was designed so that people could regularly paste in photographs of themselves together with health details, with the aim of early diagnosis and cure, while on a national scale such albums could provide useful details of hereditary diseases. Addressing 'The Owner of this Book', Galton quoted from his recent essay in the *Fortnightly Review*: 'The world is beginning to perceive that the life of each individual is in some real sense a prolongation of those of his ancestry. His character, his vigour, and his disease, are principally theirs.... The life-histories of our relatives are, therefore, more instructive to us than those of strangers; they are

[199] A. C. Benson, *The Thread of Gold* (London: John Murray, 1907), 17–18.
[200] Anon., 'Magazines and Reviews', *Academy* 328 (17 Aug. 1878), 166.
[201] Anon., 'Boys and Schoolboys', *Saturday Review* 46 (3 Aug. 1878), 141.

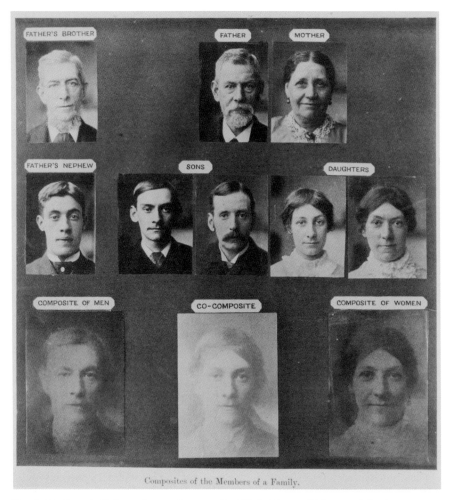

Fig. 1.14. Francis Galton, *Composite portrait of Eight Men and Women of the Same Family* (1881), photograph. University College London. The Galton Papers, UCL Library Services, Special Collections.

especially able to forewarn and to encourage us, for they are prophetic of our own futures.'[202] Galton's gathering of large amounts of data relating to the individual over time resulted in a notion of life-history very different from Pater's, but his concern with hereditary family frailties was not.

Galton merged art and science, portraiture, and eugenics. His advocacy of the family photo album, chronicling the lives and developments of individuals, constituted one cornerstone of his activities, while at the same time he was running together

[202] Galton, *Life History Album* (London: Macmillan, 1884), 'To the Owner of this Book', n.p. Galton is quoting from his 'Photographic Chronicles from Childhood to Age', *Fortnightly Review* 37 (Jan. 1882), 26–31, 31.

the faces of generations in search of an abstract family face. His composites of two generations of the male and female members of the same family morphed into a 'face of indeterminate sex' (Fig. 1.14) which was exhibited at the Loan Photographic Exhibition at the Society of Arts in February 1882.[203] Keen to promote a new type of family photograph, Galton realized that not everyone involved in his experiments thought as highly of them as he did himself: 'I have made several other family portraits, which to my eye seem great successes, but must candidly own that the persons whose portraits are blended together seldom seem to care much for the result, except as a curiosity. We are all inclined to assert our individuality, and to stand on our own basis, and to object to being mixed up indiscriminately with others.'[204] Galton freely admitted the failures of his experiments, as their transgressive nature went against the cult of the unique. Where Galton's studies of twins were yet another way of approaching the subject of likeness,[205] it might seem that only those born with an identical twin were happy to embrace family likeness fully.

Pater found a different kind of likeness. On one of his small slips of paper, he wrote a note to himself at some point in the 1880s, when his imaginary portraits were established as a genre. He traced back the ancestry of what he called his 'imaginative work' to his 1878 text, and—apart from bursting into extravagant French—piled a heap of nouns all denoting origin, growth, progress, or evolution together:

> Child in the House:
> Voilà, the germinating,
> original, source, specimen,
> of all my <u>imaginative</u> work.[206]

Pater was thinking about the generic, about the portraits as specimens of a type of texts. Modern scholars may hold up 'Diaphaneitè' as the Ur-portrait, but the desire to look for seriality and sequence was Pater's own. Given how death-ridden and moribund 'The Child in the House' is, it proved wonderfully capable of literary procreation.

[203] Galton, *Inquiries*, 13. [204] Ibid., 13.

[205] His seminal 'The History of Twins as a Criterion of the Relative Powers of Nature and Nurture' had been published in the *Journal of the Anthropological Institute* 5 (1 Jan. 1876), 391–406, and until his death Galton continually returned to the studies of twins.

[206] Houghton bMS Eng. 1150(4) [Gaston de Latour]. The underlining is Pater's own.

2
Life-Writing

When Pater's *Imaginary Portraits* were published in volume form in May 1887, the author sent a number of presentation copies to friends and colleagues. The destination of one such copy has long intrigued me, namely the one sent to Virginia Woolf's father, Leslie Stephen.[1] Woolf would become one of Pater's most sophisticated descendants within the genre of the imaginary portrait, and the impact of his presentation copy became far greater than the author could possibly have imagined. The *Imaginary Portraits* remained the only volume by Pater in the Stephen family library until 1905, when, shortly after her father's death, Virginia decided, out of a very limited budget, to invest in the eight-volume *De Luxe Edition* (1900) of Pater's collected works.[2] Her formative reading of the *Imaginary Portraits* may well have inspired her extravagant purchase, outlined in a diary entry of 13 March: 'Out to Hatchards to buy Stevenson and Pater—I want to study them—not to copy, I hope, but to see how the trick's done. Stevenson is a trick—but Pater something different & beyond.'[3] Stephen, a leading critic, essayist, and notably, since 1881, editor of the *Dictionary of National Biography*, had had a keen interest in the selection and definition of subjects suitable for life-writing. A prolific writer, he had written the lives of Samuel Johnson (1878), Alexander Pope (1880), and Jonathan Swift (1882) for Macmillan's 'English Men of Letters' series. In addition to being general editor of the *DNB*, he wrote 283 signed entries in the sixty-three-volume *Dictionary* which appeared between 1885 and 1900.

Why did Pater send one of his presentation copies to Stephen? Did he want to suggest alternative ways of life-writing, or to question history and biography based on the lives of great individuals? Was the book a token of admiration for Stephen's own efforts as a biographer, or a subtle provocation? Stephen had stepped down as editor of the *Cornhill Magazine*, so the gift was hardly a review copy. Given the limited body of primary material relating to Pater's life, we shall probably never know the answers to these speculations. In 1882, Stephen had outlined his project for a biographical dictionary, declaring only the English, Scottish, and Irish as suitable subjects of a publication aimed at 'giving the greatest possible amount of information in a thoroughly business-like form. Dates and facts should be given abundantly and precisely' with 'a clear reference to the primary authorities'. By contrast, 'Philosophical

[1] Meisel, 12. See also *Catalogue of Books from the Library of Leonard and Virginia Woolf* (Brighton: Holleyman & Treacher, 1975), 33.

[2] Meisel, 16–17; *Catalogue*, 5. See Lene Østermark-Johansen, 'From Periphery to Centre: The Female Writer in Walter Pater and Virginia Woolf', in ed. Bénédicte Coste, Catherine Delyfer, and Christine Reynier, *Reconnecting Aestheticism and Modernism: Continuities, Revisions, Speculations* (Abingdon: Routledge, 2016), 56–66.

[3] V. Woolf, *A Passionate Apprentice: The Early Journals 1897–1909 of Virginia Woolf*, ed. M. A. Leaska (London: Hogarth Press, 1990), 25.

Walter Pater's European Imagination. Lene Østermark-Johansen, Oxford University Press. © Lene Østermark-Johansen 2022.
DOI: 10.1093/oso/9780192858757.003.0003

and critical disquisition, picturesque description, and so forth, are obviously out of place, and must be rigorously excised'. The same went for the 'kind of diffuseness... which comes from simple verbosity'. 'Elaborate analysis of character or exposition of critical theories' were 'irrelevant'.[4] Pater's volume contained the lives of three Frenchmen, a classical deity in France, a young Dutchman, and a young German, so the focus was European rather than British. Apart from 'A Prince of Court Painters', dates and facts are conspicuously absent in the portraits, and as anyone who has done a minimal amount of historical fact-checking will know, the author takes considerable liberties with chronologies. Philosophical and critical discussion abounds, and although 'character' is a problematic concept with Pater, his portraits do revolve around temperaments and individual development. While the texts cannot exactly be called verbose, they might be characterized by a certain 'kind of diffuseness'; certainly, Pater's writing contains more 'picturesque description' than passages which can be described as 'business-like'.

It is tempting to see the presentation copy as a tease to the editor of the *DNB*. The *Imaginary Portraits* constitute a set of alternative lives which problematize the interrelationship between fact and fiction, dates and developments. International in scope, ranging from medieval France to eighteenth-century Germany, Pater's slim volume poses a counter discourse to the great patriotic monument of the multivolume *Dictionary*. Pater was a constant and keen reader of biographies, national, as well as foreign. Pater's own, not always entirely reliable, biographer Thomas Wright informs us that he adored the *DNB*, 'the volumes of which he read religiously from cover to cover, one by one, as they came out',[5] an anecdote which finds some confirmation in B. A. Inman's recording of his library borrowings in the 1890s.[6] Her magisterial two-volume mapping of Pater's reading reveals the large part of his borrowings, from early youth until his death, which fall under the heading 'biography'. From saints' lives to the lives of emperors, artists, philosophers, writers, warriors, not to mention Ernest Renan's *Vie de Jesus* (1863), Pater's reading encompasses collective groupings of lives (Plutarch, Vasari, Brantôme, Sainte-Beuve), frequent borrowings of Ferdinand Hoefer's forty-six-volume *Nouvelle Biographie Générale* (1852–66), and canonical lives of great individuals. The Victorian double-decker— the 'life and letters' counterpart to the three-volume novel—would be put to rest by Lytton Strachey, who wisely observed that 'it is perhaps as difficult to write a good life as to live one':

> Those two fat volumes, with which it is our custom to commemorate the dead— who does not know them, with their ill-digested masses of material, their slipshod style, their tome of tedious panegyric, their lamentable lack of selection, of detachment, of design? They are as familiar as the *cortège* of the undertaker, and wear the same air of slow, funeral barbarism. One is tempted to suppose, of some of them, that they were composed by that functionary, as the final item of his job.[7]

[4] Leslie Stephen, 'A New "Biographia Britannica"', *Athenaeum* 2878 (23 Dec. 1882), 850.
[5] *Wright*, 2:117. [6] Inman 1990, 482–3, 486–7.
[7] Lytton Strachey, 'Preface' to *Eminent Victorians* (1918), (London: Chatto & Windus, 1993), ix.

80 WALTER PATER'S EUROPEAN IMAGINATION

Pater's reading of Carlyle's lives of Oliver Cromwell (1845) and Frederick the Great (1858), of Arthur Penrhyn Stanley's *Life and Correspondence of Dr Thomas Arnold* (1846), and Richard Monckton Milnes's *Life, Letters and Literary Remains of John Keats* (1848) may fall into Strachey's category, although both Carlyle and Monckton Milnes were far more lively writers than most Victorian biographers.[8] Pater's studies of the diaries of John Evelyn, Samuel Pepys, of Gilbert Burnet's life of the Earl of Rochester, and not least, his repeated reading of Boswell's life of Samuel Johnson, alert us to his taste for everyday anecdote and juicy details, for wit and racy humour.[9] Some of his early texts originate as reviews of biographies: the Winckelmann essay (1867) of Otto Jahn's *Biographische Aufsätze* (1866),[10] and the Leonardo essay of Arsène Houssaye's *Histoire de Léonard de Vinci* (1869).[11] His 'Pico della Mirandola' draws heavily on Thomas More's English translation of Pico's nephew's life of the neo-platonic philosopher,[12] and a dialogue with Vasari runs as a constant undercurrent through *The Renaissance*.[13]

The opening lines of the Leonardo essay alert us to Pater as a discerning reader of Vasari, fully aware that the popular *Lives of the Artists* existed in two editions (of 1550 and 1568), and that, like Pater himself, Vasari was a keen reviser: 'In Vasari's Life of Leonardo da Vinci as we now read it there are some variations from the first edition.'[14] Pater alerts us to the subjectivity of life-writing, to the fact that Vasari's Life of Leonardo is *a* life (and Houssaye's another), and that even Vasari's life is subject to change between the first and the second editions. Christopher Coates points out how 'Instead of adopting Vasari as a faithful medium for the life of Leonardo, we are dealing in "editions", making sure that the text is situated "as we now read it." "Lives" are, in fact, bound up in discourse.'[15] The Leonardo essay is one of Pater's earliest explorations within the biographical mode as he imitates the biographer's 'from-cradle-to-grave' structure, letting the essay progress chronologically, while spicing it with dates, references to documents, drawings, and anecdotes. Uninterested in archives, he takes most of his information from secondary sources. Pater desires to convey the personality of a Renaissance genius with all the suggestiveness that anecdote can provide. As Coates argues, 'questions that surround Pater's use and abuse of "sources" become just so much antiquarianism. The predictable criticism—that these manipulations are dishonest and unbecoming in a scholar—only goes so far. Such criticism begs the question by assuming the impermeability of the line between fiction and scholarship, whereas Pater's work suggests that this line creates an autonomy for the two disciplines that they have never enjoyed.'[16]

[8] Inman 1990, 463, 468, 230, 489. [9] Inman 1981, 214, 234, 323; Inman 1990, 340, 438, 442, 439.
[10] *Ren.*, 411. [11] Ibid., 229.

[12] Ibid., 27, 28. G. F. Pico della Mirandula, *Here is coteyned the lyfe of Johan Picus erle of Mirandula. With dyuers epystles & other werkes of ye sayd Johan Picus*, tr. Thomas More (London: W. de Worde, c.1525).

[13] For Pater's dialogue with Vasari, see Paul Barolsky, *Walter Pater's Renaissance* (University Park and London: Pennsylvania State University Press, 1987), 113–27.

[14] *Ren.*, 77.

[15] Christopher Coates, 'Writing it "Better, Over Again": Walter Pater and Victorian Biography', *Genre* 24:4 (Winter 1991), 381–96, 383.

[16] Ibid., 385.

Reviewing Denis Donoghue's *Walter Pater: Lover of Strange Souls*, Adam Phillips pointed out that while reviewers like Sidney Colvin had criticized *The Renaissance* for its lack of factual information, the focus should really be turned towards the book's peculiar merging of autobiography and biography. 'All of Pater's writing about art is an idiosyncratic mixture of the biographical and the autobiographical, as though for him they were always inextricable. There is no biography, he implies, without autobiography; but also, and more interestingly, there is no autobiography without biography. We make our lives, though often hermetically, out of the lives of others.'[17] We have seen how Freud's study of Leonardo was to some extent also a study of Freud's private preoccupations, as he asked what the stories of the lives of others could tell us about ourselves.[18] For Freud truth-telling, the account of someone's life, could only be done by the person himself, through the method of free association;[19] one drastic result of such an approach being his own destruction of large quantities of personal documents, preventing others from accessing them and assuming control.[20] The gradual unearthing of the past, as layer after layer was stripped off, in an almost archaeological process, inevitably made 'facts from a psychoanalyst's point of view look more complicated than they do in other people's views'.[21] Freud's continued search for the past behind the past gave an instability to the factual; just as Pater was operating in editions of Vasari (although admittedly going for the more recent rather than the earlier), so Freud was operating with palimpsestic layers of knowledge, something which is also reflected in the use of archaeological metaphors in his writing. Pater's interest in Leonardo's 'art of going deep' in his study of human personality makes him almost a Freudian *avant la lettre*. And yet, as Phillips points out, the biographer is what the psychoanalyst is trying not to be; whereas the analyst wants to cure, the biographer wants to write a good biography.[22] Pater's delight in absorbing Vasari's anecdotes places him safely in the camp of the biographers. Where Freud was writing pathographies of the brilliant men of history—Leonardo, Michelangelo, Shakespeare—explaining their works through their illnesses, those patients of the past were beyond cure. Once submitted to the analyst's taxonomical categorization, his patients' sufferings made them less unique and more typical. Leonardo shared his Oedipal complex with a host of other men, irrespective of his artistic genius.

The Renaissance and the imaginary portraits form a set of complementary texts, concerned with life-writing, questioning how one sums up a life. Most of the Renaissance lives are the study of artistic genius, from Luca della Robbia and Botticelli to Leonardo and Michelangelo. In the 'Preface', in a characteristically layered discourse, Pater quotes William Blake's annotations to Joshua Reynolds's *Discourses*, filtered through Alexander Gilchrist's *Life of William Blake* (1863): 'The

[17] Adam Phillips, 'Provocation', review of Denis Donoghue, *Walter Pater: Lover of Strange Souls, London Review of Books* vol. 17, no. 16, 24 Aug. 1995, https://www.lrb.co.uk/the-paper/v17/n16/adam-phillips/provocation (accessed on 4 Jul. 2021).

[18] See Adam Phillips, 'Against Biography' in Phillips, *In Writing: Essays on Literature* (London: Penguin, 2016), 43–63, 50.

[19] Ibid., 62. [20] Phillips, *Becoming Freud*, 25. [21] Ibid., 4.

[22] Phillips, 'Against Biography', 56.

82 WALTER PATER'S EUROPEAN IMAGINATION

ages are all equal…but genius is always above its age.'[23] The innovative genius of Watteau is framed by the paler copies of Jean-Baptiste Pater and the all-domineering voice of Marie-Marguerite in 'A Prince of Court Painters', but many of the imaginary portraits dwell on the lives of the less illustrious. The historical documentation may be inaccurate, full of chronological inconsistences and slippery facts, as the annotations to my recent critical edition of Pater's short fiction make abundantly clear, but the texts are covered by a veneer of historicity, as a method of anchoring Pater's vague protagonists. The historical past may be atmosphere, philosophy, architecture, art, and literature, but Pater's portraits show few signs of an attempt at a Rankean recreation of the past, of an interest in *wie es eigentlich gewesen war*.[24]

As a reader of biographies, as an author, who in much of his writing traded on the discourses of biography and autobiography, Pater was profoundly concerned with *Bildung*, with the fundamental question of what constituted a human life. Elinor Shaffer reminds us that the nineteenth century was the century when the biography and the *Bildungsroman* both took off as popular genres, simultaneously theorized and dealt with critically in James Field Stanfield's *An Essay on the Study and Composition of Biography* (1813) and Karl von Morgenstern's 'Über das Wesen des Bildungsromans' (1819).[25] Pater's interest in 'brain-building' in 'The Child in the House' and in the conflation of memory, recreation, and commemoration are a continuation of his study of how Leonardo became Leonardo. The question of 'how do we become what we are' engaged him from his very first essays to the unfinished chapters of *Gaston*. His two novels could be classified as *Bildungsromanen*, and 'The Child in the House', 'An English Poet', 'Denys l'Auxerrois', 'Sebastian van Storck', 'Duke Carl of Rosenmold', 'Hippolytus Veiled', and 'Emerald Uthwart' all revolve around the transition from childhood to youth and adulthood, around education and becoming.

Galton had used his *Life History Album* as a cumulative way of making people document their own genetic, physical, and pathological development from child to adult. The albums were intended both for personal use and as contributions towards a grander national project on eugenics. After Galton's death Sidney Lee, Stephen's co-editor and successor as editor of the *DNB*, revealed how the scientist had put pressure on the editors to construct the entries so that they would be useful for the study of eugenics. Lee spoke of the 'peril to biographic method' of bringing science and biography 'into too close a conjunction',[26] of making biography serve as the 'handmaid to this new and absorbing department of biology and anthropology'.[27] He paraphrased the scientist's requests to him as editor of the *DNB*: 'The biographer should collect, after due scrutiny, those details of genealogy, habit and physiological

[23] 'Preface', *Ren.*, xxi, 299.

[24] In the 'Preface' to his *History of the Latin and Teutonic Nations* (1824), Leopold von Ranke had spoken of a historicism in which it was possible to reconstruct history *wie es eigentlich gewesen war* ('as it actually was'). See Bann, Chapter 1.

[25] Elinor S. Shaffer, 'Shaping Victorian Biography: From Anecdote to Bildungsroman', in ed. Peter France and William St Clair, *Mapping Lives: The Uses of Biography* (Oxford: Oxford University Press, 2002), 115–33, 115–16.

[26] Sidney Lee, *Principles of Biography: The Leslie Stephen Lecture* (Cambridge: Cambridge University Press, 1911), 30.

[27] Ibid., 31.

characteristics which may help the student of genetics to determine human types, to diagnose "variations from type", to distinguish acquired from inherited characteristics, and to arrive by such roads at a finite conception of human individuality.[28] He concluded by dismissing the inevitable distortions into studies of minor characters such a project would entail, and left it to the scientists to pursue 'the secret of genius.'[29]

Pater's interest in congenital conditions, in hybrid origins, children whose genetic material results from the mixing of bloods from different backgrounds, pervades many of the portraits. Leonardo is the issue of an extramarital liaison between the wealthy Piero da Vinci and a servant maid. Florian Deleal is of French descent and inhabits a house characterized by a foreign whiteness and trimness which, by extension, make him unique. Pater continued his Anglo-French dialogue in 'Imaginary Portraits 2: An English Poet', most likely composed shortly after 'The Child in the House'. In spite of the national denomination in the title, the poet is only half-English. His mother, a 'pale English girl', is briefly infatuated with a sophisticated Parisian but remains 'faithful in affection to the plain young Frenchman she had married so young and to whose child, a fragile creature, she presently gave what remained of her own life.' The poet's mother expires abroad, but 'The languid child went early away to be reared in the braver air of its English relations among the stern Cumberland mountains.'[30]

In 'A Prince of Court Painters', war, rather than blood, accounts for mixed national identity. Relishing her 'Flemish cleanliness' our diarist declares in an entry of 1705 that 'French people as we have become, we are still old Flemish, if not at heart yet on the surface. Even in *French* Flanders, at Douai and Saint Omer,[31] as I understand, in the churches and in people's houses, as may be seen from the very streets, there is noticeable a minute and scrupulous air of care-taking and neatness.'[32] Sebastian van Storck is mixed race; his physical attraction resides in the mingling of northern and southern bloods in him: 'Yet with all his appreciation of the national winter, Sebastian was not altogether a Hollander. His mother, of Spanish descent and Catholic, had given a richness of tone and form to the healthy freshness of the Dutch physiognomy, apt to preserve the youthfulness of aspect far beyond the period of life usual with other peoples.'[33] In 'Denys l'Auxerrois' and 'Hippolytus Veiled' Pater exploits the existing myths of children who issue from liaisons between deities and mortals. Dionysus is the child of Jupiter and Semele, Dithyrambus, 'twice-born': first prematurely as his mother is killed by her lover's thunderbolt, and subsequently sewn into his father's thighs, delivered when full-born. As the issue of the Count of Auxerre

[28] Ibid., 31.

[29] Ibid., 32. See also David Novarr, *The Lines of Life: Theories of Biography, 1880–1970* (West Lafayette, Indiana: Purdue University Press, 1986), 10–11.

[30] *CW* 3:146.

[31] Douai was taken by the troops of Louis XIV in 1667 and became French in 1668 at the Treaty of Aix-la-Chapelle. Besieged repeatedly from 1710–12, it was almost destroyed but became the seat of the Flemish parliament. From the 1560s until the end of the eighteenth century it was an important seat of education for English Catholics seeking education abroad. Saint Omer was frequently besieged by the French, the English, the Spanish, and the Flemish. The town became French territory in 1677. Like Douai, it became an important site for the education of English Catholics.

[32] *CW* 3:62. [33] *CW* 3:97.

84 WALTER PATER'S EUROPEAN IMAGINATION

and a country girl, killed by lightning, Denys's mixed pedigree has a classical reference. Hippolytus is the result of a love affair between the mythical King Theseus and Antiope, queen of the Amazons, with Artemis as fairy godmother. Pater raises questions about national identity, given that for centuries the borders between states and countries were being re-drawn by the endless warfare on the European continent. The national and patriotic discourse which shaped such nineteenth-century undertakings as the National Portrait Gallery and the *Dictionary of National Biography* was challenged by Pater's brief portraits of individuals, none of whom would ever have merited inclusion in the NPG or in the *DNB*.

Life-writing has always played an important role in nation and identity formation by providing exempla to be imitated, celebrating the great men and women of a nation, exalting the self-image of a profession, or showing how an individual life takes a meaningful shape.[34] It may be no coincidence that the word 'biography' makes its first appearance in Restoration England; the *OED* registers 1661 as its first occurrence, immediately after the end of the Civil War. With the return of Charles II to England, the interest in chronicling the lives of those who had played a major part in recent political and religious events became prominent, and as a result, the King's Chaplain, Thomas Fuller, produced the Restoration forerunner to the *DNB*: *A History of the Worthies of England* (1662).[35] In the tradition of Petrarch's *De viris illustribus*, a classical form with a great impact on the European Renaissance, Fuller's project should also be anchored in the political atmosphere of seventeenth-century England. Ian Donaldson connects the trauma of the Civil War with the need for commemoration, to both remember and forget, and the plethora of biographical and autobiographical writings which saw the light of day towards the end of the seventeenth century is significant. Although not published until the nineteenth century, John Aubrey's *Brief Lives* were conceived in the 1680s and '90s, in close dialogue with Anthony à Wood's *Athenae Oxonienses; An Exact History of all the Writers and Bishops who have had their Education in the University of Oxford* (1691–2). The diaries of John Evelyn and Samuel Pepys chronicled the lives of English intellectuals abroad and at home, in everyday trivia, and in moments which would make history, such as the return of Charles II, the London Plague, the London Fire, and the early days of the Royal Society. All became popular texts in new transcriptions and editions in the nineteenth century, and they formed part of Pater's reading in the 1880s as he was working on his portraits, profoundly interested in the emerging national identity of the Restoration.[36] The diary format as a narrative framework or a literary device figures recurrently in Pater's fiction: prominently in 'A Prince of Court Painters', as a secret text in 'Sebastian van Storck', a spurious text in *Marius*, and in two different voices, one of which has the final word in 'Emerald Uthwart'. Aubrey and Wood's compilations of lives coincided with John Dryden's supervised translation and edition of Plutarch (1683–6),[37] another text which would be given a

[34] Peter France and William St Clair, 'Introduction' in France and St Clair, 3.

[35] See Ian Donaldson, 'National Biography and the Arts of Memory: From Thomas Fuller to Colin Matthew,' in France and St Clair, 67–82.

[36] Inman 1990, 438, 439, 453.

[37] *Plutarch's Lives: Translated from the Greek by Several Hands. To which is Prefixed the Life of Plutarch*, 5 vols (London: J. Tonson, 1683–6).

nineteenth-century veneer in A. H. Clough's edition (1859),[38] used and quoted in 'Hippolytus Veiled'.[39] Inman gives no record of Pater borrowing Plutarch from the Oxford libraries, but he quite likely had his own copy of the Clough edition.

The seminal role of Plutarch's *Parallel Lives*, the contrasting biographies of ancient Greeks and Romans, can hardly be overestimated. In Elizabethan England Thomas North's translation (1579) of Jacques Amyot's French translation (1559–65) provided Shakespeare with plots and characters for his Roman plays;[40] in France Plutarch became a key text for Michel de Montaigne and Jean-Jacques Rousseau. In Restoration England Dryden sneered at North's inelegant style, accusing him of merely making a copy of a copy by translating from Amyot, and Plutarch—now translated from Greek into English—became a foundational text on statesmanship. For the romantics, it became one of the three texts which civilized the monster in Mary Shelley's *Frankenstein* (1818), and for the mid-Victorians the *Lives* went hand-in-hand with Benjamin Jowett's promotion of Classics as a way into the civil service, a useful background for colonial administration. The purely literary quality of the lives, as studies of complex individuals who left their mark on world history, transcended period fashion and secured Plutarch a status as a classic, also outside intellectual circles. The many nineteenth-century reprints of the Dryden-Clough edition, on either side of the Atlantic, speak their own clear language of Plutarch's popularity. His flawed heroes prevented the lives from becoming the pagan equivalent of Christian hagiography. Pater based Hippolytus' absent father on Plutarch, whose accounts of Theseus' liaison with the Amazons and his bad track record with women made engaging reading. In his 'Life of Alexander' Plutarch's introduction outlines his approach with a distinction between achievements and character:

> It must be borne in mind that my design is not to write histories, but lives. And the most glorious exploits do not always furnish us with the clearest discoveries of virtue or vice in men; sometimes a matter of less moment, an expression or a jest, informs us better of the characters and inclinations, than the most famous sieges, the greatest armaments, or the bloodiest battles whatsoever. Therefore as portrait-painters are more exact in the lines and features of the face, in which the character is seen, than in the other parts of the body, so I must be allowed to give my more particular attention to the marks and indications of the souls of men, and while I endeavour by these to portray their lives, may be free to leave more weighty matters and great battles to be treated of by others.[41]

The emphasis on the 'inner life' helped secure Plutarch a thriving nineteenth-century popularity. Although a gulf of some 1800 years separates Plutarch from Edmund Gosse, who defined biography as 'the faithful portrait of a soul in its adventures through life', a long line runs from the 'Life of Alexander' to Pater, Gosse, and

[38] *Plutarch's Lives. The Translation Called Dryden's. Corrected from the Greek and Revised by A. H. Clough*, 5 vols (London: Sampson Low, 1859).

[39] *CW* 3:161–3, 297–300.

[40] Jacques Amyot has a brief walk-on part in *Gaston*, 23, as a humanist who consults manuscripts in the library at the Cathedral of Chartres.

[41] *Plutarch's Lives*, ed. Clough, 4:159.

Gamaliel Bradford's ideas of 'psychography', developed at the *fin de siècle*.[42] Sidney Lee celebrated Plutarch in his lecture on 'National Biography' at the Royal Institution on 31 January 1896 declaring that 'It is to the prosaic, yet more accessible and more adaptable, machinery of biography that a nation must turn if her distinguished sons and daughters are to be accorded rational and efficient monuments. Biography is of its essence public and perspicuous; it is not less certainly permanent. The marble statuary that surmounted the burial places of the heroes of Greece and Rome has for the most part crumbled away, but "Plutarch's Lives" remain.'[43] Strachey's memorable image of Victorian biography as issuing from the undertaker's office partly referred to its literary tone and cumbersome length, while downplaying its resurrectionist aspect. As Laura Marcus points out, biography has a transcendental, spiritualist quality, keeping the dead alive, imparting a textual afterlife to the departed,[44] reminiscent of portraiture. Strachey was merely developing Gosse's slightly earlier conflation of life and death in the biographical genre. A close friend of Pater's since the late 1870s, Gosse was much involved in controlling the writer's afterlife, in collaboration with Pater's sisters and Shadwell, as indeed, he would control the afterlives of other literary celebrities. Thus his destruction of a large number of the private papers of J. A. Symonds makes one wonder whether, in part, we have Gosse to thank for the paucity of private papers relating to Pater.[45] He became one of Pater's early biographers,[46] wrote the entry on 'biography' for the 1910 *Encyclopedia Britannica* (as indeed he wrote the entry on Pater for the *DNB*), and authored the controversial autobiography *Father and Son* in 1907. Gosse's 'The Custom of Biography' in the short-lived *Anglo-Saxon Review* began by outlining English biography as something of a national characteristic:

> Various nations have diverse ways of building the tombs of their prophets. The Americans endow institutions—usually styled 'universities'—and give to them the names of the deceased. The French, believing with Goethe that the best memorial of a man is his effigy, fill the squares of their country towns with bronze statues. We in England bury our dead under the monstrous catafalque of two volumes (crown octavo), and go forth refreshed, as those who have performed a rite which is

[42] See Novarr, 17–34. [43] Quoted in Donaldson, 79.

[44] Laura Marcus, 'The Newness of the "New Biography": Biographical Theory and Practice in the Early Twentieth Century', in France and St Clair, 193–218, 206.

[45] See *Letters of John Addington Symonds*, ed. Herbert Schueller and Robert L. Peters, 3 vols (Detroit: Wayne State University Press, 1967–9), 2:381n–82: 'Janet Vaughan [Symonds's granddaughter] writes us on September 23, 1967, on the destruction of John Addington Symonds' papers by Edmund Gosse: 'When I was a young medical student I used to take tea with Edmund Gosse and Mrs Gosse on Sunday afternoon....One afternoon Gosse said he particularly wanted to talk to me. He said he knew how glad I should be to hear what he had done to preserve the good name of my grandfather J. A. S. He hinted that he had done the same sort of thing for Swinburne. Then he explained that when Horatio Brown died, Horatio had left all J. A. S.'s papers to him, Gosse, to dispose of as he thought best. Hagburgh Wright [the librarian of the London Library] & I had a bonfire in the garden and burnt them all, my dear Janet, all except his autobiography which we have deposited in the London Library not to be available or published for 50 years. I am sure you will agree this was the right and proper thing to do. I said very little...Gosse's smug gloating delight as he told me, the sense that he had enjoyed to the full the honor fate had given him, was nauseating. There was nothing to be said. I walked out and never went back.'

[46] Gosse, 1894.

not in itself beautiful, perhaps, but is inevitable and eminently decent. The custom has now grown into an institution, almost without our perceiving it, until it has become like the Christmas plum-pudding or the Oxford and Cambridge boat-race. We certainly have not realized that we are the only nation in the world that has adopted the big-biography habit, as part of our recognized convention, to such an extent that the 'life' of the deceased begins on the day of his 'death'.[47]

Gosse employed what may seem an apologia for this national custom of a resurrection in print of all and sundry, great and small, for a profound criticism of English biography. He evoked the proliferation of national biography as an almost uncontrollable force, gathering momentum and assuming a life of its own, as the volumes 'rise behind the glass fronts of our bookcases, in funereal splendour, serried, undisturbed, making of this portion of the library a sort of solemn Kensal Green. And still in battalions they advance. Since I began to write this page, no doubt, the memoirs have been published of a bishop, a hospital nurse, tree railway inspectors, two botanists, and a military man. How did we, as a nation, fall into the biographical habit? What led us to cultivate it with such astounding indifference to form, purpose, and proportion?'[48]

Seen in this light, biography poses a literary menace, threatening to outnumber focused, polished writing in the short format. Such mechanical mass production of dreary lives of anonymous individuals and professional types, advancing like an army in a literary war, constitutes a national and international embarrassment, a sign of decadence, and calls for a new kind of biography, Gosse argues. Brevity, elegance of style, and focus are called for, and although not often acknowledged, Gosse's outcry heralds the 'new biography', to use the title of Woolf's review of Harold Nicolson's *Some People* (1927).[49] This was where Strachey, Nicolson, and Woolf herself would take over, but the controller of Pater's afterlife was one of the first critics to articulate this movement away from the Victorian 'double-decker'. Gosse was merely theorizing what Pater had practiced in his essays and portraits. When Gosse argued for biography as a fine art, in counter-argument to the widespread notion that anyone could write a biography, not least the faithful widow,[50] he was, in effect, arguing for an elevation of the genre, not unlike the way Wilde and others had argued for the elevation of criticism as a fine art. Pater's modernity may make it desirable to approach his texts through the Modernists, reading the 1880s and 1890s through the 1920s. It may, at times, take early twentieth-century Cambridge to explain late nineteenth-century Oxford.

Pater's Brief Lives

The commemorative aspect of biography, celebrated by Lee, problematized by Gosse, is an integral part of most of Pater's imaginary portraits. The majority end in an early

[47] Edmund Gosse, 'The Custom of Biography', *Anglo-Saxon Review: A Quarterly Miscellany* 8 (Mar. 1901), 195–208, 195.
[48] Ibid., 195–6. [49] Woolf, 'The New Biography' in *EVW* 4:473–80. See Marcus 2002.
[50] Gosse 1901, 208.

88 WALTER PATER'S EUROPEAN IMAGINATION

death and conclude with a brief summing up of the life recently lost, sometimes almost in an epitaph, reminding us of that other biographical genre, the obituary. Pater experimented with the 'brief life' in some of the concluding paragraphs of his portraits, while in others he played with notions of resurrection, giving transcendence to physical form in the suggestion that death is not always final. In 'A Prince of Court Painters', the diary concludes with the death of Watteau, although, presumably, our diarist continues her life and with it her diary. The final words in her last entry of July 1721 echo the view of Watteau represented in Edmond and Jules de Goncourt's *L'Art du XVIIIe Siècle* (1873–4):[51] 'He has been a sick man all his life. He was always a seeker after something in the world, that is there in no satisfying measure, or not at all.'[52] This brief, and private, assessment of Watteau's life is so far from whatever public *éloge* the French Académie Royale might have bestowed on one of their most illustrious members. In the decades immediately after Watteau's death, obituaries, biographies, and commemorative collections of his drawings proliferated, contributing to an early cult of the artist which would be renewed by the French Decadents. Referring to Jean de Jullienne, Antoine de la Roque, and the Comte de Caylus in his text, Pater made us aware that he was perfectly familiar with this early Parisian cult of Watteau, if only through the Goncourts, who printed much of the biographical material.[53] By contrast, Pater's lines leave the reader with the diarist's frustrated portrait of a pathological dreamer, a Faustian fantast bent on self-destruction in eternal pursuit of unrealistic ambitions. The final sentence contains the painful contrast between the painter's hopes and his biographer's pragmatic awareness of the real world, almost to reinforce the image of an artist who, although a historical figure, turned his life and art into fiction.

Sebastian van Storck's parents find their son drowned off the coast of Holland, and the inevitability of his early death is stated by the authoritative medic who remarks that 'in any case he must certainly have died ere many years were passed, slowly, perhaps painfully, of a disease then coming into the world; disease begotten by the fogs of that country—waters, he observed, not in their place, "above the firmament"— on people grown somewhat over-delicate in their nature by the effects of modern luxury.'[54] Smitten by the philosophical ideas of the tubercular Baruch de Spinoza, Sebastian may well have caught more than a mode of thinking from the philosopher, who has a brief walk-on part in the narrative. Yet he is, first and foremost, a representative of a *Zeitgeist*, tied to climate theories and a moral theory of the detrimental effects of consumerism and over-refined living. With 'luxury' as the final word, we are reminded of one of the seven deadly sins, that of *luxuria* (sexual desire), misdirected

[51] See Anne Marie Candido, 'Biography and the Objective Fallacy: Pater's Experiment in "A Prince of Court Painters"', *Biography: An Interdisciplinary Quarterly* 16:2 (Spring 1993), 147–60; Fossi 1996; Kit Andrews, 'The Figure of Watteau in Walter Pater's "Prince of Court Painters" and Michael Field's *Sight and Song*', *English Literature in Transition, 1880–1920* 53:4 (2010), 451–84.

[52] *CW* 3:79.

[53] See Edmond and Jules de Goncourt, *L'Art du dix-huitième siècle*, deuxième édition, 2 vols (Paris: Rapilly & Marchand, 1873–4) 1:3–72. The Goncourts printed their short essay on Watteau (3–17), followed by their annotated reprint of Comte de Caylus's biography (20–67) and Charles-Antoine Coypel's response to the Comte de Caylus (69–72).

[54] *CW* 3:113.

in a sterile desire for materialistic gratification. The medic's verdict thus becomes the death-sentence, not only of the young man but of a whole decadent culture.

Having traced the story of Denys through stained glass, ancient tapestries, and manuscripts, the nineteenth-century narrator concludes: 'To me, Denys seemed to have been a real resident at Auxerre. On days of a certain atmosphere, when the trace of the Middle Age comes out like old marks in the stones in rainy weather, I seemed actually to have seen the tortured figure there—to have met Denys l'Auxerrois in the streets.'[55] As a medieval version of Dionysus, a classical fertility deity, Denys experiences annual revival. Does Denys' continued ghostly presence in Auxerre run through genetic material in his descendants, given his popularity with the local women? Or are we dealing with a hallucinating narrator who has become so infatuated with Denys' story that he denies its fatal conclusion? Pater's phrasing makes us question the validity of ocular proof; our narrator is not entirely sure of what he has seen: 'I seemed actually to have seen'. Whichever way we read Pater's final words, Denys is a presence, inextricably tied to the town whose name is incorporated into his own.

The idea of resurrection structures the last portrait in Pater's 1887 volume, 'Duke Carl of Rosenmold'. We begin with the bones of a male and female skeleton, found in the soil and identified by nineteenth-century 'German bone-science' as the remains of Duke Carl and his 'beggar maid'. We end with an anecdote from Goethe's autobiography of the young Goethe skating like a god over the river Main as a reincarnation of everything Carl had hoped to become: 'That was Goethe, perhaps fifty years later. His mother also related the incident to Bettina Brentano:—"There, skated my son, like an arrow among the groups. Away he went over the ice like a son of the gods. Anything so beautiful is not to be seen now. I clapped my hands for joy. Never shall I forget him as he darted out from one arch of the bridge, and in again under the other, the wind carrying the train behind him as he flew." In that amiable figure I seem to see the fulfilment of the *Resurgam* on Carl's empty coffin—the aspiring soul of Carl himself, in freedom and effective, at last.'[56] As the conclusion to the portrait of yet another dreamer, Pater's narrator directs our attention to a subjective way of seeing: 'I seem to see'. The narrative literally moves from the bowels of the earth under the heraldic family tree to the open coffin, the empty grave, the vision of Carl as the typological precursor of the quasi-divine Goethe. The protagonist's bodily remains have long since decomposed, but the rebirth of his aspirations is given full luminosity in the enlightenment figure of Goethe. As the narrative had chronicled Carl's abortive attempts as a playwright, architect, musician, connoisseur, and poet, the final apotheosis into the polymath of Weimar serves as the culmination of an unsuccessful life. Wolfgang Iser described Pater's volume as studies in failure,[57] and Stephen, if ever he read Pater's volume, may have noticed how unlike the lives chronicled in the *DNB* Pater's lives were. With the exception of Watteau, none of Pater's protagonists achieve what they set out to achieve, thus inviting us to contemplate the affinities between biography and tragedy. Captured in their early pursuit of romantic,

[55] *CW* 3:95. [56] *CW* 3:131–2.

[57] Wolfgang Iser, *Walter Pater: The Aesthetic Moment*, tr. David Henry Wilson (Cambridge: Cambridge University Press, 1987), 153–4.

artistic, philosophic, or personal success, Pater's protagonists are allowed to live just long enough for their hopes to be thwarted, allowing us to think of life-writing as a hybrid genre, with close affinities not just to history, the novel, and portraiture but also to that darkest of the dramatic genres: tragedy.

Pater's 'Hippolytus Veiled: A Study from Euripides' moves within the realms of tragedy, life-writing, and fiction.[58] Based on a Euripidean fragment, and a classical body of texts about Hippolytus, Pater constructs his own tragic narrative of a young man suddenly killed in his chariot by a divine curse. Left alone with the dead body of her son, Hippolytus' grieving mother is the last thing we see before the curtain drops. Pater invents a narrative sequel, not unrelated to the resurrections of Denys and Carl: 'Later legend breaks a supernatural light over that great desolation, and would fain relieve the reader by introducing the kindly Asclepius, who presently restores the youth to life, not, however, in the old form or under familiar conditions.'[59] To her, surely, counting the wounds, the disfigurements, telling over the pains which had shot through that dear head now insensible to her touch among the pillows under the harsh broad daylight, that would have been no more of a solace than if, according to the fancy of Ovid, he flourished still, a little deity, but under a new name and veiled now in old age, in the haunted grove of Aricia, far from his old Attic home, in a land which had never seen him as he was.'[60] The elegiac tone makes us aware that, like ancient Greek culture, Hippolytus is lost forever; the painful reality of maternal grief has the final word in the commemoration of perhaps the liveliest of Pater's young male protagonists.

Emerald makes a couple of narrow escapes before he eases himself into his death bed:

> [H]e stretched himself in the bed he had occupied as a boy, more completely at his ease than since the day when he had left home for the first time. Respited from death once, he was twice believed to be dead before the date actually registered on his tomb. 'What will it matter a hundred years hence?' they used to ask by way of simple comfort in boyish troubles at school, overwhelming at the moment. Was that in truth part of a certain revelation of the inmost truth of things to 'babes,' such as we have heard of? What did it matter—the gifts, the good-fortune, its terrible withdrawal, the long agony? Emerald Uthwart would have been all but a centenarian to-day.[61]

The course of Emerald's life is summed up with great economy: 'the gifts, the good-fortune, its terrible withdrawal, the long agony.' The subdued centenary celebration of an altogether unremarkable man, whom none but his mother would remember after his death, is undercut by Pater's postscript. Just as the cadence of the last sentence has

[58] See Lene Østermark-Johansen, 'Pater's "Hipolytus Veiled": A Study from Euripides?', in ed. Martindale, Evangelista, and Prettejohn, *Pater the Classicist*, 183–99.

[59] One version of the Hippolytus legend states that Artemis asked Asclepius, son of her twin brother Apollo and god of medicine and healing, to resurrect the dead youth. This is the version explored by Robert Browning in 'Artemis Prologizes' (1842).

[60] *CW* 3:173. [61] *CW* 3:197.

prepared us for the sense of an ending,[62] just as we think that 'nothing more...could be said', Pater invents a coda in the form of a surgeon's diary, composed after he has been called in to remove a bullet from Emerald's cardiac region. With the change in narrative voice, Emerald assumes a new corporeality. The lifelike body suggests a male counterpart to Snow White; the surgeon's professional, yet desiring, gaze makes us briefly hope that a kiss will revive the young man. The postscript progresses as a necrophiliac striptease: layer after layer is lifted, until the bullet is removed, whereupon the layers are restored one by one, until the coffin lid is safely screwed on. Sight, touch, and smell are all invoked as part of the process, and we sense the deep impression made on the surgeon who 'found the body lying in a coffin, almost hidden under very rich-scented cut flowers, after a manner I have never seen in this country, except in the case of one or two Catholics laid out for burial'.[63] He adopts both an artistic and a phrenological approach to Emerald's physical form, and predicts a predisposition for disease which would have manifested itself, if an early death had not prevented it. To the medical mind, an excess of the imaginative faculty is a liability, a wonderfully ironic comment from Pater in an imaginary portrait: 'The extreme purity of the outlines, both of the face and limbs, was such as is usually found only in quite early youth; the brow especially, under an abundance of fair hair, finely formed, not high, but arched and full, as is said to be the way with those who have the imaginative temper in excess. Sad to think that had he lived reason must have deserted that so worthy abode of it!'[64] From skull reading, the surgeon progresses through an evocation of the tactile sense which is so powerful that the reader feels he is probing his finger, tracing the clear outlines, touching that firm flesh to feel a youthful body in denial of its new status as a corpse: 'I was struck by the great beauty of the organic developments, in the strictly anatomic sense; those of the throat and diaphragm in particular might have been modelled for a teacher of normal physiology, or a professor of design. The flesh was still almost as firm as that of a living person; as happens when, as in this case, death comes to all intents and purposes as gradually as in old age.'[65] Once his mission has been completed, the bullet has been wrapped in an old letter, and placed within Emerald's uniform, the surgeon attempts to return the contents of the coffin to the state in which he found it. It is an unnerving experience with such a lifelike corpse, and the reader shudders as the lid is screwed on, as we are reminded of our fears of being buried alive: 'The flowers were then hastily replaced, the hands and the peak of the handsome nose remaining visible among them; the wind ruffled the fair hair a little; the lips were still red. I shall not forget it. The lid was then placed on the coffin and screwed down in my presence. There was no plate or other inscription upon it.'[66]

The surgeon's postscript is one long inscription, one long epitaph in celebration of the handsome young man whose life has been brought to an untimely end, in recollection of the stele of Tryphon in the British Museum (Fig. 2.1). 'He was better; was more like a real portrait of a real young Greek, like *Tryphon, Son of Eutychos*, for instance, (as friends remembered him with regret, as you may see him still on his

[62] See William Shuter, 'The Arrested Narrative of "Emerald Uthwart"', *Nineteenth-Century Literature* 45:1 (Jun. 1990), 1–25.

[63] *CW* 3:198. [64] *CW* 3:198. [65] *CW* 3:198. [66] *CW* 3:198.

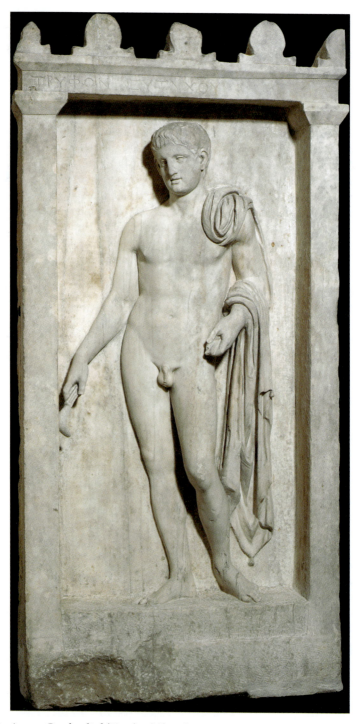

Fig. 2.1. Anon., Greek relief, 'Tryphon' (fourth century BC–first century AD), Pentelic marble, 177.5 × 90 × 26.5 cm. British Museum, London. © The Trustees of the British Museum. All rights reserved.

tombstone in the British Museum),[67] alive among the paler physical and intellectual lights of modern England, under the old monastic stonework of the Middle Age.'[68] Pater's repetition of 'real' makes us question the application of the term when it comes to portraits from the past: what is 'a real portrait'? And how can we, at the end of the nineteenth century, judge whether a Hellenistic portrait is a good likeness? The surgeon paints a very ideal portrait of the dead Emerald, of a Greek body buried with all the sensuousness suggestive of Catholicism. Given how this, the longest of Pater's imaginary portraits, was so pervasively concerned with education from school to university, it is so much the more intriguing how the beautiful body is the image with which the reader leaves the text. The mind, nourished on Homer and Horace, has long since proved its inability to survive, but the beautiful body remains, embalmed under fragrant flowers.[69] By concluding with an evocation of the body, Pater might be alluding to the convention well known from Renaissance life-writing of rendering a physiognomic portrait at the very end, often after a detailed description of the subject's death. Such a return to the subject's body, in life or as if in life, conflates commemoration and resurrection, and brings together some of the most essential aspects of biography.[70]

Pater's brief lives increase in length. The epigrammatic two-liner which concludes the female diary expresses the wish to forget, not unrelated to the diarist's own pain as Watteau's rejected lover, whereas the surgeon's diary entry swells into a lengthy celebration, an aestheticization of the dead body, with the body itself as a monument to the life. Although Pater's portraits should not be bracketed as 'life-writing', they engage with many components of the genre and raise fundamental questions of authority and voice. Who can sum up the life of another person, and what does it take to do so? How can anyone claim to know another person well enough to write their life? Is writing one's own life, in fact, the only kind of life-writing possible? If one cannot know oneself, how can one claim to know the lives of others? Essential questions like the above run as undercurrents in Pater's portraits, which constantly make us aware of point of view and authority. Pater wants us to be alert to authorial voice and to question it; his imaginary portraits may be brought into relief by the opening paragraph of France and St Clair's volume on European life-writing: 'Is biography possible? Jean-Paul Sartre's early fictional hero Roquentin is driven in *La Nausée* to the conclusion that he cannot seriously undertake to write the life of another person. Biography is for him an impossibility, a work of "pure imagination", emanating from the biographer, and bearing no verifiable resemblance to the

[67] In 1839 the British Museum purchased a Greek funerary relief (fourth century BC), with a re-cut Roman head (first century AD), depicting a handsome young male nude with a strigil in his hand. The inscription in Greek identified the young man as one 'Tryphon'.

[68] *CW* 3:186. [69] See Maxwell 2017, 117–31.

[70] Pater returned to the relief in 'The Age of Athletic Prizemen' (1894): 'See, for instance, Trypho, "the son of Eutychus," at the British Museum—one of the very pleasantest human likenesses there, though it came from a cemetery—a son it was hard to leave in it at nineteen or twenty. With all the suppleness, the delicate muscularity, of the flower of his youth, his handsome face sweetened by a kind and simple heart, in motion, surely, he steps forth from some shadowy chamber, *strigil* in hand, as of old, and with his coarse towel or cloak of monumental drapery over one shoulder. But whither precisely, you may ask, and as what, is he moving there in the doorway? Well! in effect, certainly, it is the memory of the dead lad, emerging thus from his tomb, —the still active soul, or permanent thought, of him, as he most liked to be' *CW* 8:170.

94 WALTER PATER'S EUROPEAN IMAGINATION

supposed subject. Biography is fiction, but without the freedom that the novel bestows on the writer.[71] For Pater, fiction gets the upper hand, but with the frequent tease that this might as well be fact. Pater is not a historian, but toys with the verisimilitude of the diary form to give us the illusion that we are reading 'real' documents, produced by 'real' people, about other 'real' people. The voice of the friend, the lover, or the professional authority is, of course, no more real than Emerald is (although we can nearly touch him), but this is part of the pact between author and reader which one accepts when embarking on an imaginary portrait.

English Men of Letters and English Poets: The Literary Portrait

Pater was and remained a Macmillan author his entire life, and after his death both the De Luxe edition (1900) and the Library Edition (1910) of his works were published by Macmillan.[72] Where his essays had appeared in the 1860s and '70s in the *Westminster Review* and, most notably, in the *Fortnightly Review* under the editorship of John Morley (1876–82), nearly all his fiction appeared in *Macmillan's Magazine*. As a consequence, the 1887 volume *Imaginary Portraits* became a Macmillan publication. We must consider the genre of the literary portrait, represented in France most prominently by Charles Augustin Sainte-Beuve and in England by John Morley's Macmillan series 'English Men of Letters', which began to appear in 1878, at the same time as the first of the imaginary portraits. Between 1878 and 1892, thirty-nine volumes of 'English Men of Letters' came out in what was to constitute the first series; a second series of twenty-five volumes appeared between 1902 and 1919.[73] With a standard format of some 60,000 words, amounting to about 200 printed pages, these 'little books about great men' were praised by Gosse for their 'wholesome discipline of compression',[74] mixing biography with literary criticism. Morley's attitude was that it took one man of letters to write the life of another, and he accordingly commissioned volumes from some of the leading contributors to the periodical press, resulting in a stellar cast of authors and subjects: Stephen wrote the volumes on Johnson, Pope, and Swift; Symonds the volumes on Sidney and Shelley, Gosse on Browne and Gray, Anthony Trollope on Thackeray, Mark Pattison on Milton, and Anthony Froude on Bunyan. To my knowledge, Morley never asked Pater for a contribution, but he joined the list in the end when, in 1906, Benson's *Walter Pater* appeared in the English Men of Letters. The 1879 prospectus defined the intended audience as 'the general public' and reflected a general editor who was himself a busy man: the books were published 'with a view both to stirring and satisfying interest in literature and its great topics in the minds of those who have to run as they read'.[75] The popularity

[71] France and St Clair, 1.

[72] For this life-long relationship with the House of Macmillan and the correspondence between the author and his publisher, see Seiler 1999.

[73] The volumes on literary women like Fanny Burney, Maria Edgeworth, Jane Austen, and George Eliot were only part of the latter series, which, however, did not change its name accordingly.

[74] Gosse 1901, 204.

[75] Quoted in F. J. M. Korsten, 'The "English Men of Letters" Series: A Monument of Late Victorian Literary Criticism', *English Studies* 6 (1992), 503–16, 505. See also John L. Kijinski, 'John Morley's "English Men of Letters" Series and the Politics of Reading', *Victorian Studies* 34:2 (Winter 1991), 205–25.

of the 'English Men of Letters', which sold in millions of copies over the years, made it required reading for the English gentleman. Harold Nicolson satirized this in *Some People* (1927), where the figure of the aspiring (but admittedly not very successful) diplomat J. D. Marstock is advised by his tutor to have read the complete series before sitting the final examination of the Foreign Office.[76] Intriguingly, the corresponding Macmillan series, 'English Men of Action' (1889 onwards) sold much less well and had, accordingly, a much shorter life. The biographies of George Gordon, Francis Drake, Horatio Nelson, and Captain Cook, may, ironically, have been less suited for future members of the diplomatic service than the 'English Men of Letters'.

The House of Macmillan was branding itself on promoting Englishness and supporting the literary education of the middle classes, at the same time as the debates about establishing English as a university subject were being conducted in the periodical press, a debate to which also Pater contributed.[77] Throughout October, November, and December of 1886 the pages of the *Pall Mall Gazette* were filled with contributions to the debate of 'English at the Universities?', spurred on by the fierce attack in the *Quarterly Review* on Gosse's Clark lectures in Cambridge for extreme dilettantism.[78] The ensuing cry for the need for a professionalization of the study of English literature made the editors of the *Gazette* solicit responses from a range of academics, many of whom were Oxford affiliated: T. H. Huxley, Max Müller, William Morris, T. H. Warren, J. A. Symonds, the Provost of Oriel, the Warden of All Souls, etc. One major issue was whether the establishing of English as an academic subject would be at the expense of Classics, and whether the two disciplines could be taught in conjunction with one another. Other issues related to the balance between philology and literature in the Oxford Merton Chair (established 1885), and whether a degree in English was essentially a degree in theory and criticism. With the gradual emergence of English literature as a field in its own right, new primers, biographies, and anthologies were needed, aimed to create a 'celebratory and consensual' view of the Englishness of English literature, which in turn provided fuel for English cultural nationalism.[79] 'As English literature was mined to find the supposedly distinctive characteristics of Englishness, that very quest for Englishness provided a justification for why literature mattered, and why it should be studied in schools and universities.'[80] Macmillan provided their fair share of such publications; Pater may not have been asked to contribute to the 'English Men of Letters', but his neighbour, colleague, and friend Thomas Humphry Ward asked for contributions to both the first and second edition of his multi-volume anthology 'The English Poets'. For the first edition (1880),

[76] 'Marstock was large but also tidy. On his mantelpiece he had a set of the English Men of Letters Series which began with those square red ones and ended with those thin yellow ones. "My tutor," Marstock would say, "told me that the examiners expect one to have read the E. M. of L. S."' Harold Nicolson, *Some People* (Oxford: Oxford University Press, 1983), 88.

[77] See Pater's contribution (paired with that of Frederick Myers), 'English at the Universities', *Pall Mall Gazette* 44 (27 Nov. 1886), 1–2. See also Charles Martindale, Lene Østermark-Johansen, and Elizabeth Prettejohn ed., *Walter Pater and the Beginnings of English Studies* (Cambridge: Cambridge University Press, 2023).

[78] The lectures were published under the title *From Shakespeare to Pope: An Inquiry into the Causes and Phenomena of the Rise of Classical Poetry in England* (Cambridge: Cambridge University Press, 1885).

[79] Stefan Collini, *Public Moralists: Political Thought and Intellectual Life in Britain 1850–1930* (Oxford and New York: Clarendon Press, 1991), 347.

[80] Evangelista 2021, 20.

96 WALTER PATER'S EUROPEAN IMAGINATION

Pater contributed an essay on Coleridge; for the second (1883), an essay on D. G. Rossetti, who had died only in 1882. Both essays would find their place in Pater's *Appreciations, with an Essay on Style* (1889), a volume which could also be seen as part of Macmillan's attempt to strengthen a general interest in English literature. The canonization implied in both the 'English Men of Letters' and the 'English Poets' series is indisputable; when seen with twenty-first-century eyes, the list of authors in both series reflects late Victorian England, not least the gender imbalance is striking.

For all his critical contributions to the periodical press and to Ward's anthology, Pater probably also had ambitions of using his imaginary portraits as a kind of literary portraiture in a merging of fiction, life-writing, and criticism. I am here interested in his fragmentary portrait, composed in the late 1870s,[81] and only published posthumously: 'Imaginary Portraits 2. An English Poet.'[82] Pater may have kept tampering with the text in the 1880s, as his quotation from Octave Feuillet, whom he reviewed in 1886, and his debate about the English language, which echoes his essay on 'Style' (1888), might suggest.[83] As a fairly polished manuscript found after Pater's death, it stops mysteriously in mid-sentence. The last pages may have been lost in the 1920s when the Ottley family, who held the literary copyright of Pater's writings after Hester Pater's death in 1922, attempted to place the manuscript with a publisher. 'An English Poet' was referred to as being 'quite complete' by Canon Ottley in a letter to George Macmillan sent on 11 January 1924,[84] but the text which eventually saw publication in 1931, edited by the Canon's wife May Ottley, is cut off abruptly, even before reaching a full-stop period. The manuscript itself appears to have been lost, which is unfortunate, as May Ottley confesses to having tampered with the text.[85] There is even inconsistency with respect to the title; the heading of the piece is 'Imaginary Portraits 2: An English Poet', while the title which precedes Pater's narrative carries the definite article: 'The English Poet.' Irrespective of whether Pater desired the definite or the indefinite article, the text is the only one of his portraits which foregrounds national identity and it is tempting, I think, to see it as an allusion to Morley and Ward's Macmillan series and to the ongoing debate about English literature as a university subject. In the manuscript as published, we find descriptions of the making of the poet's own verses as sculptural processes associated with metal and stone, in a language wrought to a high degree of refinement to suit form and matter. The poet's Englishness partly resides in a merging of ancestry and the notion

[81] See *Letters of Walter Pater*, ed. Evans, xxix, 35 n. 2; *Bibl.*, no. 29.

[82] 'Imaginary Portraits 2: An English Poet', *Fortnightly Review* 129 (1 Apr. 1931), 433–48.

[83] Pater quotes (in French) from Feuillet's *Le Journal d'une femme* (1878) (*CW* 3:151). His 'M. Feuillet's "La Morte"' appeared in *Macmillan's Magazine* 54 (Dec. 1886), 97–105. His reference to the 'racy sources of fully male English speech' (*CW* 3:152) is suggestive of the 'Racy Saxon monosyllables, close to us as touch and sight' of the essay on 'Style', 733.

[84] B. A. Inman, 'Tracing the Pater Legacy, Part II: Posthumous Sales, Manuscripts and Copyrights', *Pater Newsletter* 32 (1995), 3–8, 4.

[85] 'The editor of the essay has touched it as little as is possible. Of a choice of words, that written last, or at the top of one or two others, is as a rule, printed here; defective words or phrases are marked by brackets or a question mark. Sometimes, in the original essay, the grammar is faulty, and therefore the sense is obscure. The editor has taken the liberty of cutting out one or two unessential passages. What is left would seem to be "of quality and fabric," such as no lover of Walter Pater would willingly let die.' May Ottley, Prefatory note to 'An English Poet', 435.

of 'mother tongue' which gives him an affinity with the English language, despite his Anglo-French origin. Add to this his formative reading of English literature, a childhood in Cumberland, and the imprint on his soul of romantic landscape, rustic inhabitants, and the ghost of Wordsworth, and we have an English poet, whose own verses remain an enigma to which we are never given access, at least not in the published text as we have it:

> What was strange was that, although half of foreign birth, he had come to be so sensitive of the resources of the English language, its rich expressiveness, its variety of cadence (the language of " ")[86] with all the variety of that soft modulation at which foreigners with an ear wonder and admire. Expression, it may be verbal expression, holds of what may be called the feminine element and tradition in things, and is one of those elemental capacities which the child takes for the most part from its mother.
>
> And such inheritance of an instinctive capacity for utterance he, the boy, had developed among the racy sources of fully male English speech among the Cumberland mountains, and among people to whom a great English poet attributed a natural superiority in the use of words.[87]
>
> And so it happened that while he hardly felt at all the impress of that same rich temperance in English scenery and English character, the English tongue had revealed itself to him as a living spirit of mysterious strength and sweetness and he had elected to be an artist in that.[88]

The text has fourteen occurrences of 'English', several of which cluster in the passages above. Pater invited the reader's contemplation of the interrelationship between language, style, and literature as something which arises out of an interplay with landscape, spirit of place, and national character. Yet he was keen to tie his English poet to the European continent. Not only is the poet's father French; the fragrant flower which triggers his imagination is the French red honeysuckle, in curious conjunction with a flowery metal screen wrought in Germany. The poet returns to Normandy in the last pages and experiences a personal and poetic awakening, as North is replaced with South and his aesthetic sense aroused. The lure of European culture and landscape forms a necessary counterpart to the mountainous roughness of Cumberland and its inhabitants. The return to Normandy takes place just before the manuscript breaks off, at some 5,300 words of text. What Pater wrote, or intended to write, for the remaining 2,000–3,000 words (if we take it that 'An English Poet' was to be of the same length as the other portraits) is impossible to know, but the poet's Englishness was surely intended to be foiled by his European experience.

The poet starts out as 'a fragile creature', son of a consumptive mother who dies in childbirth. Her poetic spirit, kindled by her discovery of an old Roman coin in the

[86] This is one of Pater's celebrated manuscript 'blank spaces'.

[87] Pater is thinking of Wordsworth who was born in Cumberland and spent the major part of his life there. In the 1800 Preface to the *Lyrical Ballads* Wordsworth had famously defined the poet as 'a man speaking to men' and stressed the humble aspects of rustic life depicted in the poems.

[88] *CW* 3:151–2.

Norman soil and her brief romance with a handsome Parisian with a Roman profile, literally consumes her from within. She bequeaths her poetic spirit and tuberculosis to her son, and although our poet has been toughened by the northern mountain air, the taint of death is upon him: 'the action already within him of that strange malady which holds so closely of the too-clinging humours of our English climate, which is also, in part, a matter of inheritance, and was established in him by that long tension of spirit to which the distinction of his intellectual quality was due.'[89] The artistic frame of mind is tied to 'the too-clinging humours of our English climate'; the narrator includes himself among the unhealthy Englishmen, just as, in 'A Prince of Court Painters', the narrator subscribes to climate theories when Watteau crosses the English Channel: 'His thirst for change of place has actually driven him to England, that veritable home of the consumptive. Ah me! I feel it may be the *coup de grâce*. To have run into the native country of consumption—strange caprice of that desire to travel, which he has really indulged so little in his life—of the restlessness which, they tell me, is itself a symptom of this terrible disease!'[90] Pater's pastiche of the eighteenth-century sentimental heroine and the portrait of the English romantic poet may well make us question whether the author himself subscribed to climate theories; admittedly, both he and his sisters frequently complained of bad health in their letters.

Apart from the genetic and environmental moulding of the poet, a major part of Pater's portrait deals with his *Bildung* through reading, with the strong formative influence of his study of English literature. To the impact of landscape on the poet's mind, Pater adds his intellectual education, and marks out the awakening of the poet's imaginative and the critical faculty, together with a sense of literary topography which connects books with places. Thus, 'a passion for reading came to him; and he found the exotic full-blown at last in books of prose and poetry'. A catalogue comprising Hawthorne, Ruskin, Carlyle, Arnold, Coleridge, Clare, and Browning is expanded with the Renaissance writers Browne, Webster, Chapman, and Shakespeare, giving us a sense of a canonical education with reference to the writers' investment in European topography, from Valhalla and the Alps to the Roman Campagna and the coast of France. Just as Pater had been concerned with chronicling the growth of Florian's aesthetic awareness, so, in 'An English Poet', was he keen to trace the origins of the poetic spirit and the interplay between reading, perceiving, and creating. Pater's own literary beginnings as a poet may run as an autobiografictional undercurrent; in the mid and late 1850s, when a schoolboy and young undergraduate, he had repeatedly tried his hand at poetry before turning to prose in the 1860s.[91]

'An English Poet' is in every respect a wonderfully romantic text. Not only does it deal with the coming into being of a young orphaned poet, whom tuberculosis has singled out as its victim, rooted in hereditary taint and an ardent artistic soul; it also deals with the impact of nature and literature on the individual. The text is a fragment, and we shall presumably (unless the remaining pages of manuscript turn up one day) never know what conclusion Pater intended for his narrative, whether he

[89] *CW* 3:154. [90] *CW* 3:77.
[91] See *Bibl.* 138–56, largely based on details given in *Wright*.

LIFE-WRITING 99

ever wrote it, or why he stopped when he did. It is an important foundational text, elucidating Pater's experiment with fiction as criticism in dialogue with Sainte-Beuve within the genre of the literary portrait.[92] Between 1827 and 1849 Sainte-Beuve published some 150 literary essays under the heading 'Portraits': in 1839 the five-volume edition of *Critiques et portraits* appeared, in 1844 his *Portraits des femmes* and his *Portraits littéraires*, and in 1846 the three-volume edition of his *Portraits contemporains*. From 1849 until Sainte-Beuve's death in 1869 the *Portraits* were replaced by his *Causeries du lundi*, the 640 essays contributed on a weekly basis to *Le Constitutionnel* and *Le Moniteur* about French and European literature of the past and the present.

We know that Pater was an ardent reader of Sainte-Beuve, from 1866 and probably until his death. In the 1860s he regularly took out copies of the *Portraits* from the Oxford libraries, and in his private book collection volumes by Sainte-Beuve were a considerable presence.[93] Nearly all of the French subjects for Pater's essays had already been treated by Sainte-Beuve, from Ronsard, du Bellay, and Montaigne, to Marguerite de Navarre, Pascal, Flaubert, and Prosper Merimée. 'An English Poet' is, most likely, the most Sainte-Beuvean text among Pater's portraits; I suggest that we examine it within this framework in an attempt to contextualize the Anglo-French dialogue, to think of the creative recreation of character within criticism, which Pater takes from Sainte-Beuve, who merges biography with criticism. Furthermore, we should consider the obsession with beginnings, with the tracing of the origin of talent, and its earliest manifestations which characterizes so many of Sainte-Beuve and Pater's portraits.

As Ann Jefferson points out in her exploration of biography in nineteenth- and twentieth-century France, the French did not have a craze equivalent to the Victorian double-decker biography. The interest was for large biographical dictionaries, like Louis-Gabriel Michaud's fifty-two-volume *Biographie universelle ancienne et moderne* (1811–28) and Jean-Chrétien-Ferdinand Hoefer's forty-six-volume *Nouvelle biographie générale* (1852–66), both of which were frequently consulted by Pater.[94] Biography was primarily a collective phenomenon, a gathering of totalities out of a collection of individual entries, as also testified by Théophile Gautier's *Les Grotesques* (1844), Eugène de Mirecourt's *Histoire contemporaine: Portraits et silhouettes au XIXe siècle* (1867), and most notably by Sainte-Beuve's *Portraits*. Jefferson concludes that 'whether as dictionary, as newspaper or publisher's series, or as collected volume, biography made its most powerful impact in collective form'.[95] Whether Pater, in his 1878 covering letter to the editor of *Macmillan's Magazine*, intended a similarly collective project for his imaginary portraits, is mere guesswork, but his vision of them as a series is worth bearing in mind.

[92] For Pater's dialogue with French literature more broadly, see John Conlon, *Walter Pater and the French Tradition* (Lewisburg: Bucknell University Press, 1982).

[93] See Inman 1981, 109, 192, 215, 219. Pater's own collection contained the *Portraits contemporains* and 15 volumes of the *Causeries du lundi*. Ibid., 336–8.

[94] See Ann Jefferson, *Biography and the Question of Literature in France* (Oxford: Oxford University Press, 2007), 83–99.

[95] Ibid., 86.

In Sainte-Beuve's *Portraits* the figure of the poet was given a special status, differing from statesmen, conquerors, and philosophers. In the realm of literature '"human initiative has primacy and is less subject to general causes; individual energy modifies and, so to speak, assimilates things." The individual genius of the writer is as much determining as determined, and this makes the great writer fundamentally different from all other figures.'[96] Sainte-Beuve frequently traced the family origins of the poets he portrayed, together with their education. What particularly interested him were the first signs of the onset of their poetic talents, the moment when their genius came into its own: 'If you understand the poet at this critical moment, if you unravel the node to which everything will be connected from that moment on, if you find what you might call the key to this mysterious link made half of iron and half of diamonds joining his second, radiant, dazzling, and solemn existence to his first, obscure, repressed, and solitary one (the memory of which he would more than once like to swallow up), then one could say of you that you thoroughly possess and know your poet.'[97]

Pater's concern with the English poet's family background, with his upbringing, and education gives us the very same focus as that recommended by Sainte-Beuve. The images of iron and stone recall Pater's evocation of the way the poet works with language and matches form to matter. Our narrator has the longer view; he knows the young man will turn into a poet before we see it happening in the narrative in a way similar to the omniscience of Sainte-Beuve's critic. I suspect that with 'An English Poet' Pater intended a dialogue with one of Sainte-Beuve's earliest works, his *Vie, poésies et pensées de Joseph Delorme* (1829), a study in the poetic mind of a fragile medical student and poet who dies an early death (whether of tuberculosis or of a weak heart remains uncertain) and leaves his poems (also written by Sainte-Beuve) to posterity. The text appeared anonymously, as an edited heterogeneous text, comprising prose and poetry, explanatory narrative, and extracts from the young man's journal followed by some of his verses. The life explains the poetry, just as the poetry explains the life in a circular movement. From the very beginning, we are made aware that we will be witnessing the confessions of a romantic young man: 'The friend whose works we now publish was torn from us very young, some five months ago. A few hours before dying, he left to our care a journal in which are confined the main circumstances of his life and some pieces of poetry which are nearly all devoted to the expression of his personal grief.'[98] Matthew Arnold, in his essay on Sainte-Beuve written for the *Encyclopedia Britannica* (1886), described Joseph Delorme as 'not the Werther of romance, but a Werther in the shape of Jacobin and medical student, the only Werther whom Sainte-Beuve by his own practical experience really knew.'[99] With his English poet Pater projects some of Sainte-Beuve's ideals

[96] Jefferson, 128–9, quoting from Sainte-Beuve's portrait of Nicolas Boileau.

[97] From Sainte-Beuve, 'Pierre Corneille'. Quoted from and translated by Jefferson, 130.

[98] English translation mine. 'L'ami dont nous publions en ce moment les oeuvres nous a été enlevé bien jeune, il y a environ cinq mois. Peu d'heures avant de mourir, il a légué à nos soins un journal où sont consignées les principales circonstances de sa vie, et quelques pièces de vers consacrées presque toutes à l'expression de douleurs individuelles.' C. A. Sainte-Beuve, 'Vie, poésies et pensées de Joseph Delorme' in *Poésies complètes de Sainte-Beuve* (Paris: Charpentier, 1840), 5–22, 5.

[99] Arnold, 'Sainte-Beuve' in *The Complete Prose Works of Matthew Arnold*, 11:106–19, 113.

LIFE-WRITING 101

and early history onto a fictitious character in dialogue with Arnold, who became one of the French writer's chief promoters in England. Arnold had known Sainte-Beuve well, visiting and corresponding with him,[100] and in his encyclopaedia article he made the reader aware of Sainte-Beuve's English background: his mother was half-English, and he was brought up in Boulogne-sur-mer in a geographical location which closely corresponds to that of Pater's English poet, to which he returns at the end of the narrative. Arnold highlights Sainte-Beuve's admiration for English poetry (hardly surprising, given the context in which his essay was published), and his advice to a friend to learn English in order to be able to appreciate it:

> 'Since you are fond of the poets,' he writes to a friend, 'I should like to see you read and look for poets in another language, in English for instance. There you will find the most rich, the most dulcet, and the most new poetical literature. Our French poets are too soon read; they are too slight, too mixed, too corrupted for the most part, too poor in ideas even when they have the talent for strophe and line, to hold and occupy for long a serious mind.' And again: 'If you knew English you would have treasures to draw upon. They have a poetical literature far superior to ours, and, above all, sounder, more full. Wordsworth is not translated; these things are not to be translated; you must go to the fountainhead for them. Let me give you this advice: learn English.'[101]

Sainte-Beuve's awareness of the interdependence between language and literature, of language as that which gives poetry its national specificity, reminds us of Pater's English poet: rhythm and rhyme reside in language, and with Sainte-Beuve's allusion to Wordsworth, and hence to the interrelationship between landscape, language, demotic and vernacular verse,[102] Pater's English poet becomes solidly rooted in a nineteenth-century Anglo-French context. His unfinished portrait engaged with the English nineteenth-century poet who for most of his life grappled with the growth of the poetic mind, with the leading French critic and experimenter with the literary portrait—a man who like Pater himself had turned from poetry to critical prose—and with the Oxford Professor of Poetry, who mastered both poetry and prose and served as a go-between of the English and French literary worlds. With such an ambitious merging of *Bildung*, criticism, and life-writing with the poetry of place, it is perhaps little wonder that Pater never finished the manuscript sufficiently to publish it.

Pater was acknowledging his indebtedness to the French writer at many levels. Richard Chadbourne pointed out Sainte-Beuve's 'flair for bringing secondary and often minor figures to life'. 'Apart from their usefulness in helping the literary geographer, as he fancied himself to be, to measure the giant peaks around them, they appealed to him as worthy subjects in themselves.'[103] Pater's transparent protagonists,

[100] See Arnold Whitridge, 'Arnold and Sainte-Beuve', *PMLA* 53:1 (Mar. 1938), 303–13; R. H. Super, 'Documents in the Matthew Arnold-Sainte-Beuve Relationship', *Modern Philology* 60:3 (Feb. 1963), 206–10.

[101] Arnold, 'Sainte-Beuve', 113.

[102] For a discussion of 'An English Poet' in the context of Wordsworthian 'spots of time', sculpture, and language, see Østermark-Johansen 2011, 278–90.

[103] Richard M. Chadbourne, *Charles-Augustin Sainte-Beuve* (Boston: Twayne Publishers, 1977), 84.

102 WALTER PATER'S EUROPEAN IMAGINATION

observing major historical events from the margins, are such worthy subjects. Chadbourne comments on the flat and 'pale' characters in Sainte-Beuve's fiction while suggesting that in his criticism, the author's recreation of real persons is much more successful, as he turns them into characters.[104] Something similar could be said for Pater: his Winckelmann, Leonardo, and Michelangelo are far more vibrantly alive than many of the protagonists of his imaginary portraits. The many allusions to the visual arts in Sainte-Beuve's portraits indicate his awareness of his own artfulness, as his criticism hovers teasingly between the objective and the subjective.[105] Sainte-Beuve's elaborate narrative frames often serve to alert us to this artfulness, to the fact that the portrait on which we are about to embark is self-consciously poised half-way between two worlds. In choosing the term 'portrait' for his fictions, and by employing many of the Sainte-Beuveian devices, Pater acknowledged his indebtedness to the French writer and his particular merging of criticism and life-writing with a touch of fiction and self-reflection.

In 'An English Poet', the life is foregrounded at the expense of the works, to which we never gain access. As Paula Backscheider points out, this is often the case with biographies of poets; frequently the life is represented as a far more interesting read than the poet's own works, even in so-called 'literary biographies'.[106] The process by means of which one gets at the subject, from the life and into the works or vice versa, makes for very different readings and approaches to the complex subject of voice. Pater's English poet has been silenced; the omniscient narrator may give us access to his thoughts and sensations through descriptive passages which sometimes blend the experiences of the poet with those of the narrator himself by means of pronouns such as 'one' and 'you', but the poet's direct voice is never heard. By comparison, Sainte-Beuve often lets his subjects speak, allowing their own texts to form the core of his portraits (as he had also done in his portrait of the fictitious Joseph Delorme). The function of the critic becomes partly a framing device, introducing the subject's own words by means of a biographical narrative, sometimes preceded by the critic's own meta-reflective thoughts on his task, as when, in the portrait of Pierre Corneille, he compares the biographer's task to the sculpting of a portrait bust.

Sainte-Beuve's almost scientific approach to the study of character found expression in one of his *Pensées* at the end of his *Portraits littéraires*: 'I have only one joy, I analyze, I botanize, I am a naturalist of souls. What I would like to create is a *natural history of literature*.'[107] This phrase, the 'naturalist of souls', reappeared when Gamaliel Bradford entitled his book *A Naturalist of Souls: Studies in Psychography* (1917), expressing his admiration of Sainte-Beuve and stating the need to turn from the ordered chronology of biography to psychography, defined as the 'condensed, essential, artistic presentation of character'.[108] The *OED* traces 'psychography' back to the

[104] Ibid., 88. [105] Ibid., 94–5.

[106] See ch. 1, 'The Voice of the Biographer' in Paula R. Backscheider, *Reflections on Biography* (Oxford: Oxford University Press, 2001).

[107] English translation mine: 'je n'ai plus qu'un plaisir, j'analyse, j'herborise, je suis un naturaliste des esprits. Ce que je voudrais constituer, c'est *l'histoire naturelle littéraire*.' 'Pensée XX' in Sainte-Beuve, *Portraits littéraires*, ed. G. Antoine (Paris: Robert Laffont, 1993), 1075.

[108] Gamaliel Bradford, *A Naturalist of Souls: Studies in Psychography* (New York: Dodd, Mead, and Company, 1917), 9.

LIFE-WRITING 103

mid-nineteenth century as a term associated with spiritualism, the production of writing and drawing through the hand of a medium, but by the end of the century it would seem that its use in the sense of a 'spiritual biography' was becoming increasingly common. George Saintsbury had already applied the term 'psychographer' to Sainte-Beuve,[109] addressing his ability to capture the uniqueness of his subjects, male and female, famous and less well known. The conflation of scientific and artistic approaches in Sainte-Beuve himself and in his admirers is intriguing and might, perhaps, at first, suggest a contradiction in terms. And yet, at the root of this 'naturalism of souls' is the cultivation of the notion that each human being is unique, and that it is the writer's task to observe and discover that uniqueness and bring it across in artistic form, by turning the subject into a character. Pater's portraits are pivotal in such discussions as they frequently play on what might have been real but may well be imaginary instead. The self at the centre, constructed in elaborate interplay with natural and social surroundings, with genetic heritage and education, is a being in a constant state of becoming. In spite of his reverence for Sainte-Beuve, Bradford rebelled against the term 'portrait' which he found too static, too focused on the frozen moment:

> Now the aim of psychography is precisely opposite to this. Out of the perpetual flux of actions and circumstances that constitutes a man's whole life, it seeks to extract what is essential, what is permanent and so vitally characteristic. The painter can depict a face and figure only as he sees them at one particular moment, though, in proportion to the depth and power of his art, he can suggest, more or less subtly, the vast complex of influences that have gone to building up that face and figure. The psychographer endeavours to grasp as many particular moments as he can and to give his reader not one but the enduring sum total of them all.[110]

Bradford goes back to Lessing's eighteenth-century distinction between the visual arts which evolve in space, and literature which evolves over time. With his focus on 'moments of being', epiphanies, Bradford aligns his psychography with Wordsworthian romanticism and its revival in Pater's portraits in such scenes as the red hawthorn scene, Florian's confrontation with the graves of the children, or the English poet's encounter with the bean-fields of France.[111] The significance of moments of being for the becoming of the self, which Bradford stresses in 1917, is merely a natural development of a nineteenth-century concern with accounting for the growth of the self from the most significant moments of childhood into maturity. The more autobiographical of Pater's portraits all revolve around such moments in the making of the self, a self which may have certain similarities to the author, but which certainly is also a constructed character. The modernity of Pater's portraits, with their changing narrative voice and frames, changing geographical and historical backgrounds, and oscillations between the autobiografictional, the mythological, and the purely fictitious, would perhaps only be fully realized by the generation of writers

[109] See Marcus, 207. [110] Bradford, 5.
[111] See Jay B. Losey, 'Epiphany in Pater's Portraits', *English Literature in Transition, 1880–1920* 29 (1986), 297–308.

who pretended to react so strongly against the Victorians. In some respects, it would take a Marcel Schwob, a Lytton Strachey, a Harold Nicolson, or a Virginia Woolf to explain what Pater had been trying to do.

Marcel Schwob, the Modernists, and the New Biography

In 1894, the year of Pater's death, a series of brief imaginary lives began appearing in France in *Le Journal*. Two years later, the twenty-two lives were collected in a thin volume entitled *Vies imaginaires*. A glance at the table of contents might give us allusions to what Pater's intended series of imaginary portraits could have looked like, had they all been completed and put together in volume form. There are a number of similarities:

> Empédocle, dieu supposé
> Érostrate, incendiaire
> Cratès, cynique
> Septima, incantatrice
> Lucrèce, poète
> Clodia, matrone impudique
> Pétrone, romancier
> Sufrah, géomancien
> Frate Dolcino, hérétique
> Cecco Angiolieri, poète haineux
> Paolo Uccello, peintre
> Nicolas Loyseleur, juge
> Katherine la Dentellière, fille amoureuse
> Alain le Gentil, soldat
> Gabriel Spenser, acteur
> Pochahontas, princesse
> Cyril Tourneur, poète tragique
> William Phips, pêcheur de trésors
> La Capitaine Kid, pirate
> Walter Kennedy, pirate illettré
> La Major Stede Bonnet, pirate par humeur
> Mm. Burke et Hare, assassins.[112]

With a wide range of subjects, from that of an ancient supposed divinity to the Scottish body snatchers, who in 1828 made the streets of Edinburgh dangerous territory and subsequently inspired one of Stevenson's most famous short stories, Marcel Schwob's compilation of lives spanned a similar historical and geographical range as Pater's portraits. Greek, Roman, Italian, French, Oriental, English, and northern American individuals people the pages of his book, each of them defined, not only

[112] Marcel Schwob, *Vies imaginaires* (Paris: Éditions Gérard Lebovivi, 1986). In the recent English translation, *Imaginary Lives*, tr. Chris Clarke (Cambridge, MA: Wakefield Press, 2018), the epithets are missing from the table of contents.

LIFE-WRITING 105

by name but also by profession, social status, faith, philosophical stance, or whatever else it might take to sum up an individual. With his provocative juxtaposition of name and epithet, Schwob intended us to question the tension between individual and type, the name given at birth and other people's assessment of one's life, once it is over. From deity to assassin, cynic to woman in love, Schwob challenges any Carlylean notion of history as made up of great men only. All lives deserve to be imagined and written, and while most of Schwob's subjects, unlike Pater's, were actual historical figures, the approach to their lives, in most cases based on extensive reading and research, was subjective and imaginative. As Pierre Champion, Schwob's first biographer and editor, pointed out:

> It would be easy for us to provide all the sources of these beautiful tales, as is done nowadays, not without pedantry, in the theses on literary history defended in the Sorbonne. There would be no difficulty in listing the documents that furnished [Schwob] with the elements for the biographies of Empedocles and Herostratus, in giving references for all the words uttered by Lucretius, in naming all the Italian chronicles used to portray Cecco Angiolieri, the Franciscan sources for the life of Frate Dolcino, the use he made of Vasari to sketch the madness of Paolo Uccello in a single stroke, the documents that contributed to the writing of the life of Spenser, Shakespeare's contemporary, and the classic lives of the English pirates by which he brings back to life for us the buccaneers who hoisted their black flag over the seas. But to what purpose? Those who are curious will find some of them indicated in the catalogue of Marcel Schwob's library.[113]

The editor of Pater's imaginary portraits is likewise caught between the scholarly duty to elucidate sources and trace intertextual echoes and an acute awareness that the author himself might not have appreciated such uncovering of his working methods. The realm of the imaginary should not be weighed down by footnoting. Schwob had his own copy of Hoefer's forty-six-volume *Nouvelle biographie générale*, and he would have been an ideal contributor to the biographical dictionary, given his extensive learning and ability to write concisely.[114] The length of his lives was slightly longer than the average entry in a biographical dictionary, and even his focus on pirates and assassins complied with Michaud's definition of what merited inclusion in the *Biographie universelle*: 'History, in alphabetical order, of the public and private lives of those men who have made themselves famous by means of their writings, their deeds, their talents, their virtues or their crimes.'[115] Schwob's choice of minor figures—Cecco Angiolieri rather than Dante, Nicolas Loyseleur rather than Jeanne d'Arc, and Gabriel Spenser rather than Ben Jonson or Shakespeare—is quite Paterian

[113] Pierre Champion, 'Notice' to *Vies imaginaires*, in *Les Oeuvres complètes de Marcel Schwob (1867–1905)*, ed. Pierre Champion, 10 vols (Paris: François Bernouard, 1927–30), 2:195–200, 196. Quoted and translated in Jefferson, 202.

[114] Jefferson, 203.

[115] English translation mine. 'Histoire, par ordre alphabétique, de la vie publique et privée de tous les hommes qui se sont fait remarquer par leurs écrits, leurs actions, leurs talents, leurs vertus ou leurs crimes.' Purpose statement for Michaud's *Biographie universelle*, quoted in Jefferson, 203.

106 WALTER PATER'S EUROPEAN IMAGINATION

with its focus on life experienced from the margins. In his 'Preface', Schwob claimed
biography for the realm of art by drawing parallels to portrait painting:

> Unfortunately, biographers have usually believed that they were historians. And in
> doing so they have deprived us of admirable portraits. They supposed that only the
> lives of great men could interest us. Art is unconcerned with these considerations.
> In the eyes of a painter, the portrait of an unknown man painted by Cranach has as
> much value as a portrait of Erasmus. It is not because of Erasmus's name that the
> painting is inimitable. The art of the biographer should be to attach as much import-
> ance to the life of a poor actor as he would to Shakespeare's life.[116]

Concerned with the unique individual, Schwob found Plutarch's notion of parallel
lives problematic as it suggested similarities between individuals which Schwob was
keen to erase. In the body snatching duo of Burke and Hare, which concludes his
volume, he makes it clear that although 'their names remain inseparable in their art,
much like those of Beaumont and Fletcher',[117] one was the inventor and innovator,
the other the rather anonymous hand who helped transform ideas into deeds: 'It is
Mr. Burke who has bequeathed his name to the special technique for which the two
collaborators became known. The monosyllabic verb *to Burke* will live on on the lips
of men a great while yet, whereas Mr. Hare will have sunk into the oblivion that
unjustly engulfs those who toil in obscurity.'[118] Before becoming the objects of Dr
Knox's anatomical dissections, their victims would be selected at random in the
streets, invited into Hare's rooms, and exploited as biographical subjects, the sources
of excellent narratives:

> Mr Burke would question him about the most surprising incidents of his life. He
> was an insatiable listener, that Mr. Burke. The tale was always interrupted by Mr.
> Hare, before the break of day. Mr. Hare's method of interruption was invariably the
> same, and quite peremptory. In order to interrupt the story, Mr. Hare had the cus-
> tom of stepping around the sofa and placing his two hands over the mouth of the
> story-teller. At the same moment, Mr. Burke would go and sit across the victim's
> chest. The two of them, in that position, immobile, would imagine the end of the
> tale that they would never hear. In this way, Messrs. Burke and Hare brought a con-
> clusion to a good number of stories that the world will never know.[119]

Burke and Hare become allegories of the author himself: collectors and selectors of
biographical narratives, capable of killing off both narratives and narrators at their
leisure while spinning whatever end to the tales they like. Controllers of lives and
narratives, the sinister duo endow themselves with almost divine powers, thrown
into relief by Schwob's narrator who chooses to leave them in 'the very midst of their
crowning glory. Why destroy such a beautiful piece of art by dragging them languidly
to the end of their career, and revealing their failures and their disappointments?', he

[116] Marcel Schwob, 'Preface', *Imaginary Lives*, 12. [117] Ibid., 149.
[118] Ibid., 149. [119] Ibid., 151.

asks.[120] As the conclusion to Schwob's volume, the Burke and Hare double portrait is a celebration, however sinister, of the writer's complete mastery of his art of selection, even when dealing with historical characters. The power to cut lives and narratives short and to tease the reader with the thought of untold lives resides forcefully and unquestionably with the author. Many of Schwob's imaginary lives revolve around strange and sudden deaths, and similarly, Pater's portraits reflect the author's keen awareness that he controls his subject. Rather than longevity, he favours the brief life for his protagonists; both in terms of narrative length and life span, brevity becomes an ideal.

The presentation copy of the *Imaginary Portraits* became the beginning of Woolf's long dialogue with Pater. Her essay 'The New Biography', published in 1927 as a review of Nicolson's *Some People*, marked a return to Pater's (and Schwob's) *fin-de-siècle* play with fact and fiction. The essay began as patricide by substitute, as she took her starting point in Sidney Lee's definition of the aim of biography as 'the truthful transmission of personality'.[121] She found the concept oxymoronic, a contradiction in terms, and developed an elaborate dichotomy between 'truth' and 'personality' which structured her review: 'On the one hand there is truth; on the other there is personality. And if we think of truth as something of granite-like solidity and of personality as something of rainbow-like intangibility and reflect that the aim of biography is to weld these two into one seamless whole, we shall admit that the problem is a stiff one and that we need not wonder if biographers have for the most part failed to solve it.'[122] Attacking the dullness of Lee's heavily documented lives of Shakespeare and Edward the Seventh, Woolf followed the path of Gosse and Strachey in criticizing the Victorian biography for its length and emphasis on primary material. The living subject was sacrificed at the altar of evidence, Woolf argued, subscribing to Strachey's declaration: 'Human beings are too important to be treated as mere symptoms of the past. They have a value which is independent of any temporal processes—which is eternal, and must be felt for its own sake.'[123] What Boswell had achieved with his anecdotes and his evocation of Dr Johnson's voice had been lost in the nineteenth century. As argued in 'Mr Bennett and Mrs Brown' (1923) and 'Character in Fiction' (1924), Woolf called for a modern emphasis on character and personality to mark a break with the 'soulless bodies' inhabiting the novels and biographies produced by the previous generation of writers.[124] Woolf's criticism of the 'shapelessness of character' in recent fiction subscribed to the view that all literature, whether fiction or biography, must begin and end with people, with character; only once that had been established could circumstantial fact, such as descriptions of houses and places, be taken into account. What she delighted in, when reading Nicolson's *Some People*, was the author's 'method of writing about people and about himself as though they were at once real and imaginary'. He had, she declared, 'succeeded remarkably, if not entirely, in making the best of both worlds. *Some People*

[120] Ibid., 154.

[121] Lee 1911, 25–6: 'The aim of biography is not the moral edification which may flow from the survey of either vice or virtue; it is the truthful transmission of personality.'

[122] Woolf, 'The New Biography', 473. [123] Strachey, ix.

[124] Woolf, 'Mr Bennett and Mrs Brown' in *EVW* 3:384–9; 'Character in Fiction', ibid., 3:420–38.

108 WALTER PATER'S EUROPEAN IMAGINATION

is not fiction because it has the substance, the reality of truth. It is not biography because it has the freedom, the artistry of fiction.'[125] Asserting that 'the life which is increasingly real to us is the fictitious life; it dwells in the personality rather than in the act',[126] Woolf pointed out how 'the biographer's imagination is always being stimulated to use the novelist's art of arrangement, suggestion, dramatic effect to expound the private life.'[127] And last, but perhaps not least, Woolf was acutely aware of the wit behind Nicolson's portraits: 'Mr. Nicolson laughs. He laughs at Lord Curzon; he laughs at the Foreign Office; he laughs at himself. And since his laughter is the laughter of the intelligence it has the effect of making us take the people he laughs at seriously.'[128] The elegance of Nicolson's style, his ironic detachment, and use of pastiche and caricature, denoting a highly self-conscious writer, underscored his ludic oscillation between fact and fiction, a constant tease which kept not least the Foreign Office guessing for a long time.

Nicolson's gift for pastiche transpires in a letter of 18 June 1918 to his wife, Vita Sackville-West, on seeing William Strang's portrait of her, *Lady with a Red Hat* (1918):

> It is, I think, one of the best portraits I have ever seen. It is so young and so grown up. It doesn't date. She is younger than the sham Chippendale chair on which she sits, and the eyelids are a little weary. And she has arrayed herself in strange webs from diverse merchants, and as Miss Vita has been the distant princess of my exile, and as Viti the mother of Ben and Nigel. That little head is that on which a thousand kisses have fallen—and she has been down to the sea at Polperro and come back just the same to the little cottage.[129]

Endowed with a fine-tuned ear, a perfect sense of rhythm, and acutely perceptive of the characteristics of Pater's prose, Nicolson can almost be heard laughing out loud here (as did, undoubtedly, the recipient of his letter). The bathos of his passage makes us aware of what an institution Pater's *Mona Lisa* had become for the Modernists. The domestication of Pater's *Mona Lisa* in a letter between husband and wife, playing with the near and the distant, affectionate nicknames and exalted unobtainability, cements Pater's status as a modern classic, as the ultimate description of a beautiful painting of an enigmatic woman. The famous lines have become formulaic, recognizable by their rhythm, a few set phrases, and one imaginary portrait is easily substituted by another. Beauty is in the eye of the beholder, and Nicolson goes as much beyond the actual painting as Pater does with Leonardo's *Mona Lisa*.

With his nine imaginary portraits, composed in 1926 during his posting as a diplomat in Teheran, Nicolson turned to a Paterian format. His letter to his parents on completing the manuscript may serve to elucidate aspects of Pater's portraits. Aware that he had violated the rule of not publishing anything relating to the Foreign Service, he was, as he said, nevertheless ready 'to face the music':

[125] Woolf, 'The New Biography', 475–6. [126] Ibid., 478. [127] Ibid., 478.
[128] Ibid., 476.
[129] *Vita and Harold: The Letters of Vita Sackville-West and Harold Nicolson 1910–1962*, ed. Nigel Nicolson (London: Phoenix, 1993), 68–9.

[T]he idea of the book is original. I take nine people and describe them in the manner I described Jeanne de Hénaut. You see, it is really an autobiography—only each person is made the centre of the picture and I only appear in the background. Most of the people are wholly imaginary, only real people and real incidents mix in with them. Everybody will be terribly puzzled as to who everybody else is, and there will be a great deal of identification going on. But as a matter of fact, they are all composite portraits except Jeanne who is of course drawn straight from life.[130]

Nicolson speaks of his texts as layered characters, made up of several different people, thus bringing us back to Galton's composites. In the realm of the imaginary, it may well take fragments of many people to make up the central, prominent figure, while the author himself recedes into the background, still maintaining some sort of presence as a character in his own fiction. Nicolson's spatial and pictorial language reminds us of Pater, as does the self-conscious toying with degrees of authorial presence, with humour and irony as distancing weapons. Woolf had mentioned Voltaire and Max Beerbohm as influences on Nicolson, but there is no doubt that Pater is at least as important. He makes three cameo appearances in the book: as part of the list of subversive, but formative, reading (Lucretius, Shelley, Pater, Beerbohm), given the young 'Nicolson' by his sixth-form tutor;[131] as a gift from his college tutor at Balliol to kill the last traces of an infatuation with a dandy undergraduate from Magdalen: an inscribed copy of *Marius the Epicurean* which leaves 'Nicolson' with the conclusion, 'By this homæopathic treatment I was quickly cured'.[132] And finally as the subject of conversation with a French aristocratic student on a starlit night outside Oxford.[133] Pater hovers, like an *éminence grise*, as a hugely influential presence in so many Modernist texts of the 1920s, but perhaps most evocatively in the long imaginary portrait Virginia Woolf was writing in 1927, as she was reviewing Nicolson. The cross-pollination between reading, admiring, reviewing, and creating is complicated even further by personal relationships, blurring the lines between fiction, scholarship, and life to an extreme degree.

Woolf's infatuation, begun in 1922, with Nicolson's 'Lady with a Red Hat' had led to her turbulent relationship with Sackville-West. From the spring of 1927 Woolf began the composition of her ambitious love poem in prose to Sackville-West, *Orlando: A Biography* (1928), a text which from the very beginning puzzled both critics and booksellers, the latter being uncertain whether to place the book in the 'Fiction' or the 'Biography' section of their shops. Although entitled 'A Biography' and issued with family portraits and an index, Woolf's text challenged conventional life-writing as the chronicle of a more than usually long-lived subject with a life-span of some five hundred years and no significant sign of ageing. The sex change undergone by the subject in the eighteenth century added to the improbability of plot and character; questioning the reader's notion of the stability of gender and identity, Woolf's novel challenged the 'Aristotelian' unities of time, place, and action by having

[130] Harold Nicolson to his parents, 14 January 1927, in *The Harold Nicolson Diaries 1907–1964*, ed. Nigel Nicolson (London: Phoenix, 2005), 56.
[131] Nicolson, *Some People*, 33. [132] Ibid., 47–8. [133] Ibid., 66.

110 WALTER PATER'S EUROPEAN IMAGINATION

an unconventionally vagrant protagonist, travelling not only in space but also in time. In spite of all the outer changes, the voice and personality of Orlando as a lover, reader, and poet remained a constant factor, in illustration of the author's belief in the centrality of character to modern fiction. By extending our notions of what a life is, or can be, how it may be captured in writing, and how name and identity can remain constants amid external flux, Woolf was joining Nicolson in a hearty laughter at conventions. In terms of the novel's anchoring in the real world, the modern editors of the novel sum up the ambitious project: 'Virginia experiments with a new form for the novel; she tells a playful version of Vita's life-story; she re-writes the history of the Sackville family; she re-imagines the genre of biography; she offers a detailed social history of England; she recreates some of the golden moments of British literature; and she sketches a detailed geographical history of the city of London.'[134]

Unlike Pater and Schwob, Woolf defies death; Queen Elizabeth may age and wither, but her protagonist seems to be granted immortality, as do, indeed, poetry and literature. An extended love poem, neither the eternal summer of Orlando nor his poetry will ever fade, and the novel is a great tribute to and celebration of English literature. Our hero is as much a reader as a poet, and in Woolf's exploration of *Bildung*, of what goes into the making of the self, a continued engagement with literature is an essential component. Her imaginary portrait becomes an, at times burlesque, piece of criticism, a catalogue of influence, foregrounded in the very opening words of the 'Preface': 'Many friends have helped me in writing this book. Some are dead and so illustrious that I scarcely dare name them, yet no one can read or write without being perpetually in the debt of Defoe, Sir Thomas Browne, Sterne, Sir Walter Scott, Lord Macaulay, Emily Brontë, De Quincey, and Walter Pater, —to name the first that come to mind.'[135] Pater's prominent position, as the last of the first that come to mind, singles him out in this rather peculiar list of dead literary friends, which is neither chronological nor alphabetical. Woolf is confessing her allegiance to the 'School of Walter Pater' and the significance of the presentation copy which entered the family library some forty years previously. The dual activities of reading and writing are completely interdependent in Woolf, who also makes great demands on her readers' literary backgrounds. In her novel, the flux of outer change is counterbalanced by the protagonist's literary activities. The Oak Tree poem, which stays with Orlando from beginning to end, is a constant force, a text woven and unwoven with an almost Penelopean patience and a Paterian desire for revision before eventually, in the late nineteenth century, it is read by Orlando's fellow poet Nicholas Greene and taken to a publisher. From his first appearance as a scruffy Elizabethan poet and chum of Christopher Marlowe and Shakespeare, Nick Greene re-emerges as the embodiment of the late nineteenth-century professionalization of English literature: 'With another bow he acknowledged that her conclusion was correct; he was a Knight; he was a Litt.D.; he was a Professor. He was the author of a score of volumes.

[134] 'Introduction' in Virginia Woolf, *Orlando: A Biography*, ed. Suzanne Raitt and Ian Blyth (Cambridge: Cambridge University Press, 2018), xxxvii.
[135] Opening lines of the 'Preface'. Ibid., 5.

He was, in short, the most influential critic of the Victorian age.'[136] The dandified, respectable figure of modern criticism signals the new public status of literature as an establishment activity. By contrast, Orlando's passion for writing is of an entirely private nature:

> The truth was that Orlando had been afflicted thus for many years. Never had any boy begged apples as Orlando begged paper; nor sweetmeats as he begged ink. Stealing away from talk and games, he had hidden himself behind curtains, in priest's holes, or in the cupboard behind his mother's bedroom which had a great hole in the floor and smelt horribly of starling's dung, with an inkhorn in one hand, a pen in another, and on his knee a roll of paper. Thus had been written, before he was turned twenty-five, some forty-seven plays, histories, romances, poems; some in prose, some in verse; some in French, some in Italian; all romantic, and all long.[137]

A manuscript often hidden in the poet's bosom, the Oak Tree poem remains a private, not to say intimate, text, whose exact contents are never revealed to the reader. The life is foregrounded at the expense of the poetry, and readers must consequently construct their own Oak Tree poem or acknowledge the secrecy of the text. In Woolf's cross-gendered novel, with its passages of pastiche, as she occasionally 'does the police in many voices', we must accept that we are operating through the concealing layers of modernity, and that not everything will be known at the end. Nothing is what it seems, something which is also suggested in the illustrations where Angelica Bell dresses up as the Russian Princess, and Sackville-West assumes many different poses, alongside her family ancestors, in a friendly nod to one of Woolf's female ancestors, Julia Margaret Cameron, whose performative mid-Victorian photographs revolutionized the medium.[138] The stylistic, historical, and geographical flux of the narrative, from the Renaissance to the early twentieth century, is punctuated by the insertion of the portraits in the text, asking the reader to 'STOP and LOOK at the small slices of space and time that they present.'[139] The images look back at us from the pages of the book, interrupting our reading, while also forcing us to make comparisons between text and image, with the inevitable conclusion that the visual representations of Orlando differ from what we imagined he/she would look like. Dennis Denisoff speaks of 'ekphrastic slippage', as Woolf thwarts our expectations by giving us images that are almost recognizable, yet not quite.[140] Giving prominence to the power of the written word, Pater never included illustrations in his books; whatever

[136] Ibid., 253. [137] Ibid., 71.

[138] See Natasha Aleksiuk, '"A Thousand Angles": Photographic Irony in the Work of Julia Margaret Cameron and Virginia Woolf', *Mosaic* 33:2 (Jun. 2000), 125–42; Talia Schaffer, 'Posing Orlando', in ed. Ann Kibbey, Kayann Short, and Abouali Farmanfarmaian, *Sexual Artifice: Persons, Images, Politics, Genders* 19 (New York: New York University Press, 1994), 26–63. Vanessa Bell and Virginia Woolf possessed a range of authentic Cameron photographs, some of which were published in the Hogarth Press publication *Victorian Photographs of Famous Men and Fair Women* (1926), for which Roger Fry wrote the introduction. Prior to that Woolf had written a mock-biographical essay on Cameron in 1926 and a play *Freshwater* (1923), in which Bell was cast in the part of Cameron.

[139] Aleksiuk, 136.

[140] Dennis Denisoff, 'The Forest beyond the Frame: Women's Desires in Vernon Lee and Virginia Woolf', in *Sexual Visuality from Literature to Film, 1850–1950* (Basingstoke: Palgrave Macmillan, 2004), 98–120, 113.

ekphrastic slippage he might desire would have to reside in a confrontation between his words and the reader's recollection of a particular work of art.

Woolf's *Orlando* is as full of life as Pater's English poet is inherently consumptive. The authors' concern with the *Bildung* of their characters, through love of literature and same-sex desire, connect them with each other at a profound level, and Woolf's membership of 'The School of Walter Pater' can hardly be denied. Pater's treatment of homoeroticism in his Greek writings most likely had a significant impact on Woolf and a number of other Sapphic writers in the creative liberation of their sexual energies,[141] and *Orlando* is an important experiment in Sapphic writing. Woolf could hardly have been familiar with Pater's 'English Poet' before writing her novel, much as one would have liked her to be. May Ottley published the text in 1931, and it is probably wishful thinking that the manuscript might have been run across the Hogarth Press in the 1920s, as the Ottleys were trying to place it with a publisher. Even more wishful thinking is the idea that Clara Pater, who served as an apparently mediocre teacher of Latin and Greek for Woolf between 1898 and 1901, might have shown the young Virginia her brother's incomplete manuscript. Yet the Pater siblings remained with Woolf long after their deaths as complex doubles, intricately tied up with education, women's writing, and portraiture. Clara and her sister Hester would have served as immediately tangible connections to the past and to their dead brother, to whom Clara, at least, bore a considerable physical resemblance. Woolf's letters between 1898 and 1905 have passing references to both sisters, who became friends of the Stephen household.[142] They turned up at garden parties, 'dressed in the oddest fashions—like Botticelli angels,'[143] as solitary old spinsters whose 'summer disorders generally drive them back to town and doctors about the first week in September'.[144] Clara figured as a dear, but frightening, example of a woman, whose life was lived in the shadow of her illustrious brother, yet as somebody whose character and sayings remained with Woolf long after her death in 1910. Even as late as 1926, as she was finishing *To the Lighthouse*, Woolf recalled a saying of Clara's, which would give her the title for a short story: 'As usual, side stories are sprouting in great variety as I wind this up: a book of characters; the whole string being pulled out from some simple sentence, like Clara Pater's, "Don't you find that Barker's pins have no points to them?"'[145] The short story which evolved in 1928 was entitled 'Moments of Being: Slater's Pins have no Points',[146] and the characters were a thinly veiled double portrait of Walter and Clara Pater, alluded to in the name 'Slater'. The siblings Julius and Julia Craye are two sides of the same coin: odd, unmarried, intensely devoted to each other, collectors living in a glassworld, into which the real world is never allowed to penetrate. As delicate reflections of each other they have shared a quiet life

[141] See Theodore Kouloris, *Hellenism and Loss in the Work of Virginia Woolf* (Farnham: Ashgate, 2011).

[142] See V. Woolf, *The Flight of the Mind: The Letters of Virginia Woolf*, ed. N. Nicolson and J. Trautmann, vol. 1: 1888–1912 (Hogarth Press, 1975).

[143] Ibid., 33, letter to Emma Vaughan, Jun. 1900.

[144] Ibid., 94, letter to Emma Vaughan, 2 Sept. 1903.

[145] V. Woolf, *The Diary of Virginia Woolf*, ed. A. O. Bell and A. McNeillie, 6 vols (London: Hogarth Press, 1980), 3:106, 5 Sept. 1926.

[146] The text was first published in the New York journal *Forum* in Jan. 1928. See V. Woolf, *The Complete Shorter Fiction of Virginia Woolf*, ed. S. Dick (London: The Hogarth Press, 1985), 209–14.

with cats and antique art objects. Julius, a famous archaeologist, has died, but lives on in his sister's memory. Apart from family blood, from being the masculine and feminine versions of the same name—which coincides with that of Woolf's mother, Julia—the Craye siblings are united by their queerness: Woolf more than hints at same-sex desire as being at the heart of their oddity. The strangely double-sexed text forms a neat complement to *Orlando*, published in the same year, and the intriguing allusion to both mother and father figures suggests the need for some generational rebellion. Character develops into caricature in this short imaginary double portrait in close dialogue with the caricatures of the past. Thus the rose that Julia Craye unsuccessfully attempts to pin on the dress of her desirable piano pupil Fanny Wilmot—an action which produces the line 'Slater's pins have no points'—may well refer to W. H. Mallock's satirical portrait of Pater as the aesthete Mr Rose in *The New Republic* in 1876.[147] By 1928 Woolf's pins certainly had points, and Mr Rose would have bled, had he been pricked by them.

The innovative aspects of Pater's experiments with life-writing in the early portraits demand that we look at romantic notions of *Bildung*, at the same time as we look across the Channel to Sainte-Beuve's literary portraits and his merging of biography and criticism in order to understand their origins. Pater's extensive—and life-long—reading of biographies made him acutely aware of the conventions, differences, and challenges within European life-writing, from antiquity to his contemporaries, and some of the portraits may be regarded as precursors of the 'new biography'. The modernity of Pater's portraits can sometimes best be perceived through the modernists who were much more articulate about their Paterian practices than the master himself. The central focus on the individual human being, advocated by Schwob, Strachey, and Woolf, takes its beginnings in Pater. As he experimented with narrative form as a means of conveying character, his use of the journal as an inlet into voice and self became yet another way of constructing a person, of conveying privacy and creativity. From the concealed writings of the English poet Pater stepped into full visibility with his pastiche of the eighteenth-century sentimental novel, letting us glance over the shoulder of a thinking, feeling, and writing female subject. If, as seems likely, given that it opens Pater's volume, 'A Prince of Court Painters' was the first imaginary portrait the young Virginia Woolf read, there is every reason to understand why she became intrigued.

[147] *The New Republic or Culture, Faith and Philosophy in an English Country House* was first serialized in *Belgravia* in 1876 and published in book form in 1877. It contained satirical portraits of other leading Oxford figures: Benjamin Jowett, John Ruskin, and Matthew Arnold.

3

Narrating the Self

Harold Bloom, otherwise one of Pater's great admirers, was curiously dismissive about the author's fiction, and pontificated pompously that 'Pater had no gifts for narrative, or drama, or psychological portrayal, and he knew this well enough'.[1] The statement is so provocative, so plainly erroneous, that it demands contradiction. This chapter serves to disprove Bloom, as it explores Pater's work with literary form and voice with the aim of demonstrating how Pater, a highly sophisticated reader of literature in the major European languages, was perfectly capable of constructing narrative, drama, and fictitious personalities without much anxiety of influence. Bloom failed to recognize Pater as other than a brilliant essayist, as he briskly swept aside the author's elaborate use of narrative frames, of dramatic irony, his choice of first- or third-person narrators, use of the historical present, together with his ability to compress and extend the action in his narratives—to mention just a few of the characteristics of Pater's fiction.

In order to understand Pater's command of the tools of literature, it is essential to develop an awareness of the cross-pollination between Pater the essayist, Pater the reviewer, and Pater the writer of fiction. At the heart of his activity as a writer is the voracious reader, and his experiments with literary form are greater in the fiction than in the reviews and the essays. Pastiche, wit, irony are aspects of Pater's literary style frequently neglected by critics; like his modernist successors, Pater enjoyed 'doing the police in many voices', and his gifted ear served not merely to create rhythmical cadences, but also for imitation and commentary. We often forget the accounts by Pater's contemporaries of his sense of humour and mimic talents. His school and university friend John Rainer McQueen recounted how enjoying Pater's company 'was almost like having a Charles Dickens book, *viva voce*, as one's companion';[2] when at school he was reputedly 'always imitating some favourite author—F. D. Maurice, Kingsley and others'.[3] Described as 'an incorrigible mimic', there was, apparently, 'not a single personage in the circle of his friends whom he did not at one time or another take off'.[4] McQueen reported how 'Pater, who was an excellent actor', had 'imitated to perfection Charles Kean whom he had seen at the Princess's Theatre', and furthermore 'once astonished the company and brought tears into the eyes of the ever-susceptible [Dean] Stanley by his remarkable rendering of a scene in

[1] Harold Bloom, *Essayists and Prophets* (New York: Chelsea House Publishers, 2005), 153.

[2] Letter from McQueen to Wright of 17 May 1906, *Wright*, 1:xviii–xix. See also Laurel Brake, 'Walter Pater's Circle: The Queer Family Relations of John Rainer McQueen, 1840–1912', *Studies in Walter Pater and Aestheticism* 5 (Summer 2020), 1–30.

[3] *Wright*, 1:xix.

[4] Ibid., 1:253. This is confirmed by Gosse's account of Pater's gift for 'inventing little farcical dialogues, into which he introduced his contemporaries; in these the Rector of Lincoln generally figured, and Pater had a rare art of imitating Pattison's speech and peevish intonation.' Gosse 1894, 809.

Walter Pater's European Imagination. Lene Østermark-Johansen, Oxford University Press. © Lene Østermark-Johansen 2022. DOI: 10.1093/oso/9780192858757.003.0004

Shakespeare's *King Henry IV*.[5] McQueen pointed out the darker aspects of Pater's dramatic talent: 'I have in recent times wondered yet more, what the real Pater was. He was an admirable (because unconscious) *actor*; and I think an instance of Jekyll and Hyde dualism.'[6]

Something similar can be discerned from Gosse's obituary portrait: 'There are animals which sit all day immovable and humped up among the riot of their fellows, and which, when all the rest of the menagerie is asleep, steal out upon their slip of greensward and play the wildest pranks in the light of the moon. Pater has often reminded me of some such armadillo or wombat. That childishness which is the sign-manual of genius used to come out in the oddest way when he was perfectly at home. Those who think of him as a solemn pundit of æsthetics may be amazed to know that he delighted in very simple and farcical spectacles and in the broadest of humour.'[7] Having watched Arthur Pinero's farce *The Magistrate* in Pater's company, Gosse concluded that 'Not a schoolboy in the house was more convulsed with laughter, more enchanted at the romping "business" of the play, than the author of "Marius".'[8] If, in Buffon's words, 'the style is the man himself',[9] we should not be surprised to see some of Pater's sense of humour, his mimicry, his fondness for impersonation reflected in his imaginary portraits.

A glance at the subjects of Pater's essays and reviews in the late 1870s and 1880s reveals his interest in drama, character, and contemporary fiction: the three essays on Shakespeare (1874, 1878, 1889) and the review of Doran, *Annals of the English Stage, from Thomas Betterton to Edmund Kean* (1888); the reviews of Symons's monograph on Robert Browning (1887), of Mary Ward's *Robert Elsmere* (1888); Octave Feuillet's *La Morte* (1886); 'Style' (1888) and the reviews of Flaubert (1888 and 1889); Ferdinand Fabre's *Norine* ('An Idyll of the Cevennes', 1889), 'Toussaint Galabru' (1889), 'Prosper Merimée' (1890), and Wilde's *Picture of Dorian Gray* (1891).[10] In all of the above, Pater was concerned with narrative voice and structure, with character in fiction, with poets capable of creating a multitude of personalities (Shakespeare and Browning). Pater's reviews constitute an interesting parallel commentary on his fiction. In the absence of letters, notebooks, or diaries, they provide us with some evidence of the concerns Pater brought to his reading and writing of fiction.

Some of the unfinished manuscripts left at Pater's death offer us an invaluable insight into how he worked when conceiving his portraits. Jotting down ideas, either on small slips of paper or on the full-size sheets used for his manuscripts, Pater made notes on narrative technique, geographical setting, and plot outline. One such gem is the small slip relating to Pater's projected imaginary portrait inspired by a painting by Giovanni Battista Moroni, which had joined the National Gallery in 1862 (Fig. 3.1). Pater confided to Symons that he meant to write a portrait 'on the picture by Moroni known as *The Tailor*, which he thought a very fine and dignified figure. He would

[5] *Wright*, 1:134. [6] Ibid., 1:201. [7] Gosse 1894, 808. [8] Ibid., 809.

[9] Buffon's discussion took place in the context of zoology, and style as an expression of the man himself should be seen in a scientific, rather than an aesthetic, context as the style of humanity. See Inman, 'Reaction to Saintsbury in Pater's Formulation of Ideas of Prose Style', *Nineteenth-Century Prose* 24 (Autumn 1997), 108–26.

[10] *Bibl.*, xv–xviii.

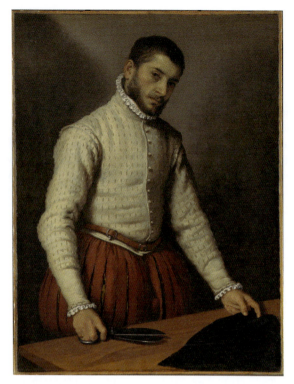

Fig. 3.1. Giovan Battista Moroni, *The Tailor* (*c*.1570), oil on canvas, 99.5 × 77 cm. © National Gallery, London.

make him, he said, a Burgomaster.'[11] In elevating the tailor to Burgomaster, Pater was picking up on the gentlemanly air of Moroni's sitter, a man who, with his ring, codpiece, and elegant clothes, is not depicted as merely a craftsman.[12] Charles Eastlake had suggested that the sitter was performing an act, dressing up as a tailor,[13] an idea given new life by the painting's popularity as a subject for charades in Victorian party games.[14] Moroni's tailor is young, erect, confrontational, sexualized by the codpiece which emerges from his breeches. Clad in luminous red and white in a tight-fitting

[11] Benson, *Walter Pater*, 123. See also Arthur Symons, 'Walter Pater', *Monthly Review* 24 (Sept. 1906), 14–24, 21–2.

[12] For a comparison, see Girolamo Mazzola Bedoli's *Portrait of a Tailor* (*c*.1540) in the Capodimonte in Naples.

[13] Cf. Eastlake's earliest notes on the painting, encountered in an Italian collection in 1855: 'Morone— St Tagliapanni—an emblematical portrait of a young man as a tailor in allusion to name (cloth & scissors).' In *The Travel Notebooks of Sir Charles Eastlake*, ed. Susanna Avery-Quash, 2 vols (London: The Walpole Society, 2011), 1:246.

[14] For the nineteenth-century reception of the painting, see Allison Goudie, 'Verso una storia popolare del *Sarto* di Moroni in Gran Bretagna', in *Giovan Battista Moroni Il Sarto*, exhibition catalogue Accademia Carrara (Milan: Silvana Editoriale 2015), 33–9; Østermark-Johansen 2019, '"This will be a popular picture"'.

doublet which accentuates the shape of his torso,[15] he is a powerful presence, potent as a tool-using creature, invested with both phallic power and the scissors of castration. His slashed breeches bear testimony to his ability to use those scissors, and the black cloth in the foreground, with its discreet white chalk lines, lays out the path for the right cut. Depicted in the 'pregnant moment', just before cutting the cloth, Moroni's tailor is the embodiment of drama. Also known as *Il Tagliapanni*—the cutter of clothes—the tailor has a profound bodily awareness. He sees the body underneath the cloth, knows what the right cut might do for it, and operates in the interface between dressed and undressed. His engaging gaze, sizing you up, measures the viewer as he would measure a customer. No wonder that the painting attracted Pater's attention.

In a brief note to himself (Fig. 3.2), probably of the late 1880s, Pater wrote a plot outline revolving around the true nature of his protagonist, a ladies' man in Bergamo (where Moroni practiced as a portrait painter), followed by disease and sudden death, all framed as a nostalgic retrospective, questioning the role of the individual within a social context:

> Might it be told by the father—cf. Amber-witch.
>
> Il Sartore.
>
> After all, his p[ride] asserted itself, —his nat[ure] w[ould] come out—a notion that he is en deuil—[therefore] the g[rea]t ladies fin[ally] come near him—he feels all that—vague affection concurs with heart-disease—dies in a g[rea]t fête, wh[ich] he has organised—It had been a charmed 10 y[ea]rs at Bergamo—& how much had he had to do with it?[16]

Pater's note in the top right-hand corner on narrative technique is intriguing. He owned a copy of the 1861 edition of Lady Duff Gordon's English translation of Wilhelm Meinhold's Gothic novel, *Mary Schweidler, the Amber Witch. The most Interesting Trial for Witchcraft ever Known, printed from an imperfect manuscript by her Father, Abraham Schweidler, edited by W. Meinhold* (1844).[17] This is a classic case of a gothic hybrid text, of manuscript fragments 'found', 'transcribed', 'edited', and further mediated through translation. It becomes a curiously double-gendered text, with a female subject, male printers and editors, and a female translator. As the text originally appeared, anonymously, it pretended to be a transcription of a bundle of seventeenth-century manuscripts found in a German church. The hoax was so convincing that Meinhold had to write several public letters to assert his authorship and prove his fraudulence.[18] The narrative of a widowed father, left to care for his prepubescent daughter in a small community on the Baltic coast under the growing

[15] The *Tailor*'s doublet and slashed breeches have been reconstructed, see Alessio Francesco Palmieri-Marinoni, et al., 'Aspetti di costume e moda nel *Sarto* di Giovan Battista Moroni', in *Giovan Battista Moroni Il Sarto*, 59–71 and Palmieri-Marinoni and Paci, 'L'abito del Sarto: la ricostruzione', ibid., 73–7.

[16] 'Il Sartore', Houghton bMS Eng. 1150 (22) | fol. 12r. Kindly transcribed and edited by Lesley Higgins.

[17] Inman 1990, 489. Pater's book is in the collection of Brasenose College, Oxford (PATER 44), donated by Catherine Runcie.

[18] See the introductions to *The Amber Witch: A Romance by Wilhelm Meinhold*, tr. Lady Duff Gordon, ed. and intr. Joseph Jacobs and ill. Philip Burne-Jones (London: D. Nutt, 1895) and Wilhelm Meinhold,

Fig. 3.2. Walter Pater, 'Il Sartore', Houghton bMS Eng. 1150 (22) | fol. 12r. Houghton Library, Harvard University.

suspicions of the girl's witchcraft, was spiced with accounts of northern European witch hunts, while revolving around the tension between the naïve male narrator and his charismatic daughter. The nineteenth-century editor pointed out how 'It is indeed the character of the father who tells the story—the simple old rector of Coserow,

The Amber Witch, tr. Lady Duff Gordon, intr. and ed. Barbara Burns, MHRA European Translations 4 (London: Modern Humanities Research Association, 2016).

with his pedantry and simplicity, his superstition and servility, his trust in God and belief in the Devil—which constitutes Meinhold's greatest triumph in the book before us. It was this indeed which gave the book its mediæval tone and produced the effect of *vraisemblance* which took in the critics at the first.'[19] Meinhold's novel soon appeared in two different English translations, and his companion novel, *Sidonia the Sorceress* (1848) found an English translation already in 1849 by Lady Wilde, mother of Oscar, who subsequently reported that both the Meinhold novels had been his 'favourite romantic reading when a boy'.[20] Edward Burne-Jones's two small water-colour and gouache paintings of Sidonia and Clara von Bork—the wicked and the angelic sister, respectively—(both 1860, now in Tate Britain) testify to Meinhold's mid-Victorian popularity, as does William Wallace's four-act opera *The Amber Witch* (1861), performed at Her Majesty's Theatre, conducted by Sir Charles Hallé. By 1868 Pater could speak of William Morris's Medea as having 'a hundred touches of the mediæval sorceress, the sorceress of the Streckelberg or the Blocksberg' without having to footnote his reference to *The Amber Witch*,[21] and in his 1876 essay 'Romanticism', Meinhold figured as the epitome of the German romantic spirit: 'In Germany, again, that spirit is shown less in Tieck, its professional representative, than in Meinhold, the author of *Sidonia the Sorceress* and the *Amber Witch*.'[22]

Pater's brief note suggesting that he model his portrait of Moroni's Bergamasque *Tailor* on the narrator of Meinhold's Gothic text merges Italian *Seicento* portraiture with Teutonic romanticism. It is in itself suggestive of the eclecticism of Pater's European project, with a constant desire to connect the arts and the Renaissance with the nineteenth century. The note leaves a number of questions: did Pater intend a pastiche of *The Amber Witch* while desiring his readers to detect his narrative source? Or was he rather (which I suspect) fascinated by the possibilities for dramatic irony provided by a gullible, first-person narrator and the reader's awareness of the son's double nature, without immediately revealing the source—cleverly disguised by the change in gender, historical period, and setting? Pater's general fondness for covering his tracks suggests the latter. His paper slip makes us wonder about the existence of other similar slips in preparation for his completed portraits. Was this method one which he frequently applied, while engaging creatively with texts which had made their impact on him, because of their form, their plot, their characters? The instance of the 'Sartore' makes us reconsider our notions of Pater and the imaginary: taking his starting point in an actual painting of a charismatic, anonymous sitter,[23] and contemplating a literary portrait with a narrative technique derived from the Gothic tradition, Pater emerges as a far more interesting plotter of both narrative and protagonist than previously supposed.

From Pater's letters it transpires that he had planned a trilogy, consisting of *Marius the Epicurean* (1885), *Gaston de Latour* (fragment 1888–94), and a third novel with

[19] Jacobs, 'Introduction', *Amber Witch* 1895, xix.
[20] Oscar Wilde, *Complete Shorter Fiction*, ed. Isobel Murray (Oxford: Oxford University Press, 1980), 3.
[21] 'Poems by William Morris', *Westminster Review* 34 (Oct. 1868), 300–12, 308.
[22] 'Romanticism', *Macmillan's Magazine* 35 (Nov. 1876), 64–70, 64.
[23] Attempts have been made to identify the sitter among the tailors in Bergamo and Albino. See Silvio Leydi, 'Sarti a Bergamo (ed Albino) nel maturo Cinquecento', in *Giovan Battista Moroni Il Sarto*, 41–57.

120 WALTER PATER'S EUROPEAN IMAGINATION

the working title *Thistle*, of which only a short manuscript fragment survives.[24] Writing to Carl Wilhelm Ernst in 1886 he declared, 'I may add that "Marius" is designed to be the first of a kind of trilogy, or triplet, of works of a similar character; dealing with the same problems, under altered historical conditions. The period of the second of the series would be at the end of the sixteenth century, and the place France: of the third, the time, probably the end of the last century—and the scene, England.'[25] The 'Thistle' manuscript (*c.*1890), carries a similar note from Pater to himself with suggestions of literary works on which to model his narrative. He sets the period, intellectually and poetically, and indicates the location:

> Thistle.
> The beginning of this cent. in Eng/d.
> Rousseau & Voltaire, have been.
> Kant, has been—opening a double way.
> The Fr. rev/n has been.
> STC, Keats, Shelley, Wordsworth, Byron, are around.
> He finds, defines, realises, something diff/t from all those forces—
> a something rep/d best by Newman—of whom in a way, &
> amid quite other cond/s, outward & inward, he is an
> anticipation.
>
> ~~In S~~ Ts much interested, preoccupied, with, Morte d'Arthur—
> especially the episode of The Grail.
> An Obermann, &c. with the cure.
> The most beautiful parts of England—Oxford—[26]

Pater outlines the philosophical and historical climate; as Marius moved among Marcus Aurelius and Lucian, and Gaston fraternized with Ronsard, Montaigne, and Bruno, so his Thistle would appear to come within the orbit of the romantic poets, to flirt with medievalism, and prefigure Cardinal Newman. In type, he is likened to the melancholy protagonist of Étienne Pivert de Senancour's epistolary novel *Obermann* (1804), a text almost forgotten today, but much admired by Sainte-Beuve (who prefaced the 1833 edition of the novel and wrote a literary portrait of its author), George Sand (who likewise prefaced an edition of the text), and Matthew Arnold. The epistolary autobiography of a young, solitary romantic, given to introspection as he restlessly wanders the mountains of Switzerland, or leads a lonely life in Paris, followed in the wake of Rousseau's *Reveries of the Solitary Walker* (1778) and Goethe's Werther (1774). Senancour introduced a type of novel which was not plot-driven: 'It will be seen that these letters are the self-expression of a man who feels and not of a man who acts.'[27] He defined his *oeuvre* by negation: 'These letters are not a romance. There is no dramatic movement, there are no events preconcerted and led up to, and there is no catastrophe; there is nothing in the collection which is generally understood by interest, nothing of that progressive sequence, of those episodes, of that stimulus to

[24] 'Thistle', Houghton bMS Eng. 1150 (31). [25] See letter to Ernst of 28 Jan. 1886, *CW* 9.
[26] 'Thistle', Houghton bMS Eng. 1150 (31), 3r. Transcription kindly provided by Lesley Higgins.
[27] Senancour, *Obermann*, lxxix.

curiosity which are the magic of many good books and the trickery of many others.'[28] The soul's conversation with itself constitutes the inner drama of Senancour's novel, which provides an inlet into much of Pater's fiction.

Arnold's poems, 'Obermann Once More' and 'Stanzas in Memory of the Author of Obermann. November 1849' reflect how profoundly Obermann's meditations on life, death, and nature had made their impact on him. His 1869 note to the latter poem struck a key echoed in Pater's 'Thistle': 'The stir of all the main forces, by which modern life is and has been impelled, lives in the letters of *Obermann*; the dissolving agencies of the eighteenth century, the fiery storm of the French Revolution, the first faint promise and dawn of that new world which our own time is but now more fully bringing to light—all these are to be felt, almost to be touched, there.'[29] Scattered references to *Obermann* occur in Pater's writings: in the 'Romanticism' essay (1876), in his review of Mary Ward's translation of Amiel's *Journal Intime* (1886), and in the 'Merimée' essay (1890). In 'Romanticism', Obermann heralds modern subjectivity: Rousseau's 'passionateness, his lacerated heart, his deep subjectivity, his *bizarrie*, his distorted strangeness—he makes all men in love with these. *Je ne suis fait comme aucun de ceux que j'ai sus—si je ne vaux pas mieux, au moins je suis autre. —*These words, from the first page of the *Confessions*, anticipate all the Werthers, Rénés, Obermanns, of the last hundred years.'[30] The hero of Senancour's novel has become generic, a type of the romantic loner. In the review of Amiel's *Journal Intime* Obermann is, with Werther and Chateaubriand's Réné (1802), a man with 'a double weariness about him', a 'renunciant'.[31] By 1890 Pater had become more outspoken about his dislike of the 'renunciant' type, born in literature at the same time as Merimée (1803), 'the very genius of *ennui*, a Frenchman disabused even of patriotism, who has hardly strength enough to die.'[32] In Merimée 'the passive *ennui* of Obermann became a satiric, aggressive, almost angry conviction of the littleness of the world around; it was as if man's fatal limitations constituted a kind of stupidity in him, what the French call *bêtise*.'[33] With his ability to detect 'the fundamental nothingness under the surface of things',[34] Merimée developed an ironic stance to the world, residing in a polished style, both in the man's appearance and in his writings. Merimée and Senancour's novel made a joint appearance in Pater's 'Thistle' manuscript, as he contemplated a suitable literary form for his novel in the epistolary format:

> <u>Thistle</u>.
>
> ?
>
> For its <u>form</u>, cf. Lettres à une inconnue.
>
> Obermann: also at beginning of this cent.[35]

[28] Ibid., lxxx.

[29] Matthew Arnold, Note (1869) to 'Stanzas in Memory of the Author of Obermann. November 1849' in *The Poems of Matthew Arnold*, ed. Kenneth Allott (London: Longmans, 1965), 129–30. See also his review of Sand's edition of the novel, 'Obermann', *Academy* (9 Oct. 1869), 1–3.

[30] 'Romanticism', 67–8. [31] 'Amiel's "Journal Intime"', 24.

[32] A lecture given in the Taylorean Institute, Oxford, on 17 Nov. 1890, subsequently at the London Institute on 24 Nov. 1890 and eventually published: 'Prosper Merimée', *Fortnightly Review* 48 (Dec. 1890), 852–64, 852. *Bibl.*, 41.

[33] 'Prosper Merimée', 853. [34] Ibid., 853. [35] 'Thistle', 4r.

122 WALTER PATER'S EUROPEAN IMAGINATION

The text above which Pater placed a question mark was one which had generated a considerable amount of interest in the literary world in the 1870s and 1880s. On 29 November 1873, some three years after Merimée's death, a volume of 170 of his private letters addressed to an unknown woman appeared with a preface by Hippolyte Taine, revealing a romantic correspondence spanning some four decades of the author's life.[36] For a while, the recipient of Merimée's letters remained unknown, although the *Pall Mall Gazette* announced already on 1 January 1874 that she was a Mlle Jenny Dacquin, of English origin: 'Her name was discovered by the publisher who resorted to a chemical process to remove some ink with which the lady had obliterated it.'[37] The identity of *l'inconnue* as Jeanne-Françoise Dacquin from Boulogne-sur-Mer, an amateur writer and lady companion with English connections, was gradually made public. She had contacted one of Merimée's friends to have the correspondence published, albeit in edited form, and given the subsequent disappearance of the letters, the veracity and exactitude of the correspondence were and still are disputed. Dacquin's own letters to Merimée most likely disappeared in the flames when his Paris flat was damaged by fire in 1871.

Known for his reserve, Merimée had a reputation as a very private man, so the publication of a long-lasting romantic correspondence created a major stir in the critical world, on either side of the English Channel. The literary status of the publication was debated; the *Revue des Deux Mondes* described it as 'à la fois un roman et un journal biographique' ['at one and the same time a novel and a biographical journal'],[38] and the publication received considerable press coverage.[39] Three English translations were issued,[40] and predictably, in 1889 an anonymous volume appeared (from Pater's publisher Macmillan): *An Author's Love: Being the Unpublished Letters of Prosper Merimée's 'Inconnue'.*[41] The book, prefaced by lengthy quotations from Taine's preface to the French 1874 volume, purported to be the letters from Jenny Dacquin to Merimée. The publication was a hoax, as revealed in the author's Postscript,[42] and the author, subsequently identified as Elizabeth Balch, constructed an imaginary dialogue with Merimée's letters; when read side by side, the two volumes

[36] Prosper Merimée, *Lettres à une inconnue*, 2 vols (Paris: Michel Lévy, 1874). According to Alphonse Lefebvre, *La Célèbre Inconnue de Prosper Merimée. Sa Vie et ses Oeuvres authentiques, avec Documents, Portraits et Dessins inédits*. Préface introduction par Félix Chambon (Paris: E. Sansot & Cie, 1908), both the first and second editions appeared within the last months of 1873 but carry 1874 as the date of publication.

[37] *Pall Mall Gazette* (1 Jan. 1874), 3.

[38] *Revue des Deux-Mondes* (1 Dec. 1873), 481–524, quoted from Lefebvre, 21.

[39] Lefebvre (24) lists the following reviews: *The Hour* (31 Dec. 1873); *The Standard* (2 Jan. 1874); *Saturday Review* (3 Jan. 1874); *Daily Telegraph* (7 Jan. 1874); *Saturday Review* (17 Jan. 1874); *Quarterly Review* (Jan. 1874).

[40] *Letters to an Incognita* (1874), *Letters to an Unknown* (1897), and *The Love-Letters of a Genius* (1905).

[41] Anon. [Elizabeth Balch], *An Author's Love: Being the Unpublished Letters of Prosper Merimée's 'Inconnue'* (London: Macmillan & Co., 1889).

[42] 'By the tideless sea at Cannes on a summer day I had fallen asleep, and the plashing of the waves upon the shore had doubtless made me dream. When I awoke the yellow paper-coloured volumes of Prosper Merimée's *Lettres à une inconnue* lay beside me; I had been reading the book before I fell asleep, but the answers—had they ever been written, or had I only dreamed? THE AUTHOR.' Ibid., n.p. See also Lefebvre, 25–6. A French version of the text was published as *La passion d'un auteur. Réponses à Prosper Merimée* (Paris: Paul Ollendorff, 1889). Lefebvre's publication is a refutation of the authenticity of the Dacquin correspondence.

form a full correspondence in which short letters alternate with long ones, some pretend to be torn off, or even missing. The voice of Balch's Jenny Dacquin is that of a temperamental, argumentative, and capricious woman, at times aggressive and demanding, at others docile and gentle.

By 1890, when Pater wrote his Merimée lecture and jotted down his thoughts on the 'Thistle' novel, he was intrigued by the letters to Jenny Dacquin. He had recently reviewed Flaubert's published correspondence,[43] and questioned such posthumous intrusion into people's privacy. He found the public exposure of Merimée's passionate self problematic. For a man 'carrying ever, as a mask, the conventional attire of the modern world',[44] (and one is inevitably reminded of the many references to Pater as the Jamesian 'mask without the face'),[45] the publication of documents testifying to Merimée's emotional loss of control had been no act of friendship. The success of his literary *oeuvre* resided in the author's ability to preserve an impersonal stance in relation to his characters.[46] Pater was aware of the 'psychological interest' the letters provided, documents which took even Merimée himself by surprise and left him 'somewhat humbled, by an unsuspected force of affection in himself'.[47] The letters enabled Pater to construct a twin portrait of writer and recipient: 'His correspondent, unknown but for these letters except by name, figures in them as, in truth, a being only too much like himself, seen from one side; reflects his taciturnity, his touchiness, his incredulity except for self-torment. Agitated, dissatisfied, he is wrestling in her with himself, his own difficult qualities'.[48] The struggling souls in Merimée's intimate correspondence constitute a contrast to the sculptural impersonality of his fiction, the product of 'pure *mind*', utterly devoid of 'what we call *soul* in literature'.[49] Pater had succeeded in creating a complex portrait of Merimée which combined soul and mind; had he progressed to write the 'Thistle' novel, the emphasis would have been on 'soul', something which an epistolary narrative technique would have reinforced.

The Diary Form and Fiction: 'A Prince of Court Painters'

Pater's manuscript fragments alert our attention to his continued concern with the voice of the first person, whether in narratives, letters, or diaries, as literary genres which represent the self, either to an audience of one, to one significant other, or to a wider readership. We may not immediately think of Pater as a writer in the first-person mode, but the 'I' nevertheless manifests itself across his writings, from the

[43] 'The Life and Letters of Flaubert', *Pall Mall Gazette* 48 (25 Aug. 1888), 1–2; 'Correspondance de Gustave Flaubert', *Athenaeum* 3223 (3 Aug. 1889), 155–6.

[44] 'Prosper Merimée', 853.

[45] See James's famous description of Pater: 'He is the mask without the face, and there isn't in his total superficies a tiny point of vantage for the newspaper to flap his wings on.' Letter to Gosse, 13 Dec. 1894: *Letters*, ed. Leon Edel, 4 vols (Harvard: Belknap Press, 1980), 3:492. Arthur Symons also spoke of Pater's 'whole outer mask, in short, worn for protection and out of courtesy, yet moulded upon the inner truth of nature like a mask moulded upon the features which it covers.' 'Walter Pater', 1906. Quoted from Seiler 1987, 123–4.

[46] See John Coates, 'Pater as Polemicist in "Prosper Merimée"', *Modern Language Review* 99:1 (Jan. 2004), 1–16.

[47] 'Prosper Merimée', 863. [48] Ibid., 863. [49] Ibid., 864.

124 WALTER PATER'S EUROPEAN IMAGINATION

inclusion of private letters in the 'Winckelmann' essay (1867), in 'Sir Thomas Browne' (1886), to the quotation from Flaubert's letters in the essay on 'Style' (1888), from Pater's interest in Wordsworth (1874) and Charles Lamb (1878), to his reviews of Amiel's *Journal Intime* (1886) and Octave Feuillet's diary novels (1886). In 'A Prince of Court Painters' (1885) and 'Emerald Uthwart' (1892), Pater creates fictitious first-person narrators; another fragmented manuscript of fiction reveals how part of the narrative (6v) had likewise been drafted in the first person.[50] In his essays, Pater was not much given to the use of the first person, compared with some of the essayists he admired: Montaigne, De Quincey, and Lamb. The social mask, 'worn for protection', also made itself felt in the essays, and Pater's interest in Flaubert and Merimée's impersonal style reflects his own tendency to mask himself in his prose. In his fiction he occasionally enjoyed the invention of powerful first-person voices as a tribute to his dramatic sense and psychological interest.

In 'The Child in the House' Pater had experimented with Bunyanesque allegory combined with childhood recollections in the manner of Lamb, while the Wordsworthian and Sainte-Beuvian *portrait littéraire* of the 'English Poet' was abandoned before completion. When, after the publication of *Marius* (1885), Pater returned to his short fiction, he went exploring into his own Continental family background, under the presumption that the Paters were of French or Dutch extraction, as outlined by Gosse:

> His family was of Dutch extraction, his immediate ancestors having, it is believed, come over from the Low Countries with William of Orange. It was said, and our friend loved to believe it, that the court-painter, Jean-Baptiste Pater, the pupil of Watteau, was of the same stock. If so, the relationship must have been collateral and not direct, for when the creator of so many delicate *fêtes champêtres* was painting in Flanders—he died in 1736—the English Paters had already settled at Olney, in Buckinghamshire, where they lived all through the eighteenth century.[51]

Subsequently, Benson and Wright differed with respect to Pater's Dutch origin.[52] In 'A Prince of Court Painters' (1885) and 'Sebastian van Storck' (1886) Pater dealt with aspects of his family past, explored through epistolary form. As the most painterly of his portraits, they are intensely concerned with the visual arts. They form a complimentary whole: one a feminine text in the first-person narrative of the diary format, giving us the private confessions of Jean-Baptiste Pater's sister Marie-Marguerite. The other only briefly allows us to hear the misogynistic voice of the otherwise silent Sebastian; the contents of his private journal are paraphrased through internal

[50] 'An Imaginary Portrait', Houghton bMS Eng. 1150 (32). [51] Gosse 1894, 796.

[52] Cf. Benson, 1: 'The name Pater is uncommon in England and not at all uncommon in Holland, the Dutch frequently Latinizing their names; this, and the fact that a Dutch Admiral of that name settled in England at the time of William of Orange, made some members of the Pater family think they were originally of Dutch extraction; but this has never been verified.' Wright began his biography by asserting the Dutch ancestry: 'The Paters are of Dutch descent, though the family must have settled in England at a very early date—perhaps in the reign of Elizabeth, for there were Paters resident in Thornton, Buckinghamshire, within a year or two of her death; though whether or not Pater descended from this stock, it is impossible to say. The fact, however, that Pater was of Dutch lineage should be constantly borne in mind by those who wish to understand his temperament and character.' Wright, 1:1.

monologue. One is the unrequited lover, showering affection on her brother and Watteau. Sebastian, by contrast, is the object of many people's affection, but himself incapable of loving. Where Marie-Marguerite is keen to have her portrait painted, Sebastian shuns all portrait painters. Pater's female diarist observes life from the margins, from provincial Valenciennes, and never visits the Parisian metropolis. Sebastian is plunged, much against his will, into the busy social and artistic city life of the Dutch burghers and must fight for his much-desired solitude. Sebastian is Pater's counterpart to Henri-Frédéric Amiel, whose *Journal Intime* he was reading and reviewing as he was composing his portrait. A real-life 'renunciant', an Obermann in mid-nineteenth-century Geneva, the tubercular Amiel had a temperament summed up by Pater as 'one intellectually also a *poitrinaire*'.[53] Extracts from his voluminous diaries were published in English translation in 1885,[54] and in addition to his review, Pater made a fictitious character study of the 'renunciant' type. With a sick mind in a sick body, Sebastian was unfit for survival: dead by drowning, admittedly, but also a consumptive who would not have lived long.

If Pater might have made a note to himself about Amiel's *Journal intime* when he began work on 'Sebastian van Storck', I wonder about his preparatory notes for 'A Prince of Court Painters'. Among all of Pater's texts it stands out as the only one consistently told in a female voice, contained within the diary format from beginning to end. Revolving around three historical figures, it foregrounds the insignificant, anonymous, and conventionally silent female figure, and pushes the two named and famed painters into background position, while never for a moment mentioning the family name shared with the author. To disprove Bloom's statement, no Paterian text could be better suited than Marie-Marguerite's diary, constructed as a quiet domestic drama, playing itself out in the mind of a spinster over some twenty years as an increasingly interesting psychological study. The tone may sound like the pastiche of a sentimental diary novel, to which has been added a melancholy layer. Where the diaries and letters in early fiction are often news-oriented, driving the plot forward, the psychological interest in the nineteenth-century epistolary tradition, especially in Germany, focuses on internalization and introspection, as in the works of Bettina Brentano-von-Arnim and Elizabeth von Stägemann.[55]

The nineteenth century saw the publication of a large number of real diaries, thus giving new context to the fictitious ones. Male diarists such as John Evelyn and Samuel Pepys were published in 1818 and 1825, respectively (both in expurgated versions),[56] and the interrelationship between Fanny Burney's novels and her voluminous diaries could be explored, when the latter were published between 1842 and 1846. Burney kept a journal—a best friend not to be neglected—between the ages of 15 and 88. The opening entry of 27 March 1768 suggests a need for private confidence and confession: 'To NOBODY, then, will I write my Journal! Since To Nobody can I be wholly unreserved—to Nobody can I reveal every thought, every wish of my

[53] 'Amiel's "Journal Intime"', 21. [54] Amiel, *The Journal Intime*, tr. Mrs Humphry Ward, 1885.

[55] See Thomas O. Beebee, *Epistolary Fiction in Europe 1500–1850* (Cambridge: Cambridge University Press, 1999), 130–2.

[56] Catherine Delafield, *Women's Diaries as Narrative in the Nineteenth-Century Novel* (Farnham: Ashgate, 2009), 19.

126 WALTER PATER'S EUROPEAN IMAGINATION

Heart, with the most unlimited confidence, the most unremitting sincerity, to the end of my Life!'[57] Marie-Marguerite's diary is a similarly close friend, the only one we hear about. While Pater plays with our expectations to the diary genre as one rooted in earnestness and sincerity, he is also suggesting self-delusion. His psychological experiment with a ventriloquist voice is reminiscent of Browning, for whom his profound admiration surfaces when corresponding, especially with younger writers like Vernon Lee and Symons,[58] just as references to Browning can be found in the essays.[59] The complexity of Browning's portraits, created entirely through voice, appealed to Pater, who, when reviewing Symons's monograph in 1887,[60] stressed how imaginatively, like Shakespeare, 'Mr. Browning has been a multitude of persons' and 'almost never simple ones'.[61] The poet was reflected in his characters, whom he controlled 'all to profoundly interesting artistic ends by his own powerful personality.... It makes him pre-eminently a modern poet—a poet of the self-pondering, perfectly educated, modern world, which, having come to the end of all direct and purely external experiences, must necessarily turn for its entertainment to the world within'.[62] Modernity was related to interiority, '"a drama of the interior, a tragedy or comedy of the soul, to see thereby how each soul becomes conscious of itself."'[63] With Marie-Marguerite, Pater turned to this world within, constructing one particular self about whom history had left almost no documents, thus giving the modern writer free reins to paint her to his very own liking.

Marie-Marguerite's diary is the drama of situations, with each entry a miniature narrative, a dramatic moment confided to the journal as an outlet for passions, disappointments, and hopes which the writer is unwilling to expose in public. 'I know better how to control myself', she confesses, in contrast to her weeping sisters, who mourn the departure of their younger brother.[64] The fictional diary exists in the interface between manuscript and print, between private and public: on the page it imitates the entry in an actual diary, set apart with place and date, sometimes reflecting by its length, its space on the page, whether the particular day was an eventful one or not. As we imagine the conversion from manuscript to print, we witness the transition from the private and intimate to the public and prolific, from a carefully controlled text with an audience of one to a text which may fall into any number of hands. The experiencing and the narrating self are identical in diary fiction, yet there is often a gap between the event and its transcription. By subtitling his text 'Extracts from an Old French Journal', Pater added a further layer to the textual transmission, namely an editing self (if we take it, that is, that 'Marie-Marguerite' has 'herself' made the extracts published in *Macmillan's Magazine* and signed by Walter Pater). We do not know, of course, whether another imaginary anonymous editor has done the editing, or whether what we see is the result of 'Marie-Marguerite's' 'own' weeding in her voluminous diary, yielding the selection of entries relating to Watteau that

[57] Quoted from Delafield, 26.

[58] See letters to Violet Paget, 18 Nov. 1882, 4 Jun. 1884, to Symons, 2 Dec. 1886, 15 Jan. 1890 in *CW* 9.

[59] See Samuel Wright, *An Informative Index to the Writings of Walter H. Pater* (West Cornwall: Locust Hill Press, 1987), 70.

[60] Arthur Symons, *An Introduction to the Study of Browning* (London: Cassell, 1886).

[61] 'Browning', *Guardian* (9 Nov. 1887), in *Essays from the Guardian*, 39–51, 43.

[62] Ibid., 43. [63] Ibid., 44. [64] *CW* 3:65.

she will allow us to see. The function of the word 'extract' is not dissimilar to that of the romantic fragment or the Michelangelesque *non finito*, which Pater discussed perceptively in his Michelangelo essay (1871): our awareness of incompletion makes us curious about the rest—the many blanks in the chronology of the diary (what is she hiding from us?), the missing pages from Pater's 'English Poet' manuscript, or the idea of the final form Michelangelo would have given to his sculptures, had he lived to finish them.

The words 'diary' and 'journal' derive from the Latin *dies* and the French *jour*, respectively (the French also going back to the Latin), with the implication that they contain the chronicling of daily events, day by day. In the unedited diary, the diary knows no more than the day knows. A serial autobiography, with the plotlessness of a lived life, the diary can only be turned into a plot if edited into form and structure. Through his use of the word 'extract', Pater alerts us to the very process of plot construction. Our diarist is herself a constructor of plot: her confession of how she persuaded a scene-painter to bring Watteau to Paris contains the bitter irony that she is herself the cause of her own experience of loss and absence.[65] A controller of time, Pater's 'editor' speeds up events, prolongs, or silences them, as the chronology sometimes jumps a year (October 1701 to December 1702, February 1712 to March 1713, etc.), sometimes more than three (August 1705 to January 1709 to February 1712), while at others, such as the summers of 1705 and 1717, or all of 1714, time seems to move at a different pace. Watteau's disease is introduced as a sudden surprise with an element of sensationalism in the last eight entries (from June 1718 to July 1721), in which thwarted love, jealousy, portrait-painting, and international encounters yield extra drama and pace to a long-drawn-out romance, which may, indeed, exist only in Marie-Marguerite's mind. When death finally sets in, it is the end, not merely of the artist, but also of the diary, although, presumably, its author lives on and continues chronicling her uneventful life from her marginal existence in provincial Valenciennes.

The self-reflexivity of the diary form, as its author attempts to capture her *moi* by using the act of writing as a disciplining tool to control herself, when emotionally upset, or to keep herself busy when she is bored, turns our attention to the act of writing itself as an addictive one. The sensationalism of confiding one's secrets to a diary, of subsequently reading those secrets, or even making them public, is part of the diary genre, exploited to great extent in the sensation novels of the 1860s and '70s,[66] and coolly satirized by the autoeroticism of Wilde's Gwendolen who, in Act Two of *The Importance of Being Earnest* (1895), famously declared that 'I never travel anywhere without my diary. One should always have something sensational to read in the train.'[67] Indeed, the 'war of the diaries' between the two young female protagonists of Wilde's play, Cecily and Gwendolen, makes it perfectly clear how by the end of the nineteenth century the diary had become a female literary form strongly associated with fiction, where fictitious diary entries of the past can determine reality in the present with an authority which forces life to mirror art, as both the young male suitors are compelled to comply with what has already been set out in the young

[65] *CW* 3:61. [66] See Delafield.
[67] Oscar Wilde, *The Importance of Being Earnest*, Act II, in *The Works of Oscar Wilde* (London: Collins, 1948), 321–69, 352.

128 WALTER PATER'S EUROPEAN IMAGINATION

ladies' journals. Characteristically, perhaps, Pater's female diarist has no such power over reality to conquer love and distance, and his imaginary portrait is a tragedy, rather than a comedy, of the soul, as a study of wasted and infertile female desire whose only begotten issue is the diary.

Pater lived his entire adult life with his two spinster sisters. The figure of the unmarried woman was, in other words, one with which he was very familiar on a daily basis. The ease with which he slips into the voice of the older female sister (in an apparently motherless family) testifies to his familiarity with female domesticity.[68] A vehicle for women's authorship, the diary provides a private space in a sphere otherwise taken up with domestic duties. Marie-Marguerite is not much of a blue-stocking: all the authorities she quotes are men, whether her own father, Watteau *père*, or the men of the next generation. Her diary writing creates a self in constant relation to the men who surround her, and in their absence she turns to the authority of God in her visits to religious sites. Pater's many silent puns on his own surname should not be ignored: his diarist is never named, and only subsequent scholarship has given her a name based on archival research.[69] The tension between her anonymity and her continued presence in the text makes her an *inconnue*, at once familiar and unknown. Pater constructs a female subject with a persuasive voice, but I suspect the construction of femininity would have been different, had the author been female. Feminists have hailed the literary form of the diary as a site of resistance within a patriarchal family structure, a feminine form of writing which rebels against the ideology of the very home which creates it. Certainly, a real-life diary contemporary with Marie-Marguerite's, the diary (1889–92) of Alice James, sister of Henry and William, served such a function in rebellion against her subordinate role in a family of prolific brothers, where her only literary claim to fame became her posthumously published diary.

The image of the lettered woman begins with male ventriloquism and has a long history going back to Ovid's *Heroides*, his series of letters by mythological women abandoned by their lovers: Penelope, Dido, Medea, Phaedra, Ariadne among them. As the women resort to writing to express their woe, the absent males become muses to the outpourings of the female heart. Ovid clearly delighted in inventing voices so different from his own. Taken up in the twelfth century by a woman—Heloïse in her letters to Abelard— the female complaint provided 'a model for the lettered woman's construction of her subjectivity in the loopholes of epistolary convention', as Thomas Beebee suggests.[70] During the Renaissance the female complaint flourished in France and England in theatrical circles where cross-dressing was part of the representation of gender on the stage.[71] Undoubtedly aware of this tradition, Pater engaged with its rococo permutations in the epistolary novel: Marivaux's *Vie de Marianne* (1731–45)

[68] Fossi, 84–5, 92, points out that in real life Marie-Marguerite was the only female out of five siblings.

[69] See Lesley Higgins, 'But Who is She? Forms of Subjectivity in Walter Pater's Writings', *Nineteenth-Century Prose* 24:2 (1997), 37–65.

[70] Beebee, 116.

[71] See John Kerrigan, ed., *Motives of Woe: Shakespeare and 'Female Complaint': An Anthology* (Oxford: Oxford University Press, 1991); Elizabeth D. Harvey, *Ventriloquized Voices: Feminist Theory and English Renaissance Texts* (London and New York: Routledge, 1992).

and Rousseau's *Julie, ou la Nouvelle Héloïse* (1761),[72] not to mention the novels of Samuel Richardson: *Pamela: Or, Virtue Rewarded* (1740) and *Clarissa* (1748). Ovid's *Heroides* became an important translated text, and within an eighteenth-century framework the lettered woman was 'created out of the absence of the man she must write to. Ovid's collection thus implies that men act in and on the world, while women act in and on the text'.[73] In the literary world of the Enlightenment, the *femme lettré* was transformed from victim to artist: 'She is a site of cultural contestation which moves in many directions at once: between the two meanings of *lettré*— the more literal one of being identified with and even imprisoned by her letters, and the figurative one of educated; between the active and the passive implications of the verb; and between self-actualizing autobiography and restrictive ventriloquism or prohibition.'[74]

Marie-Marguerite's diary reflects the rise of the novel in its mimicry of the female voice and sensibility, and its predominantly female readership. Our diarist is herself an engaged reader of novels, absorbed, like Watteau's Parisian ladies, by the strong sentiments of Abbé Prévost's *Manon Lescaut*,[75] set in the same parts of France which stir Marie-Marguerite's emotions (Arras and Paris), while raising issues of romantic passion, betrayal, and unrequited love. A first-person narrative in the voice of the deceived lover, Prévost's novel reminds Marie-Marguerite of her own situation in a self-reflective moment, in which writing meets reading before she abruptly breaks off her diary: 'certainly I have to confess that there is a wonderful reality about this lovers' story; an accordance between themselves and the conditions of things around them, so deep as to make it seem that the course of their lives could hardly have been other than it was. That impression comes, perhaps, wholly of the writer's skill; but at all events, I must read the book no more.'[76]

The segregation in eighteenth-century France of the literary world into the male academies and the female-dominated *salons* made the *écriture de femme* a desirable mask for such non-conformist writers as Marivaux in which they could 'experiment with a more freewheeling, playful, and apparently spontaneous writing as an alternative to established forms of literary expression'.[77] Aurora Wolfgang points out that 'while women writers embraced the less prestigious genre of the novel and prose fiction to claim their own place within the literary field, male writers began to invent fictions of "female voice" to experiment safely with these same narrative prose forms that strayed too far from "masculine" writing as defined by classical models'.[78] We must credit Pater with a similar degree of literary experimentation, of adopting a for him completely new literary mask (although one with a long history), allowing him to investigate aspects of the more intimate sides of human life otherwise absent from

[72] See Aurora Wolfgang, *Gender and Voice in the French Novel, 1730–1783* (Aldershot: Ashgate, 2004).

[73] Beebee, 103. [74] Ibid., 105.

[75] In their essay on Watteau, the Goncourts made a passing reference to *Manon Lescaut* (1733). This inspired Pater's discussion of the novel in an entry preceding the publication date by some sixteen years, an imprecision rectified in an equally imprecise note in the second edition (1890): 'Possibly written at this date, but almost certainly not printed till many years later.' Prévost's novel about the prostitute Manon's relationship with the Chevalier des Grieux, her deportation to New Orleans, and the subsequent ruin of both lovers, long retained its popularity as a novel displaying the destructive forces of desire.

[76] *CW* 3:76. [77] Wolfgang, 89. [78] Ibid., 4.

his writings. Pater's imaginary diary is one of the author's most playful texts in which he explores the emotional palette of human existence, testifying to his powers of observation and imagination. When Emilia Dilke reviewed the volume, she saw Pater's own self 'now masquerading delicately in the flowered sacque of Watteau's girl friend'.[79] Dilke's image of transvestism may suggest the writer's own fluctuating moods and his mimic powers, enabling him to construct multiple selves through complex mechanisms. She found in Pater 'one of the most intellectual phases of the modern mind' and recommended that his '"Imaginary Portraits" should be read by all lovers of psychological problems',[80] thus suggesting the diary as the precursor of the Freudian case study.

We might see Marie-Marguerite's diary as her own form of 'talking cure'. Based on dialogue, Freudian psychoanalysis often includes the patients' diaries as a means of gaining access to their past and to deeper levels of consciousness. The dialogue of 'A Prince of Court Painters' is a dialogue of one, one woman's cathartic conversation with herself. The resigned author of the last diary entries gradually comes to terms with her unhealthy infatuation with Watteau, and as life saps out of him, so her romantic fantasies fade. Sigmund Freud and Joseph Breuer's *Studies in Hysteria* (1899) revolve around repressed sexuality with the figure of the spinster as the central type of patient.[81] Chronology structures the case study as it structures the diary, and both texts are edited texts, in the case study with the therapist as editor. Indeed, in Freud's case studies we are reading the diary of the therapist rather than that of the patient, with the therapist himself as both character and narrator in his own narrative. The planar transposition of therapist and patient makes the reader wonder who the real patient is, and as the patient slips into the background for the therapist's self-observing eye, the case study obtains literary qualities which come close to the constructed narratives of modernist fiction where point of view and reliability are essential. As Freud noticed in his study of 'Fräulein Elisabeth von R.', 'I myself find it strange that the case histories that I write read like novellas and lack, so to speak, the serious stamp of science.'[82] The complexities of the first-person narrative emerge in the Freudian case study where multiple selves are at work: names and identities fluctuate, as patients' thinly veiled identities hide behind pseudonyms, and the therapist becomes an autofictitious character. The anonymity of Pater's diarist places her with Anna von O., Emmy von N., Miss Lucy R., and Fräulein Elisabeth von R. as a male study of female hysteria, built on sexual repression, reminiscing, day-dreaming, and a split consciousness as she leaps in and out of her diary.[83] She is herself foregrounded with the Paterian editor as a very discrete presence. Marie-Marguerite's diary is a study in the oscillation between moments of acute observation, of memory, reverie, and meditation, moments of emotional crisis—loss, jealousy, or disappointment—and moments of sad resignation. The woman who knows better how to control

[79] Anon. [attr. to Emilia Dilke], '*Imaginary Portraits*. By Walter Pater', *Athenaeum* (25 Jun. 1887), 824–5, 824.

[80] Ibid., 825.

[81] See Sigmund Freud and Joseph Breuer, *Studies in Hysteria*, tr. Nicola Luckhurst, intr. Rachel Bowlby (London: Penguin, 2004).

[82] Ibid., 164. [83] Ibid., 11, 14, 15.

herself is walking a tightrope line between chaos and collapse, trying to maintain equanimity through her writing, with a powerful superego capable of a high degree of repression.

Marie-Marguerite's view of the world is as subjective and potentially deceptive as that of any of Browning's speakers. The *ménage-à-trois* she constructs between herself, her younger brother, and Watteau is reminiscent of the triangle between Bettina Brentano-von Arnim, Goethe, and Goethe's mother in Brentano-von Arnim's 'Goethe Book', *Goethe's Briefwechsel mit einem Kinde* (1835), an important text in the Victorian Goethe cult.[84] Like Watteau, Goethe is the brilliant genius, the distant object of desire for the young *ingénue*, inspiring lengthy epistolary writing, thus reversing the conventional gendered roles between writer and muse. Absence begets writing, fiction, and distortion of reality: in real life, the relationship between Bettina and Goethe was far from close, and they met face-to-face only a few times. However, 'the letters present an image of warm and intimate, quasi-erotic mutual admiration,'[85] and Bettina constructs her self with constant reference to the absent Goethe, 'the Hebrew God, unseen and unapproachable, an abstract light which colours the correspondence between his mother and Bettina.'[86] This triangulation casts Bettina in the role as the flirtatious, yet innocent child, aware of her desires, while remaining 'the cloistered, Ovidian lettered woman invoking the absent man (Goethe), but without staking her being on the fruits of adult passion.'[87] Like Pater, Brentano-von Arnim created a triple portrait through epistolary form, with the foreground female figure as a vibrant quasi-fictitious self, with some root in the historical personage bearing her name.[88] In Pater's writings, Goethe assumes background status with foreground impact both in 'Winckelmann' (1867) and most notably, in 'Duke Carl of Rosenmold' (1887), where the figure of the skating genius closes the imaginary portrait: 'That was Goethe, perhaps fifty years later. His mother also related the incident to Bettina Brentano: —"There, skated my son, like an arrow among the groups. Away he went over the ice like a son of the gods. Anything so beautiful is not to be seen now."[89] The text is that of the 1887 volume; the periodical version had no reference to Bettina Brentano and Frau Rat.[90] One of the reasons for Pater's expansion of his text may have been to link the last text in the volume with the first. *Goethes Briefwechsel mit einem Kinde* could well have been one of the texts noted down by Pater on an initial paper slip when contemplating literary form for 'A Prince of Court Painters'. His fascination with other European texts—Senancour, Meinhold, Merimée—which blurred the lines between the fictitious and the real within an epistolary or a Gothic framework in the pursuit of a first-person narrative voice might well have placed Brentano-von Arnim among them.

[84] Bettina Brentano-von Arnim, *Goethe's Correspondence with a Child*, 3 vols (London: Longman, Orme, Brown, Green, and Longmans, 1837–9). Aware of the potentially large English audience, Bettina searched for an English publisher and translator for her book and took, in spite of her minimal knowledge of English, an active part in the translation process. See Marjanne E. Goozé, 'A Language of Her Own: Bettina Brentano-von Arnim's Translation Theory and her English Translation Project', in ed. Elke P. Frederiksen and Katherine R. Goodman, *Bettina Brentano-von Arnim: Gender and Politics* (Detroit: Wayne State University, 1995), 278–303.

[85] Beebee, 131. [86] Ibid., 130. [87] Ibid., 130.

[88] There is a subtle distinction between 'Bettine' in the Goethe Book, and Bettina, the authoress.

[89] *CW* 3:131. [90] *CW* 3: 55, 238.

The Speaking Portrait

My previous claim about the shortage of documents relating to Marie-Marguerite Pater deserves one major modification, namely that of her portrait (Fig. 3.3), painted by her brother and given to the Musée des Beaux Arts in Valenciennes by M. Bertin in 1873.[91] The painting would have been in the provincial museum when Pater, who often spent the Long Vacation in France, most likely visited. It may well have been an encounter with the portrait which prompted the diary narrative. In the portrait in Valenciennes, the sitter is marked out as a virgin, framed by one pearl in her hair and another on her *décolletage*. Her ruddy cheeks may have given Pater the idea of a relatively plain girl, dressed up in silks, lace, and feathers for her portrait; the lavish red cloak with the gold lining seems too large and luxurious for her slim body and adds an almost baroque extravagance. While her right hand is absent from the painting, her left holds a laurel twig. Why was she issued with the symbol of writing, commonly used in Renaissance portraiture to indicate a poetess? Was she a writer? Did she have literary aspirations? Her gaze has a sensitive vulnerability reflected in Pater's text. In constructing Marie-Marguerite's narrative, Pater becomes the missing right hand, as he takes up the pen to write her story. As with Moroni's *Tailor*, Pater constructs a personality and a narrative on the basis of an appealing and engaging sitter. The portrait itself becomes a plot device in a minor drama revolving around three portraits and three painters. The painting in Valenciennes is attributed to Jean-Baptiste, but Pater gave the plot an extra twist by imagining it as a work begun by Watteau, imposing his Parisian fashions on the local girl, making her ill at ease. As a sign of his restless lack of concern, Watteau gives up the painting and leaves it to his assistant to finish. For Marie-Marguerite, her abandoned portrait becomes an alter ego, from which she is alienated, as Watteau's essay in performativity, introduced in his fashionable French terms ('a certain air of piquancy'), is in glaring contrast to the sitter's Flemish simplicity:

> *July* 1714.
>
> My own portrait remains unfinished at his sudden departure. I sat for it in a walking-dress, made under his direction—a gown of a peculiar silken stuff, falling into an abundance of small folds, giving me 'a certain air of piquancy' which pleases him, but is far enough from my true self. My old Flemish *faille*, which I shall always wear, suits me better.[92]

As the portrait languishes unfinished, like its sitter, so the rumour from Paris of the appearance of two finished portraits sends our diarist into a fit of jealousy and despair, which prompts her reflection on the therapeutic value of her journal:

[91] Fossi, 81–2, 89. The inventory number is P.46.1.179. Last restored in 1969, the painting is in need of restoration and is currently not exhibited. I am grateful to the chief restorer who took me into the storage room to see it during a visit in May 2019. According to the museum's files, after its entry in the collection in 1873, it was first exhibited outside the museum in 1918, so Pater would have seen it in Valenciennes.

[92] *CW* 3:69.

Fig. 3.3. Jean-Baptiste Pater, *Portrait of Marie-Marguerite Pater* (*c.*1720), oil on canvas, 79.2 × 62.9 cm. Musée des Beaux-Arts, Valenciennes. Photo © RMN-Grand Palais/ Michel Urtado.

June 1718.

And he has allowed that Mademoiselle Rosalba—'*ce bel esprit*'—who can discourse upon the arts like a master, to paint his portrait: has painted hers in return! She holds a lapful of white roses with her two hands. *Rosa Alba*—himself has inscribed it! It will be engraved, to circulate and perpetuate it the better.

One's journal, here in one's solitude, is of service at least in this, that it affords an escape for vain regrets, angers, impatience. One puts this and that angry spasm into it, and is delivered from it so.

And then, it was at the desire of M. de Crozat that the thing was done. One must oblige one's patrons. The lady also, they tell me, is consumptive, like Antony himself, and like to die. And he, who has always lacked either the money or the spirits to make that long-pondered, much-desired journey to Italy, has found in her work the veritable accent and colour of those old Venetian masters he would so willingly have studied under the sunshine of their own land. Alas! How little peace have his great successes given him; how little of that quietude of mind, without which, methinks, one fails in true dignity of character.[93]

[93] *CW* 3:76.

Marie-Marguerite is engaging with another contemporary diarist: the prolific Venetian portrait painter Rosalba Carriera (1675–1757), who spent the year from March 1720 until March 1721 in Paris, recording her experiences in a diary, published in a French well-annotated translation in 1865.[94] According to her entry of 21 August 1720, her first encounter with Watteau took place that summer;[95] by 9 February 1721 she was painting his pastel portrait, commissioned by his banker patron Pierre Crozat (Fig. 3.4).[96] In the 1865 edition, the notes are far more voluminous than the entries, which tend to be one- or two-liners, in which the busy painter noted down the people she met, the art works she saw, painted, or had commissioned. These daily journal entries give us a sense of a working woman with no time for melancholy self-reflection, an interesting counter discourse to Marie-Marguerite's. Rosalba was in every respect her contrast: as the most celebrated woman artist of her time, she travelled the major European countries and led an extrovert life among male artists

Fig. 3.4. Rosalba Carriera, *Portrait of Jean-Antoine Watteau* (1721), pastel on paper, 55 × 43 cm. Museo Civico, Treviso. The Picture Art Collection/Alamy Stock Photo.

[94] *Journal de Rosalba Carriera pendant son séjour à Paris en 1720 et 1721*, traduit, annoté et augmenté d'une biographie et des documents inédits sur les artistes et les amateurs du temps par Alfred Sensier (Paris: J. Techener, 1865).
[95] 'Vu M. Vateau, et an Anglois', ibid., 119.
[96] 'J'entrepris de faire pour M. Crozat le portrait de M. Vateau,' ibid., 222–3.

and intellectuals. Her many self-portraits reveal her as rather a masculine-looking woman, a strong and forceful character, fully capable of self-assertion.

In Marie-Marguerite's diary entry for June 1718, Pater creates a *ménage-à-trois* between three portraits and their sitters, testifying to his sense of drama, but also to his talent for comparative visual analysis. He had detected similarities between the portrait in Valenciennes and an engraving by Jean-Michel Liotard from a lost portrait by Watteau of a woman carrying roses (Fig. 3.5). *Décolleté*, wrapped in voluminous cloaks, with feathery hair decorations, both women are depicted against a landscape background, as their left hands present foliage or flowers, perhaps relating to their favourite activities or names. The woman with the roses looks delicate, and the accompanying five lines of verse allude to the conventional trope of female beauty as a short-lived rose, with echoes from Pierre de Ronsard's 'À Cassandre':

> La plus belle des fleurs ne dure qu'un matin
> Elle touche en naissant à son heure dernière;
> Pourquoy donc petite Catin
> La beauté sujette au déclin
> Peut-elle vous rendre si fière.

Fig. 3.5. Jean-Michel Liotard, after Antoine Watteau, *La plus belle des fleurs ne dure qu'un matin* (1717–27), etching with some engraving, 19.3 × 15.6 cm. © Royal Academy of Arts, London.

136 WALTER PATER'S EUROPEAN IMAGINATION

The engraving was included below an early self-portrait of Watteau in the *Oeuvre gravé* of the so-called *Recueil Jullienne*,[97] the multi-volume collection of engravings after Watteau's painted and graphic work (1723–35), instigated by his close friend and patron, Jean de Jullienne, Director of the Manufacture des Gobelins.[98] Jullienne may have placed the two images next to each other in order to perpetuate the myth of a love affair between them. The portrait of 'la plus belle des fleurs' was mentioned in the Goncourts' *L'Art du dix-huitième siècle* (1873–4) as Watteau's portrait of Rosalba Carriera,[99] and Pater spun his own drama from that myth.[100] He may have seen the engraving, possibly in the British Museum, which since 1838 had owned a copy of the *Receuil Jullienne*. In Marie-Marguerite's diary, the implied contrast between her own unfinished portrait and the engraved portrait of Carriera alerts our attention to artistic medium, to the contrast between the private and unique, the public and printed portrait.

Pater's imaginary portrait has elements of the speaking portrait and the it-narrative. If the text springs from the author's encounter with the painting in a French collection, we might conceive of it as an account of its creation and subsequent abandonment. The portrait becomes a powerful presence, which never for a moment lets go of the reader, as one diary entry—chronicling events, meditations, or mini-crises— replaces the next until the final crisis silences both portrait and sitter. The confluence of looking, reading, writing, and speaking is complex, as is the layering of German, English, and French eighteenth-and nineteenth-century intertexts into something which may resemble pastiche, but which cannot be so simply labelled. As Richard Dyer points out, 'It works as pastiche if you know what it is imitating'.[101] The problem with Pater is that he is rarely imitating just one text; his portrait may be a meta-text, a creative, fictitious text which carries elements of literary criticism, demanding that his readers activate their own critical reading in a redefinition of the epistolary genre. Such literary criticism is 'different from analytic criticism precisely because it does not keep its distance and gives way to the style of the work it is criticizing'.[102] James Austin informs us that: 'For modern readers, even reading pastiche may be liminal between reading and writing, as when one reads a pastiche, one also has the feeling of somehow re-writing a former text'.[103] Marie-Marguerite's diary reminds us of other diary fiction we have read and demands that we reflect on the literary form. It thus 'does something beyond replication, but not taken to the point that it becomes parody, ridicule or burlesque'.[104] Each period

[97] Watteau's self-portrait carries the following four lines: 'Avec un air-aisé, si vif, Et si nouveau, / Wateau dans ce qu'l peint, montre tant de genie; / Que les moindres sujets de son heureux pinceau, / Des Graces, des amours, semblent tenir la vie.'

[98] Jean de Julienne, ed., *L'Œuvre d'Antoine Watteau, Peintre du Roy en son Académie Roïale de Peinture et Sculpture, gravé d'après ses tableaux et desseins originaux tirez du cabinet du Roy et des plus curieux de l'Europe par les soins de M. de Jullienne* (Paris: Chez Gersaint, 1735), 53.

[99] Since the Goncourts had found a specimen of the engraved copy on which was inscribed 'Rosa Alba', they thought that the lost original was a portrait of Rosalba Carrierra.

[100] For Pater and his nineteenth-century French sources, see Fossi and Andrews.

[101] Richard Dyer, *Pastiche* (London: Routledge, 2007), 60. [102] Ibid., 59.

[103] James Austin, *Proust, Pastiche, and the Postmodern, or Why Style Matters* (Lewisburg: Bucknell University Press, 2013), 68.

[104] Dyer, 54.

brings something of its own to its imitation of the texts of the past; while Fielding turned his pastiche of Richardson into parody, Pater's dialogue with the epistolary tradition adds to it layers of nineteenth-century interiority in a process of deformation which selects certain aspects of the diary novel, while suppressing others. The author, 'masquerading delicately in the flowered sacque of Watteau's girl friend', may attempt to both look and write like an eighteenth-century woman, but he is neither able, nor does he desire, to escape nineteenth-century ideas of subjectivity. His triple portrait of some twenty years in the lives of two siblings takes the epistolary genre into a more elegant, neo-rococo, self-reflective, phase, almost mannerist in its *sprezzatura*, in its apparent simplicity, profoundly deceptive of all the study and artifice which has gone into its making.

Only recent scholarship has associated Jean-Baptiste's portrait of his sister with Pater's text.[105] In the case of Pater's Dutch portrait, his contemporaries would seem to have looked for the original of his young male protagonist almost immediately. Published in periodical form in 1886, in volume form in 1887, 'Sebastian van Storck' found its way into the pages of E. T. Cook's *Popular Handbook to the National Gallery* already in 1888. Pausing in front of Jacob van Oost's *Portrait of a Young Boy* (Fig. 3.6) (then attributed to Isaac van Ostade), Cook observed, 'A boy of eleven—so the inscription on the right-hand corner states—Mr. Pater's Sebastian van Storck, it might be'.[106] He inserted the lengthy quotation about Sebastian's mixed parentage and its artistic appeal, with the result that the entire catalogue entry revolved around Pater's text. The recreation of the seventeenth-century Dutch boy in contemporary fiction foregrounded the modern relevance of the Old Masters, indeed, closed a historical gap of some two hundred years, while showcasing Pater's new literary genre as one which made good use of the national collection. Pater had literally been framed, and one wonders what he might have thought of such an exposure of his use of visual material in a narrative centring on a more than usually evasive protagonist. Cook's idiosyncratic handbook had many quotations from Ruskin,[107] but his inclusion of Pater here (and again for cat. no. 963 Isaac van Ostade, *A Skating Scene*)[108] gives an interesting prominence to the imaginary portrait within the national collection of Dutch art. It might be taken as an invitation for more such imaginary portraits based on the paintings in Trafalgar Square; some of Cook's own catalogue entries, most notably that on Moroni's *Tailor*, verge on the speculative and fictitious while drawing comparisons to Kingsley's *Alton Locke*.[109]

There is little doubt that Pater had drawn much inspiration from the collection of Dutch art in London, expanded significantly with the inclusion of Sir Robert Peel's private collection in 1871 which, with its seventy paintings, was 'the largest single

[105] See Fossi and Østermark-Johansen 2016.

[106] *A Popular Handbook to the National Gallery, including, by special permission, notes collected from the works of Mr. Ruskin, compiled by Edward T. Cook, with a preface by John Ruskin* (London: Macmillan & Co., 1888), 231–2.

[107] Cook would subsequently, with Alexander Wedderburn, become the editor of the thirty-nine-volume *Complete Works of John Ruskin* (London: George Allen, 1903–12).

[108] Cook, 250. [109] Ibid. 168.

Fig. 3.6. Jacob van Oost the Elder, *Portrait of a Boy Aged Eleven* (1650), oil on canvas, 80.5 × 63 cm. © National Gallery, London.

addition to the gallery since its foundation in 1824'.[110] Twenty-seven Dutch painters have brief walk-on parts in Pater's narrative, representing virtually every genre of Dutch painting: interiors, genre painting, still lives, architectural and topographical painting, landscapes, marine paintings, Italianate scenes, history painting, and portraits. Several of the paintings mentioned have their counterparts in the National Gallery: the Gerhard ter Borch *Ratification of the Treaty of Münster* (1648) NG896; the Rubens landscape (1638) NG157; the van Ostade *Winter Scene* (1640s) NG848, etc. Pater would not have agreed with Ruskin's attacks on the Dutch, 'the various Van somethings and Back somethings', as he phrased it contemptuously in *Modern Painters* I (1843),[111] whose 'effect on the public mind is so totally for evil, that...I conceive the best patronage that any monarch could possibly bestow upon the arts, would be to collect the whole body of them into one gallery and burn it to the ground'.[112] The prominence given to the Dutch over the Turner Bequest in Trafalgar Square remained a cause of grievance for Ruskin throughout his life.

[110] J. B. Bullen, *The Expressive Eye: Fiction and Perception in the Work of Thomas Hardy* (Oxford: Clarendon Press, 1986), 43.
[111] *CWR* 3:85. [112] *CWR* 3:188–9.

If Pater's shaping of the character of Sebastian took its beginning in van Oost's portrait of the young boy, acquired only in 1883, he selected a work which forms an interesting contrast to Marie-Marguerite. The sitter's gaze does not engage with the viewer; we see a meditative, introvert, slightly delicate, young boy, rendered in monochrome austerity. Depicted life-size, in three-quarter profile rather than *en face*, he seems lost in his own thoughts, a symphony in brown, with brown eyes, brown hair, against an even brown background. Tonalities and textures define difference; framed by fur, which crowns his head and hides his hands, van Oost's sitter has a subtle sensuousness with a tactile appeal: the softness of the fur, the shiny, red lips invite touch, as does the white part of his blouse which peeps out from his unbuttoned doublet. The sitter's southern rather than Flemish complexion, eyes, and hair may well have suggested Sebastian's mixed ancestry to Pater, who had an interest in the Protestant-Catholic conflict in Holland. Compared with the ruddy robustness of Marie-Marguerite's portrait with its outdoor setting, our young Dutch sitter has an indoor presence, despite his head and hands being dressed for the great outdoors.

Pater experiments with word painting. The text is pervaded by colour and thermodynamics, with the constant opposition between the vibrant polychrome and convivial warmth of the Dutch as a nation and Sebastian's solitary and singular love of the wintry season and its muted colour scheme. The opening paragraph is ekphrastic in character, as we zoom in on the skating Sebastian, a premonition of the skating Goethe who concludes 'Duke Carl of Rosenmold':

> It was a winter-scene, by Adrian van de Velde, or by Isaac van Ostade. All the delicate poetry together with all the delicate comfort of the frosty season was in the leafless branches turned to silver, the furred dresses of the skaters, the warmth of the red-brick house-fronts under the gauze of white fog, the gleams of pale sunlight on the cuirasses of the mounted soldiers as they receded into the distance. Sebastian van Storck, confessedly the most graceful performer in all that skating multitude, moving in endless maze over the vast surface of the frozen water-meadow, liked best this season of the year for its expression of a perfect impassivity, or at least of a perfect repose. The earth was, or seemed to be, at rest, with a breathlessness of slumber which suited the young man's peculiar temper. The heavy summer, as it dried up the meadows now lying dead below the ice, set free a crowded and competing world of life, which, while it gleamed very pleasantly russet and yellow for the painter Albert Cuyp, seemed wellnigh to suffocate Sebastian van Storck.[113]

For Pater's narrator the world is a painting, and one might suspect him of wanting to out-Ruskin Ruskin in his nuanced and sensuous description of texture and light effects in nature and on the material world: silver, fur, brick, gauze, metal are all evoked within the first few lines, as Pater sets the scene before introducing his protagonist in circular movement over the ice. Sebastian is in perpetual pursuit of a self from beginning to end; evasive, he refuses to be captured in paint or drawing, to leave any permanent trace of himself. The portrait with muff and squirrel hat remains

[113] *CW* 3:97.

the only completed painting of him, as he (and the narrator) explores a long line of likenesses that might have been, before eventually Sebastian destroys his youthful portrait prior to departing for the sea.[114] One of the leading Dutch portrait painters detects in Sebastian the type of ideal Greek male beauty and pursues his subject both outdoors and indoors:

> Thomas de Keyser, who understood better than any one else the kind of quaint new Atticism which had found its way into the world over those waste salt marshes, wondering whether quite its finest type as he understood it could ever actually be seen there, saw it at last, in lively motion, in the person of Sebastian van Storck, and desired to paint his portrait. A little to his surprise, the young man declined the offer; not graciously, as was thought.[115]

Sebastian courts silent marble images of the dead as representations of a self with whom he would rather identify: Peter de Keyser's tomb monument to Wilhelm the Silent in Delft seems a more fitting image: 'When, about this time, Peter de Keyser, Thomas's brother, unveiled at last his tomb of wrought bronze and marble in the *Nieuwe Kerk* at Delft, the young Sebastian was one of a small company present, and relished much the cold and abstract simplicity of the monument, so conformable to the great, abstract, and unuttered force of the hero who slept beneath.'[116] Pater may have seen the enormous baroque mausoleum in the Nieuwe Kerk in Delft or come across it in some of the many representations by Bartholomeus Bassen, Hendrick van Vliet, or Emanuel de Witte. The latter's *Interior of the Nieuwe Kerk in Delft with the Tomb of William the Silent* (1656) (Fig. 3.7) was in the Palais des Beaux Arts in Lille, where Pater could have seen it when in search of Watteau's family line.[117] Pater creates a small genre painting, an episode or scene within the major painting. Sebastian's witnessing of the unveiling of a sculptural monument within an architectural structure directs our attention to the act of spectatorship, to spatial issues, and intermediality more broadly. Later in Pater's narrative, Jean-Antoine Houdon's statue of the Carthusian Saint Bruno in the Basilica of Santa Maria degli Angeli in Rome, another hero cultivating silence, emerges to Sebastian's mind as a potentially attractive self, while his father dreams of seeing him depicted as a prominent and useful leader of the Dutch navy: 'Admiral-general of Holland, as painted by Van der Helst, with a marine background by Backhuizen: —at moments his father could fancy him so.'[118] The imaginary portrait envisioned by van Storck Senior of his son as a public figure, in service to the nation—the result of a collaborative effort between a leading portrait artist and a prominent marine painter—is reminiscent of the *Portrait of Johan de Liefde* (1668) (Fig. 3.8). The warm, glowing reds and golden colours of the foreground partition off the individual from the collective, indoors from outdoors,

[114] *CW* 3:107. [115] *CW* 3:98. [116] *CW* 3:99.

[117] Jean-Antoine Watteau's nephews, Louis-Joseph Watteau (1731–98) and François Watteau (1758–1823), both known as 'Watteau de Lille', imitated his style and moved from Valenciennes to Lille, where many of their works are held. Whether Florian Deleal's mysterious surname is an allusion to Watteau's descendants is mere speculation, but not entirely unlikely.

[118] *CW* 3:104.

civilization from nature, while the subject's left hand bridges the two worlds. Sebastian's mother, on the other hand, wishes to see Sebastian as a natural participant in the family group portrait, but with his keenness to leave the material world behind, her arrogant son dismisses the project with a misogynistic one-liner:

> And all his singularities appeared to be summed up in his refusal to take his place in the life-sized family group (*très distingué et très soigné*—remarks a modern critic of the work) painted about this time. His mother expostulated with him on the matter: —she must needs feel, a little icily, the emptiness of hope, and something more than the due measure of cold in things for a woman of her age, in the presence of a son who desired but to fade out of the world like a breath—and she suggested filial duty. 'Good mother,' he answered, 'there are duties towards the intellect also, which women can but rarely understand.'[119]

Sebastian's love of hard, cold, and polished surfaces attracts him to the materiality of marble and ice rather than the soft texture and colour of paint, to the ideal rather than the real. As suggested by his surname, he is an exotic white bird in a community of colourful Dutch birds of a feather, collaborative and sensuous in their approach to the world. Sebastian's one line of direct speech, unusual in Pater, serves to highlight his cult of silence and extreme privacy, and much of Pater's portrait revolves around images of erasure, deletion, and surfaces into which no indentations have been made.[120] Thus Sebastian refuses to sign his letters in the most non-committal form of writing, and the *tabula rasa* is invoked no fewer than three times to epitomize Sebastian's general philosophy of life and desire for self-effacement. The concept of the *tabula rasa*—that man's mind at birth is a blank, or more accurately, an erased slate, waiting for inscription—goes back to antiquity, and can be found in Aristotle's *De anima*. In the Middle Ages Islamic and Thomistic thinkers returned to Aristotle's idea. Pater more likely had in mind the influential discussion of the concept in John Locke's *Essay Concerning Human Understanding*, first published in 1690, and hence, strictly speaking, slightly too late for Sebastian.[121] The Lockean emphasis on the individual's freedom to mould his own mind through his choice of experience feeds straight into Sebastian's train of thought, even in its negative form of erasure, detachment, and self-effacement; we can see why the idea of being captured for posterity in paint would be problematic. With his love of the abstract and ideal, rather than the quotidian and real, Sebastian can contemplate vast expanses such as the icy sea in the North-West Passage and the pallid Arctic sun in his philosophical search for equilibrium.[122]

'Equilibrium' and 'void' become synonymous in Sebastian's vocabulary, as he strives to escape the sensuous world of Dutch community, solidly lodged in materiality. His reality is different from theirs: 'The very emphasis of those objects,

[119] *CW* 3:106.

[120] Sigi Jöttkandt, 'Effectively Equivalent: Walter Pater, "Sebastian van Storck" and the Ethics of Metaphor', *Nineteenth-Century Literature* 60:2 (Sept. 2005), 163–98.

[121] Pater's own copy of the 1817 edition of Locke's essay has recently been purchased by Brasenose College.

[122] *CW* 3:110.

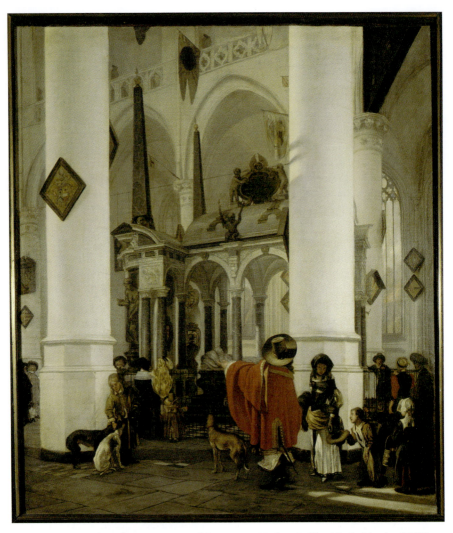

Fig. 3.7. Emanuel De Witte, *Interior of the Nieuwe Kerk in Delft with the Tomb of William the Silent* (1656), oil on canvas, 97 × 80 cm. Palais des Beaux-Arts, Lille. Photo (C) RMN-Grand Palais/Philipp Bernard.

their importunity to the eye, the ear, the finite intelligence, was but the measure of their distance from what really is. One's personal presence, the presence such as it is, of the most incisive things and persons around us, could only lessen by so much, that which really is. To restore *tabula rasa*, then, by a continual effort at self-effacement!'[123] Perhaps more than any of Pater's protagonists, Sebastian lives in a symbiotic relationship with the land which has moulded him. The low lands, with their frequent

[123] *CW* 3:111.

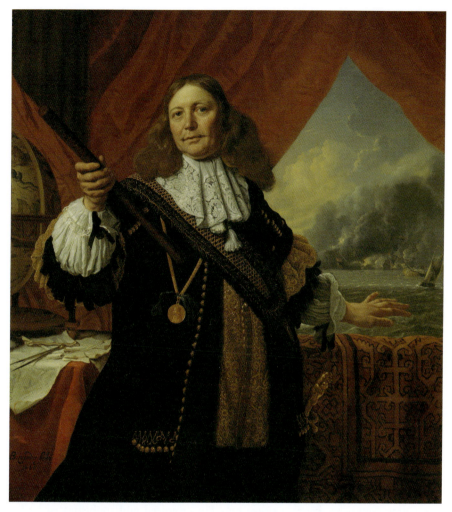

Fig. 3.8. Bartholomeus van der Helst (figure) and Ludolf Bakhuizen (naval background), *Portrait of Johan de Liefde* (1668), oil on canvas, 139 × 122 cm. Rijksmuseum, Amsterdam. Wikimedia Commons.

inundations, are alluded to repeatedly, and the pervasive images of water—cleansing, destructive, invasive, erasing—are integral to Sebastian's personality and outlook on life. His existence is washed away by the sea, he has destroyed the only portrait of himself in existence, and all that remains is his mysterious journal.

The Secret Diary: 'Sebastian van Storck'

Sebastian's secret journal, not shown to anyone, falls into the hands of the curious and causes some consternation. Pater includes his reader among the curious;

144 WALTER PATER'S EUROPEAN IMAGINATION

although we never read individual diary entries, the last third of his narrative consists of one long interior monologue based on Sebastian's journal, with quotations from his self-destructive axioms reflecting his encounter with Spinoza.[124] Pater's narrator steps in as editor and interpreter of the journal.[125] The only element which ties its content to the real world is the draft version of Sebastian's letter (which we never see), rejecting the worldly Miss Westrheene who in her grief retires into a Béguinage. The conventional realist details of time and place are suppressed for abstract ideas, and the heart of Marie-Marguerite has a cool counterpart in Sebastian for whom the world exists solely in mind, as he turns the material world into thought: 'The volume was, indeed, a kind of treatise to be: —a hard, systematic, well-concatenated train of thought, still implicated in the circumstances of a journal. Freed from the accidents of that particular literary form with its unavoidable details of place and occasion, the theoretic strain would have been found mathematically continuous.'[126] Pater relentlessly forces his reader inside the sick mind of Sebastian, as one self-destructive thought follows another, once the world of visual representation has been given up. Sebastian may be keen to see the real world as an illusion, but it is a very different kind from the illusionism represented in colourful oils by the Dutch painters with their well-developed sense of the richness of the material world. Sebastian's *ennui* is one which belongs to a decadent young man: for Henry James, travelling to Holland in 1874, an arty young critic, blasé in his approach to the world, the realism of Dutch art left him feeling jaded:

> You have seen it all before; it is vexatiously familiar; it was hardly worth while to have come! At Amsterdam, at Leyden, at The Hague, and in the country between them, this is half your state of mind; when you are looking at the originals, you seem to be looking at the copies; and when you are looking at the copies, you seem to be looking at the originals. Is it a canal-side in Haarlem, or is it a Van der Heyden? Is it a priceless Hobbema, or is it a meagre pastoral vista, stretching away from the railway track? The maid-servants in the streets appear to have stepped out of the frame of Gerard Dow, and appear equally equipped for stepping back again.[127]

The young American, keen to prove how Europeanized and sophisticated he has become, has seen enough of early realism, and juggles the dichotomies of life and art in a manner anticipating Wilde. Pater, by contrast, tried to do both time-travel and retain his nineteenth-century perspective when he stepped into the mind of the Dutch and focused on optics, on new ways of seeing, while also taking his readers back to the praise of realism voiced by Honoré de Balzac, George Eliot, and Thomas Hardy a few decades previously:[128]

[124] See B. A. Inman, ' "Sebastian van Storck": Pater's Exploration into Nihilism', *Nineteenth-Century Fiction* 30:4 (March 1976), 457–76; I. C. Small, 'The Sources for Pater's Spinoza in "Sebastian van Storck"', *Notes and Queries* 25 (1978), 318–20.

[125] Continually searching for precise phrasings of Sebastian's nebulous thoughts, Pater inserted the largest number of changes in this part of the text, see *CW* 3:225–8.

[126] *CW* 3:108.

[127] Henry James, 'In Holland', *Transatlantic Sketches* (Boston: Houghton Mifflin & Co., 1903), 380–90, 382.

[128] See Ruth Bernard Yeazell, *Art of the Everyday: Dutch Painting and the Realist Novel* (Princeton: Princeton University Press, 2008).

The Dutch had just begun to see what a picture their country was—its canals, and *boompjis*, and endless, broadly-lighted meadows, and thousands of miles of quaint water-side: and their painters, the first true masters of landscape for its own sake, were further informing them in the matter. They were bringing proof, for all who cared to see, of the wealth of colour there was all around them in this, supposably, sad land. Above all, they developed the old Low-country taste for interiors. Those innumerable *genre* pieces—conversation, music, play—were in truth the equivalent of novel-reading for that day; its own actual life, in its own proper circumstances, reflected in various degrees of idealisation, with no diminution of the sense of reality (that is to say) but with more and more purged and perfected delightfulness of interest.[129]

Pater's nineteenth-century narrator imposes a pictorialism on the Dutch landscape while toying with aestheticism ('landscape for its own sake') *avant la lettre*; he suggests a change in the collective Dutch visual perception. Painting teaches the nation to see, and, apart from taking us straight into the landscapes of Hobbema and Ruysdael, Pater alerts us to the transformative powers of art. The nation's appreciation of the natural world is a tribute to their highly developed visual powers; learning how to see nature through art reverses conventional mimetic theories while making the reader aware of the artifice of Pater's imaginary portrait, even when he is dealing with so-called 'realist' art. As frames of social life, interiors form the counterpart to the vast expanses of flat land celebrated in landscape paintings, and within those interior spaces the real merges with the ideal. Pater thus places a discreetly correcting touch onto the links between the realist novel and genre painting which by 1886 had become an established convention, begun by Balzac and carried on by Eliot.

In the opening chapter of his novel set in Flanders, *The Quest for the Absolute* (1834) (*La recherche de l'absolu*), Balzac had praised the warmth and homeliness of realist art, at once cosmopolitan and national. Part of his *comédie humaine*—his depiction of French and European society, across social classes, in the post-Napoleonic period—Balzac's novel represented the democratic treatment of the human in art as symptomatic of political freedom, suggesting a link between art and politics: 'So Flanders, with its practical turn, has constantly assimilated the intellectual and material wealth of its masters and neighbours, until the country, originally so dreary and unromantic, has recast its life on a model of its own choosing, acquiring the habits and manners best suited to the Flemish temperament without apparently losing its own individuality or independence. The art of Flanders, for instance, did not strive after ideal forms; it was content to reproduce the real as it had never been reproduced before.'[130] Chapter 17 in Eliot's *Adam Bede* (1859), 'In which the story pauses a little', had defended Dutch realism (and by implication the realist novel) at the expense of ideal art:

[129] *CW* 3:100.
[130] Honoré de Balzac, *The Quest of the Absolute* (1834), tr. Ellen Marriage (London: J. M. Dent, 1908), 5–6.

> It is for this rare, precious quality of truthfulness that I delight in many Dutch paintings, which lofty-minded people despise. I find a source of delicious sympathy in these faithful pictures of a monotonous homely existence, which has been the fate of so many more among my fellow-mortals than a life of pomp or of absolute indigence, of tragic suffering or of world-stirring actions. I turn, without shrinking, from cloud-borne angels, from prophets, sibyls, and heroic warriors, to an old woman bending over her flower-pot, or eating her solitary dinner, while the noon-day light, softened perhaps by a screen of leaves, falls on her mop-cap, and just touches the rim of her spinning wheel, and her stone jug, and all those cheap common things which are the precious necessaries of life to her;[131]

The chapter headings in Eliot's novel sounded, quite intentionally, like the titles of Dutch genre paintings: 'The Workshop', 'The Preaching', 'After the Preaching', 'Home and Its Sorrows', 'The Hall Farm', 'The Dairy', etc., and Eliot's many descriptions of interiors allude to Dutch interior scenes.[132] Hardy's 1872 novel, *Under the Greenwood Tree*, subtitled 'A Rural Painting of the Dutch School', was, with its almost complete lack of plot, suggestive of the quiet human existence in Dutch painting, while Hardy's framing of his figures in windows and doors were in recollection of the domestic scenes of seventeenth-century Holland.[133] In the 1860s when Hardy was working in a London architect's office, he made a habit of paying a daily visit to the National Gallery, 'twenty minutes after lunch to an inspection of the masters there, confining his attention to a single master on each visit, and forbidding his eyes to stray to any other'.[134] His composition of *Under the Greenwood Tree* coincided with the exhibition of the Robert Peel collection in the National Gallery, and as J. B. Bullen points out, 'Hardy's rendition of the pictorial image is decidedly more technical than George Eliot's', as he 'focuses exclusively on the visual image as it might appear in a picture; appeal is made only to the sense of sight, and associations of a non-visual kind are excluded.... For George Eliot the picture is a powerful source of sentiment.'[135] As the trained draughtsman, Hardy had a greater interest in formalism than Eliot, and the 'consciousness of the picture within the text creates the effect of observing life at one remove, and as such, it is surely a deliberate and anti-naturalistic device.' Indeed, 'pictorialism is a subtle reminder to the reader that the text, like the pictures which are used as models, is in fact a work of art; the very presence of "pictures" in the text draws attention to the fact that the scenes are not fragments of life but are essentially verbal transcriptions of visual effects.'[136] Pater met Hardy for the first time in the summer of 1886, shortly after he had published 'Sebastian

[131] George Eliot, *Adam Bede*, ed. Carol A. Martin (Oxford: Clarendon Press, 2001), Chapter XVII, 164–72, 166.

[132] See Hugh Witemeyer, *George Eliot and the Visual Arts* (New Haven and London: Yale University Press, 1979), 105–25.

[133] See Bullen 1986, 47; Yeazell, 127–35.

[134] Florence Emily Hardy, *The Early Life of Thomas Hardy, 1840–1891: compiled largely from contemporary notes, letters, diaries, and biographical memoranda, as well as from oral information in conversations extending over many years* (New York: Macmillan, 1928), 69.

[135] Bullen 1986, 46. [136] Ibid., 48.

NARRATING THE SELF 147

van Storck,[137] and as near neighbours in Kensington in the late 1880s, they occasionally encountered each other.[138]

Although no trained draughtsman, Pater came much closer to Hardy's formalist pictorialism than to Eliot's. When he turned to a Dutch setting for Sebastian, he was writing himself into a fifty-year-old discourse, linking realist art with the realist novel. Yet Pater's imaginary portraits are not exercises in nineteenth-century realism. Neither his characters nor his descriptions aim at realist detail and verisimilitude, and while they court the painterly and the artistic, they remain within the world of art and ideas without ever getting into the simple life of Eliot's lowly woman by the spinning wheel.[139] The art of describing, to borrow Svetlana Alpers's term,[140] is very different in Pater. Alpers's basic distinction between the narrative and the descriptive art of southern and northern Europe, respectively is reflected in Pater's Dutch portrait, by deliberate choice almost devoid of plot and narrative, as is much of the art represented in his text. Pater is interested in Golden Age Holland as a culture of science, thought, optics, and art, and he explores the interplay between them in the tension between the real and the ideal which reflects his profound understanding of Dutch culture. It is a culture of surfaces, concerned with writing, with the graphic inscription on the surface, rather than with the central perspective of the Italian Renaissance; to the Dutch the world is a map rather than the neatly framed window, which Leonbattista Alberti had advised his fellow Italians to think of when constructing a perspectival view.[141] To prove her point, Alpers reminds us that Italian window and picture frames often resembled one another, while with the Dutch, the similarity was much closer between mirror and picture frames.[142]

Pater's young Sebastian had inscribed the hard planar surface of the ice in the opening scene, as he skated above the frozen water. The only contemporary art form he engages with is the most map-like of all: the panoramic landscape. Bird-like, he prefers towers and roof-tops, opening up to broad open vistas, to portraits and cluttered domestic spaces. In the seventeenth century, many Dutchmen retreated to such towers or dunes in order to view their national landscape from above.[143] Pater's evocation of Sebastian's private room and limited art collection suggests a reluctance to engage with other human beings: panoramic paintings have replaced windows, and art has substituted nature as an extension of the protagonist's fear of the world. With Sebastian, the reader becomes a soaring bird above the vast expansive landscapes of Philip de Koninck (Fig. 3.9):

> For though Sebastian van Storck refused to travel, he loved the distant—enjoyed the sense of things seen from a distance, carrying us, as on wide wings of space itself, far out of one's actual surrounding. His preference in the matter of art was, therefore, for those prospects à vol d'oiseau—of the caged bird on the wing at last—of which Rubens had the secret, and still more Philip de Koninck, four of whose choicest works occupied the four walls of his chamber; visionary escapes, north,

[137] Florence Hardy, 236. [138] Ibid., 275, 278.
[139] Eliot's reference was to Gerard Dou's *The Spinner's Grace* (1645) in Munich.
[140] Svetlana Alpers, *The Art of Describing* (Chicago: Chicago University Press, 1983).
[141] Ibid, 122. [142] Ibid., 42. [143] Ibid., 148.

Fig. 3.9. Philip de Koninck, *An Extensive Landscape with a Hawking Party* (*c.*1670), oil on canvas, 132.5 × 160.5 cm. National Gallery, London. Wikimedia Commons.

south, east, and west, into a wide-open though, it must be confessed, a somewhat sullen land. For the fourth of them he had exchanged with his mother a marvellously vivid Metsu, lately bequeathed to him, in which she herself was presented. They were the sole ornaments he permitted himself.[144]

Sebastian is the keeper of his own cage, in self-confined imprisonment formed of his obsessive journal and his predilection for solitary towers. His escapist love of de Koninck's bird's-eye-view landscapes transforms him into a travelling eye which explores in both depth and breadth the panoramic qualities of an imaginary landscape, safe from touch and devoid of other human beings. With their multiple viewpoints, de Koninck's landscapes are the size of large wall maps; indeed, 'Koninck aims at making the piece of Holland he is describing seem a part of the larger world. By introducing a gentle curve to the horizon he lets the earth into what is a mapped view of an area of his native land. While Brueghel expands his neighborhood into the world, Koninck brings a world view to Holland.'[145]

Alpers directed our attention to the Dutch fondness for calligraphy, to how painters were also printers and mapmakers, how maps merged science, art, and script, and

[144] *CW* 3:100–1. [145] Alpers, 145.

how the written word frequently occurs in Dutch painting. The art of describing is tied to script and the graphic; reading or writing are frequently occurring motifs in genre painting.[146] Rarely are we able to read the contents of letters, planar surfaces, which absorb all the sitter's attention within the pictorial space. The letter is a device which makes us think of presence, absence, and distance, between writer and recipient. We may have entered the intimate space of the writer or reader of a letter, but we never become the sitter's eye and mind, capable of fully participating in their reading. Gabriël Metsu's *Woman Reading a Letter* (1664–6) (Fig. 3.10) is a case in point; the marine painting on the wall may reflect a tempestuous relationship or a correspondent away at sea, while the maid serves as anonymous messenger, a go-between, with her back towards us. Pater turns this convention on its head, by giving us the text of one important letter while omitting the reader's reaction, let alone the context in which the letter is read. The letter from Sebastian's tutor, speaking of his student's impressionability and 'intellectual fearlessness', is our first glimpse into the mind of the protagonist, an early verbal portrait:

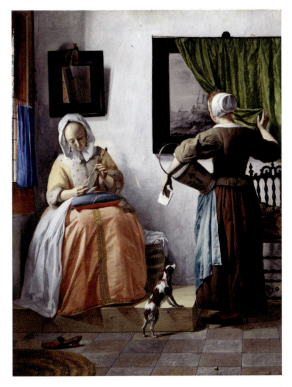

Fig. 3.10. Gabriel Metsu, *Woman Reading a Letter* (1664–6), oil on panel, 52.5 × 40.2 cm. National Gallery of Ireland, Dublin. Wikimedia Commons.

[146] See Peter C. Sutton et al., *Love Letters: Dutch Genre Paintings in the Age of Vermeer* (London: Frances Lincoln, 2003) in collaboration with National Gallery of Ireland and the Bruce Museum of Arts and Science.

150 WALTER PATER'S EUROPEAN IMAGINATION

'At present,' he had written, 'he is influenced more by curiosity than by a care for truth, according to the character of the young. Certainly, he differs strikingly from his equals in age, by his passion for a vigorous intellectual gymnastic, such as the supine character of their minds renders distasteful to most young men, but in which he shows a fearlessness that at times makes me fancy that his ultimate destination may be the military life; for indeed the rigidly logical tendency of his mind always leads him out upon the practical. Don't misunderstand me! At present, he is strenuous only intellectually; and has given no definite sign of preference, as regards a vocation in life. But he seems to me to be one practical in this sense, that his theorems will shape life for him, directly; that he will always seek, as a matter of course, the effective equivalent to—the line of being which shall be the proper continuation of—his line of thinking. This intellectual rectitude, or candour, which to my mind has a kind of beauty in it, has reacted upon myself, I confess, with a searching quality.'[147]

A text within a text, the tutor's letter forms a contrast to Sebastian's own letter to Miss Westrheene, the exact contents of which remain a secret, while the impact on its female reader is reported. Just as Pater alluded to different types of Dutch portraiture and landscapes, so did he toy with the reader's familiarity with genre painting, a technical term which, according to the *OED*, only arose in the mid-nineteenth century, as the form experienced a major revival. In 1887 Symons linked Pater's imaginary portraits to contemporary genre painting: 'The term Portrait is very happily given to these four studies in narrative form. Not merely is each a portrait, in the looser sense of the term, of a single soul, but it is a *portrait*, in the literal sense, a picture painted with a brush. So microscopic a brush only a Meissonier could wield. The touches which go to form the portrait are so fine that it is difficult to see quite how much they do and mean, until, the end being reached, the whole picture starts out before you.'[148]

Speaking of portraits and alluding to the etymology of the word (*trait pour trait*, 'feature by feature'), Symons referred to the works of the French genre painter, Jean-Louis Ernest Meissonier. Symons raised the issue of where portraiture ends and genre begins, thus suggesting the fundamental schism between individual and type. Meissonier had produced a series of genre paintings of young male subjects generally popular with English collectors. With titles such as *The Reader, The Philosopher, The Painter*, and *The Poet* (Fig. 3.11), his small-scale portraits owed much to the Dutch tradition, and were frequently compared to paintings by Terburg and Metsu. Meissonier had exhibited at the 1855 Exposition Universelle and at the International Exhibition in London in 1862.[149] An entire issue of the *Gazette des Beaux-Arts* was devoted to him in 1862, with a laudatory essay by Théophile Gautier.[150] Richard Wallace had bought some fifteen of his paintings, all exhibited at Bethnal Green in

[147] *CW* 3:98.

[148] Arthur Symons, '*Imaginary Portraits*' in Seiler 1980, 175–82, 178.

[149] See cat. 187–91 in *Exposition Universelle de 1862 à Londres. Section française. Catalogue Officiel*. Publié par ordre de la Commission Impériale (Paris: Imprimerie Impériale, 1862).

[150] Théophile Gautier, 'Artistes contemporains: Meissonier', *Gazette des Beaux-Arts* (May 1862), 419–28.

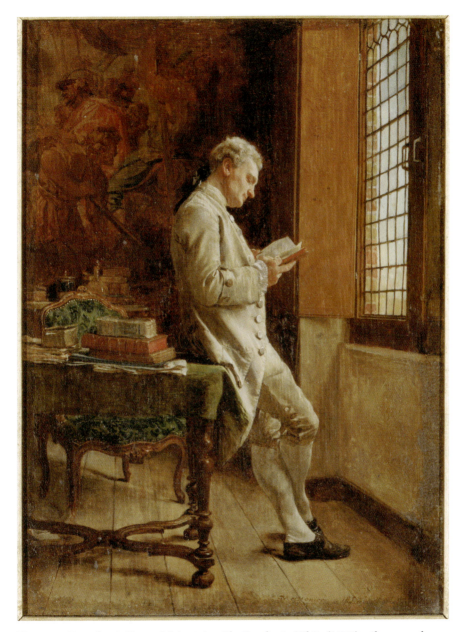

Fig. 3.11. Jean-Louis Ernest Meissonier, *The Reader in White* (1857), oil on wood, 21.7 × 15.5 cm. Musée d'Orsay, Paris. Photo © RMN-Grand Palais (Musée d'Orsay)/ Hervé Lewandowski.

152 WALTER PATER'S EUROPEAN IMAGINATION

1872.[151] John Mollett issued a monograph on Meissonier in 1882,[152] the artist had a major one-man show in Paris in 1884, reviewed in *Macmillan's Magazine* by Pater's friend, Mary Ward,[153] and the 1887 issue of the *Art Annual* was devoted to Meissonier.[154] Meissonier was everywhere, and in his much-celebrated 'miniaturisme' Symons found a painterly equivalent to Pater's sense of detail, while drawing our attention to a contemporary artist who, like Pater, always set his male portraits in the past, who was concerned with the solitary figure, and interested in the blurred boundaries between individual and type. Pater and Meissonier's young men are characterized by their interiority. In the paintings, the young men rarely face the viewer; figures in an interior, they are often depicted in some form of solitary activity, like reading, writing, or studying a work of art. What books are they reading, what drawings are they examining, what letters are they writing? Such acts of reading or writing inspire endless questions, as text in an image always begs to be read. The nineteenth-century fascination with the untold tale was addressed by Lionel Robinson:

> [T]here is underlying most of Meissonier's simplest figures the suggestion of an untold tale. It may not be one that he who runs may read, but it reveals itself bit by bit to those who, magnifying glass in hand, are content to unravel the artist's delicately concealed thoughts. Another distinguishing feature of Meissonier's work is its thorough reasonableness. When we look at his smokers, his students, his chess-players or his connoisseurs, we can fancy ourselves in a similar position. The costumes are not our costumes, but the thoughts and attitudes and sentiments are those of all time.[155]

Robinson's stress on the universal timelessness of Meissonier's subjects captures some of the attraction of genre painting. The anonymity of these young men, defined by their profession or temporary activity, provides a counterpart to Pater's subjects. They are not necessarily nobodies, but their immediate appeal lies in their being 'nobody in particular'. They may take their privacy from Dutch genre painting, yet they are highly aestheticized young men, devoid of ugly and realistic details, as indeed all of Pater's young men are more handsome than most. The context is in the detail, and the attention to detail required for the appreciation of Meissonier's small canvases connect them with Pater's portraits, which likewise demand slow reading and only gradually grow on the reader.

Pater's journal-writing protagonist had a counterpart in a Swiss professor of philosophy at the University of Geneva who had died of tuberculosis only in 1881: Henri-Frédéric Amiel. In 1882 and 1884 two volumes of extracts from Amiel's

[151] Charles C. Black, *Catalogue of the Collection of Paintings, Porcelain, Bronzes, Decorative Furniture and Other Works of Art, lent for exhibition in the Bethnal Green Branch of the South Kensington Museum, by Sir Richard Wallace* (London: Eyre and Spottiswoode 1872).

[152] John W. Mollett, *Meissonier* (London: Sampson Low, Marston, Searle & Rivington, 1882).

[153] Mary Ward, 'Meissonier', *Macmillan's Magazine* 50 (Jun. 1884), 92–8.

[154] Lionel Robinson, *J. L. E. Meissonier, Honorary Royal Academician, His Life and Work*, The Art Annual for 1887 (London: J.S. Virtue, 1887).

[155] Ibid., 9.

NARRATING THE SELF 153

17,000-page private journal, kept over a period of forty-three years, were published. The text became an immediate cult book as a study of the *malaise* of modernity, recommended by Ernest Renan and Paul Bourget, and it went into fourteen French editions before the First World War.[156] The publication of Amiel's journal heralded a new generation of so-called *intimistes*:[157] nineteenth-century diary writers whose journals appeared in print shortly after their deaths, subsequently inspiring a new form of *fin-de-siècle* diary novel. Lorna Martens linked the renewed popularity of the diary novel with the attacks on the French naturalist novel in the 1880s, and pointed out how 'a wave of publications of the personal, private diaries of near contemporaries, of recently deceased figures of the immediate past, was initiated':

> The major works were Henri-Frédéric Amiel's *Fragments d'un journal intime* (1882–84), Jules Michelet's *Mon Journal* (1888), Eugène Delacroix's *Journal* (1893), and Benjamin Constant's *Journal intime de B. Constant et lettres à sa famille et à ses amis* (1895). It is noteworthy that these intimate journals were published as *diaries* rather than as extracts, thoughts, testimonials, or sources of historical or biographical information. Something like a consciousness of a diary had come into being. With these publications, the intimate diary became an established public fact.[158]

As texts ostensibly not written for publication, the *journaux intimes* had an appealing authenticity: self-centred, introspective, self-analytical, the *intimistes* conveyed their rich interior worlds to the modern reader, together with a sense of *Weltschmerz*, yet without the yearning for domesticity which Goethe's Werther had expressed a century earlier. In 1886 the young André Gide began to keep his own journal, after having been given a copy of Amiel by his teacher,[159] and some five years later his first novel, *Les Cahiers d'André Walter* (1891) appeared. Édouard Rod's plotless, decadent novel *La Course à la mort* (1885), a dark diary novel with a Schopenhauerian pessimist protagonist, expressed his reaction against naturalism. Rod, a professor of comparative literature at Geneva, had read his Amiel hot off the press and based his own fiction on the *Journal Intime*.

After two lengthy essays on 'The Literature of Introspection',[160] Mary Ward published her translation of Amiel in 1885, thus bringing the journal to an English audience.[161] Pater's laudatory review was published in March 1886, the very same month as 'Sebastian van Storck'. Probably shortly afterwards, Wilde penned a review which he never completed, provisionally entitled 'Amiel and Lord Beaconsfield',[162] in which

[156] Martens, 117.

[157] See Alain Girard, *Le journal intime* (Paris: Presses universitaires de France, 1963).

[158] Martens, 115–16. [159] Ibid., 119.

[160] Mary Ward, 'The Literature of Introspection. Two Recent Journals', *Macmillan's Magazine* 49 (Jan. 1884), 190–201; 'The Literature of Introspection. Amiel's *Journal Intime*', *Macmillan's Magazine* 49 (Feb. 1884), 268–78.

[161] Ward's translation appeared in a second edition in 1889 and saw several reprints as testimony to its popularity.

[162] The manuscript is in the William Andrews Clark Memorial Library in Los Angeles, Finzi 2417, MS Wilde W67221M3. A516. It is transcribed, edited, and introduced in Anya Clayworth and Ian Small, '"Amiel and Lord Beaconsfield": An Unpublished Review by Oscar Wilde', *English Literature in Transition, 1880–1920* 39:3 (1996), 284–97.

he compared the *Journal Intime* to the recently published correspondence of Benjamin Disraeli, to the latter's advantage. Wilde much preferred the dandiacal Disraeli to Amiel's 'tragedy without a hero'[163] 'always poring over impossible problems'[164] and would rather attend the discourse at Piccadilly than that of the Parnassus.[165] In 1887 the ageing Matthew Arnold felt the need to have his say about Amiel, discussed in the light of an old favourite, Senancour's *Obermann*.[166] When compared with the poetic landscape descriptions and meditations in *Obermann*, Amiel's thirst for the infinite and adherence to speculative Germanized philosophy were utterly inferior, Arnold declared, while asserting that Amiel's philosophy of nothingness was of little value to society. He found the journal of pathological rather than psychological interest and wished that Amiel had stuck to his literary criticism (recommending his essay on Sainte-Beuve) instead of wallowing in his self-centred journal.

Pater recommended Amiel's journal to those who 'interest themselves in the study of the finer types of human nature'[167] describing it as primarily a book of thoughts, while noting the absence of outward events in Amiel's life. The pervasive melancholy outlook could only in part be attributed to a pessimistic philosophy of life, and partly to 'the consumptive tendency of Amiel's physical constitution, causing him from a very early date to be much preoccupied with the effort to reconcile himself with the prospect of death, and reinforcing the far from sanguine temperament of one intellectually also a *poitrinaire*.'[168] In the mid-1880s, we see Pater as both a writer and a reader of diaries, displaying a profound psychological interest in Amiel's journal. Like Montaigne, the complex, multifaceted personality described himself as many men in one. In Sebastian, Pater isolated one of the many facets of Amiel and cultivated it almost to the point of caricature. In his review, Pater enters into a critical dialogue with Amiel, quoting extensively from his journal, merging the Swiss professor's prose with his own, giving us a portrait of a split personality, never at ease with himself: '"This nature," he observes, of one of the many phases of character he has discovered in himself, "is, as it were, only one of the men which exist in me. It is one of my departments. It is not the whole of my territory, the whole of my inner kingdom"; and again, "there are ten men in me, according to time, place, surrounding, and occasion; and in my restless diversity, I am forever escaping myself."'[169]

Pater isolated two opposed personalities in Amiel: the renunciant, akin to Obermann and René, a real-life specimen moulding his life on fictitious characters while conducting 'the culture of *ennui* for its own sake'.[170] He also detected 'that other, and far stronger person, in the long dialogue; the man, in short, possessed of gifts, not for the renunciation, but for the reception and use, of all that is puissant, goodly, and effective in life, and for the varied and adequate literary reproduction of it; who, under favourable circumstances, or even without them, will become critic, or poet, and in either case a creative force'.[171] The Amiel who emerges from Pater's critical portrait is more balanced than what we find in Wilde or Arnold's essays, and Pater celebrates him as one of his own: 'he was meant, if people are ever meant for

[163] Ibid., 287. [164] Ibid., 289. [165] Ibid., 287.
[166] Matthew Arnold, 'Amiel', *Macmillan's Magazine* 56 (Sept. 1887), 321–9.
[167] 'Amiel's "Journal Intime"', 20.
[168] Ibid., 21. [169] Ibid., 23–4. [170] Ibid., 24. [171] Ibid., 25.

special lines of activity, for the best sort of criticism, the imaginative criticism; that criticism which is itself a kind of construction, or creation, as it penetrates, through the given literary or artistic product, into the mental and inner constitution of the producer, shaping the work.'[172] Praising Amiel's Hegelianism and analytical powers, Pater expresses his sympathies with his 'despondency in the retrospect of a life which seemed to have been but imperfectly occupied'.[173] What could have been a balanced life, is upset by disease and early death, and Amiel's 'Book of Thoughts' becomes influenced by the author's pathological condition.

Pater transposed some of Amiel's diary entries into Sebastian's philosophical axioms. The many references to Spinoza and Amiel's peculiar cult of nothingness resemble Sebastian's frozen philosophy: 'the individual life is a nothing ignorant of itself, and as soon as this nothing knows itself, individual life is abolished in principle. For as soon as the illusion vanishes, Nothingness resumes its eternal sway, the suffering of life is over, error has disappeared, time and form have ceased to be for this enfranchised individuality; the coloured air-bubble has burst in the infinite space, and the misery of thought has sunk to rest in the changeless repose of all-embracing Nothing.'[174] We never hear Sebastian's thoughts about romance and the female sex, but Amiel's restless sterility and broken engagements may well have proved inspirational: 'I have not given away my heart: hence this restlessness of spirit. I will not let it be taken captive by that which cannot fill and satisfy it; hence this instinct of pitiless detachment from all that charms me without permanently binding me; so that it seems as if my love of movement, which looks so like inconstancy, was at bottom only a perpetual search, a hope, a desire, and a care, the malady of the ideal.'[175] Pater deliberately avoids the first-person voice of the diary entry; the intimacy and direct appeal of the 'I' would have been too personal for a protagonist who refuses to sign his letters and addresses even his mother in the third person. Amiel's six million words, amounting to twelve printed volumes in the complete edition of his *Journal Intime*,[176] is a prime example of pathographesis, the sustained writing out of bodily and mental pathology.[177] His diary is both a symptom and a cause of his mental illness, both poison and cure, a fetishistic addiction where the boundaries between self and diary are erased. The progress of the consumption, which would eventually kill him at the age of sixty, is explored step by step, diary entry by diary entry, as life gradually ebbs out of him. His poetic description of his mental state some two months before his death, with its powerfully evocative image of floating down the Dutch canals in a barge, connects water with death, beauty, obsession, and renunciation in a way which flows into 'Sebastian van Storck':

> Although just now the sense of ghostly remoteness from life which I so often have is absent, I feel myself a prisoner for good, a hopeless invalid. This vague, intermediate state, which is neither death nor life, has its sweetness, because if it implies

[172] Ibid., 29. [173] Ibid., 35.

[174] Amiel, *The Journal Intime*, tr. Ward, 2nd edn, 1898, 172 (entry for 9 Jun. 1870).

[175] Ibid., 56 (entry for 21 Jul. 1856).

[176] Henri-Frédéric Amiel, *Journal intime*, ed. B. Gagnebin and B. M. Monnier, 12 vols (Lausanne: L'âge de l'Homme, 1976–94).

[177] See Rousseau and Warman.

156 WALTER PATER'S EUROPEAN IMAGINATION

renunciation, still it allows of thought. It is a reverie without pain, peaceful and meditative. Surrounded with affection and with books, I float down the stream of time, as once I glided over the Dutch canals, smoothly and noiselessly. It is as though I were once more on board the *Treckschute*. Scarcely can one hear even the soft ripple of the water furrowed by the barge, or the hoof of the towing horse trotting along the sandy path. A journey under these conditions has something fantastic in it. One is not sure whether one still exists, still belongs to earth. It is like the *manes*, the shadows, flitting through the twilight of the *inania regna*. Existence has become fluid.[178]

In one of his very last entries, Amiel continues the watery image: 'I shall end like the Rhine, lost among the sands, and the hour is close by when my thread of water will have disappeared.'[179] This, in effect, predicts Sebastian's death; although he dies by drowning, we know that life would soon have ebbed out of him. Part of Amiel's identity is tied to his awareness of his consumption, and he positions himself in the company of other famous consumptives of the past: Spinoza, Pascal, and Merimée whose letters he reads at the very end: 'I have finished Merimée's letters to Panizzi. Mérimée died of the disease which torments me—"*Je tousse, et j'étouffe*". Bronchitis and asthma, whence defective assimilation, and finally exhaustion. He, too, tried arsenic, wintering at Cannes, compressed air. All was useless. Suffocation and inanition carried off the author of *Colomba*.'[180] In Pater's writings, his sensitive heroes succumb to consumption: Spinoza, Pascal, Sebastian, Watteau, Merimée, Amiel, the English Poet—the catalogue continues. The restless seekers after infinite truth, infinite beauty, infinite ideals burn themselves out from within with the modern *malaise*.[181] The last thing Pater wrote was an essay on Blaise Pascal,[182] another 'renunciant' who takes us back to Amiel and Sebastian. In speaking of Amiel's *Journal* as 'a Book of Thoughts', Pater intended an allusion to Pascal's *Pensées*, a book which he would describe in 1894 as 'the outcome, the utterance, of a soul diseased, a soul permanently ill at ease.'[183] Pascal's 'great fine sayings... seem to betray by their depth of sound the vast unseen hollow places of nature, of humanity, just beneath one's feet or at one's side. Reading them, so modern still are those thoughts, so rich and various in suggestion, that one seems to witness the mental seed-sowing of the next two centuries, and perhaps more, as to those matters with which he concerns himself.' Pater's constant bridging of seventeenth-century France and Holland with nineteenth-century Switzerland and England ties together European mind, thought, and writing while questioning the beginnings of modernity, as indeed in *Gaston*, in his chapter entitled 'Modernité', he would bring the Baudelairean concept of modernity back to sixteenth-century France. The sixteenth and seventeenth centuries hold the key to modern thought, and in Pater's repeated return to those periods of western art and thought, he firmly establishes the coherence of European culture and philosophy

[178] Amiel 1898, 292 (entry for 18 Feb. 1881). [179] Ibid., 295 (entry for 10 Apr. 1881).
[180] Ibid., 293 (entry for 14 Mar. 1881). [181] See Sontag's *Illness as Metaphor*.
[182] See Hayden Ward, '"The last thing Walter Wrote": Pater's "Pascal"', in ed. Laurel Brake and Ian Small, *Pater in the 1990s* (Greensboro: ELT Press, 1991), 143–53.
[183] 'Pascal' in *Miscellaneous Studies*, 82.

with the condition of being human. The journal is not merely a female literary form for Pater, but one which is inextricably tied to the emergence of the modern subject, to the establishing of an articulate, thinking, and feeling self. The journal's self-reflexivity—as it becomes a text about reading, writing, and remembering—progressively constructs a self in chronological development. No matter whatever degree of autobiografictional element one may detect in Pater's portraits, as he explores his French and Dutch ancestry, he is also constructing a female and a male self, the one keen on articulation and commemoration, the other keen on silence and erasure. Bloom may have found Pater wanting in narrative, drama, and psychological portrayal, but when read patiently, attentively and on their own terms, the imaginary portraits contain it all.

4

Character and Caricature

Much of Virginia Woolf's fiction revolved around character: Clarissa Dalloway, Mrs Ramsay, and Orlando bear testimony to her success in creating scintillating figures, vibrantly alive, inviting us to contemplate the interrelationship between characters in books and in real life. Her argument with Arnold Bennett about character in modern fiction reflects how, by the 1920s, 'character' had become a contested issue. Considering character as a literary construct, Woolf insisted on linking the real world and the world of fiction:

> In real life there is nothing that interests us more than character, that stirs us to the same extremes of love and anger, or that leads to such incessant and laborious speculations about the values, the reasons, and the meaning of existence itself. To disagree about character is to differ in the depths of the being. It is to take different sides, to drift apart, to accept a purely formal intercourse for ever. That is so in real life. But the novelist has to go much further and to be much more uncompromising than the friend.[1]

Paul Ricoeur's observation that 'stories are recounted, life is lived' addresses the intersections between the world of the text and the world of the reader, the insides and the outsides of a text, with the keen awareness that it is the reader who must complete the story, bringing to it referentiality, communicability, and self-understanding.[2] When Baruch Hochmann maintained that 'characters in literature have more in common with people in life than contemporary critical discourse suggests,'[3] he was taking issue with structuralism's reduction of character to 'actants', to performers of giving, helping, supporting transactions in a formalized grammar of narrative. Reclaiming the link between lived life and fictional character, Hochmann asserted that however fictitious, characters were dependent on 'the model, which we carry in our heads, of what a person is. Both characters and people are apprehended in someone's consciousness, and they are apprehended in approximately the same terms. Yet they are clearly not identical.'[4]

The conundrum of literary character has generated a vast critical literature, and I am slightly cautious about opening this can of worms. Yet a discussion of Pater's fiction, of portraiture, voice, and self would seem curiously lacking without some acknowledgement of how narratives centred on one individual are dependent on the author's notion of character. Few Paterian protagonists could be described as being 'vibrantly alive'. Students who find Pater's fiction a challenge often complain that his

[1] Woolf, 'Mr Bennett and Mrs Brown', *EVW* 3:384–9, 387. [2] Ricoeur, 25.
[3] Baruch Hochman, *Character in Literature* (Ithaca and London: Cornell University Press, 1985), 7.
[4] Ibid., 7.

Walter Pater's European Imagination. Lene Østermark-Johansen, Oxford University Press. © Lene Østermark-Johansen 2022.
DOI: 10.1093/oso/9780192858757.003.0005

figures are vague and evasive, thus echoing Symons's evocation of them as 'ghosts, names, puppets', never endowed 'with flesh and blood, with the breath of life'.[5] Readers have their expectations thwarted and twisted, and are teased by Pater's anti-heroes who rarely aim at the 'life-like'. How many of us have encountered a Florian or an Emerald in real life? Is Pater not deliberately suggesting a non-realist universe by entitling his fiction 'imaginary portraits', questioning the very concept of likeness and suggesting the dreamlike, the allegorical, the mythological? He seems to be doing his best to avoid realist characters whose physiognomies can be classified, after their faces have been read, while their direct speech gives them away through sociolect or regional dialect.

This chapter originates in my own sense that Pater's fictional characters are peculiarly challenging. While some, such as Marie-Marguerite, are easy to relate to, others, like the Poet, Apollo, Duke Carl, and Denys, seem curiously impenetrable. I am intrigued by Pater's experiments with character across historical time, by his use of mythological figures (Hippolytus, Hyacinthus, Dionysus, Apollo), transposed into other geographical regions and more recent historical periods than the classical world. Heinrich Heine's essay on 'The Gods in Exile' (1853) is often quoted as a major influence;[6] his basic idea—that the pagan gods assumed new and often debased forms in the Christian world—constitutes an undercurrent in 'Denys l'Auxerrois' and 'Apollo in Picardy', but can a mythological figure ever become a character? While one of the appealing aspects of the Greek gods is their apparent humanity, their superhuman qualities put them above character. Are Pater's characters historically determined, gaining greater depth, the closer they come to the age of sensibility? The difference between Hippolytus and Florian would seem to suggest that. From ancient tragedy to romantic allegory, Pater's protagonists cover a great span, with medieval France as a site in which paganism and Christianity encounter one another and beget a new kind of person. Whether that person is a character, remains to be seen; sometimes we find a caricature instead. The twin masks of comedy and tragedy repeatedly raise their heads in Pater's fiction, but in spite of his interest in drama, we rarely encounter characters who contain a fully developed dramatic complexity. Pater's concern with the pictorial and the artificial makes for a new kind of protagonist with a surface existence whose actions (of which there generally are few) are rarely explained in relational terms.

Aware of the impossibility of arriving at a neat definition of Pater's view on character in fiction, I have chosen a prismatic approach which places Pater in dialogue with classical writers, with his contemporaries, and with the modernists. Pater as a reader of other people's fiction may be as informative on the matter as contemporary responses to his fiction. Pater the constructor of character, Pater the reviewer, or Pater himself as a character provide us with suggestions. If our notions of character in fiction are related to our experience of people in real life, then Pater's own experience of being turned into a character, of being caricatured, fed into his fiction. His

[5] Symons (1887). Quoted from Seiler 1980, 178–9.
[6] Heine's essay appeared first as 'Les Dieux en exil' in the *Revue des deux mondes* (1 Apr. 1853), 5–38. He revised it for publication in German later in 1853. Pater translated the passages on Apollo from the German version for inclusion in 'Pico della Mirandola' (1871).

turning to fiction shortly after having been caricatured as Mr Rose in W. H. Mallock's satirical novel, *The New Republic: Culture, Faith and Philosophy in an English Country House* (1876) is not insignificant. The Paterian figure would appear in Victorian fiction alongside the emergence of Pater's own fiction: Walter Hamlin in Lee's *Miss Brown* (1884), Mr Langham in Ward's *Robert Elsmere* (1887), and Lord Henry Wotton in Wilde's *Picture of Dorian Gray* (1890). As a target for caricature, visual as well as verbal, Pater was confronted with other people's views of him as a prominent figure within the aesthetic movement. Part of his fiction was a response to these caricatures, with the target himself turning caricaturist, attempting to rectify misconceptions of his aesthetic standpoints. 'The Child in the House', 'Duke Carl of Rosenmold', 'Apollo in Picardy', and *Gaston* all contain responses to the caricatures of Pater. The aesthetically perceptive figure is reworked repeatedly in Pater's writings, sometimes with sympathy, sometimes mercilessly caricatured. Caricature exaggerates that which is characteristic, condenses and enlarges, and may, though operating on the surface, cut right to the core of character.

Pater challenges many of the conventional components of fiction: plot, character, voice, dialogue. With the exception of Marie-Marguerite, Pater's protagonists hardly ever engage in direct speech, thus questioning John Frow's definition that 'to be a fictional character is to be both an agent and an object of discourse; at once a speaker, a person spoken to and a person referred to.'[7] The imaginary conversations among Pater's characters are far more imaginary than Walter Savage Landor's; we must construct them with very little prompting. The absence of dialogue in Pater's fiction deprives it of one of the chief devices for conveying character. What may intrigue us as readers is a sense of a detachment towards character, as Pater's plots leave us melancholy at best, admiring structure, style, and wit. A certain mannerist aspect emerges, as we perceive Pater's artfulness at the expense of emotional involvement. E. M. Forster's distinction between 'flat' and 'round' characters, proposed in his 1927 Cambridge Clark lectures (subsequently published as *Aspects of the Novel*) may be useful. Forster traced etymology and focussed on the sculptural meaning of 'character' as 'engraving': 'Flat characters were called "humours" in the seventeenth century, and are sometimes called types, and sometimes caricatures. In their purest form, they are constructed round a single idea or quality; when there is more than one factor in them, we get the beginning of the curve towards the round.'[8] Forster knew perfectly well that only rarely do we find entirely flat or entirely round characters: 'The test of a round character is whether it is capable of surprising in a convincing way. If it never surprises, it is flat. If it does not convince, it is flat pretending to be round. It has the incalculability of life about it—life within the pages of a book.'[9] Forster's study of Dickens suggests how easily writers may deceive their readers. While questioning the value of his own major distinction, he manages to make us think about surface and depth and the ways in which characters exist as extensions of their authors, while they may threaten to assume a life of their own:

[7] John Frow, *Character and Person* (Oxford: Oxford University Press, 2016), 34.
[8] E. M. Forster, *Aspects of the Novel* (London: Hodder & Stoughton, 1993), 65. See also Marta Figlerowicz, *Flat Protagonists: A Theory of Novel Character* (Oxford: Oxford University Press, 2016).
[9] Forster, 75.

CHARACTER AND CARICATURE 161

Dickens's people are nearly all flat (Pip and David Copperfield attempt roundness, but so diffidently that they seem more like bubbles than solids). Nearly every one can be summed up in a sentence, and yet there is this wonderful feeling of human depth. Probably the immense vitality of Dickens causes his characters to vibrate a little, so that they borrow his life and appear to lead one of their own. It is a conjuring-trick; at any moment we may look at Mr Pickwick edgeways and find him no thicker than a gramophone record. But we never get the sideway view. Mr Pickwick is far too adroit and well-trained. He always has the air of weighing something, and when he is put into the cupboard of the young ladies' school he seems as heavy as Falstaff in the buck-basket at Windsor. Part of the genius of Dickens is that he does use types and caricatures, people whom we recognize the instant they re-enter, and yet achieves effects that are not mechanical and a vision of humanity that is not shallow. Those who dislike Dickens have an excellent case. He ought to be bad. He is actually one of our big writers, and his immense success with types suggests that there may be more in flatness than the severer critics admit.[10]

Perhaps this is the stance to adopt with Pater: 'there may be more in flatness than the severer critics admit.' Personally, I would gladly have heard Forster's views on Pater's characters; only a very brief two-page draft for a talk on Walter Pater, possibly to be given at the Theosophical Society in Alexandria around 1917, survives.[11] The ironic detachment, the satire on the aesthetic life, and on the *inglese italianto* in the character of Cecil Vyse in *A Room with a View* (1908) suggest that Pater made a major impact on Forster, whose own fictitious characters have become popular classics in a way that Pater's protagonists never have. Whatever conclusions we may reach about Pater and character, they will inevitably undermine Bloom's dismissive comments about the author's lack of gifts for narrative and psychological portrayal. Pater knew perfectly well what he was doing in terms of character construction and had a complex range of literary and linguistic devices at his command which he could and did draw on when creating his protagonists.

Do we inevitably 'read into the text and its characters the configuration of our own experience and our consciousness of it'?[12] The disagreements among contemporary reviewers of the *Imaginary Portraits* testify to how differently the texts were read. It may seem surprising that the flamboyant Wilde pronounced his favourite protagonist to be the reticent and secluded Sebastian: 'From the first glimpse we get of him, skating over the watermeadows with his plume of squirrel's tail and his fur muff, in all the modest pleasantness of boyhood, down to his strange death in the desolate house amid the sands of the Helder, we seem to see him, to know him, almost to hear the low music of his voice.'[13] Seeing, knowing, hearing: Wilde's praise suggests vivid character drawing on Pater's part, generating empathy, at least with a reader who would have been favourably predisposed merely by the protagonist's first name,

[10] Ibid., 69.
[11] E. M. Forster, *Talk on Walter Pater* (*c.*1917), MS, King's College Archives, Cambridge, The Papers of Edward Morgan Forster EMF/6/32.
[12] Hochmann, 39.
[13] Oscar Wilde, unsigned review, *Pall Mall Gazette* (11 Jun. 1887), 2–3. Quoted from Seiler 1980, 163.

162 WALTER PATER'S EUROPEAN IMAGINATION

which since the Renaissance had been associated with same-sex love, a name Wilde himself would adopt after his imprisonment when he emerged on the European continent as Sebastian Melmoth. Wilde described the *Imaginary Portraits* as 'philosophic studies, in which the philosophy is tempered by personality', and his sympathy with one of Pater's most self-destructive protagonists speaks volumes about one of his own character traits. Wilde's celebration of Pater's successful delineation of character development contrasts with G. E. Woodberry's dry assertion that in 'Sebastian', 'the landscape is the one thing successfully treated.'[14] Eleanor Price mainly engaged with Marie-Marguerite's inner drama, and found Sebastian 'Cold, stoic, ungracious, entirely intellectual...a type of the intellectual movement in Holland at that time' but concluded that 'it is the saddest book that Mr Pater has yet written.'[15] She insisted on seeing his male protagonists as 'types', a response shared by Symons who summed up Pater's project as that of giving 'concrete form to abstract ideas', of representing 'certain types of character', tracing 'certain developments, in the picturesque and attractive way of narrative.'[16] Perhaps the contrasting responses from two of Pater's disciples support Forster's view that there is more to the flat character than its sternest critics will admit.

The sculptural aspects of character are inherent in the terms we employ about individuals in real life and fiction. Pater's 'language of sculpture' is profoundly invested in a perception of the worlds of art and literature that goes beyond the two-dimensional.[17] The Greek and Latin origin of 'character' and its connection to the art of letter-writing—'to make sharp, cut furrows, engrave' (*OED*)—reminds us of the sculptural relief. John Frow speaks of 'character' in narrative fiction as both figural and figurative: 'at once a figure of speech and a figural representation, the figure that stands out from a narrative ground and, more generally, the human shape or form. If character is a mark made by engraving or impressing, "figure" by contrast, is originally a shape that emerges from a hollow mould (*forma*), although it then comes (by a similar transfer from instrument to effect) to mean form or shape in the sense of outline, a body that stands in relief against a ground.'[18] Frow points out how, in classical literature, a range of semantic transfers took place, gradually approaching the modern meanings of 'character':

> When *kharakter* first appears in Greek literature, in Aeschylus's *Suppliants*, where it means the impression stamped on a coin, there is already a semantic transfer from the instrument to the mark, and the notion of the distinctive mark then generates a series of moral equivalents: to Herodotus 'character' was a speech characteristic; to Aristophanes, style as spoken expression; to Euripides, abstract entities like virtue and noble descent; to Plato, an individuating quality. But it is only with Menander and the New Comedy that it comes to denote 'the individual nature of a single person'.... That trajectory, from distinctive *symbolic* mark to a distinctive spoken or written style, to a distinctive set of moral qualities, and, beyond this to the

[14] G. E. Woodberry, unsigned review, *Nation* (28 Jul. 1887), 78–9. Quoted from Seiler 1980, 174.
[15] Eleanor Price, unsigned review, the *Spectator* (16 Jul. 1887). Quoted from Seiler 1980, 167–72, 171.
[16] Symons (1887). Quoted from Seiler 1980, 179. [17] Østermark-Johansen 2011.
[18] Frow, 8–9.

CHARACTER AND CARICATURE 163

representation of those qualities (in a reference or in public report) and, finally, quite late in this sequence, to the sense of 'a personality invested with distinctive attributes and qualities, by a novelist or dramatist; also, the personality or "part" assumed by an actor on the stage' (*OED* 17a) involves a series of metonymic transfers from the more concrete to the more abstract, without ever quite losing sense of the impressed physical mark; 'character' as letter of the alphabet or as the repeatable and combinable unit of printer's type which both represents and imprints it (a singularity that produces distinctiveness through repetition) carries through to a sense of character as something imprinted on the features—'characters graven on thy brows' [*Tamburlaine*, I, ii]; 'this thy fair and outward character' [*Twelfth Night* I, ii, 57]—suggesting the external, physiognomic traits of an inwardly figured personality.[19]

The opening passage of Dickens's *Great Expectations* (1861) puns on such etymological and metonymic aspects of 'character', as the young Pip goes in search of his true self and his ancestry in the local country churchyard:

I give Pirrip as my father's family name, on the authority of his tombstone and my sister—Mrs. Joe Gargery, who married the blacksmith. As I never saw my father or my mother, and never saw any likeness of either of them (for their days were long before the days of photographs), my first fancies regarding what they were like, were unreasonably derived from their tombstones. The shape of the letters on my father's, gave me an odd idea that he was a square, stout, dark man, with curly black hair. From the character and turn of the inscription, "*Also Georgiana Wife of the Above,*" I drew a childish conclusion that my mother was freckled and sickly.[20]

The transferral in the child's imagination from letter to character, from typography to physiognomy, is a piece of masterly writing, as Dickens's protagonist explores what remains of his family roots. The character to which we get access is, of course, Pip's own, not through any outer description, but through an inlet into his imaginative faculty. Pater's own copy of *Great Expectations* (Fig. 4.1) has Pater's own 'character' inscribed in the top right-hand corner (as he used to do);[21] the hand, the signature, is an extension of the Paterian person. On confronting it, we inevitably ponder the physiognomy and person who produced it and felt assertive? possessive? or insecure enough to add a period after his name. The popularity of the Victorian autograph book testifies to an era of graphology and to the autograph as a kind of metonymic relic, often displayed with portraits of celebrities. Pip is both the individual and the generic child, reminding us of Frow's paradox: 'a character is both peculiar, particular, distinctive, and at the same it is repeatable, generalizable, able to be used and reused in a variety of circumstances.'[22] Literary figures may end up as types: a Hamlet,

[19] Ibid., 7–8.
[20] Charles Dickens, *Great Expectations*, ed. Margaret Cardwell, intr. Kate Flint, Oxford World's Classics (Oxford: Oxford University Press, 1998), 3.
[21] The book is now in the private collection of Daichi Ishikawa, who has kindly provided me with an image.
[22] Frow, 8.

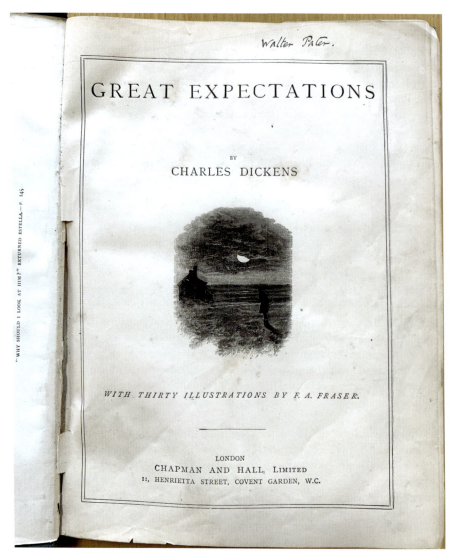

Fig. 4.1. Title page of Pater's private copy of Charles Dickens, *Great Expectations*, with thirty illustrations by F. A. Fraser (London: Chapman and Hall, n.d.). Private collection, © Daichi Ishikawa.

a Bovary, or a Lolita have become such familiar character types that they are shorthand for a cluster of characteristics. As reductive and generalized forms of the protagonists of tragedies or novels, they become related to the Theophrastan character study, popular in seventeenth-, eighteenth-, and nineteenth-century England. It toys with the typological aspect of character,[23] often isolated from a longer narrative framework.

[23] See Smeed.

The subject of Pater and character might be approached through his role as a critic of fiction. Such reviews reveal him as an extremely sensitive reader, highly perceptive of the tools of the literary profession, of strengths and inconsistencies in character drawing. When reviewing Ward's novel *Robert Elsmere* in the *Guardian* on 28 March 1888, Pater noted that 'her success should be more assured in dealing with the characters of women than with those of men. The men who pass before us in her pages, though real and tangible and effective enough, seem, nevertheless, from time to time to reveal their joinings. They are composite of many different men we seem to have known, and fancy we could detach again from the *ensemble* and from each other.'[24] Unlike Galton's composite images, Ward's blend did not entirely erase the originals, one of whom, Mr Langham, bore clear traces of Pater himself. The languid, melancholy, and mannered Oxford don, who becomes one of Elsmere's two tutors (the other being a Mr Grey, a thinly veiled portrait of the Hegelian T. H. Green), would have been recognized by Pater as a dark and phlegmatic, though better-looking, version of himself.[25] Acknowledging the intellectual qualities of Ward's novel, he praised its charm, lyrical landscape backgrounds, and sense of the interaction between person and place, its *genius loci*. Commenting on Ward's 'unmistakable virility and grasp and scientific firmness', Pater recognized her romantic heritage: 'Mrs. Ward has been a true disciple in the school of Wordsworth, and really undergone its influence. Her Westmorland scenery is more than a mere background; its spiritual and, as it were, *personal* hold on *persons*, as understood by the great poet of the Lakes, is seen actually at work, in the formation, in the refining of character.'[26]

The Westmoreland scenery becomes personified in its ability to form persona and character. Pater's 'English Poet' is a protagonist refined by his intercourse with the landscape of the Lakes; the latter half of the unfinished imaginary portrait may well derive from 1888, an interesting phase in Pater's career. Having published his *Imaginary Portraits* (1887), he was at work on *Gaston*, the first parts of which were serialized in *Macmillan's Magazine* in the autumn. The construction of character in fiction engaged him profoundly, and the *Elsmere* review demonstrates his reading of and sensitivity to, especially female, novelists. Thus Ward's novel was 'A *chef d'oeuvre* of that kind of quiet evolution of character through circumstance, introduced into English literature by Miss Austen, and carried to perfection in France by George Sand (who is more to the point, because, like Mrs. Ward, she is not afraid to challenge novel-readers to an interest in religious questions).'[27] Set during the French religious wars, Pater's second novel would take up the topic, as Gaston's character was gradually constructed through encounters with Ronsard, Montaigne, and Bruno. Whether Pater would ever have described *Gaston* as 'a novel of character' is another matter, but he applies the term to Ward's novel and singles out her treatment of religion as contributing to the elevation of character.

It is quite likely that Pater was tapping into the ongoing debate about the art of fiction to which Walter Besant and Henry James had recently contributed. James's

[24] 'Robert Elsmere', *Essays from the Guardian* (London: Macmillan, 1910), 53–70, 57–8.
[25] See the descriptions of Langham in Ward, *Robert Elsmere*, ed. Rosemary Ashton (Oxford: Oxford University Press, 1987), 54–68.
[26] 'Robert Elsmere', 62–3. [27] Ibid., 55.

essay 'The Art of Fiction' challenged such denominations as 'the novel of character' and 'the novel of incident' and insisted on the novel's organic quality.[28] The author of the *Portrait of a Lady* (1881) saw the novel as 'a living thing, all one and continuous,'[29] and asserted that he could 'as little imagine speaking of a novel of character' as he could imagine 'speaking of a picture of character': 'When one says picture, one says of character, when one says novel, one says of incident, and the terms may be transposed. What is character but the determination of incident? What is incident but the illustration of character? What is a picture or a novel that is *not* of character?'[30] One may disagree with James, but the interdependency of character and action in his definition of pictures and novels is significant. His emphasis on the interrelationship between inner and outer self, on actions, big and small, as psychologically motivated, questioned the interest in plot-driven novels at the expense of character, perhaps with reference to the sensation novel. His suggestion that character could be found in the particular way a woman rested her hand at a table and looked at an interlocutor allowed character to emanate from tiny gestures, thus directing our attention to some of the many quiet existences in late nineteenth-century literature.

Character, Tragedy, and Ekphrasis

Links between character in writing and character in painting were essentially Aristotelian. Aristotle famously placed character second to plot in his *Poesis*: 'The plot, then, is the first essential of tragedy, its life-blood, so to speak, and character takes the second place. It is much the same in painting; for if an artist were to daub his canvas with the most beautiful colours laid on at random, he would not give the same pleasure as he would by drawing a recognizable portrait in black and white. Tragedy is the representation of an action, and it is chiefly on account of the action that it is also a representation of persons.'[31] Aristotle's observation that many Greek tragedies had action without the proper representation of persons had its roots in his demand that, in order to be properly represented, characters had to be 'good', 'appropriate', 'lifelike', and 'consistent', even in their inconsistency.[32] His allowance for the flawed character demanded some element of idealization, the model of which he found in portrait-painting: 'Since tragedy is a representation of people who are better than the average, we must copy the good portrait-painters. These, while reproducing the distinctive appearance of their sitters and making likenesses, paint them better-looking than they are. In the same way the poet, in portraying men who are hot-tempered, or phlegmatic, or who have other defects of character, must bring out these qualities in them, and at the same time show them as decent people, as Agathon and Homer have portrayed Achilles.'[33] Where such idealization did not exist, he found characterless tragedy and portraiture: 'A similar contrast could be drawn between

[28] Henry James, 'The Art of Fiction', *Henry Longman's Magazine* 4 (Sept. 1884), 502–21.
[29] Ibid., 511. [30] Ibid., 512.
[31] Aristotle, *On the Art of Poetry* in *Aristotle, Horace, Longinus: Classical Literary Criticism*, tr. and intr. T. S. Dorsch (Harmondsworth: Penguin, 1978), 29–75, 40.
[32] Ibid., 51. [33] Ibid., 52.

Zeuxis and Polygnotus as painters, for Polygnotus represents character well, whereas Zeuxis is not concerned with it in his painting.'[34] The Jamesian conflation of character and incident rebels against Aristotle's three categories of action, thought, and character, which become muddled in their interdependency: 'Thought and character are, then, the two natural causes of actions, and it is on them that all men depend for success or failure.'[35] It is hard to imagine one without the other, with character as 'that which enables us to define the nature of the participants, and thought comes out in what they say when they are proving a point or expressing an opinion.'[36]

My reason briefly to include Aristotle here is to ponder the subjects of tragedy and character in the context of late nineteenth-century fiction. Pater's aestheticization of tragedy removes his narratives from the horrors of drama, and while Victorian melodrama often reduced Aristotelean pity and fear to bathos, tragedy was subject to considerable experimentation. In the 1890s James embarked on a career as a playwright and famously failed, with *Guy Domville* booed and swept off the stage in 1895 by the box-office success of Wilde's *Importance of Being Earnest*. Pater never attempted the move to the stage, something which is hardly surprising, given his limited interest in dialogue. The tragic genre was undergoing a number of permutations; apart from productions of classical and Shakespearean tragedy, the genre surfaced in non-English drama: in the Wagnerian wave, in Scandinavian drama—Ibsen and Strindberg—in the symbolist drama of Maeterlinck and Wilde, and in the Shavian problem play. Tragedy also morphed into fiction, at a point when it was leaving the three-volume format. The tragic tenor of most of Hardy and James's writings is undeniable, and much of Pater's fiction could be read as tragedy, with its rise and fall, sudden reversals of fortune, and lives cut short. Yet if, as Aristotle asserts, character in tragedy depends on speech and action, it is intriguing to observe how Pater cuts out speech and minimizes action for his own experiments. I am partly interested in Pater's dialogue with Euripides, but more so with Philostratus who, in his *Imagines* (third century AD), was experimenting with the ekphrastic form of the short prose narrative in a transformation of the plots and characters of Greek tragedy into brief descriptions of paintings.

Pater explored tragedy in other formats: in the essay, 'The Bacchanals of Euripides' (1889), and in the imaginary portrait. His 'Denys l'Auxerrois' is a rewriting of Euripides' *Bacchae*, transposed to medieval France, while his 'Hippolytus Veiled: A Study from Euripides' (1889) is a narrative based on a short Euripidean fragment, giving Pater's own version of a well-known myth, retold from Seneca to Racine.[37] Pater's choice of Euripidean drama is hardly surprising: the emphasis on spectatorship and ekphrasis in the works of the Greek tragedian, who reputedly was himself a painter, appealed to him.[38] In Euripides, death often takes place off stage and has to be recounted by a messenger who employs the powers of language to evoke the pitiful sight of a tragic death. Pater's transformation of a classical fragment into a

[34] Ibid., 40. [35] Ibid., 39.
[36] Ibid., 39. [37] See Østermark-Johansen 2017.
[38] Froma I. Zeitlin, 'The Artful Eye: Vision, Ecphrasis and Spectacle in Euripidean Theatre', in ed. Simon Goldhill and Robin Osborne, *Art and Text in Ancient Greek Culture* (Cambridge: Cambridge University Press, 1994), 138–96, 141.

168 WALTER PATER'S EUROPEAN IMAGINATION

coherent narrative, concluding in the sudden, violent death of an idealized protagonist, juggles the components of the mythological Hippolytus and transposes *peripeteia* until the very end: Phaeton-like, our hero is flung out of his chariot, and brought home to his mourning mother. Pater had chronicled the development of an attractive young man, who is suddenly killed off in one sentence. The catastrophe takes place so late that there is no time for *anagnorisis*, for the protagonist's self-reflection leading to an awareness of his own flaws. This is a deliberate choice; had Pater wanted introspective moments with meditations on the consequences of having made the wrong choices, he would have included them. No matter whether the protagonist's death is caused by internal factors—consumption, a heart-wound (Watteau, Sebastian, the Poet, Emerald)—or outer forces (Denys, Carl, Hippolytus, Hyacinth), it happens within the last pages. As in tragedy we are left with a body on the stage, yet in the case of Pater's classical figures always with the hope of resurrection or metamorphosis in a pagan cyclical mythology. Hippolytus, Hyacinthus, Carl, and Denys live on in other forms, as deities, flowers, the great Goethe, or modern Burgundian citizens.

Hippolytus, an innocent youth, stained by contact with his lascivious stepmother Phaedra, is subject to the divine machinery, to battles between Artemis, Aphrodite, and Poseidon. Classical sources make much of the unnatural behaviour of Hippolytus' father, the jealous Theseus, cursing his son and invoking the powers of his own father Poseidon to punish him. Pater omits this domestic drama and writes out Theseus from the final scenes, choosing to focus on the grieving mother. The swiftness of death is as two-dimensional as the male protagonist, and the same goes for Pater's young novice in 'Apollo in Picardy'. Pater's last completed portrait conflated a French medieval setting with the mythological figures of Apollo and his lover Hyacinthus. It is one of the few pieces of published fiction for which a manuscript fragment still exists.[39] On the verso is a draft for an essay on 'Evil in Greek Art' (1893–4),[40] in which Pater distinguishes between medieval ideas of evil, inherent in man and associated with sin, as opposed to Greek notions of evil. The fragment constitutes the philosophical counterpart to the portrait used as scrap paper and gives us some idea of why Pater's pagan characters die so swiftly and inexplicably:

> By the Greek \mind it was/ is conceived to be misfortune, the occasional ill-luck, not \neither/ \even if/ to be foreseen, not \or nor/ to be avoided of that lucky being—death—death in youth especially \as/ cutting him off in the very midst of his opportunities by the \most aggravated/ \grievous/ consummate form of such ill-luck.*/ \No!/ Greek poetry and Greek art so far as it deals with \is cognisant of/ it all is thus preoccupied with evil, the mischief that is in the world or \not as sin, not as disorder, but/ as misfortune or mischance[.][41]

[39] The transcription of the manuscript will appear in vol. 10 of the Oxford *Collected Works of Walter Pater*. It has been collated with the published version of 'Apollo in Picardy', and the textual variants can be found in *CW* 3:244–9.

[40] 'Evil in Greek Art', Houghton bMS Eng. 1150 (14).

[41] Ibid., fol. 1r. Pater's insertions are indicated with oblique lines. Kindly transcribed by Lesley Higgins.

CHARACTER AND CARICATURE 169

'Ill-luck', 'misfortune', 'mischance', 'mischief' would all seem to be synonyms for an ancient concept of evil. It is hardly a coincidence that the author recycled the draft pages for a narrative in which a young novice is beheaded by a flying discus, a 'devil's penny-piece'. The death of Hyacinthus remains a mystery: is it accidental—the result of a sudden capricious wind—or does Apollyon commit intended murder?[42] Pater's narrative has Greek overtones, as its protagonist becomes the living, moving, killing version of Myron's *Discobolus* (Fig. 4.2):

> On the moonlit turf there, crouching, right foot foremost, and with face turned backwards to the disk in his right hand, his whole body, in that moment of rest, full of the circular motion he is about to commit to it, he seemed—beautiful, pale, spectre—to shine from within with a light of his own, like that of the glow-worm in the thicket, or the dead and rotten roots of the old trees. And as if they had a proper motion of their own in them, the disks, the quoits, ran, amid the delighted shouts and laughter of the boy, as he follows, scarce less swift, to score the points of their contact with the grass. Again and again they recommence, forgetful of the hours; while the death-bell cries out harshly for the grave's occupant, and the corpse itself is borne along stealthily not far from them, and, unnoticed by either, the entire aspect of things has changed. Under the overcast sky it is in darkness they are playing, by guess and touch chiefly; and suddenly an icy blast of wind has lifted the roof from the old chapel, the trees are moaning in wild circular motion, and their devil's penny-piece, when Apollyon throws it for the last time, is itself but a twirling leaf in the wind, till it sinks edgewise, sawing through the boy's face, uplifted in the dark to trace it, crushing in the tender skull upon the brain.
>
> His shout of laughter is turned in an instant to a cry of pain, of reproach; and in that which echoed it—an immense cry, as if from the very heart of ancient tragedy, over the Picard wolds—it was as if that half-extinguished deity, its proper immensity, its old greatness and power, were restored for a moment. The villagers in their beds wondered. It was like the sound of some natural catastrophe.[43]

With masterly economy and stylistic precision, Pater creates a tragic death with cosmic implications. The sudden reversal of fortune known from Greek tragedy sets in when the fun is at its highest, against the sinister backdrop of an ongoing funeral at dusk in the monastic cemetery. Apollo's statuesque deity—idealized beauty in movement—causes a violent and painful death which reverberates outside the walls of the monastery, with reminiscences of the world's response to the death of Pan.[44] Pain is

[42] Cf. Revelation 9:11: 'And they had a king over them, which is the angel of the bottomless pit, whose name in the Hebrew tongue is Abaddon, but in the Greek tongue hath his name "Apollyon"'. In Greek, Apollyon is an active participle of 'apollumi', to destroy, in Hebrew Abaddon an intensive form of 'destruction'. Abaddon/Apollyon is represented as a devil-like figure in Christian apocalyptic theology. He finds popular representation in Bunyan's *Pilgrim's Progress* (1678) where Christian fights him in the Valley of Humiliation. Apollyon is described as a dragon-like creature with bear's feet and lion's mouth as in Revelation 13:2 and scales like those of Leviathan in Job 41:15. Christian enters into verbal, and subsequently physical, battle against Apollyon, who throws darts at him. After Christian's victory, Apollyon takes off into the distance.
[43] *CW* 3:211. [44] Plutarch, 'De Oraculorum defectu', 17.1.

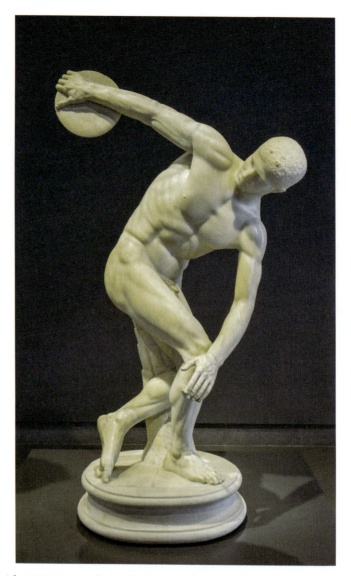

Fig. 4.2. After Myron, *Discobolus*, Roman copy (*c.* AD 140), marble, 155 cm. Museo Nazionale Palazzo Massimo, Rome. Wikimedia Commons.

aestheticized, as blood turns into fertilizer which, mingled with the rain, produces a cover of blue hyacinths, recalling the myth as recounted by Ovid.[45] Nature's cosmic mourning and resurrection of the novice becomes an instance of the mysteries of Providence which Pater intended to discuss in his 'Evil in Greek Art' through a quotation from Aristotle: 'closing wounds naturally, or (as Aristotle says) by

[45] Ovid, *Metamorphoses* 10, 185–219.

CHARACTER AND CARICATURE 171

\bringing/ some greater \piece/ of good-fortune \(quote)/ as A suggests \says/ in its turn.[46] Apollo/Apollyon is both classical and medieval, pagan and Christian: cool, perfect, hard as marble and yet, when he kills the doves in the dovecot and causes a hideous bloodbath, full of a medieval sense of guilt and contrition described by Pater in his manuscript on the verso of 'Apollo in Picardy'. He is, in other words, on the point of becoming a person.

'Hippolytus' and 'Apollo' close with the image of the slain handsome youth. Hippolytus and Hyacinthus are retained in their role as (surrogate) son, of the Amazon and Prior Saint-Jean, respectively. Death sets in shortly after their first encounter with eroticism, impersonated by Phaedra and Apollo, and is only made bearable by allusions to resurrection or metamorphosis. The ekphrastic endings of Pater's narratives remind us of Philostratus' (AD 170–250) *Imagines*, his descriptions of a series of paintings in a Neapolitan gallery, supposedly narrated to a boy accompanying the poet during a visit. The pederastic context, the fact that a large number of the (probably fictitious) paintings depict the deaths of young men (what Goethe in his 1818 essay 'Philostrats Gemälde' would classify as 'Heroic and Tragic Subjects'),[47] and the fact that 'paintings' of the deaths of both Hyacinthus and Hippolytus are among the works described, will justify our turning to Philostratus' *Imagines* as likely intertexts for Pater's mythological portraits.[48]

Pater's interest in the Second Sophistic period—a period defined by Philostratus himself in his *Lives of the Sophists* (AD 231–7)—pervades *Marius* (1885): with translations from Apuleius and Lucian and the appearance of Lucian as a character in the novel, we can hardly question his engagement with the Sophists. The Euphuism discussed in his account of the Golden Book is Sophism illustrated and explained.[49] As a classical writer, involved with the artful transformation of plot into picture, as epic and tragic scenes from Homer or Euripides turn into brief, framed, descriptions of fictitious paintings, Philostratus played with form, reading, and visualization. Jaś Elsner points out his inversion of the function of ekphrasis within tragedy:

> Ecphrasis within tragedy (as well as within epic and the prose novel) generally has an interventive role, disrupting the larger narrative structure of the text, pausing or varying the pace, supplying a different kind of (descriptive) narrative.... With his customary panache, Philostratus inverts this pattern in his *Imagines*. Instead of the

[46] 'Evil in Greek Art', fol. 4r. Kindly transcribed by Lesley Higgins.

[47] Johann Wolfgang von Goethe, 'Philostrats Gemälde' in *Goethes sämmtliche Werke in Vierzig Bänden* 34: 212–44 (Stuttgart: J. G. Cotta, 1869).

[48] Philostratus, *Imagines*, 1.18 has a description of the Bacchants bearing a strong resemblance to Euripides' play. Jaś Elsner lists the eroticized description of the dead youth as a favourite Philostratean trope: Menoeceus 1.4.3–4; Memnon 1.7.2; Hyacinthus 1.24.3; Hippolytus 2.4.3–4; Arrichion 2.6.5; Antilochus 2.7.5; Abderus 2.25.1 See Elsner, 'Philostratus Visualizes the Tragic: Some Ekphrastic and Pictorial Receptions of Greek Tragedy in the Roman Era', in ed. Chris Kraus, Simon Goldhill, Helene P. Foley, Jaś Elsner, *Visualizing the Tragic: Drama, Myth, and Ritual in Greek Art and Literature: Essays in Honour of Froma Zeitlin* (Oxford: Oxford University Press, 2007), 309–37, 314–15. In the 1880s Philostratus was being edited and translated as art-writing: A. S. Murray, 'An Ancient Picture Gallery', *Magazine of Art* 5 (January 1882), 371–6 (a lengthy review of Auguste Bougot's 1881 edition, *Philostrate l'Ancien: Une Galerie Antique* (Paris: Renouard, 1881)).

[49] See Lene Østermark-Johansen, 'The Death of Euphues: Euphuism and Decadence in Late Victorian Literature', *English Literature in Transition, 1880–1920* 45:1 (2002), 4–25.

172 WALTER PATER'S EUROPEAN IMAGINATION

ecphrasis being contained as a brief interlude in the play, Philostratus' picture (and the description it generates) comes to encompass the entire play, indeed to constitute its only reality within the world of the *Imagines*.[50]

As 'the ancient verse forms of tragic drama are made accessible as modern prose' and the visual content of a panel picture is made verbal, Philostratus performs a kind of paragone, resulting in a new genre, the 'hypervisual literary performance of display ecphrasis, which for the first time in antiquity comes to constitute a self-standing text (or set of texts) valid in its own right.'[51] Although less consistently 'pictorial', less 'serial', Pater's imaginary portraits partake in a Philostratean tradition, especially when it comes to his portraits with mythological subjects. Norman Bryson was intrigued by the Philostratean 'Look!', as the poet exclaims to his young companion guiding his spectatorship while toying with our notions of pictorial and literary presence. Bryson pointed out how in the *Imagines* 'word and pictures collaborate to produce a hyper-real, sensuously intense experience that goes beyond the limits of both pictures and words.'[52] He continued: 'This strange, hallucinatory power of ecphrasis calls on the capacities of words and pictures to describe the world, but goes beyond their several powers into a visionary moment when "Look!" becomes the only appropriate response. The exclamation directs the reader not towards the text, or its image, but past them both into another space where presence is alive to all the senses at once (sight, hearing, touch, taste).'[53]

Wilde's experience of 'seeing, knowing, hearing' Pater's Sebastian springs to mind; the young Dutchman's presence went beyond the page when Oscar read the text. The educational aspect of the *Imagines* is repeatedly invoked, as the young boy is lost in wonder and amazement at the images, while the adult viewer guides his vision through description with the full awareness of the powers of rhetoric. Where Euripides often invoked the collective 'we', involving both speaker and audience in a state of compassion, Philostratus employs the distancing second-person pronoun, 'you', at times confusing us as to whether he addresses the young boy inside or the young boy outside the pictorial frame, thus breaking down the artificial distinctions between life and art in what is already an elaborate literary and pictorial joke. 'The first speaker [in Philostratus] declares that whereas the uneducated, *idiotai*, are lost in wonder at the images, unable to verbalise a response, the educated man would never stand simply staring at visual beauty and leave it mute and voiceless, but would rather speak.'[54] With its rivalry between word and image, the paragone is repeatedly invoked in this contest between silence and speech, between an internalization of a fictitious painting and an articulate description of it, reminding us that 'ekphrasis' means 'a speaking out'. Philostratus' characteristic 'Look!', what Jaś Elsner calls the

[50] Elsner 2007, 309–10. [51] Ibid., 311.

[52] Norman Bryson, 'Philostratus and the Imaginary Museum', in ed. Simon Goldhill and Robin Osborne, *Art and Text in Ancient Greek Culture* (Cambridge: Cambridge University Press, 1994), 255–83, 273.

[53] Ibid., 273.

[54] Zahra Newby, '*Absorption and Erudition in Philostratus'* Imagines', in ed. Ewen Bowie and Jaś Elsner, *Philostratus* (Cambridge: Cambridge University Press, 2009), 322–42, 327.

CHARACTER AND CARICATURE 173

'classic hyperrealistist Philostratean trope',[55] is also a feature employed by Pater in 'Emerald Uthwart', as he addresses the reader's sense of vision in order to lift Emerald off the page: 'See him as he stands', 'See him then as he stands', 'But only see him as he goes', 'as you may see him still on his tombstone in the British Museum', and 'See him lingering for morsels of food'.[56] Is Pater inviting the reader inside the frame, inside his world of fiction, or suggesting that Emerald is so full of life that he steps outside it? This vivid visualization makes us for a moment doubt where we find ourselves.

In his 'Hippolytus', Philostratus steps inside the painting and addresses the youth with great compassion, painting an image of a brutally maltreated body, still handsome, in the last minutes of life before the breath stops. The pathos is un-Paterian, but the lingering over the beauty of pain, and the final aestheticization of the dying boy have strong affinities with Pater. This is double, if not triple or quadruple, spectatorship as the poet, the boy, and Hippolytus himself gaze at his wounds. As the dying boy's gaze pans over his wounded body, so does the reader's in what is essentially an elegiac act:

> And thou, O youth that lovest chastity, thou hast suffered injustice at the hands of thy step-mother, and worse injustice at the hands of thy father, so that the painting itself mourns thee, having composed a sort of poetic lament in thine honour. Indeed yon mountain-peaks over which thou didst hunt with Artemis take the form of mourning women that tear their cheeks, and the meadows in the form of beautiful youths, meadows which thou didst call 'undefiled', cause their flowers to wither for thee, and nymphs thy nurses emerging from yonder springs tear their hair and pour streams of water from their bosoms. Neither did thy courage protect thee nor yet thy strong arm, but of thy members some have been torn off and others crushed, and thy hair has been defiled with dirt; thy breast is still breathing as though it would not let go of the soul, and thine eye gazes at all thy wounds. Ah, thy beauty! how proof it is against wounds no one would have dreamed. For not even now does it quit the body; nay, a charm lingers even on thy wounds.[57]

In 1931 Arthur Fairbanks pronounced Philostratus a master of Sophistic sentiment, asserting that 'The excellence of the picture...lies in its effective delineation of character, in the pathos of the situation, or in the play of emotion it represents.'[58] Elsner went into a different register when he described the ending of the 'Hippolytus' as 'camp melodrama'. The transpositions and elisions to the Euripidean plot pointed out by Elsner reminds us of Pater, yet the telescoping effect, as focus is so forcefully narrowed down to the final death scene, alerts us to the limitations of painting outlined in Lessing's *Laocoön* (1766):

[55] See Elsner 2007, 331. [56] *CW* 3:177, 178, 186, 186, 195.

[57] Philostratus the Elder, 'Hippolytus', *Imagines* II, 4 in Philostratus the Elder and Philostratus the Younger, *Imagines*, tr. Arthur Fairbanks, Loeb Classical Library (Cambridge, MA: Harvard University Press, 1931), 140–3, 143.

[58] Ibid., xviii.

In the 'Hippolytus', the shift in media from tragedy to painting is simultaneously a radical change in emotive register and a significant shift in subject matter. The narrative may remain broadly the same, but Philostratus has no interest in Theseus and Phaedra, or indeed in the Euripidean tragic movement of Hippolytus from the scorner of Aphrodite to the hearer of Artemis' cool judgement at the end. His focus in entirely on Hippolytus as an exquisite pastoral tragedy of youth unjustly cut off, and as an erotic tableau—the oxymoron of beauty lingering on wrecked and defiled limbs....Philostratus not only narrates a process from the general story via the chaos of the horses to the focus on mourning for the dying youth, but he focalizes this by means of shifting the persons of his address and the figures addressed. The result is that he emulates the way tragedy can move its viewers by taking us inside a picture whose very landscape responds with what would later be called 'pathetic fallacy' to the emotive demands his interpretation has made. But the price (if that be a fair term here) is that the effect is high camp melodrama in place of catharsis.[59]

Philostratus' 'Hyacinthus' contains less pathos, as the figure of the *Discobolos* emerges, recalling Pater's technical interest in how to throw a discus and how to balance the body. Philostratus takes a distancing position from the very beginning: we are here to examine the painting and not to discuss the myth. Apollo is the focus, the all-pervading presence, while Hyacinth emerges as less significant:

A raised thrower's stand has been set apart, so small as to suffice for only one person to stand on, and then only when it supports the posterior portions and the right leg of the thrower, causing the anterior portions to bend forward and the left leg to be relieved of weight; for this leg must be straightened and advanced along with the right arm. As for the attitude of the man holding the discus, he must turn his head to the right and bend himself over so far that he can look down at his side, and he must hurl the discus by drawing himself up and putting his whole right side into the throw. Such, no doubt, was the way Apollo threw the discus, for he could not have cast it in any other way; and now that the discus has struck the youth, he lies there on the discus itself—a Laconian youth, straight of leg, not unpractised in running, the muscles of his arm already developed, the fine lines of the bones indicated under the flesh; but Apollo with averted face is still on the thrower's stand and he gazes down at the ground. You will say he is fixed there, such consternation has fallen upon him. A lout is Zephyrus, who was angry with Apollo and caused the discus to strike the youth, and the scene seems a laughing matter to the wind and he taunts the god from his look-out. You can see him, I think, with his winged temples and his delicate form; and he wears a crown of all kinds of flowers, and will soon weave the hyacinth in among them.[60]

Pater balances fate, cruelty, an ominous background event with a sinister wind, the innocent mirth of Hyacinthus with the elegance of Apollo's movements. Conflating a celebration of a powerful and dazzlingly beautiful deity with the elegy over a

[59] Elsner 2007, 321–2. [60] 'Hyacinth', *Imagines* I, 24. Ibid., 92–7, 95–7.

CHARACTER AND CARICATURE 175

handsome lover, he adds the tragic demise of the mad Prior Saint-Jean (a thinly veiled portrait of the aging Ruskin).[61] The result is one of his most masterly portraits in which pagan and Christian, classical and gothic, sculpture and architecture are interwoven against the backdrop of a community which is eventually abandoned by all three protagonists. The Prior and the novice both die and never leave the premises, while the deity departs to spread further havoc. Apollo's duplicity in Greek mythology—as god of the arts, leader of the muses, but also god of pestilence (whose son Asclepius is left to heal the wounds)—is here displayed in all its cruelty. For once Pater's protagonist does not die; he becomes a threat, ever on the move, ready to open men's eyes to the beauty of the male body, but just as ready to sacrifice them. The tragedy of aestheticism becomes a universal (male) tragedy which no mortal survives. Apollo remains as opaque as solid marble, never issued with a soliloquy, or an interior monologue. He may throw the devil's penny pieces with great expertise, but compared with Milton's Satan, he is devoid of rhetoric. Pater's deity is no character; we are never meant to understand Apollo, or empathize with him, and Pater's continued comparison of Apollo to ideal sculpture—to the *Discobolos* (Fig. 4.2) and the *Apollo Belvedere* (Fig. 4.3)—remind us that we are in the realm of the ideal rather than the real.

Of the three protagonists, only the medieval character, the scholar and man of the church, is capable of inspiring pathos. He loses everything: his novice, his scholarship, dignity, reason, and freedom. The portrait of the aging Ruskin, who since his final mental breakdown in 1888 had been confined to private care in the Lake District, revolves—predictably, perhaps, given that we are dealing with the High Priest of Victorian visual culture—around vision, inner and outer, mistaken and real:

> Prior Saint-Jean arose, and looked forth—with wonder! A brief spell of sunshine amid the rain had clothed the vale with a marvel of blue flowers, if it were not rather with remnants of the blue sky itself, fallen among the woods there. But there, too, in the little courtyard, the officers of justice are already in waiting to take him, on the charge of having caused the death of his young server by violence, in a fit of mania, induced by dissolute living in that solitary place. One hitherto so prosperous in life would, of course, have his enemies.
>
> The monastic authorities, however, claim him from the secular power, to correct his offence in their own way, and with friendly interpretation of the facts. Madness, however wicked, being still madness, Prior, now simple Brother, Saint-Jean, is detained in a sufficiently cheerful apartment, in a region of the atmosphere likely to restore lost wits, whence indeed he can still see the country—*vallis monachorum*. . . . He is like the damned spirit, think some of the brethren, saying 'I will return to the house whence I came out.' Gazing thither daily for many hours, he would mistake mere blue distance, when that was visible, for blue flowers, for hyacinths, and wept at the sight; though blue, as he observed, was the color of Holy Mary's gown on the illuminated

[61] See Robert Keefe, ' "Apollo in Picardy": Pater's Monk and Ruskin's Madness', *English Literature in Transition, 1880–1920* 29:4 (1986), 361–70.

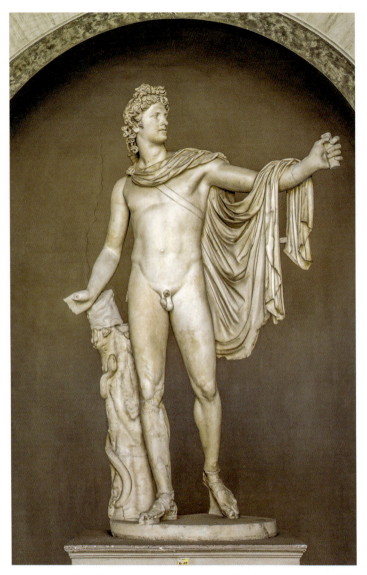

Fig. 4.3. Anon., *Apollo Belvedere*, Roman copy after a Greek original of the fifth century BC, marble, 224 cm. Musei Vaticani, Rome. Wikimedia Commons.

page, the color of hope, of merciful omnipresent deity. The necessary permission came with difficulty, just too late. Brother Saint-Jean died, standing upright with an effort to gaze forth once more, amid the preparations for his departure.[62]

Pater, rather naughtily, ends on a Whistlerian 'Symphony in Blue'. Formerly Prior, now Brother, Saint-Jean's melancholy tonal hallucinations in shades of blue flit and

[62] *CW* 3:212.

flicker, apparently aimlessly, yet with great Paterian precision, through Ruskinian topics: colour and perspective, the natural world and mythology, Christian iconography, and the revival of medieval crafts. Pater's language mimics Ruskin's associative, exalted, and accumulative style, often building up towards a major climax. With bitter irony, the climax becomes an anti-climax, as Saint-Jean expires in the final sentence, not as a handsome body to be admired, but as a distressed soul in aesthetic ecstasy.

Oxford Characters

Pater's satire on Ruskin might confirm Bloom's idea of the sage of Brantwood as the 'one and onlie begetter' of Pater's writings.[63] Bloom famously outlined an Oedipal conflict in Pater against Ruskin as the predominant authoritative mid-nineteenth-century voice on matters aesthetic, from the early essays on Renaissance art to the essays on medieval architecture of the 1890s. When Ruskin had resigned the Oxford Slade Professorship in 1885, Pater was one of the contenders for the post, but was defeated by Hubert von Herkomer. Pater had been a recurrent figure in the audience during Ruskin's Slade lectures in the 1870s;[64] the parallelisms of their publications— on Botticelli, Michelangelo, Luca della Robbia, sculptural relief, Notre Dame d'Amiens, and medieval architecture—suggests a continuing dialogue, with Pater as the more active party.[65] While there is only limited evidence of Ruskin's awareness of Pater's writings,[66] there is enough cross-referencing across Pater's *oeuvre* to prove his continued desire to engage with the Slade Professor's publications and ideas.

[63] Harold Bloom, 'Introduction' in *Selected Writings of Walter Pater*, ed. Harold Bloom (New York: Signet Classics, 1974), vii–xxxi, x–xxiii.

[64] See J. B. Bullen, 'Pater and Ruskin on Michelangelo: Two Contrasting Views', in ed. Philip Dodd, *Walter Pater. An Imaginative Sense of Fact* (London: Cass, 1981), 55–73; Wendell V. Harris, 'Ruskin and Pater—Hebrew and Hellene—Explore the Renaissance', *Clio* 17:2 (1988), 173–85; Kenneth Daley, *The Rescue of Romanticism: Walter Pater and John Ruskin* (Athens: Ohio University Press, 2001); Østermark-Johansen 2011, 32–45.

[65] Ruskin was not ignorant of Pater's existence. On 19 Sept. 1871, he wrote to his secretary, St John Tyrwhitt, asking him to 'lend me, that paper on Sandro [Botticelli], which I was so pleased with, in some magazine last year, by an Oxford man—you told me who, so must know.' See Gail S. Weinberg, 'Ruskin, Pater and the Rediscovery of Botticelli', *Burlington Magazine* 129 (1987), 25–7, 27; Paul Tucker, '"Reanimate Greek": Pater and Ruskin on Botticelli', in ed. Laurel Brake, Lesley Higgins, and Carolyn Williams, *Walter Pater: Transparencies of Desire* (Greensboro: ELT Press, 2002), 119–32. In another letter to Tyrwhitt of late Sept. 1872, Ruskin referred explicitly to Pater: 'I have your nice abstracts from Crowe & C. and the fortnightly with Pater's article—in looking over which I am surprised to find how much I have changed in my own estimation of Sandro in my last Italian journeys—for I recollect thinking Pater's article did him full justice—and now—though quite *right*—it reads lukewarm to me.' Quoted in Jay Wood Claiborne, 'Two Secretaries: The Letters of John Ruskin to Charles Augustus Howell and the Rev. Richard St. John Tyrwhitt', PhD thesis (Univ. of Texas, 1969), 307–8.

[66] Ruskin was reading Pater on Botticelli in preparation for Letter XXII of Oct. 1872 of *Fors Clavigera* and for his Slade lectures on Botticelli. Ruskin quoted 'with appreciation' Pater's description of Botticelli's *Birth of Venus* during one of his lectures but left out this reference in the published version. See W. G. Collingwood, *The Life and Work of John Ruskin*, 2 vols (London: Methuen, 1893), 2:137. Nine years later, Pater would assert his prior claim to having popularized Botticelli: Cf. letter to H. J. Nichols of 28 Nov. 1881, referring to his Botticelli essay of 1870, 'which I believe to be the first notice in English of that old painter. It preceded Mr. Ruskin's lectures on the same subject by I believe two years.' CW 9.

178 WALTER PATER'S EUROPEAN IMAGINATION

'Apollo in Picardy' is also a comment on the monastic male culture of Oxford,[67] with monks and novices as precursors to scholars and students. Such close-knit communities often define themselves in terms of insiders and outsiders. Always an insider, Prior Saint-Jean is an institutional creature: nursed and educated in one monastic institution, he transfers to another but does not survive his encounter with the roaming Apollo, free to wander in and out, from North to South. Thriving only in protected confinement, Saint-Jean is not fit for survival. His monasticism and scholarly efforts are challenged by his exposure to music, art, and the beauty of the male body. The Prior's magnum opus, a twelve-volume treatise on mathematics, remains unfinished at his death.

I am interested in Oxford as a character-moulding institution. A concern with the education of the individual for the benefit of the nation, manifest in Benjamin Jowett's use of Oxford Greats as a training for the civil service, made educational institutions popular frameworks for the *Bildungsroman*, from Thomas Hughes's *Tom Brown at Oxford* (1859), to Ward's *Robert Elsmere* (1888), Evelyn Waugh's *Brideshead Revisited* (1945), and Alan Hollinghurst's *The Sparsholt Affair* (2017). The list of 'Oxford novels' is seemingly endless, even without the many detective novels which expose the more sinister aspects of collegiate life and relations between dons and students. Building character begets characters, many of which spring from the Oxford community of which Pater was an integral part. The slippery transition between real-life and fictitious characters, between characters as portraits or caricatures of leading Oxford academics, easily recognizable by the insiders, and enjoyed by the outsiders as representatives of an elitist, but influential, community, is worth exploring. Late Victorian Oxford was the undisputed seat of aestheticism, just as, a few decades later, Cambridge would become the hub of modernism. As a community both local and global, parochial and national, with a much larger impact on the nation and the world than most other English towns of that size, Oxford holds a special status within which Pater played a central role as an educator. 'Schooling', the power of influence as a way of male begetting, is a theme in much aestheticist writing, and from Mallock's parody of Pater as Mr Rose in *The New Republic* (1876) to Ward's Mr Langham, and Wilde's Lord Henry, the figure of the Paterian dandy/educator becomes a recognizable type who speaks Patersque and holds aesthetic ideals, most of which can be traced back to *The Renaissance* or misreadings of it. The Paterian persona becomes associated with Oxford, both as a place and as an institution, and I am keen to examine some of the ways in which the real-life individual gives rise to a type which the original can in turn satirize in his own fiction.

Pater's paternal authority may have been less militant than Ruskin's, but this did not preclude Oedipal conflicts with the members of the immediate 'School of Pater'—Lee, Wilde, Johnson, Berenson, Beerbohm, Symons, Moore, Le Galllienne, Yeats—before the modernists took their turn. The 'incorrigible Max' (Beerbohm), an undergraduate at Merton College in the early 1890s, only knew Pater from a distance. In a career of 'relentless retrospection',[68] Beerbohm engaged with Pater—partly through his friendship with William Rothenstein—as the father figure of

[67] See Dowling 1994.

[68] Lawrence Danson, *Max Beerbohm and the Act of Writing* (Oxford: Clarendon Press, 1989), 3.

aestheticism. This section travels backwards in time, from the mid-1890s, at the time of Pater's death and immediately after it, towards the 1870s and 1880s as Pater himself emerged as a character. As Pater and the Pateresque became increasingly well known, and hence a character or a style to caricature, a complex process of imitation and distortion, in word and image, evolved in an attempt to capture the essence of the *fin de siècle*, personified by Pater, before its last exhalation. Pater's own role in shaping the Pateresque is complex, but Wilde was not the only one who knew how to turn life into art.

In 1881 a pamphlet appeared: *Oxford Characters after the Manner of Theophrastus: Or, A Menagerie of Curious Beasts*. It contained verbal caricatures of dons and students, easily identified by local readers: Jowett as 'The Don who Thinketh Freely', and Pater's friend, the Assyriologist A. H. Sayce, as 'The Philosophic Man'.[69] We also find a portrait of the most modern of Oxford characters, 'The Aesthete', described in mock-archaic language.[70] The epitaph is from Hotspur's speech in Shakespeare's *Henry IV, Part I*, the monologue which Pater recited at Speech Day at the King's School:[71] 'He was perfumed like a milliner / . . . / For't make me mad / To see him shine so brisk, and smell so sweet, / And talk so like a waiting-gentlewoman.'[72] The portrait of the 'aesthetic man' who 'will let grow his hair and despise comb and brush', who 'deligteth in blue china and strange vessels' and 'intoxicateth himself on *Eau de Cologne*', parallels George du Maurier's satires in *Punch* and Gilbert and Sullivan's *Patience*, which opened the very same year. He is 'an aesthetic sham' who 'never laughs nor smiles, but talketh much of an early death, of the grape plucked ere it be ripe, of kisses that burn and bite and do other curious things; yet eateth he an hearty dinner'.[73]

The Oxford aesthete is a hybrid of Swinburne, Pater, and Wilde, a curious beast described in the tradition of Aristotle's pupil, Theophrastus (371 to 287 BC), whose thirty short prose sketches of imaginary characters were composed around 319 BC. While Aristotle had included a few moralizing character sketches in his *Rhetoric* (ii, 12–17), 'Theophrastus seems to have been the first to have hit on the idea of taking various moral and social qualities, examining them as manifested in imaginary but typical individuals, and presenting these descriptions in a complete and self-contained form'.[74] The Theophrastan *Characters* form counterparts to Philostratus' *Imagines*: a short, isolated form, centring on the human individual, arranged in a sequence which may be rearranged, just like the portraits in a picture gallery. The form became popular with rhetoricians, in Quintilian and the Ciceronian *Ad Herennium*, and constituted a component part of the Liberal Arts. As John Smeed declared, 'The book seemed to offer an invitation to later writers to borrow the method and use it to describe their own contemporaries. I cannot think of a smaller book with a greater influence.'[75]

In England the character study evolved from Joseph Hall's *Characters of Virtues and Vices* (1608) into an Oxford-centred form practised by Thomas Overbury (1614)

[69] William Hammon Devenish, *Oxford Characters after the Manner of Theophrastus: Or, A Menagerie of Curious Beasts* (Oxford: A. Thos. Shrimpton & Son, 1881), 5–6.

[70] Ibid., 10–11. [71] *Wright*, 1:134; Levey, 54.

[72] Shakespeare, *Henry IV, Part I*, I, iii, 361, 378–80. [73] Devenish, 11.

[74] Smeed, 6. [75] Ibid., 5.

180 WALTER PATER'S EUROPEAN IMAGINATION

and John Earle (1628), and became a popular genre, republished at the *fin de siècle*.[76] The major romantic essayists—Charles Lamb, Leigh Hunt, William Hazlitt—wrote character sketches,[77] and many Victorian novelists experimented with such studies, typically early in their careers, though with George Eliot, at the very end: Edward Bulwer-Lytton, *England and the English* (1833), Dickens, *Sketches by Boz* (1833–6), W. M. Thackeray's *Book of Snobs* (1846–7), and Eliot, *The Impressions of Theophrastus Such* (1879). The pages of *Punch* were full of character studies, as was the *Pall Mall Gazette* where Anthony Trollope's characters appeared before they were published in book form: *Hunting Sketches* (1866), *Travelling Sketches* (1866), *London Tradesmen* (1880). Henry Mayhew's social-realist *London Labour and the London Poor* (1851), known as *London Characters*, gave the genre a political twist, matching character with place. The relationship between the character sketch and the novel is a study in itself; the generalizing tendencies of the Theophrastan sketch clashed with the novelist's 'desire to show the *un*characteristic elements which single a man out from his fellows'.[78] In many Victorian novels, the character sketch co-existed with more complex characters, as 'most character-writers seem to have realized and surmounted the problems involved in combining the individual and the generic, so that the reader seldom has difficulty in recognizing all drunkards within the individual Drunkard'.[79]

'The Aesthete' in the 1881 *Oxford Characters* is far from a sophisticated portrait of Pater and his fragrant ilk,[80] but it brings the character study back to Oxford and serves as a precursor for the more notorious *Oxford Characters* issued by the aesthetes' leading publisher, John Lane, in 1896. In the summer of 1893, the painter William Rothenstein was entertained at Christ Church by the historian Frederick York Powell. Rothenstein had been commissioned by Lane to do twenty-four portrait drawings of eminent Oxonians, for which Powell and others were to write short character sketches.[81] Beerbohm met Rothenstein at a college dinner and followed him closely, as he pursued the most eminent men in Oxford: 'He was a wit. He was brimful of ideas. He knew Whistler. He knew Edmond de Goncourt. He knew everyone in Paris. He knew them all by heart. He was Paris in Oxford.'[82] Beerbohm's description of 'the Rothenstein effect' gives us a sense of its transformative powers (even if one deducts the Beerbohmiesque hyperbole):

In the Summer Term of '93 a bolt from the blue flashed down on Oxford. It drove deep, it hurtlingly embedded itself in the soil. Dons and undergraduates stood around, rather pale, discussing nothing but it. Whence came it, this meteorite? From Paris. Its name? Will Rothenstein. Its aim? To do a series of twenty-four portraits in lithograph for the Bodley Head, London. The matter was urgent. Already

[76] *A Book of Characters, selected from the Writings of Overbury, Earle, and Butler* (Edinburgh: n.p., 1865); John Earle, *Micro-cosmographie* (London: John Murray 1868); Henry Morley, ed., *Character Writings of the Seventeenth Century* (London: G. Routledge, 1891); John Earle, *Micro-cosmographie: or, A piece of the world discovered; in essayes and characters* (Cambridge: Cambridge University Press, 1903).
[77] Smeed, 116. [78] Ibid., 245.
[79] Ibid., 2. [80] See Maxwell 2017.
[81] William Rothenstein, *Men and Memories: Recollections of William Rothenstein*, 2 vols (London: Faber & Faber, 1931), 1:125, 131, 137.
[82] N. John Hall, *Max Beerbohm—A Kind of Life* (New Haven: Yale University Press, 2002), 23–4 (quoting from Beerbohm, *Seven Men* (London: Heinemann, 1919), 4–5).

CHARACTER AND CARICATURE 181

the Warden of A, and the Master of B, and the Regius Professor of C, had meekly 'sat'. Dignified and doddering old men, who had never consented to sit to any one, could not withstand this dynamic little stranger. He did not sue: he invited; he did not invite: he commanded. He was twenty-one years old.[83]

The headstrong Rothenstein 'insisted, much against Lane's wishes, on including a few portraits of undergraduates among those of the dons, arguing that, in a record of contemporary Oxford, undergraduates should have a place'.[84] The result is a publication which matches senior scholars with rowers, cricketeers, and rugby players, with the suggestion that *Bildung* is an ongoing exchange of ideas and energies between the old and the young. While the coupling of the older and the younger man may suggest the *erastes* and the *eromenos*—the Greek terms for the older, active lover and the younger, passive lover, respectively—it would be too limiting to see the *Oxford Characters* merely within the context of Greek love. Powell and Rothenstein's publication addresses the essence of Oxford life, implicitly asking what an Oxford character is. Is character subject or object, someone making Oxford what it is, or someone made in and by Oxford? To which extent should we take 'character' to mean 'a great personality', 'someone unique and very special', or someone playing a part in the great spectacle of England's elitist universities? The generic Theophrastan element has been suspended in the case of the scholars but retained in the portraits of the young. Portraits of Max Müller, James Murray, Ingram Bywater, Hillaire Belloc, and Charles Henry Olive Daniel intermingle with those of sporty undergraduates.[85] The book may allude to a Greek ideal of healthy minds in healthy bodies, yet with a clear separation between the white-haired or balding seated dons and the dapper standing undergraduates, suggestive of a division between headwork and bodywork. The exclusivity of the publication—who decided who was worthy of inclusion and who should be left out?—stressed a culture of insiders and outsiders, even though it was designed by a Jewish outsider from the North of England, trained in London at the Slade school by Alphonse Legros and in Paris by Toulouse-Lautrec. Beerbohm looked back on the *Oxford Characters* as the project which made Rothenstein's career:

That impulse which first whirled Will up to Oxford, the impulse to do a 'set' of the people who mattered most in a place that matters much, has never since loosened its hold on him. Celebrities come and go. Celebrities leave Will cold—unless they be something more than celebrated. Distinction is what he likes; and if it be coupled with obscurity, no matter: there it is, and all the better perhaps. There is something almost snobbish in Will's austere freedom from snobbery. Private nullity he will patiently record. To the public kind he is adamant. One is guilty of the weakness of

[83] Ibid., 24. [84] Rothenstein 1:144.

[85] Rothenstein and Powell, *Oxford Characters*. The work was published in eight parts, the first seven of which contain two portraits each, the last part ten portraits. Rothenstein's prefatory note outlined the sequence: 'Sixteen of these Lithographed Portraits were done during the year 1893; the remaining eight were drawn in the month of February of this year, and are dated '96. I would wish to record my thanks due to those friends of mine who have so generously and willingly supplied the Biographical Sketches facing my Drawings'.

182 WALTER PATER'S EUROPEAN IMAGINATION

shedding a tear for those famous men whose names are *not* here enshrined. They have been judged and found wanting.[86]

Ruskin was one such name found wanting; although he had been an undergraduate at Christ Church and a fellow of Corpus Christi, his withdrawal to the Lake District had made him an outsider. Most likely Rothenstein, trained in the very artistic schools which Ruskin had criticized, saw him as a man of the past and did not feel inclined to include him, although few could doubt Ruskin's influence on 'the Oxford character'. He was merely granted a brief reference in Sir Henry Acland's portrait.[87] Powell probably wrote most of the character sketches, including his own:[88] witty, suggestive, and capricious in their selection of character traits and academic achievements. The texts have the elegance of the long life compressed into very short form, often foregrounding the insignificant or whimsical at the expense of the standard life. With our awareness that much has been left out, we know we are reading subjective texts, reflective of 'the Oxford character'. While the portraits of senior academics are individualized, those of the undergraduates are generic (the brilliant cricketer/rower/public speaker): young men to whom a long life and career are all in the future. It remains unknown who did the 'matching' of senior academics and sporting undergraduates in the first seven parts of the book.

The only signed character sketch is the one Pater wrote of his close colleague at Brasenose, the musicologist F. W. Bussell with whom he was himself 'coupled' in Part VI of the publication.[89] A dandy figure, known for his 'very showy ties', together with the 'hot-house flowers sent him from London of the same colour as his ties, to wear in his button-hole',[90] Bussell was a 'character' in every sense of the word, indeed was celebrated as one such in the *Times* obituary.[91] C. J. Holmes, a Brasenose undergraduate from 1887 to 1890, and Director of the National Portrait Gallery from 1906 to 1916, painted a vivid portrait of Bussell, 'with his eyeglass and dandified air, his smart riding breeches and equally smart repartees; his phenomenal knowledge of philosophy and political history, of silver Latin and of stocks and shares; his precocious Doctorate

[86] Max Beerbohm, 'Preface' in *The Portrait Drawings of William Rothenstein 1889–1925. An Iconography by John Rothenstein with a Preface by Max Beerbohm and 101 Collotype Plates* (London: Chapman & Hall, 1926), xii–xiii.

[87] Rothenstein and Powell, Part I (no pagination).

[88] 'Universal acclamation hails Professor York Powell as one of the most omniscient and popular men in Oxford. Though he has largely devoted himself to the theory and practice of the art of self-defence, his friends would bet heavily on him in a contest with any specialist (German or otherwise) on a fair subject. He can afford to give points in the art of objurgation, in half a dozen languages, to the liveliest Professor of Natural Science; indeed, the only thing he finds really difficult to do is to keep an appointment. Though his sympathy with the unconventional makes the world suppose him an anarchist, he is really much too good a fellow to be anything but the wisest and most genial of Tories.' Ibid., Part VIII.

[89] See letters to John Lane of 15 Mar. 1894, 25 Mar. 1894 and 5 Apr. 1894 in *CW* 9.

[90] Sabine Baring-Gould *Further Reminiscences 1864–1894* (London: John Lane Bodley Head, 1927), 135.

[91] 'His departure deprived Oxford of one of her most notable characters, one who already in his undergraduate days had become a well-known and much talked of personality in the university and conspicuous for his loud check suit and monocle.' Anon., 'Rev. Dr. F. W. Bussell, Late Principal of Brasenose', *Times* (1 Mar. 1944), 7.

in music and his singing of nigger-songs in an amazing falsetto treble.'[92] He linked Bussell's teaching of stylistics in Latin prose to his close association with Pater. Rothenstein connected the friendship between Bussell and Pater with undergraduate entertainment, of the athletic rather than the aesthetic types. Brasenose had a distinctly sporting, rather than academically high-achieving, profile, and the juxtaposition of Pater with a group of athletically trained bodies, with Bussell as accomplice, makes for a good anecdote: 'Just as certain intellectuals affect a passion for detective stories, so Pater made a practice of entertaining the football-and-cricket-playing undergraduates, while he rather ignored the young *précieux*. He gave regular luncheon parties on Wednesdays; each time I was invited, I met very tongue-tied, simple, good-looking youths of the sporting fraternity. But Pater's close companion, Bussell, was always of the party, to share Pater's slightly malicious enjoyment.'[93] Pater drew parallels between Greek athletes and the young men of the Oxford playing fields: his 1894 essay 'The Age of Athletic Prizemen' returned to Myron's *Discobolos*:

> What is a portrait? That one can so much as ask the question is a proof how far the master, in spite of his lingering archaism, is come already from the antique marbles of Aegina. Was it the portrait of one much-admired youth, or rather the type, the rectified essence, of many such, at the most pregnant, the essential, moment, of the exercise of their natural powers, of what they really were? Have we here, in short, the sculptor Myron's reasoned memory of many a quoit-player, of a long flight of quoit-players; as, were he here, he might have given us the cricketer, the passing generation of cricketers, *sub specie aeternitatis*, under the eternal form of art?[94]

Pater's own portrait of Bussell, composed in late March 1894,[95] was to be the last completed and published piece he would write before his death in July. As College Chaplain and close friend, Bussell would repay the tribute when he gave Pater's memorial sermon in the College Chapel on 14 October 1894.[96]

> Mr F. W. Bussell, Fellow of B.N.C. and Mus Bac.
>
> Is as young as he looks here. He was early distinguished in the University, and has already preached some remarkable sermons in Saint Mary's pulpit. His friends love him; and he is popular with the undergraduates whom he instructs. His versatility is considerable; but he is above all a student, with something like genius for classical literature, especially for the early Christian theology and late Pagan philosophy of the imperial age, which he reads as other people read the newspapers. His expression after some hours of such reading is here recorded with remarkable fineness. He is capable of much.
>
> WALTER PATER.[97]

[92] C. J. Holmes, *Self & Partners (Mostly Self): Being the Reminiscences of C. J. Holmes* (London: Constable, 1936), 102.

[93] Rothenstein 1931, 1:139. [94] *CW* 8:179.

[95] The piece was enclosed with a letter to John Lane, dated 'Easter Day [25 Mar.] 1894.' *CW* 9.

[96] The sermon, in the extended version which appeared in the *Oxford Magazine* 13 (17 Oct. 1894) 7–8, is reprinted in Seiler 1987, 177–81.

[97] Rothenstein and Powell, 1896, Part VI.

184 WALTER PATER'S EUROPEAN IMAGINATION

Academic distinction, and versatility, together with a prodigious command of Latin, stand out in Pater's portrait. Bussell was Pater's junior by twenty-three years, and Pater's delight in his youth—in looks, attitude, intellect—transpires clearly. The final sentence is open to interpretation. Pater stresses Bussell's Sophistic interests; amongst Bussell's own publications we find titles suggesting the proximity to Pater's interests: *The School of Plato: Its Origin, Development, and Revival under the Roman Empire* (1896), *Marcus Aurelius and the Later Stoics* (1909), and *Religious Thought and Heresy in the Middle Ages* (1918). Rothenstein had approached Pater in the autumn of 1893, first by inviting him to Paul Verlaine's Oxford lecture,[98] and subsequently asking him to sit for his portrait. The don applied in the affirmative and invited Rothenstein to dinner at home, together with Bussell.[99] Pater's acceptance is interesting; did he agree, out of vanity, pleased to be included in the Oxford set? Apparently, Bussell played a not insignificant part in persuading him:

> I wanted to include a portrait of Pater in the Oxford set, but he was morbidly self-conscious about his appearance. He had been drawn as a youth by Simeon Solomon, and was reluctant, later in life, to be shown as he was. Still, he seemed interested in the drawings I was doing and, hesitatingly, suggested I should try Bussell first. Bussell sat and Pater approved of the result. Perhaps Bussell added his persuasion to mine; at any rate he said that Pater was no longer averse to sitting. A drawing was duly made, and sent away to be put down on the stone. When the proofs came I showed one to Pater. He said little, but was obviously displeased; according to Bussell he was more than displeased, he was upset. He had taken the print into Bussell's room, laying it on the table without comment. They then went together for their usual walk; but not a word was spoken. On their return, as Pater left Bussell at his door, he broke silence. 'Bussell, do I look like a Barbary ape?' Then came a tactful letter from Pater:
>
> *Oxford March | 11th.*
>
> My dear Rothenstein,
>
> I thought your drawing of me a clever likeness, but I doubt very much whether my sister, whom I have told about it, will like it; in which case I should rather not have it published. I therefore write at once to save you needless trouble about it. Put off the reproduction of the drawing till you come to Oxford again, and then let her see it. I thought your likeness of Bussell most excellent, and shall value it. It presents just the look I have so often seen in him, and have not seen in his photographs. I should have liked to be coupled with him, and am very sorry not to be. I think, however, you ought to publish him at once, with some other companion; and I will send you four or five lines for him soon.
>
> With sincere thanks for the trouble you have taken about me, I remain,
>
> Very truly yours,
> WALTER PATER[100]

[98] See Pater's letter to Rothenstein of 23 Nov. 1893, *CW* 9.
[99] See Pater's letter to Rothenstein of 16 Jan. 1894, *CW* 9. [100] Rothenstein 1931, 1:155–6.

CHARACTER AND CARICATURE 185

Pater was probably 'morbidly self-conscious about his appearance', and although he had used his sister's taste as an excuse, the letter he wrote directly to Lane four days later leaves no doubt where the real problem lay. It is, for Pater, an unusually direct, even 'imperious and rather manipulative' letter,[101] demanding action on Lane's part:

64 St. Giles's | Oxford. | March 15th.

Dear Mr Lane,

When my friend, Mr Rothenstein, left me the other day, I understood that the lithograph of his drawing would be submitted to me for approval, before publication. He tells me, however, that the printing of it is begun, and refers me to yourself. The fact is, I think it is a very unpleasing likeness of me, and am certain my friends here will dislike it even more than I do. I am sure I only have to tell you this, to prevent the further printing or publication of it in any way.

I must add that Mr. Rothenstein's drawing of Mr. Bussell is a really good likeness; and will, I feel confident, be very popular in Oxford. I should be glad to send you a few lines to accompany it, as soon as you please, if you desire that I should do so.

Believe me

Very truly yours
Walter Pater.
R. S. V. P.

It would appear that writing Bussell's character sketch was Pater's own idea, a compensation for being difficult? or an attempt to control Bussell's afterlife? In both letters, 'friends' and the Oxford community are factors to be taken into account, suggesting a publication which is as much self-reflective and inward-looking, as a picture of Oxford characters directed to the outside world. After some four weeks of palaver, Pater requested on 5 April that his portrait be withdrawn, while offering to sit a second time for a better likeness.[102] Pater's portrait was only included (Fig. 4.4), together with Bussell's (Fig. 4.5) two years after his death, with a dull character sketch.[103] One might ask why Rothenstein, Powell, and Lane did not simply abandon Pater and match Bussell with someone else? Was Pater's refusal to have his portrait

[101] B. A. Inman, 'Pater's Letters at the Pierpoint Morgan Library', *English Literature in Transition, 1880–1920* 34:4 (1991), 407–17, 416.

[102] See letter to John Lane of 5 Apr.1894, *CW* 9.

[103] 'Was born at Shadwell, at that time a pleasant suburb of London, on August 4, 1839. From the King's School, at Canterbury, he proceeded to Oxford in 1858, and entered as a commoner at Queen's College; four years later he took his degree; and in 1864 was elected a Fellow of Brasenose College. His first essay was a note on Coleridge, which he wrote and printed at the age of twenty-seven; and his first volume was the "Studies in the History of the Renaissance", which appeared in 1873. For the next twelve years he published nothing; but, at length, in 1885, was issued "Marius the Epicurean". This, in its scope and proportions his greatest work, was followed in 1887 by the "Imaginary Portraits", in 1889 by the "Appreciations", and in 1893 by the lectures on "Plato and Platonism". He died suddenly and unexpectedly on July 30, 1894; before he had completed his fifty-fifth year, and before the extraordinary originality of his mind had exercised its full influence. A volume of "Greek Studies", recently issued, is one of three posthumous volumes, which will complete the publication of his works. Hei mihi, qualis erat! Quantum mutates ab illo!' Rothenstein and Powell, Part VI.

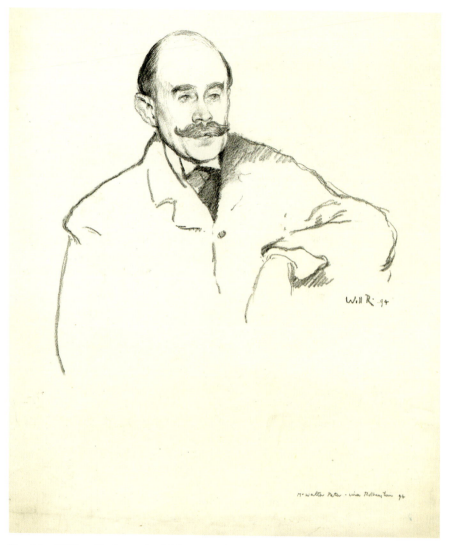

Fig. 4.4. William Rothenstein, *Walter Pater* (1894), lithograph from *Oxford Characters Part VI*. The William Andrews Clark Memorial Library, University of California, Los Angeles.

included instrumental in postponing publication?[104] Part VIII, drawn in the wake of the Wilde scandal, abandoned the coupling of young and old, perhaps in premonition of the reviewers' judgements: commenting of the juxtaposition of permanence (the scholars) and ephemerality (the students), Frederick Wedmore called the *Oxford*

[104] By 24 Oct. 1894 it had been agreed to publish Pater's portrait. Lionel Johnson, going through Pater's manuscripts in Oxford, wrote back enthusiastically to Rothenstein, 'Delighted to hear that the Pater lithograph is to appear.' Rothenstein 1931, 1:157.

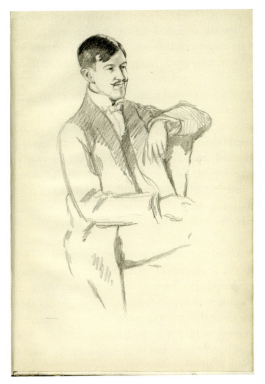

Fig. 4.5. William Rothenstein, *F. W. Bussell* (1894), lithograph from *Oxford Characters Part VI*. The William Andrews Clark Memorial Library, University of California, Los Angeles.

Characters 'an audacious adventure, which had youth for its excuse', an 'abstract and brief chronicle, of the Oxford of a day'.[105] The *Athenaeum* found the matching of young and old, celebrating brawn over brain, unfortunate, but admitted that the portraits, which at first might strike the viewer as caricatures, were 'wonderfully faithful and full of humour', full of 'characteristic expressions and attitudes'.[106] The *Daily Chronicle* reviewed the collection under the heading 'Oxford Caricatures',[107] and singling out the Pater portrait as 'among the least satisfactory', the *Saturday Review*, spoke of Rothenstein's unconscious 'tendency towards caricature' which nevertheless in most cases resulted in a good likeness.[108] The grey-zone area between character and caricature was a point to which the reviewers returned; in most cases Rothenstein had captured the essence of personality, to the extent that it sometimes made sitters and audiences feel uncomfortable. The artist himself found that each of his sitters 'thought twenty-three of the twenty-four drawings excellent likenesses; the

[105] Frederick Wedmore, 'The Revival of Lithography II', *Art Journal*, Feb. 1896, 41–4, 41.
[106] Anon., 'Oxford Characters', *Athenaeum* 3617 (20 Feb. 1896), 251.
[107] Rothenstein 1931, 1:294.
[108] Anon., 'Oxford Characters', *Saturday Review* 82 (7 Nov. 1896), 504–5.

twenty-fourth was his own.[109] Several sitters had their portraits drawn twice, so Pater was not alone in requesting a second sitting. Rothenstein reflected that 'Had I paid too much attention to my sitters' feelings, few of my portraits would ever have seen the light. Any record sincerely made from the life has a certain value; this fact, I felt, was my justification.[110]

Pater's elusive appearance proved a challenge to the artist who would make a life-time profession as a caricaturist: Beerbohm repeatedly tried to capture Pater, but 'couldn't hit on a formula'.[111] With his mask-like face, heavy eyelids, and moustacioed mouth (Fig. 4.6), Beerbohm's inexpressive face covered a lively parodic self. Wilde's question to their mutual friend Ada Leverson—'When you are alone with him, Sphinx, does he take off his face and reveal his mask?'—pinpoints the tension between inner and outer which James had also suggested in his description of Pater as 'the mask without the face'.[112] Beerbohm's correspondence with Rothenstein reveals plans for a parallel series to the *Oxford Characters*:

> John Lane has consented to publish a series of caricatures of Oxford Celebrities by me: they are to appear concurrently with yours in order to make the running. In case any ill feeling should arise between us on this account, I am sending you the proofs of the first number. Very satisfactory, I think. Do not think harshly of John Lane for publishing these things without consulting you—there is a taint of treach-ery in the veins of every publisher in the Row and, after all, though our two styles may have something in common, and we have chosen the same subjects, I am sure there is room for both of us.[113]

Several scholars suggest that Beerbohm's letter was merely a joke, but there may well have been more to the project.[114] In a letter to Rothenstein of September 1893, Aubrey Beardsley referred to Rothenstein's recent time in Paris with 'Jean Lane (who by the way is behaving (I think) very treacherously both to you and myself)', a remark which may suggest Beerbohm's proposed series.[115] Even before Rothenstein was commissioned to do his *Oxford Characters*, Beerbohm had similar plans, declaring to Reggie Turner on 19 December 1892: 'I am going to employ my time with a series of Oxford Studies (this is quite true): a kind of types such as Rudolph the Lehmann published in *Punch*: they will be for the most part personal attacks on my friends... but not a word to *anybody*: for they will be published very anonymously by Blackwell or somebody and will be of wonderful brilliancy.'[116] Beerbohm's Oxford series never

[109] Rothenstein 1931, 1:155. [110] Ibid., 1:155. [111] Ibid., 1:146.

[112] Leverson's 'Reminiscences' in *Letters of Oscar Wilde to the Sphinx*, in ed. Violet Wyndham, *The Sphinx and her Circle: A Biographical Sketch of Ada Leverson 1862–1933* (New York: Vanguard Press, 1963), 119.

[113] Rothenstein 1931, 1:145.

[114] David Cecil, *Max: A Biography* (London: Constable, 1964), 66–7 where more youthful pranks between the two are chronicled. Mary M. Lago and Karl Beckson, ed., *Max and Will: Max Beerbohm and William Rothenstein. Their Friendship and Letters 1893–1945* (London: John Murray, 1975), 17.

[115] *The Letters of Aubrey Beardsley*, ed. Henry Maas, J. L. Duncan, and W. G. Good (London: Cassell, 1970), 54–5.

[116] Max Beerbohm to Reggie Turner, 19 Dec. 1892, in Beerbohm, *Letters to Reggie Turner*, ed. Rupert Hart-Davis (London: Rupert Hart-Davis, 1964), 29.

CHARACTER AND CARICATURE 189

Fig. 4.6. Elliott & Fry, *Max Beerbohm* (*c.*1900), photograph. [Elliott & Fry]/[Conde Nast Collection]/Getty Images.

materialized, but a drawing which has recently surfaced may well have been part of it: *Walter Pater by Will Rothenstein* (Fig. 4.7).[117] It belongs to a group of what Mark Samuels Lasner has appropriately called 'curious cross-caricatures': drawings made in the 1890s by Rothenstein and Beerbohm in the style of each other, with 'false' signatures.[118] The exact number of those cross-caricatures has not yet been established, but they occasionally turn up on the art market, leaving art dealers and connoisseurs in doubts as to the true identity of the artist. Inviting us to distrust both line and signature, or merely one or the other, the cross-caricatures play tricks with our decoding skills, with names and identities, in a way which resembles Wildean Bunburying: one can never be entirely sure of one's own identity, and identity theft is likely to occur, even from one's best friends.

In the drawing Pater's 'brazennosed' frontality is terrifying: a big head with enormous ears and a moustache which stretches across the entire width of the face rests

[117] I am grateful to Joe Bristow for having drawn my attention to the drawing, and to the Clark Library Archivist, Rebecca Fenning Marschall for helpful correspondence.
[118] Personal communication in e-mail correspondence of April 2021. I owe Mark Lasner many thanks for informing me of the friendship between Beerbohm and Rothenstein.

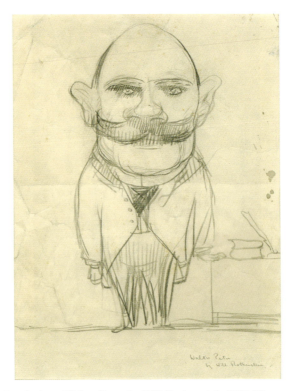

Fig. 4.7. Max Beerbohm, *Walter Pater by Will Rothenstein* (1894?), pencil, 20.3 cm × 25.4 cm. The William Andrews Clark Memorial Library, University of California, Los Angeles.

on feeble ground.[119] The crude linear hatching around the eyes, the nose, and moustache may create a sense of movement in an otherwise rigidly static figure. Do we see a fluttering of the eyes, a twitching of the nose, a slight quivering of the moustache, or do the many parallel strokes rather express a certain Oedipal anger towards the defining features which sum up the Pateresque face? The tiny feet seem incapable of supporting the bulky corpus, and Pater accordingly rests one small hand on a table. This is the aesthete's equivalent of John Tenniel's Humpty Dumpty (1871), come down from his wall, balancing his delicate hand on the lectern in order not to fall over. The sitter's gaze contributes towards an overall impression of a confrontational figure, very different from Rothenstein's seated Pater, caught in the usual three-quarter profile. The drawing is creased and crumpled; someone, most likely Beerbohm himself, appears to have tried to destroy it and throw it away.[120] The

[119] Pater's friends assembled in Oxford to discuss what could be done to improve his less fortunate exterior and came up with the Bismarckian moustache as a solution. See 'A Story of a Moustache', *Wright*, 1:192–3.

[120] The provenance is short: Professor Majl Ewing, who left the drawing to the Clark Library, bought it in March 1961 from the bookseller G. F. Sims (lot. 513), who put up a sale of Beerbohm's private collection after the artist's death in 1956. The drawing may have remained in Beerbohm's collection.

question is whether the Clark drawing primarily tells us something about Beerbohm, about Pater, or about Rothenstein's manner of drawing Oxford characters. Does the aggressive hatching show us a side of Pater with which we are not familiar, does it project Beerbohm's own anger, or does it exaggerate Rothenstein's controversial line which made many of his sitters uneasy once they were confronted with their portraits? Although coarse and distorted, the sitter is immediately recognizable, also without Beerbohm's inscription in the corner. Compared with his other Pater caricature of 1926 (Fig. 4.8), the early drawing suggests youthful rebellion, also in drawing technique. In a letter to the critic E. F. Spence, Beerbohm outlined his particular way of looking at a person, transforming exterior into caricature as a means of using the outer to get at the inner man. The passage provides food for thought about diminutive feet and moustaches, and makes us think about likeness, character, and caricature:

> When I draw a man, I am concerned simply and solely with the physical aspect of him. I don't bother for one moment about his soul. I just draw him as I see him. And (this is how I come to be a caricaturist) I see him in a peculiar way: I see his salient points exaggerated (points of face, figure, port, gesture and vesture), and all his insignificant points proportionately diminished. *Insignificant*: literally, signifying nothing. The salient points do signify something. In the salient points a man's soul does reveal itself, more or less faintly. At any rate, if it does not always reveal itself through them, it is always latent in them. Thus if one underline these points, and let the others vanish, one is bound to lay bare the soul. But that is not sacrificing physical resemblance. If, instead of intensifying it, one misses it, then one misses the soul also. It is because (and only because), or, let us rather say, when (and only when) my own caricatures hit exactly the exteriors of their subjects that they open the interiors, too.[121]

Pater had become a favourite Oxford figure for undergraduates to capture: Holmes made two pen drawings of him, one of his Oxford appearance (wearing his hair long and unkempt) (Fig. 4.9), and the other of his spruce London self (Fig. 4.10).[122] James Hearn ('JCR Spider'), who matriculated at Brasenose in 1892, drew Pater as 'Marius the Epicurean' (Fig. 4.11), a drawing which may well have served Beerbohm as inspiration. By the mid-1890s, Pater's centrality as an Oxford character can hardly be doubted; in Beerbohm's early autobiographical essay 'Diminuendo', Oxford was synonymous with Pater.[123] Published by John Lane in 1896, the same year as the *Oxford Characters*, the essay concluded a slim volume entitled *Works*, a title which 'claims to

[121] Letter to E. F. Spence, 31 May 1903, now in the Beinecke Rare Book and Manuscript Library, Yale University. Quoted from Lago and Beckson, *Max and Will*, 8.

[122] 'Pater's appearance at the time of my coming to Brasenose differed considerably from that which some three years later became familiar in Kensington. There he tripped along in a smart top-hat and black jacket, with stiff clipped moustache, neatly rolled umbrella and dog-skin gloves. But for the dreamy fixity of his gray eyes he might have been a retired major in the Rifle Brigade. At Oxford his hair was left to grow rather long, his moustaches to droop, his walk was a paddle, and the general effect that of a foreign musician, or possibly an organist.' Holmes, 102.

[123] For Beerbohm's Oxford, see Alex Murray, 'Stirring the Cumnor Cowslips in Decadent Oxford', in Murray, *Landscapes of Decadence: Literature and Place at the Fin de Siècle* (Cambridge: Cambridge University Press, 2016), 88–122.

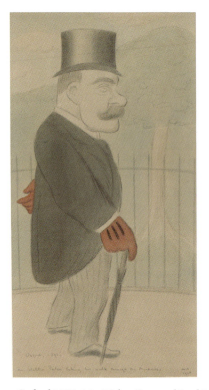

Fig. 4.8. Max Beerbohm, *Oxford 1891. Mr. Walter Pater taking his walk through the Meadows* (1926), pencil, ink, and watercolour on paper, 38.1 × 20 cm. Mark Samuels Lasner Collection, University of Delaware Library, Museums and Press.

have won what by the same token it mocks, a literary reputation.'[124] Lane's Bibliography to the volume claimed identical birth dates for Beardsley and Beerbohm,[125] asserting *fin-de-siècle* decadence by linking Beerbohm with the tubercular Beardsley. While marking the death of the Pater era, the Diminuendo essay also paid it homage: the Brasenose don is a physical presence, a voice, a style, a philosophy, a father figure against whom to react. If Beerbohm celebrated Rothenstein's youthful energy, his own stance was that of the old man, already weary with life and ready for retirement. Beerbohm had read *Marius* as a child and imagined coming up to Oxford as an event similar to Marius' arrival in Rome. The reader was bound to be disappointed, as life rarely measured up to art: 'Bitter were the comparisons I drew between my coming to Oxford and the coming of Marius to Rome. Could it be that there was at length no beautiful environment wherein a man might sound the harmonies of his soul? Had civilization made beauty, besides adventure, so rare? I wondered what counsel Pater, insistent always upon contact with comely things, would

[124] Danson, 35. [125] Beardsley was born on 21 Aug. 1872, Beerbohm on 24 Aug. 1872.

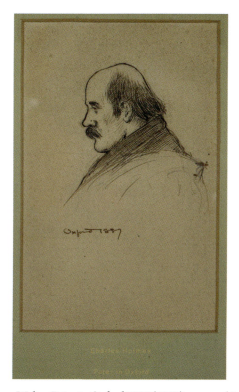

Fig. 4.9. C. J. Holmes, *Walter Pater in Oxford 1889* (1889), pen and ink. Brasenose College, Oxford (D.13 in the College Picture Catalogue). Gift of Martin Holmes. With the kind permission of the King's Hall and College of Brasenose, Oxford.

offer to one who could nowhere find them?'[126] The Oxford which awaited him—'*On aurait dit* a bit of Manchester through which Apollo had once passed'[127]—provoked a sense of decadence. Spotting Pater one day in a stationer's shop, Beerbohm's disappointment was complete:

> In the year of grace 1890, and in the beautiful autumn of that year, I was a freshman at Oxford. I remember how my tutor asked me what lectures I wished to attend, and how he laughed when I said that I wished to attend the lectures of Mr. Walter Pater. Also I remember how, one morning soon after, I went into Ryman's to order some foolish engraving for my room, and there saw, peering into a portfolio, a small, thick, rock-faced man, whose top-hat and gloves of *bright* dog-skin struck one of the many discords in that little city of learning or laughter. The serried bristles of his moustachio made for him a false-military air. I think I nearly went down when they told me that this was Pater.

[126] Max Beerbohm, 'Diminuendo', *The Works of Max Beerbohm*, with a Bibliography by John Lane (London: John Lane, 1896), 147–60, 152.
[127] Ibid., 152.

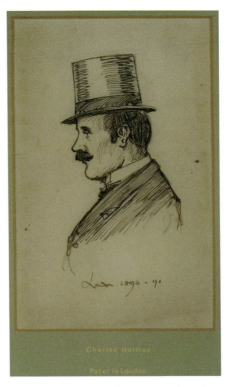

Fig. 4.10. C. J. Holmes, *Walter Pater in London 1890–91* (1891), pen and ink. Brasenose College, Oxford (D.14 in the College Picture Catalogue). Gift of Martin Holmes. With the kind permission of the King's Hall and College of Brasenose, Oxford.

> Not that even in those more decadent days of my childhood did I admire the man as a stylist. Even then I was angry that he should treat English as a dead language, bored by that sedulous ritual wherewith he laid out every sentence as in a shroud—hanging, like a widower, long over its marmoreal beauty or ever he could lay it, at length, in his book, its sepulchre. The writing of Pater had never, indeed, appealed to me…having regard to the couth solemnity of his mind, to his philosophy, his rare erudition.…And I suppose it was when at length I saw him that I first knew him to be fallible.[128]

Beerbohm proceeds on a Pateresque note in a double parody of Pater and himself. He caricatures the Paterian way of life as crude physical indulgence from which the author attempts to abstain: 'It was, for me, merely a problem how I could best avoid "sensations", "pulsations", and "exquisite moments" that were not purely intellectual.'[129] Yet the author's hyperboles mark him out as one of the 'young men into whose hands' the 'Conclusion' to *The Renaissance* had fallen. Beerbohm makes a giant stride of

[128] Ibid., 149–50. [129] Ibid., 157.

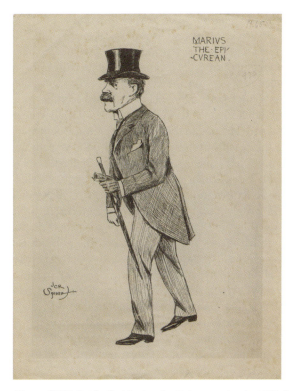

Fig. 4.11. James Hearn ('JCR Spider'), *Marius the Epicurean* (early 1890s), pen and ink. Brasenose College, Oxford (MPP 134 B3 in the College Archive Catalogue). With the kind permission of the King's Hall and College of Brasenose, Oxford.

incongruous pairing as he progresses from Pater in the local stationer's shop to a vision of the Prince of Wales as a Paterian disciple, hunting wild elephants in India:

> He has danced in every palace of every capital, played in every club. He has hunted elephants through the jungles of India, boar through the forests of Austria, pigs over the plains of Massachusetts. From the Castle of Abergeldie he has led his Princess into the frosty night, Highlanders lighting the torches the path to the deer-larder, where lay the wild things that had fallen to him on the crags. He has marched the Grenadiers to chapel through the white streets of Windsor. He has ridden through Moscow, in strange apparel, to kiss the catafalque of more than one Tzar. For him the Rajahs of India have spoiled their temples, and Blondin has crossed Niagara along the tight-rope, and the Giant Guard done drill beneath the chandeliers of the Neue Schloss. Incline he to scandal, lawyers are proud to whisper their secrets in his ear. Be he gallant, the ladies are at his feet. *Ennuyé*, all the wits from Bernald Osborne to Arthur Roberts have jested for him. He has been 'present always at the focus where the greatest number of forces unite in their purest energy', for it is his presence that makes their forces unite.[130]

[130] Ibid., 154–5.

196 WALTER PATER'S EUROPEAN IMAGINATION

Harold Nicolson would sing his wife's praises in parody of Pater's *Mona Lisa*, but Beerbohm's lust-led Prince of Wales has a physical energy which leaves the seated Lady Lisas breathless. The peculiar tension within the 'incomparable Max' between the old man and the child mirrors the incongruity between the plain and commonplace physical appearance of Pater and the ecstatic and extravagant lifestyles (wrongly) attributed to his philosophy. *Diminuendo* soon becomes *rallentando*, as the 24-year-old Beerbohm declares with world-weariness: 'I shall write no more. Already I feel a trifle outmoded. I belong to the Beardsley period. Younger men, with months of activity before them, with fresher schemes and notions, with newer enthusiasm, have pressed forward since then. *Cedo junioribus.* Indeed, I stand aside with no regret. For to be outmoded is to be a classic, if one has written well. I have acceded to the hierarchy of good scribes and rather like my niche.'[131] Max would carry on in his own peculiar vein of relentless retrospection for another fifty years, and was, in Danson's words, 'anything *but* "incomparable": the constant invitation to comparison is one of the things that makes *The Works* so risky. The problem is less one of comparative greatness—is Max the parodist a bigger or a smaller writer than Pater the parodee?—than of originality and personality. How in imitating others to be oneself?'[132] As a subversive form, parody dissolves boundaries between one author and another while also questioning our ideas about the integrity of personality and artistic product. 'As a parodist Beerbohm is a contradiction in terms: an original artist in the mode of mimicry, creating a distinct personality through the imitation of others.'[133] Where does parody stop and writing begin, and what does our reading of Beerbohm do to our reading of Pater?

My reason for dwelling at some length on Beerbohm is to look at him as a transitional figure, between the aesthetes and the modernists, doing the police in many voices, picking up on the proto-modernist aspects of Pater's writings, such as the ways in which he adopted the pastiche in an attempt to create character, while at the same time becoming an Oxford character with such a distinctive voice that at least two generations of writers felt compelled to imitate it. The paradoxical conundrum of 'being devious in order to be oneself in writing',[134] was not merely an issue for Beerbohm, but one which goes much further back and connects Beerbohm and Pater with Lamb and Montaigne in palimpsestic layers of quotations and misquotations. What Pater in his essay on Lamb called 'the *Montaignesque* element in literature' dealt with the duplicity of being both self and other in one's writing.[135] Woolf echoed Pater in 'The Modern Essay' in 1922, but gave the wreath to the incomparable Max: 'What Mr Beerbohm gave [to the modern essay] was, of course, himself. This presence, which has haunted the essay fitfully from the time of Montaigne, had been in exile since the time of Charles Lamb. Matthew Arnold was never to his readers Matt, nor Walter Pater affectionately abbreviated in a thousand homes to Wat. They gave us much, but that they did not give.'[136]

[131] Ibid., 160. [132] Danson, 58.
[133] Ibid., 143. [134] Ibid., 26.
[135] 'Charles Lamb: The Character of the Humourist', 471–2.
[136] Virginia Woolf, 'The Modern Essay', *EVW* 4:216–27, 220.

Caricaturing Mr Rose

While complex and richly intertextual, Beerbohm's youthful parodies and caricatures also belong in the tradition of the undergraduate prank, the juvenile imitation of one's teachers, of which Pater had long been the target. Pater had become an Oxford character and an Oxford voice when still in his thirties in Mallock's *The New Republic: Culture, Faith and Philosophy in an English Country House*, serialized between June and December 1876 in *Belgravia: An Illustrated London Magazine* and published in volume form the following year. A former Balliol undergraduate, Mallock had studied under Jowett and was well informed on local gossip. His parody of Plato, kept almost exclusively in dialogue form, contained portraits of well-known Oxford characters: Ruskin, Arnold, Pattison, Jowett, Huxley, and Pater as the aesthete Mr Rose. Much has been written about Mallock's Mr Rose, and Pater's contemporaries disagreed on whether the caricature was an apt portrait or not.[137] By 1881, when Lee met Pater for the first time, she expected to find Mr Rose, but confessed to her mother (with a touch of disappointment?) that 'He is heavy, but to my surprise quite unaffected, & not at all like Mr. Rose'.[138] A few years previously James had commented to Grace Norton, 'Pater seems to me quite the best figure [in *The New Republic*] and indeed superbly successful'.[139] While many of Pater's friends perceived his vulnerability to the parody, and linked his withdrawal from the candidature as Oxford Professor of Poetry to Mallock's satire, Gosse insisted that Pater had been flattered to be included in such illustrious company.[140] Yet Gosse's refutation of all negative rumours in the obituary portrait has the opposite effect. We can be fairly certain that Pater took Mallock's criticism to heart; much of his writing over the next two decades exposed the shallowness of aestheticism, while challenging lives devoted exclusively to the pursuit of art for art's sake.

Introduced as 'the pre-Raphaelite' who 'always speaks in an undertone' on 'self-indulgence and art',[141] Mr Rose employs rhythms and cadences, easily recognizable by anyone familiar with *The Renaissance*; echoes of the *Mona Lisa* passage and the 'Conclusion' abound. The dreamy Mr Rose, all words and no action, speaks in an incantatory style while often carried away by the mesmerizing sound of his own voice. A ladies' man, he nevertheless argues in favour of male friendships,[142] a delicate topic, given that William Money Hardinge, the so-called 'Balliol Bugger' with whom Pater had been scandalously involved,[143] appeared as the character of 'Robert

[137] Oscar Browning, Mary Robinson, and William Sharp all found Mallock's caricature misleading. See Seiler 1987, 26, 64, and 93.

[138] Letter of 18 Jul. 1881, *Vernon Lee's Letters*. With a Preface by her Executor, ed. Irene Cooper Willis (London: privately printed, 1937), 79.

[139] Letter of 1 May 1878, quoted in Seiler 1987, 62.

[140] Pater 'thought the portrait a little unscrupulous, and he was discomposed by the freedom of some of its details. But he admired the cleverness and promise of the book, and it did not cause him to alter his mode of life or thought in the smallest degree. He was even flattered, for he was an author much younger and more obscure than most of those who were satirised, and he was sensible that to be thus distinguished was a compliment.' Gosse 1894, 803–4.

[141] Mallock, 15. [142] Ibid., 189.

[143] See B. A. Inman, 'Estrangement and Connection: Walter Pater, Benjamin Jowett and William M. Hardinge', in Brake and Small 1991, 1–20.

198 WALTER PATER'S EUROPEAN IMAGINATION

Leslie' in Mallock's novel. The nebulous Mr Rose invokes a somatic aestheticism, in which everything is rooted in the body. The search for powerful sensory impressions manifests itself in a modern consumerism, centred on interior design, with a certain floral focus confirming the aptness of his name. This cosmopolitan character, bent on incorporating the past into the present, shrinks the world into a single room: 'Mr. Rose had taken a crimson flower from a vase on the table, and, looking at it himself with a grave regard, was pointing out its infinite and passionate beauties to the lady next to him.'[144] 'I rather look upon life as a chamber, which we decorate as we would decorate the chamber of the woman or the youth that we love, tinting the walls of it with symphonies of subdued colour, and filling it with works of fair form, and with flowers, and with strange scents, and with instruments of music.'[145] In search of aesthetic patterning, Mr Rose finds comfort in the windows of London art dealers. Given to effeminate fainting, he is a specimen of the new man, much satirized in the pages of *Punch*. The inappropriate matching of male character with flowers suggests a troubling kind of masculinity:

> Their windows, as I look into them, act like a sudden charm on me—like a splash of cold water dashed on my forehead when I am fainting. For I seem there to have got a glimpse of the real heart of things; and as my eyes rest on the perfect pattern (many of which are really quite delicious; indeed, when I go to ugly houses, I often take a scrap of some artistic cretonne with me in my pocket as a kind of aesthetic smelling salt), I say, when I look in at their windows, and my eyes rest on the perfect pattern of some new fabric for a chair or for a window-curtain, or on some new design for a wall-paper, or on some old china vase, I become at once sharply conscious, Mr. Herbert, that, despite the ungenial mental climate of the present age, strange yearnings for, and knowledge of, true beauty, are beginning to show themselves like flowers above the weedy soil.[146]

The merging in Pater's writings of antiquity, the Middle Ages, Renaissance, and modernity into a cosmopolitan eclecticism is satirized in Mr Rose's vision for the new republic: 'I can at this moment see our metropolis already transplanted and rebuilt. I seem to see it now as it were from a distance, with its palaces, its museums, its churches, its convents, its gardens, its picture-galleries—a cluster of domed and pillared marble, sparkling on a gray headland. It is Rome, it is Athens, it is Florence, arisen and come to life again, in these modern days. The aloe-tree of beauty again blossoms there, under the azure stainless sky.'[147] Mr Rose's incantatory enthusiasm may seem Swinburnian rather than Paterian, but the pervasive idea of renascences (to use the Panofskian term), of past flourishing cultures revived in modernity into one cohesive western civilization, reflects a Paterian outlook which his portraits would address, both individually and collectively. While Pater may briefly have laughed at Mallock's spoof, there are traces in his writings well into the 1890s which suggest his need to answer back. The identity as Mr Rose clung to Pater for the rest of

[144] Mallock, 20. [145] Ibid., 27–8.
[146] Ibid., 262. [147] Ibid., 267.

his life, and his immediate biographers—Gosse, Benson, and Wright—were keen to contribute their assessments of Mallock's parody for Pater's private as well as professional life. Benson, sensitive to implications about Pater's sexuality, outlined the powers of parodic language and the misrepresentation of character. While Mallock 'would no doubt justly maintain that in Mr. Rose he was merely parodying a type of the aesthetic school', [148] Benson objected to the false voice of Mr Rose. Describing Pater as 'one whose private life and conversation were of so sober and simple a character',[149] he saw Mr Rose as being, literally 'out of character', of misrepresenting the speaker, while justifiably attacking 'the advanced type of the aesthetic school'. Wright devoted an entire chapter to the refutation of Benson, asserting, on the authority of Pater's friend McQueen, that the voice and ideas of Mr Rose represented 'the truth as to one side of Pater's nature.'[150] Wright's Pater is far more mischievous than Benson's: his response is a hearty laughter and a sense of being troubled, 'not because people might recognize the portrait, but because he feared they might not recognize it. "I am pleased," he said to one friend, "to be called Mr. Rose—the rose being the queen of flowers; and the joke is a good one, but in years to come the humour will have evaporated, for nobody will know who Mr. Rose is." '[151] Can this camp queen, angling for celebrity, be identified with Benson's 'sober and simple character'? How can we reconcile Benson with Wright? In the war between the early biographers over the writer's afterlife we find a reflection of the complexity of Pater's character. Pater's responses to having become Mr Rose turn consumerism into spirituality, while exhibiting an almost Augustan laughter, keen to repay wit with wit. One likely outcome of Mallock's parody may well have been to remind Pater of his own parodic talents. Having been turned into a character, Pater decided to create his own. Pater's most explicit riposte, 'Duke Carl of Rosenmold', deserves discussion in its own right after a brief mentioning of a couple of Pater's more serious retorts.

'The Child in the House' was an immediate response to Mallock, turning materialism into 'soul-stuff', as its protagonist with the flowery name, Florian Deleal, likened to lilies and wall-flowers, goes exploring in the house of memory. Florian's house is everything that Mr Rose's ideal house is not: a bright, airy, and white abode, suggestive of the pre-existence of the soul, while still linked to the world of the senses.[152] The house is an almost transparent container for the soul, as indicated in the references to the caged bird. Pater would repeat the image of the soul as a bird in *Marius*,[153] which deals with the protagonist's search for the ideal house, from his childhood home 'Whitenights', through the houses of Marcus Aurelius, Tullius Cicero, to Cecilia's House, and back to 'Whitenights' again. In dialogue with Sophistic ekphrases of domestic architecture, Pater experiments with descriptions of the interiors of a series

[148] Benson, 52. [149] Ibid., 53.
[150] *Wright*, 2:10–18, 18. [151] Ibid., 2:18.
[152] See John Coates, 'Pater's Apologia: "The Child in the House"', *Essays in Criticism* 54:2 (Apr. 2004), 144–64.
[153] Marius's mother advises him: 'A white bird, she told him once, looking at him gravely, a bird which he must carry in his bosom across a crowded public place—his own soul was like that!', *Marius the Epicurean*, ed. Gerald Monsman (Kansas City: Valancourt Books, 2008), 19.

200 WALTER PATER'S EUROPEAN IMAGINATION

of houses, none of which fulfils the requirements of the ideal house.[154] Marius and Florian's homes are haunted houses, inhabited by their dead ancestors, who seem as real as the few other inhabitants referred to. Florian's house takes its place in a long line of Victorian gothic texts, from Brontë's *Wuthering Heights* (1848) to James's *The Turn of the Screw* (1898). Pater's interweaving of such different strands of romanticism with seventeenth-century allegory, autobiography, and a rebuttal of contemporary satire sets the high standard which his subsequent portraits would follow.

Where Mr Rose is all talk and no action, Duke Carl of Rosenmold is all action and no talk. This pre-romantic fairy tale is a gothic story with a twist: the rose motif has been given a decadent touch in Pater's imaginary German duchy. Rosenmold is Pater's version of Edward Burne-Jones's *Briar Rose* series (1871–2) (Fig. 4.12), where all life has ground to a halt, overgrown with a green mould, as the entire nation awaits the arrival of Prince Fortunate, a role eventually fulfilled by the *Aufklärung*, personified by the Apollo-like figure of Goethe. Only then is the spell of German cultural dearth broken. Carl, 'our lover of artificial roses',[155] is himself a rose, albeit a short-lived one, as fragile as the Dresden figurine he resembles 'with his full red lips and open blue eyes'.[156] Like Mr Rose, this 'floridly handsome youth'[157] is an idealist, a fantasist, who imagines a better world in which the return of Apollo to Germany will illuminate northern darkness and bring about a flourishing of music, art, and literature. Carl is no mythological figure, but a restless lad in perpetual search of stimuli in ambitious emulation of *le Roi Soleil*, finding in the imperial materialism of the Sun King a means to access near divinity. Drawn by the South—by Greece, Italy, France, and all things French—Carl is a man with a mission, namely that of transforming a nation of 'candle-lit people' into a new race of Greeks. Carl's notion of rococo as a new Renaissance connects Greek antiquity with fifteenth-century Italy, seventeenth-century France, and eighteenth-century Germany in a Pan-European eclecticism which out-Roses even Mr Rose's wildest ambitions.

Ensconced in a court culture of sycophants, Carl's male world is only interrupted by the arrival of two females: the first, Raphael's *Sistine Madonna*, purchased in an attempt to import Umbrian Mariolatry into Rosenmold,[158] is a failed mission, as the encounter with the legendary masterpiece makes the young duke realize his preference for Rubens. The second, the beggar maid, may beget a new vivacity in Carl, but life is soon cut short as the couple is slaughtered by invading French soldiers. Seeking life, but finding death, Carl moves from aspirations towards divine light to the darkness of the German soil. Unearthed at the beginning of the nineteenth century, his remains are treated with irreverence by a populace bent on treasure hunting. The general consumerism inspired by his own emulation of life at the court of Louis XIV now backfires in a popular greed for gold. All that glitters is not gold, and the glitzy life at the court of Rosenmold, a gilded cage of court flattery, has detrimental effects:

[154] See Shelley Hales, 'A Search for Home: The Representation of the Domestic in *Marius the Epicurean*', in ed. Martindale, Evangelista and Prettejohn, *Pater the Classicist*, 135–48.

[155] *CW* 3:129. [156] *CW* 3:124. [157] *CW* 3:118.

[158] Pater may have selected Raphael in response to Mr Rose's comment, 'Your Raphael, Miss Merton, who painted you your "dear Madonnas," was a luminous cloud in the sunset sky of the Renaissance, —a cloud which took its fire from a faith that was sunk or sinking.' Mallock, 276–7.

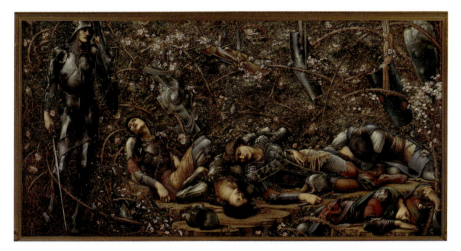

Fig. 4.12. Edward Burne-Jones, *The Briar Wood* (from the large *Briar Rose* series) (1870–90), oil on canvas, 124.46 × 249 cm. Buscot Park, Faringdon.

> Often it was a weary, deflowered face that his favourite mirrors reflected. Yes! people were prosaic, and their lives threadbare: —all but himself and organist Max, perhaps, and Fritz the treble-singer. In return, the people in actual contact with him thought him a little mad, though still ready to flatter his madness, as he could detect. Alone with the doating old grandfather in their stiff, distant, alien world of etiquette, he felt surrounded by flatterers and would fain have tested the sincerity even of Max, and Fritz who said, echoing the words of the other, 'Yourself, Sire, are the Apollo of Germany!'[159]

As Carl assumes the role of Hannibal in Marivaux's play and impersonates the Nordic sun god Balder in a musical interlude, the hyperbolic atmosphere reaches its climax, testifying to Pater's thinly veiled delight in the invention of a grotesque universe, revolving around a megalomaniac protagonist. Pater's joy in constructing a series of outrageous references to light and enlightenment is obvious. 'Duke Carl of Rosenmold' is the aesthetic life taken to its utmost extremes, from the heights of the Parnassus to the bathos of being identified by modern German bone science. Carl is himself a parodist, caricaturing his courtiers and provoking his audience to laughter. In faking his own death and funeral he imitates his namesake Charles V, who reputedly had a requiem sung for himself and a catafalque erected, while taking part in his own funeral procession in the mid-1550s. Life at the court of Rosenmold is nothing but imitation and hence a very fitting riposte to a text in which Pater had himself been the target of parody.

Reviewing the *Imaginary Portraits* Wilde noticed another subtext to Pater's German tale, namely the life of Ludwig II of Bavaria, who had died only in 1886. Known as the 'Swan King' or the 'Fairy Tale King' due to his life-long escapist lifestyle,

[159] *CW* 3:123.

202 WALTER PATER'S EUROPEAN IMAGINATION

reinterpreting northern mythology in mock medieval interiors, Ludwig had spent the family fortune supporting the arts in imitation of the Sun King. His extravagant building projects,[160] resulting in a range of spectacular neo-gothic castles which leave the Disney Castle as a pale imitation (Fig. 4.13), ran up enormous debts, while his ardent patronage of Wagner consolidated his interest in northern mythology within the modern opera. Already in October 1870 English readers could enjoy a discussion of the close friendship between the controversial opera composer and the King.[161] Ludwig's close male friendships left few people in doubts about his sexual orientation, and his deposition from the throne on the grounds of madness in 1886 was soon followed by his mysterious death together with a medical attendant in the Starnbergersee. It caused considerable media interest, also in England: the obituaries proliferating in the summer of 1886 abounded in anecdotes illustrative of the king's extravagant lifestyle, sometimes defending the young king for choosing a life of beauty and art, at other times criticizing his overspending and lack of political engagement.[162] Romantic travellers' accounts of journeys into the realm of the fairy prince began soon after Ludwig's death, and the architecture and interiors of his castles were assessed critically.[163] In his regular column on 'Contemporary Life and Thought in Germany', H. Geffcken began his contribution with the scandalous life and death of Ludwig and ended it with a laudatory obituary of the historian Leopold von Ranke—modern Germany had lost two men who had re-lived the past, each in his own way. Geffcken's description of Ludwig's operatic theatricality and Francomania may well lie as a subtext to Pater's:

> Hitherto the figures of German legends had peopled his castles, he himself appearing as Lohengrin, in gold armour, drawn by swans and lighted by coloured electric light; now the *roi soleil* became his grand ideal: portraits of the French King surrounded him; he built a state coach and a state sledge in the style of that epoch, of a gorgeousness unseen at any court, but which were simply for show; he went *incognito* to Versailles in order to study thoroughly its style; had those times represented dramatically on the stage; and at last resolved upon building a copy of the château on an island of the Chiemsee, but far outstripping the original in size as well as in gorgeous magnificence; the state bed cost £25,000, and the toilet was of massive gold with *lapis lazuli*; worst of all, he had copied the Versailles pictures representing the devastation of the Bavarian palatinate, which even then provoked the indignation of Europe. It was this enterprise which brought about the final crisis.[164]

[160] See Andres Lepik and Katrin Bäumler, *The Architecture under King Ludwig II—Palaces and Factories* (Berlin and Boston: de Gruyter, 2018).

[161] Anon., 'Wagner and the Fairy Prince', *London Society: An Illustrated Magazine of Light and Amusing Literature for the Hours of Relaxation* 106 (Oct. 1870), 289–96.

[162] Anon., 'Recent Bavarian Kings', *Saturday Review* (19 Jun. 1886), 845–6; Maurice Kufferath, 'Louis II of Bavaria', *Musical World* (26 Jun. 1886), 403–5; Anon., 'Louis the Second of Bavaria', *Temple Bar, with which is incorporated Bentley's Miscellany* (Aug. 1886), 511–28.

[163] Anon., 'Foreign Notes' (on Ludwig II's grotto), *Magazine of Music* (Mar. 1886), 278; E. M. Abdy-Williams, 'An Enchanted Island', *Time* (Aug. 1886), 214–20; R. Phéné Spiers, 'The Palaces of the Late King of Bavaria', *Art Journal* (Jul. 1888), 213–16.

[164] H. Geffcken, 'Contemporary Life and Thought in Germany', *Contemporary Review* 50 (Aug. 1886), 277–93, 278.

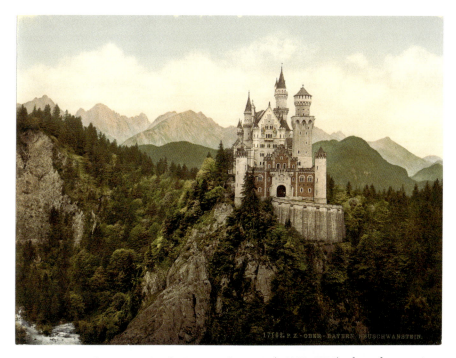

Fig. 4.13. Neuschwanstein Castle, Bavaria, Germany (*c*.1890–1905), photochrom print. Library of Congress, Photochrom print collection. Prints and Photographs LC-DIG-ppmsca-00179.

Geffcken's own indignation at Ludwig's treachery is clearly audible; megalomania at the expense of national integrity is severely judged, and Ludwig's death marks the end of romanticism:

> The true solution will probably never be known; it lies concealed under the green waves of the lake. Such was the end of the last representative of Romanticism on the throne. Tall, handsome, and, like Saul, richly gifted, he appeared to be called by Providence to his exalted position to become a blessing for his people; but not knowing how to bridle his passions by the sense of duty and responsibility, he quickly lost all moral equipoise, melancholy clouded his spirit with darkness, and when his extravagant ideas of his personal pre-eminence were shattered by the stubborn reality, he, like that first king of Israel, came to an untimely death by his own hand.[165]

The 'Fairy King' was a subject made for an imaginary portrait, and Wilde knew this well enough, as his suggestive phrasing outed Pater and his queer source: 'Duke Carl is not unlike the late King of Bavaria, in his love of France, his admiration for the *Grand Monarque*, and his fantastic desire to amaze and to bewilder, but the

[165] Ibid., 279.

204 WALTER PATER'S EUROPEAN IMAGINATION

resemblance is possibly only a chance one.'[166] Pater's double—or even triple—parody, of Ludwig II and of Mallock's Mr Rose, makes for a complex series of layers, or masks in which eighteenth- and nineteenth-century Germany intersects with nineteenth-century Oxford. The contemporary reference made Pater's imaginary portrait a far more daring text in response to Mallock than if the focus had been merely eighteenth century.

As a character, Carl is only a puppet, controlled by the much more interesting voice of the modern narrator whose ironic detachment and incisive comments contrast with the voice of the nebulous Mr Rose. The narrator becomes himself a character, looking back at events from the beginning of his own century before transposing us to the early eighteenth century for the central narrative. Pater's text opens with a strange blending of fairy tale and forensic science, of 'Once upon a time' mixed with the coolly descriptive voice, almost of the pathologist, keen to modify or question statements:

> One stormy season about the beginning of the present century, a great tree came down among certain moss-covered ridges of old masonry which break the surface of the Rosenmold heath, exposing, together with its roots, the remains of two persons. Whether the bodies (male and female, said German bone-science) had been purposely buried there was questionable. They seemed rather to have been hidden away by the accident, whatever it was, which had caused death—crushed, perhaps, under what had been the low wall of a garden—being much distorted, and lying, though neatly enough discovered by the upheaval of the soil, in great confusion. People's attention was the more attracted to the incident because popular fancy had long run upon a tradition of buried treasures, golden treasures, in or about the antiquated ruin which the garden boundary enclosed;[167]

'Whether'...'was questionable', 'whatever it was', 'perhaps'; already within the first paragraph Pater has created a questioning voice which does not give much away, apart from his scepticism. Stringing us along with masterly narrative expertise, his narrator leads us down a number of garden paths, pretending ignorance, while knowing everything. He picks up on the question Pater had originally presented when submitting 'The Child in the House': 'What came of him?': 'It had never been precisely known what was become of the young Duke Carl, who disappeared from the world just a century before, about the time when a great army passed over those parts, at a political crisis, one result of which was the final absorption of his small territory in a neighbouring dominion. Restless, romantic, eccentric, had he passed on with the victorious host, and taken the chances of an obscure soldier's life?'[168] Pater returns to the bodily remains of Carl and his maid and proceeds to a narrative rooted in soil, mould, and matter. Giles Whiteley has suggested that Pater's narrator changes voice from the opening to the end of 'Duke Carl', from fairy tale to historical context, from Pater the writer of fiction to Pater the critic.[169] In his rare use of the first-person

[166] Wilde in Seiler 1980, 164.
[167] *CW* 3:115. [168] Ibid., 115.
[169] Giles Whiteley, 'Pater's *Parerga*: Framing the Imaginary Portraits', *Victoriographies* 3:2 (2013), 119–35.

pronoun, Pater the essayist steps in, Whiteley argues, destabilizing the relationship between text and context, unsettling our ideas of the inside and the outside of the text, of frame, narrative, and genre, thus blurring the distinctions between art and life. With Goethe as a reincarnation of Carl, Pater is parodying, with almost blatant blasphemy, the empty grave of Christ, and of Heine's Apollo, while merging a fictitious character with a historical one. As in the Winckelmann essay, the reference to Goethe is a tantalizing brief appearance of real genius, for a moment transposed to foreground status in a series of parallel figures contained within the same frame. The art of Pater's narrator is a constant tease of distance and nearness, of scorn and endearment. Historically, geographically, and personally, the narrator is a retrospective commentator, doing his best to distinguish himself from Carl and eighteenth-century Rosenmold: 'the youth', 'the young duke', 'the lad' all indicate distance in age, status, and period. The 'somewhat questionable form of the contemporary French ideal' detected at the court of Rosenmold,[170] leaves us in no doubt that the narrator knows when things are third-rate, gilded rather than of solid gold. While exposing Carl's fanciful ideas and the discrepancy between his ambitions and their fulfilment, our narrator is fascinated by his youthful energy and human fallibility, leaving the reader with a sense of endearment towards the 'lover of artificial roses'. Affected by his upbringing, Carl can hardly be blamed for his inability to distinguish between real and imitation. The difference in tone between the opening and the ending suggests a change in the narrator's stance, from forensic observer to engaged speaker, not unlike the ending of 'Denys l'Auxerrois'. 'I seem to see', 'I seemed actually to have seen': can we trust the narrator's eyes? In making his narrator a nuanced character and commentator on Carl's search for the aesthetic life, Pater constructs a sophisticated response to Mallock with a delay of some ten years. He shares with James an interest in the framed narrative, in that curiously attractive filter of the anonymous and not always reliable narrator as the reader's sole authority. The narrator of 'Duke Carl of Rosenmold' is one aspect of the Paterian mask: witty, ironic, sarcastic, yet with a humane touch which occasionally rises to the surface. As a frame, or foil, for his caricatured aesthete, he provides a measured and mature retort to Mr Rose, suggesting, as Forster was fully aware, that 'there may be more in flatness than the severer critics admit'.

[170] *CW* 3:117.

PART II
BACKGROUNDS

5

The Poetics of Space

From Rooms to Cathedrals

In Thomas Wright's richly illustrated *Life of Walter Pater* we find a photograph of *Pater's sitting-room at Brasenose* (Fig. 5.1). We get the impression that Pater has just left: the kettle is in the fireplace, and the desk in the foreground has books and scattered paper, suggesting recent activity. The inhabitant may be back any minute to offer us a cup of tea and a learned conversation. Yet, with our awareness that the photograph occurs within a posthumous biography, we know that if Pater were to return to the room, it would be as a haunting ghost. We do not even know whether the photograph was taken while Pater still occupied the room, or whether it is of more recent date, coinciding with Wright's biography (1907). Like all abodes, college rooms change their inhabitants over time, and while they may still be known as 'Pater's rooms' to Brasenose fellows and students, they have not (like Beerbohm's at Merton College) been converted into the Pater memorial rooms. Michael Hatt reminds us of the temporality of interiors, as dust gathers, furniture is moved around, and new inhabitants take over; the popular *fin-de-siècle* photographs of artists' and writers' interiors are deceptive: 'While the photograph is a valuable source, it would be all too easy to read such an image as if it were, say, a painting or print, complete in itself rather than a staged record of an interior at a particular moment—often when newly installed—and flattened into a two-dimensional representation. It is an obvious point, but one often forgotten, that the interior is not the timeless and unchanging space one sees in the photograph, but an environment that is established and then inhabited. It has a temporality the two-dimensional image cannot capture.'[1]

Wright's photograph is elegiac; if taken while Pater still inhabited the rooms, it captures a presence which is forever lost. The image is the visual counterpart to the many written records of a visit to Pater's rooms, provided by friends, colleagues, and former students in the years immediately after his death. Mr Rose's interest in interior design still cast its long shadow; the accounts of Pater's aesthetic interiors suggest the experience of visiting him as a *Gesamtkunstwerk* in which the inhabitant's care for detail in his speech, thought, and personal appearance was complemented by a minute concern with interior design. The anonymous 'F.' outlined the dialectics between the inside and the outside world in Pater's collegiate universe:

> Yes; there were indeed rose-leaves on the table, set in a wide, open bowl of blue china, and it was just possible to detect their faint smell. The warm blue tone of the room was the first impression one received on entering: the stencilled walls, the

[1] Michael Hatt, 'Space, Surface, Self: Homosexuality and the Aesthetic Interior', *Visual Culture in Britain* 8:1 (Summer 2007), 105–28, 105–6.

Walter Pater's European Imagination. Lene Østermark-Johansen, Oxford University Press. © Lene Østermark-Johansen 2022.
DOI: 10.1093/oso/9780192858757.003.0006

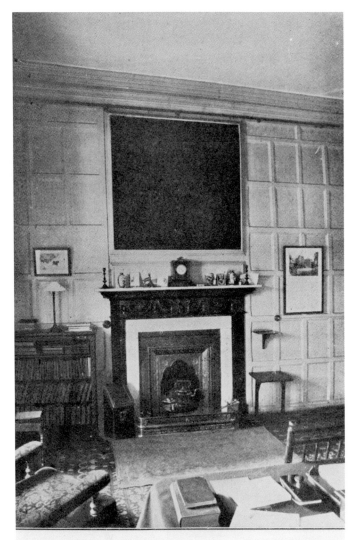

PATER'S SITTING-ROOM AT BRASENOSE.

Fig. 5.1. *Pater's Sitting-Room at Brasenose* (c.1907), from Thomas Wright, *The Life of Walter Pater*, 2 vols (London: Everett & Co., 1907), 1:227. Private collection. Photo © Christoffer Rostvad.

cushions of the chairs, the table-covers, and the curtains to the mullioned window, that projected over the pavement—all these were blue. And whatever in the room was not blue seemed to be white, or wood in its natural colour, or polished brass. The books in their low neat case seemed all white calf or vellum; above them an alto-relief in plaster showed white, in the corner a pure-white Hermes on a pedestal stood with tiny wings outspread. The room was small, but the Gothic window with

its bow enlarged it, and seemed to bring something of the outside Oxford into the chamber so small in itself. The Radcliffe just a few hand-breadths from the pane, the towers and crockets of All Souls beyond, and to the right the fair dream of St. Mary's spire, filling up the prospect with great suggestions—through the window one took in all these, and they seemed for the moment to become almost the furniture of the student's chamber.[2]

The foregrounding of the roses is suggestive,[3] and the author's 'Harmony in Blue and White' is confirmed by another visitor: 'Like most of us, he may have wished to live up to his blue china.'[4]... In the matter of beautiful objects he was entirely free from the spirit of the collector. A reproduction of a beautiful coin or statue had its full value for him as a thing of beauty.'[5] The controlled colour palette and the attention to materiality and texture rather than monetary value recur in the descriptions of Pater's rooms. The synaesthetic interplay between flowers, fabrics, sculptural objects, and books reflects an intellectual aesthete with a keen sense of tonal harmonies and delicate fragrances. The outside world—the Radcliffe Camera, All Souls College, and St Mary's Church—is telescoped into the small interior space. By contrast, the photograph in Wright's book suggests seclusion and withdrawal into an aesthetic interior, and thus resembles the many windowless photographs of Arts and Crafts interiors which appear as 'Huysmanian retreats *from* rather than interventions *in* the world.'[6] My own experience of visiting Pater's rooms altered my perception of the man significantly. The bay window enabled one to look out onto the world, while being hidden from any prying gazes from Radcliffe Square. As a consequence, Pater took on a new persona: the shy and secluded Oxford don turned into an almost Jamesian voyeur as the large windows became eyes, taking in far more of the external world than anyone would have imagined. For William Sharp, who in Pater's last years became a relatively close friend, the 'snug, inset, cushioned corner, much loved and frequented by its owner' became 'always thereafter to me a haunted corner in a haunted room.'[7] The space took on a life of its own, after its occupant had left it, and presence became a suggestive absence. As Hatt reminds us, 'Interior spaces are not simply stage sets into which characters walk and act. The relationship between self and space is more complex, and the interior needs to be understood as a mix of the real and the imagined; the projection of the imagination onto or into space and space itself enabling that imagining.'[8]

[2] 'F', 'In Pater's Rooms', *The Speaker* (26 Aug. 1899), 207–8, 207.

[3] The roses recurred: 'You miss the small white room, with the Donatello cast on the wall, the carefully ordered books, the large bowl of dried rose petals on the table, and the man himself and the voice.' Anon., 'Walter Pater. By an Undergraduate', *Pall Mall Gazette* (2 Aug. 1894), 3. Quoted from Seiler 1987, 169–70, 170.

[4] For this term, popularized by Oscar Wilde in the late 1870s, see Anne Anderson, '"Fearful Consequences... of Living up to One's Teapot": Men, Women and "Cultchah" in the Aesthetic Movement', in ed. Jason Edwards and Imogen Hart, *Rethinking the Interior, c.1867–1896* (Farnham: Ashgate, 2010), 111–29.

[5] 'Walter Pater. By an Undergraduate', 170. [6] 'Introduction' in Edwards and Hart, 15.

[7] William Sharp, 'Some Personal Reminiscences of Walter Pater', *Atlantic Monthly* 74 (Dec. 1894), 804–14. Quoted from Seiler 1987, 78–98, 84.

[8] Hatt, 106.

212 WALTER PATER'S EUROPEAN IMAGINATION

The accounts of Pater's rooms suggest a hybrid between a public and a private space, and we must ask ourselves why it became so important to recollect and reconstruct the ambience in which Pater wrote, taught, and entertained. College rooms combine the institutional with the private, the collective with the personal: within the building there are many such rooms which each have been given their personal touch by the occupant. What is the significance of that room, and why do we want to imagine Pater in it? We may think of it as an extension of the person, as a way of getting closer to the writer, even to the extent of treasuring desks and chairs which Pater may have used, as a desk in Stratford and the Petrarchan chair in the poet's house in Arquà have become relics, perhaps once touched by the bards' hands or buttocks. With such an elusive person as Pater, the room, and whatever material imprint he may have left on it, gain imaginative significance: we start inhabiting them, creating narratives to fill out the blanks. The literal invasion of Pater's private space becomes one of the few ways of gaining access to the man in the absence of diaries, notebooks, or revealing correspondence.

Our interest in Paterian domestic and architectural space reflects our reading of his works, many of which are concerned with the interrelationship between the subject and its surroundings, with the notion of 'home', of belonging. This aspect of Pater's fiction has only been sporadically explored.[9] Carl in his castle, Sebastian in his tower, Denys in his Cathedral, Marie-Marguerite in her salon, Emerald's family home, Apollyon in the monastery, not to mention the many houses in *Marius*, or the visits to Ronsard's Priory, Montaigne's Tower, and Jasmin's interiors in *Gaston*: the Paterian self is nearly always framed by some architectural structure, by the notion of a past or a present home. Architecture anchors the self in space, providing a framework for religious, intellectual, creative, or domestic activities. Architectural spaces are receptacles of memories, stimulating the very art of memory, as Frances Yates reminded us, with reference to a long oratorical tradition.[10] The architecturally rooted oscillation between past and present which pervades Pater's portraits is key to an understanding of his weaving and unweaving of the self. His awareness of architectural space as something constituted by a balance between materiality and immateriality, between bricks and mortar on the one hand, and dreams and memories on the other, makes for atmospheric evocations of architecture, in which one or two significant features stand out, while the rest must be imagined. Master of suggestiveness, Pater rarely provides long architectural descriptions, with catalogues of details. Ironically, the many accounts of his own rooms tend to abound in such detailed catalogues, in his admirers' attempts to trap the departed inhabitant in all the private knick-knack and bibelots so absent from his writings.

Pater's spaces deal as much with an awareness of absence as an awareness of presence, as they often evoke a sense of loss: a lost childhood, a lost member of the

[9] See Hales; Maureen Moran, 'Walter Pater's House Beautiful and the Psychology of Self-Culture', *English Literature in Transition, 1880–1920* 50:3 (2007), 291–312; Benedetta Bini, '*Genus loci*: il pellegrinaggio di Emerald Uthwart', in ed. Elisa Bizzotto and Franco Marucci, *Walter Pater (1839–1894): Le forme della modernità. The Forms of Modernity* (Milan: Cisalpino, 1996), 187–202; Ellen Eve Frank, *Literary Architecture: Essays toward a Tradition: Walter Pater, Gerard Manley Hopkins, Marcel Proust, Henry James* (Berkeley: University of California Press, 1979), 15–49.

[10] Francis Yates, *The Art of Memory* (London: Routledge and Kegan Paul, 1966).

family, a lost pet, or friend associated with a building or an interior. Loss begets memory, imagination, and narrative, and in the portraits the tension between architectural framework and subject allows for explorations into what is no longer physically there. This chapter deals with such embodied spaces, varying in scale from the reliquary—the last home to the dislodged bones of saints—to individual rooms or houses, to large-scale cathedrals. The aesthetics of space can be examined through phenomenological 'topoanalysis' or 'psychic geography' as one way of bridging literature and architecture. Gaston Bachelard's poetics of space employs Aristotelian notions of *poesis* ('making'), as Richard Kearney explains: 'for Bachelard this is a two-way process: we are made by material images that we remake in our turn. We are inhabited by deep imaginings—visual and verbal, auditory and tactile—that we reinhabit in our own unique way. Poetics is about hearing and feeling as well as crafting and shaping. It is the double play of re-creation.'[11] Not only is a 'stanza' both a poetic and a spatial unit, reminding us of a profound connection between literature and architecture, but the embodied room which takes shape after its inhabitant is dependent on the receptive and expressive qualities of its owner: the nest, shaped by the bird using its own breast as a sculptural tool, the mollusc's shell, the snail's house, are case studies examined by Bachelard whose notion of the 'oneiric house', the dream house, is essential to his poetics of space. 'Not only our memories, but the things we have forgotten are "housed". Our soul is an abode. And by remembering "houses" and "rooms", we learn to "abide" within ourselves. Now everything becomes clear, the house images move in both directions: they are in us as much as we are in them.'[12]

At Home or *Chez Soi*: From 'The Child in the House' to a Visit to Montaigne

Pater's chiastic change in the title of his first portrait from 'The House and the Child' to 'The Child in the House', from conjunction to preposition, suggests the importance of an anchoring of the self in space, as it draws our attention inwards and stresses the house as an architectural unit rather than a personification. Bachelard engages with our birthplace as the profoundest embodiment of home, dreams and memories, and points out the almost sculptural imprint of the early house, making us recollect both Paterian and Lockean wax tablets of the mind:

> [T]he house we were born in is physically inscribed in us. It is a group of organic habits. After twenty years, in spite of all the other anonymous stairways, we would recapture the reflexes of the 'first stairway', we would not stumble on that rather high step. The house's entire being would open up, faithful to our own being. We would push the door that creaks with the same gesture, we would find our way in the dark to the distant attic. The feel of the tiniest latch has remained in our hands.... We are the diagram of the various functions of inhabiting that particular house,

[11] Richard Kearney, 'Introduction', in Bachelard, *The Poetics of Space*, xix.
[12] Bachelard, 21.

and all the other houses are but variations on a fundamental theme. The word 'habit' is too worn a word to express this passionate liaison of our bodies, which do not forget, with an unforgettable house.[13]

Bachelard's concern with beginnings, with the imprint of the first house on the creative mind, is an essentially romantic idea, taking us back to Sainte-Beuve's interest in the birthplace, in the childhood of literary genius. The nineteenth-century craze for literary tourism relies on the notion that the moulding of genius resides in architecture and the spirit of place. Henry Wallis's 1853 painting *The Room in which Shakespeare was Born* (Fig. 5.2) is strangely evocative in its rectangular bareness. Resounding with absence the space begs a number of questions: can we imagine the Bard born under such lowly circumstances? How did an early childhood in this room shape him? Does Shakespeare's soul reside here, or do we merely see an empty site of celebrity culture? Unlike the photograph of Pater's rooms, this is not a space of retreat; we are meant to imagine the young Shakespeare looking out of the window, aware of a much larger world outside. The room is womb and tomb at the same time: the cradle may be missing, but the so-called 'Kesselstadt death mask', discovered in a junk shop in Mainz in 1849, shows its ominous profile in the windowsill, together with a couple of miniature reproductions of Shakespeare's tomb monument in Holy

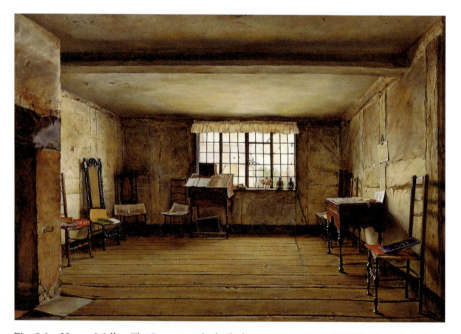

Fig. 5.2. Henry Wallis, *The Room in which Shakespeare was Born* (1853), oil on board, 29.2 × 41.9 cm. Tate Britain, London. Purchased 1955. Photo © Tate.

[13] Ibid., 36.

Trinity Church, Stratford, catering for the growing tourist industry.[14] On the walls are layers of visitors' signatures, as generations of writers—Byron, Schiller, Scott, Browning among them—literally inscribed the space with their own admiration of the Bard. The empty room may resound with an awareness of the loss of the man who was reputedly born here, but the walls speak the language of world literature and its indebtedness to him. The tension between speech and silence, between writing in print, or on the walls, and the awareness of a voice which will no longer be heard, imbues this white interior, with its uneven floorboards, low ceiling, and patchy timbered walls, with a profound literary and sentimental significance. The materiality of chairs, desks, books, and busts appeals to our notion of touch, of the imprint of the body which once housed the great spirit. The slightly later *carte de visite* with the same title as Wallis's painting (Fig. 5.3) views the room from a narrower angle, the same uncomfortable high-backed chairs, inviting us to visit and watch the Bard at work, although admittedly only a plaster bust remains. 'Shakespeare was here'—or was he? New Place had belonged to his father, but there was no evidence that his son had actually been born there. Already at Wallis's time the authenticity of the place, bought in 1847 by the Shakespeare Memorial Trust, was being questioned,[15] and when Henry James dealt with the cult which had grown up around New Place in

Fig. 5.3. Francis Bedford, *The Room in which Shakespeare was Born* (1860s), *carte de visite*. National Museums of Scotland. From the Howarth-Loomes Collection. Image © National Museums Scotland.

[14] The Kesselstadt mask also featured as a prop in Wallis's *A Sculptor's Workshop in Stratford-upon-Avon, 1617* (1857) which depicts the carving of Shakespeare's tomb monument.
[15] See Michael Rosenthal, 'Shakespeare's Birthplace: Bardolatry Reconsidered', in ed. Harald Hendrix, *Writers' Houses and the Making of Memory* (New York: Routledge, 2008), 31–44.

'The Birthplace' (1903), Shakespeare's name was excluded in the most Jamesian fashion, where silence often speaks more than words.[16]

The cult of birthplaces is rooted in Christianity, where an iconography of the Nativity has a long tradition of celebrating the lowly stable framing the birth of Christ. The literary tourist is a pilgrim, paying homage to literary shrines, often tracing the scope of literary biography, from cradle to grave. As Nicola Watson points out, the two bookends of a literary life provide different stimuli. As sites of memory, birthplaces and cemeteries have something different to offer:

> It is one thing to pay your respects to the bodily remains of a poet, filed away explicitly for viewing by posterity in the organized system of memorial represented by church, churchyard or cemetery. It is altogether another thing to make pilgrimage to the place where he or she was born. The grave was already the sort of site upon which memorial was conventional, and which provided physical evidence of the bodily existence of the author outside of the text; but to make a birthplace into a memorial of the author's physical existence requires a substantial effort of the collective imagination. Although both grave and cradle may be said to speak of 'origins', they are clearly different concepts or origin. The grave speaks of textual origin simply as the site of the body that existed beyond or in addition to the composition, dissemination and reading of the text; the cradle speaks of the origin of the body itself, and then, by implication, of the importance of environment in the making of the child who will become the writer.[17]

Wallis had previously produced an even more elliptical interior space: *Staircase in the Birthplace* (Fig. 5.4). The painting is silent about whether this was the staircase at Shakespeare's time, or in its mid-nineteenth-century state. A narrow, claustrophobic space, with light falling in from a door outside the picture, the scene invites the spectator to ascend. The apocryphal birth-room is, presumably, at the end of the stairs, but whether we listen in on the moment of the Bard's birth, or whether he has long since left, we shall never know. Preserved as a water-colour sketch, now at the Birth-Place Trust, the painting was enlarged into an oil painting in 1854, and bought by John Forster, Chairman of the London Committee of the Royal Shakespearian Club. Some thirteen years later Forster allowed his friend Edwin Landseer to retouch it. *Shakespeare's House* (Fig. 5.5) thus has Wallis's staircase background, to which has been added a series of props suggestive of *Hamlet*: the spade, the skull, the heron, the rat, while a discarded glove reminds us of the profession of Shakespeare *père* as a gloves' maker. Forster, apparently, was thrilled with the additions.[18] Now peopled with a dog, the painting evokes a coming and going on those stairs, Shakespearian domesticity, if we imagine that the scattered objects served as inspiration for one of the playwright's greatest tragedies.

[16] See Peter Collister, 'Shakespeare for Tourists: Henry James's "The Birthplace"', *Modern Philology* 116:4 (May 2019), 377–400; Andrea Zemgulys, 'Henry James in a Victorian Crowd: "The Birthplace" in Context', *Henry James Review* 29:3 (Fall 2008), 245–56.

[17] Nicola Watson, *The Literary Tourist* (Basingstoke: Palgrave Macmillan, 2006), 57.

[18] See Collister, 385–8.

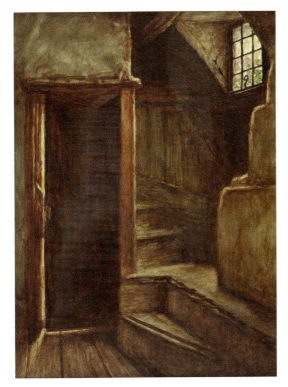

Fig. 5.4. Henry Wallis, *Staircase in Shakespeare's Birthplace* (1847), watercolour on paper, 33 × 44.5 cm. Courtesy of the Shakespeare Birthplace Trust, Stratford-upon-Avon. © Shakespeare Birthplace Trust.

Like doors, stairs connect spaces. They enable ascent towards heaven and descent into the grave in a vertical dynamics which for Yeats would turn into a system of spiralling gyres, enabling the subject to look down over the space travelled in the past, while travelling it at a higher level of recognition. Within a neo-platonic framework, stairs enable us to leave earthly life and materiality behind, while aspiring upwards towards immateriality. My reasons for dwelling on Wallis's evocative interiors as a route into Paterian spaces are several: first of all, Pater was himself fascinated with birthplaces, stairs, and the notion of ascent. The narratives of Florian, Emerald, Marius, and Gaston all begin with the birthplace. Although none of Pater's protagonists are candidates for a celebrity culture, the importance of rooting the self in a birthplace loses none of its significance, and a return to it becomes commemorative on a private, rather than a public level. Birthplaces invite circular narratives: Emerald and Marius return to their birthplace to die, and Gaston would most likely also have done so, had Pater completed the manuscript. Florian's approach to the world is moribund, and a feeling of homesickness, a longing for that first home, is the note on which Pater's narrative finishes. For Pater and Wallis, less is more; the empty space leaves room for the imagination and for ghosts. The suggestiveness of absence in a

Fig. 5.5. Henry Wallis and Edwin Landseer, *Shakespeare's House, Stratford-upon-Avon* (1854/67), oil on canvas, 65.5 × 49.5 cm. © Victoria and Albert Museum, London.

whitewashed room makes it an ideal site for dreams and memories, one of Bachelard's oneiric houses.

'The Child in the House' is the most Bachelardian of Pater's texts: a dream, a recollection, provoked by the mere mentioning of a place name, Pater's house is from first to last immaterial, the myth of the first home; we do not even know whether the house still exists at the time of the narrative. Pater's biographers have speculated whether the original house was the demolished family home in Enfield or Fish Hall near Hadlow in Kent where one of Pater's aunts lived.[19] As the first and most formative of the houses in Pater's fiction, it becomes the 'Ur-house', a precursor of Marius's Whitenights in a novel with an epitaph from Lucian's *Dream*: 'A winter's dream when the nights are longest'. Recollecting the house he had left some thirty years previously, Florian's mind travels through the house from ground floor and garden to the nursery, to the attic full of children's toys, to the roof with a bird's eye-view of the neighbouring town. Like Sebastian, Florian likes to explore the world from above and has an interest in the effects of light, whether seen through fog or shining through windows. The physical ascent is balanced by the family tree demonstrating the descent from Watteau:

[19] *Wright*, 1:25–30; Levey 40–9.

The *old house*, as when *Florian* talked of it afterwards he always called it, (as all children do, who can recollect a change of home, soon enough but not too soon to mark a period in their lives) really was an old house; and an element of French descent in its inmates—descent from Watteau the old court-painter, one of whose gallant pieces still hung in one of the rooms—might explain, together with some other things, a noticeable trimness and comely whiteness about everything there— the curtains, the couches, the paint on the walls with which the light and shadow played so delicately, might explain also the tolerance of the great poplar in the garden, a tree most often despised by English people, but which French people love, having observed a certain fresh way its leaves have of dealing with the wind, making it sound in never so slight a stirring of the air, like running water.[20]

Interiors and exteriors interact: walls, doors, and windows are membranes through which the great outside, whether in the form of light, sound, fog, or fragrance, invades the house and its inhabitants in an elaborate process of weaving. The plasticity of the house results in an exchange of impressions which never leave the material world completely: wood and bricks balanced by that very peculiar Paterian coinage 'soul-stuff':

> In that half-spiritualised house he could watch the better, over again, the gradual expansion of the soul which had come to be, there—of which indeed, through the law which makes the material objects about them so large an element in children's lives, it had actually become a part; inward and outward being woven through and through each other into one inextricable texture—half, tint and trace and accident of homely colour and form, from the wood and the bricks; half, mere soul-stuff, floated thither from who knows how far. In the house and garden of his dream he saw a child moving, and could divide the main streams, at least, of the winds that had played on him, and study so the first stage in that mental journey.[21]

The child in the garden has an extraordinary sensitivity to colour and fragrance: his encounter with the red hawthorn becomes an epiphanic moment in which he realizes his own impressionability, while his delight in the golden-rod and the yellow wall-flower invites us to think about the interrelationship between bricks and the organic, between culture and nature. '*Flos-parietis*, as the children's Latin-reading father taught them to call it, while he was with them.'[22] With the wit of the Oxford Classics don, Pater translates directly from English into Latin (the Latin for wall-flower is *Erysimum*), provoking us to think about the implications of a flower emerging from a wall. Wall-flowers are at one with the wall, inseparable from it; they grow and age with the house, clinging to it, while needing its support. Once detached, the wall-flower will collapse. While the wall-flower image is struck delicately in 'The Child in the House', indicating the interrelationship between the growth of the child and the natural world in symbiosis with the house, the image is further developed in 'Emerald', where the protagonist's epitaph is inscribed on the walls, like the epitaphs

[20] *CW* 3:134. [21] *CW* 3:133–4. [22] *CW* 3:135.

220 WALTER PATER'S EUROPEAN IMAGINATION

of the German students in S. Caterina in Siena studied in the opening paragraph. Epitaphs are also part of the wall, not seasonal, but permanent. Out of a family of gardeners, residing in the home counties, Emerald returns home to die and be smothered in flowers. The narrator recollects how he was always a wall-flower: 'In fact, he was scarcely ever to lie at ease here again, till he came to take his final leave of it, lying at his length so. In brief holidays he rejoins his people, anywhere, anyhow, in a sort of hurry and makeshift:—*Flos Parietis!* thus carelessly plucked forth. Emerald Uthwart was born on such a day "at Chase Lodge, in this parish, and died there." '[23]

Two words resound in 'The Child': 'house' with twenty, and 'home' with twenty-one occurrences, to which is added the French *chez soi*: 'Out of so many possible conditions, just this for you, and that for me, brings ever the unmistakable realisation of the delightful *chez soi*; this for the Englishman, for me and you, with the closely drawn white curtain and the shaded lamp; that, quite other, for the wandering Arab, who folds his tent every morning, and makes his sleeping place among haunted ruins, or in old tombs.'[24] The French term, which, according to the *OED*, entered the English language by the mid-eighteenth century, contains the accentuated French word for 'self', and thus carries very different connotations from the 'homely words', 'house' and 'home', of Germanic and Anglo-Saxon origin. The even balance between 'house', an architectural structure, and 'home', a concept, referring to sentiments of belonging and comfort (*OED* 2b), or retreat (*OED* 4), suggests the oscillation between the physical and the emotional life of the self. Intriguingly Pater chooses a French word for the sentiment of home; in his comparison between English cosiness and the nomadic life of the Arab, we are invited to see them as equally homely, with an awareness that tastes and needs are personal, possibly even national. The French term inevitably makes us ask whether being *chez soi* is any different from an English sense of 'home'? Edmond de Goncourt juxtaposed the same words in the 'Préambule' to *La Maison d'un artiste* (1881), the elegiac perambulation, room by room, of his house in Auteuil, which would serve as important inspiration for Joris-Karl Huysmans's *A Rebours* (1884) and Mario Praz's *The House of Life* (1958).[25] Pater's narrator asserts the homeliness of Florian's house as the epitome of Englishness: the individual's sense of home becomes emblematic for the entire nation. French ancestry is submerged by an influx of Englishness in a passage echoing with 'home':

> With *Florian*, then, the sense of home became singularly intense, his good fortune being that the special character of his home was in itself so essentially home-like. As, after many wanderings, I have come to fancy that some parts of Surrey and Kent are, for Englishmen, the true landscape, true home-counties, by right, partly, of a certain earthy warmth in the yellow of the sand below their gorse-bushes, and of a certain grey-blue mist after rain, in the hollows of the hills there, welcome to

[23] *CW* 3:178. [24] *CW* 3:136.

[25] 'De notre temps on va bien encore dans le monde, mais toute la vie ne s'y dépense plus, et le *chez-soi* a cessé d'être l'hôtel garni òu l'on ne faisait che coucher. Dans cette vie assise au coin du feu, renfermée, sédentaire, le créature humaine, et la première venue, a été pousée à vouloir les quatre murs de son *home* agréables, plaisants, amusants aux yeux.' 'Préambule' in Edmond de Goncourt, *La Maison d'un artiste*, 2 vols (Paris: Charpentier, 1881), 1:2. Italics are de Goncourt's own. See Juliet Simpson, 'Edmond de Goncourt's *Décors*—Towards the Symbolist *Maison d'Art*', *Romance Studies* 29:1 (2011), 1–18.

fatigued eyes, and never seen farther south; so, I think that the sort of house I have described, with precisely those proportions of red-brick and green, and with a just perceptible monotony in the subdued order of it, for its distinguishing note, is, for Englishmen at least, typically home-like.[26]

Pater's sense of home is far from unproblematic. It is closely tied to notions of the human love of the earth, explored in the study of the cult of Demeter,[27] characterized by the duplicity of the fertile and the chthonic, of birth and the underworld.[28] In the vertical dynamics of Florian's story, the route from the ascent to the roof to a descent into the grave is speedy; one moment we are looking over the steeples of the neighbouring city, the next we are inhabitants of the grave where a relentless rain may suggest imminent decomposition. Florian finds 'some power of solace to the thought of sleep in the home churchyard, at least—dead cheek by dead cheek, and with the rain soaking in upon one from above.'[29] The circular movement from birthplace out into the world and back to the local churchyard is also the narrative of Shakespeare's journey out of Stratford and back again. The magnetic attraction of 'home' as the first house, which abides with you always and which you cannot escape, makes the Paterian birthplace a haunted house, awaiting the home-coming of the dying and the dead. If contemporary reviewers complained that Florian never came across as a living, rumbustious child, they were justified in their observations by the references to him as one 'marked...out for a saint', in love with 'church lights, holy days, all that belonged to the comely order of the sanctuary, the secrets of its white linen, and holy vessels, and fonts of pure water',[30] with an early habitation described as 'a sort of material shrine or sanctuary of sentiment'.[31] Once the living inhabitants depart, the house begins to resemble the dead faces in the Paris Morgue or the Munich Cemetery, a process which makes us question whether the house, when alive, was actually more alive than its saint-like occupant.

Pater's interest in deserted houses revisited was closely linked to his essay on Charles Lamb (1878).[32] This 'casual writer for dreamy readers', 'of the true family of Montaigne',[33] 'felt the genius of places', resembling 'the places he knew and liked best, and where his lot fell'.[34] 'A lover of household warmth everywhere, of that tempered atmosphere which our various habitations get by men living within them, he "sticks to his favourite books as he did to his friends," and loved the "town", with a jealous eye for all its characteristics, "old houses" coming to have souls for him.'[35] Lamb's short autobiographical essays, published in *Essays of Elia* (1823) and *Last Essays of Elia* (1833), contained evocative personal journeys, visits to sites of memory tied to the author's past: 'The South-Sea House', 'Oxford in the Vacation', and not least

[26] *CW* 3:136–7.

[27] On 29 Nov. 1875 Pater delivered a lecture on 'The Myth of Demeter and Persephone' at the Birmingham and Midland Institute, the manuscript of which is in Brasenose College. It was subsequently published in the *Fortnightly Review* 19 (1 Jan. 1876), 82–95 and 19 (1 Feb. 1876), 260–76.

[28] See Linda Dowling, 'Walter Pater and Archaeology: The Reconciliation with Earth', *Victorian Studies* 31:2 (Winter 1988), 209–31.

[29] *CW* 3:136. [30] *CW* 3:143. [31] *CW* 3:136.

[32] 'The Character of the Humourist: Charles Lamb'. [33] Ibid., 471.

[34] Ibid., 474. [35] Ibid., 472.

222 WALTER PATER'S EUROPEAN IMAGINATION

'Dream-Children: A Reverie', and 'Blakesmoore in H—shire'. Taking us into a house which bears a strong resemblance to Blakesware in Hertfordshire, where the author spent parts of his childhood, the two texts leave us in the realm of the autobiografictional, an empty shell housing the imaginary. 'Blakesmoore in H—shire' invites us into solitary contemplation in empty spaces; in search of what once was home, and encountering the dilapidated, old house, Lamb restores it in his imagination: 'I was here as in a lonely temple. Snug firesides—the low-built roof—parlours ten feet by ten—frugal boards, and all the homeliness of home—these were the condition of my birth—the wholesome soil which I was planted in.'[36] The blurred lines between art and life are teasingly addressed in a visit to the family portrait gallery, where the sense of home is related to descent and likeness. The portraits are Lamb's version of Pater's *revenants*: 'Mine was that gallery of good old family portraits, which as I have gone over, giving them in fancy my own family name, one—and then another—would seem to smile, reaching forward from the canvas, to recognise the new relationship; while the rest looked grave, as it seemed, at the vacancy in their dwelling, and thoughts of fled posterity.'[37] Pater's essay on Lamb presents us with his likeness, a character sketch of a witty man, known for his quiet reserve and celebrated for his interest in autobiography.[38] This links him to the sixteenth-century inventor of the *essai*, while suggesting that writing is, essentially, self-expressive, an imprint of the self upon the text: 'with him, as with Montaigne, the desire of self-portraiture is, below all more superficial tendencies, the real motive in writing at all—a desire closely connected with that intimacy, that modern subjectivity, which may be called the *Montaignesque* element in literature. What he designs is to give you himself, to acquaint you with his likeness.'[39] The *Montaignesque* was crucial to Pater: in the Joachim du Bellay essay (1873), Montaigne is a chief representative of the French 'intimacy of sentiment'.[40] This *intimité* is closely related to the domestic, the pedestrian, the observations from every-day life, at the heart of so many of Montaigne's essays. His scepticism, expressed in his motto '*Que sais-je?*' (What do I know?), surface in Pater's essay on one of Montaigne's English disciples, 'Sir Thomas Browne' (1886).[41] In Pater's very last unfinished essay, the last third of the manuscript represents Montaigne as the fundamental 'under-texture' to Pascal's *Pensées*.[42]

For Pater Montaigne becomes a sixteenth-century *intimiste*, inhabiting his famous book tower like the mollusc its shell, an interrelationship that had to be captured in fiction. The man who withdrew from public life at the age of thirty-eight in order to read and write, and whose influential essays—issuing from that very tower—on everything from fear to dreams, cannibals, education, and friendship, was an

[36] Charles Lamb, 'Blakesmoor in H—shire', *Elia and The Last Essays of Elia*, ed. E. V. Lucas (London: Methuen & Co., 1912), 174–8, 176.

[37] Ibid., 177.

[38] See ch. 1, ' "Our Debt to Lamb": The Romantic Essay and the Emergence of Tact', in David Russell, *Tact: Aesthetic Liberalism and the Essay Form in Nineteenth-Century Britain* (Princeton: Princeton University Press, 2018), 12–40.

[39] 'Charles Lamb', 471–2. [40] *Ren.*, 137–8.

[41] 'Sir Thomas Browne', *Macmillan's Magazine* 54 (May 1886), 5–18, 14.

[42] *Miscellaneous Studies*, 78. See Dudley M. Marchi, *Montaigne among the Moderns: Receptions of the Essais* (Providence: Berghahn Books, 1994), 185–222.

irresistible subject for a study of the self within its architectural framework. Gaston pays a visit to Montaigne in his tower near Bordeaux in Gascony, sent as a messenger from Ronsard, whose priory in Touraine he had visited just previously. Spending a significant nine months in the womb-like interior of Montaigne's Tower as amanuensis, Gaston eventually moves on towards Paris. Pater's thinly veiled pun, Gascon de la Tour, must make us wonder whether, by staying with Montaigne for the full gestation period of the human foetus, Gaston was, in fact, performing the impossible act outlined in Pater's Morris essay (1868) of entering into the womb again and being born.[43] After a discourse on modernity with Ronsard, Gaston is ready to be re-born, a modern man.

The round tower at the Château de Montaigne is all that remains of the French essayist's family home; the Château burnt down in 1885 but was rebuilt in 1886—just as Pater was writing his novel. Built in the fourteenth century, the tower served as bell-tower and had its own chapel. While Montaigne's father, Pierre Eyquem de Montaigne, had spent his life extending and fortifying the property, Montaigne's contribution was primarily as interior designer: when he withdrew from public life in 1571, he brought in an Italian artist for mural decorations, established a bedroom on the second floor, and a library and *studiolo* on the third. Most of the books in his collection had belonged to his close friend Étienne de la Boétie, who had died in 1563, a relationship commemorated in Montaigne's long essay 'On Friendship'. It was in this room that he read, composed his essays, received visitors, and kept panoptic surveillance over his property, servants, and family. The daily ascent to his library on the top floor was both physical and spiritual, and Montaigne described his delight in his private retreat: 'By being rather hard to get at and a bit out of the way it pleases me, partly for the sake of the exercise and partly because it keeps the crowd from me. There I have my seat. I assay making my dominion over it absolutely pure, withdrawing this one corner from all intercourse, filial, conjugal and civic.'[44]

Montaigne's *studiolo* is a speaking library: the inhabitant had quotations from biblical and classical literature painted on the walls and beams, enabling him to be in continuous communication with the ancient writers, as he gazed up from his books or walked around.[45] The tower became a popular destination after the publication in 1774 of Montaigne's travel diary, an autobiographical text giving new impetus to literary tourism.[46] Already by the 1820s people were inscribing their names on the walls, and there was a fascination with the emptiness of the site, with what Alain Legros calls an *inventaire négatif*, as rendered in one nineteenth-century account: 'There is his chapel, his bedroom, his closet and his library. There is nothing left of all of those, except the crumbling walls, under a roof partly ruined by the winds and the rains: you will not find a single piece of furniture, or a book, or anything else which

[43] 'Poems by William Morris', 307.

[44] 'Three Kinds of Social Intercourse' in Michel de Montaigne, *The Complete Essays by Michel de Montaigne*, tr. and ed. M. A. Screech, Penguin Classics (Harmondsworth: Penguin, 1993), 933.

[45] See Alain Legros, *Essais sur poutres. Peintures et inscriptions chez Montaigne*. Preface de Michael Screech (Paris: Klincksieck, 2000).

[46] Alain Legros, '"Visite à Montaigne" au XIXe siècle: petite histoire d'un genre méconnu', *Montaigne Studies: An Interdisciplinary Forum* 12:1–2 (2000), 185–208.

224 WALTER PATER'S EUROPEAN IMAGINATION

was used by the philosopher.'[47] In 1828 Landor composed an imaginary conversation between the French Calvinist Joseph Scaliger and Montaigne set in Montaigne's tower. The conversation between the two revolves around good food and wine, poetry, and religion, and Montaigne emerges as the domesticated man, more interested in the quality of his food than in theological disputes.[48] Reports of visits to the site, such as Charles Marionneau's *Visites aux ruines du château de Montaigne* (1885), and Jean-Baptiste Galy and Léon Lapeyre, *Montaigne chez lui. Visite des deux amis à son château* (1861) constituted a new genre, in which each visitor made of the inhabitant's relation to his abode what suited his purpose: a tomb or a cenotaph (Montaigne died in his tower but his body was buried in a convent in Bordeaux); an observatory or a laboratory; a monk's cell; a place to communicate with the ancient writers; a place to receive visitors; a sanctuary dedicated to a deceased friend; an open book with texts to be studied and meditated upon. The focus was on Montaigne at work, writing, reading, engraving the quotations on the ceiling, rather than on his ghost.[49]

We do not know whether Pater ever made the literary pilgrimage to Montaigne's Tower; I suspect he did. His accounts of the landscape, of the approach to the Tower, and its interior space suggest that he was there. My search for his personal signature on the walls during my own visit yielded no result, but with a man who—unlike Montaigne—never left any marginalia in his books,[50] it could hardly be expected that he would desecrate such a literary shrine. Like Browning's 'Childe Roland to the Dark Tower Came' (1852/5), Gaston is on a quest towards an almost mythical tower set within a garden, where entering becomes an initiation rite. In Pater's paradisial garden of Gascony, Montaigne's Tower constitutes a Tree of Knowledge: 'Might one enjoy? Might one eat of all the trees?—There were those who had already eaten and who needed, retrospectively, a theoretic justification, a sanction of their actual liberties, in some new reading of human nature itself and its relation to the world around it.'[51] He has intimations of the Romantic critics' view of Montaigne as a self-indulgent philosopher, advocating a hedonistic kind of self-culture.[52] Warned that we are about to witness a fall, we observe Gaston's approach with interest. Amongst those who would eat—and Pater is making interesting jumps in time here to Montaigne's seventeenth-century readers—are philosophers and playwrights, finding intellectual freedom: 'To Pascal, looking back upon the sixteenth century as a whole, Montaigne was to figure as the impersonation of its intellectual licence; while Shakespeare, who represents the free spirit of the Renaissance moulding the drama, hints, by his well-known preoccupation with Montaigne's writings, that just there was the philosophic counterpart to the fulness and impartiality of his own artistic reception of the

[47] My translation. '*Il y avait* sa chapelle, sa chambre, son cabinet et sa bibliothèque. Il ne reste de tout cela que des murs dégradés, sous un toit à moitié ruiné par les vents et les pluies: vous n'y trouveriez *pas un* meuble, *pas un* livre, *rien* qui ait été à l'usage du philosophe.' Ibid., 194.

[48] Walter Savage Landor, *The Complete Works*, ed. T. Earle Welby, 16 vols (London: Chapman & Hall, 1927–36), Vol. 7: *Imaginary Conversations*, 'Joseph Scaliger and Montaigne'.

[49] Legros, 205.

[50] The impressive collection of books once owned by Pater now in Brasenose Library does not contain any marginalia in Pater's hand.

[51] *CW* 4:80.

[52] See Jane Spirit, 'Nineteenth-Century Responses to Montaigne and Bruno: A Context for Pater', in ed. Laurel Brake and Ian Small, *Pater in the 1990s* (Greensboro: ELT Press, 1991), 217–27.

experiences of life.'[53] We approach the tower travelling backwards in time, through the reception of the essays as portraits of the artist, to the great man himself. In his preface, Montaigne had stated that readers would find 'some traits of my character and of my humours', a painting of himself 'drawn from life', issuing a final warning against a topic 'so frivolous and so vain', while concluding that 'I myself am the subject of my book':[54]

> Those essays, as happens with epoch-making books, were themselves a life, the power which makes them what they are having accumulated in them imperceptibly by a thousand repeated modifications, like character in a person. At the moment when Gaston presented himself, to go along with the great 'egotist' for a season, that life had just begun. Born here, at the place whose name he took—*Montaigne*, the *acclivity* of Saint Michael—just thirty-six years before, brought up simply, earthily, at nurse in one of the neighbouring villages, to him it was doubled strength to return thither, when, disgusted with the legal business which had filled his days hitherto, seeing that 'France had more laws than the rest of the world', and was—what one saw! he began the true work of his life, a continual journey in thought, 'a continual observation of new and unknown things', his bodily self remaining, for the most part, with seeming indolence at home.[55]

Pater weaves his own textual tapestry of quotations from a wide range of the *Essays*. We see the philosopher's dialectic mind in dialogue with itself, but never hear the young disciple's voice, although traces of the conversations with the great philosopher supposedly passed into the *Essays*. We see through Gaston's eyes and occasionally gain access to his mind as he enters in broad daylight and ascends to the top, until he is lulled asleep in darkness:

> Montaigne would boast that throughout those invasive times his house had lain open to all comers, that his frankness had been rewarded by immunity from all outrages of war, and of the crime war shelters. And certainly openness—that all was wide open, searched through by light and warmth and air from the soil—was the impression it made on Gaston, as he passed from farmyard to garden, from garden to court, to hall, up the wide winding stair to the uppermost chamber of the great round tower. In this sun-baked place the studious man still lingered over a late breakfast, telling, like all around, of a certain homely epicureanism, a rare mixture of luxury with a preference for the luxuries that after all were home-grown and savoured of his native earth.[56]

Montaigne may enjoy the intellectual light at the top, closer to the sun and the heavens, but he is still rooted in his native soil, as home-grown as the vegetables he enjoys for breakfast. The attraction to the earth and what springs from it is part of his identity; he is 'of the mountain' on which his tower stands, just as Denys l'Auxerrois is 'of

[53] *CW* 4:80. [54] 'To the Reader', in *The Complete Essays by Michel de Montaigne*, lxiii.
[55] *CW* 4:80. [56] *CW* 4:80–1.

226 WALTER PATER'S EUROPEAN IMAGINATION

Auxerre' and Duke Carl is 'of Rosenmold'. After a discussion of Plutarch and Seneca, Gaston desires to ascend further, and follows Sebastian and Florian in an exploration of the bird's eye-view of the surrounding landscape, keen to contextualize the tower and its inhabitant, who has dozed off in the midday heat: 'the guest was mounting a little turret staircase, was on the leaden roof of the old tower, amid the fat, noonday Gascon scenery. He saw, in bird's eye-view, the country he was soon to become closely acquainted with, a country of passion and capacity (like its people) but though at that moment emphatically lazy.'[57] By the evening he has been smitten by the southern indolence and is lulled into a pleasant life:

> How imperceptibly had darkness crept over them, effacing everything but the interior of the great circular chamber, its book-shelves and enigmatic mottoes and the tapestry on the wall—Circe and her sorceries, in many parts, to draw over the windows in winter.... Was Circe's castle here? If Circe could turn men into swine, could she also restore them again? It was frailty, certainly, that Gaston remained here week after week, scarce knowing why, the conversation begun that morning lasting for nine months, over books, meals, in free rambles chiefly on horseback, as if in the waking intervals of a long day-sleep.[58]

Gaston becomes a reader of the inscriptions on the ceiling and of the iconography of Montaigne's tapestry. Scenes from Ovid's *Metamorphoses* were depicted on the walls of Montaigne's Tower, and Pater selects the motif of Circe—the sorceress encountered by Ulysses in Homer's *Odyssey* (X), discussed in Plutarch's *Moralia*, and Ovid's *Metamorphoses* (XIV)—as symptomatic of the relationship between host and visitor. Transformed by his encounter with the sorcerer, the visitor to the tower-island is content to linger, taking over his host's homely epicureanism. A popular motif in literature and painting, Circe was the ultimate *femme fatale*, turning men into swine in much *fin-de-siècle* art, an aspect developed in Pater's novel, when later he compares Queen Marguerite to Circe. In Chapter VII Gaston would meet Bruno, who had previously invoked Circe in his mnemonic dialogue *Cantus Circaeus* (1582) (*The Incantation of Circe*), in which men assumed the animal forms which corresponded to their souls. With the myths of the Fall and Circe,[59] Pater is teasing our notions of both Christian and pagan seduction, leaving us with a worldly Montaigne *chez soi* in a *Gesamtkunstwerk* of inscriptions, books, textiles, food, and conversation.

Pater might have seen Wallis's painting *Montaigne in his Library* which depicts the philosopher conversing with his young female editor Marie de Gournay by a window, next to a large tapestry.[60] Wallis had visited the Château de Montaigne on 21 July 1856, together with his friend, the painter Peter Augustin Daniel, and had only

[57] *CW* 4:82–3. [58] *CW* 4:83.

[59] Gerald Monsman, 'Walter Pater, Circe, and the Paths of Darkness', *Nineteenth-Century Prose* 24:2 (Fall 1997), 66–77, 69–70.

[60] The present whereabouts of the painting is unknown, and it is therefore not reproduced. A poor reproduction of it can be found in Sarah Bakewell, *How to Live: A Life of Montaigne in One Question and Twenty Attempts at an Answer* (London: Vintage, 2011), 295.

been allowed to spend two hours there.[61] He subsequently debated suitable depictions from Montaigne's life with his lover, Mary Ellen Meredith, and her father Thomas Love Peacock.[62] The chosen subject is a rare one in depictions of Montaigne, an imaginary scene, as de Gournay only visited the Château after the philosopher's death.[63] Exhibited at the Royal Academy in 1857, the painting was singled out by Ruskin as 'a beautiful and characteristic fragment of homely French architecture seen through the window'.[64] Pater may have mistaken de Gournay for Montaigne's wife when recollecting the image; in *Gaston* Madame suddenly enters and takes up a game of dice with her husband's visitor. Pater and Wallis's domestication of Montaigne is suggestive: he remains the homely man, a spider spinning his textual web. Wallis's Montaignean *chez moi* is packed with objects: the mirror and the tapestry, the rug, the philosopher in his chair next to his disciple with her pen and paper, all crammed into a narrow space.

This cluttered interior contrasts with the drawing by Wallis which served as frontispiece to the second volume of his friend Bayle St John's life of the philosopher, published in 1858 (Fig. 5.6).[65] In format the drawing resembles *The Room in which Shakespeare was Born* with its courage to take on the empty space and make absence its main subject, suggestive of the great person and his daily habits now lost to us. The dramatic effect of light brings life to the room, reminding us of walls and windows as membranes through which the outside passes onto the inside. The spirit of Montaigne inhabits the space; after all, he selected and installed the many Greek and Latin inscriptions on the ceiling. In his choice of Wallis's empty space, Bayle St John provided room to imagine Montaigne in his tower. His biography contained two chapters on the tower, and a third discussing which books Montaigne might have had in his library. His account of how the philosopher would sit 'perhaps with a Seneca slily in his hand, or a night-cap on his head',[66] domesticated Montaigne to an extreme degree. Remarking how admirers of Montaigne were frequenting the site, St John painted a portrait of the typical pilgrim who paid homage to the shrine; Pater could easily have been among them:

You will generally observe that the admirers of Montaigne have a great many books of their own, not modern cheap editions, but solid calf-bound volumes, bought at second-hand much cheaper; that they are, if not exactly eccentric people, people of marked features of character; that they have often a good sober-looking volume in their pockets, and form, in fact, a coterie of observers and thinkers, who run

[61] See Nicholas Joukovsky, 'The Early Meredithian Milieu: New Evidence from Letters of Peter Augustin Daniel', *Studies in Philology* 115:3 (Summer 2018), 615–40, 630–1; Diane Johnson, *The True History of the First Mrs Meredith and Other Lesser Lives* (London: Heinemann, 1973), 101.

[62] *The Letters of Thomas Love Peacock*, ed. Nicholas A. Joukovsky, 2 vols (Oxford: Clarendon Press, 2001), 2:357.

[63] Philippe Desan, *Portraits à l'essai: l'iconographie de Montaigne* (Paris: H. Champion, 2007), 123.

[64] 'Academy Notes', *CWR* 14:113.

[65] St. John thanked Wallis 'whose excellent painting of the interview between the Essayist and Marie de Gournay, all visitors to the last Exhibition of the Academy will remember for the sketch of the interior of Montaigne's Tower, which forms the frontispiece of the second volume.' 'Preface' in Bayle St. John, *Montaigne the Essayist: A Biography, with Illustrations*, 2 vols (London: Chapman and Hall, 1858), vol. 1.

[66] Ibid., 1:311.

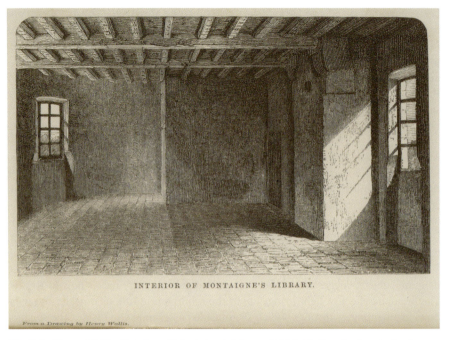

Fig. 5.6. Henry Wallis, *Interior of Montaigne's Library* (1856–7), frontispiece to Bayle St. John, *Montaigne the Essayist: A Biography, with Illustrations*, 2 vols (London: Chapman and Hall, 1858), vol. 2. © Widener Library, Harvard University.

> together like quicksilver when they meet, and are rather formed to instruct youth and suggest wisdom to the idle or impetuous, than themselves to take any active part in this world's affairs.[67]

For the nineteenth century Montaigne *chez soi* epitomized the male privilege of having time, money, books, and intellect at his leisure to pursue what he enjoyed most: reading and writing. Visiting that space and recreating it imaginatively was one way of inscribing oneself in that privileged position of leisure, while engaging with a long tradition of gentleman scholarship. Montaigne's humanist advocacy of a room of his own is a precursor of Woolf's assertion of the intellectual woman's need of 500 pounds a year and a room of her own in order to write, be happy, and independent. The poetics of space becomes political in her hands, and the French philosopher's restless spirit, which constantly changes direction as he argues with the classical writers and with himself, becomes peculiarly Woolfian, as she engages with the essay, with the man, and the sense of flux which connect them across genders and centuries. In her essay on the Cotton/Hazlitt edition of Montaigne used by Pater,[68]

[67] Ibid., 1:306.
[68] Inman 1981, 335. Pater owned the three-volume 1877 edition of Cotton's translation of Montaigne, probably purchased in the late 1870s. In Oct. 1877 he borrowed the Brasenose copy, but no subsequent borrowings are registered. Inman 1990, 404.

published in the *Times Literary Supplement* in January 1924, Woolf applied a very Montaignesque relativism to the structure of her argument, oscillating from contemplation to restlessness, demonstrating how the man was constantly at war with himself:

> Surely then, if we ask this great master of the art of life to tell us his secret, he will advise us to withdraw to the inner room of our tower and there turn the pages of books, pursue fancy after fancy as they chase each other up the chimney, and leave the government of the world to others. Retirement and contemplation—these must be the main elements of his prescription. But no; Montaigne is by no means explicit. It is impossible to extract a plain answer from that subtle, half smiling, half melancholy man, with the heavy-lidded eyes and the dreamy, quizzical expression. The truth is that life in the country, with one's books and vegetables and flowers, is often extremely dull. He could never see that his own green peas were so much better than other people's. Paris was the place he loved best in the whole world—'jusques à ses verrues et à ses taches.' As for reading, he could seldom read any book for more than an hour at a time, and his memory was so bad that he forgot what was in his mind as he walked from one room to another.[69]

Woolf's Montaigne is far more mobile than Pater's, and as Dudley Marchi has demonstrated, Montaigne is an important subtext for her *Orlando*, who carries his Oak Tree poem in his bosom throughout most of the narrative, as Montaigne carried the manuscript of his essays on his journeys.[70] The family name 'Eyquem', which Montaigne abandoned in 1568, is the French for 'Oakham', 'hamlet of oaks'. Orlando reads Montaigne indirectly through his reading of Browne, as Woolf read Montaigne, Browne, and Pater. At a yet deeper level, as an extended love poem to Sackville-West, Woolf was driven by the energy of same-sex desire which pervaded Montaigne's construction of the library as an act of homage to his deceased friend. A room of one's own may have more than one inhabitant, but often the others belong to a literary or a personal past. Bachelard's oneiric house is inextricably tied to the past, to the memories and dreams generated by that past, and for Pater, certainly, and his reading of Montaigne, the house, the style, and the past were the man himself. Even for a writer often hailed as the first of the moderns, the past is part of the packaging, and the architectural structure of the birthplace, at once shell and membrane, becomes key to an understanding of the *Montaignesque*.

The Aesthetic Interior: Living Up to One's Blue China

Gaston may, like Woolf's Montaigne, have felt bored in the country. His visit to the philosopher is contrasted with his visit to Jasmin de Villebon, with whom he had been a novice in Chartres. From the robust epicureanism of Gascony, Gaston goes exploring in the mannerist and labyrinthine architecture of central Paris. Chapter VIII,

[69] Virginia Woolf, 'Montaigne', in *EVW* 4:71–81, 73. [70] Marchi, 233–77.

230 WALTER PATER'S EUROPEAN IMAGINATION

entitled 'An Empty House'—never published during Pater's lifetime—sends Gaston to the house of his friend, who has joined the world of power and fashion at Queen Marguerite's court. Both the outside and the inside of the house are symptomatic of the decadent mannerism of Valois France: structural features are abandoned for ornamental ones, and northern gothicism is replaced with classicizing or Italianate features, suggestive of a culture striving for a foreign elegance. We read the exterior of the building as we would read the face of a character in a realist Victorian novel; physiognomy works as well for houses as for human beings:

> In that choice place, a little *hôtel* or town-house, of which his father's death had left this youthful mirror of French fashion the master, one had a favourable opportunity for estimating what we now call aesthetic culture was come to under the last of the Valois. It was a Gothic house of the later fifteenth century, when, in anticipation of the exotic elegance of that Medicean taste which would ere long supplant it altogether, the national architecture was already losing its Medieval precision, and therewith its strength. To the trained eyes of that day, eyes, we may suspect, in collusion with certain inward tendencies towards relaxation of the *moral* fibre, it was delightful to see the severe structural lines give way till they vanished, or figured as but graceful pencillings on a quiet surface jealous of all emphatic relief. The column lost its capital and roved softly into the arch, rippling now for ornament rather than support, above the pleasant windows which betrayed, through their fine-grained glass, the fastidious comfort that reigned within.[71]

The Paterian eye distinguishes between a sixteenth-century taste for the dainty, and a nineteenth-century awareness of the structural healthiness of the gothic, inspired by Ruskin. Pater's awe of the gothic in 'Denys' and 'Notre Dame d'Amiens' runs as a counter discourse to the delicacy of Valois Paris. The empty house we are about to explore is one of surfaces, distortions, and coloured light against velvet-clad walls, which eliminate the outside, a retreat from, rather than an engagement with the world.

Pater had highlighted the word 'aesthetic'; Jasmin's abode was 'as poetic, as "aesthetic" as ever'. As Edwards and Hart remind us, 'the concept "aestheticism", as another form of the phrase "art for art's sake", was first employed in 1855. "Aestheticise" was introduced in 1864; "aestheticist" and "aesthetic", as the name for an art movement, in 1868; "aesthetic" as a characteristic pertaining to persons or animals in 1880; and the noun "aesthete" in 1881'.[72] Walter Hamilton's *The Aesthetic Movement in England* had been published in 1882, and by the time Pater put 'aesthetic' in inverted commas, it was a much-used and abused term, not least in George du Maurier's many caricatures in *Punch*, famously in the dialogue between the 'Aesthetic Bridegroom' and his 'Intense Bride' in *The Six-Mark Tea-Pot* of 30 October 1880 (Fig. 5.7). When speaking of 'what we now call aesthetic culture' (without inverted commas), Pater was imposing contemporary optics on sixteenth-century culture, evoking *fin-de-siècle* culture as much as decadent Valois mannerism.

[71] CW 4:123. [72] Edwards and Hart, 6.

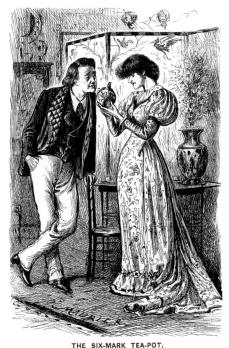

Fig. 5.7. George du Maurier, 'Six-Mark Teapot', *Punch, or the London Charivari*, 30 Oct. 1880. Punch Cartoon Library/TopFoto.

This becomes so much the more obvious when we look at the manuscript (Fig. 5.8). Immediately below the chapter heading, yet struck out by the author, Pater had written: 'Live up to your blue china'. 'Apocryphal saying'. He must have done so quite late in his composition process; the manuscript is neat and polished, and only second thoughts must have made the author wonder whether incorporating such an explicit address to Wilde was a good idea. Oscar Browning records Wilde's saying— that he found it increasingly difficult to live up to his blue china—as going back to 1876; on 27 February 1879 the *Oxford and Cambridge Undergraduate's Journal* had a satirical piece on Wilde as 'O'Flighy' commenting, 'How often I feel how hard it is to live up to my blue china'.[73] By 1882, a lengthy account of Wilde's Magdalen rooms had made it into Hamilton's defence of the aesthetic movement,[74] while the rector of

[73] Richard Ellmann, *Oscar Wilde* (London: Hamish Hamilton, 1987), 44; Dennis Denisoff, *Aestheticism and Sexual Parody, 1840–1940* (Cambridge: Cambridge University Press, 2001); Gerald Monsman, 'The Platonic Eros of Walter Pater and Oscar Wilde: "Love's Reflected Image" in the 1890s', *English Literature in Transition, 1880–1920* 45:1 (2002), 26–45.

[74] 'He soon began to show his taste for art and china, and before he had been at Oxford very long, his rooms were quite the show ones of the college, and of the university too.... His blue china was supposed by connoisseurs to be very valuable and fine, and there was plenty of it.... He was hospitable, and on Sunday nights after "Common Room", his rooms were generally the scene.... It was at one of these

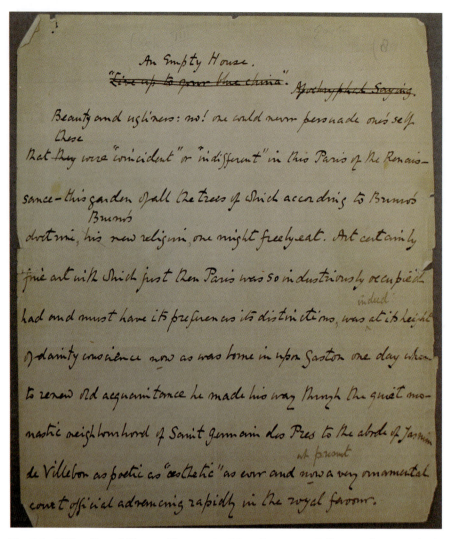

Fig. 5.8. Walter Pater, MS page Chapter viii, fol. 1r. Brasenose College Archives, Oxford. With the kind permission of the King's Hall and College of Brasenose, Oxford.

St Mary's Church declared that 'When a young man says not in polished banter but in sober earnestness, that he finds it difficult to live up to the level of his blue china, there has crept into these cloistered shades a form of heathenism which it is our bounden duty to fight against and to crush out, if possible.'[75] Thorstein Veblen would define this kind of heathenism as 'conspicuous consumption' in *The Theory of the*

entertainments that he made his well-known remark, "Oh, would that I could live up to my blue china!"' Walter Hamilton, *The Aesthetic Movement in England* (London: Reeves & Turner, 1882), 89–90.
 [75] Quoted in Ellmann, 44.

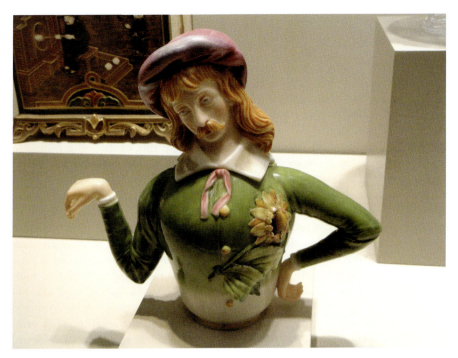

Fig. 5.9. James Hadley, *Aesthetic Teapot* (1882) made by the Royal Worcester Porcelain Company, glazed and enamelled Parian ware, 15.9 × 16.5 × 7.6 cm. Art Institute of Chicago. Wikimedia Commons.

Leisure Class (1899),[76] a fierce attack on the consumerist middle classes, who mindlessly acquired useless objects as tokens of their privileged status, replacing production with collecting. In her exploration of *fin-de-siècle* Chinamania,[77] centred on James Hadley's *Aesthetic Teapot* (1882) (Fig. 5.9), Anne Anderson pointed out why the object was so daring: 'By collapsing two feminine commodities, china and tea, into one product and linking this to an erosion of masculinity, the *Aesthetic* teapot may be one of the first "pink" commodities. It is certainly "camp", peculiarly British, and laden with innuendoes.'[78] The self-parodic teapot inscribed 'bad collecting':

> The 'bad' collector, like the 'sentimental' consumer, invests his persona in 'things', as mementoes and souvenirs, rather than acquiring objects as a sign of social achievement or furthering academic knowledge. The unmanly collector, attracted to china, developed female susceptibilities, acquiring a taste for the costly, exotic, useless and, above all, novel. If the teapot signals female vacuity, by association the male china collector lacks depth. Led astray by his obsessions, the aesthete lost his intellectual

[76] Thorstein Veblen, *The Theory of the Leisure Class: An Economic Study in the Evolution of Institutions* (London: Macmillan, 1899).
[77] 'The first *Chinamania* cartoon, *The Passion for Old China*, appeared in *Punch* on 2 May 1874 and the last on 30 Oct. 1880, this being the famous *Six-Mark Tea-Pot*.' Anderson, 114.
[78] Ibid., 123.

234 WALTER PATER'S EUROPEAN IMAGINATION

capacity. A man only concerned with his clothes or his china could not be expected to take the lead in affairs of state.[79]

In Pater's novel Gaston ascends into an empty, yet inhabited, house. Summoned by Queen Marguerite to attend her at court, Jasmin has left his abode, but leaves a welcoming note for Gaston, asking him to 'make himself at home for awhile, eat, and drink of the choice wine set ready, amuse himself with the books, the pictures, say!'. Gaston concludes that 'if the owner was absent, all around seemed eloquent concerning him'.[80] There is an element of fairy tale about this, of the solitary visits to unknown houses by heroines like Snow White or Goldilocks. As the visitors go exploring, trying to read the interior and the absent inhabitants, so does the reader. Gaston has some acquaintance with the owner, yet his visit to Jasmin's empty house is a classic case of the Freudian uncanny, in which the familiar turns unfamiliar. The novice from Chartres has been transformed by life in Paris, and Gaston's wonder at Jasmin's metropolitan domicile is continuously fed by an element of strangeness, as he realizes that he is as much the observed as the observer. The empty house is alive, albeit in an eerie and unsettling way which confronts the visitor with his own mutability, as he begins to blend in with the period face. The white light of recollection of Florian's oneiric house is transformed into a distorted nightmare version in muted atmospheric colours. Gaston grapples with language in an attempt to get to grips with the subject of his quest: 'as you may sometimes explain an enigma in the world of events by seeing or coming to know an actual person, to appreciate a personal influence, so here, breathing this atmosphere and amid the peculiar complexion of shadow and light in Jasmin's house, Gaston for the first time was able to define for himself something, a humour, a quality, a character, that was all about one in the Parisian life—something physiognomical, closely connected, therefore, as effect or cause with what must be moral in its operation.'[81] Gaston's search for the self through a vocabulary ranging from the fluid and immaterial to the substantial suggests the difficulty of the task: 'something, a humour, a quality, a character...something physiognomical'. Drawn to the family portrait gallery, he notices a peculiarly trans-European type: painted in the Italian style, the portraits depict individuals representing the North and the South, the gothic and the Gallic, summing up the significance of France as the meeting point of all of Europe. The 'life-likeness of those who would be at home here, reigned in this room, and that as from a throne', we learn:

> Amid all their exotic Italian tendencies, these people had had a measure of old Gallic or Gothic energy within them, forcing their peculiar tastes, their peculiar standard of distinction, as law upon others. To harmonise the living face with its lifeless *entourage*, to make atmosphere, is, we know, the triumph of pictorial art. Here, such sifted atmosphere as Leonardo or Titian could weave for his portraits, had overflowed the frame and become a common medium, for visitors to this privileged place to move in as freely as they would. How these pictured people saw or liked to see things, had determined a new visual faculty, if it were not rather an

[79] Ibid., 126–7. [80] CW 4:125. [81] CW 4:126.

THE POETICS OF SPACE 235

endemic infection of the eye; which helped to explain certain visible peculiarities of the living world beyond these enchanted walls, and might be for Gaston a guide to some further refinements of selection therein.[82]

Pater problematizes our notions of perception: how does the way we perceive affect the ways we depict human beings and display them in our homes? Will a diseased mind find visual expression in distorted design? The portraits exist in the collective, contained by their frames in an aesthetic harmony of pale green, ebony, and gold, the colour scheme of Clouet court portraiture. These ruling presences control the interior by means of an almost magnetic influence which goes beyond their frames. The passage is all atmosphere; in this space, inhabited by lifeless sitters, the reciprocal exchange of gazes between Gaston and the portraits gives rise to thoughts about the individual and the collective, the national and the European, as the visitor comes to terms with contemporary portraiture. Receptacles of the past, the portraits condense European history and project their values onto the cluttered interior. Pater's telescoping of the macrocosmic into the microcosmic unit of the framed portrait may give us an idea of the scope and powers of his last novel and of the ways in which he intended portraiture to serve as the crucial art form in a major narrative about the European individual at a moment of great religious, political, and aesthetic crisis. Gaston gradually becomes more involved with the faces on the wall. Character modulates into the caricature of a period face, reflecting the Italo-German influence on art and a stifling mannerism symptomatic of a troubled nation and era:

> There was certainly something over-charged, something questioning and questionable, in the expression of these portraits which became almost caricature in the purely imaginary faces: an air which the very furniture of the period seemed mockingly to reflect. But again, was it only that art had reached its highest power of expression, and must soon become 'mannered', with an expressiveness really beyond anything there was to express? Meantime the artistic mode of the day, professedly derivative from the genial traditions of Italy, had put on the wan Transalpine complexion of Dürer's *Melancholia*, the out-look of a mind exercised absorbingly, but by no means quite pleasurably, with a bewildering variety of thoughts.[83]

If ever there was a 'mood image' in which atmosphere exudes from the central human figure, Dürer's *Melencolia* must be the classic example. The image crops up again in Pater's mind as an externalization, a *Sinnbild*, of the spirit of the age. It becomes a haunting presence, a northern European decadent image, of the pallor and internalization of the self, characteristic of Valois France. Pater departs from notions of likeness in his reference to the 'purely imaginary faces', while evoking an allegorical portrait which moves beyond the representation of a particular individual to a generalized state of mind. Melancholy modulates into mania as the narrator comments on the effect produced by the era's consumerist craze on the faces of Gaston's contemporaries: 'Could there be in this almost exclusive preoccupation with

[82] *CW* 4:126. [83] *CW* 4:128.

236 WALTER PATER'S EUROPEAN IMAGINATION

things, to which indeed a sincere care for art may at any time commit us, something of that disproportion of mind which is always akin to mental disease? The physiognomist remarks certainly that the most characteristic pictured faces of that day have an odd touch of lunacy about them.'[84] Unusually for Pater, we find a physiognomist who detects the malaise of the age in the human face, almost as if he were conducting a systematic study of *fin-de-siècle* faces of degeneration.[85] From the examination of others, Gaston turns to the examination of himself. For the aesthete, perception becomes almost uncannily creative: you become what you see, and the flux of appearance destabilizes the self. Confronting his own face in a mirror leads to profound speculations about the powers of portraiture:

> If according to the Platonic doctrine people become like what they see, surely the omnipresence of fine art around one must re-touch, at least in the case of the sensitive, what is still mobile in a human countenance. The period, as artistic periods at all events do, had found its expression in a recognised facial type, and Gaston too was conforming to it. Did portraiture not merely reflect life but in part also determine it? The image might react on the original, refining it one degree further. Given that life was a matter of sensations, surely he too was making something of its 'brief interval' between the cradle and the grave. Here was the perfected art of the day, and it was a miracle of dainty scruples, of discernment at least between physical beauty and all that was not that[.][86]

Transformed, Gaston begins to assimilate into his metropolitan surroundings with a plastic sensitivity that threatens to erase his individuality. Pater is toying with the notion of a period face, a standard type to which his protagonist gradually conforms. The arty retouching of our hero into the 'perfected art of the day' is a process of double artistic refinement as a character is turned from breathing original into a period face in imitation of Jasmin's portraits. This is life mirroring art in a manner not unrelated to Wilde's provocative theories in 'The Decay of Lying' that the increase in London fogs responded to the fashion for flimsy light effects in Impressionist painting.[87] The mannerism with which Pater associates Valois France stresses its own artfulness, the *bella maniera* of making the already artful even more so, inviting the reader to reconsider the interrelationship between art and life. A complex dialogue between Pater and Wilde seems at work. They reviewed one another;[88] Pater not merely rewrote Wilde but also his own younger self when quoting what sounds like 'The Conclusion': 'Given that life was a matter of sensations, surely he too was making something of its "brief interval" between the cradle and the grave.' In the

[84] *CW* 4:128–9.

[85] See Daniel Pick's *Faces of Degeneration: A European Disorder, c.1848–c.1918* (Cambridge: Cambridge University Press, 1993).

[86] *CW* 4:130–1.

[87] See Oscar Wilde, 'The Decay of Lying' in *The Complete Works of Oscar* Wilde, volume 4, *Criticism: Historical Criticism, Intentions, The Soul of Man*, ed. Josephine M. Guy (Oxford: Oxford University Press, 2007), 73–103, 95.

[88] Pater reviewed *The Picture of Dorian Gray* in the *Bookman* in Nov. 1891, 59–60. Wilde had reviewed the *Imaginary Portraits* in the *Pall Mall Gazette*, and *Appreciations* in the *Speaker*. See Seiler 1980, 162–5 and 232–7.

'Conclusion' the word 'interval' is repeated with emphasis, bringing home our awareness of the brevity of life. Pater is teasing the reader in *Gaston*, adding to our sense of mannerist distortion: at no point in the 'Conclusion' does the phrase 'brief interval' appear.[89] Is Pater amusing himself by the anachronism of giving us a protagonist in late sixteenth-century France who has read and understood the doctrines of a book published in London in 1873 while now attempting to live his life according to its maxims? The omniscient narrator applies contemporary aestheticism to Valois Paris, while making us question (if we remember our 'Conclusion' well enough) whether his protagonist is a sophisticated and discerning an aesthetic critic. Is he 'for ever curiously testing new opinions and courting new impressions', grasping at 'any stirring of the senses, strange dyes, strange colours, and curious odours', or is he guilty of a 'roughness of the eye that makes any two persons, things, situations, seem alike?'[90]

At the heart of Pater's 'Conclusion' is the clash between science and aestheticism, between a search for the generic, and an eye for the specific. A similar dichotomy is brought out in the tension between the collective family portraits in Jasmin's house and the solitary spectator who gradually erases his individuality and assimilates the period aesthetic. We may ask whether the faces in the portraits are actually indistinguishable from one another as a sign of the decadence of the period, or whether our spectator is incapable of discerning any differences? Gaston's impressionability allows him to be influenced at the risk of a loss of self, and his awareness of the dangers of lingering in Jasmin's house may well be the reason why he leaves in a last effort at self-preservation, the moment the owner returns. In this speaking house, the velvet walls, the Venetian mirror, the books, and the portraits are more eloquent about the inhabitant than he is himself. When in the evening Jasmin emerges, his visitor leaves, concluding, 'Yes! The house, the style, was the man.'[91]

Life has ground to a halt within the walls of Jasmin's residence. In this 'age great in portrait-painting', the hectic activities captured in the Abbé de Brantôme's *Lives of Great and Illustrious French Captains* have been frozen into 'a sort of "still life"'.[92] Although physically absent, Jasmin has left behind his garments, leading his visitor to conclude that, after all, he was 'scarcely missed while his evening suit in cloth of silver and pearls, marvellously *godronné*, a "symphony in white", lay ready there to be looked at like the other high-priced objects around.'[93] The Jasmin he used to know has been replaced by an ornamental covering of the self which makes Gaston doubt the interrelationship between shadow and substance: 'Was the house then empty after all? Was it not the essential man? His "effects" we say, with unconscious irony— of a man's goods—the French themselves of the bag or box he has with him, and power thus passing away from man into his works, it was as if he were already dead.'[94]

With Jasmin's empty house, Pater was engaging with contemporary publications on the aesthetic interior. Several new journals dealing with interior design had seen

[89] Cf. the 'Leonardo' essay: 'Through Leonardo's strange veil of sight things reach him so; in no ordinary night or day, but as in faint light of eclipse, or in some brief interval of falling rain at daybreak, or through deep water.' *Ren.*, 87.

[90] *Ren.*, 189. [91] *CW* 4:131. [92] *CW* 4:125.

[93] *CW* 4:129. [94] *CW* 4:129.

238 WALTER PATER'S EUROPEAN IMAGINATION

the light of day: *The Architect* (1869), *The House Furnisher and Decorator* (1871), *The Furniture Gazette* (1872), *The Art-Workman* (1873), *The Magazine of Art* (1878), *The Journal of Decorative Art* (1881), and *The Studio* (1893).[95] Mary Eliza Haweis had long been an influential voice on the subject with books on *The Art of Beauty* (1878), *The Art of Decoration* (1881), and *Beautiful Houses* (1882). With her pictorialization of the room, expressed in her notion of the interior as a picture to be composed, she painted colour harmonies in tertiary colours in a kind of Whistlerian tonal painting.[96] The interrelationship between the room and its inhabitant remained one which preoccupied her and for which she received much criticism, as her ideas were frequently misconstrued. In some respects, she was a precursor of Bachelard, declaring that one of her 'strongest convictions, and one of the first canons of good taste in house decoration, is that our houses, like the fish's shell or the bird's nest, ought to represent our individual tastes and habits, never the habits of a class.'[97] She explored the empty shell or the nest, before supplying us with its inhabitant: 'A room is like a picture; it must be composed with equal skill and forethought; but unlike a picture, the arrangement must revolve around a point which is never stationary, always in motion; therefore, the "keeping" becomes a problem far harder than the colour. The main point of interest to which the decorations should work up, is the inhabitants; but as they can never be reckoned upon, the picture must be composed as it were without the subject, like a poem without a point or a story without an end.'[98]

In *Beautiful Houses* (1882), she went exploring in a dozen houses, among them the homes of Frederick Leighton, William Burges, Lawrence Alma-Tadema, each time a solitary experience, as the visitor read the interior without the owner's presence.[99] With the interior as an extension of the self, Mrs Haweis detected the cosmopolitan life of Leighton, the medievalism of Burges, and the Dutch background of Alma-Tadema, as her perambulations led her from room to room in an ekphrastic journey of domesticity. Nowhere did she find elaborate costumes equivalent to Jasmin's, but her general philosophy of the 'two D's'—dress and decoration—could well have led her to include a metonymic piece of clothing. Her essay 'Mixed Aesthetes' argued for a personal approach to both interior design and dress, aware that the Aesthetic Movement was often at the receiving end of much ridicule: ' "Dressing up to one's house" is a practice for which æsthetes are sneered at: and we do not want houses dressed down to the level of the ugliest inmate. But if people remembered that the two D's—dress and decoration—are practically inseparable, and cannot do without each other, because they mean the perception of beauty in detail, we should not be pestered by these empty watchwords, or by so many eyesores in common life.'[100] Interior decoration should essentially form a background to the individual, and one

[95] Charlotte Gere and Lesley Hoskins, *The House Beautiful: Oscar Wilde and the Aesthetic Interior* (London: Lund Humphries, 2000), 77.

[96] Anne Anderson, 'Harmony in the Home: Fashioning the "Model" Artistic Home or Aesthetic House Beautiful through Color and Form', *Interiors* 5:3 (2014), 341–60.

[97] Mary Eliza Haweis, *The Art of Decoration* (London: Chatto & Windus, 1881), 23–4.

[98] Ibid., 10.

[99] Mary Eliza Haweis, *Beautiful Houses; Being a Description of Certain Well-Known Artistic Houses*, 2nd edn (London: Sampson, Low, Marston, Searle & Rivington, 1882).

[100] Mary Eliza Haweis, 'Mixed Æsthetes', *Time* 9 (Oct. 1883), 433–8, 436.

should match, rather than rival, the other. Mrs Haweis's ideas of the walls as background harmonized with Morris's saying that 'Whatever you have in your rooms, think first of the walls',[101] and as Charlotte Gere points out, 'artistic practice was in general agreement that the walls set the tone for the whole decorative scheme'.[102] Aware that 'A great deal of small fun was made out of my supposed assertion that ladies should dress up to their rooms, or re-decorate them to suit every new dress, or refuse to dine out without a warranty of the colour they were expected to sit against',[103] Mrs Haweis insisted that 'different hues must be arranged with thought and skill where juxtaposition to faces and complexions is unavoidable'.[104]

Her language of 'tones', 'hues', and 'arrangements' places great emphasis on the process of selection; we sense the excitement of the Veblerian consumer: 'Most people are now alive to the importance of beauty as a refining influence. The appetite for artistic instruction is even ravenous. We cannot be too thankful that it is so, for the vacuum can be filled as easily as the purse can be emptied. Just now every shop bristles with the ready means: books, drawings, and *objets de vertu* from all countries are within everybody's reach, and all that is lacking is the cool power of choice'.[105] Mrs Haweis's commonsensical voice is such a contrast to Pater's criticism of living up to one's blue china, and all that goes with it, while essentially their views coincided. 'Why not be yourself?', she asked. 'Why not admit that you are miserable in a Queen Anne chair, and that you hate yellow and mud colour, and that you think modern things much nicer than ancient ones?' 'Better be simple and happy than aesthetic and ridiculous', she concluded in 1883,[106] the very same year that she nevertheless moved into Dante Gabriel Rossetti's aesthetic Tudor House in Chelsea, shortly after his death.[107]

Ambiguous responses to the aesthetic interior characterize the period. Wilde's Oxford flamboyancy contrasted with some of the messages given during his 1882 lecture tour of northern America, advertising *Patience*, Gilbert and Sullivan's satirical operetta on the Aesthetic Movement.[108] His lecture 'The Practical Application of the Principles of Aesthetic Theory to Exterior and Interior House Decoration, with Observations upon Dress and Personal Ornaments', first given in Chicago on 11 March 1882, was soon abbreviated to 'The House Beautiful', in allusion to Clarence Cook's American book on interior design, *The House Beautiful* (1881). Mrs Haweis's 'two D's' were again matched, and while arguing for aesthetic, colourful dress, rather than the funereal black fashion in vogue, Wilde advocated craftsmanship, manual labour, and honesty of material in a curious mixture of Ruskinian arts-and-crafts idealism and Whistlerian aestheticism. Arguing for symphonies of secondary colours, with clear keynotes, he promoted Whistler's gold, yellows, and blues in Frederick Leyland's *Peacock Room* (1877), itself a monument over a culture keen to live up to its blue china, centring around Whistler's *La princesse du pays de la porcelaine* (1863–5) and Leyland's collection of china. Wilde's equally popular lecture on

[101] Quoted in Gere and Hoskins, 115. [102] Ibid., 115.
[103] Haweis, *The Art of Decoration*, 22–3. [104] Ibid., 23. [105] Ibid., 3.
[106] Haweis, 'Mixed Aesthetes', 434. [107] Gere and Hoskins, 65.
[108] See David Friedman, *Wilde in America: Oscar Wilde and the Invention of Modern Celebrity* (New York: Norton & Co., 2014).

240 WALTER PATER'S EUROPEAN IMAGINATION

'The Decorative Arts' emphasized manual labour and craftmanship together with the structural power of design, with the result that the term 'ornamental' almost became a term of abuse. By the early 1880s the voices of the arts-and-crafts movement were still audible in Wilde; he may have dressed in velvet breeches and silk stockings, reminiscent of an aristocratic look of the past, but he was also arguing for a democratic world of crafts, aimed at bringing beauty into the homes of all social classes, not just those of industrial magnates like Leyland.

The dangerous den into which Gaston enters has its forebears in the houses of Wilde's Dorian Gray and in the aesthetically saturated interiors of Des Esseintes, the protagonist of Huysman's novel *À Rebours* (*Against Nature*) (1884). Pater may well have been writing Chapter VIII of *Gaston* in the autumn of 1891 as he was reviewing Wilde's novel. Controlled and urbane in tone, his review only hints at the dismay he may have felt when encountering Lord Henry, who speaks a thinly veiled parodic form of Pateresque. A promoter of 'a kind of dainty Epicurean theory', Lord Henry is described by Pater as a cynic and 'a kind of satiric sketch'.[109] To have the target of the satire review the book was risky, and with his continuous references to true and misconstrued Epicureanism, Pater addressed the misreadings and adjustments of his 'Conclusion' and the interrelationship between his first book and *Marius*. Commenting on the 'very plain moral' of Wilde's story, 'pushed home, to the effect that vice and crime make people coarse and ugly',[110] Pater may have been repaying the satire by pointing out one of the fundamental paradoxes of Wilde's text: the discrepancy between the novel's 'Preface' and its sequel. Delighted with the supernatural aspects of Wilde's narrative, Pater concluded by levelling one of the most frequently repeated criticisms at the author: 'Mr. Wilde's work may fairly claim to go with that of Edgar Poe, and with some good French work of the same kind, done, probably, in more or less conscious imitation of it.'[111] The perceivable 'Frenchiness' of Wilde's text surfaces everywhere, from the explicit references to French literature, to French breakfasts, and the elegant interiors of Lord Henry's Mayfair mansion, filled with imported Valois decadence:

It was, in its way, a very charming room, with its high panelled wainscoting of olive-stained oak, its cream-coloured frieze and ceiling of raised plaster-work, and its brickdust felt carpet strewn with silk long-fringed Persian rugs. On a tiny satin-wood table stood a statuette by Clodion, and beside it lay a copy of "Les Cent Nouvelles", bound for Margaret of Valois by Clovis Eve, and powdered with the gilt daisies that Queen had selected for her device. Some large blue china jars and parrot-tulips were ranged on the mantleshelf, and through the small leaded panes of the window streamed the apricot-coloured light of a summer day in London.[112]

The French influence assumes material form in the yellow book which Lord Henry sends to Dorian. Contained within its cover, the reader finds a condensed form of aestheticism centring around a character study; the Paterian echoes—rhythm,

[109] 'A Novel by Mr. Oscar Wilde', *The Bookman* 1 (Nov. 1891), 59–60, 59.
[110] Ibid., 60. [111] Ibid., 60.
[112] Wilde, *The Picture of Dorian Gray*, *The Complete Works of Oscar Wilde* 3:208 (1891 text).

vocabulary, and misconceived philosophy—fall with great density in Wilde's description of the book: 'It was the strangest book that he had ever read. It seemed to him that in exquisite raiment, and to the delicate sound of flutes, the sins of the world were passing in dumb show before him.'[113] The Pateresque passes subtly from Lord Henry's into Dorian's mind, and the protagonist's narcissistic love of mirrors as sites for his frequent comparisons between his own reflection and the painted portrait leads us to Gaston's study of his changed self in the Venetian mirror. If Pater's protagonist had similarities with Snow White's exploration of the dwarfs' deserted house, Dorian is Wilde's version of the wicked step-mother, constantly demanding reassurance from the mirror on the wall of his unsurpassed beauty. Among the objects in his mutable interior, the mirror remains a constant item in the triangulation between Dorian and his two reflected images. The other constant is the yellow book, providing him with yet further insights into the soul of 'the wonderful young Parisian, in whom the romantic and the scientific temperaments were so strangely blended' as to become for Dorian 'a kind of prefiguring type of himself'.[114] A 'symbol of the modern idea', Dorian is Wilde's *Mona Lisa*, turned collector and interior designer in an apparently endless pursuit of sensory gratification. Where Pater selects one or two significant items in order to evoke atmosphere, Wilde is driven by the inventory, as he piles detail upon detail, sometimes with cloying effect. The materiality of fabrics, flowers, paintings, and books evokes Dorian's obsessions, as he attempts to cure the soul by means of the senses.

Having inspected the family portrait gallery and detected his genetic ancestors, Dorian realized that, furthermore, 'one had ancestors in literature';[115] Dorian's typological forebear in the yellow book had his ancestor in the protagonist of *À Rebours*. Pater saw that very clearly, and Wilde made no attempt at covering his tracks. Huysmans began his novel in the family portrait gallery, a room which obtained almost topological status within the nineteenth-century novel:

> Judging by the few portraits that have been preserved in the Château de Lourps, the line of the Floressas des Esseintes consisted, in bygone days, of muscular warriors and grim-looking mercenaries. Cramped and confined within those old frames where their great shoulders stretched across from side to side, they startled you with their staring eyes, their handlebar moustaches, and their swelling chests that curved outward to fit the enormous shell of the breast-plate.
>
> Those were the ancestors: the portraits of the descendants were missing;[116]

Huysmans's novel attempts to fill the space left by painting the portrait of the last surviving family member: 'Of this family, which had once been so numerous that it occupied almost all the lands of the Île-de-France and the Brie, there now remained but one solitary descendant, the Duc Jean, a frail young man of thirty, nervous and anaemic, with hollow cheeks and cold, steel-blue eyes, a straight nose with flaring

[113] Ibid., 274. [114] Ibid., 276. [115] Ibid., 289.
[116] Joris-Karl Huysmans, 'Prologue', *Against Nature*, tr. Margaret Mauldon, Oxford World's Classics (Oxford: Oxford University Press, 1998), 3.

242 WALTER PATER'S EUROPEAN IMAGINATION

nostrils, and dry, slender hands.'[117] The contrast between the active captains of Jasmin's family, celebrated by Brantôme, now reduced to still-life portraiture, may well be a reminiscence of the opening of Huysmans's novel. The novel which ensues creates a frame for this delicate protagonist; we encounter the inhabitant before we explore his home, the mollusc before its shell, and the grotesque interior which Des Esseintes creates for himself—with perfume-exuding organs, rare books, Moreau paintings, flowers—is one long extension of a diseased soul. Wilde's catalogue descriptions are short by comparison to Huysmans's, which emphasize artifice, as even nature is made to look artificial in order to stir the numbed senses of the bored protagonist. 'As he was wont to remark, nature has had her day.'[118] In his house in Fontenay, blinds cover the windows to keep out natural daylight, the servants wear felt slippers so as not to produce disturbing noise as they go about their business, and the inhabitant sleeps by day and lives by night. The world is 'too much with him' and can only be admitted into Des Esseintes's interiors through the carefully filtered selection process of the owner's aesthetic tastes.

All that lives must eventually die. The tortoise, brought in to highlight the colours and patterns of the Oriental carpets, has its gilded shell encrusted with gems. Famous for its longevity, the animal must succumb to the deadening weight of artifice: 'It was still quite motionless and he felt it with his fingers; it was dead. Accustomed, no doubt, to an uneventful existence, to a humble life spent beneath its poor carapace, it had not been able to bear the dazzling splendour thrust upon it, the glittering cope in which it had been garbed, the gems with which its back had been encrusted, like a ciborium.'[119] A creature with its own shell as an extension of itself, the tortoise has been violated in an attempt to fit into Des Esseintes's larger shell. By dressing the creature in an inappropriate garment, Huysmans's protagonist has sinned against Mrs Haweis's 'two D's'; what may look like a ciborium does not hold the Eucharist, but merely a slow-moving animal which has nothing to do in an aesthetic interior. Huysmans's narrative can be read as another moral tale about the (self)destructive powers of excessive aestheticism. The author's conversion to Catholicism a few years later and his creation of an artists' retreat in Burgundy in 1898—*La Maison Notre-Dame*—testified to his search for the spiritual life,[120] a development also pursued in his four post-conversion novels (*Là-Bas*, *En Route*, *La Cathédrale*, and *L'Oblat*). The novels argue for the authenticity of the aesthetic experience when religious works of art are encountered within religious architecture. Durtal, Huysmans's new protagonist, 'corrected the "dilettante" attitudes of Des Esseintes by showing the superiority of art still displayed in its original context'.[121]

Pater's talents for synthesis were unique; if the jewelled tortoise sat as a monument to the perversions of aestheticism, Pater created his own version of a relic he had encountered in the cathedral of Amiens. Gaston pays a visit to Marguerite de Navarre, who, like the *Mona Lisa*, resides in the Louvre. One object catches the visitor's eye as a sinister reminder of the fates of the queen's admirers: the head of her

[117] Ibid., 3. [118] Ibid., 20. [119] Ibid., 42–3.

[120] See Elizabeth Emery and Laura Morowitz, *Consuming the Past: The Medieval Revival in Fin-de-Siècle France* (Aldershot: Ashgate, 2003), chs 2, 3, and 4.

[121] Ibid., 98.

former lover, Joseph Boniface de la Môle. 'If Queen Margaret's chamber was like some place of strange worship, herself at once its idol and priestess, its chief relic was as ghastly as church relics usually are; a dead man's face, with the stamp of his violent end, mummied and brown, lying there exposed among the best prized objects of the lady's personal property, mounted in a kind of shrine or pyx of good goldsmith's work, and set with gems picked from milady's own jewel-case.'[122] The morbid fate of la Môle's head was not Pater's invention; it was rumoured already in the sixteenth century and featured in Alexandre Dumas's *La Reine Margot* (1845). Pater's description of it, however, reminds us of Des Esseintes's pet, combined with the preserved head of Saint John the Baptist, chief relic in Notre Dame d'Amiens (Fig. 5.10). In his essay on the church, Pater refers briefly to the frescoes of 'the histories of John the Baptist, whose face-bones are here preserved',[123] but his recreation of it as Queen Marguerite's special trophy gives it a resonance which goes beyond its religious

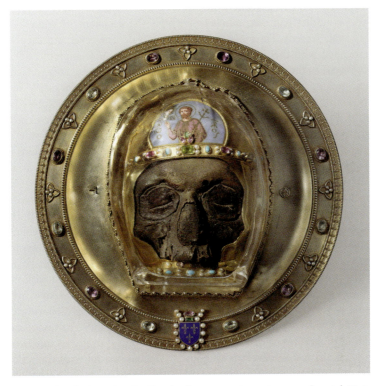

Fig. 5.10. Relic head of St John the Baptist, bone, precious stones and metal. Notre Dame d'Amiens. Photographer: Patrick Müller, 1999. Amiens, Cathedral. © 2021. CMN dist. Scala, Florence.

[122] *CW* 4:148.
[123] 'Some Great Churches in France. 1. Notre Dame d'Amiens', *Nineteenth Century* 35 (March 1894), 481–8, 487.

244 WALTER PATER'S EUROPEAN IMAGINATION

status. Marguerite is in the same league as Salome, who features in Gustave Moreau's paintings in Des Esseintes's collection. The decapitated man, whose head is served on a plate, is provided with a foil, a setting for the self, in grim recollection of the ways in which the mirror frames the living face. On encountering it, Gaston is confronted with the aesthetes' desire for a proper framing of the self, in life as well as in death; in yet another mirror, 'Gaston saw himself also closely enough conformed to the aesthetic demand of the day, that he too had taken the impress and colour of his age, the hue (like the insect on the tree) of what mentally he fed on.'[124] Assimilation may be taken too far, when the self merges too closely with its surroundings, as the insect with the bark or the wallflower with the wall.

From the Reliquary to the Cathedral

Apparently 'Michael Field' (Katharine Bradley and Edith Cooper) at some point exclaimed, 'Wouldn't one give much to surprise the bacchant in Walter Pater!',[125] suggesting that, secretly, Pater had a Dionysiac streak. The revel and carnivalesque chaos associated with the deity corresponded to Pater's more anarchic sides which only rarely came to the surface: 'his rapturous description of maenads is itself a form of rapture, making Pater into an enthusiastic worshipper of Dionysus.'[126] In 'Denys l'Auxerrois', both the fertile and the chthonic aspects of the god are explored, as they had been in Pater's essay on Dionysus (1876).[127] No fewer than three exhumations take place: the discovery of a Greek coffin containing an ancient bottle of wine launches the Golden Age of Auxerre, while the exhumation of a local saint initiates the protagonist's delight in relics leading to the disinterment and reburial of his mother. If Pater was secretly a bacchant, he was most certainly also secretly a worshipper of relics, coffins, and tombs, yet one with an innate sense of claustrophobia, if one can judge from the many open graves and coffins in his texts.[128] The lugubrious side of his imagination frequently comes to the fore: Florian's recollection of the open graves, the decomposing bodies in 'Duke Carl', the buried military leader in Chartres who erupts from his coffin. Pater's argument with the earth,[129] with the buried past, runs from Winckelmann's fingering the relics of the past with unsinged hands till one of Pater's last, unfinished portraits, 'Gaudioso, the Second', where the protagonist is 'submissively at work, day by day, in mouldering ossuaries, charnelhouses', while his 'dainty fingers grew used to the touch of those rotting discoloured bones, the tardy process of corruption through prolonged centuries quickened now in the quicker air, and achieved in an hour.'[130] Gaston had fingered the relics in the Cathedral of Chartres: 'It was in one's hand, —the finger of an Evangelist!', 'bones of the "Maries", with some of the earth from their grave: these, and the like of these,

[124] *CW* 4:154. [125] *CW* 4:59.

[126] Yopie Prins, 'Greek Maenads, Victorian Spinsters', in ed. Richard Dellamora, *Victorian Sexual Dissidence* (Chicago: University of Chicago Press, 1999), 43–82, 52.

[127] 'A Study of Dionysus: The Spiritual Form of Fire and Dew', *Fortnightly Review* 20 n.s. (1 Dec. 1876), 752–72.

[128] See Jay Fellows. [129] See Dowling 1988. [130] Monsman 2008, 91.

were what the curious eye discerned in the recesses of those variously contrived reliquaries, great and small, glittering so profusely about the dusky church.'[131] Touch, stench, and decomposition are aspects of Pater's disinterment of a tangible past in need of housing. While the living individual has some control of its physical surroundings, such control ceases the moment it is reduced to a pile of bones. Bones may travel, change their place, become rehoused, and coffins, urns, and reliquaries may provide more or less appropriate houses for the earthly remains of the dead.

Pater's study of Sir Thomas Browne (1886) zooms in on one such lover of bones and relics, described in terms so sympathetic that Pater himself seems to lurk behind the seventeenth-century physician. Browne constructs his own shell-like house in Norwich around his cabinet of antiquities, 'his old Roman, or Romanised British urns, from Walsingham or Brampton, for instance; and those natural objects which he studied somewhat in the temper of a curiosity-hunter or antiquary'.[132] With his study of ancient burial rites, *Urn Burial* (1658), Browne explored funerals by earth, fire, water, and air across a range of different cultures, from the Greeks, the Romans, to the Muslims, the Danes, the British, and the Normans. Browne's interest in the elements directs Pater to a study of him as a 'humourist', a representative of the melancholy temper. Pater comments wryly that it may all be very well to regard life as a 'meditation upon death: but to many, certainly, Browne's would have seemed too like a life-long following of one's own funeral'.[133] Fascinated with the stratification of the earth, Browne mixed the man-made with the natural, the sediments of civilization constituting the upper layers, as evoked in his grand opening passage:

> In the deep discovery of the subterranean world, a shallow part would satisfie some enquirers; who, if two or three yards were open about the surface, would not care to rake the bowels of *Potosi*, and regions towards the Centre. Nature has furnished one part of the Earth, and man another. The treasures of time lie high, in Urnes, Coynes, and Monuments, scarce below the roots of some vegetables. Time hath endless rarities, and shows of all varieties; which reveals old things in heaven, makes new discoveries in earth, and even earth it self a discovery.[134]

Browne's private museum world inspires a 'spiritual ardency', an excitement over 'all those ugly anatomical preparations, as though over saintly relics'.[135] Admittedly, organs and limbs in glass cases are, just like the venerated piles of bones in catholic churches, a morbid display of bodily fragments not originally intended for the human gaze. Browne's text is one long defence of cremation: 'to have our sculls made drinking-bowls, and our bones turned into Pipes, to delight and sport our enemies, are Tragicall abominations, escaped in burning Burials.'[136] He spells out how worms and maggots devour the remains of the buried body, whereas 'Teeth, bones, and hair, give the most lasting defiance to corruption.'[137] Such is the stuff of which reliquaries are full. Pater's Browne is a traveller into realms where few go willingly:

[131] *CW* 4:51. [132] 'Sir Thomas Browne', 8. [133] Ibid., 8.
[134] Thomas Browne, *Hydriotaphia: Urne-Burial or, a Brief Discourse of the Sepulchrall Urnes Lately Found in Norfolk* (London: Penguin, 2005), 1.
[135] 'Sir Thomas Browne', 8. [136] Browne, 30. [137] Ibid., 31.

246 WALTER PATER'S EUROPEAN IMAGINATION

Like the soul, in Blake's design, 'exploring the recesses of the tomb,' he carries a light, the light of the poetic faith which he cannot put off him, into those dark places, 'the abode of worms and pismires,' peering round with a boundless curiosity and no fear; noting the various casuistical considerations of men's last form of self-love; all those whims of humanity as a 'student of perpetuity,' the mortuary customs of all nations, which, from their very closeness to our human nature, arouse in most minds only a strong feeling of distaste.[138]

Browne ties life and death together in surprising ways, as when he comments on the circular form of most urns, 'the common form with necks...making our last bed like our first; not much unlike the Urnes of our Nativity, while we lay in the nether part of the Earth, and inward vault of our Microcosme.'[139] 'Womb' and 'tomb' have long been married by rhyme, but Browne's formalist observations—coming from a man who had attended anatomical dissections—add new resonance to the rhyme. The uterocentric universe of the dissecting theatre shown on the frontispiece to Andreas Vesalius' *De humani corporis fabrica* (1543) (Fig. 5.11) combined the ges-ture of male discovery of newfound territory with public display of the central life-giving organ. Browne, by contrast, provided an illustrative frontispiece of some of the urns found in Walsingham (Fig. 5.12). Other kinds of life flowed within the urns: Browne commented on the preserved bay leaves, oils, and 'Aromaticall Liquors' which 'attended noble Ossuaries. And some yet retaining a Vinosity and spirit in them, which if any have tasted they have farre exceeded the Palats of Antiquity.'[140] Pater was working on his Browne essay while writing 'Denys', and the green bottle with the well-preserved ancient wine contained in the Greek sarcophagus may well have had its origin in Browne, whose proto-Paterian observation that 'Life is a pure flame, and we live by an invisible Sun within us,'[141] reminds us of the undercurrent in his book of the inseparability of life and death.

Pater is with Browne for part of his journey into the world's ossuaries, just as Browne's excitement is also Pater's own: 'As another might be moved at the sight of Alexander's bones, or Cecilia's, or Saint Edmund's, so he is full of a fine poetical excitement at such lowly relics as the earth hides almost everywhere beneath our feet.'[142] His suggestive image of the world as one great cemetery is no less morbid than all the bizarre curiosities in Browne's cabinet: the earth as a universal Golgotha which we all traverse with the knowledge that one day our own bones will be added to the pile. Pater would never have seen the bones of Alexander the Great. Reputedly buried in Alexandria, his tomb had been mythical since antiquity, and several nineteenth-century attempts were made to locate it. The relics of St Cecilia he would, however, have encountered in the Roman church of S. Cecilia in Trastevere, the ancient necropolis which Marius visits, with a keen awareness that the children bur-ied in the catacombs under his feet are the dark counterparts of the happily singing cherubs above ground: 'when he saw afterwards the living ones, who sang and were busy, above—sang their psalm *Laudate pueri Dominum!*—their very faces caught for

[138] 'Sir Thomas Browne', 16. [139] Browne, 20.
[140] Ibid., 21. [141] Ibid., 50.
[142] 'Sir Thomas Browne', 17.

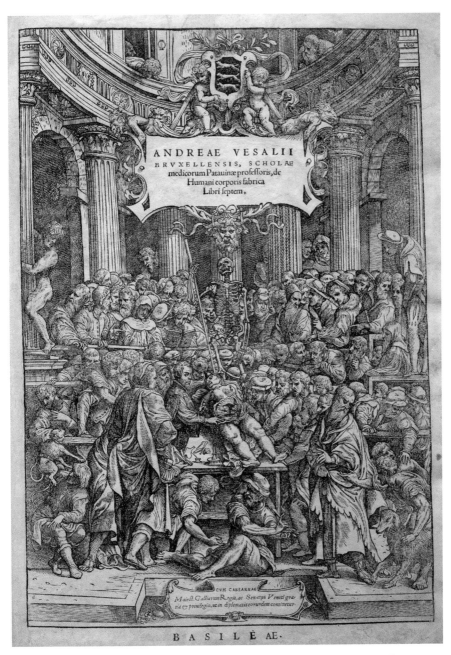

Fig. 5.11. Frontispiece of Andreas Vesalius, *De corporis humana fabrica* (Basel: Oporini, 1543). Wikimedia Commons.

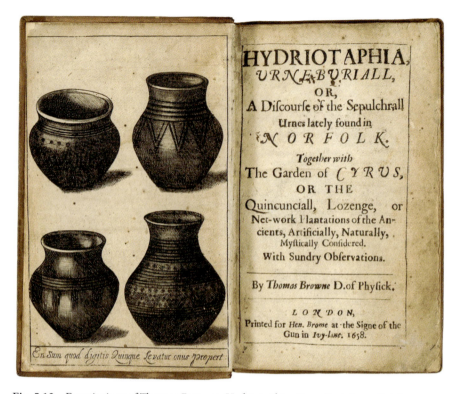

Fig. 5.12. Frontispiece of Thomas Browne, *Hydriotaphia: Urne-Burial or, a Brief Discourse of the Sepulchrall Urnes Lately Found in Norfolk* (London: Henry Brome, 1658). Private collection. PBA Galleries/Justin Benttinen.

him a sort of quaint unreality, from the memory of those others, the children of the Catacombs, but a little way below.'[143] For the moribund Marius, the dead bodies in the Catacombs are the real ones. The scene has a parallel in the last chapter of *Gaston*, 'Mi-carême', in which the protagonist pays a solitary visit to the Cemetery of the Innocents in central Paris.[144] An overgrown chaos of mass graves and prostitutes, the cemetery has one rebellious inhabitant who refuses to stay in his coffin. The recurring flourishing hawthorn has been given new life, with vampiric overtones, as the blood of the dead is literally in its roots:

> [T]he earth for her part seemed anxious to give up its ragged dead already, or at least to be but a careless keeper of the bones, having made its natural use of the body's juices. As if mistaking the jubilant sunshine of this first summer day for the resurrection morning, the occupant of a nameless old stone coffin had tumbled forth. Hanging luxuriantly in the irregularities of the wasted mouldered grey walls,

[143] *Marius the Epicurean: His Sensations and Ideas*, 2 vols (London: Macmillan 1885), 2:105.
[144] The cemetery was demolished shortly before the French Revolution and is now commemorated by a copy of Jean Goujon's water fountain by Les Halles.

THE POETICS OF SPACE 249

an immense *aubépine* of immemorial age flowered above it, filling its hollows with nests of fiery crimson; had flowered, as if with a second youth of late years, miraculously, it had seemed to the crowds who had come to visit it, being *arrosée, rejeunie, fortifiée*, drinking strength to blossom anew from the blood of the heretic it had come by, after the carnage of Saint Bartholomew.[145]

With Pater one's earthly remains are never laid fully to rest; if not the actual resurrection, then a mock resurrection is a likelihood. Duke Carl's *déroute*, from the pompous mock funeral with *resurgam* written on the coffin, to the pile of anonymous bones, left on open display, is one such case. Another is that of St Edmund of Abingdon,[146] whose bodily remains are exhumed under great publicity in 'Denys':

The body of Saint Edme had lain neglected somewhere under the flagstones of the sanctuary.[147] This must be piously exhumed, and provided with a shrine worthy of it. The goldsmiths, the jewellers and lapidaries, set diligently to work, and no long time after, the shrine, like a little cathedral with portals and tower complete, stood ready, its chiselled gold framing panels of rock crystal, on the great altar. Many bishops arrived with King Lewis the Saint himself,[148] accompanied by his mother, to assist at the search for and disinterment of the sacred relics. In their presence, the Bishop of Auxerre, with vestments of deep red in honour of the relics, blessed the new shrine, according to the office *De benedictione capsarum pro reliquiis*.[149] The pavement of the choir, removed amid a surging sea of lugubrious chants, all persons fasting, discovered as if it had been a battlefield of mouldering human remains. Their odour rose plainly above the plentiful clouds of incense, such as was used in the King's private chapel. The search for the Saint himself continued in vain all day and far into the night. At last from a little narrow chest, into which the remains had been almost crushed together, the bishop's red-gloved hands drew the dwindled

[145] *CW* 4:177.

[146] St Edmund was only mentioned in the 1886 periodical text. In the 1887 book and all subsequent editions, the saint is only referred to as 'one of the local patron saints'.

[147] Educated at Oxford and Paris, Edmund Rich (1175–1240) was renowned as one of the first teachers of Aristotle at Oxford, where he gave his name to St Edmund Hall. In 1233 he became Archbishop of Canterbury, and after religious controversies, retired to the Abbey at Pontigny, near Auxerre, as had two other Canterbury Archbishops, Stephen Langton and Thomas Becket, before him. Both Langton and Beckett died in England, whereas Rich died in France on 16 November 1240. Soon his grave became associated with miracles. His body rests in the Abbey at Pontigny. Edmund was canonized in 1246, when his grave was opened in the presence of Queen Blanche and King Louis IX. In 1249 his apparently uncorrupted body was placed in a reliquary at Pontigny, replaced in the seventeenth century by a Baroque reliquary tomb. Since the thirteenth century his grave has been popular with pilgrims, Pontigny being on the route to Santiago de Compostela.

[148] King Louis IX, also known as Saint Louis (1214–70, king 1226–70), was the only French monarch to become canonized, in 1297. Louis was one of the great Crusader kings, patron of the arts, promoting the spread of gothic architecture throughout his realm.

[149] The *De Benedictione Capsarum pro Reliquiis, et aliis Sanctuariis includendis* is the name given in the Roman Pontificale to the ceremony of the blessing of relics. It means 'On the Blessing of Reliquaries and other Sacred Objects to be included in Santuaries'. 'Capsa' means a container.

250 WALTER PATER'S EUROPEAN IMAGINATION

body, shrunken inconceivably, but still with every feature of the face traceable in a sudden oblique ray of ghastly dawn.[150]

This is a rare instance of Paterian farce: we begin with the shrine, before we follow an entire community's indefatigable search, assisted by bishops and royalty, for the bones of a foreign saint. Before the saint's body has been even located, the costly and elaborate miniature cathedral is in place and blessed. Eventually, a plethora of bones emerges with none of the odour of sanctity. The malodorous experience of unearthing the past cannot be submerged by even the royal, and presumably superior, incense. When, finally, St Edmund is discovered, his humble lodging in a narrow chest has left his body unchanged. Browne had remarked that 'Characters are to be found in skulls as well as faces',[151] and some character would seem to be left in the exhumed Englishman. Pater selected a saint of personal importance to him, connected with the two seats of learning, Canterbury and Oxford, which had formed his own education. The eastern part of the Chapel in Brasenose College covered the very site where Edmund's house reputedly stood.[152] There is nothing elevated about the disinterred saint; like the Scandinavian bog people, he is exposed in all his humanity, and the costly shrine which awaits him may not be to his taste at all. Pater might have read about the shrine in local medieval sources,[153] or he might have been inspired by the neo-gothic shrine to the relics of another Anglo-French saint, St Germain, in the Cathedral of Auxerre (Fig. 5.13). The church within the church conveys a double sanctity, a microcosm relating the individual to a larger monument to faith. In Pontigny, where Edmund's body rested in a baroque monument above the altar, a glass pane was inserted so that pilgrims could peep in at the saint, facilitated by a large wooden staircase erected in the nineteenth century. More than 350 English pilgrims visited in the company of Cardinal Manning in 1874. Pater may himself have peeped in or been familiar with a nineteenth-century postcard of St Edmund (Fig. 5.14), dressed in his bishop's robes and waving a benedictory left hand. In his medieval tale, he was certainly demonstrating his ability to 'do gothick', to incorporate a literary style which suited the period and the architecture with all its Ruskinian grotesque savageness.

Pater may have intended a pun on the Greek 'sarcophagus' and 'omophagus', the first meaning 'an eater of flesh', the second 'an eater of raw flesh'. The coffin unearthed marks the beginning of the fertile Dionysian phase in Auxerre's history, inaugurated with the sudden arrival of Denys. Returning after a journey to the East, the vegetarian Denys becomes a carnivore, a microcosmic development with macrocosmic implications, triggering the city's decline. The exhumation of St Edmund is an attempt to bring Christian healing, yet with the unintended side effect of arousing

[150] 'Denys l'Auxerrois', *Macmillan's Magazine* 54 (Oct. 1886), 413–23, 420–1. On 3 Sept. 1849, a group of priests and delegates of the Archbishop of Sens examined the relics of Saint Edmund, which were found to be largely undamaged.

[151] Browne, 32.

[152] Frances de Paravicini, *Life of St. Edmund of Abingdon, Archbishop of Canterbury* (London: Burns & Oates, 1898), 78.

[153] A ratification by Pope Innocent IV to Jacques, Prior of Pontigny, of 12 Dec. 1250, described the reliquary to St Edmund as taking the form of a miniature church made of gold or silver and decorated with precious stones and rock crystal (100 J 10-2 Archives Département Yonne).

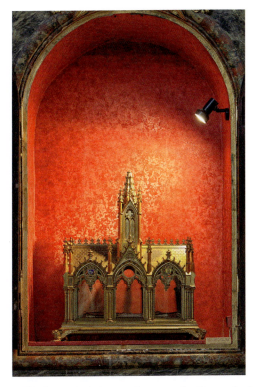

Fig. 5.13. Reliquary of St Germain (nineteenth century), gilt wood, glass, and metal. Cathédrale St Étienne, Auxerre. © JOHN KELLERMAN/Alamy Stock Photo.

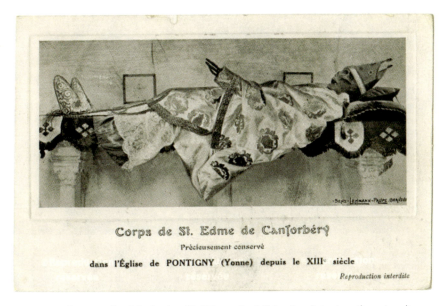

Fig. 5.14. Photograph of the body of St Edmund of Abingdon (nineteenth century). Archives of Yonne. Arch. dép. Yonne, 2 Fi 10268.

Denys's interest in graves and relics, as he takes up the occupation as sexton. His own body is torn to shreds by the local citizens in imitation of the Dionysian ritual of the 'sparagmos' (literally the 'tearing to pieces') and disappears, all that remains being his heart, which finds a humble burial in the cathedral, whether in an urn or a chest we are never told. A friend with the not insignificant name of Hermes performs a private interment. As the only god who travels freely in and out of the underworld, Hermes paves the way for other worlds. Resurrection is always at hand in Pater; his text concludes with the narrator's sighting of Denys in the nineteenth-century streets of Auxerre. According to Theban legend, the still throbbing heart of the dismembered Dionysus was brought to his father Zeus, and subsequently to his mother Semele, who reclothed it in new flesh, thus giving birth to another Dionysus.[154]

Pater's interest in the open grave stayed with him; Gaudioso the Second swears by the resurrection and constructs his clerical life in dual activity above and below

Fig. 5.15. Girolamo Romanino, *S. Alessandro Altarpiece* (1525), oil on panel. © National Gallery, London.

[154] 'A Study of Dionysus', 772.

ground, as an aristocratic patron of art and archaeology believing in the transcendental powers of beauty, while serving as a handler of bones and ossuaries in the local crypts.[155] The title plays with the notion of a resurrection, as a sixteenth-century bishop, depicted in Girolamo Romanino's *S. Alessandro Altarpiece* in the National Gallery (Figs 5.15 and 5.16) is conceived as a Renaissance successor in both name and status to St Gaudioso, fifth-century Bishop of Brescia. As a reincarnation of one of the legendary local saints, whose relics can be found in the churches of S. Alessandro and SS. Nazaro e Celso, Gaudioso gives new life to a local figure by bringing early Christianity into the Renaissance in a city which is a historical palimpsest full of Roman remains. The text exists in close dialogue with Pater's 'Art Notes in North Italy',[156] which served as 'prologue to an Imaginary Portrait with Brescia for background'.[157] He concluded his essay with a description of the figure of Gaudioso in the Romanino altarpiece:

Fig. 5.16. Girolamo Romanino, *S. Gaudioso* (detail from the *S. Alessandro Altarpiece*) (1525), oil on panel, 74.2 × 65.2 cm. © National Gallery, London.

[155] Secondary literature on 'Gaudioso, the Second' is limited. See Maria Luisa de Rinaldis, 'The Sacred in Pater's Aesthetic: Ambivalences and Tensions', *English Literature* 2:2 (2015), 383–99.
[156] 'Art Notes in North Italy', *New Review* 3 (Nov. 1890), 393–403.
[157] Letter to Arthur Symons, 18 Oct. 1890, *CW* 9.

254 WALTER PATER'S EUROPEAN IMAGINATION

The face, of remarkable beauty after a type which all feel though it is actually rare in art, is probably a portrait of some distinguished churchman of Romanino's own day; a second Gaudioso, perhaps, setting that later Brescian church to rights after the terrible French occupation in the painter's own time, as his saintly predecessor, the Gaudioso of the earlier century here commemorated, had done after the invasion of the Goths. The eloquent eyes are open upon some glorious vision.... Here at least, by the skill of Romanino's hand, the obscure martyr of the crypts shines as a saint of the later Renaissance, with a sanctity of which the elegant world itself would hardly escape the fascination, and which reminds one how the great Apostle Saint Paul has made courtesy part of the content of the Divine charity itself.[158]

The 'obscure martyr of the crypts' is a key to the conflation of the two different Gaudiosos in Pater's fictional text. Septimius Celius Gaudiosus, known as Gaudiosus of Naples, was originally Bishop of Abitina in Tunisia. Expelled, he settled on the hill of Capodimonte in Naples, where he built a monastery to which he introduced the *Rule of St. Augustine*, a series of instructions on the monastic life. His bones are buried in the Catacombs of St Gaudioso, the second-largest in Naples, abandoned in the Middle Ages, but resumed in the seventeenth century, when the local aristocracy created their own bizarre portrait gallery with frescoes by Giovanni Baldinucci of their dressed skeletons, their skulls inserted into the walls. The sinister methods employed for the disembowelment and draining of the corpses of their bodily liquids were legendary. Gaudioso's Brescian namesake, the twelfth Bishop of Brescia, led a less adventurous life, his remains buried in several local churches in the mid-fifteenth century.

Pater had begun his art historical essay with a brief discussion of Titian's *Averoldi Altarpiece* in the Brescian church of SS. Nazaro e Celso (Fig. 5.17), where reliquaries with fragments from Gaudioso's body are enshrined. The subject of Titian's Michelangelesque polyptych is a triumphant Resurrection. In the lower left-hand panel is a profile portrait of the donor, Altobello Averoldi, a scruffy cleric accompanying Nazaro and Celsus. The protagonist of Pater's imaginary portrait is a Domenico Averoldi, member of the same leading Brescian aristocratic family as Titian's patron. Pater begins his narrative in the family portrait gallery where good looks become 'a thing to live up to':

> The good looks of Domenico Averoldi, under the title of Gaudioso the Second, Bishop of Brescia, who in Romanino's picture represents, with so deep an impress of sanctity, Gaudioso the First, Bishop and Saint, were in truth hereditary in his family: —a gift of which, like shrewd Italians, the Averoldi had ever been well aware, —of their masculine charm; duly estimating, —well! its pecuniary value: all it had helped them to in a world less exclusively practical in its application of the gift of sight than it is apt to suppose. Since the days of an earlier Domenico who three centuries before had brought an infatuated empress to her ruin, onwards, the family portrait gallery bore witness to the wonderful uniformity, from age to age, of

[158] 'Art Notes', 403.

Fig. 5.17. Titian, *Averoldi Altarpiece/The Resurrection of Christ* (1520–2), oil on panel, 278 × 272 cm. SS Nazaro e Celso, Brescia. Wikimedia Commons.

that masculine charm, as the family records might have illustrated almost every variety of the use, and the misuse of it. Only, always, amid whatever moral obliquities, it had brought with it a certain æsthetic fineness of habit: was a thing to live up to, and to make life a kind of chivalrous service, as to a trust.[159]

[159] Monsman 2008, 88–9.

Fig. 5.18. Reliquaries (among them St Gaudioso), silver, glass, precious stones. SS Nazaro e Celso, Brescia. Photo © Christoffer Rostvad.

Gaudioso is an unusual Paterian protagonist, intended to reach high old age: 'Would the face lapse into obesity? interested observers asked themselves. It never did. When age came at last, it was like a return to the delicacy of childhood, over eighty years.'[160] Like Wilde's Dorian, he keeps the good looks captured in painting till the bitter end. In his 'Art Notes', Pater had commented on the preponderance of bishops' hats in Brescian art; the works of Moretto and Romanino feature a large number of bishops, as do the reliquaries with fragments of Gaudioso's body in SS. Nazaro e Celso (Fig. 5.18). As indicated by his name, Gaudioso is joyful by nature, of a triumphant belief in man's ability to conquer the grave. The text conflates two images of the triumph over death and gravity: Titian's muscular and soaring Christ (present indirectly via the art historical essay) and the first-century AD winged Venus, the *Venus Victrix* (Fig. 5.19), a large and well-preserved bronze statue found at the *Capitolium* in Brescia in 1826, only six years after the discovery of the *Venus of Milo*. Gaudioso wishes, anachronistically, that he had 'stumbled on the buried Venus, now one of the central treasures of a place so rich in various art? —Aye! *Venus Victrix*, though couched there, upside down in the dust, for fifteen centuries. He was spared such temptation to relieve the ashen tenour of the thoughts prescribed him: and set up, all about, another sort of inscriptions also: "My flesh shall rest in hope!"'[161] The resurrectionist discipline of archaeology, epitomized by the winged Venus, becomes an image of the resurrected Christian soul.

Gaudioso's Brescia is a new version of Catullus' Brixia, combining the pagan with the Christian. Pater was alluding to Merimée's short story, 'La Vénus d'Ille' (1837), in which an archaeologist is haunted by a recently excavated statue of Venus who eventually kills a young man on his wedding night, a supernatural tale in which the pagan

[160] Ibid., 90. [161] Ibid., 91–2.

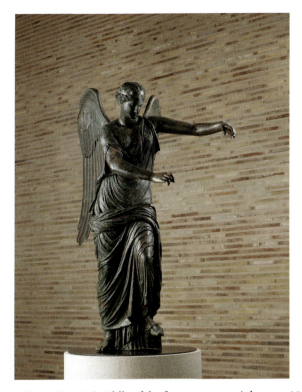

Fig. 5.19. Anon., *Venus Victrix* (middle of the first century AD), bronze, 195 cm. Archaeological Park of Brescia Romana—Capitolium. © Archivio Fotografico Musei di Brescia. Fotostudio Rapuzzi.

past comes back to haunt the present. The 'Art Notes' essay was published in November 1890, Pater's Merimée essay in December 1890. Pater's text finishes with the bishop turned archaeologist/builder/architect, ready to take pagan gods into his new Christian building, alongside the Christian martyrs, aware that the same earth shelters both deities and mortals. Haunted by his subterranean experiences, he turns earth into his building material. Gaudioso resurrects both his fifth-century namesake, and the early Christian past into a new and more tolerant Renaissance Brescia:

> It was as if *Venus Victrix*, lying there so near his fresh morning walks to San Pietro in Oliveto, beset him, or in those forced subterranean researches had actually set a finger in contact with him, claimed that he should restore her, too, to the light of day. His predecessors doubtless had suspected, discredited, unhesitatingly excommunicated, the victorious beauty of those old gods and their worshippers. But were they perhaps not quite past praying for after all, after some form not prescribed, certainly, in Missal or Breviary? Buried along with those old Brescian martyrs, they might well arise together now in the new cathedral, the new Brescia he designed, meant to build, was building already in earthly stones of price, with the relics of [old saints/martyrs] enshrined in glory, of [Faustinus/Nazarus] and [Jovita/Celsus],

258 WALTER PATER'S EUROPEAN IMAGINATION

while the hands of [Romanino] and [Moretti] recorded their heroic sanctity on the walls, the [sacred personages/bishops], the last [reminiscence] of [the old religion/ worship of visible beauty], glorious in pontifical attire: so he chose to think of them and their doings.[162]

Gaudioso's church would have been very different from Denys's cathedral, one of the eighty cathedrals built in France between 1180 and 1270.[163] Whether Pater would ever have taken as great an interest in Italian Renaissance churches as he took in the French gothic cathedrals is doubtful; when thinking about Pater and the poetics of space, whether that of the grave, the reliquary, or the urn, we must examine the gothic cathedral which fascinated Pater so profoundly. He was a man of his time, familiar with J. M. W. Turner's *Rivers of France* (1837) and the gothic cathedral as a popular motif in romantic painting and poetry; Wordsworth's 'Tintern Abbey' was close to his heart. Ruskin's continued discourse on 'the Nature of Gothic' in *Seven Lamps of Architecture* (1849), *The Stones of Venice* (1851–3), and *The Bible of Amiens* (published in volume form in 1885) were important intertexts. Eugène Viollet-le-Duc's extensive restoration projects (1838–79) for the French Commission of Historic Monuments of churches damaged during the religious wars and the Revolution generated an enormous interest in gothic architecture, as Vézelay, Amiens, Saint-Denis, Notre Dame de Paris, etc. underwent major restoration works, alongside the publication of Viollet-le-Duc's six-volume *Dictionnaire raisonné de l'architecture française du XIe au XVIe siècle* (1858–75). With Merimée as inspector-general of historic buildings (1834–60), Pater also had a literary colleague profoundly involved in the gothic cathedrals, as was another of his heroes, Victor Hugo. Although historically inaccurate, Hugo's linking of the development of gothic architecture to the rise of democracy had a broad nineteenth-century appeal,[164] which surfaces in Pater.

This minimalist survey of the cathedral craze introduces Pater's continued engagement with gothic architecture from 'Denys l'Auxerrois' (1886), over his treatment of 'literary architecture' in 'Style' (1888), to his evocation of the cathedral of Chartres in *Gaston* (1888), monastic architecture in 'Apollo in Picardy' (1893), and his three essays on French cathedrals: 'Notre Dame d'Amiens' (1894), 'Vézelay' (1894), and the incomplete 'Notre Dame de Troyes' (1894).[165] Through most of his life Pater lived in close proximity to gothic cathedrals: in Canterbury at the King's School on the precincts of the Cathedral, in Oxford with St Mary's Church next to Brasenose College. Pater the aesthete, scholar, and tourist engaged with the gothic cathedral in ways which resonated with his contemporaries both in England and on the Continent. The cathedral constituted a complex site of memory for Pater, relating to his profound interest in European culture and partaking in the broader appeal of the cathedral as a spatial and cultural entity. As a site of synaesthesia in which sight, hearing,

[162] Ibid., 94.
[163] Michael Camille, *Gothic Art: Visions and Revelations of the Medieval World* (London: Callmann and King, 1996), 27.
[164] Emery and Morowitz, 17.
[165] The manuscript of 'Notre Dame de Troyes' is Houghton bMS Eng. 1150 (20).

touch, smell, and taste conjoined into one aesthetic experience, the gothic cathedral was an Ur-museum, where religious artworks and artefacts could be experienced *in situ*, if they had not already become decontextualized, included in private collections and museums, or turned into *bric-à-brac*. Cathedrals were receptacles of national memory, connected to the local landscapes, regions, and monastic orders. They constituted illustrated and material histories of style, places of refuge from war, noise, vandalism, modern technology, and ugliness. The nineteenth-century mythologization of the cathedral was closely tied to the rise of the nation-state, to larger competitive disputes between the European nations about the origins of gothic, determining to which nation gothic truly belonged.[166] The conflation of political, religious, aesthetic, and architectural interests made the gothic cathedral a complex symbol with an inside and an outside, a nineteenth-century presence and a shell for a reconstruction of a distant past, a reconstructed relic and a site for a romance of the golden Middle Ages. Both man-made and natural, the gothic cathedral was an impressive architectural construction and an organic mass of stone resembling a mountain, a pan-European phenomenon: 'Just as the Gothic had spread across Europe in the Middle Ages, the renewal of interest in and the study of the Gothic in the modern period was a transnational phenomenon of cross-linguistic fertilization.'[167] Stephanie Glaser gives examples of how architects and restorers were recognized on either side of the English Channel, just as, in the Middle Ages, both workmen and architects would travel, spreading styles, techniques, and ideas: 'Expertise was internationally recognized: Didron and Reichensperger attended the consecration of Pugin's St Giles Church (Cheadle, Staffordshire, England) in 1846, and English architects won the competitions for the Nikolaikirche in Hamburg (1845–63) and the cathedral in Lille (1854–99), for which Reichensperger and Didron served on the jury (1854–6). In 1850 Britain's Ecclesiological Society made Lassus and Viollet-le-Duc honorary members, and in 1866 Reichensperger became an honorary member of the Royal Institute of British Architects.'[168] With the French defeat in the Franco-Prussian War 1870–1, some of this pan-European cosmopolitanism ground to a halt, as the French turned towards their own medieval past in a new phase of patriotism: 'Instead of fighting about the present situation of France, everyone could embrace the Middle Ages as the birthplace of the nation, a time when France was indisputably great. In this new understanding of French history, based on the Middle Ages, the French accepted a kind or primordial link greater and more powerful than all of the issues that divided them. Medieval France, which survived the Germanic invasions by building a solid society based on successful previous models, served as a positive example for rebuilding the wounded French nation.'[169] As the Parisian historian Fustel de Coulanges remarked in 1871, 'Each person makes his own, imaginary Middle Ages'.[170]

[166] See Sylvain Amic and Ségolène Le Men, ed., *Cathédrales 1789–1914: Un Mythe Moderne* (Paris: Somogy éditions, 2014).

[167] Stephanie A. Glaser, 'Introduction: The Medieval Edifice in the Modern Period', in Stephanie A. Glaser, ed., *The Idea of the Gothic Cathedral: Interdisciplinary Perspectives on the Meanings of the Medieval Edifice in the Modern Period* (Turnhout: Brepols, 2018), 1–44, 18.

[168] Ibid., 21. [169] Emery and Morowitz, 21. [170] Ibid., 34.

Pater's imaginary Middle Ages revolved around communities: cities whose inhabitants formed arts-and-crafts centres from which cathedrals arose, or monastic communities as centres of learning. Pater's mind constantly oscillated between what he was looking at in the nineteenth century and an imaginary sense of what things would have looked like in the thirteenth. Emerald's school, based on Pater's own King's School, Canterbury, is the monastic community taken into the nineteenth century, a counterpart to the medieval monastic community of 'Apollo in Picardy'. The monastery of Saint Germain, which Denys joins, is another such community, the Cathedral of Chartres another, a religious academy which forms the first of Gaston's many schools, resulting in what Pater calls 'the somewhat Gothic soul of Gaston'.[171] What do we imagine from a 'Gothic soul'? Someone whose mind is light, airy, spacious, in touch with the divine? Pater's image suggests some form of spiritual architecture, a spatial visualization of the soul, not unlike the way in which the house is as much inside the child as the child is in the house. Yet, Gaston's soul is only 'somewhat Gothic', with the hint that it is a soul not yet fully formed, that there is something else besides the gothic. Pater's image is striking, because we conventionally perceive a spiritual aspect of gothic architecture and by extension can imagine a character who internalizes the space of a cathedral.

Perhaps Pater himself possessed a 'somewhat Gothic soul'. He was, at any rate, perfectly skilled in incorporating several aspects of the gothic in his writing, whether in the form of the supernatural and the morbid, or of a suggestive architectural framework, animated and anthropomorphic. When, in the autumn of 1893, he wrote to William Cantor, Editor of the *Contemporary Review*, that he had just returned 'from France, where I have been studying some fine churches, of which my mind is rather full just now',[172] he had been gathering material for the four 'gothic' texts he would produce over the next six months: the imaginary portrait of Apollo, set in the Notre-Dame-des-Prés in Picardy, and the architectural essays intended for the *Nineteenth Century* on Amiens, Vézelay, and Troyes. The first is a sinister tale of mystery, myth, and madness, set in a monastery with a chapel and a churchyard, while the architectural essays are serial character studies, Ruskinian in the way they linked architectural form and space to character. Pater described the Amiens essay as 'the first of a series, to be ready at intervals, on "Some Great Churches of France"',[173] a sentence similar to the one with which he had introduced 'The Child in the House'. In 'The Nature of Gothic', Ruskin had declared his subject to be 'this Gothicness, — the character which, according as it is found more or less in a building, makes it more or less Gothic'.[174] He pointed out how the gothic character was itself 'made up of many mingled ideas, and can consist only in their union. That is to say, pointed arches do not constitute Gothic, nor vaulted roofs, nor flying buttresses, nor grotesque sculptures; but all or some of these things, and many other things with them, when they come together so as to have life'.[175] His linking of gothicness to a northern

[171] *CW* 4:50. [172] Letter to William Cantor, 18 Oct. 1893, *CW* 9.
[173] Letter to Thomas Knowles, 22 Jan. 1894, *CW* 9.
[174] Ruskin, 'The Nature of Gothic', *CWR* 10:181.
[175] Ibid., 182.

culture led to an almost physiognomic and psychological study of tribes, tempers, and the encounters between North and South:

> I am not sure when the word 'Gothic' was first generically applied to the architecture of the North; but I presume that, whatever the date of its original usage, it was intended to imply reproach, and express the barbaric character of the nations among whom that architecture arose. It never implied that they were literally of Gothic lineage, far less that their architecture had been originally invented by the Goths themselves; but it did imply that they and their buildings together exhibited a degree of sternness and rudeness, which, in contradistinction to the character of the Southern and Eastern nations, appeared like a perpetual reflection of the contrast between the Goth and the Roman in their first encounter.[176]

Pater's three gothic churches differ in character: the oldest, Vézelay, interesting as a representative of the transitional phase between romanesque and gothic, exudes a classical sense of repose, its romanesque arches bringing to mind the arenas and aqueducts of the Romans. A pilgrim church, in close communication with the surrounding landscape and attached to a derelict monastery, it has become an empty shell, deserted and ghostly: '*Maintenant il n'y a personne là*', Pater concludes, summing up 'a very exclusive monasticism, that has verily turned its back upon common life, jealously closed inward upon itself'.[177] By contrast, Amiens is the people's cathedral, at the heart of a major city, buzzing with life, 'restless', catering for the worship of the many. A structure in which brick walls have been replaced with windows as transparent membranes through which light and life can pour, the church offers a new kind of space for Pater, devoid of mysticism: 'Light and space—floods of light, space for a vast congregation, for all the people of Amiens, for their movements, with something like the height and width of heaven itself enclosed above them to breathe in; —you see at a glance that this is what the ingenuity of the Pointed method of building has here secured.'[178]

Pater is interested in the way light can be preserved in a gothic building, giving it an intriguing materiality; he talks about the very 'ancient light' that 'has been lying imprisoned thus for long centuries', which has 'now become almost substance of thought, one might fancy, —a mental object or medium'.[179] It thus resembles the ancient wine in the glass bottle in the sarcophagus in Auxerre: antiquity can be stored, imprisoned even, by emerald-green bottles or gothic structures, but when unleashed, it catapults the past into the present. The Paterian 'weaving and unweaving' of self takes place as the past interferes with the present, the outside with the inside, and the importance of glass, of transparency, is felt in such passages as the above. Eve Ellen Frank saw this interrelationship between inner and outer as both mental and physical movement: 'externalized configurations of internal consciousness, descriptive not only of the quality and structure of minds but filled with a metaphoric furniture

[176] Ibid., 184–5.
[177] 'Some Great Churches in France. 2. Vézelay', *Nineteenth Century* 35 (June 1894), 963–70, 970.
[178] 'Notre Dame d'Amiens', 482.
[179] Ibid., 484. See Charlotte Ribeyrol, '"The Golden Stain of Time": Remembering the Colours of Amiens Cathedral', *Word & Image* 36:1 (2020), 37–47.

262 WALTER PATER'S EUROPEAN IMAGINATION

of thought derived from particular sensuous experience of an outside world as it intruded through windows and doors, making its impress felt.[180]

When Pater describes Amiens as 'restless', his observation is related to the tension between an architectural structure made up of many components, held together by outer pressure, and the movement which goes on inside. The tension between the static and the kinetic aroused Pater's interest in the resurrection, in windows, doors, and other openings. His sense of claustrophobia contributed to a continuous 'break through to open windows, to skies, to that which is spiritually transcendent, anything which distracts from or invigorates a deterministic, generally pessimistic world view'.[181] Frank points out how 'The seesaw of static against kinetic, rest against motion, mind against soul, structure against inhabitant (not to mention structure against weather, territory against space) is endlessly in play; and just as in literary style, given optimum conditions, the passive and active coexist, so in the artistic personality the two work harmoniously if possible'.[182]

The term 'literary architecture' was a Paterian coinage from the essay on 'Style', where architectural metaphors abound. Thus the house the writer has built is a body he has informed along Vitruvian lines, and the architectural structure of writing takes us from art structure to human structure to life structure with the organic process as its focal point: 'For the literary architecture, if it is to be rich and expressive, involves not only foresight of the end in the beginning, but also development or growth of design, in the process of execution, with many irregularities, surprises, and afterthoughts; the contingent as well as the necessary being subsumed under the unity of the whole.'[183] The organic process of Pater's literary architecture suggests a gothic rather than a classical building, with its irregularities, surprises, and afterthoughts. For Pater, both writing and architecture rested on structure, be it that of the sentence, the paragraph, or the text as a whole. He found a similar master of structure in Prosper Merimée, whose care for architecture, whose 'curiosity about it, were symptomatic of his own genius. Structure, proportion, design, a sort of architectural coherency: that was the aim of his method in the art of literature, in that form of it, especially, which he will live by, in fiction.'[184]

Auxerre is the '"perfect type of that happy mean between northern earnestness and the luxury of the south," both in its architecture and its surrounding countryside.'[185] Denys's first appearance takes place inside the cathedral, immediately after the completion of a long building process. Paganism intrudes, first in the form of the Greek sarcophagus, secondly with the arrival of Denys on Easter Day. Pater does not discuss St Étienne as a Christian edifice; rather, he is interested in the collective effort of its erection and the political implications of such a communal project. Denys becomes the leader of maenadic riots, subsequently receives the tonsure, and joins the monastic community in St Germain, where he labours with the decoration of the cathedral. The building retains its magnetic hold over him: he returns to it as an organ-builder, constructing a musical house within the space

[180] Frank, 18. [181] Ibid., 46.
[182] Ibid., 38. [183] 'Style', 736.
[184] 'Prosper Merimée', 856.
[185] Bernard Richards, 'Pater and Architecture', in ed. Brake and Small, 189–204, 194.

which will eventually shelter his heart, after he has been torn to shreds, shortly after having played the organ for the first time. Like Hugo's Quasimodo, Denys grows and develops in continuous dialogue with the cathedral, an outcast, a rebel, a single exotic figure seen against the anonymous crowds. Pater outlined the difference between the classical and the gothic building in musical terms, as the difference between melody and harmony.[186] The cathedral houses Denys as the constructor and player of a musical instrument which expands melody into harmony, yet he is, nevertheless, destroyed in the process. Pater's merging of Euripides' *Bacchae* and Hugo's *Notre Dame de Paris* makes for a violent encounter between pagan and Christian culture, with Denys as the inevitable victim, having, after all, interfered with Easter, with both crucifixion and resurrection.

Pater recalled Hugo's description of the façade of Notre Dame as 'a vast symphony in stone', as 'pages of architecture',[187] which progressed into an even broader reading: 'Each face, each stone of this venerable monument is a page not only of our country's history, but also of the history of science and architecture.'[188] The organic unfolding of a gothic construction was, according to Hugo, a product of deep time, even, geological time:

> Great buildings, like great mountains, are the work of centuries. Often architecture is transformed while they are still under construction: *pendent opera interrupta*, they proceed quickly in keeping with the transformation. The new architecture takes the monument as it finds it, assimilates it to itself, develops it as it wants and, if possible, finishes it. This is achieved without fuss, or strain, or reaction, in accordance with a tranquil law of nature. A graft occurs, the sap circulates, the vegetation recovers. Indeed, many a massive tome and often the universal history of mankind might be written from these successive weldings of different styles at different levels of a single monument. The man, the individual and the artist are erased from these great piles, which bear no author's name; they are the summary and summation of human intelligence. Time is the architect, the nation the builder.[189]

Hugo's metaphorical language, taking us into images of music, print, mountains, and trees in order to capture the grandeur of the gothic cathedral as a national monument, reflects the scope of his novel. Set in the late fifteenth century, the novel explores the battle between print and architecture, suggests the growth of the book at the expense of architecture, while still inviting us to read buildings as books, to perceive cathedrals as narratives, receptacles of memory. This would become the view taken by the iconographer Émile Mâle, who towards the end of the nineteenth century insisted on reading cathedrals as books in stone. By contrast, Viollet-le-Duc took a much more structural view of the gothic cathedrals, as he set about restoring them. In his choice of Vézelay and Amiens as the subjects for his architectural essays,

[186] 'For the mere *melody* of Greek architecture, for the sense as it were of music in the opposition of successive sounds, you got *harmony*, the richer music generated by opposition of sounds in one and the same moment', 'Notre Dame d'Amiens', 483.

[187] Victor Hugo, *Notre Dame of Paris*, tr. John Sturrock (Harmondsworth: Penguin, 1978), 123.

[188] Ibid., 128. [189] Ibid., 129.

264 WALTER PATER'S EUROPEAN IMAGINATION

Pater was keen to engage with Viollet-le-Duc: Vézelay was the first church he restored; Amiens, another of his grand restoration projects, he had celebrated as 'the Parthenon of Gothic architecture'.[190] Pater's atmospheric renditions of space both inside and outside the French cathedrals tapped into discourses and sites which had gained new national importance in France; at the same time, they engaged with the voice of Ruskin who was still pontificating on matters gothic by the 1880s.

In 1885 Pater had put himself forward to become Ruskin's successor as Slade Professor of Art in Oxford but was defeated by Hubert von Herkomer. That same year the volume edition of Ruskin's *Bible of Amiens* was published, a text which would engage the mind of Marcel Proust, who translated it into French in 1901, provided it with a preface and notes,[191] and absorbed much of it in *À la recherche du temps perdu*. Annotating his preface to Ruskin, Proust observed: 'What an interesting collection one could make with landscapes of France seen through English eyes: the rivers of France, by Turner; *Versailles*, by Bonnington; *Auxerre* or *Valenciennes*, *Vézelay* or *Amiens* by Walter Pater; *Fontainebleau*, by Stevenson; and so many others!'[192] This astute reader perceived the interrelationship between Ruskin and Pater's topographical and architectural writings, the interdependence between landscape and building structure in an essentially romantic tradition. Ruskin and Pater wrote about several of the same sites: in 1880, as Ruskin began his grand unfinished project *Our Fathers Have Told Us: Sketches of the History of Christendom for Boys and Girls who have been Held at its Fonts*—intended to cover Amiens, Verona, Rome, Pisa, Florence, the Monastic Architecture of England and Wales, Chartres, Rouen, Lucerne, and Geneva—he visited northern France to look at cathedrals,[193] and travelled repeatedly across the Channel to compare Canterbury and Amiens.[194] In 1882 he visited Troyes and Sens, entering into his diary on 19 August: 'The Seine divinely beautiful here. I have never enough thought out that Turner's work was the "Rivers" of France, not the "towns" of it—how he was the first painting living creature who saw the beauty of a "coteau"! The glorious lines of the ascending vineyards to be sketched this morning if possible, and the statues of the porch deciphered. They are the finest I hitherto know, north of the Alps.'[195] Thinking of the interplay between river, vineyards, and churches in 'Denys', one could almost suspect Pater of having looked over Ruskin's shoulder. On 4 December 1882 Ruskin had lectured on Cistercian Architecture at the London Institution.[196] Pater may well have been present in the audience; his introductory distinction between the Orders of Cluny and Cîteaux in the Vézelay essay contains echoes of Ruskin's lecture.

[190] Eugène Viollet-le-Duc, *Dictionnaire raisonné de l'architecture française du XIe au XVIe siècle*, 10 vols (Paris: Bance et Morel, 1854–9), 1:71. See Martin Bressani, *Architecture and the Historical Imagination: Eugène-Emmanuel Viollet-le-Duc, 1814–1879* (Farnham: Ashgate, 2014).

[191] Marcel Proust, *On Reading Ruskin*, tr. and ed. Jean Autret, William Burford, and Philip J. Wolfe, intr. Richard Macksey (New Haven: Yale University Press, 1987).

[192] Note 34 to his 'Preface'. Ibid., 69.

[193] John Ruskin, *The Bible of Amiens*, CWR XXXIII (1880–5), part 1 of 'Our Fathers', 21–189, lxv.

[194] Ibid., xxiii and xxxiv. [195] Ibid., xxxv.

[196] The lecture was not published until 1894 as 'Mending the Sieve; or, Cistercian Architecture' (*CWR* XXXIII, 227–54), but was paraphrased by Alexander Wedderburn, 'Mr. Ruskin on Cistercian Architecture', *Art Journal* (Feb. 1883), 46–9. Ibid., xiv.

Ruskin saw Amiens as an exemplary work of art; 'this first cathedral of French Christianity', the first episcopal seat, was located in a city which he regarded as the first capital of the Franks.[197] Praising its architectural purity, Ruskin pointed out how the cathedral complied with his expectations to the gothic builder: 'to raise, with the native stone of the place he had to build in, an edifice as high and as spacious as he could, with calculable and visible security, in no protracted and wearisome time, and with no monstruous or oppressive compulsion of human labour.'[198] The building fulfilled the need to 'admit as much light into the building as was consistent with the comfort of it; to make its structure intelligibly admirable, but not curious or confusing; and to enrich and enforce the understood structure with ornament sufficient for its beauty'.[199] Reading the external sculpture as one long biblical narrative, as the visualization of St Jerome's Vulgate Bible, Ruskin regarded Amiens as a foundation stone in the library of Europe with biblical authority inscribed on its stones. Amiens was another cathedral by a river, the 'Venice of Picardy',[200] thus tying his observations in France to his exploration of Venetian gothic. As so often with Ruskin, the examination of a local stone, a local site, had far wider implications. Amiens became the meeting point between northern and southern tribes, the omphalos of Europe, while the character of the Franks, in extension of the character of the cathedral they had built, became a transnational characteristic of the northern European race, educating even the English:

Here their first capital, here the first footsteps of the Frank in his France! Think of it. All over the south are Gauls, Burgundians, Bretons, heavier-hearted nations of sullen mind: —at their outmost brim and border, here at last are the Franks, the source of all Franchise, for this our Europe. You have heard the word in England before now, but English word for it is none! *Honesty* we have of our own; but *Frankness* we must learn of these; nay, all the western nations of us are in a few centuries more to be known by this name of Frank.[201]

When, in 1886, Pater described Denys as leader of the local rebellion against the feudal lords, there is little doubt that he was alluding to Ruskin: 'That revolution in the temper and manner of individuals concurred with the movement then on foot at Auxerre, as in other French towns, for the liberation of the *commune* from its old feudal superiors. Denys they called *Frank*, among many other nicknames.'[202] The broad brushstrokes of Ruskin's work, which soon evolves into a history of Europe from early Christianity to the Renaissance, is counterbalanced by Pater's study of an individual Frank who, in spite of pagan affinities, has his life interwoven with the local cathedral. Ruskin had peopled his text and church with legendary and real kings and saints, but perhaps most strikingly, in the opening passages, with the imaginary nineteenth-century railway traveller, too busy even to stop at Amiens and barely capable of detecting the spire, the *flêche*, from amongst the many industrial chimneys in the city. The brutal clash between mechanized modernity and medieval

[197] *The Bible of Amiens*, 30. [198] Ibid., 122. [199] Ibid., 122–3.
[200] Ibid., 26. [201] Ibid., 31. [202] *CW* 3:87. Italics are Pater's own.

religious architecture gives us a double optics similar to Pater's between the nineteenth-century traveller/narrator in the picturesque tradition and the medieval protagonist, yet with the significant difference that where Ruskin's traveller hurries onwards in his journey, only stopping at Amiens to enjoy a sandwich, Pater's traveller lingers, unable to leave the city. The poetics of space has become externalized as Denys becomes one with the stones of Auxerre, and space morphs into place. As Pater observed in 'Emerald Uthwart', 'The very place one is in, its stone-work, its empty spaces, invade you; invade all who belong to them, as Uthwart belongs, yielding wholly from the first: seem to question you masterfully as to your purpose in being here at all, amid the great memories of the past....In Uthwart, then, is the plain tablet, for the influences of place to inscribe.'[203] For Pater, the proper positioning of the self depended as much on the poetics of place as on the poetics of space, as we shall see.

[203] *CW* 3:180.

6

The Poetics of Place

Mapping Pater's Europe

Pater's morphing of space into place is suggestive of the ways in which the immaterial and the material blend in his writings, where space is often subjective, tied to memory and history, and experienced through the self. Diffuse, atmospheric, space is connected to the three-dimensionality of architecture and the openness of landscapes and cityscapes. For Pater, architecture is anchored in place, tied to the ground, with place as something geographically determined, even mappable. He thus challenges Edward Casey's 'tempocentrism': 'Place, reduced to locations between which movements of physical bodies occur, vanished from view almost altogether in the era of tempocentrism (i.e. belief in the hegemony of time) that has dominated the last two hundred years of philosophy in the wake of Hegel, Marx, Kierkegaard, Darwin, Bergson, and William James.'[1] Stressing the need for 'a renascence of place', Casey reminds us that 'To be at all—to exist in any way—is to be somewhere, and to be somewhere is to be in some kind of place. Place is as requisite as the air we breathe, the ground on which we stand, the bodies we have. We are surrounded by places. We walk over and through them. We live in places, relate to others in them, die in them. Nothing we do is unplaced.'[2] Casey finds a connection between person and place in what he calls our 'active desire for the particularity of place—for what is truly "local" or "regional"', concluding that place 'brings with it the very elements sheared off in the planiformity of site: identity, character, nuance, history'.[3]

Employing an etymological approach which would have pleased Pater, Casey points to the links between human activity, morals, and place: 'Both "politics" and "ethics" go back to Greek words that signify place: *polis* and *ethea*, "city-state" and "habitats", respectively. The very word "society" stems from *socius*, signifying "sharing"—and sharing is done in a common place. More than the history of words is at issue here. Almost every major ethical and political thinker of the century has been concerned, directly or indirectly, with the question of *community*.'[4] Most of Pater's portraits establish an interrelationship between the individual, a community, and one or several places: Denys within the community of Auxerre, Sebastian foiled by Dutch urban life, Emerald and his school, and Prior Saint-Jean within his monastic community. The shaping of human character takes place in a social context, in which place leaves its imprint on the self. The central role played by place in Aristotle's *Physics* and literary theory as the prerequisite for any form of change, and hence for any plot or development, are outlined by Casey with a reference to Aristotle's

[1] Edward S. Casey, *The Fate of Place: A Philosophical History* (Berkeley: University of California Press, 1997), x.
[2] Ibid., ix. [3] Ibid., xiii. [4] Ibid., xiv.

Walter Pater's European Imagination. Lene Østermark-Johansen, Oxford University Press. © Lene Østermark-Johansen 2022.
DOI: 10.1093/oso/9780192858757.003.0007

268 WALTER PATER'S EUROPEAN IMAGINATION

assertion that 'there cannot be change (*kinesis*) without place and void and time.... Because they are common to everything and universal.'[5] Any kind of movement or development presupposes the existence of place, whether physical or metaphorical, from place to place.

Pater's portraits are often structured on circular movement: home, away, and home again. The centrality of a place which is 'home' invites an exploration of what constitutes that particular place, the spot which generates a sense of 'home'. With the concept of the *genius loci*, the spirit of place, Pater invited a fusion of the anthropomorphic and atmospheric combined with the geographical. The Latin term was frequently employed in James's travel writings and gave the title to Lee's collection of European travel sketches.[6] It carries the double meaning of 'A guardian spirit or god associated with a place' (*OED* 1) and 'The essential character or atmosphere of a place' (*OED* 2). Place becomes person, endowed with qualities usually associated with character, sometimes with an eerie will to exert a powerful influence over a human subject, as seen in Lee's supernatural tales. As she stated in the 'Introduction' to her *Genius Loci: Notes on Places*: 'To certain among us, undeniably, places, localities (I can find no reverent and tender enough expression for them in our practical, personal language) become objects of intense and most intimate feeling. Quite irrespective of their inhabitants, and virtually of their written history, they can touch us like living creatures; and one can have with them friendship of the deepest and most satisfying sort.'[7] Yet the *genius loci* should never be conceived as a mere personification: 'The Genius Loci, like all worthy divinities, is of the substance of our heart and mind, a spiritual reality. And as for visible embodiment, why that is the place itself, or the country; and the features and speech are the lie of the land, pitch of the streets, sound of bells or of weirs.'[8]

The evocation of the *genius loci* requires a heart, a mind, and a perceiving body which allows itself to absorb place and recreate it in writing. Pater's portraits depend to a significant degree upon the author's own experience of place: he went to Rome in 1882 to prepare for *Marius*, to France in the 1880s prior to composing 'A Prince of Court Painters', 'Denys', and *Gaston*, and his early experiences of Germany feed into 'Duke Carl'. Person and place sit inseparably at the heart of his narratives where Auxerre, Rosenmold, and Florian's house become fellow protagonists. When describing Emerald's school, he explicitly used the Latin term about the Canterbury institution which had proved so formative. Thus 'Uthwart was come where the *genius loci* was a strong one',[9] to a unique combination of architectural structure and geographical place, embodying centuries of Anglo-French monastic and scholastic life, inscribed on Pater's protagonist with religious and secular learning.

Bakhtin's observation that 'The image of man is always intrinsically chronotopic' sums up the merging of space, place, and time in Emerald's school, as the building and the institution embody history while providing both background and framework for Emerald's evolution as a human being.[10] Bakhtin's definition of the chronotope as 'the intrinsic connectedness of temporal and spatial relationships that are

[5] Aristotle, *Physics* 200b21 (tr. Hussey). Quoted as a footnote to Casey, 13.
[6] Lee, *Genius Loci.* [7] Ibid., 3–4. [8] Ibid., 4. [9] *CW* 3:180.
[10] Bakhtin, 85.

artistically expressed in literature' alerts our attention to the ways in which the poetics of space, place, and time interact along vertical and horizontal axes:[11] 'In the literary artistic chronotope, spatial and temporal indicators are fused into one carefully thought-out, concrete whole. Time, as it were, thickens, takes on flesh, becomes artistically visible; likewise, space becomes charged and responsive to the movements of time, plot and history. The intersection of axes and fusion of indicators characterizes the artistic chronotope.'[12] I have separated place and time in this book for the sake of clarity, but the separation is an artificial one. Pater's geographical locations and historical periods interact profoundly: Sebastian's Haarlem is embedded in the seventeenth century, and Carl's Rosenmold is tied to the idea of the dawning enlightenment. Casey may wish for a renascence of place, but in Pater's case it was never really absent and always intricately connected to time.

In attempting to map the European territory of Pater's fiction, some fundamental questions need answering. First of all, what did Pater understand by 'Europe'? The term is complex, and definitions of 'Europe' and 'European' are often dependent on the author's own position. National differences may appear more accentuated when seen from within Europe than from without, as Anthony Pagden pointed out: 'Paradoxically seen from within Europe, the differences that separate German from Italian culture are easy enough to perceive. Viewed from, say, Japan, those differences will seem less obvious than the similarities. Viewed from Europe there may be no such thing as a "European culture." Viewed from Japan there clearly is.'[13] For James, whose writings reflect a lifelong preoccupation with Europe, seen from an American perspective, 'Europe', comprising both the British Isles and the European continent, was a very different entity from Pater's. For the polyglot Lee, brought up on the European continent with occasional visits to England, the heart of Europe was Mediterranean. Inevitably, we are led to ponder Pater's Europe: where did it begin? where did it end? and why choose Valenciennes, Auxerre, Montreuil, Brescia, Bergamo, and Haarlem as literary settings? Can we detect any underlying pattern in the locations Pater selected for his portraits which may lead to an overall impression of Europe which we can call Paterian?

Discussions of the idea of Europe often question our notions of North and South, East and West, natural and cultural boundaries, and boundaries defined by peace treaties, as we deal with nations, separate and united, and communities, real and imagined. Writing in the aftermath of the Franco-Prussian War, as the new nation states of Germany and Italy were emerging, as Britain invaded Egypt in 1882, and the Greeks and Turks were at war in 1886, Pater would have been aware of contemporary debates about nationhood, the local and the global. Seen from a twenty-first-century perspective, Pater's geographical framework is remarkably Eurocentric. Africa, India, China, the Americas, Russia glimmer by their absence, and although notions of the exotic are far from absent in Pater's writings, such notions relate to the emergence of pagan deities within a Christian framework, the Asiatic influence on Greek art, Oriental plagues imported by Roman warfare, or discussions of where the West ends

[11] Ibid., 84. [12] Ibid., 84.
[13] Anthony Pagden, 'Introduction', in ed. Anthony Pagden, *The Idea of Europe: From Antiquity to the European Union* (Cambridge: Cambridge University Press, 2002), 1–32, 24.

270 WALTER PATER'S EUROPEAN IMAGINATION

and the Orient begins. The porous boundaries between East and West fascinated Pater, yet always from the vantage point of Europe, as he was writing on the basis of European scholarship for a European audience, with what Edward Said would call 'exteriority', positioning himself 'outside the Orient, both as an existential and as a moral fact'.[14] Especially in his late essays on Greek art, Pater probed our notions of where the Dorian and the Ionic cultures met, as he experimented with the very concept of 'European influence'. In his portraits Pater revisited the European territory covered in *The Renaissance*, now drawing his own map of Europe, mostly avoiding the large and famous places, while opting for a range of liminal locations.

According to the *OED*, a number of new terms arose in the nineteenth century, expanding, defining, or developing aspects of the adjective 'European', which had entered the language in the sixteenth century. Thus 'Europeanism' (1824) and 'Europeanization' (1845) emerged as alternatives to 'Europeanity' (1805), while the verb 'to Europeanize' is first registered in 1821. Things could be done 'Europeanly' by 1831, and by 1881 the 'Europeanist' had appeared. Whether Pater would qualify as one such Europeanist is another matter; anecdotal remarks about his xenophobia and reserve towards foreigners, whether at home or abroad, may suggest that on a direct, confrontational level, he found it hard to act as one who 'promotes or adopts European culture, attitudes, etc.' (*OED* 1), or who 'emphasizes the importance of Europe or European culture; (also) an expert or specialist in the study of Europe' (*OED* 1B). However, in his private convictions and in his writings, Pater would definitely count as a 'Europeanist', constantly stressing the cohesive powers of European culture, across national borders and centuries. In mapping Pater's poetics of place and his notion of Europe, I suggest that we see him as one such 'Europeanist', the embodiment of a newly coined concept, and one who did not take his 'Europeanization' outside the Continent in a colonial manner, but rather kept his 'Europeanity' within European territory.

Wright traced Pater's fascination with the imaginary to his childhood friendship with McQueen, a prime source for Pater's time at the King's School. Like the Brontë siblings, McQueen had constructed narratives set in imaginary countries, 'written in an exercise-book in minute writing, and illustrated with pictures of the fictitious towns, trees, animals...to be found in these lands'.[15] Boardgames and books stimulated such imaginative travelling: some of the most popular children's books— *Pilgrim's Progress*, *Gulliver's Travels*, and *Robinson Crusoe*—encouraged imaginary travelling, and McQueen was far from unique in his escape into fantasy lands. Out of a family of geographers, he drew accompanying maps of imaginary countries which supposedly inspired Pater's imaginary portraits.[16] Wright downplayed Pater's interest in landscape description and topography to celebrate his interest in the individual. Yet Pater was far from uninterested in landscapes and topographies; the author repeatedly left his armchair and went abroad. Pater's places are both real and imagined, and only when we accept this can we approach his texts with the respect they deserve.

[14] Edward Said, *Orientalism* (London: Penguin, 2003), 20–1.
[15] *Wright*, 1:85. [16] Ibid., 88.

THE POETICS OF PLACE 271

Pater's notions of Europe derive from many different sources. Introducing the catalogue of the English Poet's reading, Pater linked reading to topography, book to place, in a memorable passage which invites us to ponder geophysical, metaphoric, and poetic place:

> The good book would be like an actual place visited, and to which one might return again and again at discretion for the infallible exercise therein of a special recognised influence, a certain controlling atmosphere, always to be experienced there, when one had a will to turn the key, acting almost independently of effort on one's own part, and remaining as an objective material fact while the pilgrim shifts to and fro. The shore with its tang of salt air, the house where you are to hear such or such songs, see such pictures, meet such people, or that great temple to which the sick came from afar to sleep, sure that a sacred dream would come to reveal how the sickness might be healed and with no fee due to the priests from the poor boy for letting him lie there; the genuine literary creations of past time have been not less palpable in influence; and a true education mainly consists in the well-pondered experience of what we shall find on demand in these places.[17]

The imaginary and the real merge in this passage, perhaps suggesting that just as Pater would re-read (and re-write) himself, so he would return to favourite books and favourite places. The circularity of movement (unlike the pilgrim whose route is linear, moving towards one goal) calls for a different approach to book and place, as we embrace the spatiality and topography of reading and imagining.

As for Pater the traveller, we know very little. Brief references in his letters give vague allusions to the countries visited during the long vacations, and on the basis of such references, chronologies like the ones now prefacing the Oxford *Collected Works of Walter Pater* can be established. From letters dated late July or early August, we discern a regular pattern of visits to France / the Continent / Italy for five to six weeks. Pater's biographers—Gosse, Benson, Wright, Levey, and Donoghue—construct vague itineraries, sometimes helped by topographical references in the essays and portraits. Gosse, closest to Pater in time and friendship, gave the following account of Pater the tourist in Europe:

> The vacations in these years were very pleasant to Pater; they were almost always spent abroad—in France, in the company of his sisters. He would walk as much as possible, scouring a neighbourhood for architectural features, and preserving these impressions of travel, which most of us lament to find so fugitive, with astonishing exactitude. He was no linguist, and French was the only language in which he could even make his wants understood. Although so much in Germany in his youth, he could speak no German. When he was travelling he always left a place, if any one staying in the hotel spoke to him. He had no wish to be competent in modern languages; he used to say: "Between you and me and the post, I hate a foreigner," and when exotic persons of distinction threatened to visit Brasenose, Pater used to

[17] *CW* 3:150–1.

disappear until he was sure they had gone. He loved the North of France extremely, and knew it well....I note, in a letter of 1877, describing a visit to Azay-le-Rideau, this characteristic sentence: 'We find always great pleasure in adding to our experiences of these French places, and return always a little tired indeed, but with our minds pleasantly full of memories of stained glass, old tapestries, and new wild flowers.'...He could ill endure exciting travel, or too rapid hurrying from one impressive place to another. His eye absorbed so slowly, and his memory retained what he saw so completely, that to be shown too much was almost physical pain to him, and yet he was always inflicting it upon himself.[18]

Gosse presents Pater as a man for whom, as Gautier would say, the visible world existed,[19] a man with a slow and thorough method of viewing and a prodigious visual memory. The conventional image of the effete aesthete in dainty interiors is challenged by Pater the walker and botanist of wild flowers, adding a new enjoyment of the great outdoors. Gosse is surprisingly scathing about the writer's linguistic skills. Considering Pater's command of Greek, Latin, French, Italian, German, and English, it comes as a surprise to learn that he had 'no wish to be competent in modern languages'. Gosse saw himself as an excellent linguist, proud of his skills in the Scandinavian and other modern European languages, and may not have wanted to be upstaged. Yet, as John Murray commented in the 'Preface' to the phrasebook in four languages, issued alongside his famous red guidebooks: 'even a scholar, who is able to read foreign works with tolerable facility, finds himself at a loss when he comes to reduce his knowledge to practice, and to attempt the colloquial phraseology of the road-side'.[20] Pater's daily exercises in translation, from several different languages into English, his extensive reading in European literature in the original languages, and his sprinkling of foreign terms, phrases, and concepts throughout his writings should make us question Gosse's downplaying of his interest in foreign languages, which was, indeed, profound.

When asked in November 1886 by the Editor of the *Pall Mall Gazette* whether English literature should be considered a future university subject, Pater expressed his concern that such a development might be at the expense of Classics, while admitting that 'much probably might be done for the expansion and enlivening of classical study itself by a larger infusion into it of those literary interests which modern literature, in particular, has developed; and a closer connection of it, if this be practicable, with the study of great modern works (classical literature and the literature of modern Europe having, in truth, an organic unity)'.[21] Pater's 'organic unity' was rooted in nineteenth-century concerns with the pan-European, even stretching

[18] Gosse 1894, 803.

[19] 'Critiques et louanges m'abîment et me louent sans comprendre un mot de mon talent. Toute ma valeur, ils n'ont jamais parlé de cela, c'est que *je suis un homme pour qui le monde visible existe*.' Gautier in Edmond and Jules de Goncourt, *Journal des Goncourt: Mémoires de la vie littéraire*, 9 vols (Paris: Charpentier & Cie, 1888–96), 1:182.

[20] John Murray, *A Handbook of Travel-Talk: Being A Collection of Questions, Phrases, and Vocabularies in English, German, French, and Italian Intended to Serve as Interpreter to English Travellers Abroad or Foreigners Visiting England*, by the Editors of the Handbooks, new edition, carefully revised (London: John Murray, 1877), iii–iv.

[21] 'English at the Universities', 1.

THE POETICS OF PLACE 273

towards the Orient. The early nineteenth-century study of Indo-European languages sits at the heart of the discipline of comparative philology, developed by Friedrich Schlegel, Jakob Grimm, Rasmus Rask, and Max Müller, enabling a bridging of East and West and a thinking across national boundaries. Attempts to contain and define Europe were counterbalanced by philology and mythology which demonstrated the interconnectedness of Asia and Europe. Contemporary with Pater, L. L. Zamenhof's creation in 1887 of the artificially constructed language of Esperanto, literally 'full of hope', with a vocabulary made up of words of primarily Romance and Germanic origin, was aiming at a universal language not tied to national identity but enabling communication across borders and nationalities.

Pater had, I think, clear notions of what constituted 'at home' and 'abroad'. Writing to William Sharp, shortly before embarking on his research trip to Rome, he observed: 'We went to Cornwall for our summer holiday, but though that country is certainly very singular and beautiful, I found there not a tithe of the stimulus to one's imagination which I have sometimes experienced in quite unrenowned places abroad.'[22] Much of his fiction is set in such 'unrenowned places abroad'; although Pater's European itineraries have yet to be documented, there is no doubt that the author's encounter with the unfamiliar abroad proved a powerful trigger to the imagination. The historical stratification of cultural remains on the Continent, from the Romans onwards, provided Pater with ocular proof of the organic unity of European culture, of centuries of destructive wars and revolutions, and civilization's persistent re-erection of architectural structures in a reaffirmation of the survival of culture. The Paterian traveller portrayed by Gosse resided in a sentient body, which perceived the world abroad with every sense available, even to the point of exhaustion, attempting to comprehend the particular corner of Europe under exploration.

Pater's excitement is captured towards the end of 'An English Poet'. Having left the British Isles, the poet has just arrived at the Continent: 'And as he waited for his friend that they might start on their wanderings together, not unwilling to linger a little among the voices of the toy-like French children at play, all Europe in its priceless art and choicer scenery crowded together, seemed to hang just beyond the horizon in his fancy, like some precious stone, with soft shiftings and variations.'[23] The alluring vision of a multifaceted gemlike Europe provides a promising invitation, as the poet, the narrator, and the reader imagine its weightless suspension, with a magnetic attraction drawing us towards the distance. The aural presence of the French children is challenged by the imaginary unity, 'all Europe', which abandons national differences. Pater's oscillation between the almost real children—they can be heard, yet they are likened to toys—and the distant ideal of something inconceivably large, contained within one single image, challenges us to consider modes of perception, scale, the near and the far, the real and the imaginary. Pater's poetics of place contains it all, and we must be prepared to embrace such complexities in order to grasp the significance of his settings.

[22] Letter to William Sharp, 4 Nov. 1882, *CW* 9. [23] *CW* 3:154.

The Idea of Europe

The poet's vision of Europe was alluring because it was neither his native France nor his adopted England. Europe the soaring jewel toys with our notions of gravity, geography, and optics: a mirage, alien in its distortion, projecting a continent into thin air in a process of reflection. This might be Pater's way of teasing us into thinking about what Europe actually is: a myth? a construct? a territory? a cultural entity? a geopolitical unit? Our Anglo-French poet sees himself as standing outside of Europe; where does Europe begin and where does it end are questions which we are invited to consider.

These may seem like profitless speculations that will never be answered, as Pater never finished his text, but they are pertinent to any considerations about how we use the term 'Europe', and what we understand by it. Pagden pointed out how 'The identity of "Europe" has always been uncertain and imprecise, a source of pride for some and hatred or contempt for others. Like all identities it is a construction, an elaborate palimpsest of stories, images, resonances, collective memories, invented and carefully nurtured traditions. It is also particularly elusive because continents, far more than nations, tend to be simply geographical expressions.'[24] Ever since the invention of the myth of Zeus's rape of Europa, the tension between East and West, Asia and Europe, has been pivotal. Daughter of the Asian king Agenor, Princess Europa was seduced by Zeus disguised as a white bull and dumped, together with her offspring, on the Continent which now carries her name. The Europeans are thus partly Asian, partly Greek. The challenge of defining where the eastern boundary of Europe runs is a recurrent one; as Said pointed out: 'neither the term Orient nor the concept of the West has any ontological stability; each is made up of human effort, partly affirmation, partly identification of the Other.'[25] Such 'supreme fictions' that 'lend themselves easily to manipulation and the organization of collective passion'[26] are consequently in a continuous state of flux.

Other definitions of Europe are related to the westward expansion which took place after the collapse of Rome. As for 'Europe', 'No one has ever been certain quite where its frontiers lie. Only the Atlantic and the Mediterranean provide obvious "natural" boundaries. For the Greeks, Europe had sometimes been only the area in which the Greeks lived, a vaguely defined region that shaded into what was once Yugoslavia in the North and is still Turkey in the South. For most, however, Europe had a larger, more indeterminate geographical significance. It was seen as the lands in the West, whose outer limits, the point at which they met the all-encircling Okeanos, were still unknown.'[27] J. G. A. Pocock points out how 'The word "Europa" was in use in the Roman empire but was not used self-descriptively; Rome may have known that it was in Europe but did not characterize itself as European, since the word was not used that way. The reason for this was that the Roman empire was not continental but Mediterranean.'[28] Any definition and location of Europe is always

[24] Anthony Pagden, 'Europe: Conceptualizing a Continent', in ed. Pagden, *The Idea of Europe*, 33–54, 33.

[25] 'Preface' (2003) in Said, xii. [26] Ibid., xii. [27] Ibid., 45.

[28] J. G. A. Pocock, 'Some Europes in their History', in ed. Pagden, 55–71, 59.

THE POETICS OF PLACE 275

dependent on the writer's own position vis-à-vis Europe and the Orient. Analysing the relations between East and West, Said related Orientalism to what Denys Hay called 'the idea of Europe',[29] 'a collective notion identifying "us" Europeans against all "those" non-Europeans, and indeed it can be argued that the major component in European culture is precisely what made that culture hegemonic both in and outside Europe: the idea of European identity as a superior one in comparison with all the non-European peoples and cultures.'[30]

Pater engaged with the fluid eastern boundary of Europe, in antiquity and throughout history, at times even posing as an 'Orientalist'. Like Winckelmann he never encountered the ancient world beyond Rome. Pater's correspondence reveals no desire to travel further East; Greece remained a place of the mind for him, accessible through his readings of Herodotus, Homer, Euripides, and Pausanias. His lectures in Oxford on Pausanias in the Michaelmas term of 1878 were the first of their kind,[31] and the Greek topographer's *Periegesis* provided Pater with early examples of ekphrastic criticism and travelogue, enabling the kind of Oriental armchair travelling which characterizes his 'Greek Studies'.[32] Troy, Mycenae, Troezen, Thebes, Athens, Sparta, Olympia, Corinth, Aegina, Crete—sites which occur in his Greek writings—were imaginary places, known from classical literature and contemporary archaeology. The material presence of the East in the West, as museum exhibits or collectors' items, was an important aspect of Pater's Orientalism. His readings of Heinrich Schliemann's well-illustrated volumes about his excavations of Troy and Mycenae, hot off the press in the 1870s, testify to his excitement at the ongoing attempts to reconstruct the sites around which some of the most important ancient mythology revolved.[33]

We should not underestimate the allure of the Orient for Pater. In his mythological writings, Dionysus provided him with a focal point for an exploration of the encounter between East and West in the texts which spanned mythology, literary criticism, and imaginary portrait: 'A Study of Dionysus: The Spiritual Form of Fire and Dew' (1876), 'The Bacchanals of Euripides' (1877/89),[34] and 'Denys l'Auxerrois' (1886). His selection of the most Oriental of Euripides' plays, which represents the seductive and destructive forces of Dionysus as an eastern deity, is in itself symptomatic. In the Dionysus essay, Pater traced the god's birthplace, moving gradually eastwards, pointing out how each local population saw the deity as an outsider. His origin is pursued

[29] See Denys Hay, *Europe: The Emergence of an Idea* (Edinburgh: Edinburgh University Press, 1968).
[30] Said, 7.
[31] See L. R. Farnell, *An Oxonian Looks Back* (London: M. Hopkinson, 1934), 76–7; Østermark-Johansen 2011, 216–20.
[32] See Charlotte Ribeyrol, 'Hellenic Utopias: Pater in the Footsteps of Pausanias', in ed. Martindale, Evangelista, and Prettejohn, *Pater the Classicist: Classical Scholarship, Reception, and Aestheticism*, 201–18.
[33] See Inman 1990, ix, 409 and 433 for Pater's borrowings of Schliemann's *Mycenae: A Narrative of Researches and Discoveries at Mycenae and Tiryns* (London: John Murray, 1878) and his *Troy and Its Remains: A Narrative of Researches and Discoveries Made on the Site of Ilium and in the Trojan Plains* (London: John Murray, 1875).
[34] The essay was probably quite advanced by 1877 when it was listed in the Table of Contents of Pater's abandoned book. See Laurel Brake, 'After *Studies*: The Cancelled Book', in Brake, *Print in Transition, 1850–1910: Studies in Media and Book History* (Basingstoke: Palgrave Macmillan, 2001), 213–24. See also *Bibl.* no. 25. It was published in periodical form: 'The Bacchanals of Euripides', *Macmillan's Magazine* 60 (May 1889), 63–72, and subsequently included in *Greek Studies* (1895).

276 WALTER PATER'S EUROPEAN IMAGINATION

to an imaginary place in the East, to 'a cave in Mount Nysa, sought by a misdirected ingenuity in many lands, but really, like the place of the carrying away of Persephone, a place of fantasy, the oozy place of springs in the hollow of the hillside, nowhere and everywhere, where the vine was "invented".'[35] Eventually, Dionysus' origin is located in Asia Minor, where he becomes an invasive force, spreading westwards and southwards as Pater takes his cue from the new disciplines of comparative philology and mythology:

> Through the fine-spun speculations of modern ethnologists and grammarians, noting the changes in the letters of his name, and catching at the slightest historical records of his worship, we may trace his coming from Phrygia, the birthplace of the more mystical elements of Greek religion, over the mountains of Thrace. On the heights of Pangaeus he leaves an oracle, with a perpetually burning fire, famous to the time of Augustus, who reverently visited it. Southwards still, over the hills of Parnassus, which remained for the inspired women of Boeotia the centre of his presence, he comes to Thebes, and the family of Cadmus. From Boeotia he passes to Attica; to the villages first, at last to Athens; at an assignable date, under Peisistratus; out of the country, into the town.[36]

Dionysus personifies eastern effeminacy and sensuousness, the embodiment of much of the prejudice against the East found in nineteenth-century western writings on the Orient. His influence spreads to the disciplined Dorian world while upsetting Apolline norms. Pater was fascinated with the chaos and violence erupting in the last half of Euripides' *Bacchae*; the clash between East and West originated in a failed cultural encounter, as the Theban community refused to acknowledge the Oriental deity. Thebes becomes the outer bastion of western order, succumbing to eastern chaos by denying one of its chief deities the respect demanded by his cult. Transposing the tragedy into his portrait of Denys, Pater sent his travelling deity north-west; Denys enters Auxerre, a town which in the Middle Ages was on the eastern border of the Burgundian kingdom. Although located much further West than Boeotia, Auxerre once constituted an eastern outpost, and the presence of the Dionysian Denys invites renewed speculations about where the West ends and the East begins in thirteenth-century Europe. After the Islamic invasions from across the Mediterranean, notions of East and West were challenged and subjected to significant changes, with the East now literally coming from the South.

In Pater's 1880 essays 'The Beginnings of Greek Sculpture' and 'The Marbles of Aegina', he repeatedly pushed his points of reference further East, thereby challenging the notion of a specifically European culture in antiquity. He began by invoking the imaginative sense necessary for a full perception of Greek art, in all its colour and sensuousness, isolated 'within the grey walls of the Louvre or the British Museum'.[37] With Homer and Pausanias as his guiding lights, he pursued the cradle of European art eastwards: Cyprus, Troy, Phoenicia, Japan. Entwining the myths of such arts- and craftsmen as Hephaistus and Daedalus with the sites of Cyprus and Crete, he

[35] *CW* 8:99. [36] *CW* 8:105. [37] *CW* 8:114.

abandoned myth and narrative for purely formalist observations concluding that when it came to 'every form of imitation, reproduction, and combination—leaf and flower, fish and bird, reed and water—... that art of Japan is not so unlike the earliest stages of Greek art as might at first sight be supposed.'[38] Pater's bridging of Greek and Japanese art over a gulf of some 2,400 years involved mythic time and space. Artistic culture in Homer's Greece was as foreign and distant to him as the art of Japan. What remained were the objects and artefacts themselves, speaking their own clear language of transcendent aesthetic form. For the aesthetes of the West, the beauty of early Greek and Oriental artworks had a timeless appeal.

In Pater's writings the adjective 'European' is far from a high-frequency word. It is therefore so much the more remarkable that it has no fewer than seven occurrences in 'The Marbles of Aegina', qualifying nouns like 'tendency', 'ideas', and, repeatedly, 'influence': 'European influence', 'this Dorian, European, Apolline influence', or 'the Dorian, the European, the true Hellenic influence'. Why this interest in tracing 'European' influence on Greek art, and what does Pater mean by using the adjective almost synonymously with 'Dorian', 'Hellenic', and 'Apolline'? Pater's discussion occurs as an overture to his exploration of the fifteen pedimental marble sculptures (fifth century BC) for the temple of Aphaea on the island of Aegina in the Saronic Gulf, South of Athens. On display in the Munich Glyptothek since the early nineteenth century, the sculptures of nude warriors in battle (Fig. 6.1), symmetrically arranged around a standing figure of Athena, marked an innovative phase in Greek figurative art. To Hegel and his contemporaries, the Aegina marbles constituted the archaic, orientalizing, style, while the Elgin marbles were the classical and

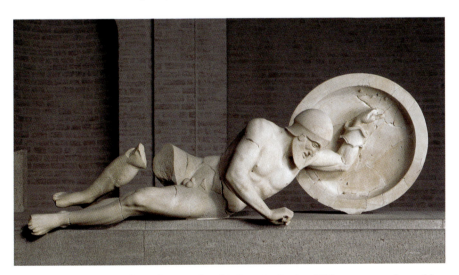

Fig. 6.1. *Dying warrior* from the Temple of Aphaea in Aegina (fifth century BC), marble. Antike am Königsplatz, Munich. Staatliche Antikensammlungen und Glyptothek München. Photograph by Renate Kühling.

[38] *CW* 8:130.

278 WALTER PATER'S EUROPEAN IMAGINATION

aesthetically pleasing culmination of the evolution of Greek sculpture.[39] Pater celebrated the naked body in the Aegina marbles in what he read as a depiction of scenes from the Persian War, involving battles between Greeks and 'Asiatics', perhaps with the suggestion that the figures derived from the very moment when Europe became European, when the Oriental smile melted into European sculpture.[40]

In the museum world, Pater studied art decontextualized from its original use and ambience. As he removed himself from what he called the 'chryselephantine' art of Homeric Greece, rich in colour and sensuousness, he proceeded westwards, from the Ionian to the Dorian influence on art. The schism between East and West became for him one of temperaments, running deep in their impact on individual lives, politics, and art; we detect an almost Nietzschean distinction between the Dionysian and the Apolline, forces which he distinguished in terms of their centrifugal or centripetal dynamics.[41] From his vantage point as an orderly European, Pater saw the centrifugal energy of the Ionian influence as chaotic, disruptive, potentially destructive: 'its restless versatility drives it towards the assertion of the principles of separatism, of individualism,—the separation of state from state, the maintenance of local religions, the development of the individual in that which is most peculiar and individual in him. Its claim is in its grace, its freedom and happiness, its lively interest, the variety of its gifts to civilization; its weakness is self-evident, and was what made the unity of Greece impossible.'[42] Pater professed his preference for the Dorian mode, associated with Plato and his sense of order, simplicity, and structure. Is Plato, then, for Pater the father of Europe, the man who makes Europe European? Plato becomes 'the European influence', 'that salutary European tendency, which, finding human mind the most absolutely real and precious thing in the world, enforces everywhere the impress of its sanity, its profound reflections upon things as they really are, its sense of proportion. It is the centripetal tendency, which links individuals to each other, states to states, one period of organic growth to another, under the reign of a composed, rational, self-conscious order, in the universal light of the understanding.'[43] Pater's two opposed influences thus become geopolitical, philosophical, aesthetic, and historical; his theories of the 'organic unity' of European literature and culture have their roots in an East-West dichotomy which goes back to antiquity, to Plato and Platonism.

With his view of western society as a Platonic one, Pater makes sweeping connections across time and territories. A direct line runs from the Dorians to the Italian Renaissance: the nude bodies of the Aegina warriors become precursors of the renaissance cult of the body, 'its motives already clearly pronounced, the care for physical beauty, the worship of the body'.[44] The Aegina marbles' 'enduring charm of an unconventional, unsophisticated freshness' is found 'not less than in the work of

[39] See Elizabeth Prettejohn, *The Modernity of Ancient Sculpture: Greek Sculpture and Modern Art from Winckelmann to Picasso* (London: I. B. Tauris, 2012), 38–60.

[40] Now interpreted as depictions of the Trojan rather than the Persian Wars.

[41] See Robert and Janice A. Keefe, *Walter Pater and the Gods of Disorder* (Athens: Ohio University Press, 1988). It remains uncertain whether Pater ever read Nietzsche, but given the proximity in their interests, and Pater's general familiarity with German literature, it seems unlikely that he did not.

[42] *CW* 8:145–6. [43] *CW* 8:146. [44] 'Preface', *Ren.*, xxii.

Verrocchio and Mino of Fiesole', we learn.[45] As civilization moves further West, so do the boundaries of Europe. Pater was basing his essays on Greek art on nineteenth-century German scholarship. The Germans may not have been such a pervasive political and military power in the Orient as the British and the French,[46] but they dominated scholarship within the fields of mythology, philology, and archaeology. Apart from his reading of Schliemann, Pater was studying the voluminous works on the Dorian tribes by Karl Otfried Müller and Ernst Curtius; in the latter's *History of Greece*, the Dorians were the pivotal points, the spine of civilization.[47] When Wilde's *Picture of Dorian Gray* appeared in 1890, the protagonist's first name had already received a solid grounding in literature: ancient Greek, Italian Renaissance, German nineteenth-century history, and Paterian art criticism all contributed towards the European eclecticism of Wilde's handsome young man, embedded in a European cultural tradition.

Pater's Greek essays connect to his Dionysian and Apolline imaginary portraits. As he had first explored the eastern boundaries of Europe, so he turned his gaze towards the North in 'Duke Carl of Rosenmold' (1887) and 'Apollo in Picardy' (1893). His interweaving of the ancient myth of the Hyperboreans with real, geographical places—the merging of Heidelberg and Dresden into the fictitious 'Rosenmold' and the Carthusian monastery in Montreuil-sur-Mer in Picardy—enabled him to question our notions of the North, a concept which since antiquity had been as fraught with myth as our ideas of the East. In Greek myth, the seat of Boreas, god of the northern wind, provided a northern boundary for the known world. The cold, destructive, wind which heralded the coming of winter was designated a number of different residences North of Attica, and the *terra incognita* beyond Boreas constituted an imaginary realm, never subjected to the harsh weather conditions of frost and snow. Inhabited by a race of happy people, Hyperborea was supposedly bathed in eternal sunlight and provided ideal conditions for long, golden lives filled with innocent pastimes. The Hyperboreans were inseparably associated with the myths of Apollo; the sun god left Greece in the autumn to spend the winter in the far North, in a life of music, song, and art, and returned to Greece in the spring, in a chariot drawn by northern swans. The myth of Apollo and the Hyperboreans went back to Hesiod, Homer, Herodotus, and Pindar,[48] and became increasingly complex by the time it appeared in the writings of Diodorus, Pliny, and Pausanias.[49] Revolving around the dichotomies of North-South and light-darkness, the myth raised the question of where the North begins, and where it ends, if ever. Beyond the North is only the North Pole. Classical sources disagreed about the location of Boreas: in northern Greece? in the Alps? or by the Ister—the Greek name for the Danube? As the Greek world expanded, the Hyperboreans moved further North and further West, with the

[45] *CW* 8:153. [46] Said, 19.

[47] See Inman 1990, 172, 214–15, 435, 470, 479 for Pater's borrowings of K. O. Müller's *History and Antiquity of the Doric Race*, tr. Henry Tufnell and George C. Lewis, 2 vols (Oxford: John Murray, 1830) and of Ernst Curtius' *The History of Greece*, tr. A. W. Ward, 5 vols (London: R. Bentley, 1868–73).

[48] Herodotus, *Histories* 4.32–6; *Odyssey* 10.82; Homeric Hymn 7 (to Dionysus) 27; Pindar, *Pythian Ode* 10.27.

[49] Diodorus Siculus, *Library of History* 2.47.1–6; Aelian, *On Animals* 11.1; Pliny the Elder, *Natural History* 4.88, 6.34; Pausanias, *Description of Greece* 5.7.6–9.

280 WALTER PATER'S EUROPEAN IMAGINATION

result that by the time the Greek historian Diodorus was writing in the first century BC, they were believed to live on the British Isles, across the sea beyond the Celts.[50] Was Hyperborea bounded by sea, by rivers, or by mountains, and who could cross from the known world into the unknown? Apollo's privileged status as a transitional figure, crossing boundaries, assured him a life in eternal summer. Seen from a Greek perspective, the Hyperboreans constituted the fantasy of a northern golden world imagined from the South. The myth forms a counterpart to the northern desire for the South, brought on by a 'fatigue du Nord',[51] expressed in much romantic writing. The golden land of Greece, longed for by Winckelmann, Goethe, and Symonds, becomes a nineteenth-century parallel to the ancient sunlit plains of Hyperborea: an aesthetic ideal place of the mind, where man, nature, art, and the divine lived in perfect harmony against a perpetually blue sky. The myth of the Hyperboreans proliferated widely in much of the German scholarship Pater had studied in the 1860s and 1870s. Keen to cultivate a northern-European identity, separate from, yet linked to classical antiquity, the nineteenth-century heirs of Winckelmann—Karl Otfried Müller, Friedrich Welcker, and Ludwig Preller—all included chapters on the Hyperborean Apollo in their works, weighing ancient sources against each other in the attempt to find a more exact location.[52]

If Pater never travelled to Greece or the Orient, it should be noted that he never explored the North of Europe either. His honorary doctorate at the University of Glasgow took him to Scotland in the spring of 1894 via some northern English cathedral towns (York among them), and in 'An English Poet' the passages set in Cumberland suggest some familiarity with the Lake District, beyond a reading of romantic poetry. Visits in the late 1850s to Pater's Aunt Bessie, in charge of his sisters, took him to the southern and eastern parts of Germany, to Heidelberg and Dresden, and he most likely returned to England via Holland. Amsterdam or Haarlem may well have been the furthest North Pater ever ventured on the Continent. Unlike Gosse, who travelled to Denmark in 1872 and 1874, and was instrumental in popularizing Henrik Ibsen and Scandinavian literature to an English audience, Pater never seems to have taken any interest in those northern countries and cultures that launched his friend's career as a literary critic. In his fiction, Haarlem and Rosenmold become sites from which protagonists dream of places or figures associated with the far North: this is where Sebastian dreams of the North-West Passage and where Carl stars in a musical interlude as the northern Sun God Balder. Anything beyond Holland or Germany is relegated to the realm of myth.

Pater alludes to this mythical realm in the opening passage of 'Apollo in Picardy', a quotation from an unidentified 'writer of Teutonic proclivities' who sounds like a

[50] Diodorus Siculus, *Library of History* 2.47.1–6.

[51] Pater applied the term to Winckelmann (1867), quoting from Mme de Staël's *De l'Allemagne* (1810): ' "He felt in himself", says Mme de Staël, "an ardent attraction towards the south. In German imaginations even now traces are often to be found of that love of the sun, that weariness of the north (*cette fatigue du nord*) which carries the northern peoples away into the countries of the south." ' *Ren.*, 142.

[52] Müller, 1:284–94; Ludwig Preller, *Griechische Mythologie*, 2 vols (Leipzig: Weidmannsche Buchhandlung, 1854), 1:157–9; Friedrich Welcker, *Griechische Götterlehre*, 3 vols (Göttingen: Verlag der Dieterischer Buchhandlung, 1857–63), 2:348–64.

clone between Heine and Pater himself.[53] In avoidance of German censorship, Heine spent the last twenty-five years of his life exiled in Paris, a subject which fed into his *Les Dieux en exil* (1853) which explored the new lives of the classical gods in the Christian world. Exile plays on our ideas of 'at home' and 'abroad', the familiar and the unfamiliar; a brief reference to Heine occurs, not surprisingly, in Freud's essay on 'The Uncanny'.[54] With their Doppelgänger forms the pagan gods upset the usual order of things in their new abodes, far from the Mediterranean and closer to the North. Pater revisits Heine and the Hyperborean Apollo, taking the reader much further North than the classical writers ever dreamed of, while alluding to a chaotic topsy-turvy of summer and winter, caused by a Sun God reluctant to return to his native Greece:

'Consecutive upon Apollo in all his solar fervor and effulgence,' says a writer of Teutonic proclivities, 'we may discern even among the Greeks themselves, elusively, as would be natural with such a being, almost like a mock sun amid the mists, the northern or ultra-northern sun-god. In hints and fragments the lexicographers and others have told us something of this Hyperborean Apollo, fancies about him which evidence some knowledge of the Land of the Midnight Sun, of the sun's ways among the Laplanders, of a hoary summer breathing very softly on the violet beds, or say, the London-pride and crab-apples, provided for those meagre people, somewhere amid the remoteness of their icy seas. In such wise Apollo had already anticipated his sad fortunes in the middle age as a god definitely in exile, driven north of the Alps, and even here ever in flight before the summer. Summer, indeed, he leaves now to the management of others, finding his way from France and Germany to still paler countries, yet making or taking with him always a certain seductive summer-in-winter, though also with a divine or titanic regret, a titanic revolt in his heart, and consequent inversion at times of his old beneficent and properly solar doings. For his favors, his fallacious good-humor, which has in truth a touch of malign magic about it, he makes men pay sometimes a terrible price, and is, in fact, a devil!'[55]

Apollo's dark double is always in transit, spreading his influence as he leaves Picardy just after the winter solstice. Pater is more interested in northern darkness, both in the physical and in the spiritual sense, than in heat and light. The eerie darkness which pervades the narrative may well be a response to some of the major nineteenth-century anxieties about the cooling of the sun, brought about by geological and evolutionary discoveries. Gillian Beer maps some of these theories, expressed in the

[53] J. S. Harrison observes that the passage 'reads like a synthesis of his [Pater's] own reflections' and suggests that 'the observant reader is inclined to suspect that Pater is really quoting from himself'. 'Pater, Heine, and the Old Gods of Greece', *PMLA* 39:3 (Sept. 1924), 655–86, 655. In chs II and XXI of *Marius*, Pater quotes an unnamed 'German mystic', whom neither Ian Small nor Gerald Monsman, editors of the novel, have been able to identify: 'Very likely Pater invented this quotation', *Marius the Epicurean* 2008, 13, n. 3.

[54] Freud, *The Uncanny*, 143: 'The double has become an object of terror, just as the gods become demons after the collapse of their cult—a theme that Heine treats in "Die Götter im Exil".'

[55] *CW* 3:199.

1860s and 1870s by such scientists as William Thomson and Hermann Helmholtz, that the sun had only a limited store of heat which, given its recently established great geological age, with all likelihood had been almost spent.[56] These mid-Victorian anxieties found expression in anything from scientific publications to periodical essays and fiction, almost in confirmation of Max Müller's theories that all linguistic activity could be traced to man's preoccupation with the movements of the sun. Müller's concern with race, language, and myth took its starting point in his claim that for the Aryan people, language and solar myth were inseparably connected: 'In Müller's system all linguistic and mythological signification leads back towards the sun and the phenomena of weather, and to the fear of non-recurrence. He claimed that primitive peoples constantly feared that the sun would not rise again.'[57] Pater's figures are illuminated by the cold lunar light emanating from a full moon, associated with madness. Or is it the northern light, the *Aurora Borealis*, transposed from the far North to the North of France? Tied to the magnetic pole of the northern hemisphere, the *Aurora Borealis* is caused by collisions between electrically charged particles released from the sun and gases such as oxygen and nitrogen emitted from the North Pole. The further away from the North Pole, the lower on the horizon the aurora will be. In Pater's narrative it becomes the eerie double of the dawn:

> In this wonderful season, the migratory birds, from Norway, from Britain beyond the seas, came there, as usual, on the north wind, with sudden tumult of wings; but went that year no farther, had built their nests by Christmas-time, filled that belt of woodland around the vale with the chatter of their business and love quarrels. In turn, they drew after them strangers no one here had ever known before; the like of which Hyacinth, who knew his bestiary, had never seen even in a picture. The wild-cat, the wild-swan—the boy peeped on these wonders as they floated over the vale, or glided with unwonted confidence over its turf, under the moonlight, or that frequent continuous aurora which was not the dawn.[58]

The interference of the North with the South leads to the tragic conclusion of the tale. Resting place for the northern migratory birds, Picardy attracts untimely mating and rare northern animal species. Natural light in darkness, birds mating at Christmas, and a pagan protagonist who poses as Christ with the lamb in a Christian chapel are all examples of the upsetting of the natural order. The discus, which kills the young Hyacinthus, is thrown by Apollyon but potentially misdirected by the sudden appearance of Boreas, the northern wind, setting afoot a course of events which becomes almost apocalyptic in its scope. 'Apollo in Picardy' is Pater's Pindaric Ode to the North Wind: the cyclical recurrence of the Hyperborean Apollo gives us Pater's own bleak version of a Shelleyan Destroyer and Preserver, a nature deity with roots in nineteenth-century science, philology, and mythography. The Hyperborean Apollo is as restless as the wind, ruled by the magnetic attraction of the North Pole.

[56] Gillian Beer, '"The Death of the Sun": Victorian Solar Physics and Solar Myth', in ed. J. B. Bullen, *The Sun is God: Painting, Literature and Mythology in the Nineteenth Century* (Oxford: Oxford University Press, 1989), 159–80.

[57] Ibid., 165. [58] *CW* 3:206.

The interplay between a classical myth, defining notions of the North for the Greeks, a nineteenth-century German resurrection of the pagan gods in modern Europe, and the North-South dynamics of the natural world with its cyclical passing of the year, may indicate the complexities of Pater's narrative. The passing visit of a southern deity en route for the North in a monastery in northern France questions North and South, pagan and Christian, with the result that the South may be further North, or the North may be further South than we think.

Pater's own experience of northern Europe fed into 'Duke Carl of Rosenmold'. The mouldy duchy which provided the setting for his young German, keen to discover Greek ancestors and adopt the fashions of the French Sun King, was an amalgamation of Heidelberg and Dresden. Both sites were popularly known by references to the South: Heidelberg as 'Athens of the North', due to its university and intellectual culture, Dresden as 'Florence of the Elbe', due to its rich cultural life. Carl's 'dark northern country',[59] with its 'long, slumberous, northern nights'[60] revolves around a court 'with a continuous round of ceremonies, which, though early in the day, must always take place under a jealous exclusion of the sun', in which 'one seemed to live in perpetual candle-light'.[61]

When choosing a name for his protagonist, Pater associated him with two of the famous rulers conventionally represented as 'fathers of Europe':[62] Charlemagne and Charles V, the Holy Roman Emperor. As Pagden reminds us, 'Charlemagne, although frequently claiming some kind of world sovereignty, called himself *pater europae*—"the father of the Europeans."' The Emperor Charles V, who in the early sixteenth century came closer than any ruler before or since to uniting Europe under one sovereign, was addressed as *totius europae dominus*—"lord of all Europe"—an obvious allusion to Antoninus Pius's claim to be *dominus totius orbis*'.[63] Their visions of a Christian state, covering the entire Continent, provided Carl with an ambitious ancestry which his brief rococo life unsuccessfully attempted to replicate. Carl might be able to live up to his Dresden china, but living up to his namesakes was beyond him. Pater satirically presents us with a protagonist who imports foreign culture, whether from the South or from the North: architectural imitations of Versailles, a Raphael Madonna, a proto-Wagnerian *Singspiel* about Balder, in order to enrich life at his dark northern court. A precursor of the German enlightenment, Carl is obsessed with the very notion and representation of light in all its forms. The discovery of the fifteenth-century German humanist Conrad Celtis's 'Ode to Apollo' initiates Carl's cult of the Greek Sun God: 'To bring Apollo with his lyre to Germany! It was precisely what he, Carl, desired to do—was, as he might flatter himself, actually doing.'[64] His grandiloquent European ambitions draw him still further South and

[59] *CW* 3:129. [60] *CW* 3:116. [61] *CW* 3:117.

[62] See Padgen, and John McCormick, 'The Idea of Europe', in ed. McCormick, *Europeanism* (Oxford: Oxford University Press, 2010), 1–26.

[63] Pagden, 45.

[64] *CW* 3:117. For a further exploration of the significance of Pater's allusion to Celtis, see Lene Østermark-Johansen, 'The Dream of a German Renaissance: Conrad Celtis, Albrecht Dürer, and Apollo in Walter Pater's "Duke Carl of Rosenmold" (1887)', in *Studia Humanitatis: Essays in Honour of Marianne Pade on the Occasion of her Sixty-Fifth Birthday 8 March 2022*, *Nordic Journal of Renaissance Studies* 18 (2022), https://www.njrs.dk/18_2022/30_Østermark_Johansen.pdf.

East in his imaginary travels, as he realizes that European culture originates in Greece, and that Italian and French culture are merely imitations. In Pater's spoof on the conventional quest narrative, Carl goes in search of foreign light, but realizes, before he crosses the Alps, that true self-knowledge lies in exploring his native culture with a new patriotism which briefly roots him in his homely soil, before invading French soldiers kill him. Carl literally sees the light abroad and realizes that for him light is northern darkness. He becomes no conquering Hannibal—or Charlemagne or Napoleon—crossing the Alps. Ironically, the sight of the Alps as the gateway to southern Europe makes Carl realize where his true heart lies:

> On very early spring days a mantle was suddenly lifted; the Alps were an apex of natural glory, towards which, in broadening spaces of light, the whole of Europe sloped upwards. Through them, on the right hand, as he journeyed on, were the doorways to Italy, to Como or Venice, from yonder peak Italy's self was visible! —as, on the left hand, in the South-german towns, in a high-toned, artistic fineness, in the dainty, flowered ironwork for instance, the overflow of Italian genius was traceable.[65]

Pater's image of Europe sloping upwards is another of his striking European images, with Ruskinian 'Mountain Gloom and Glory' (*Modern Painters* IV) as an intertext. An intrepid walker in the Alps, Ruskin visited Switzerland regularly, climbing and drawing, from 1842 until his last visit in 1888.[66] Ann Colley points out that 'Ruskin understood that the haptic and the optic are not autonomous but work together. To touch, to observe, and to move one's feet over stones were all part of the act of seeing and comprehending.'[67] In spite, or perhaps because, of being one of the most 'eye-driven' of Victorian critics, Ruskin suffered from bad eyesight, but was driven by a desire for both outer and inner sight: 'Ruskin climbed not only for the thrill of exertion and the rage to collect his geological specimens, but also for a perspective that reveals more than a panorama—one that also exposes, in spite of the accompanying annoyances and frustrations, the privilege of the imperfect vision, which opens up a space for the imagination and leads one into the spiritual mystery of the landscape.'[68]

Pater engaged with light and landscape. The open vistas, the sense of both physical and spiritual ascent with a panoramic view of an ideal and distant country awaiting from the top: landscape, light, and the imagination merge into one alluring image of the delights awaiting those who cross the Alps, an experience also evoked by Leslie Stephen, an expert mountaineer, in 1871 in his collection of Alpine essays, *The Playground of Europe*.[69] Chronicling the literary cult of the Alps from Horace Walpole, Thomas Gray, Goethe, Rousseau, to Chateaubriand, the English Romantics, and Arnold, Stephen founded his Alpine impressions on a long literary tradition, while also adding his own physically strenuous experiences on the slopes to the mix. Bound in red cloth with gold print, the book looked like Murray's and Baedeker's guidebooks, while offering another voice on the Alpine territory which, since the

[65] *CW* 3:128.
[66] Ann Colley, *Victorians in the Mountains: Sinking the Sublime* (Farnham: Ashgate 2010), 147.
[67] Ibid., 154–5. [68] Ibid., 171.
[69] Leslie Stephen, *The Playground of Europe* (London: Longmans, Green & Co., 1871).

THE POETICS OF PLACE 285

arrival of Thomas Cook's package tours to the mountains in the 1860s, was fast becoming a gathering-place for European *litterati*, tourists, and mountaineers with the Alps as a theatrical backdrop to a range of different spectacles, climbing being one of them.

As for Carl, the exuberance of Italy trickles into homely South German artefacts which, in the end, prove more alluring than the great unknown beyond the mountains. Faced with the choice of Hercules—should he turn right or left—he chooses the familiar: 'A kind of ardent, new patriotism awoke in him, sensitive for the first time at the words *national* poesy, *national* art and literature, *German* philosophy. To the resources of the past, of himself, of what was possible for German mind, more and more his mind opens as he goes on his way.'[70] Rather than travel the full journey, searching for Hellas at home seems a more appealing option, as the Aurora Borealis draws him North. For Carl, Europe remains an idea, which assumes an insurmountable form at the Alps. A visit to Strasbourg and the awareness of the proximity of Switzerland and Italy are all too much for him. Transnationalism backfires and begets extreme patriotism, and Carl literally turns his back on Europe as he returns home. The new Germanic culture to which he turns is narrow by comparison, and there is an undertone of determinism in Pater's tale: German he is and German he must remain. In spite of Carl's mock funeral, he is caught alive and summoned back to become Duke as he was destined to be.

Pater fully understood the complexity of Europe as a construct: myth-ridden, in continuous flux, potentially expansive towards the North and the East, with fluid boundaries, where they are not naturally given in the form of channels, seas, and oceans. Carl's chief failure lies in his inability to engage with Europe in the real world, outside the realm of art. For Pater France and Italy constitute the quintessential European countries: they provide the settings for his two novels, for three of his completed short portraits, and for three and a half (counting 'An English Poet') of his unfinished short portraits. They were the countries to which he most frequently travelled, and with whose literature he was most familiar. Considering the horizontal and vertical axes of the chronotope, France and Italy had the further attraction of being the parts of the European territory in which antiquity was a continued forceful presence. So much of Pater's fiction revolves around the notion of the landscape as a palimpsest in which antiquity occasionally rears its head. The author's intense experience of such places added an unmistakeable Paterian poetics to them in his rendition of setting and place. Untravelled parts of Europe, such as the Iberian Peninsula, remain absent from his writings; in the case of other untravelled parts, such as Greece and Scandinavia, they are brought to mythical life through Pater's reading.

The big issue remains of the western border, of whether England is part of Pater's Europe. No easy answer can, I think, be provided. Is Pater's Europe tied to the Continent, and what is the significance of the English Channel? In geopolitical, historical, and cultural terms, Pater was continuously asserting a coherence across the Channel through references to English medieval architects working in France ('Denys'), English sculptors working in Holland ('Sebastian'), the French need to

[70] *CW* 3:127. Italics are Pater's own.

travel to England for medical treatment ('Prince'), Florian's French ancestry ('Child'), English saints buried in French soil ('Denys'), or English girls married to Frenchmen ('Poet'). The underlying awareness of Picardy and Normandy as formerly English territory and of the impact of the Norman Conquest on places like Canterbury are subtexts for Pater's portraits which contribute towards making the Channel less of a dividing gulf than it might seem. In *Gaston* our awareness of a range of cross-Channel exchanges enrich our understanding of Valois France: of François, Duke of Anjou as suitor to Elizabeth I, of Amyot's translation of Plutarch as the foundation for North's translation which inspired Shakespeare's Roman plays, of Giordano Bruno's collaboration with Sir Philip Sidney, of Montaigne as the father of the English essay.

Pater was acutely aware of his own mixed national background, possibly with ties to both Holland and France. In his fiction the cultural, political, and historical ties between European cultures constantly recur: in *Gaston* the Flemish influence of the Clouet painters gives us northern painting in France, while the presence of Catherine de Medici and the Italian School of Fontainebleau, not to mention the legacy of Leonardo, gives us 'Italy in France'. In 'A Prince of Court Painters', Marie-Marguerite's formerly Flemish identity must now change to French, while Watteau's admiration of Rubens draws him back to his former culture, while developing an entirely new kind of French painting. Sebastian's dark beauty and his Spanish ancestry remind us of the presence of Spain in Holland, and the import of French court culture to Carl's court gives us 'France in Germany'. In *Marius*, set in the Second Sophistic period, the presence of Greece in Rome is strongly felt in figures like Marcus Aurelius and Lucian, while the wars against the East bring back the Antonine plague as a less welcome form of 'Greece in Italy'. The English poet has French ancestry and is drawn back towards France after an education in English literature in the landscape associated with the English romantic poets. Emerald goes to war in Flanders, leaves behind his comrade in Flemish soil, and returns to England, wounded for life by his Continental experience. Pater was an incorrigible transnationalist, bent on tying together the cultures of Europe across national and geographical boundaries in an assertion of European interdependence. His notion of the 'movement of the Renaissance' expresses man's innate desire for travel from one place to another. The Heracleitean epitaph to the 'Conclusion'—'Heraclitus says, "All things are in motion and nothing at rest"—is, at a very profound level, symptomatic of Pater's view of the human desire for movement—physical, spiritual, intellectual—not to be contained within national boundaries.

At Home and Abroad: Travelling with *Murray's Handbook* to France

In her monograph, *Chaucer: A European Life*, Marion Turner reconstructs Chaucer's England and his journeys to the European continent, often on the basis of relatively limited historical material relating specifically to Chaucer himself.[71] What emerges is

[71] Marion Turner, *Chaucer: A European Life* (Princeton: Princeton University Press, 2019).

a portrait of a cosmopolitan fourteenth-century Europe with Chaucer himself as a significant figure, placed in relief against European politics, trade, diplomacy, and literary developments. Surprising as it may seem, some of Chaucer's movements on the Continent are better documented than Pater's. Five hundred years apart, the two writers have mainly left traces of their travelling in their writings, and although one would expect a nineteenth-century writer to have deposited abundant evidence of his movements, Pater is hard to pin down as a traveller. If the settings of his imaginary portraits are mainly real places of which Pater gives us almost the exact addresses, inviting us to go and see for ourselves—Notre-Dame-de-Pratis, Valenciennes, the church and monastery in Auxerre, Haarlem and the Helder, the school and cathedral in Canterbury—we must take him literally and travel, while imagining why Pater stopped, what drew him to those particular sites, in an attempt to get to grips with the ways in which place had an impact on person.

Many questions emerge the moment we drag Pater out of his Oxford college rooms and begin to think of him abroad. Should we look upon him as a tourist or a traveller, part of a crowd, or cultivating solitary or small-group travelling? Did he belong to the category sketched in the *Temple Bar* in 1875: 'He is going to see the Rhine; he is off to the valley of the Rhone; he will try if he can cross a glacier; he will see what gliding in a gondola feels like; he will behold that fair Florence of which he has heard so often; he will wander in the Coliseum by moonlight; he will hear the twang of the light guitar, and watch the dance of the Phrygian-capped fishermen on the sands of the lovely Bay of Naples. He has never done any of these things, and he is going to do them now.'[72] Pater may have done such conventional things, but he certainly did not write about them. In his study of nineteenth-century tourism, James Buzard observed that 'If there is one dominant and recurrent image in the annals of the modern tour, it is surely that of the *beaten track*, which succinctly designates the space of the "touristic" as a region in which all experience is predictable and repetitive, all cultures and objects mere "touristy" self-parodies.'[73] Pater played with the touristy self-parody in the frame narrative of 'Denys'; his narrator is one such nineteenth-century tourist, on the lookout for the picturesque in Burgundy. The ironic distance suggests that Pater did not see himself as a tourist, although he could do picturesque description, if it suited him. He might have preferred life as a different kind of traveller seeking to distinguish himself from the 'mere tourists' he saw abroad: 'the authentic "culture" of *places*—the *genius loci*—was represented as lurking in secret precincts "off the beaten track" where it could be discovered only by the sensitive "traveller", not the vulgar tourist.'[74] Most of Pater's sites are 'off the beaten track', relatively undescribed and unexplored in literature, something which differentiates him from James who set most of his fiction in well-known locations like Rome, Florence, Venice, Paris, and London, almost to prove that even on the beaten track, there was still room for fiction.

[72] Anon., 'The Pleasures and Drawbacks of Travelling', *Temple Bar* 45 (Nov. 1875), 347–55, 348.
[73] James Buzard, *The Beaten Track: European Tourism, Literature, and the Ways to Culture, 1800–1918* (Oxford: Clarendon Press, 1993), 4.
[74] Ibid., 6.

288 WALTER PATER'S EUROPEAN IMAGINATION

Why did Pater travel in the first place? to get away from Oxford and London? to educate himself and his sisters? for health reasons? to relieve himself of boredom? to meet up with friends abroad? to seek inspiration for new writings? All of the above reasons most probably drew him across the Channel repeatedly, in a mixture of vaguely work-related leisurely travel which proved essential for his imaginary portraits. If we imagine that Pater had merely stayed in Oxford and London, his fiction would have taken quite a different turn. The geopolitical backdrop of the portraits bears witness to Pater's intellectual ambition of exploring the self against centuries of European cultural history. Although his reading of European literature was daunting, the portraits would never have materialized in their present form without his travels to the Continent. The dense, difficult, and intellectually allusive nature of Pater's portraits has long made critics ignore the author's own body in movement, from place to place, absorbing nature, culture, architecture, and transforming it into fiction, sometimes with an autobiographical twist. Let us imagine Pater abroad, in late August and September, visiting France, most likely with a red Murray's *Handbook for Travellers in France* in his luggage.

With Byron's *Childe Harold's Pilgrimage* as one of the most popular literary guidebooks to the Continent, the cult of the solitary traveller, engaged in the staging and exploration of self, in relief against spectacular natural scenery and ancient ruins, was one prevailing trend. In the decades immediately after the Napoleonic Wars, when direct access to France was again made possible, the boom in middle-class tourism was facilitated by the rapidly expanding network of railways on either side of the Channel, now calling for a new type of guidebook, full of practical information. Byron's publisher, John Murray, immediately saw an opportunity for business and began providing such guidebooks in the 1830s, at the same time as Karl Baedeker provided his for a German audience. The early Murray handbooks followed in Byron's footsteps, as did the young Benjamin Disraeli in the 1820s. By 1863 the American sculptor William Wetmore Story, living in Rome, observed that 'Every Englishman [abroad] carries a Murray for information, and a Byron for sentiment, and finds out by them what he is to know and feel at every step'.[75]

When, in the 1860s, the Baedekers were translated into English, they became rival volumes of the Murray handbooks, similar in appearance, with their red cloth covers with gold print. While the Baedekers cultivated a certain anonymous authority, with survey chapters of historical sketches and geographical outlines,[76] Murray's guidebooks resounded with a personal voice. Jonathan Keates confessed how, 'We believe these voices, hectoring, warning, spluttering, hissing, enthusing, romancing, expatiating or elaborating, to the extent that they become embodied for us'.[77] Keates points out that while the Murrays' authors 'may not know everything about a cathedral, a palace or a castle', 'they are *knowing* about it in a fashion which manages to be both opinionated and insouciant at the same time'.[78] As travelling and reading

[75] William Wetmore Story, *Roba di Roma*, 2nd edn, 2 vols (London: Chapman & Hall, 1863), 1:7.

[76] See Karl Baedeker, *Northern France from Belgium and the English Channel to the Loire, Excluding Paris and its Environs. Handbook for Travellers with 9 Maps and 25 Plans* (London: Dulau & Co., 1889).

[77] Jonathan Keates, *The Portable Paradise: Baedeker, Murray, and the Victorian Guidebook* (London: Notting Hill Editions, 2011), 29.

[78] Ibid., 32.

THE POETICS OF PLACE 289

complemented one another, they constituted 'a cyclic ritual in which readers both shaped their expectations and relived their past travels, through texts'.[79] One thing was reading at home, another was reading abroad. In his handbooks, Murray expressed his admiration of the French public libraries and reading-rooms, 'arranged in convenient apartments, with salaried librarians, common in all French provincial towns'.[80] Open to all, locals and foreigners alike, the reading-rooms were mentioned as great resources and meeting-places, and Murray noted down every city which had one, as a sight on equal footing with architectural or historical sites. We might, perhaps, imagine Pater availing himself of some of those reading-rooms during his annual six weeks abroad. It is hard to imagine him not reading while away.

Murray's handbooks were closely tied to the Continental network of railways. Most of the routes followed the railways, detailed maps were provided, and for every single destination Murray noted if there was a railway connection. Directed towards an English audience, the handbooks repeatedly alluded to the presence of the English on the Continent. Thus we learn about Calais that, apart from being a railway hub with frequent train connections to Arras, Paris, Boulogne, Amiens, Lille, Brussels, and Antwerp, the city had been in the hands of the English between 1347 and 1558.[81] The ghost of Thomas à Becket, exiled in France in the twelfth century and murdered in Canterbury Cathedral in 1170, is constantly recurring. Any doubts about this Saint Thomas are dispelled by the number of relics directly related to him in France. In Arras, 'The *Chapel of the Bishop's Palace* contains numerous relics, including the blood-stained *Rochet* which Becket wore when he was murdered at Canterbury (1170).'[82] In Sens 'the vests and mitre of Thomas Becket, his alb, girdle, stole, maniple, and chasuble, to all appearance genuine; they have been repaired. He fled to Sens in 1164, when he escaped out of England from the wrath of Henry II. The altar of *St. Thomas* is said to be the same at which Becket performed his devotions, and is very ancient.'[83] Further South, 'These walls doubtless echoed to the voice of Becket in 1168, when he repaired to Vézelay on Ascension-day, when the church was crowded, and, mounting the pulpit, cursed by bell, book, and candle, all those who maintained in England "the Customs of their Elders".'[84] The Abbey of Pontigny was 'remarkable as having been the residence of many English prelates, and the retreat of Thomas Becket during his exile, 1164–6. While here he carried the practice of the austerities of the Cistercian order to the very extreme, and while in prayer before one of the altars of the church had a divine vision, accompanied by the words, "Thomas, Thomas, my church shall be glorified by thy blood": such, at least, the legend.'[85] In Pontigny, 'A religious brotherhood calling themselves "Pères de St. Edme", now

[79] Buzard, 160–1.

[80] John Murray, *A Handbook for Travellers in France, Alsace, and Lorraine: Being a Guide to Normandy, Brittany; the Rivers Seine, Loire, Rhône and Garonne; the French Alps, Dauphiné, the Pyrenees, Provence, and Nice, &c. &c. &c; the Railways and Principal Roads*, 12th edn, entirely revised, with maps and plans of towns (London: John Murray, 1873), xxvi.

[81] Ibid., 5. [82] Ibid., 8.

[83] *A Handbook for Travellers in France, being a Guide to Normandy, Brittany; the Rivers Seine, Loire, Rhône, and Garonne; The French Alps, Dauphiné, the Pyrenees, Provence, and Nice, &c, &c, &c. Their Railways and Roads. With Maps and Plans. Ninth Edition, Revised and Corrected*, 2 vols (London: John Murray, 1864), 2:366.

[84] Ibid., 369. [85] Ibid., 370.

290 WALTER PATER'S EUROPEAN IMAGINATION

occupy the ruins. They possess curious deeds and letters relating to St. Edmund (1243).'[86] Murray's continued documentation of the presence and cult of the major saint of Canterbury made northern France less foreign. The French possessed more relics of Thomas à Becket than the English did, and for Victorian travellers the story of the English saint testified to a long history of English presence on the Continent. One of the most popular English guidebooks to France thus ran a parallel project to Pater's, demonstrating the close ties between medieval England and the Continent. Pater visited all of the above sites, but chose, characteristically, to include the much less known St Edme in 'Denys'.

Murray recolonized the European continent, 'liberated' by Wellington when putting an end to the Napoleonic Wars. The long coastal lines on either side of the Channel serve as reminders of centuries of invasions, and Murray's description of Boulogne resounds with a pride of the English colonization of the very spot from which Napoleon had contemplated an invasion of England in 1801:

> The number of Inhab. is 40,251, including at least 3000 English residents; indeed, Boulogne, being within 4 ½ hours of London, and 1 hr. and 40 min. by steam from Folkstone, is one of the chief British colonies on the Continent. Thus, by a singular reciprocity, on the very spot whence Napoleon proposed the invasion of our shores, the sons and daughters of his intended victims have quietly taken possession and settled themselves down. The town is enriched by English money; warmed, lighted, and smoked by English coal; English signs and advertisements decorate every other shop-door, inn, tavern, and lodging-house; and almost every third person you meet is either a countryman or speaking our language; while the outskirts of the town are enlivened by villas and country-houses, somewhat in the style and taste of those on the opposite side of the Channel. There are numerous boarding-schools (pensionnats) for the youth of both sexes, many of them under English managers and masters.[87]

This is 'England in France': English money, English coal, English goods, English architecture, and, with the boarding-schools under English tutelage, also a suggestion of new generations of Britons ready to populate French territory. Murray's description of Boulogne may have provided reassuring comfort for Victorian travellers uneasy about life across the Channel. As Ford Madox Ford would comment: 'Most of the country from the English Channel to Paris is really England—or, if you prefer to put it the other way round, most of the country from La Manche to the South Riding of Yorkshire is really France.'[88] Pater was interested in this mirroring across the Channel with the narrow strait of sea as the central axis. In the introduction to their study of the Channel as a cultural contact zone for the decadents and the modernists, Andrew Radford and Victoria Reid point out how, referencing Edward Said, the period from 1880 to 1940 was the age of the displaced person: 'A dizzying array of literary *émigrés*, renegade secessionists, publishers, purveyors of culture and

[86] Ibid., 370. [87] *A Handbook for Travellers in France* (1873), 14.
[88] Ford Madox Ford, *A Mirror to France* (London: Collins, 1926), 86.

impresarios contributed to a European republic of letters'.[89] In Pater's immediate circles, Symons, Stevenson, James, Wilde, Swinburne, Moore, and Lee were all frequent cross-Channel travellers, as were, among the artists, Whistler, Sargent, Sickert, and Rothenstein, to mention the most obvious. The traffic in the other direction—Mallarmé, Verlaine, Hugo, Bourget, Dalou, Légros, Pissarro, Manet, Tissot, Sisley—was no less significant. In such an age of displacement, the narrative of Thomas à Becket gained new relevance: from Byron's sombre solitary exiled genius to Wilde as the wandering Sebastian Melmoth, the nineteenth century was framed by the displaced, and Heine's pagan gods in exile, reworked by Pater, were merely another manifestation of this spirit.

Lee's recurrent delight on reaching the Continent found expression in *Genius Loci*: 'France again! I have that feeling whenever I get off the boat, even after an absence of only a couple of months. I believe I should have it after an absence of a couple of days. I can so well understand the emotion of our great-grandfathers and great-grandmothers, getting off the packet at Calais or Boulogne, and climbing into their lumbering carriage or more modest chaise. For that vehicle could take them straight, without interruption, to the South; those whiter roads led across the Alps, skirted the southern seas, came to an end (if at all!) only just opposite Africa. France! The Continent!'[90] Examining the Bayeux Tapestry, Lee pondered issues of nationality; on either side of the Channel, she concluded, people were all Romans at heart: 'Frenchmen? Englishmen? Men of the Middle Ages? Surely not: but Romans run to savagery. And here, as elsewhere, Antiquity rises up to say that it was not quite dead and done with. Indeed, one sometimes feels inclined to wonder, looking at mediaeval things, did Antiquity *ever* come to an end, did Rome ever cease ruling the world?'[91] Although one of the most cosmopolitan of writers with an impressive command of foreign languages, Lee identifies with the English, when meditating on the significance of the Norman Conquest. The threat of the North and the attraction of the South are felt in every sentence, as she compares cultural hybridity with centralization:

> Surely one of the chief things which the Conquest did for us, was that it took us out of Scandinavia, out of the vague Teuton anarchies, moored England to the Continent and civilisation, made us European and half-Latin. Half-Latin? Surely more! Think of the Provençal and French England of Henry II, of Chaucer, and of Froissart, less British, far, than ours. The Conquest also gave us our beautiful language, so rich because it participates in the nature of two great races; our wealth of synonyms, of delicate distinctions; above all, our utter freedom of grammar. And with this mixed language it gave us the possibility of assimilating once and again the wealth of Latin form and feeling, giving us Spenser and Shakespeare and Milton; and again Shelley, Rossetti, and Swinburne, wonderful hybrids of North and South. And while it did this for the conquered country, the Conquest was probably a

[89] Edward Said, *Reflections on Exile and Other Essays* (Cambridge, MA: Harvard University Press, 2000), 174. Quoted in Andrew Radford and Victoria Reid, 'Introduction', in ed. Radford and Reid, *Franco-British Cultural Exchanges, 1880–1940: Channel Packets* (Basingstoke: Palgrave Macmillan, 2012), 1–16, 3–4.

[90] Lee, 'In France Again!', *Genius Loci*, 100. [91] Lee, 'Bayeux and the Tapestry', ibid., 156.

292 WALTER PATER'S EUROPEAN IMAGINATION

frightful source of misfortune for France, placing England in her very vitals, with the Norman and Angevin succession breaking to bits, withering her beautiful beneficent Middle Ages with the miseries and barbarism of the endless wars of defence; forcing centralisation on the dismembered country, foredooming it (who knows?) to Ancien Régime and Revolution.[92]

Lee's sweeping brushstrokes, from the Norman Conquest to Swinburne, remind us of the observation of another exile, Ezra Pound: 'For the best part of a thousand years English poets have gone to school to the French.... The history of English poetic glory is a history of successful steals from the French.'[93] Pater might well have agreed; the lure of the European and at least half-Latin was infinitely preferable to the 'vague Teuton anarchies'. Going back to Pater via Murray's handbook, we might consider the very first route outlined after arrival to Calais, namely the route through Picardy and Normandy. 'Apollo in Picardy' was set in Montreuil-sur-Mer, a medium-sized railway town, while 'An English Poet' began in the countryside of Normandy. Reading in his Murray, Pater would have found that Normandy, 'among the most attractive portions of France', was 'full of interest', full of 'beautiful valleys bounding in orchards':

> Parts of the upper country are certainly a flat, monotonous table-land; but in its joyous sunny slopes and winding dales, in its hedgerows, orchards, thatched cottages with gardens, in the general character of the landscape of La Basse Normandie, especially in its verdure, frequent village spires, and white chalk cliffs, an Englishman recognises with pleasure the features of his own country, which no other part of the Continent affords. He may also take pleasure in remembering that this was the cradle whence came the hardy bands of conquerors from whose possession of England that country dates her early prosperity and greatness.[94]

The opening paragraph of 'An English Poet' provides an echo:

> The great characteristic of the *Pays de Caux*, the district from which our Norman conquerors mostly came, is the singular arrangement by which each of its farms is isolated from the outer world by a dense enclosure of trees. These square enclosures are dotted all over the high country, otherwise treeless—a broad expanse of corn declining to the edge of the white cliffs. On the sea-side of the enclosure the trees grow leaning from the salt wind—a smooth sloping wall of little rusty knots and twigs, the long bands of grey lichen growing thickly over them and keeping up in winter a faint semblance of foliage. The gate is usually surmounted by a rough penthouse, overgrown with moss and tall house-leeks, and the heavy stone gate-posts will be sometimes quaintly carved. In the space within there is room and to spare for the large straggling barns and the house with its white plastered walls. There is room for a garden also, and a careless orchard, where the blossoms hang almost motionless all their season through, although a strong wind may be abroad without,

[92] Ibid., 157. [93] Ezra Pound, 'The Approach to Paris, II', *The New Age* 13:20 (1913), 577.
[94] *A Handbook for Travellers in France* (1873), 1–2.

THE POETICS OF PLACE 293

rocking roughly the bigger trees. The apples will be full of goodly juices, for the salt comes but faintly to them. Here the principle of the *chez-soi* is complete; in winter especially when the snow lies in deep drifts around the place, one has time for fancies, and the English girl, married to the plain young Norman farmer, who found in the furrow one autumn morning a golden Roman coin with a clear high profile on it which looked to her as might an image of immortal youth, is left alone with her day-dreams.[95]

Misshapen trees reveal the presence of the sea which can be smelled, almost tasted, in the juicy apples, which grow from the abundant blossoms, as spring moves into summer and autumn, before winter sets in. The Anglo-French union of poetic maid and plain farmer results in the English poet upon whom the profile of the Roman coin imprints itself, taking us back to Lee's idea of the survival of the Romans, the first invaders, on either side of the Channel. As the pagan artefact surfaces, ancient heritage is renewed, while the exiled English girl dreams of romance: 'the principle of the *chez-soi* is complete', we learn, as Pater teasingly mixes a foreign term with his native language, as if suggesting that one is never more at home than when abroad. Our poet, drawn by the alluring image of Europe, starts his life in transnational homeliness, essential for the growth of the self.

Emerald's home across the Channel has a view of the sea. The flowers are made sweeter by the sea-salt in the air in parallel to the juicy apples in Normandy. Pater would seem to suggest a fertile cross-pollination between England and France; the winds which carry the salt from the sea into the gardens on either side add extra flavour and fragrance to the fruit and flowers. This is another circular narrative: Emerald, wounded, physically and emotionally, seeks out the balm of the *genius loci* of his home. Out of a family of gardeners, he grows up in floral abundance and is buried smothered in fragrant flowers: 'think, thereupon, of the years of a very English existence passed without a lost week in that bloomy English place, amid its English lawns and flower-beds, its oldish brick and raftered plaster. You may see it still, not far off, on a clearing of the wooded hill-side sloping gradually to the sea.'[96]

'Sweet' is a recurrent adjective in Pater's description of the flowers in the garden, with the suggestion that Emerald is the sweetest of them all. Homecoming is associated with a desire to be buried in the family garden, alongside the family pets. Emerald's military expedition to Flanders, to fight in Wellington's army, falls a few days short of the final victory as, accused of deserting their post, he and his friend Stokes are sentenced to death, with Emerald reprieved in the very last minute, degraded, and stripped of his military honours. The tedium of military service in flat Flanders is compared to stillness on board a ship, quiet before the storm: 'It was like a calm at sea, delaying one's passage, one's purpose in being on board at all, a dead calm, yet with an awful feeling of tension, intolerable at last for those who were still all athirst for action.'[97] After his degradation Emerald drifts penniless across the Continent until, in the immediate aftermath of the Battle of Waterloo, he is swept back across the Channel: 'Falling in with the tide of its heroes returning to English

[95] CW 3:145. [96] CW 3:176. [97] CW 3:192.

294 WALTER PATER'S EUROPEAN IMAGINATION

shores, his vagrant footsteps are at last directed homewards.'[98] The sea metaphors reflect Emerald's powerlessness; he is static or drifts along, governed by forces greater than himself. Pater operates with the notion of fate; as Emerald's reading teaches him, 'the Greeks had a special word for the Fate which accompanied one who would come to a violent end. The common Destinies of men, Μοῖραι, Mæræ,[99]— they accompanied all men indifferently. But Κὴρ,[100] the extraordinary Destiny, one's Doom, had a scent for distant blood-shedding; and, to be in at a sanguinary death, one of their number came forth to the very cradle, followed persistently all the way, over the waves, through powder and shot, through the rose-gardens; —where not? Looking back, one might trace the red footsteps all along, side by side.'[101] The dividing waters of the Channel have no impact on fate; destiny defies geography, is transnational, and rules in Flanders fields as well as in the garden of England. In spite of his repeated use of 'English', Pater constructs a narrative which goes beyond the national; his protagonist, hailed as a 'young Apollo', is first and foremost subject to greater, essentially Greek, forces.

In 'Sebastian', the text that most explicitly deals with the dangers and opportunities of being a lowland seafaring nation, the daily threat of the sea to submerge nation, culture, and capital is a factor to be reckoned with. Pater's protagonist, who eventually succumbs to the invasive waters, is in love with the waxing and waning watery powers, aware that much of what is now sea was once land: 'he found it pleasant to think of the resistless element which left one hardly a foot-space amidst the yielding sand; of the old beds of lost rivers, surviving now only as deeper channels in the sea; of the remains of a certain ancient town, which within men's memory had lost its few remaining inhabitants, and, with its already empty tombs, dissolved and disappeared in the flood.'[102] The works of Thomas Browne, written in Norwich across the North Sea at exactly the same latitude as Sebastian's Haarlem (52°), run as an intertext to Pater's portrait. Browne's meditations on lowlands in *Certain Miscellany Tracts* (1683) and the *Religio Medici* (1643) serve as points of reference, as do Pliny the Elder's notes on the areas north-west of the Rhine in the *Natural History* (AD 77). Pater was composing 'Sebastian van Storck' and 'Sir Thomas Browne' at the same time (1886), and the temperamental ties between the two seventeenth-century figures, one fictitious, the other historical, are enhanced by our awareness that the landscapes that surround them are similar, that in 7000 BC it would have been possible to walk on dry land from Haarlem to Norwich when the land bridge between Britain and the Continent, now known as Doggerland, was still above water. Britain's former existence as a peninsula off the European continent is subtly alluded to by Pater; it is no coincidence that Browne and van Storck both ponder the submersion of ancient cultures by water at a latitude of 52°. Just as he was toying with the flexible eastern boundaries of Europe, so Pater made us think about the western boundaries with an awareness that what is now a watery border was not always so.

[98] *CW* 3:195.

[99] One's portion in life, lot, destiny. The term occurs in Greek prose and poetry and refers to the goddesses of fate.

[100] Kêr. Doom, death, destruction. This term is primarily used by Homer and signifies a goddess of death rather than of fate.

[101] *CW* 3:183. [102] *CW* 3:103.

THE POETICS OF PLACE 295

Pater may well have enjoyed cartography ever since McQueen presented him with his imaginary maps in the 1850s. He was fascinated by some of the essential questions of geography, pondering why cultures and civilizations are where they are. In his fiction he established new connections, new ties between cultures, often of quite an unexpected kind. His three Apollo figures—Emerald in Sussex, Apollyon in Montreuil, and Carl in Heidelberg—all live at latitudes of 50° and 49°, perhaps the very northernmost point at which Pater could imagine emanations of the southern Sun God. I have long been intrigued by the Carthusian monastery which provides the setting for the triangular drama between Apollyon, Hyacinthus, and Prior Saint-Jean. Why did Pater stop at Montreuil? For the modern traveller without a car it is a cumbersome journey: the railway line has been closed, and only very few *navettes* from Étaples are available, depositing the traveller outside the gates of a fortified city which is now a ghost of its former self. In the nineteenth century, however, it was on the main route between Calais and Amiens with eleven trains daily, and several well-known people broke their journeys there: stopping briefly in September 1837 with his mistress Juliette Drouet, Victor Hugo was impressed by the place and subsequently appointed his protagonist of *Les Miserables* (1862), Jean Valjean, Mayor of Montreuil. Whether the Hugo connection made Pater stop there is mere speculation. Ruskin halted en route from Paris in August 1844,[103] Dickens in 1861 when he wrote a piece about the local hospital for children suffering from scrofula.[104] Eight years later, Dickens's 'Nobody' stopped at Montreuil: 'Here was found excellent accommodation "at the inn celebrated by Sterne". The Reverend Mr. Yorick seems to have been the Murray of the eighteenth century and the beginning of the present one, and it is astonishing that his publishers did not put forth an advertising edition of the Sentimental Journey', we read.[105] Dickens's passage needs unpicking; had he looked at his Murray, he would have found the following entry:

Montreuil-Verton stat. [The town of Montreuil 3655 Inhab. (*Inn*: H. de France et d'Europe), lies 6 m. to the l. [of Etaples], and is pleasantly situated on a hill crowned by a fort. It is principally known to Englishmen as the spot in which Sterne laid one of the scenes in the 'Sentimental Journey'.] The rly. from Montreuil Stat. follows the coast until it reaches the Somme, traversing a wide desolate expanse of sandy flats and shallows, with a few vessels lying on their sides or riding at anchor.[106]

In Laurence Sterne's *Sentimental Journey through France and Italy by Mr Yorick* (1768), Montreuil is a place of beggars and young lovers, visited en route for Amiens and Paris. Here Yorick picks up a local handsome servant, La Fleur, to accompany him on his tour under much cursing and swearing. La Fleur's repeated invocation of the devil, his favourite swear word being *Diable!*, is worth noting,[107] given the repeated emphasis on 'Devil's work', *'diablerie'*, 'devilry' in Pater's narrative. We may

[103] Diary entry of 21 Aug. 1844, *CWR* 12:453.
[104] Charles Dickens, 'Sands of Life', *All the Year Round* (14 Sept. 1861), 585–9.
[105] Charles Dickens, 'Nobody Abroad', *All the Year Round* (12 Jun. 1869), 32–7, 33.
[106] *A Handbook for Travellers in France*, 18.
[107] Laurence Sterne, *A Sentimental Journey*, ed. Ian Jack, intr. Tim Parnell (Oxford: Oxford University Press, 2008), 26, 27, 30, 32–3.

296 WALTER PATER'S EUROPEAN IMAGINATION

recall that Prior Saint-Jean also travels in the company of an attractive local youth, and that travelling leads to temptation and the encounter with various kinds of devilry. Where topographical descriptions are largely absent from Sterne, atmosphere, panoramic landscape descriptions, and the interrelationship between character, architecture, and nature, are fundamental for Pater's traveller. 'Apollo in Picardy' revolves not merely around the clash between Christianity and paganism, but also around the meeting between a secluded, local, cleric who has never left his native town, and Apollyon, an inveterate wanderer. Saint-Jean is as much a product of the fortified town as of the monastery; like Pater's other dwellers in towers—Sebastian, Montaigne—he views the world from above, yet prefers his books:

> He had been brought to the monastery as a little child; was bred there; had never yet left it, busy and satisfied through youth and early manhood; was grown almost as necessary a part of the community as the stones of its material abode, as a pillar of the great tower he ascended to watch the movement of the stars. The structure of a fortified medieval town barred in those who belonged to it very effectively. High monastic walls intrenched the monk still further. From the summit of the tower you looked straight down into the deep narrow streets, upon the houses (in one of which Prior Saint-Jean was born) climbing as high as they dared for breathing space within that narrow compass. But you saw also the green breadth of Normandy and Picardy, this way and that; felt on your face the free air of a still wider realm beyond what was seen. The reviving scent of it, the mere sight of the flowers brought thence, of the country produce at the convent gate, stirred the ordinary monkish desires, sometimes with efforts, to be sent on duty there. Prior Saint-Jean, on the other hand, shuddered at the view, at the thoughts it suggested to him; thoughts of unhallowed wild places, where the old heathen had worshipped 'stocks and stones,' and their wickedness might still survive them in something worse than mischievous tricks of nature, such as you might read of in Ovid, whose verses, however, he for his part had never so much as touched with a finger. He gave thanks, rather, that his vocation to the abstract sciences had kept him far apart from the whole crew of miscreant poets. —Abode of demons.[108]

Pater plays with time and space, as he sends Saint-Jean on a journey to Notre-Dame-De-Pratis. The Carthusian monastery is located in Neuville, a few miles outside Montreuil, but in Pater's narrative it is a full day's journey on foot, taking us through the valley of the monks in a poetic rendition of landscape, as the Prior and his companion enter a magical place, where features of June in late November make one question the time of year. The sense of wonder, so integral to *The Tempest*, is echoed in Saint-Jean's encounter with the local landscape, an enchanted place 'full of noises', where supernatural events are likely to occur. The white, pearly, and golden vision ahead of them, lit by the moon and northern lights, constitutes an alluring contrast to the dark, fortified town they have left behind:

[108] *CW* 3:200–1.

How unlike a winter night it seemed, the further they went through the endless, lonely, turf-grown tracts, and along the edge of a valley at length—*vallis monacho-rum*, monksvale—taken aback by its sudden steepness and depth, as of an immense oval cup sunken in the grassy upland, over which a golden moon now shone broadly. Ah! there it was at last, the white Grange, the white gable of the chapel apart amid a few scattered white gravestones, the white flocks crouched about on the hoar-frost, like the white clouds packed somewhat heavily on the horizon, and *nacrés* as the clouds of June, with their own light and heat in them, in their hollows, you might fancy.

From the very first, the atmosphere, the light, the influence of things, seemed different from what they knew; and how distant already the dark buildings of their home! Was there the breath of surviving summer blossom on the air? Now and then came a gentle, comfortable bleating from the folds, and themselves slept soundly at last in the great open upper chamber of the Grange; were awakened by the sound of thunder. Strange, in the late November night! It had parted, however, with its torrid fierceness: modulated by distance, seemed to break away into musical notes. And the lightning lingered along with it, but beautiful, glancing softly: was, in truth, an aurora, such as persisted month after month on the northern sky as they sojourned here. Like Prospero's enchanted island, the whole place was 'full of noises.' The wind, it might be, passing over metallic strings, but that they were audible even when the night was breathless.[109]

This 'Symphony in White and Gold', monochrome in its controlled colour scheme, plays delicately with allusions to sound (the bleating, thunder, musical notes, the wind on metallic strings) and might count as one of Alex Murray's 'landscapes of decadence': 'The word "landscape" foregrounds not the type of place represented, but the mode of representation itself.'[110] The majority of the definitions of 'landscape' in the *OED* refers to the artistic representation of nature, rather than to nature itself (definitions 1a, 1b, 1c, 3, 4d, 4f). With his focus on the literary forms used to repre-sent places at the *fin de siècle*, Murray argues for the emergence of 'a place-based writing…that attempted to foreground literary style' with the purpose of emphasizing 'the artificial, constructed nature of place and to interrogate claims that specific places were imbued with "natural" characteristics.'[111] Murray references Philip Gilbert Hamerton's *Imagination in Landscape Painting* (1887) as a ground-breaking volume which 'saw the artistic contemplation and creation of landscapes losing all substance and becoming an exercise in a sort of interior composition.'[112] Abandoning artistic ideals of verisimilitude, 'Hamerton uses Wordsworth's phrase "eye music" in which "painting is then no longer a study of tangible things at all, but a dream like the dreams of musicians". The imagination then becomes "musically creative", so that the composition of the picture can, like music, only be understood in its own language.'[113] Murray speaks of a kind of 'self-reflexive formalism': 'When we come to this kind of imagination, in which substance is either banished altogether or reduced to a

[109] *CW* 3:201–2. [110] Murray, 11. [111] Ibid., 11. [112] Ibid., 18.
[113] Ibid., 18, referencing Philip Gilbert Hamerton, *Imagination in Landscape Painting* (London: Seeley & Co., 1896), 241, 243.

minimum, whilst the delicacies of colour are retained, the only intelligent way of considering it is to think of it as an art existing on its own basis which is almost, though not quite, independent of Nature.'[114] The landscape surrounding the monastery is more of a vision than a realist description; the white light, clouds, and buildings belong in the realm of the poetic imagination, and our attention is turned to the artifice of the author's craft, rather than to an actual place. Yet, Pater gives us the exact name of the institution, so that we can go and see for ourselves, thus undermining the poetics of his own imaginary place. Pater cannot be pigeonholed, as he juxtaposes the imaginary and the topographical, with topos being so concrete that it can be pinned down to a set of coordinates.

In England, Henry II had founded the first Carthusian monastery in penance for the murder of Thomas à Becket in 1181. The Chartreuse de Neuville, also known under the names of Notre-Dame-de-Pratis or Notre-Dame-des-Prés, is one of the largest Carthusian monasteries in France. Founded by Robert, Count of Boulogne and Auvergne, in 1325, it was sacked by the English in 1354 and again by the Huguenots in 1574, until in 1791, in the aftermath of the French Revolution, it was almost razed to the ground. We do not know when Pater visited Montreuil, but the 1870s, '80s, and '90s were an exciting period as the monastery was being reconstructed and re-inhabited. Inspired by Viollet-le-Duc, the local architect Clavis Normand had it rebuilt in neo-gothic style between 1871 and 1875, when twenty-two monks, one novice, and a score of clerical brothers moved into the imposing building. They took up the Carthusian way of living, praying, and working again, until 1901 when, with the separation of church and state in France, they were forced to move abroad, travelling by train with their 12,000 books and a printing press, to the Carthusian monastery of Parkminster in Surrey, likewise designed by Normand. Ever since its foundation in the eleventh century, the Carthusian order has been given to textual work, to the copying and illumination of manuscripts. In 1875 the Imprimerie de l'Ordre des Chartreux was installed in the Montreuil monastery, printing all books for the Carthusian Order all over Europe, together with secular books.

Pater had alluded to St Bruno, founder of the Carthusian Order, in 'Sebastian',[115] and his interest in ascesis and discipline would have made him favourably disposed towards the cult of solitude and silence so integral to the daily life of the Carthusians. With its twenty-two hermits' houses with separate gardens, arranged around a central court with an internal cemetery, the monastery cuts a spectacular sight on the outskirts of Montreuil. Pater would have been drawn by it as a site for serious scholarly and religious activity, with medieval traditions recently revived and modernized. As one of the most private of all religious orders, the Carthusians do not accept visitors. The fathers live eremitic lives in silence in their hermits' cells, while the brothers have some contact with the world outside the monastery through community work, such as printing. After its closure in 1901, the building served as a sanatorium and war hospital during the two world wars; now the premises are open to the public as a cultural centre to be visited on appointment. Visiting with Pater's text in mind, one

[114] Ibid., 18, referencing Hamerton, 246. [115] CW 3:104.

has a sense that 'Pater was here'. His evocation of the scriptorium, the chapel, the cemetery, and the surrounding landscape conveys a powerful sense of place; yet, the response given by the archivist guide, when asked whether it would have been possible to visit in the late nineteenth century, was a firm 'no', with the only exception of a male person accompanying a novice. However attractive the idea, the likelihood of Pater befriending a future novice during a short stay in Montreuil is minimal, I think. How, then, did he get a sense of the place, of its layout, of monastic life inside the walls?

The new generation of Carthusians, who settled in the 1870s, revealed great talent when it came to branding the order and its daily life inside the walls to a wider audience. F.-A. Lefebvre's monumental monograph *La Chartreuse de Notre-Dame-des-Prés à Neuville* was issued by a Paris publisher in 1881 and re-issued from the monastery's own press in 1890.[116] Handsomely illustrated with images and plans of the entire monastery, together with a series of atmospheric photographs of solitary monks in white cowls on stairs or in gothic cloisters, the volume metaphorically opened the doors to the reading public. Carefully posed and staged, the photographs of modern monks seem to bring the Middle Ages to life in the nineteenth century; the apparent timelessness of monastic life, with nothing but the medium of the photograph itself to indicate modernity, has an alluring, almost otherworldly, appeal. The peace, solitude, and segregation from the outside world form part of a dichotomy of inside/outside the walls.

In addition to the illustrations in Lefebvre's volume, a number of equally posed and staged photographs issued as postcards were in circulation, possibly printed at the local *imprimerie* (Figs 6.2 to 6.7). Two monks reading and working next to astrolabes and antiphonaries in the monastic library let us into the illusion that we are part of their world and daily habits (Fig. 6.5). There are even two empty chairs in the foreground, should we wish to join them. The solitary monk at the crossroads, meditating on mortality next to a range of simple anonymous crosses, highlights monastic life as one which revolves as much around the earthly life as the life of the beyond (Fig. 6.6). From an elevated perspective—the photographer must have been poised on the roof of the cloisters or on a scaffold—we take part in the burial of a Carthusian monk: a semi-circle of monastic backs confronts us, as we pry into a very private ritual where no faces can be seen (Fig. 6.7). The evocative photographs of monastic life invite fiction: if we are not allowed to enter, at least we can start imagining what goes on behind the thick walls, helped a little by modern technology. Definitive documentation of Pater's presence in Montreuil is still missing, but his evocation of the landscape is powerful and suggestive of the site itself, as is his sense of the monastery. None of the Oxford libraries possess a copy of Lefebvre's monograph on the Chartreuse, but we can imagine Pater reading it in a local bookshop or reading-room, perhaps even purchasing a couple of postcards of solitary monks to take back to his Oxford rooms or send to his friends.

Pater's explorations of the North-West of France had their counterparts in his evocation of the East of the Burgundian region, the very sites which in the Middle Ages

[116] F.-A. Lefebvre, *La Chartreuse de Notre-Dame-des-Prés à Neuville* (Paris: Bray et Retaux, 1881).

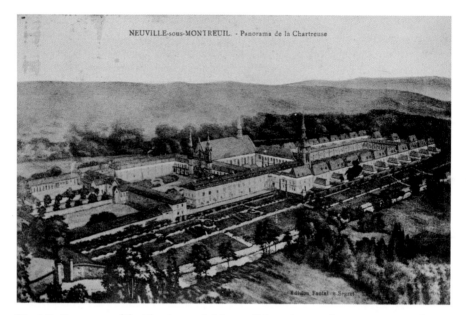

Fig. 6.2. *Panorama of the Chartreuse de Montreuil*, late nineteenth-century postcard. Private collection. Photo © Christoffer Rostvad.

had provided refuge for the clerics of Kent. In search of 'picturesque expression', his nineteenth-century narrator settles on Troyes, Sens, and Auxerre, all with a cathedral for their centre. In Troyes 'the natural picturesque' is easily transformed into the 'peculiar air of the grotesque, as if in some quaint nightmare of the Middle Age',[117] while Sens, 'cool and composed, with an almost English austerity' is characterized by 'the hard "early English" of Canterbury'.[118] With William of Sens as the architect of Canterbury Cathedral, Pater traces the 'first growth of the Pointed style in England' back to its native France.[119] Auxerre gets the prize with 'a perfectly happy conjunction of river and town being of the essence of its physiognomy—the town of Auxerre is perhaps the most complete realisation to be found by the actual wanderer.'[120] Auxerre has its own physiognomy, and so does the narrator. This is one of the very few places when we get a sense of the Paterian body in motion, walking, ascending the fortified town while looking down on the river and up at the vineyards beyond. Pater creates a panoramic view which, having just alluded to Turner's *Rivers of France*, is so obviously intended to match a painting with sweeping brushstrokes, guiding the eye up and down, from the background towards the foreground:

> Auxerre! A slight ascent in the winding road! and you have before you the prettiest town in France—the broad framework of vineyard sloping upwards gently to the horizon, with distant white cottages inviting one to walk: the quiet curve of river below, with all the river-side details: the three great purple-tiled masses of Saint

[117] *CW* 3:82. [118] *CW* 3:82. [119] *CW* 3:82. [120] *CW* 3:81.

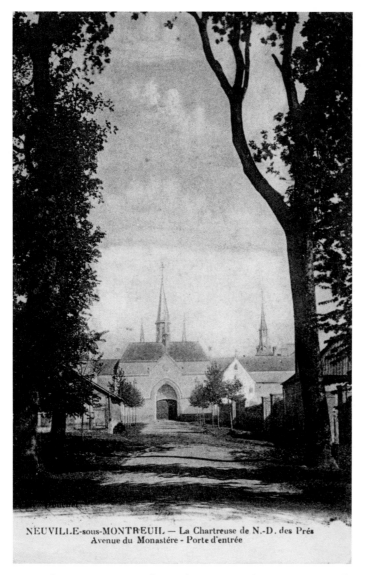

Fig. 6.3. *Avenue du monastère. Porte d'entrée*, late nineteenth-century postcard. Private collection. Photo © Christoffer Rostvad.

Germain, Saint Pierre, and the cathedral of Saint Étienne, rising out of the crowded houses with more than the usual abruptness and irregularity of French building. Here, that rare artist, the susceptible painter of architecture, if he understands the value alike of line and mass of broad masses and delicate lines, has 'a subject made to his hand.'[121]

[121] *CW* 3:83.

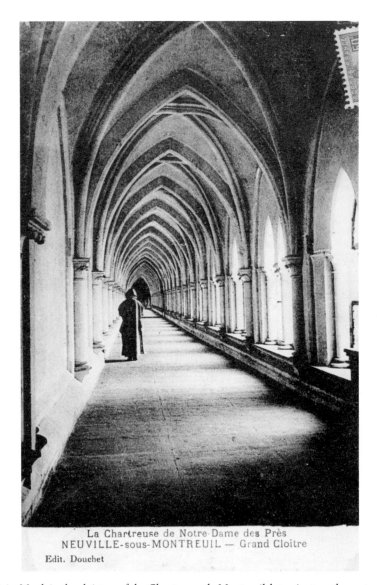

Fig. 6.4. *Monk in the cloisters of the Chartreuse de Montreuil*, late nineteenth-century postcard. Private collection. Photo © Christoffer Rostvad.

With 'the foregrounding of the stylistic and the formal', Murray argues, 'Place itself becomes secondary to the means and modes of representing it, drawing the reader or viewer into a relationship with the canvas or the page rather than using these as some means of accessing a location.'[122] Yet with Pater—arty, stylish, and sophisticated as he is—place never becomes secondary. It becomes embodied, with Pater's repeated use

[122] Murray, 14.

THE POETICS OF PLACE 303

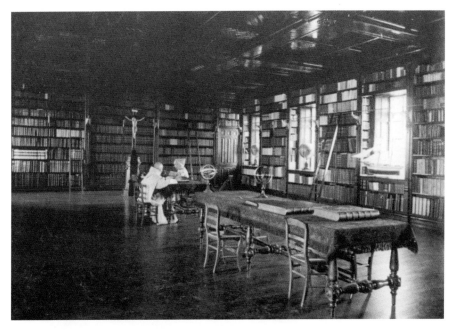

Fig. 6.5. *Two monks in the library of the Chartreuse de Montreuil*, late nineteenth-century postcard. Private collection. Photo © Christoffer Rostvad.

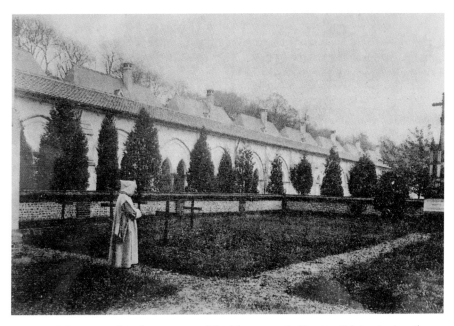

Fig. 6.6. *Solitary monk in the cemetery of the Chartreuse de Montreuil*, late nineteenth-century postcard. Private collection. Photo © Christoffer Rostvad.

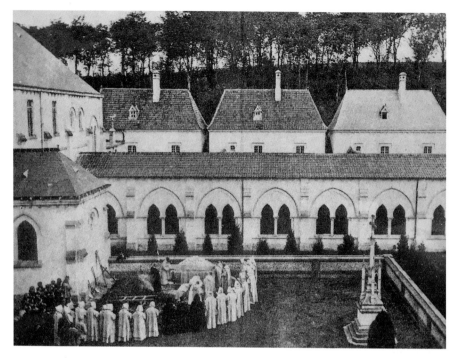

Fig. 6.7. *The burial of a Carthusian monk in the Chartreuse de Montreuil*, late nineteenth-century postcard. Private collection. Photo © Christoffer Rostvad.

of the word 'physiognomy' as a clear pointer. Place is person, and the picturesque descriptions of the town and landscape of Auxerre serve as overtures to the person himself: when, some 2,600 words into the narrative, Denys emerges, we know that he is the embodiment of the place, grown, literally, out of 'one of those little cliff-houses cut out in the low chalky hillside' which surround Auxerre.[123] The links between what grows in the soil, the pagan wine god, and the national patron saint are cleverly interwoven with the French peasants' revolt, in a landscape atmospheric in its changefulness. Midland France is literally a hybrid: where North meets South, East meets West, black and white merge into grey, there is never quite enough rain, nor quite enough sunshine. A mellowness is the result, but instead of a static picture, we get a moving one, with fluctuating clouds and the threat of imminent rain. One sometimes wonders what kind of film director Pater would have made,[124] as his inner camera pans over the Burgundian scenes, zooming in from background into foreground:

> A veritable country of the vine, it presents nevertheless an expression peaceful rather than radiant. Perfect type of that happy mean between northern earnestness

[123] *CW* 3:86.
[124] See Carolyn Williams, 'Walter Pater, Film Theorist', in ed. Elicia Clements and Lesley Higgins, *Victorian Aesthetic Conditions: Pater Across the Arts* (Basingstoke: Palgrave Macmillan, 2010), 135–51.

THE POETICS OF PLACE 305

and the luxury of the south, for which we prize midland France, its physiognomy is not quite happy—attractive in part for its melancholy. Its most characteristic atmosphere is to be seen when the tide of light and distant cloud is travelling quickly over it, when rain is not far off, and every touch of art or of time on its old building is defined in clear grey. A fine summer ripens its grapes into a valuable wine; but in spite of that it seems always longing for a larger and more continuous allowance of the sunshine which is so much to its taste. You might fancy something querulous or plaintive in that rustling movement of the vine-leaves, as blue-frocked Jacques Bonhomme finishes his day's labour among them.[125]

Although Pater would probably have arrived in Auxerre by train, his description is not the conventional panoramic account of a landscape seen through the distancing device of a glass pane framed within a railway compartment. Ruskin's observations that 'travelling becomes dull in exact proportion to its rapidity',[126] as the railway 'transmutes a man from a traveller into a living parcel',[127] may well have been shared by Pater. He toys with the picturesque and the touristic, with the kind of 'passing view from the window' which Buzard described as 'the very type of picturesque-panoramic touring: it offered objects seemingly flattened out and stretched on to an immeasurable unrolling canvas, or divided into a series of images flashed before the viewer. Repeatedly in nineteenth-century travel-writing the cities, landscapes, and inhabitants of visited regions are stretched on the Procrustean bed of picturesqueness.'[128] The synaesthetic experience of landscape in most of Pater's fiction insists on sounds, fragrances, and complex viewing techniques that involve foregrounds, middle-grounds, and backgrounds which go against the blurred panoramic vision of backgrounds resulting from rail travel, as described by Dolf Sternberger and Wolfgang Schivelbusch.[129]

[T]he vistas seen from Europe's windows had lost their dimension of depth; this happened first with the vistas seen from the train compartment window. There the depth perception of preindustrial consciousness is literally lost: velocity blurs all foreground objects, which means that there no longer is a foreground—exactly the range in which most of the experience of preindustrial travel was located. The foreground enabled the traveller to relate to the landscape through which he was moving. He saw himself as part of the foreground, and that perception *joined* him to the landscape, included him in it, regardless of all further distant views that the landscape presented. Now velocity dissolves the foreground, and the traveller loses that aspect. He is removed from that "total space" which combines proximity and distance.... The glass separates the interior space of the Crystal Palace from the natural space outside without actually changing the atmospheric quality of the latter in any visible manner, just as the train's speed separates the traveller from the space that he

[125] *CW* 3:83.
[126] Quoted in Wolfgang Schivelbusch, *The Railway Journey: Trains and Travel in the 19th Century*, tr. Anselm Hollo (Oxford: Blackwell, 1977), 60.
[127] *Seven Lamps of Architecture*, CWR 8:159. [128] Buzard, 189.
[129] See Dolf Sternberger, *Panorama of the Nineteenth Century*, tr. Joachim Neugroschel (Oxford: Blackwell, 1977).

had previously been a part of. As the traveller steps out of that space, it becomes a stage setting, or a series of such pictures or scenes created by the continuously changing perspective. Panoramic perception, in contrast to traditional perception, no longer belongs to the same space as the perceived objects: the traveller sees the objects, landscapes, etc. *through* the apparatus which moves him through the world. That machine and the motion it creates become integrated into his visual perception: thus he can only see things in motion.[130]

By contrast, Pater's walking traveller engages his own body in three-dimensional space, as he perceives contours, masses, lines, curves, slowing down, halting, as he experiences nature through art rather than technology. Describing the graceful bends of the River Yonne, 'sometimes close at hand, sometimes leaving an interval of broad meadow', he observes how it 'might pass for the child's fancy of a river, like the rivers of the old miniature-painters, blue, and full to a fair green margin.' This is nature imitating art, the well-educated traveller recognizing scenes he has seen in paintings, noticing how the riverside towns 'tempt us to tarry at each and examine its relics, old glass and the like, of the Renaissance or the Middle Age'. Touch and sight, at close hand, enable access to the past, as the modernity of the present recedes into the background, a recipe for the structure of Pater's narrative which gradually moves backwards in time to medieval Auxerre.

For Pater's immediate followers, 'Denys l'Auxerrois' became a guidebook text in its own right. We find Lee visiting Auxerre in September 1910 with the *Imaginary Portraits* in her luggage, re-reading 'Denys'. Like Nathaniel Hawthorne's *The Marble Faun* (1860), which became an alternative guidebook to central Rome—especially in its Tauschnitz edition, interleaved with empty pages into which the reader could paste their own photographs of Rome—'Denys' could be used as a topographical guide to Auxerre and a trigger of new imaginary portraits. As Lee confesses, 'Mr. Pater's visit to that particular *maison de curé* among the vines and hives near the River Yonne I never would have sworn to.'[131] As she goes exploring in the Cathedral, she discovers a series of carved gothic heads which convince her of the local origins of Pater's mythological figure: 'it had never entered my head that he could have got his exiled Dionysus from any visible work of art. When suddenly, one day, *there*, far more plainly and unquestionably than in those apocryphal arrases, *there*, before my very eyes, was *Denys l'Auxerrois*.'[132] The deictic 'there' invites us to go and seek out the three heads surrounded by vine leaves in the Cathedral Choir. Lee concludes: 'In this guise did that ambiguous immortal meet our great pre-Raphaelite prose-poet during those rainy days he records himself to have spent in that Burgundian cathedral town.'[133] Her literal reading of the interrelationship between place and person becomes the starting point for her own imaginary portrait, 'Dionysus at Rovolon', while paying tribute to Pater. Transferring her plot from France to Italy, to a site in the Euganean Hills, Lee lifts the Dionysiac out of its Burgundian surroundings and turns it into a recurring force which may emerge elsewhere in the South. In 1892

[130] Schivelbusch, 65–6. [131] Lee, 'Dionysus', 346. [132] Ibid., 346. [133] Ibid., 347.

THE POETICS OF PLACE 307

J. A. Symonds intended an allusion to Pater in his essay 'Bacchus in Graubünden',[134] now transferring the god of wine to the Swiss Alps. By 1924 Arthur Symons was paying his tribute in the essay 'The Magic of Auxerre'.[135] Symons took his starting point in Pater but soon branched off into a claustrophobic and nightmarish travel essay, evoking a visit to an eerie place: 'The fortifications and the ancient walls that surround Auxerre are, from every point of view, by day or by night, marvellous. Most of the streets are tortuous, cobbled, and they seem always to turn this way and that way at odd angles; they turn into fantastic triangles, transversal, and I never knew in what direction they would lead me'.[136] Briefly led astray by the local women, his visitor ends up in the dark crypts underneath Saint Germain, one of Denys's favourite haunts: 'spirals, of infinite spirals, which were the equivalents of nightmares, up which I had to climb, and of ladders whose rungs dropped away from me as my feet left them, and of slimy stone staircases into cold pits of darkness'.[137] He concludes with the image of a haunting presence, with the author's 'fear of a man's shadow'.[138] Is this Denys casting a long shadow from medieval Auxerre onto the twentieth-century visitor? or is it the sinister shadow of Pater himself, experienced by his immediate followers when trying their hands at his hybrid literary genre?

The embodied landscape, in which the figure almost springs from the ground, from the local soil, cliff, or stone, recurs in one of Pater's last—and unfinished— imaginary portraits. Pater's library borrowings suggest that he began work on 'Tibalt the Albigense' alongside *Gaston* in 1887, perhaps as a way of studying religious conflict in France prior to the sixteenth-century Wars of Religion.[139] Set in the twelfth century, during the reign of Raymond VI of Toulouse, the portrait explores the Languedoc as a cultural crossroads of Europe.[140] Bordering on the Angevin empire, ruled by the English kings in the twelfth and thirteenth centuries, and on Spain, where the Islamic presence manifested itself strongly at the time, Pater's Languedoc is not merely the site of religious conflict. The pressure of materialist religions, 'the eternity of matter', threatens the area and becomes a manifestation of an almost chronotopic conflation of time and place in which the Orient, invading from the East and from the South, impinge on the spiritual life: 'Had it come like infectious disease in the baggage of returning crusaders from some old cobwebbed brain long since turned to dust in the distant East? Was it a rag of old pagan philosophy still lingering like the monuments, the law, the very speech of old Rome on the soil of Languedoc, or a loan perhaps from the Saracen unbelievers in Spain grown all too neighbourly, or had it actually been secreted afresh in the perverse mind of that late day?', Pater's narrator asks.[141]

[134] J. A. Symonds and Margaret Symonds, *Our Life in the Swiss Highlands* (London and Edinburgh: Adam and Charles Black, 1892), 307–33.
[135] Arthur Symons, 'The Magic of Auxerre' (1924), in *Wanderings* (London: J. M. Dent & Sons, 1931), 178–82.
[136] Ibid., 179. [137] Ibid., 182. [138] Ibid., 182.
[139] Inman 1990, 471, notes how, in the autumn of 1887, Pater was borrowing Fauriel's translation of the Provençal *Histoire de la Croisade contre les Albigeois* and Paul Meyer's edition of the *Chanson de la Croisade contre les Albigeois*.
[140] 'Tibalt the Albigense', Houghton bMS Eng. 1150 (5). The manuscript was published in Gerald Monsman, 'Pater's Portraits: The Aesthetic Hero in 1890 (Part II)', *Expositions* 3.1 (2009), 23–40.
[141] Monsman 2009, 30–1.

The dualist religion of the Albigensians (named after the city of Albi north-east of Toulouse, where the movement was particularly active) was a challenge to the monotheistic Roman Catholic Church. The Albigensian belief in a New Testament Christ as Lord of the spiritual kingdom and in an Old Testament Satan, Lord of the material world and the sinful body, questioned the authority of the Catholic Church, with the result that in 1208 Raymond VI was excommunicated by Pope Innocent III for protecting the Albigensians, and a major Crusade was launched. A vibrant and flourishing southern French artistic culture was decimated as a consequence. Pater saw the Albigensians as a Proto-Reformation movement, blending worldly and spiritual values in a medieval foreshadowing of the Renaissance. Fascinated with their cult of the Devil, he chose to set his portrait in an unusual landscape, rather than within the cities of Toulouse or Albi. His fictitious Castel la Crête, a fortified city built out of lava stones, towers over a dark volcanic landscape, which is both Satanic and fertile: 'that girdle of cracked and calcined hilltops, the barren precipices, the starveling bitter-scented herbage of those hollows where the volcanic fires had gone out, after some old Satanic conflict, leaving ugly dust and ruin behind.'[142] It houses the vassals of Count Raymond's court—harsh people in a harsh landscape, near the town of Lodève, north-west of Montpellier. Among them Tibalt, a 'softly dreaming lad, at home among those gloomy chieftains,'[143] grows up to become a physician.[144] Stuck in his birthplace, only glimpsing distant Albi as a vision of the new Rome, Tibalt heals the bodies and souls of the local women and children in a landscape where 'Satan himself might be thought to sit enthroned', before 'a bleak sun under which a world of grey balloons or domes with wild basaltic columns, range upon range' rise up, 'a passionate if somber scenery for passionate people'. Pater's striking images of a unique landscape take us in a completely different direction from the picturesque accounts of Burgundy. His descriptions have a Miltonic visual and imaginative grandeur, being as much landscapes of the mind as physical landscapes. Externalizing spiritual dearth by selecting a region of France known for its peculiarly dark, almost apocalyptic, volcanic hills, he takes us off the beaten track. Did Pater ever go, one wonders? Devoid of a railway line, Lodève is not in Murray's handbook, but Pater may have found other means to travel, perhaps en route to Albi.

Where others find desolation, Tibalt finds growth and healing in the volcanic ground of the local churchyard, rich in medicinal flowers: 'one spot there was—he detected it by its ring of molten snow—where those old volcanic fires lay not yet quite extinct amid the cinders. Here like the relics of a warmer, more florid and genial world, certain odd, exotic, miraculously fresh flowers were begotten as by natural magic, erect in the dark clefts, their roots deep down in the medicinable salts.'[145] Here the narrative breaks off, and we shall never know what fate Pater intended for his Tibalt. Where Emerald was a flower in the rich, gentle garden of England, Tibalt blossoms in an apparently barren landscape. The 'odd, exotic, miraculously fresh flowers' he detects, where they are least likely to spring, may draw

[142] Ibid., 33. [143] Ibid., 32.

[144] Monsman, 24, links the protagonist's profession to the recent (1887) death of Pater's brother William, a physician, like his father and grandfather.

[145] Ibid., 34.

THE POETICS OF PLACE 309

their strength from a pagan underground. They may be likened to the glass bottle in the sarcophagus in 'Denys', or the Roman coin in 'An English Poet', or the 'devil's penny pieces' in 'Apollo' as specimens of a buried past which spring to life and have an impact on the present. The new anemone which grows in the mixed soil of Jerusalem and the common clay of Pisa's Campo Santo, the strange flower of the Italian Renaissance, comprising the pagan and the Christian, may be another exotic growth from the ground with which to compare Tibalt's flowers.[146]

France within Europe

The *genius loci* of most of Pater's French locations is firmly rooted in one particular town or edifice: fortifications, closed monastic walls, towers, create a dialectics of inside and outside. Pater's medieval world revolves around what the Italians call the *incastellamento*, the feudal castle, a military fortification which both protects and confines. A world torn by wars and Crusades necessitates such fortifications, and the self is defined on the basis of the communities inside the walls. This is not the grand vision of a unified nation but rather a series of local communities in a regional France: Normandy, Picardy, the Pas-de-Calais, Burgundy, Languedoc. Regional differences and characteristics run deep, perhaps deeper than an overall sense of French national identity, although, with Pater's 'double optics', there is the awareness of a future nation-state. John Murray, in 1873, had to confess that old habits die hard, that the tradition of thinking of the French in regional terms was deeply ingrained: 'The chapters into which this book is divided are arranged according to the ancient Provinces, as being less minute, more historical, and better understood by the English than the more intricate subdivisions of Departments. Though the latter are universally used by the French, some centuries must elapse before *Champagne* and *Burgundy* cease to be remembered for their wines, *Périgord* for its pies and *Provence* for its oil; nor will it be easy to obliterate the recollection of William of *Normandy*, Margaret of *Anjou*, and Henri of *Navarre*.'[147]

Pater's France is primarily a peripheral or liminal France; only Gaston travels through the central parts of the country, *la Beauce*, 'the granary of France'. Otherwise the areas which attract the writer's attention are those where borders and boundaries are porous, where other nations—be it the English, the Spanish, the Flemish, the Swiss, the Italians, or the Germans—are close at hand. Pater's France is a France under pressure: plastic, contracting, expanding, like the heart of Europe, with a pulse which can be felt across the Channel, deep into Italy, and well into both Holland and Germany. The Alps constitute a natural border towards the South; Pater uses the terms 'cis-Alpine', 'trans-Alpine', and 'sub-alpine' ('on this side of the Alps', 'across/ from the other side of the Alps', 'just below the Alps'), drawing our attention to the speaker's own geographical location and to the defining powers of the mountains, with a North-South dichotomy in mind. The beauty of Auxerre is 'a beauty cisalpine

[146] 'Pico della Mirandola', *Ren.*, 36–7. [147] 'Preface', in Murray, *Handbook*, v–vi.

and northern',[148] in *Gaston* he speaks of 'the wan Transalpine complexion of Dürer's *Melancholia*',[149] and the settings for his two unfinished Italian portraits are described as 'the two sub-alpine towns of Brescia and Bergamo.'[150] Moroni's *Tailor* and Romanino's *Gaudioso* are both on the gateway to the South but neither Roman nor Neapolitan in their southern-ness.

Heralding a new Europe for the new millennium, the French historian Jacques Le Goff instigated a book series entitled *The Making of Europe*. His own volume, *L'Europe: est-elle née en Moyen Age?* [*Was Europe Born in the Middle Ages?*] (2005), shares a general view with Pater that a European cultural identity arose in the Middle Ages. Le Goff points out how the Alps helped to define nations at the new universities. In Bologna, 'the university was organized into two groups, classified according to whether the students came from North or South of the Alps. The Cismontane students were divided into three subnations (Lombards, Tuscans, and Sicilians). The Ultramontane students formed 13 groups that more or less corresponded to the various other kingdoms and political units of Christendom.'[151] Yet, 'The Alps, which had never proved a real barrier between Italy and northern Europe, now, more than ever, became an essential passageway connecting the North and the South of medieval "European" Christendom, in which the emperors' descents to Italy took on the character of a kind of political ritual. As Alpine passes were made negotiable, hospices sprang up to house pilgrims, and commercial and human relations intensified, the importance of the Alps, at the heart of medieval "European" Christendom, was increasingly affirmed.'[152] Pagden invites us to think of the Alps as a linguistic boundary at Montaigne's time, yet one which the well educated passed with ease: 'Michael de Montaigne learned Italian, although his father had brought him up in an entirely Latin-speaking household, and when he crossed the Alps, he changed the language of his journal from French to Italian. On returning through the Mont Cernis pass, he noted, in French, "here French is spoken, so I leave this foreign language in which I feel competent but ill-grounded."'[153]

Travelling through Europe on the railways, Pater was fully aware of the mobility of medieval man, frequently on the road, *in via*, as 'the very embodiment of the Christian definition of man as a traveller, a pilgrim, *homo viator*.'[154] The monastic unification of Europe, explored in Pater's travelling monks, builders, and architects, makes us consider whether Christianity (and implicitly Latin as the *lingua franca*) was a unifying force, defining and tying Europe together. The early medieval split of Christendom into the Byzantine empire and Latin Christendom, corresponding, respectively, to an eastern and a western empire, suggests a lack of unification. Come the sixteenth century, and the unifying powers of Christianity were under severe pressure, with the division of Europe into a Protestant North and a Catholic South after the Reformation. Pater was, in fact, far more interested in the divisive powers of Christendom, as he explored the Albigensians, the French Religious Wars, and

[148] CW 3:81. [149] CW 4:128.
[150] 'Art Notes in North Italy', *Miscellaneous Studies*, 86.
[151] Jacques Le Goff, *The Birth of Europe*, tr. Janet Lloyd (Oxford: Blackwell, 2005), 175.
[152] Ibid., 41. [153] Pagden, 44–5. [154] Ibid., 65.

various aspects of antinomianism.[155] He probably worked on the Albigensians in 1887 alongside *Gaston*, but already in the opening essay on Aucassin and Nicolette in *The Renaissance* did he talk about 'this rebellious element, this sinister claim for liberty of heart and thought' which 'comes to the surface. The Albigensian Movement connected so strangely with the history of Provençal poetry, is deeply tinged with it.'[156] His intertwining of religious diversity—the rebellious spirit even embracing journeys into Hell—and the flourishing Provençal school of poetry which in the *trecento* travels to Italy, with Dante as its finest master, is a study in the aesthetic sensuousness of poetic forms, ideas, and figures which travel freely from one country to another, irrespective, almost in defiance, of religion. The Franco-centricity of Pater's idea of the Renaissance grants a crucial place to Provençal poetry. For Pater, writing in 1873, only two years after France lost its Continental supremacy to the Germans, the notion of France as a cultural centre remains pervasive. This is where the movement of the Renaissance begins and ends with the silvered verses of the *Pléiade*. It begins in the South, travels to Italy, and returns again to France in the sixteenth century, together with Leonardo, the School of Fontainebleau, Catherine de Medici, and du Bellay who, having studied in Rome, carries his notions of the vernacular language and poetry back into France. The opening of Pater's first book reminds us of the Renaissance as a transnational phenomenon, which crosses boundaries in a Europe where the Alps do not constitute a cultural obstacle:

> The history of the Renaissance ends in France and carries us away from Italy to the beautiful cities of the Loire. But it was in France also, in a very important sense, that the Renaissance had begun; and French writers, who are fond of connecting the creations of Italian genius with a French origin, who tell us how Saint Francis of Assisi took not his name only, but all those notions of chivalry and romantic love which so deeply penetrated his thoughts, from a French source, how Boccaccio borrowed the outlines of his stories from the old French *fabliaux*, and how Dante himself expressly connects the origin of the art of miniature painting with the city of Paris, have often dwelt on this notion of a Renaissance at the end of the twelfth and beginning of the thirteenth century, —a Renaissance within the limits of the middle age itself but in part abortive effort to do for human life and the human mind what was afterwards done in the fifteenth.[157]

Pater and Le Goff share the notion of the long—even, the very long—Middle Ages as constitutive for our modern notion of Europe. Challenging the Ruskinian notion of the Renaissance as the death of art, religion, and culture, Pater dragged the Renaissance back into the Middle Ages and let it potentially continue right into his own century with eighteenth-century Winckelmann and references to Wordsworth as forces which extended the movement of the Renaissance beyond conventional historical periodization. The question remains of how far back ideas of a united

[155] See Lyons.
[156] 'Aucassin and Nicolette', *Studies in the History of the Renaissance* (London: Macmillan & Co., 1873), 16.
[157] Ibid., 1–2.

312 WALTER PATER'S EUROPEAN IMAGINATION

Europe should be traced. To Le Goff, traditional representations of Charlemagne as the Father of Europe were a distortion of history,[158] as the Carolingian empire was a nationalist and a geographically restricted Europe, more of an attempt to resurrect the Roman empire than to build a united Europe. 'Charlemagne's was the first of a string of attempts to construct a Europe dominated by one people or one empire. The Europes of Charles V, Napoleon, and Hitler were, in truth, anti-Europes, and Charlemagne's attempt already smacked of a project that was contrary to any true idea of Europe.'[159]

Pater's Carl is a failed Europeanist. His capitulation when confronted with 'Europe' tells us more of his own limitations than of Pater's, and Carl's retreat to all things German could hardly be considered ideal. He would have approved of Johann Gottfried Herder's dictum: 'Denn jedes Volk ist Volk; es hat seine National-Bildung wie seine Sprache' [For every nation is a nation, with its own national education, as it has its own language].[160] Much nineteenth-century nationalism would derive from such linking between nation, education, and language. One might wonder whether, in the light of the outcome of the Franco-Prussian War, Pater was mocking the excessive German nationalism which surged after defeating the French. Ironically, Carl is killed by the very nation which he admired the most and never arrives at the grand enlightenment ideas for European peace and unification voiced by Voltaire, Gibbon, Hume, and Diderot, culminating in Immanuel Kant's essay 'Perpetual Peace: A Philosophical Sketch' (1795). Pocock points out how the enlightenment philosophers 'set about defining "Europe" as a secular civilization and supplying it with a secular history and an age of modernity. Writing history for them was a weapon against the Church, Protestant as well as Catholic, and in consequence they wrote a history of the Church designed to reduce it to secular history.'[161] Voltaire saw Europe emerging from the last phase of religious fanaticism into an age of enlightened sociability fostered by courtly monarchy and commercial refinement. Kant's cosmopolitanism 'looked toward revolutionary France to provide the political model for the new Europe, which, as he saw it in the 1790s, could only be republican and federal.'[162] Napoleon's republicanism, however, soon developed into an empire united under one single sovereign, thus putting many of the grand enlightenment ideas of a democratic unified Europe to shame.

Le Goff defined the notion of Europe as 'the combination of potential unity and a fundamental diversity, the mixing of populations, West-East and North-South oppositions, the indefinite nature of its eastern frontier, and above all, the unifying role of culture,'[163] notions that were vaguely conceived at the time of Charlemagne, but not manifested until the thirteenth and fourteenth centuries when the rise of communities such as cities and universities, and the great building projects of the gothic cathedrals became unifying forces on European territory. Diffusing the same kind of knowledge from North to South, the European universities contributed towards the harmonizing of thoughts and ideas. The conclusion of the Hundred Years' War at the

[158] Le Goff, 32. [159] Ibid., 29.
[160] Johann Gottfried Herder, *Ideen zur Philosophie der Geschichte der Menschheit* (Riga und Leipzig: J. F. Hartknoch 1785), 245.
[161] Pocock, 62. [162] Pagden, 17. [163] Le Goff, 3.

end of the fifteenth century, with the treaties of Arras and Étaples, meant the English withdrawal from the Continent, the restoration of Paris, Normandy, Brittany, Picardy, Artois, Burgundy, and Boulogne, and hence a significant fortification and expansion of a unified France. Pater's medieval portraits had all dealt with regional France; his *Gaston*, however, revolved around the newly united and fortified France, now undermined by internal religious conflict.

The central role played by France in the emergence of Europe and the Renaissance was, to some extent, fed by Pater's reading of some of the leading French nineteenth-century historians, Jules Michelet and Edgar Quinet,[164] the precursors of Le Goff as Parisian intellectual authorities, seeing the world from their own Parnassus. Ruskin, in his *Bible of Amiens*, had stressed the significance of the Franks, with Amiens as a northern counterpart to Rome, the Venice of the North. When thinking about Europe as an imagined community,[165] a community increasingly under threat, Europeans, as Pagden pointed out, have 'more than a shared past; they have a shared history of antagonisms to overcome.'[166] The stress on 'Perpetual Peace' in the title of Kant's seminal essay reflects the European continent as a war-torn territory by the end of the eighteenth century; the Napoleonic Wars, the Greek War of Independence, the Danish-German War, and the Franco-Prussian War in the nineteenth century did not exactly put an end to militant conflict on the Continent, nor did the twentieth-century world wars. The geopolitical location of France as the centre of it all, involved in continuous wars and uprisings from the Crusades, the Jacquerie, the Hundred Years' War, the Religious Wars, the Thirty Years' War, the French Revolution, and the Napoleonic Wars, is an important component of Pater's understanding of France, alluded to sometimes ever so slightly, whether in Watteau's depiction of soldiers departing, in allusions to the desecration of the monasteries during the Revolution, or more substantially in Emerald's participation in the Napoleonic Wars. War almost becomes a condition of history for Pater, an inevitable backdrop, explaining places and the relation between person and place, not just in the relation of France to the rest of Europe but also within the ancient world. The Persian War, the mythic War against the Amazons, and the Marcomannic Wars have brief walk-on parts in 'Hippolytus' and *Marius* as distant events with an impact on the narrative, even if neither Hippolytus nor Marius are belligerent by nature. None of Pater's protagonists are natural warriors, they are rather the reverse. Several of the portraits take place in brief moments of peace, in Sebastian's mid-seventeenth-century Haarlem, in Marie-Marguerite's quiet Valenciennes, and Carl's slumberous Rosenmold, yet always with the awareness that peace is brief and will soon be disturbed by less benevolent military forces.

As a belligerent nation, internally at war in most centuries since the Middle Ages, France epitomizes Pater's 'movement of the Renaissance': dynamic, constantly coming into being. Pater's fiction gives us a discourse from the margins, as centre becomes periphery, with Paris as a vague reference point, as that other France, home

[164] See Bullen 1994, chs 8 and 12.

[165] See Benedict Anderson, *Imagined Communities: Reflections on the Origin and Spread of Nationalism* (London: Verso, 1986).

[166] Pagden, 20.

314 WALTER PATER'S EUROPEAN IMAGINATION

to the gallant sea-side visitor in 'An English Poet', chosen new home of Watteau, or the seat of the Valois dynasty in *Gaston*. With the exception of Pater's unfinished novel, the metropolis—such a potent nineteenth-century point of fascination—is suppressed in Pater's portraits and with it, French politics and the academic, intellectual, world. The urban world of Paris explored in the novels of Hugo, Dumas, and Zola is not Pater's, although so many of his views of France were profoundly influenced by the Parisian intelligentsia.

Inman has documented Pater's extensive and continued reading of the works of Ernest Renan and his likely possession of at least five volumes of his writings.[167] After Pater's death, Gosse suggested his 'likeness to Renan in the attitude of his mind'.[168] Like Renan, 'refraining from opposition and argument', Pater, apparently, adopted a number of Renan's modes of speech, 'especially the "no doubt" that answered to the Frenchman's incessant "n'en doutez pas."'[169] One of the texts by Renan which Pater undoubtedly read with interest was his address to the Sorbonne on 11 March 1882 under the heading 'Qu'est-ce qu'une nation?' (What is a nation?).[170] The lecture had a great impact on European readers, and it remains one of the standard texts in discussions of the emergence of the nineteenth-century nation-state. So many of the ideas of countries and nations which pervade Pater's portraits occur in Renan's lecture. The two writers share views about the importance of the past for the present, the mutability of nations and national boundaries, national and cultural hybridity, and the significance of the Renaissance for our ideas of Europe. For Renan, it was important to separate race from nation; he stressed the hybridity of the French and the English on either side of the Channel in order to alert his listeners' attention to the great melting pot which constituted contemporary Europe:

> An Englishman is indeed a type within the whole of humanity. However, the type of what is quite improperly called the Anglo-Saxon race is neither the Briton of Julius Caesar's time, nor the Anglo-Saxon of Hengist's time, nor the Dane of Canute's time, nor the Norman of William the Conqueror's time; it is rather the result of all these. A Frenchman is neither a Gaul, nor a Frank, nor a Burgundian. Rather, he is what has emerged out of the great cauldron in which, presided over by the King of France, the most diverse elements have been simmering. A native of Jersey or Guernsey differs in no way, as far as his origins are concerned, from the Norman population of the opposite coast. In the eleventh century, even the sharpest eye would have seen not the slightest difference in those living on either side of the Channel.[171]

[167] Inman 1981, 337–8. [168] Gosse 1894, 808. [169] Ibid., 808.

[170] Ernest Renan, *Qu'est-ce qu'une nation? Conférence faite en Sorbonne, le 11 Mars 1882* (Paris: Lévy Frères, 1882).

[171] Ibid., 17–18. My translation. 'Un Anglais est bien un type dans l'ensemble de l'humanité. Or le type de ce qu'on appelle très improprement la race anglo-saxonne, n'est ni le Breton du temps de César, ni l'Anglo-Saxon de Hengist, ne le Danois de Knut, ni le Normand de Guillaume le Conquérant; c'est la résultante de tout cela. Le Français n'est ni un Gaulois, ni un Franc, ni un Burgonde. Il est ce qui est sorti de la grande chaudière où, sous la présidence du roi de France, ont fermenté ensemble les éléments les plus divers. Un habitant de Jersey ou de Guernesey ne diffère en rien, pour les origines, de la population normande de la côte voisine. Au xie siècle, l'œil le plus pénétrant n'eut pas saisi des deux côtés du canal la plus légère différence.'

THE POETICS OF PLACE 315

Nation, Renan asserted, is about neither race, nor language, nor religion, nor natural geography: neither mountains nor rivers constituted boundaries to nationhood. In his line of argument, he was gradually turning his attention to the human soul and spirit (although distinctly not addressing religion as a unifying force) in his dismissal of both biology and geology as founding factors of nationhood. The human will to share cultural values and an awareness of a shared past were stressed in Renan's definition of a nation: 'it is no more soil than it is race which makes a nation. The soil furnishes the *substratum*, the field of struggle and of labour; man furnishes the soul. Man is everything in the formation of this sacred thing which is called a people. Nothing [purely] material suffices for it. A nation is a spiritual principle, the outcome of the profound complications of history; it is a spiritual family not a group determined by the shape of the soil.'[172] To Renan, both remembering and forgetting the past were of significance. While an awareness of a shared past and an ancestral identity were at the heart of his idea of nationhood, he also argued for the benefits of forgetting past antagonisms, wiping the slate clean and looking forwards, rather than dwelling on the traumas of the past. He thus advised every French citizen to 'have forgotten Saint Bartholomew's Night or the massacres that took place in the Midi in the thirteenth century.'[173] Pater's portraits write themselves into this discourse, keeping collective memory alive through peripheral protagonists who constitute case studies of the impact of national conflict on the individual. In his definition of nationhood Renan steered away from national identity, invoking Renaissance transnationalism as an ideal which turned attention away from national difference while centring on the human spirit, thus suggesting the different approach of nations as spiritual families. 'Consider the great men of the Renaissance; they were neither French, nor Italian, nor German. They had rediscovered, through their dealings with antiquity, the secret of the genuine education of the human spirit, and they devoted themselves to it body and soul. What an achievement theirs was!'[174] Pater's 'movement of the Renaissance' transcends national difference with its greater vision across centuries and geographical boundaries. While acknowledging the current need for the nation-state, Renan's sense of human and national flux resulted in the prophecy of a future European Union, a vision which he found far from unattractive: 'Human wills change, but what is there here below that does not change? The nations are not something eternal. They had their beginnings and they will end. A European confederation will very probably replace them.'[175] Both Pater and Renan would, I think,

[172] Ibid., 25. My translation. 'ce n'est pas la terre plus que la race qui fait une nation. La terre fournit le *substratum*, le champ de la lutte et du travail; l'homme fournit l'âme. L'homme est tout dans la formation de cette chose sacrée qu'on appelle un peuple. Rien de matériel n'y suffit. Une nation est un principe spirituel, résultant des complications profondes de l'histoire, une famille spirituelle, non un groupe déterminé par la configuration du sol.'

[173] Ibid., 9. My translation. 'tout citoyen français doit avoir oublié la Saint-Barthélemy, les massacres du Midi au XIIIe siècle.'

[174] Ibid., 22. My translation. 'Voyez les grand hommes de la Renaissance; ils n'étaient ni Français, ni Italiens, ni Allemands. Ils avaient retrouvé, par leur commerce avec l'antiquité, le secret de l'éducation véritable de l'esprit humain, et ils s'y dévouaient corps et âme. Comme ils firent bien!'

[175] Ibid., 28. My translation. 'Les volontés humaines changent; mais qu'est-ce qui ne change pas ici-bas? Les nations ne sont pas quelque chose d'éternel. Elles ont commencé, elles finiront. La confédération européenne, probablement, les remplacera.'

qualify for the *OED* definition of the Europeanist. From his privileged position addressing the Sorbonne, just a decade after the French defeat against the Germans and the loss of Alsace-Lorraine, which all too clearly proved that neither rivers nor mountains constituted permanent boundaries, Renan produced a lecture which opened, rather than closed, definitions of nations towards the twentieth and twenty-first centuries, yet with a keen awareness of the significance of both antiquity and the Renaissance for his notion of nation. For his part, Pater employed his essays in *The Renaissance* and his portraits for a layered discourse and exploration of the idea of Europe. The renascence of place requested by Edward Casey had already occurred: man and the self were inextricably connected with place in Pater's writings where both the local and the national were carefully interwoven with the European.

7

The Poetics of Time

Pater and History

The one duty we owe to history is to rewrite it.

Oscar Wilde[1]

At the beginning of *Modern Painters IV* (1856), Ruskin expressed the joy he felt on approaching the European continent from England. In mid-life, the sight of the tower of the old church at Calais had become for him a beacon of European historical continuity, signifying unbroken time, the seamless transition from past to present. For a writer who throughout his life painted cultural history with broad brush strokes, zooming out from the stones of Venice or the portico of Amiens to much grander visions of the rise and fall of states and cultures across centuries, the Calais tower constituted a welcoming contrast to the fragmentation of England left behind:

> I cannot tell the half of the strange pleasures and thoughts that come about me at the sight of that old tower; for, in some sort, it is the epitome of all that makes the Continent of Europe interesting, as opposed to new countries; and, above all, it completely expresses that agedness in the midst of active life which binds the old and the new into harmony. We, in England, have our new street, our new inn, our green shaven lawn, and our piece of ruin emergent from it, —a mere *specimen* of the Middle Ages put on a bit of velvet carpet to be shown, which, but for its size, might as well be on a museum shelf at once, under cover. But, on the Continent, the links are unbroken between the past and present, and, in such use as they can serve for, the grey-headed wrecks are suffered to stay with men; while, in unbroken line, the generations of spared buildings are seen succeeding each in its place. And thus in its largeness, in its permitted evidence of slow decline, in its poverty, in its absence of all pretence, of all show and care for outside aspect, that Calais tower has an infinite of symbolism in it, all the more striking because usually seen in contrast with English scenes expressive of feelings the exact reverse of these.[2]

Maybe Ruskin was merely conveying the experience of travelling East; the accounts of American travellers like Washington Irving, Nathaniel Hawthorne, and Henry James reaching England, express a similar experience of leaving newness and fragmentation behind and finding historical continuity in the British Isles. The linearity of unbroken time is part of the romantic narrativization of history in a century when

[1] 'The Critic as Artist' in *The Complete Works of Oscar* Wilde, volume 4, *Criticism: Historical Criticism, Intentions, The Soul of Man*, ed. Josephine M. Guy (Oxford: Oxford University Press, 2007), 124–206, 147.
[2] *CWR* 6:11–12.

Walter Pater's European Imagination. Lene Østermark-Johansen, Oxford University Press. © Lene Østermark-Johansen 2022.
DOI: 10.1093/oso/9780192858757.003.0008

318 WALTER PATER'S EUROPEAN IMAGINATION

history became an academic discipline, when the emerging nation-states developed philosophies of history and extensive national histories, when the historical novel came into its own and vied with the *Bildungsroman* about how to chronicle the life and development of the individual in relation to society and major historical events.

This final chapter takes us from space and place into time in an attempt to discuss Pater's dialogue with nineteenth-century European history and fiction. This is no small task, and I am fully aware of the many omissions, the many paths not taken, in a pragmatic selection of focusing points that connect the imaginary portraits to *The Renaissance*, while thinking about Pater's broader views on the interrelationship between history and literature. Much of Pater's writing can be seen as essays in positioning the individual within time, both within the short life-span of one individual life, and within the longer time-span of a cultural and historical period, linked palimpsestically in vertical time to underlying strata of previous historical periods. This chronotopic interdependency of time and place, of places of memory imbued with layers of meaning as time superimposes new cultures, new buildings, new lives upon a site, sits at the heart of Pater's imaginary portraits. Rome, Auxerre, Picardy, Rosenmold are all cases of the intermingling of past and present, where an earlier past comes to the surface, disturbing its equanimity.

Given that Pater's portrait gallery, as we have it, is fragmented, that he had intended several other portraits which never materialized, we are left to ponder the balance between continuity and fragmentation, the extent to which he was planning a line of male portraits from antiquity to the nineteenth century, a series of significant moments in the history of western culture. The Paterian tension between movement and moment captures this: the Heraclitean 'All things are in motion and nothing at rest' counterbalances Pater's stress on momentary experience, suggesting his ability to think across both long, elastic stretches of time and to focus on the intensity of the individual moment, of the kind that would later develop into Woolf's 'moments of being'.[3] When thinking about Pater and time, we must bear in mind this oscillation between 'the movement of the Renaissance', stretching from the Middle Ages till the eighteenth century, and the moment captured in the portrait. The continuity of history runs like a background against which the portraits stand out in relief in a favourite Paterian trope.[4]

The 'poetics of time', a term used by such influential scholars of nineteenth-century historiography as Hayden White and Stephen Bann,[5] alludes to the etymology behind 'poesis', the act of making, shaping, forming. As White pointed out in the preface to *Metahistory* (1973), 'the historian performs an essentially *poetic* act, in which he *pre*figures the historical field and constitutes it as a domain upon which to bring to bear the specific theories he will use to explain "what was *really* happening" in it.'[6] Referring to Leopold von Ranke's dictum that history should 'show only what actually happened' (*wie es eigentlich gewesen*),[7] White alluded to history as

[3] See Virginia Woolf, 'A Sketch of the Past' (1939) in *Moments of Being: Unpublished Autobiographical Writings*, ed. and intr. Jeanne Schulkind (Frogmore: Panther Books, 1978), 74–159.

[4] See Østermark-Johansen 2011. [5] See Bann and White.

[6] White, 'Preface' in *Metahistory*, xxx. Italics are White's own.

[7] Ranke first used the term in the 'Preface', dated Oct. 1824, to his first major work *Geschichten der romanischen und germanischen Völker von 1494 bis 1514* (quoted in German by Bann on p. 10), and it soon became synonymous with nineteenth-century positivism.

THE POETICS OF TIME 319

representation and questioned the impartiality of nineteenth-century positivism. White's view of the historian as someone who forms, rather than finds, time, was summed up by his pupil, Michael S. Roth, in 2014: 'Crucial to White's approach to historical writing is the idea that we endow the past with meaning because "in itself" it has none. The historical writer must form the past into a narrative because the past is formless, or at least it does not have the rhetorical forms that alone make it meaningful in communication.'[8] White's theories of the 'emplotment' of history point out a number of parallels between literature and history which are profoundly Paterian. Just think of how Pater toyed with ideas of the 'real' and emplotment when constructing Marie-Marguerite's narrative out of the 'extracts from an old French journal', creating meaning and development out of the chaos of an imaginary diary. As White later pointed out, 'one cannot historicize without narrativizing, because it is only by narrativization that a series of events can be transformed into a sequence, divided into periods, and represented as a process in which the substances of things can be said to change while their identities remain the same.'[9] Roth concluded panegyrically that *Metahistory* 'reminds us that the historical imagination need not be limited by academic discipline and that it can be an extraordinary resource as we make the present our own.'[10]

Pater was, I think, keen to make the present his own, and in order to do so had to engage his historical imagination creatively. I wish to highlight Pater as a 'maker of time', as a writer acutely aware of the meta-discourses involved in writing both history and fiction and deliberately blurring the boundaries between them. Concerned with the problematic notion of the 'Truth', Pater regarded both truth and historical continuity as constructs. One might argue that from the beginning of his career Pater inaugurated a war against the positivist historians which continued for most of his life, certainly to his essay on 'Style' (1888). The very title of his *Studies in the History of the Renaissance* (1873) indicates that the volume is subjective and far from exhaustive: 'studies' suggests a process of selection (other studies could have been included), thereby questioning the notion of a truthful and complete history. Emilia Pattison famously took him to task for his abuse of the word 'history': 'The title is misleading. The historical element is precisely that which is wanting, and its absence makes the weak place of the whole book.'[11] She pointed out Pater's lack of scientific method, the absence or unreliability of facts, his detachment of the Renaissance from socio-political developments, suspended 'isolated before him, as if it were indeed a kind of air-plant independent of ordinary sources of nourishment'.[12] Pater consequently omitted the word 'history' from the title of the second and all subsequent editions of his book: from 1877, the book appeared as

[8] Roth, 'Foreword' in White, xv.

[9] Hayden White, 'Historical Discourse and Literary Writing', in *Tropes for the Past: Hayden White and the History/Literature Debate*, ed. Kuisma Korhonen (Amsterdam: Rodopi, 2006), 25–34, 30.

[10] Roth in White 2014, xx.

[11] Emilia Pattison, unsigned review, *Westminster Review* 43 (Apr. 1873), n.s., 639–41. Quoted from Seiler 1980, 71–3, 71. See also Kali Israel, *Names and Stories: Emilia Dilke and Victorian Culture* (Oxford: Oxford University Press, 1999), 258–61, and Østermark-Johansen 2015. For Pater and Emilia Pattison (subsequently Dilke), see Hilary Fraser, 'Walter Pater and Emilia Dilke', *Studies in Walter Pater and Aestheticism* 2 (2016), 21–30.

[12] Pattison, 72.

320 WALTER PATER'S EUROPEAN IMAGINATION

The Renaissance: Studies in Art and Poetry, yet the author had not abandoned his challenge to history as a scientific discipline.

As an aside, but not an insignificant one, it should be noted that throughout his life, Pater was an avid reader of history. If one ploughs through Inman's two volumes recording the books he studied in the Oxford libraries, history forms a substantial component of his reading.[13] Books on history were books he borrowed; in Inman's listings of Pater's private book collection, history glimmers by its absence.[14] Broad classifications of those borrowed books direct us to the following categories: histories of individual countries and cultures, of individual cities, of individual peoples, with religious history and the history of philosophy as minor genres. Classical history, like Herodotus, Thucydides, Tacitus, constitute a small component of his borrowings; he may well have had those texts as part of his private book collection. By far the major part of his borrowings was from an impressively broad selection of German, Italian, French, and English nineteenth-century history on Greece, Rome, France, England, and Scotland. A not entirely exhaustive catalogue of Pater's history reading, grouped by geographical subject, gives us an idea of his familiarity with the discipline:

Georg Grote, *History of Greece*;
Ernst Curtius, *History of Greece*;
Connop Thirwall, *A History of Greece*;
Wilhelm Adolf Becker, *Charicles, or Illustrations of the Private Life of the Ancient Greeks*;
Edward Gibbon, *Decline and Fall of the Roman Empire*;
Leopold Ranke, *History of the Popes*;
Theodor Mommsen, *History of Rome*;
Thomas Arnold, *History of Rome*;
Charles Merivale, *History of Romans under the Empire*;
Wilhelm Adolf Becker, *Gallus, or Roman Scenes of the Time of Augustus*;
F-J-M-T Champagny, *Les Antonins*;
Thomas Henry Dyer, *A History of the City of Rome*;
Edgar Quinet, *Les Revolutions d'Italie*;
Simonde de Sismondi, *Histoire des Français*;
Jules Michelet, *Histoire de France*;
Henri Martin, *Histoire de France*;
Henley Jervis, *A History of the Church of France*;
Claude Charles Fauriel, *Histoire de la croisade contre les hérétiques albigeois*;
Alfred Franklin et al., *Histoire de Paris*;
Ernest Renan, *Histoire du people d'Israel*;
John Lothrop Motley, *The Rise of the Dutch Republic: A History*;
Edward Freeman, *History of the Norman Conquest*;
David Hume, *History of England*;
John Lingard, *History of England*;
Thomas Babington Macaulay, *History of England*;

[13] See Inman 1981 and 1990. [14] See Inman 1981, 333–41 and 1990, 489–90.

Samuel Rawson Gardiner, *History of England*;
James Anthony Froude, *History of England*;
John Richard Green, *The History of the English People*;
Gilbert Burnet, *History of the Reformation in the Church of England*;
Anthony à Wood, the histories of the colleges, the university, and the city of Oxford;
John Hill Burton, *The History of Scotland*;
Robert Wodrow, *History of the Sufferings of the Church of Scotland*;
In addition to the above, Thomas Carlyle's *French Revolution, Cromwell's Letters and Speeches*, and his *History of Friedrich II of Prussia*.

It is an impressive list, especially given the fact that most of the works were multi-volume publications. The national bias and focus which define nearly every single one of the titles reflect the nineteenth-century interest in the nation-state and its population, at the same time as the geographical spread of Pater's portraits can be traced in his reading. What the list does demonstrate is that however harshly Pattison may have criticized Pater for being unscientific, his style and method were deliberate, as he was only too well-versed in the relatively new science of history. We should bear in mind that in 1864, the very same year as Pater took up his fellowship at Brasenose College, the first Chair in History was established at the University of Oxford, to be followed two years later by a similar Chair at Cambridge, reflecting the increased interest in history as an academic discipline at both universities.[15] The Regius Chairs of Modern History had, admittedly, been established at both universities in 1724, with much ongoing discussion about the definition of the word 'modern' and hence of the Chair's field of research, but very little teaching of the discipline took place until the mid-nineteenth century. The English universities were running some fifty years behind their German and French counterparts, where a Chair in History had been established at the University of Berlin in 1810 and at the Sorbonne in 1812. By the mid-century the discipline had become so academic as to require specialist periodicals: the German *Historische Zeitschrift* (1859), the *Révue Historique* (1876), the *Rivista Storica Italiana* (1884), and eventually the *English Historical Review* (1886).[16] Undergraduate examinations in history at Oxford had taken place since 1850; in 1879 the subject of the Oxford Chancellor's English Essay Prize was 'Historical Criticism Among the Ancients',[17] diligently answered by Oscar Wilde,[18] and by 1885 it was even possible to do a special subject on the Italian Renaissance in Oxford under the tutelage of Pater's colleague from Queen's College, Edward Armstrong. As D. S. Chambers points out, the title of the special subject was 'Italy 1492–1513', in careful avoidance of the very word 'Renaissance' which in the circles

[15] See Brian Hamnett, *The Historical Novel in Nineteenth-Century Europe: Representations of Reality in History and Fiction* (Oxford: Oxford University Press, 2015), 31, 176.

[16] Ibid., 31, 176.

[17] See *The Complete Works of Oscar Wilde*, volume 4, *Criticism: Historical Criticism, Intentions, The Soul of Man*, ed. Josephine M. Guy (Oxford: Oxford University Press, 2007), xix–xxviii.

[18] Wilde's essay 'Historical Criticism' (for which he was not awarded a prize) can be found in Guy's edited volume above, 3–67.

322 WALTER PATER'S EUROPEAN IMAGINATION

of the Oxford History Faculty had been tainted since its appearance in the title of Pater's first book in 1873.[19]

Pater challenged this new professionalization of history in 'Style', first published separately in the *Fortnightly Review* (1888), but soon given pride of place as the opening essay in *Appreciations* (1889). Questioning clear-cut distinctions such as those of prose and poetry, fact and fiction, with reference to Thomas de Quincey's distinction between the literature of knowledge and the literature of power,[20] Pater coined the concept of an 'imaginative sense of fact'.[21] The term is oxymoronic; indeed, how can fact be subjected to the imagination, to subjective perception? The writer who in his work made use of such an imaginative sense of fact would elevate his work to fine art, Pater claimed, and elegantly proceeded to a discussion of history and style, of history as writing. He took the opportunity to employ the manifesto-like opening essay of his second collection to respond to the criticism encountered by his first collection:

> In science, on the other hand, in history so far as it conforms to scientific rule, we have a literary domain in which imagination may be thought to be always an intruder. And as in all science the functions of literature reduce themselves eventually to the transcript of fact, so the literary excellences of its form are reducible to various kinds of painstaking; this good quality being involved in all 'skilled work' whatever, in the drafting of an act of parliament, as in sewing. Yet here again, the writer's sense of fact, in history especially, and all those complex subjects which do but lie on the borders of science, will still take the place of fact, in various degrees. Your historian, for instance, with absolutely truthful intention, amid the multitude of facts presented to him must needs select, and in selecting assert something of his own humour, something that comes not of the world without but of a vision within. So Gibbon moulds his unwieldy material to a preconceived view. Livy, Tacitus, Michelet moving amid the records of the past full of poignant sensibility, each after his own sense modifies, who can tell how and where? and becomes something else than a transcriber; each, as he thus modifies, passing into the domain of art proper. For just in proportion as the writer's aim, consciously or unconsciously, comes to be a transcript, not of the world, not of mere fact, but of his sense of it, he becomes an artist, his work *fine* art; and good art (as I hope ultimately to show) in proportion to the truth of his presentment of that sense; as in those humbler or plainer functions of literature also, truth—truth to bare fact there—is the essence of such artistic quality as they may have. Truth! there can be no merit, no craft at all, without that. And further, all beauty is in the long run only fineness of truth—expression—the finer accommodation of speech to that vision within.[22]

[19] D. S. Chambers, 'Edward Armstrong (1846–1928), Teacher of the Italian Renaissance at Oxford', in ed. John Law and Lene Østermark-Johansen, *Victorian and Edwardian Responses to the Italian Renaissance* (Farnham: Ashgate, 2005), 211–32, 213–15.

[20] De Quincey's 'The Literature of Knowledge and the Literature of Power' was first published as part of a longer essay on Alexander Pope in the *North British Review* in August 1848.

[21] 'Style', 729. [22] Ibid., 729–30.

Pater is claiming history as a literary genre as he moves from science to art, from the process of transcribing to the plastic processes of moulding and modifying. He progresses from the 'literary domain' to 'the functions of literature', only to end on 'literary form', as he runs through a series of modulations on the word 'fact', which becomes conceptualized and subjective, as he moves from 'the world without' to 'the vision within': 'the transcript of fact' develops into 'sense of fact', 'place of fact', 'multitude of facts', until it is claimed to be 'not of mere fact, but of his sense of it', before Pater joins it to 'truth', 'truth to bare fact'. Even 'truth' (capitalized and singled out with an exclamation mark), modulates from the historian's 'absolutely truthful intention' to the gradations of the actual 'fineness of truth' in his writing, the result of the writer's verbal and imaginative moulding process which eventually results in what Pater calls 'the finer accommodation of speech to that vision within'. In this seductive passage—plastic also to the author who made several changes to it when including it in *Appreciations*—Pater has more or less persuaded us of the subjectivity of facts and transformed the historian from a scientist to an aesthetic artist, in pursuit of the beauty of imaginative writing rather than the transcription of mere facts. He is not denying history its place as a branch of literature rooted in facts, but in questioning the historian's objectivity, Pater challenges the positivist history upon which his own intellectual training is based.

Looking back in 2014, Hayden White pointed out how 'histori*ography* was first, necessarily, and most obviously *writing*, which is to say, inscription of words or signs incised or laid upon a medium and which, by that process of inscription, are endowed with a power both material and spiritual, a power to at once "fix" things in time and seemingly reveal their meaning for their own time and for our own.'[23] The same idea justified Pater's treatment of history within 'Style' in allusion to the classical instrument of inscription, the *stilus*, and its transferred sense as quality, precision, and elegance in language and writing. White is a twentieth-century follower of the Paterian 'imaginative sense of fact', embracing Pater's view of the historian as a writer who imprints his own persona on his work through a subjective process of selection in order to reach narrative coherence and make meaning of the chaos of the past:

> My experience tells me that the process of composition begins at least as early as the moment of a choice of subject. Certainly it begins at the moment one starts to handle the materials necessary for a proper study of the subject. And *Metahistory* is a study of how, in historical discourse, a certain part of the past is worked up for historiological treatment, made to appear to be a topic worthy of being treated historiologically, and then proceeds by a process of selection and combination of signs, adjectivization and thematization, and inscription, to present its referent as a bit of history, following the path or paths of story-types endemic to the culture to which the discourse belongs.[24]

[23] White's own preface to the fortieth anniversary edition in White 2014, xxv–xxvi. Italics are White's own.

[24] Ibid., xxvii.

324 WALTER PATER'S EUROPEAN IMAGINATION

For Pater, White, and Bann, history employs—like literature—language as its tool, and this historicist philology, or what Carolyn Williams, referencing Erich Auerbach, called 'aesthetic historicism',[25] ties history and literature closely together. White and Bann examined nineteenth-century history through a range of rhetorical figures and literary genres (metonomy, metaphor, tragedy, comedy, satire, romance), partly with the aim of bridging the gulf between history and literature, but also in order to direct our attention to history as construction and representation. The ideas of the eighteenth-century Neapolitan rhetorician and historian Giambattista Vico were revived by White, in acknowledgement of Vico's influence on nineteenth-century historians: Herder, Goethe, Hegel, Coleridge, Burckhardt, Michelet. Pater read Vico's *Principi di una scienza nuova* (1725) in the autumn of 1866,[26] perhaps inspired by his reading of Coleridge earlier that year. Vico's 'verum factum principle', popularly known through the aphorism *Verum esse ipsum factum* ('What is true is precisely what is made') was first formulated in 1710,[27] and echoes of it are audible in the passage from 'Style' quoted above. If the true is the made, or if something is true because it is made, the content of that particular science becomes identical with the development of that science itself. The focus on process (or movement), on construction, is both Vichian and Paterian. Timothy Costello sums up the cyclical nature of Vico's view of history; it contains the seeds of evolution, the return of Heine's pagan gods, perhaps even Yeats's gyres:

> Society progresses towards perfection, but without reaching it (thus history is 'ideal'), interrupted as it is by a break or return (*ricorso*) to a relatively more primitive condition. Out of this reversal, history begins its course anew, albeit from the irreversibly higher point to which it has already attained. Vico observes that in the latter part of the age of men (manifest in the institutions and customs of medieval feudalism) the 'barbarism' which marks the first stages of civil society returns as a 'civil disease' to corrupt the body politic from within. This development is marked by the decline of popular commonwealths into bureaucratic monarchies, and, by the force of unrestrained passions, the return of corrupt manners which had characterized the earlier societies of gods and heroes. Out of this 'second barbarism', however, either through the appearance of wise legislators, the rise of the fittest, or the last vestiges of civilization, society returns to the 'primitive simplicity of the first world of peoples', and individuals are again 'religious, truthful, and faithful'.[28]

The awareness that one can never fully return to the past was one that Pater developed in the mid-1860s, as he was reading Vico and writing about Winckelmann and Morris, both great revivers of the past. Pater was definitive in his rejection of our return to the past. His imagery in the Morris essay (1868) is controversial, given that most of Pater's subsequent publications would revolve around the very problem of

[25] Williams, 2–3. [26] Inman 1981, 148–57.

[27] *De antiquissima Italorum sapientia, ex linguae latinae originibus eruenda* ('On the most ancient wisdom of the Italians, unearthed from the origins of the Latin language'), 1.1. Vico's wording was 'Verum et factum reciprocantur seu convertuntur' ('The true and the made are convertible into each other').

[28] Timothy Costelloe, 'Giambattista Vico', *The Stanford Encyclopedia of Philosophy* (Fall 2018 Edition), ed. Edward N. Zalta, https://plato.stanford.edu/archives/fall2018/entries/vico/, (accessed on 13 Jan. 2021).

coming 'face to face with the people of a past age': 'The composite experience of all ages is part of each one of us; to deduct from that experience, to obliterate any part of it, to come face to face with the people of a past age, as if the middle age, the Renaissance, the eighteenth century had not been, is as impossible as to become a little child, or enter again into the womb and be born.'[29] Like Galton's composite portraits, we are all made up of the individuals of the past, a compressed and integral part of our beings, yet in an evolutionary progress of time where the process cannot be reversed and where the modern composite can never face the individual components of the past. The passage expresses Pater's awareness of the past as a gulf that can never be fully breached. Operating with the notion of rebirth, he took the very image of the term 'Renaissance' to its furthest consequence, in an experiment of time travel which becomes absurd in its literal implications. Much of Pater's popular reputation would rest on the very word 'Renaissance', and this seminal passage therefore becomes paradoxical. If we cannot come face to face with the past, how can we make it speak or bring it to life? Perhaps Pater's reluctance to introduce dialogue and direct speech in his portraits resided in this very awareness that direct encounters with those long dead were impossible, once their voices had been silenced. Where Landor's imaginary conversations, reissued in 1882, brought those long dead into fictitious dialogues, Pater made few attempts to reconstruct the voices of the dead. Free indirect discourse and interior monologues may take us back to the minds of the dead, but like Denys they are figures in a historic tapestry, captured and silenced by art. Only in gothic fiction do portraits move and speak, and Pater was well aware that his own portraits were characterized by their silence.

Walter Scott, Walter Pater, and the Collective Memory

In the 1820s Landor and Scott happily gave voices to the dead, perhaps in response to the generally increasing interest in history and historiography. In her study of Scott and Carlyle, Ann Rigney argued for new generic hybridities in what she called 'Romantic Historicism'. Looking back at the controversies created by White, she problematized the sharply drawn-up camps between hard-core historians, meta-historians, and literary scholars. Her degrees of fictionality invite us to think about the slippage into which Pater deliberately inserted himself:

> When White referred to historical narratives as 'verbal fictions', he was clearly out to provoke people into thinking more deeply about the permeability of the border between historical writing and other forms of expression and about the role of imagination in producing history. But if the slipperiness of the concept of 'fictionality'—its tendency to slide from the fictive, to the fictitious, to the fictional, to the novelistic, and from there to the associated terms 'literary' and 'aesthetic'— had a polemical function in getting reflection going, it has also tended to stymie that reflection by suggesting that the semantic links between the varieties of fiction

[29] 'Poems by William Morris', 307.

326 WALTER PATER'S EUROPEAN IMAGINATION

imply a necessary link between the phenomena they designate. Admissions that all historical writing is fictive in the sense that it is made and not found readymade on the archival shelf (the starting point for White's interest in fictionality) are too easily taken to imply automatically that historians invent the events they talk about, and that they do so as part of a game of make believe following the generic conventions of the novel and with the primarily aesthetic purpose of those texts we call literary.[30]

Addressing the blending in historical novels of imaginary and historical figures, Rigney raised the question of how a narrative can be 'historical in parts' only?[31] Most of Pater's imaginary portraits resemble the historical novel in intermingling the real and the imaginary, historical figures and invented ones, as Marcus Aurelius, Lucian, Montaigne, Ronsard, Bruno, Spinoza, and Watteau feature alongside Marius, Gaston, Sebastian, and Marie-Marguerite in a hybrid genre which makes us question what is real and what is fictitious. Many critics were reluctant to embrace such hybridity: 'Theorists have thus treated fictionality (and truth) like pregnancy: something you either are or are not, and cannot be just a little bit. Accordingly the goal of analysis has usually been to categorize utterances either as truth telling or as fictional, not to explain how it might be possible for them to be at least two things at once.'[32] In all his writings, Pater slips with delight into the grey-zone area where neither the truth nor the fiction test will come out positive. His studies of Renaissance figures blend anecdote with scholarship, as Pater sometimes poses as the positivist historian, pretending to have consulted historical documents—Leonardo's notebooks and Michelangelo's letters—while in actual fact relying on nineteenth-century biography and Vasari's entertaining anecdotes. In the imaginary portraits, the slippage between real places, real spaces, real historical events/artists/thinkers, and fictitious ones is constantly exploited to challenge the reader's mental and imaginative flexibility.

Like Pater's wall-flowers, the portraits are not free-standing; they may be written under the 'aegis of the fictionality convention', according to which the writer can freely invent and the reader can enjoy entering into a world of make-believe, but 'they also call upon prior historical knowledge, echoing and/or disputing other discourses about the past'.[33] Inevitably, Scott's novels and Pater's portraits draw upon the reader's knowledge of the past and on the ongoing collective attempts to represent that past. Without our knowledge of medieval France or seventeenth-century Holland, our understanding of Denys and Sebastian would be severely limited, and while Scott's plot-driven novels popularized history, sometimes even constituting an alternative to academic history, Pater was addressing the well-educated audience of *Macmillan's Magazine*. Where Scott, in blending historical and imaginary elements, mixed the genres of serious historiography with romance and sensational entertainment, Pater's portraits were devoid of both romance and sensation, as they had little plot, not much intrigue, but relied upon the reader's familiarity with political, cultural, and religious history, reflecting the extensive reading which had gone into their making. Pater relied so heavily on his readers' general knowledge of history that he frequently offered what Balzac referred to as the novel's representation of history *en*

[30] Rigney, *Imperfect Histories*, 5–6. [31] Ibid., 9. [32] Ibid., 17. [33] Ibid., 19.

déshabillé: a historical focus which is off centre, giving us not the best-known events in history but the minor ones, the repercussions in private lives of the grand public events. Pater's fascination with the periphery provides a twist to historical fiction; like Balzac his writings reflect the romantic awareness that history is not made exclusively of influential individuals. French historiography and Michelet in particular were keen to give a voice to the silences of history with Vico, whom Michelet translated in 1827 and 1835, as a significant go-between: 'Michelet discovered in Vico's ideas on society an anticipation of his own. Above all, he took from Vico the view that ordinary people played a decisive part in the course of history, which for that reason should not be confined to the deeds of monarchs, nobles, and generals. Translations of Vico accounted for the dissemination and popularity of his ideals during the Romantic era.'[34] The quiet lives which people Pater's portraits are an extension of the Vichian views of history which permeated much nineteenth-century historiography. The democratic aspect of most historical fiction shifted the focus from the heroes and heroines—often the subjects of two-volume biographies—to the minor figures in their orbits.

'To have been alive and literate in the nineteenth century was to have been affected in some way by the Waverley novels', John Henry Raleigh pointed out.[35] William St Clair has demonstrated the extraordinary dissemination of Scott's Waverley novels, both in the British Isles and abroad, in the century leading up to the First World War, even suggesting that Scott's novels were responsible for the chivalric mindset of the generation who signed up for the trenches.[36] The Waverley novels helped shape the European historical novel,[37] and were the favourite reading of Macaulay, Balzac, Manzoni, Merimée, and Michelet.[38] In her study of Scott and cultural memory, Rigney discussed how the past was becoming collective through the mediation of the Waverley novels.[39] Employing Maurice Halbwachs's concept of 'collective memory' from the 1920s, Rigney addressed the ways in which societies remember and how that remembrance is related to the shaping of collective identities. She asserted Scott's crucial role in the forging of a nineteenth-century sense of the past, not just a local Scottish one, but a British, and even a European one. In the aftermath of the French Revolution, a collective memory came to play an increasingly important part, Rigney argues. With a growing awareness that the past was different from the present, the nineteenth century invested massively in the cultivation of a collective memory, through museums, archives, publications, and education across Europe. Scott's novels were launched at exactly the right moment: the twenty-six Waverley novels appeared anonymously between 1814 and 1826, just as the Napoleonic Wars had ended and Europe was trying to find its feet. Georg Lukács's explicit linking of the rise of the

[34] Hamnett, 31.

[35] John Henry Raleigh, 'What Scott meant to the Victorians', in ed. Harry E. Shaw, *Critical Essays on Sir Walter Scott: The Waverley Novels* (New York: G. K. Hall, 1996), 47–69, 49.

[36] William St Clair, *The Reading Nation in the Romantic Period* (Cambridge: Cambridge University Press, 2004), 427.

[37] See the seminal role played by Scott in Georg Lukács, *The Historical Novel*, tr. Hannah and Stanley Mitchell (Harmondsworth: Penguin, 1976), 32–64.

[38] See Matthew Pittock, ed., *The Reception of Walter Scott in Europe* (London: Bloomsbury, 2007).

[39] Ann Rigney, *The Afterlives of Walter Scott: Memory on the Move* (Oxford: Oxford University Press, 2012), 5.

328 WALTER PATER'S EUROPEAN IMAGINATION

historical novel and the aftermath of the French Revolution places Scott at the very centre, forging 'a potent alliance between fiction, memory, and identity that was well-adapted to the modernizing conditions of his age':

> A manufacturer of collective memory par excellence, his novels inaugurated with the help of innovative narrative techniques a tradition of imaginatively engaging with the past that was at once highly personal, historically informed, and thoroughly synthetic. The success of his novels marked the beginning of a mass-media era in which collective memory was based on imagined experience reaching across enormous territories, rather than on lived experience and the sharing of stories in face-to-face contexts.[40]

Later in the century, the Waverly novels became primarily associated with the nursery, and by the time the Modernists got their hands on him, Scott had become a relic of the past, the kind of old-fashioned literature read by the elderly man in Joyce's 'An Encounter' (1905) and by Mr Ramsay in Woolf's *To the Lighthouse* (1927). 'Scott's cultural power lasted at most until World War I when, as if symbolically to mark the end of an era, some of the fonts for his collected works were melted down for munitions.'[41] In her 1924 essay on 'The Antiquary', Woolf relegated Scott to the past as an author incapable of interiority. Grouped with Dickens as a 'playwright novelist', Scott constructed characters who all shared the same 'serious disability': 'it is only when they speak that they are alive, for it is inconceivable that they ever sat down and thought, and as for prying into their minds or drawing inferences from their behaviour, he was far too true a gentleman to attempt it.'[42] In the revised version of the essay published posthumously in *The Moment and Other Essays* (1947) Woolf concluded by praising Scott as 'perhaps the last novelist to practice the great, the Shakespearean art, of making people reveal themselves in speech.'[43] In 1928 she placed 'Sir Walter Scott' on the list of those writers to whom she was indebted in her writing of *Orlando*, the list which ended with Walter Pater.[44]

Pater was, of course, the very reverse of a 'playwright novelist': all thought and interiority, and no speech. His staging of himself, his works, and his college rooms was on a much more modest scale than the grand historical performances laid on by the Laird of Abbotsford,[45] whose sense of business, timeliness, and monumentality was phenomenal. In terms of sheer published volume, print runs, and readership, Scott was on a different scale, and yet, as suggested by Woolf's juxtaposition of the two in her 'Preface' to *Orlando*, Pater is the missing link between Scott and Woolf. Brought up on Scott—Pater was reading him extensively in 1859 and kept referring to him throughout his writings—he found in the Scottish writer visions of the European Middle Ages, of the grand scope of historical fiction at moments of crises which he would imitate *en miniature* in his portraits, together with an interest in serialization in the sense of mutually connected narratives, linked by cross

[40] Ibid., 7–8. [41] Ibid., 16. [42] *EVW* 3:454–8, 456. [43] *EVW* 6: 436.
[44] 'Preface', *Orlando*, 5.
[45] See Ann Rigney, 'Abbotsford: Dislocation and Cultural Remembrance', in ed. Harald Hendrix, *Writers' Houses and the Making of Memory* (New York and London: Routledge, 2008), 75–91.

THE POETICS OF TIME 329

references.[46] The chronological scope of the Waverley novels reminds us of Pater's portraits:

1097: *Count Robert of Paris*;
1187–94: *The Betrothed, The Talisman, Ivanhoe*;
1307: *Castle Dangerous*;
1396: *The Fair Maid of Perth*;
1468–77: *Quentin Durward, Anne of Geirstein*;
1547–75: *The Monastery, The Abbot, Kenilworth, The Siege of Malta*;
1616–18: *The Fortunes of Nigel*;
1644–89: *A Legend of Montrose, Woodstock, Peveril of the Peak, The Tale of Old Mortality, The Pirate*;
1700–99: *The Black Dwarf, The Bride of Lammermoor, Rob Roy, Heart of Midlothian, Waverley, Guy Mannering, Redgauntlet, The Antiquary*;
Nineteenth century: *St Ronan's Well*.

The Scottish settings in the early novels were gradually expanded to include foreign sites: England, France, Belgium, Switzerland, Syria, and Turkey. Scott's Middle Ages were characterized by a transnational element, by the antagonism between the Normans and the Saxons with an awareness of the presence of the French in England. The coherence of European culture, which repeatedly surfaces in Scott's novels, was commented upon by Carlyle, when reviewing Lockhart's Scott biography in 1838: 'Curious: how all Europe is but like a set of parishes of the same county; participant of the self-same influences, ever since the Crusades, and earlier; —and these glorious wars of ours are but like parish-brawls, which begin in mutual ignorance, intoxication and boastful speech: which end in broken windows, damage, waste, and bloody noses; and which one hopes the general good sense is now in the way towards putting down, in some measure!'[47]

Scott had focused on moments of crises in European history: between the English and the French in the Middle Ages, the English Civil Wars in the seventeenth century, and the conflicts between the English and the Scottish in the seventeenth and eighteenth centuries. As Lukács pointed out, the view of history which underlies Scott's selection of historical moments is essentially a Hegelian one: 'the central historical question was to demonstrate the necessity of the French Revolution, to show that revolution and historical development are not opposed to one another... Hegel's discovery of the universal law of transformation of quantity into quality is, seen historically, a philosophic methodology for the idea that revolutions constitute necessary, organic components of evolution and that without such a "nodal line of proportions" true evolution is impossible in reality and unthinkable philosophically.'[48] For Scott, accordingly, this progress is 'always a process full of contradictions, the driving force and material basis of which is the living contradiction between

[46] For Pater's reading of Scott in 1859, see *Wright* 1:171 and Inman 1981, 6–7.
[47] Thomas Carlyle, 'Memoirs of the Life of Sir Walter Scott, Baronet', *Westminster Review* 27 (Jan. 1838), 154–82, 169.
[48] Lukács, 26.

330 WALTER PATER'S EUROPEAN IMAGINATION

conflicting historical forces, the antagonisms of classes and nations'.[49] Pater was known for his friendship with the Oxford Hegelian philosopher T. H. Green, for his own Hegelianism,[50] which reputedly secured him his fellowship at Brasenose College,[51] so it is hardly surprising if a similar historical interest in the evolutionary benefit of crises runs as an undercurrent in his own writings. If we draw up a list of the major part of Pater's portraits, we can see that wars, crusades, and revolutions (and their aftermath) form a part of the historical backdrop of his narratives:

The mythic founding of Athens, the wars against the Amazons: 'Hippolytus Veiled';
AD 166 to AD 180, Marcomannic Wars: *Marius the Epicurean*;
1209–29, Albigensian Crusades: 'Tibalt the Albigense';
1358, Jacquerie, the French Peasants' revolt:'Denys l'Auxerrois';
1562–98, French Wars of Religion: *Gaston de Latour*;
1618–48, Thirty Years' War: 'Sebastian van Storck';
1701–14, War of the Spanish Succession: 'Prince of Court Painters';
1700–21, Great Northern War and
1740–8, War of the Austrian Succession: 'Duke Carl of Rosenmold';
1803–15, Napoleonic Wars: 'Emerald Uthwart'.

Yet no one would describe Pater's portraits as historical texts in which war figures as a major theme. Often, war is alluded to briefly, in passing reference to departing soldiers, popular upheavals, a wife lost, war monuments, or, exceptionally in the case of 'Emerald', a transformative event which leaves the protagonist with a lasting wound. It is the impact of war and crises on the individual human mind which interests Pater, whether in the study of Gaston's navigational skills among intellectuals and courtiers during the French Wars of Religion, or Marius's loss of a close friend through the plague brought from the East, or Marie-Marguerite's struggles with a new French, rather than Flemish, identity. Although Pater's monofocal portraits are less democratic than most of the multifocal historical fiction which tends to have a wide gallery of characters, Pater aligns himself with the nineteenth-century historical novel, summed up by Lukács:

> What matters therefore in the historical novel is not the retelling of great historical events, but the poetic awakening of the people who figured in those events. What matters is that we should re-experience the social and human motives which led men to think, feel and act just as they did in historical reality. And it is a law of literary portrayal which first appears paradoxical, but then quite obvious that in order to bring out these social and human motives of behaviour, the outwardly

[49] Ibid., 57.

[50] See Ward (1966); Whiteley (2010); Kit Andrews, 'Walter Pater as Oxford Hegelian: Plato and Platonism and T. H. Green's 'Prolegomena to *Ethics*', *Journal of the History of Ideas* 72:3 (July 2011), 437–59. Kate Hext 2013, however, disagrees, and places Pater within the philosophical contexts of Locke, Hume, Kant, and Schiller instead.

[51] See *Wright*, 1:211.

insignificant events, the smaller (from without) relationships are better suited than the great monumental dramas of world history.[52]

Where romantic hero-worshippers, such as Carlyle, would explain the age on the basis of the great individuals (Cromwell, Napoleon, Robespierre), Pater and Scott let their figures grow organically out of the age. The poetics of time may mould history, but the reverse process is equally relevant: time moulds people. Like Pater, Scott rarely wrote explicitly about contemporary affairs, yet the relevance of the past for the present in the shaping of character inevitably provokes questions about how we become who we are and the extent to which we are indebted to the times in which we live. Although Scott's novels are so stylistically different from Pater's portraits, Scott was a continuous reference point as a romantic precursor in historical fiction, concerned with the impact of time upon character, with the broader sweeps of European history, and collective memory.

Pater's 'Diaphaneitè' was inextricably associated with Scott as a text read aloud in the essay society named after one of the Waverley novels: *The Tale of Old Mortality* (1816). The eponymous aged stone mason, who features early in the novel as a travelling restorer of inscriptions on the graves of the Scottish Covenanters, is himself a memory-maker as he brings the commemorations of the long dead back to life again with his chisel, a meta-comment on the erosion of memory by time. The short-lived Oxford Society (1856 to 1866), founded by ambitious undergraduates, primarily from Balliol College, reflected the clash within Balliol life between Arnoldian students, brought straight to Balliol from Rugby, and Glaswegian Snell exhibitioners, brought up on Carlyle's writings and German idealism. As Monsman notes, commenting on the liberalist and radical views held by most members, 'These future poets, critics, historians, philosophers, professors, clergymen, and public servants who met weekly in each other's rooms, were fiercely dedicated to social amelioration, liberty of thought, and the ultimate validity of human reason in things secular and sacred. If they could no longer lay claim to the Covenanters' faith of their namesake in Scott's novel, they could at least echo that unconquerable independence of spirit to which Old Mortality's eccentric vocation bore witness.'[53] The 'History of the Old Mortality Society' in the Minute Book declares that the Society took 'mortality for its style' because 'mortality itself hath the seeds and peradventure even the form of Immortality.'[54] Essays on history and the philosophy of history featured regularly: Herodotus, Thucydides, Gibbon, Hume, Fichte, Carlyle, Froude, alongside essays on English literature from Bede to Browning.[55]

When Pater joined the Society, he heralded the first revolutionary tones of aestheticism which did not go down well. S. R. Brooke recorded listening to one of his essays on 20 February 1864: 'Pater's Essay this evening was one of the most thoroughly infidel productions it has ever been our pain to listen to. The writer in fact made no secret of his ideas. He advocated "self-culture" upon eminently selfish

[52] Lukács, 44. [53] Monsman 1970, 366.
[54] The Minute Book is now in the Bodleian Library, MS. Top. Oxon. D. 242. Quoted in Monsman 1970, 361.
[55] Ibid., 364.

332 WALTER PATER'S EUROPEAN IMAGINATION

principles, and for what to us appeared, a most unsatisfactory end. To sit in one's study all [day?] and contemplate the beautiful is not a useful even if it is an agreeable occupation.'[56] On another occasion, Pater advocated 'Subjective Immortality', a notion that all humans live on in the minds and memories of their friends, long after they are dead, a theory not appreciated by the critical Brooke either.[57] The young Pater aired ideas of transcendence and introversion verging on narcissism, in contrast to the heartier Scottish radicalism on which the Society rested. The new type of diaphanous protagonist sprang from the mind of Pater who, according to one of the other members, had such a 'speculative imagination' that it 'seemed to make the lights burn blue'.[58] Taking the subject of immortality into the spheres of male friendship and imagined communities, Pater challenged conventional notions of mortality as he laid down new paths for the inscription of the past upon the present.

Scott is a recurrent figure across Pater's writings, mentioned together with Shakespeare in the Coleridge essay (1866), in the Lamb essay (1878) for his border characters full of local colour, and a brief reference in the Dionysus essay (1876). Pater was refining his ideas of Scott as a kind of 'romanticism light', not as heavily romantic as Emily Brontë or Théophile Gautier. In one of the Houghton manuscripts, given the title 'The Young Romantic',[59] Scott is grouped with Goethe's *Götz von Berlichingen* as northern European manifestations of the 'strong, boisterous, naïve, strenuous, unperplexed middle ages'.[60] The manuscript contains the seeds of 'An English Poet' and Pater's 'Romanticism' essay, first published in *Macmillan's Magazine* in 1876, and subsequently included as the 'Postscript' of *Appreciations* where it picks up the approximation of genres, disciplines, and forms introduced in 'Style', now with the distinction between classical and romantic, discussed through references to Goethe, Stendhal, Sainte-Beuve, and other European writers. Pater's argument is essentially that the oscillation between the classical and the romantic spirit has been a recurrent feature since 'the very beginning of the formation of European art and literature'.[61] Sophocles and Dante appear as ancient and medieval manifestations of the romantic spirit, driven by a curious desire for the strangeness of beauty. Scott makes a cameo appearance no fewer than three times, first as an early manifestation of the romantic spirit:

> And as the term *classical* has been used in a too absolute, and therefore in a misleading sense, so the term *romantic* has been used much too vaguely, in various accidental senses. The sense in which Scott is called a romantic writer is chiefly that, in opposition to the literary tradition of the last century, he loved strange adventure, and sought it in the middle age. Much later, in a Yorkshire village, the spirit of romanticism bore a more genuine fruit in the work of a young girl, Emily Brontë— the romance of *Wuthering Heights*; the figures of Hareton Earnshaw, of Catherine Linton and of Heathcliffe [sic], with his tears falling into the fire, tearing up

[56] Brooke's diary is quoted in ibid., 371. [57] Ibid., 380.
[58] William Knight, *Memoir of John Nichol* (Glasgow: J. Maclehose & Sons, 1896), 150. Quoted in Monsman, 385.
[59] 'The Young Romantic', Houghton bMS Eng. 1150 (21). [60] Ibid., 1v.
[61] 'Romanticism', 65.

THE POETICS OF TIME 333

Catherine's grave and removing one side of her coffin, that he may really lie beside her in death, —figures so passionate, woven on a background of delicately beautiful, moorland scenery, —being typical examples of that spirit.[62]

Compared with Heathcliff's necrophilia, Scott's medieval adventures seem rather tame. Scott's preoccupation with the Middle Ages would seem to make him a romantic, as Pater pushes back Romanticism to the thirteenth, fourteenth, and fifteenth centuries in a peculiarly circular argument: 'The essential elements, then, of the romantic spirit are curiosity and the love of beauty; and it is, as the accidental effect of these qualities only, that it seeks the middle age; because, in the overcharged atmosphere of the middle age there are unworked sources of romantic effect, of a strange beauty, to be won, by strong imagination, out of things unlikely or remote.'[63] Pater was aware of what a problematic term 'Romanticism' had become by 1876 and made no attempts to simplify matters. At the risk of sounding like the stern Emilia Pattison, some comment on Pater's use of terms is called for, as no serious historian would be pleased with his periodization: the Middle Ages are romantic and the Renaissance begins in the Middle Ages and lasts until the eighteenth century. And who knows if we may not regard the Renaissance spirit as essentially romantic after all? Certainly, Pater's Botticelli pursued the strangeness of beauty, and with the strong Baudelairean undertones of his Leonardo and Ronsard, we may well be convinced of the romanticism of the Renaissance. Pater is deliberately collapsing the boundaries between past and present in the 'Postscript', as he juggles well-established periodical and stylistic terms to suit his argument. No wonder the Old Mortals complained that he could make the light turn blue with his philosophizing; as an undergraduate, he must have been a challenge to any college tutor. We become uncertain about his own position: is he a romantic medievalist, or a manifestation of the Renaissance spirit with a touch of the classical in him? As he assigns labels to leading figures of his own century, Pater throws the game back at us: do we accept these categories? Is Pater himself essentially a product of the German, the English, or the French School of Romanticism? The flux of his periodization is linked to his 'subjective immortality', as the romantic spirit of Sophocles travels through generations and reappears in Dante and Hugo. Writing, reading, and transmission lead to immortality, similar to the male begetting of artistic schooling which Pater had pursued among his Renaissance artists. Romanticism becomes a kind of collective memory, linking generations of writers and artists, all driven by a similar desire for the strangeness of beauty.

Just as we thought that Scott had been dismissed as not quite romantic enough, he reappears in a central passage defining the romantic spirit, this time coupled with the French arch-romantic, Victor Hugo:

Its desire is towards a beauty born of unlikely elements, by a profound alchemy, by a difficult initiation, by the charm which wrings it even out of terrible things; and a trace of distortion, of the grotesque, may perhaps linger, as an additional element of

[62] Ibid., 64. [63] Ibid., 66.

expression, about its ultimate grace. Its flowers are ripened not by quiet, everyday sunshine, but by the lightening, which, tearing open the hill-side, brought the seeds hidden there to a sudden, mysterious blossoming. Its eager, excited spirit will have strength, the grotesque, first of all, —the trees shrieking as you tear off the leaves; for Valjean, the long years of convict life; for Redgauntlet, the quicksands of Solway Moss; then, incorporate with this strangeness, superinduced upon it, intensified by restraint, as much sweetness, as much beauty, as is compatible with that.[64]

The mixing of sweetness with the grotesque is an essential feature of Pater's Romanticism, and Scott qualifies eminently. Solitude, exile, and the sudden fear of death in a sublime landscape contribute to the romantic spirit. Pater oscillates between representing the romantic spirit as a transnational phenomenon, occurring in all western European cultures, while staging a mini-competition between the three major European cultures—Germany, England, and France—as to who is the most genuinely romantic. Scott represents England, together with Byron (Pater seems to have forgotten the writer's not insignificant Scottish dimension). Towards the end of the 'Postscript', there is a sense of the waning of the Middle Ages in the North, when Pater makes one of his rare comments on modern history: the Franco-Prussian War has most likely killed off the last remains of the Middle Ages and with it, German Romanticism, he suggests. The return to Germany of Strasbourg—seat of medieval architecture and of Goethe's encounter with Herder—marks a new era when the torch of romanticism has been handed to France, with the English romantics as relatively insignificant go-betweens:

> [T]o many English readers the idea of romanticism is still inseparably connected with Germany—that Germany which, in its quaint old towns, under the spire of Strasburg or the towers of Heidelberg, was always listening in rapt inaction to the melodious, fascinating voices of the middle age, and which, now that it has got its Strasburg back again, has, I suppose, almost disappeared. But neither Germany, with its Goethe and Tieck, nor England, with its Byron and Scott, is nearly so representative of the romantic temper as France, with Mürger, and Gautier, and Victor Hugo.[65]

With the romantic temper at its most characteristic in contemporary France, Pater makes it abundantly clear that romanticism is still with us, in a revolutionary form inaugurated by Rousseau just before the French Revolution. It becomes part of the spirit of the age: 'the scholar will still remember that if "the style is the man" it is also the age.'[66] Having done his best to do away with conventional periodization, Pater links the 'Postscript' to Buffon's 'Le style c'est l'homme même', and puts romanticism back into its conventional late eighteenth-/early nineteenth-century context. The figure of Scott provides a *fil rouge* throughout and becomes part of the common heritage, a familiar national writer, a revivalist, flirting with the grotesque strangeness of beauty, part of a small canon of English romantics. Scott rarely stands alone in Pater;

[64] Ibid., 66. [65] Ibid., 66–7.

[66] *Appreciations*, 263. The passage is not in the 1876 periodical version.

he is usually coupled with some greater writer: Shakespeare, Brontë, Hugo, or even Byron. The rather ordinary heroes of Scott's novels need to be juxtaposed with something more colourful: Hugo himself, as early as 1823 when reviewing Scott's *Quentin Durward*, was aware that Scott was only a beginning and that something grander had to be created in the line of historical fiction: 'After the picturesque, but prosaic, romance of Walter Scott, a different romance remains to be created, yet more beautiful and complete in our view. This is the romance, at once both drama and epic, picturesque but poetic, real but ideal, true but great, which will enshrine Walter Scott in Homer.'[67]

The question is, of course, where Pater saw himself in relation to Scott. He wrote his portraits at a time when, according to most modern critics, the historical novel had lost its momentum, with Manzoni, Flaubert, and Eliot as the last manifestations of a genre which had been flourishing for just over half a century. While challenging conventional periodization in his essays, Pater was relatively accurate in his historical demarcation of period settings for his portraits. His provocative use of such terms as 'classic', 'romantic', and 'renaissance' advocated a fluid understanding of cultural history, but his own reading of nineteenth-century historiography ran deep, and he made thorough efforts to construct evocative historical settings for his protagonists. Mass events do occasionally occur (the religious festivals in *Marius*, the armies returning, the party of artists in Sebastian's home, Speech Day in Emerald, the crowds tearing Denys to bits), but they are brief scenes which foil the protagonist. Compared to the crowds and broad masses of much historical fiction, Pater was engaged on a different mission. He was not interested in the turmoil of the crowds, in the broad panorama of the people at large. His interest was in the outsider, in the individual who does not blend with the masses.

Jules Michelet: Renaissance, Revolution, and Resurrection

Lukács found in the French Revolution and the Napoleonic Wars a new kind of mass experience which for the first time gave the European population a sense of history, national and European. Both crises radically changed the ways in which war was conducted on European territory, by mass armies rather than flocks of mercenaries, now involving large parts of the population not previously engaged in war, moving them from one corner of the Continent to another:

> Whereas the wars fought by the mercenary armies of absolutism consisted mostly of tiny manoeuvres around fortresses, etc., now the whole of Europe becomes a war arena. French peasants fight first in Egypt, then in Italy, again in Russia; German and Italian auxiliary troops take part in the Russian campaign; German and Russian

[67] My translation. 'Après le roman pittoresque, mais prosaïque de Walter Scott, il restera un autre roman à créer, plus beau et plus complet encore selon nous. C'est le roman, à la fois drame et épopée, pittoresque mais poétique, réel mais idéal, vrais mais grand, qui enchâssera Walter Scott dans Homer.' Victor Hugo, 'Sur Walter Scott: A propos de *Quentin Durward*', in *Œuvres complètes*, ed. Jacques Seebacher and Guy Rosa, 15 vols (Paris: Laffont, 1985), 10:149.

troops occupy Paris after Napoleon's defeat, and so forth. What previously was experienced only by isolated and mostly adventurous-minded individuals, namely an acquaintance with Europe or at least certain parts of it, becomes in this period the mass experience of hundreds of thousands, of millions. Hence the concrete possibilities for men to comprehend their own existence as something historically conditioned, for them to see in history something which deeply affects their daily lives and immediately concerns them.[68]

Pater was well aware of such crowds; he had absorbed them from Hugo, Michelet, Carlyle, and Dickens, and, given his interest in the impact of crises on the individual, one might ponder why there is no imaginary portrait set at the time of the French Revolution. Perhaps we should look for the Revolution in more indirect ways in Pater's *oeuvre* and trace his notion of revolutions back to Michelet, who saw revolutions as a recurrent phenomenon in political and cultural history. Pater certainly regarded the French Revolution as a significant watershed moment, marking a clear 'before' and 'after'. His manuscript note for the third novel in his trilogy uses the perfect tense about the Revolution to indicate its having been, as an event distinctively of the past, yet familiar enough to be abbreviated:

> Thistle.
> The beginning of this cent. in Eng/d.
> Rousseau & Voltaire, have been.
> Kant, has been—opening a double way.
> The Fr. rev/n has been.
> STC, Keats, Shelley, Wordsworth, Byron, are around.[69]

Linda Orr addressed the ' "black hole" in French literature', the absence of nineteenth-century fiction dealing directly with the Revolution: 'Oddly enough, in France there was no *Tale of Two Cities*, *Danton's Death*, or Hegelian philosophy theorizing the Jacobins. Was the experience of the Revolution too close, too volatile for the French to make a fictional masterpiece of it?'[70] While crowds in Stendhal and Flaubert allude to revolutionary crowds, it would seem that fictionalizing Marat or Robespierre or the revolutionary events moved into the sphere of history writing. In many ways the distinction between literature and history among the French romantic historians is blurred, not to say indistinguishable.[71] Michelet's portrait of Robespierre, for instance, has clear literary qualities which go for his rendition of many historical personages, as Bann suggested: 'Michelet is the master of what Barthes has fittingly called the "reality effect": that imaginative supplementation of the historical account with details which may be factually based or may be probable extrapolations, but

[68] Lukács, 21–2. [69] 'Thistle', Houghton bMS Eng. 1150 (31), 3r.

[70] Linda Orr, *Headless History: Nineteenth-Century French Historiography of the Revolution* (Ithaca and London: Cornell University Press, 1990), 17.

[71] Ibid., 23.

have the role of confirming its historicity through the very vividness and, as it were, unmotivated immediacy of their effect.'[72]

Pater can hardly have felt too close to the French Revolution to not write about it. He digested the horrors of the French Revolution and its Napoleonic aftermath in elegiac form in 'Emerald Uthwart'. The narrative alludes to the destructive consequences of both the English Civil War and the Napoleonic Wars; England had had its revolution in the seventeenth century and was, in its way, like modern France, a post-revolutionary nation. The Oxford episode in Emerald's life refers to the tragic execution of Colonel Francis Windebank during the Civil Wars,[73] a story Pater had imbibed from Carlyle's *The Letters and Speeches of Oliver Cromwell* (1845). Windebank was shot in Oxford on 3 May 1645, following trial by Royalist Court-Martial for the surrendering of Bletchingdon House to Parliamentary Forces.[74] In Pater's narrative, Windebank's death becomes the precursor of Stokes and Emerald's death sentences at Wellington's Court-Martial, an exposure of the meaningless loss of young lives at times of war when the price of a human life ran low. Having left the garden of England and gone abroad to fight on the Continent, Emerald literally expires with the end of the Napoleonic Wars, testifying to the destructive forces of the mass movements set about by the Revolution. An innocent victim, brought up to believe in the glories of warfare, the encounter with the human costs of war offers a different kind of green world, as Emerald and Stokes reach Hougoumont near Waterloo:[75] 'Following, leading, resting sometimes perforce, amid gun-shots, putrefying wounds, green corpses, they never lacked good spirits any more than the birds warbling perennially afresh, as they will, over such gangrened places, or the grass which so soon covers them.'[76] Soon, smothered in fragrant flowers, Emerald will join the green corpses, albeit on the other side of the Channel.

Pater may not have written about the French Revolution, but he certainly read about it. Between 1868 and 1872 he had been borrowing volumes from Michelet's monumental *Histoire de France*,[77] and over a twelve-year period (1873 to1885) he repeatedly took out Émile Erckmann and Alexandre Chatrian's four-volume novel *Histoire d'un paysan 1789–1815. La Révolution française racontée par un paysan* (1869) from the Taylorean Library.[78] Erckmann and Chatrian were known for their colourful, often macabre, co-authored fiction with plenty of lively dialogue, and Pater's return to this fictitious eye-witness account of the Revolution is intriguing.

[72] Bann, 50.

[73] From 1642 to 1646 Oxford housed Charles I and his Queen, expelled from London by Cromwell. Oxford was split, with the Town favouring Parliamentarianism, the Gown the Royalist cause. In 1644 Charles I set up the Oxford Parliament; and only after three sieges, in 1644, 1645, and 1646, did the city surrender to the Roundheads.

[74] The Royalist Governor of Campden House, Sir Henry Bard, had written to Prince Rupert on 28 April 1645, asking him to pardon Windebank on account of his great military merits. The Prince never received the letter and arrived at Oxford only one day after the execution for cowardice of Windebank. 'Poor Windebank was shot by sudden Court-martial, so enraged were they at Oxford, —for Cromwell had not even foot-soldiers, still less a battering-gun. It was his poor young Wife, they said, she and other "ladies on a visit there", that had confused poor Windebank: he set his back to the wall of Merton College, and received his death-volley with a soldier's stoicism.' *Cromwell's Letters and Speeches* in *The Works of Thomas Carlyle*, ed. Henry Duff Traill, 30 vols (Cambridge: Cambridge University Press, 1897), 6:204.

[75] The site is originally described in Hugo's *Les Misérables* (1862) 2:1:2. [76] *CW* 3:192.

[77] See Inman 1981. [78] Inman 1981, 326 and Inman 1990, 440, 462.

338 WALTER PATER'S EUROPEAN IMAGINATION

The authors' republican stance transpired from the very beginning where the narrator addressed the readers, a man of the people speaking to the people. Having seen through all the mechanisms of the *Ancien Régime*, he desired to tell his modern readers how they had achieved their freedom and human rights: without the Revolution, he declared, they would most likely still be enslaved. The tone is proud, passionate, the embers of the Revolution still burning,[79] and Pater's reading of this book must tell us something about him which scholars do not generally address. This is popular literature, directing our attention to narrative point of view—the Revolution seen from the frog's rather than the bird's perspective—yet nevertheless giving us the *Déclaration des droits de l'homme et du citoyen decretée par l'Assemblée nationale constituante de 1789* and the *Constitution de 1793* verbatim as historical documents to study within a peasant's narrative. With clear egalitarian messages, the Erckmann-Chatrian volumes brought the significance of the Revolution straight into the Second Empire, shortly before its demise and the defeat in the Franco-Prussian War.

While researching the culture of the ancients for *Marius* in 1882, Pater had borrowed the German classicist Wilhelm Adolf Becker's two portraits of the domestic lives of young Romans and Greeks of the 1840s: *Gallus, or Roman Scenes of the Time of Augustus* and *Charicles, or Illustrations of the Private Life of the Ancient Greeks.*[80] Abounding in domestic and historical detail, heavily footnoted, Becker's two volumes afforded Pater access to the everyday lives of antiquity, not unlike the way in which Lawrence Alma-Tadema would study ancient sources and archaeology in order to get his Roman interiors as 'realistic' as possible. The Erckmann-Chatrian novel was likewise attempting to bring history to life through a kind of romance, through the study of one imaginary individual, but its political purpose went far beyond the archaeological and was nourished by propaganda rather than footnotes. Pater's reading of these works reflected his interest in the historical European individual, while also illustrating the span in historical discourse. In French nineteenth-century historiography—and perhaps Pater is right here—the spirit of romanticism infused the ways in which even archival historians (Michelet was for years employed in the Record Office) thought and wrote about the past and their own role as historians. The subjectivity of many of the French romantic historians is in sharp contrast to the dry-as-dust tone of some of the German history, mythology, and archaeology Pater consulted.

Michelet was a major influence on Pater in many ways: stylistically, his pictorial language and rhythmical prose, together with his subjective stance, left an impact on Pater's own mode of writing. A manuscript fragment entitled 'The Youth of

[79] 'Moi, je suis un homme du peuple, et j'écris pour le peuple. Je raconte ce qui s'est passé sous mes yeux.... C'est donc l'histoire de vos grands-pères, à vous tous, bourgeois, ouvriers, soldats et paysans, que je raconte ; l'histoire de ces patriotes courageux qui ont renversé les bastilles, détruit les privilèges, aboli la noblesse, proclamé les Droits de l'homme, fondé l'égalité des citoyens devant la loi sur des bases inébranlables, et bousculé tous les rois de l'Europe, qui voulaient nous mettre la corde au cou.' Émile Erckmann and Alexandre Chatrian, *Histoire d'un paysan 1789–1815. La Révolution française racontée par un paysan*, 4 vols (Paris: Hetzel & Cie, 1886), ii–iii.

[80] Inman 1990, 450.

THE POETICS OF TIME 339

Michelet',[81] presumably composed around 1884 when Pater borrowed Michelet's *Ma Jeunesse* from the Taylorian Library,[82] looks like the beginning of a book review, praising Michelet as one of the greatest nineteenth-century writers in France in a nation already rich in literary excellence. His 'literary genius' and his 'inexhaustible poetic power' contributed towards making his *History of France* one of the 'chief literary monuments' in the century,[83] but it would appear to have been the many 'painful incidents of his youth' which caught Pater's interest in the fragmented book review which breaks off into long passages of translation from Michelet's autobiography, interspersed with passages in French. The Sainte-Beuvian interest in the coming into being of literary genius, in spite of hardship, makes itself felt very clearly in the manuscript. Some five years later Michelet was granted three mentions in 'Style': praised for his 'mystical and intimate prose' with Plato and Thomas Browne;[84] joined with Livy and Tacitus as historians full of a delicate sensitivity to the records of the past, raised to the level of modifiers rather than mere transcribers of facts, and hence producing a kind of history which passes into the realm of 'art proper';[85] and finally, singled out (together with Cicero and Newman) for employing the varied charms of poetry in their prose, with the result that every syllable of their writing was granted musical value.[86] Michelet's prominent status in Pater's great theoretical essay about writing gives us some sense of his importance. Mentioned in the very best stylistic and literary company, Michelet takes a central position. When it came to ideas about history in general, about the Renaissance in particular, and about the need for history to address those long silenced by historiography, Michelet was seminal for Pater.

In 1869 Michelet published the lengthy 'Preface' to his *Histoire de France*. Full of self-reflection, autobiographical in parts, it imposes the historian's persona upon the multi-volume opus which it prefaces as Michelet collapses subject and object in a manner which is more literary than scientific. The extent to which this historian is a construct or the 'real' Michelet has been much debated; whatever the answer, the author produced powerful writing begging to be unpicked by the meta-historians of the twentieth century. For Pater, he would have qualified among the Montaignesque writers: '*je suis moi-même le sujet de mon livre*' certainly applies to the 'Preface' and to aspects of the ensuing volumes. In the plastic process of history writing, Michelet saw himself as the product rather than the maker:

> It is a fact that history, in the progress of time, makes the historian much more than it is made by him. My book has created me. It is I who became its handiwork. The son has produced the father. If it first issued from me, from my storm of youth (which still rages), it has made me much stronger, more enlightened, even given me more fertile warmth, more actual power to resurrect the past. If my work resembles

[81] 'The Youth of Michelet', Houghton bMS Eng. 1150 (28). [82] Inman 1990, 461.
[83] 'The Youth of Michelet', Houghton bMS Eng. 1150 (28), fol. 1 recto.
[84] 'Style', 728. [85] Ibid., 730. [86] Ibid., 731.

340 WALTER PATER'S EUROPEAN IMAGINATION

me, that is good. The traits which it shares with me are in a large part those which I owe to it, which I took from it.[87]

If Pater had visited the Père-Lachaise cemetery in Paris (which he might well have done, given that he was working on *Gaston* in the mid-1880s), he would have come across the grand marble monument to Jules Michelet, funded by international subscription and erected in 1882 (Fig. 7.1).[88] The intricate merging of commemoration, revolution, republicanism, and resurrection in the monument's elaborately conceived iconography is powerful.[89] From the peacefully reclining body of the dead Michelet, Clio, the Muse of History—who bears an intended resemblance to the revolutionary Marianne in Delacroix's *Liberty Leading the People* (1830)—rises triumphantly, a scroll in her left hand signifying the *Histoire de France*, while pointing with her right hand to the inscription '*L'Histoire est une resurrection*'. After Michelet had died in the South of France in 1874, his body had been brought back to where it all began:

> I had a fine disease which clouded my youth, but which was well suited to an historian. I loved death. I had lived for nine years at the gates of the Père-Lachaise cemetery, which was at that time the only place where I could take a walk. Then I lived near the Bièvre district of Paris, amidst large gardens adjoining convents, another kind of sepulchre. I led a life which the world would have described as a buried one, having no company other than the past, and for friends, entombed peoples. By recreating their legends, I awakened in them a multitude of vanished things.[90]

Repeatedly, Michelet evoked the idea of history as resurrection, of his own role as one called upon by the unnumbered Dead to give a voice to their silenced lives. In haunting prose, he imagined the French people reaching out to him, begging to be remembered, committed to pages of print:

> [T]he silences of history must be made to speak, those terrible pedal points in which history says nothing more, and which are precisely its most tragic accents. Then only will the dead be resigned to the sepulchre. They are beginning to understand their destiny, to restore the dissonances to a sweeter harmony, to say among themselves, and in a whisper, the last words of Oedipus: Remember me. The shades greet each other and subside in peace. They let their urns be sealed again. They scatter, lulled by friendly hands, fall back to sleep and renounce their dreams.[91]

...

[87] Jules Michelet, 'Preface' to *The History of France* (1869), tr. Edward K. Kaplan (Cambridge: Open Book Publishers, 2013), 133–61, https://books.openedition.org/obp/1389?lang=en (accessed on 29 Jul. 2020).

[88] For an account of the monument's coming into being, see Camille Creyghton, 'Commemorating Jules Michelet 1876, 1882, 1898: The Productivity of Banality', *French History* 33:3 (2019), 399–421.

[89] For a fine discussion of history as resurrection in Michelet, see Hilary Fraser, *The Victorians and Renaissance Italy* (Oxford: Blackwell, 1992), ch. 1, 'The Resurrection of the Dead'.

[90] Michelet, 'Preface'.

[91] Quoted from Roland Barthes, *Michelet*, tr. Richard Howard (New York: Hill & Wang, 1987), 103.

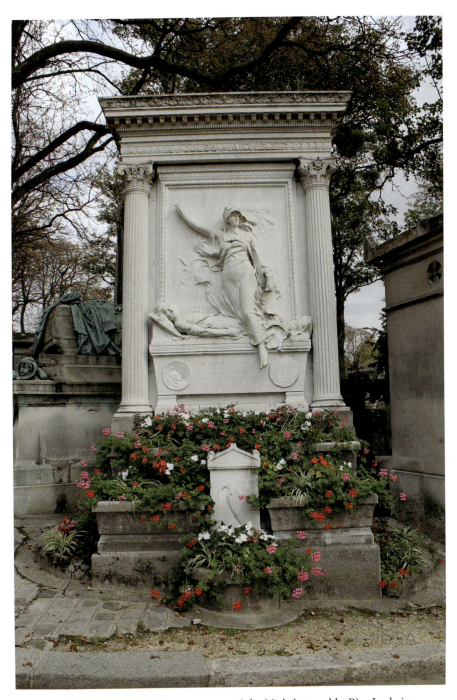

Fig. 7.1. Antonin Mercié, *Tomb monument to Jules Michelet*, marble. Père Lachaise Cemetery, Paris. Wikimedia Commons.

In the lonely galleries of the Archives where I wandered for twenty years, in that deep silence, murmurs nevertheless could reach my ears. The distant sufferings of so many souls, stifled in those ancient times, would moan softly. Stern reality protested against art, and occasionally had bitter words for it: 'What are you fooling around with? Are you another Walter Scott, recounting picturesque details at great length, the sumptuous meals of Philip the Good, the empty Oath of the Pheasant? Do you know that our martyrs have been expecting you for four hundred years?'[92]

Pater shared with Michelet a love of the macabre, a fascination with death and the resurrection. Gaston's solitary visit to the Cimetière des Innocents, where the dead erupt from their tombs, is Pater's response to Michelet's Père-Lachaise. The past refuses to be boxed in and will out, even in hideous and violent form. Florian's wandering alone among the open graves, sensing his recently dead friends reaching out to him, the haunted house still inhabited by the spirits of the past, are aestheticized responses to Michelet's philosophy of history. The living always carry the dead with them, and their stories are inextricably intertwined with those of generations past. The figure of the *revenant* is a recurrent one, not only with Pater but also with James and Lee;[93] as the fifteenth-century sculptors live on in Michelangelo, and the *Mona Lisa* travels between the grave and modernity, the resurrectionist stance matches Pater's long lines of cultural continuity. Reconstructing the past, Pater deconstructs the present, as J. B. Bullen points out. As he frequently lapses into the present tense when writing about Renaissance artists, he foreshortens the reader's sense of historical distance.[94] If Michelangelo and Leonardo have aspects of the *revenants* about them, they are as romantic as Brontë's Heathcliff who believes in life after death where desires forbidden among the living can be fulfilled.

Orr has commented on the ways in which Michelet frequently appealed to the popular reader, through rhetorical questions or the dramatic present tense, or even by embodying a reader of the people within his text: 'His competition is not "cold history", he knows, but the novels of Balzac and Sand (the tradition of Walter Scott). Michelet aspires to the audience of *La femme de trente ans*. But Michelet's *oeuvre* remains split between the upper bourgeois male reader of his history books and the (female?) reader of his books that sold for Fr. 3.50.'[95] In 1846, the year before he began writing his *History of the Revolution* (1847–53), Michelet published a volume with the title *Le Peuple*; he saw himself as the people's historian and his historical works as an integral part of nation formation. In his history of the French people, he asserted how the Revolution had forever branded itself on the national identity, both within France and abroad: 'In the eyes of Europe, let it be known, France will always have but one inexpiable name, which is her true name in eternity: the Revolution.'[96] Romantic historiography had to succeed where 1793 had failed; the dilemma of Michelet and several of his fellow historians was closely related to the challenges of

[92] Michelet, 'Preface'.

[93] See Andrew Eastham, 'Aesthetic Vampirism: The Concept of Irony in the Work of Walter Pater, Oscar Wilde and Vernon Lee', in Eastham, *Aesthetic Afterlives: Irony, Literary Modernity and the Ends of Beauty* (London: Continuum, 2011), 36–60.

[94] Bullen 1994, 275–6. [95] Orr, 86.

[96] Michelet, 'Preface' to *Le Peuple* (1846), quoted in Barthes, 77.

THE POETICS OF TIME 343

living with the disappointment of the sequels to the Revolution. Barthes suggested that the 1789 revolution became the incarnation of the revolutionary principle for Michelet, with the effect of almost killing time: 'Since the Revolution fulfils time, what can be the time that comes after the Revolution and that is precisely the time in which Michelet is living? Nothing, if not a post-History. The nineteenth century is quite awkward; why does it continue, since it has no further place in the combat of freedom? And yet it exists. Then what is it?'[97]

Struggling to grapple with the 'post-History' of 1789, Michelet retreated to the Middle Ages and discovered the revolutionary principle among the peasants in rural France, in the inscription by the local people in the bell in the Cathedral of Rheims: 'It is here that he realized that the Revolution was a totality which nourished every moment of History and that it could consequently be posited at any point in time without thereby troubling the profound order of events: it was always in its place, wherever it was.'[98] In his 'Preface' to the *Histoire de France*, Michelet conjured up the figure of the medieval peasant, Jacques Bonhomme, as the one beckoning him to write the story of his sufferings:

> France had glimpsed the town and its communes. But what about the countryside? Who knows about it before the fourteenth century? That vast world of shadows, those countless ignored masses, break through one morning. In the third volume (mostly erudition), I was not on guard, expecting nothing, when the shape of *Jacques*, rising up on a furrow, blocked my path; a monstrous and frightful shape. I felt a convulsive contraction in my heart....Great God! Is this my father? The man of the Middle Ages?...'Yes', he answered. 'Look how I am made. Behold a thousand years of sorrows....' Those sorrows, I felt them immediately as they flowed up into me from the depths of time....It was he, it was I (same soul and same person) who had endured all this. From these thousand years, a tear came to me, burning, as heavy as a world, which pierced the page. No one (friend, enemy) passed through them without weeping.[99]

In this extraordinary passage history takes over and leaves the historian out of control (although, of course, the passage is so artful that Michelet is more in control than most writers at any point). As it more or less writes itself, history—personified by Jacques Bonhomme—becomes its own muse. The individual speaks on behalf of the masses, a man of sorrows with whom the compassionate historian identifies. The materiality of Michelet's *History*—the third volume, the author's tear piercing the page, the imagined readers likewise staining the pages of the work—brings the medieval peasant straight into the reader's present. Jacques Bonhomme is a rebel who interrupts conventional procedures of writing and creates a havoc of his own. The fourteenth-century French peasants' revolt, known as the *Jacquerie* (also the title and subject of a historical novel (1828) by Prosper Merimée) thus becomes a modern rebellion as Michelet artfully collapses the boundaries between then and now.

[97] Barthes, 63–4. [98] Ibid., 62. [99] Michelet, 'Preface'.

344 WALTER PATER'S EUROPEAN IMAGINATION

Denys is Pater's response to Michelet's Jacques. We may recall that the Paterian wanderer approaching Auxerre suddenly comes across Jacques Bonhomme, and the ensuing narrative is one of the provincial countryside, of suffering, and popular uprisings. Denys is the revolutionary spirit incarnate within the small community who breaks into the nineteenth-century frame narrative and upsets the narrator, originally bent on writing a traveller's account before being led astray by the figure in the fragment of stained glass. Once he has gone down that narrative path, the narrator remains forever haunted. Before Denys is even introduced, Pater gives us a historical panorama of a medieval world in the throes of rebellion:

> Just then Auxerre had its turn in that political movement which broke out sympathetically, first in one, then in another of the towns of France, turning their narrow, feudal institutions into a free, communistic life—a movement of which those great centres of popular devotion, the French cathedrals, are in many instances the monument. Closely connected always with the assertion of individual freedom, alike in mind and manners, at Auxerre this political stir was associated also, as cause or effect, with the figure and character of a particular personage, long remembered. He was the very genius, it would appear, of that new, free, generous manner in art, active and potent as a living creature.[100]

Denys enters the narrative by interrupting the Easter service, subsequently upsets the social order of the local community, and progresses from being farmer and hunter to becoming himself among the hunted. His sufferings become increasingly framed by Christian architecture: the monastery, the cathedral, while his heart is buried by the altar. From pagan and Dionysiac deity he becomes a Christian man of sorrows, destroyed by a mob which is at once maenadic and a revolutionary crowd gone out of control. A peasant, a cultivator of the earth, he returns to the earth from whence he came, only to be resurrected in the mind of the nineteenth-century narrator as an ever-living presence, a *revenant*, in Auxerre. His rebellion—political, erotic, and Dionysiac—has burnt itself out in Michelet and Pater's post-revolutionary century.

Pater's celebration of fertility deities—Demeter and Dionysus—in the mid-1870s was concerned with cyclical mythological time,[101] as opposed to linear historical time. The recurring seasons tie time closely to the earth and to the cyclical themes of death and resurrection. In 'Denys l'Auxerrois', Pater merges cyclical, mythological time with historical time: his protagonist has divine powers over the earth and inspires a new golden age of abundant crops, while being embedded in historical time, the era of the great cathedrals, perhaps even captured in what one might call 'aesthetic time', frozen in stained glass and woven into a medieval tapestry, treasured by the modern aesthete. The earth brings both crops and an access to the past: the narrative is permeated by incidents in which the past erupts through the surface. While art freezes time and movement, the earth is in a state of constant change as the

[100] CW 3:85.

[101] See Dowling 1988 and Shawn Malley, 'Disturbing Hellenism: Walter Pater, Charles Newton, and the Myth of Demeter and Persephone', in ed. Laurel Brake, Lesley Higgins, and Carolyn Williams, *Walter Pater: Transparencies of Desire* (Greensboro: ELT Press, 2002), 90–106.

past interferes with the present and refuses to be contained. In Pater's portraits the earth contains both the man-made and man himself. The substrata of ancient remains testify to a classical civilization which, like the *revenant*, has a bearing on subsequent civilizations. At times it rebelliously interferes with and upsets harmony, like a *poltergeist*. Time gets out of joint and rapid disaster and downfall follow. The historical continuity of the Continent so admired by Ruskin hides the potential for rebellion and chaos if the past assumes a will of its own. Pater's anarchic periodization is rebellious, designed to challenge the neatly boxed-in stylistic and historical categories of the nineteenth century. His European territory is a palimpsest in which the past can continuously be glimpsed beneath the present.

Denys, Gaudioso, and Emerald are all gardeners, tied to the earth and everything it hides, whether the vine, mortal remains, or wallflowers, in full acknowledgement of their own earthiness. The significance of the etymology of the name of the first man, 'Adam' ('red earth'), and of the biblical ('The first man is of the earth, earthy: the second man is the Lord from heaven') is often felt in Pater's portraits.[102] The moribund Emerald, who even in childhood imagines himself in his grave, or Florian, meditating on open graves and boys who have departed life early, share a quiet awareness of where they belong. Young romantic protagonists, half in love with easeful death, they sing their own 'Song of the Earth' as late Victorian descendants of Keats and Shelley, far more melancholy than the middle-aged Michelet who in 1854 took the mudbaths in Acqui, near Turin, and discovered the synthesis of life and death, birth and resurrection. Covered in mud, seated in a white marble bath tub resembling a coffin, he exclaimed: 'Would I not be thus enearthed within a certain interval, in very few years, no doubt? Between this grave and the next, there is little difference. Is not our cradle, the earth, in which our race is born, also a cradle out of which to be reborn?'[103] Restorative and rebellious, the revolutionary energy of the earth appealed to Michelet: emerging, rejuvenated, from the mudbath, he shed his pains and cares, his past, in his symbiosis with the earth: 'So powerful was the marriage! And more than a marriage, between myself and the Earth! One might have said, rather, *exchange of nature*. I was the Earth, and the Earth was man. She had taken for herself my infirmity, my sin. And I, becoming Earth, had taken her life, her warmth, her youth. Years, labours, pains, all remained in the depths of my marble coffin. I was renewed.'[104]

In his first book, Pater had associated Michelet with the revolutionary aspects of the Renaissance. Writing about the medieval theologian Pierre Abelard in 'Two Early French Stories', he translated from Michelet's account of Abelard and Arnold of Brescia as intellectual rebels, stirring the theological debate with Bernard of Clairvaux and sending forth the earliest emanations of a revolutionary spirit which would evolve into the spirit of the Renaissance. The Mont Saint-Geneviève, not that far from the Bastille, became a twelfth-century furnace from which rebellious flames soon spread to Italy:

[102] 1 Corinthians 15:47.
[103] Published in Michelet's *La montagne* (1868), I, 9. Quoted from Barthes, 49.
[104] Ibid., 50.

At the foot of that early Gothic tower, which the next generation raised to grace the precincts of Abelard's school, on the 'Mountain of Saint Geneviève,' the historian Michelet sees in thought 'a terrible assembly; not the hearers of Abelard alone, fifty bishops, twenty cardinals, two popes, the whole body of scholastic philosophy; not only the learned Heloïse, the teaching of languages, and the Renaissance; but Arnold of Brescia—that is to say, the revolution.' And so from the rooms of this shadowy house by the Seine side we see that spirit going abroad, with its qualities already well defined, its intimacy, its languid sweetness, its rebellion, its subtle skill in dividing the elements of human passion, its care for physical beauty, its worship of the body, which penetrated the early literature of Italy, and finds an echo even in Dante.[105]

Michelet had 'la Révolution', clearly intending a reference to the French Revolution; Pater's lower-case 'revolution' downplayed the reference, thus, in effect, making revolution a recurrent phenomenon.[106] Twelfth-century Paris thus becomes a precursor of fourteenth- and fifteenth-century Florence and eighteenth- and nineteenth-century Paris in a Paterian narrative which interweaves theological with artistic and cultural rebellion across centuries. The dialectics of historical development generates conflict and progress, and medieval France constitutes the very heart of the European Renaissance in its earliest stages. Pater may not have written much explicitly about the French Revolution, but through his reading of Michelet, he made the cataclysmic event an integral part of his own cultural history of Europe, in his studies of the Renaissance, and in his portraits. The rebellious Middle Ages contain the seeds of both the Renaissance and romanticism for Michelet and Pater in a complex resurrectionist discourse which travels with the greatest speed across some seven centuries.

Michelet features again in the Leonardo essay as one of the most perceptive of modern critics, who discerns the artist's interiority and modernity. To a mid-nineteenth-century reader, Pater's description of the Leonardesque would have resonated with Baudelaire's ideals from the 1855 *Salon* ('Le beau est toujours bizarre'), echoed in Pater's 'Romanticism' essay: 'His type of beauty is so exotic that it fascinates a larger number than it delights, and seems more than that of any other artist to reflect ideas and views and some scheme of the world within; so that he seemed to his contemporaries to be the possessor of some unsanctified and secret wisdom; as to Michelet and others to have anticipated modern ideas.'[107] The route to the *Mona Lisa* as 'the symbol of the modern idea' is clear, I think, with Michelet as the godfather behind it all. In the 'Introduction' to his 1855 volume on the Renaissance in France, Michelet had invited the reader to join him in the galleries of the Louvre, where the old world of Fra Angelico and the modern world of Leonardo were juxtaposed, separated by a mental and intellectual distance of a thousand years.[108] Maybe those

[105] *Ren.*, 4. [106] Ibid., 307.

[107] Ibid., 77–8. See also J. B. Bullen, 'Walter Pater's Interpretation of the Mona Lisa as a Symbol of Romanticism', in ed. Karsten Engelberg, *The Romantic Heritage: A Collection of Critical Essays* (Copenhagen: Department of English, University of Copenhagen, 1983), 139–52.

[108] 'Entrez au Musée du Louvre, dans la grande galerie, à gauche vous avez l'ancien monde, le nouveau à droite. D'un côté, les défaillantes figures du frère Angelico de Fiesole, restées aux pieds de la Vierge du Moyen âge; leurs regards malades et mourants semblent pourtant chercher, vouloir. En face de ce vieux

THE POETICS OF TIME 347

thousand years recur in Pater's description of the presence beside the waters who 'is expressive of what in the ways of a thousand years men had come to desire'.[109] Drawn, as by a magnetic force, the critic approaches the three Louvre paintings attributed to Leonardo: the *Bacchus*, the *Saint John*, and the *Mona Lisa*.[110] The temporal fluidity of artworks which exert their magic across centuries, over artists, critics, and imaginary spectators alike, is quintessential Michelet. The critic, including his reader in the company, is lured into a state of fascination, culminating in the labyrinthine *Mona Lisa*. The magnetic gaze of this 'gracieux et souriant fantôme' is likened to the powers of the sorceress Alcina. Embedded in a fluctuating and serpentine landscape, the sitter is threatening to entrap the modern spectator as she entrapped Leonardo himself for years.[111]

Pater adopts much of Michelet's subjective suggestiveness in his own extended ekphrasis of the *Mona Lisa*, even paying homage to one of Michelet's other favourite enigmatic images, Dürer's *Melancholia*. Michelet had entered into an imaginary dialogue with Dürer's figure, the 'angel of science and art', in his *Histoire de France*. As Michèle Hannoosh points out, Michelet's northern Renaissance is imbued with 'the melancholy of solitude that is the reverse side of heroic individualism; the suffering of the scholar, the scientist, the philosopher, aware of the limitations of knowledge that knowledge itself has laid bare'.[112] In the historian's 'conversation' with Dürer's figure, self and other merge into one melancholy character, as Michelet 'inserts himself into the narrative, converses with the angel, relates its experience to his, and his readers', own. The text is punctuated by interjections and interpellations, vocatives, and apostrophe. The multiple verb tenses blur the boundary between past and present. The third-person narration gives way to dialogue, the dialogue returns to the third person, and this slides almost imperceptibly into the collective first-person plural....Moreover, the image speaks for itself, *contradicting* the historian's mistaken presuppositions....The historian thus becomes *like* the angel, aware of the limitations of knowledge that knowledge has laid bare, an image of melancholia himself.'[113]

The melancholia of modernity runs through Pater's *Renaissance*, described by Patricia Clements as 'the major channel to England' of Baudelaire's ideas on art, despite the absence of the French critic's name in the volume: '*The Renaissance*, which lays down the orthodoxies of high modernism, is in its most important

mysticisme, brille dans les peintures de Vinci le génie de la Renaissance, en sa plus âpre inquiétude, en son plus perçant aiguillon. Entre ces choses contemporaines, il y a plus d'un millier d'années.' Jules Michelet, 'Introduction', *Histoire de France au seizième siècle: Renaissance* (Paris: Chamerot, 1855), lxxxix–xc.

[109] *Ren.* 98.

[110] 'Bacchus, saint Jean et la Joconde, dirigent leurs regards vers vous; vous êtes fascinés et troublés, un infini agit sur vous par un étrange magnétisme. Art, nature, avenir, génie de mystère et de découverte, maître des profondeurs du monde, de l'abîme inconnu des âges, parlez, que voulez-vous de moi? Cette toile m'attire, m'appelle, m'envahit, m'absorbe; je vais à elle malgré moi, comme l'oiseau va au serpent.' Michelet, 'Introduction', *Histoire de France au seizième siècle: Renaissance*, xc.

[111] 'Une étrange île d'Alcine est dans les yeux de Joconde, gracieux et souriant fantôme. Vous la croyiez attentive aux récits légers de Boccace. Prenez garde. Vinci lui-même, le grand maître de l'illusion, fut pris à son piège; longues années il resta là sans pouvoir sortir jamais de ce labyrinthe mobile, fluide et changeant, qu'il a peint au fond du dangereux tableau.' Ibid., xci.

[112] Michèle Hannoosh, *Jules Michelet: Writing and Art History in Nineteenth-Century France* (University Park: Penn State Press, 2019), 88.

[113] Ibid., 87–8.

theoretical passages and in some of its most characteristic procedures a compound larceny. Pater transferred, from Baudelaire's account to his own, essential material for his presentation of the aesthetic critic, the constituent elements of aesthetic criticism itself, an idea of abstraction in art, a theory of the relationships of the arts to one another, a repertoire of metaphorical relations, and a conception of modernity.'[114] As the most Baudelairean text in the volume, the Leonardo essay pays tribute to French literature: begun as a review of Arsène Houssaye's *Histoire de Léonard de Vinci* (1869), a text closely related to the aesthetic circles of Gautier and Baudelaire, it borrowed significantly from Michelet, while also paying homage to Swinburne's art criticism of both the old and the modern masters.[115] Swinburne's status as the professed and articulate revolutionary disciple of Baudelaire was by the late 1860s well established.[116] Leonardo's modernity was thus closely associated with nineteenth-century France. Robert Buchanan's 'Fleshly School of Poetry' controversy, begun in the *Contemporary Review* in October 1871, had the foreign influence of Baudelaire's modernity on English poetry as one of its principal targets and ran a strongly nationalist argument throughout.[117]

Through his study of French romantic history and art criticism, Pater absorbed Michelet's merging of Renaissance and modernity. With the French Revolution as spiritual heir to the Renaissance, the relatively distant past was given an immediacy, a presence even, which enabled the critic to claim the past as his own. Recreating the past was a way of overcoming the horror and finality of death for both Michelet and Pater. In spite of his interest in 'the people', Michelet's history teems with persons, with the recreation of the charismatic individuals of the past who cross the borders between history and fiction in a way not unrelated to Pater's. Michelet was highly articulate about his thoughts and doings, and his journal entry of 4 April 1841 reveals how what he called his 'mobile lives' ('*ces vies mobiles*') transcended the boundaries between now and then, life and death:

> I need to prove to myself, and to that humanity whose fleeting appearances I sketch, that one is reborn, that one does not die....I can detail to myself all I like the real advantages of my present situation, but I really only cling to life by the faculty, such as it is, of bringing something to life, of giving life in my way.
>
> This I want, above the chain of these mobile lives, of these instants that we call men, of these flickering sparks that were persons, to weave the web of those ideas by which they perpetuated themselves, continued to live, belied death, mocked nature.
>
> She [nature] weaves, then tears, she knots, then breaks, the living fibres; we draw from ourselves, from our will, what is needed to repair the bloody fabric.[118]

[114] Patricia Clements, *Baudelaire and the English Tradition* (Princeton: Princeton University Press, 1985), 104–5.

[115] See Østermark-Johansen 2002a and 2002b. [116] See Clements, 10–76.

[117] See 'Thomas Maitland' (pseud. for Robert Buchanan), 'The Fleshly School of Poetry: Mr D. G. Rossetti', *Contemporary Review* 18 (October 1871), 334–50, for the beginnings of the lengthy feud which had contributions from D. G. Rossetti and Swinburne, among others.

[118] Michelet's journal, translated and quoted from Hannoosh, 90.

THE POETICS OF TIME 349

Pater's many unfinished lives, the fact that he had several brewing at the same time, might suggest a similar eagerness for new creation as a way of overcoming the finality of life. It certainly testifies to a much greater creative and imaginative power than is conventionally taken for granted. The demiurgic power to create new life in the portraits was significantly different from Pater's other activities: teaching, reviewing, and essay-writing. Michelet's images of weaving and tearing, knotting and breaking, remind us of the Greek Fates, weaving, measuring, and cutting the thread of life. With the power to create also follows the ability to cut lives short, and Pater linked one with the other: if you create life, you must also destroy it again. Like Michelet, he was a resurrectionist, but he also seemed almost obsessively concerned with bringing imaginary life to an end.

Modernity: Youth, *Bildung*, and Maturity

The moribund quality of Pater's fiction deprives it of the suspense of plot development, of much of the driving force which conventionally propels our reading. 'What came of him?' had been Pater's early question to the life of Florian, his first imaginary protagonist. With a focus on reaching, experiencing, and slipping out of youth, Pater only rarely dwelt on the causes and methods of death. Pater had left his own youth behind, having reached nearly forty when he published 'The Child in the House'. As far back as the myth of Proserpine, youth and beauty have been linked to flowers, inviting us to study the budding, flowering, and withering of female youth as a parallel to the rose, symbol of love and transitory beauty. The double edge of 'Gather ye roses while ye may', as both an invitation and a threat, has hedonism as its centre, accentuated by the brevity of life. Pater's young men are also flowers, as frail as their female counterparts, and a long line runs from the white lily, Florian Deleal, over Marie-Marguerite, Madame Rosalba—'*la plus belle fleur qui ne dure qu'un matin*'—to the English poet with his French honeysuckle, Duke Carl of Rosenmold, and the dead Emerald smothered in flowers. In continued dialogue with Mallock's Mr Rose, Pater returned to the linking of aestheticism and flowers in *Gaston*. Gaston reads his Ronsard, famous for his love poems to Cassandre, the most popular of which— '*Mignonne, allons voir si la rose*'—cultivates the image of the rose which lasts only from morning to evening. As gardening Prior in the Loire, Ronsard joins Pater's other gardeners, bringing forth strange poetic flowers which Gaston gradually realizes might be 'flowers of evil'. Even the Ronsardian rose turns sick like Blake's (Swinburne's 1868 monograph on Blake had claimed him to be of Baudelaire's party without knowing it), once Gaston (and the reader) realize that the Prior-gardener is a thinly veiled portrait of Baudelaire. Floral symbolism lost its innocence with romanticism; Blake's 'Sick Rose' (1793) began the development which would culminate in Baudelaire's *Flowers of Evil* (1857), and subsequently the narcissistic sunflowers and lilies of aestheticism turned symbols of life and procreation into caricatures of sterile dandies.

Inspired by his reading of Ronsard, Gaston pays a visit to the 'Prince of Poets' in the third chapter of *Gaston* entitled 'Modernity'. In Ronsard's Odes Gaston encounters a new focus on the starkness of images: in search of a new corporeality, he

350 WALTER PATER'S EUROPEAN IMAGINATION

dismisses the poetry of the past as a series of dead faces whose counterparts in the physical world no longer exist. The young man is one for whom the visible world exists, in search of fresh poetic flowers and modern faces: 'Gaston's demand (his youth only conforming to pattern therein) was for a poetry, as veritable, as intimately near, as corporeal, as the new faces of the hour, the flowers of the actual season. The poetry of mere literature, like a dead body, did not bleed, while there was a heart, a poetic heart, in the living world, which beat, bled, spoke with irresistible power.'[119] Ronsard, the 'serial monogamist of the sonnet sequence',[120] had published Petrarchan sonnets to women with names like Marie, Cassandra, and Helen, celebrating 'the eternal feminine' or the powers and resonances of a name. Pater had previously described the *Pléiade* ladies as 'only half real, a vain effort to prolong the imaginative loves of the middle age beyond their natural lifetime',[121] pointing out that 'Ronsard loves, or dreams that he loves, a rare and peculiar type of beauty, *la petite pucelle Angevine*, with golden hair and dark eyes'.[122] Interested in the poet's collaborative friendship with the court painter François Clouet,[123] Pater paid relatively little attention to Ronsard's verses, except on a more abstract level as verses appealing to the reader's visual sense, with frequent occurrences of words like '*peinture*', '*portrait*', and '*tableau*'; for Gaston the sister arts found physical manifestation in Ronsard's *Amours*, his picture gallery of female beauties:

> They might have been sisters, those many successive loves, or one and the same lady over and over again, in slightly varied humour and attire—perhaps at the different intervals of some rather lengthy, mimic *masque* of love, to which the theatrical dress of that day was itself appropriate. And then the mannered Italian or Italianised artists, including the much-prized, native Janet, with his favourite water-green backgrounds, aware of the poet's predilection, had given to one and all alike the same brown eyes and tender eyelids and golden hair and somewhat ambered paleness, varying only the curious artifices of the dress—knots and nets and golden spiderwork and clear flat stones. Dangerous guests in that simple, cloistral place, Sibyls of the Renaissance on a mission from Italy to France, to Gaston one and all seemed under the burden of some weighty message concerning a world unknown to him, which the stealthy lines of cheek and brow contrived to express, while the lips and eyes only smiled, not quite honestly.[124]

The female portraits become symptomatic of a fashion for portraiture which has worn itself out. The decadence of Valois France manifests itself in the reduction of beauty to a pattern for perpetual reproduction which erases the individual. Italianate,

[119] *CW* 4:63.

[120] Pierre de Ronsard, *Cassandra*, tr. and intr. Clive Lawrence (Manchester: Carcanet Press, 2015), ix.

[121] 'Joachim de Bellay', *Ren.*, 134.

[122] Ibid., 133. Pater had his own copy of the eight-volume *Oeuvres Complètes* of Ronsard, ed. M. Prosper Blanchemain (Paris: P. Jannet, 1857–67), with the volume entitled *Preliminaires* containing a biography of Ronsard, a number of elegies on his death, and a range of nineteenth-century verses celebrating the poet and his significance for French poetry. Inman, 1981, 335.

[123] See Roberto E. Campo, 'A Poem to a Painter: The Elegie à Janet and Ronsard's Dilemma of Ambivalence', *French Forum* 12:3 (Sept. 1987), 273–87.

[124] *CW* 4:69.

with bodies caught in webs against a flat background as in Clouet's portrait of Elizabeth of Austria (Fig. 7.2), the women are trapped by excessive ornamentation. Faces may look real on the canvas, but they are artificial to the point of becoming imaginary. Gaston is thus faced with a series of imaginary portraits in one of Pater's mannerist jokes. Although Ronsard inhabits a monastic building, the artworks which decorate it are secular, reminiscent of the resident's former status as a court poet. Ronsard's *Amours* are, like Leonardo's drawings of female heads, imaginary types who become precursors of the novel's ultimate *femme fatale*: Marguerite de Navarre, who resides in the Louvre and surrounds herself with admiring courtiers. Jean and François Clouet and Pierre de Ronsard were founders of schools in their fields; the Clouets of a kind of court portraiture which became almost formulaic,[125] Ronsard as head of the *Pléiade* poets.

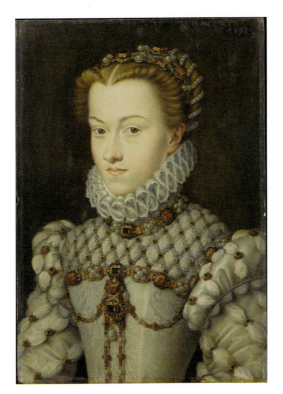

Fig. 7.2. François Clouet, *Elisabeth of Austria* (1571), oil on panel, 37 × 25 cm. Musée Condé, Chantilly. Wikimedia Commons.

[125] In his essay on Joachim de Bellay, Pater had written of the Clouets (originally of Flemish extraction) and their distinctive style: 'In the paintings of François Clouet, for example, or rather of the Clouets—for there was a whole family of them—painters remarkable for their resistance to Italian influences, there is a silveriness of colour and a clearness of expression which distinguish them very definitely from their Flemish neighbours, Memling or the Van Eycks.' *Ren.*, 124.

With his Clouet portrait gallery, Pater was tapping into the fashion for French mannerism among London's male aesthetes. Gaston's friend, the dandified white-clad Jasmin, resembles the sitters of Clouet portraiture, and the effeminate figure in Wilde's 'Portrait of Mr W. H.' is,[126] if not an authentic Clouet, then certainly 'School of': 'In manner, and especially in the treatment of the hands, the picture reminded one of François Clouet's later work. The black velvet doublet with its fantastically gilded points, and the peacock-blue background against which it showed up so pleasantly, and from which it gained such luminous value of colour, were quite in Clouet's style.'[127] Wilde had his friend Charles Ricketts paint him a Clouet portrait of Mr W. H. as a mannerist joke: a forged painting of an already forged object which had served as an essential plot device in his text. 'Ricketts, with his pale, delicate features, fair hair and pointed gold-red beard, looked', according to Rothenstein, 'like a Clouet drawing',[128] and must have seemed the ideal person for the task.[129] Wilde's friend, Lord Ronald Gower, had copied the three hundred Clouet drawings of the so-called 'Lenoir Collection' at Castle Howard in 1875, which at the end of the century was purchased by Henri d'Orleans and housed in the Musée Condé at Chantilly.[130] A flamboyant homosexual collector and artist,[131] Gower became a likely source of inspiration for the figure of Lord Henry in Wilde's *Picture of Dorian Gray*. The linking of sixteenth- and nineteenth-century decadence is intricate in Pater's novel; already in the du Bellay essay Pater had sought out traces of decadence when Ronsard's impaired hearing was made to account for his 'premature agedness' and the 'tranquil, temperate sweetness appropriate to that, in the school of poetry which he founded'.[132] Ronsard's physical weakness became symptomatic of the poetic style, not just of the master, but also of the minor stars surrounding him. Pater talked of the poetry of the *Pléiade* as being true to 'the physiognomy of its age';[133] the feeble body of the poet thus became the type of the nation's leading male figures in an exchange between art and politics whereby even the rhythm and rhyme of *Pléiade* verse assumed a physicality, however feeble, which matched its decadent era.

The female beauties in Ronsard's house serve as a foil for the great poet himself: 'a gaunt figure, hook-nosed, like a wizard, at work with the spade, too busily to turn and look.'[134] From a profile view in full figure, Pater zooms in on the face, as he now reads physiognomy in a penetrating fashion. The aged Ronsard confronts his younger

[126] First published in *Blackwood's Edinburgh Magazine* 146 (July 1889), 1–21.

[127] Oscar Wilde, 'The Portrait of Mr W. H.', *The Complete Works of Oscar Wilde. The Short Fiction*, ed. Ian Small (Oxford: Oxford University Press, 2017), 8:197–258, 198.

[128] Rothenstein 1931, 1:175.

[129] The painting was sold at the auction of Wilde's belongings in 1895, but has subsequently disappeared, although a later sketch commissioned from Ricketts to recall the original painting is now in the Clark Library in Los Angeles. See Ellmann, *Oscar Wilde*, 281; http://charlesricketts.blogspot.com/2014/07/153-portrait-of-mr-wh.html (accessed on 3 Aug. 2021).

[130] *Three Hundred French Portraits Representing Personages of the Courts of Francis I, Henry II, and Francis II, by Clouet*, Auto-Lithographed from the Originals at Castle Howard, Yorkshire by Lord Ronald Gower, 2 vols (London and Paris: Sampson, Low, Marston/Hachette & Cie, 1875).

[131] On Gower and collecting, see John Potvin, *Bachelors of a Different Sort: Queer Aesthetics, Material Culture and the Modern Interior in Britain* (Manchester: Manchester University Press, 2014), 38–67.

[132] *Ren.*, 135. [133] Ibid., 136. [134] *CW* 4:67.

THE POETICS OF TIME 353

self in a portrait *all'antica*, and Pater allows the reader to compare portrait with original in a poignant awareness of the effects of time on both the face and the soul:

> The leader in that great poetic battle of the Pleiad, their host himself, (he explained the famous device, and named the seven chief stars in the constellation,) was depicted appropriately, in veritable armour, with antique Roman cuirass of minutely inlaid gold and flowered mantle, the crisp, ceremonial laurel-wreath of a Roman conqueror lying on the audacious, over-developed brows, above the great hooked nose of practical enterprise. In spite of his pretensions to the Epicureans' conquest of a kingly indifference of mind, the portrait of twenty years ago betrayed, not less than the living face with its roving, astonished eyes, the haggard soul of a haggard generation, whose anxiously studied refinements had been after all little more than a theatrical make-believe—an age of wild people, of insane impulse, of homicidal mania. The sweet-souled songster had attained real calm in it no more than others. Even in youth nervous distress had been the chief facial characteristic.[135]

The portrait is *all'antica* in more than one sense. Pater constructs a painting echoing some of the many bust-length engravings of a laurel-crowned Ronsard in the garb of a Roman emperor (Fig. 7.3) which had proliferated since the seventeenth century. They nearly all depict the hook-nosed poet in profile in allusion to numismatic imperial portraiture. Pater transforms the type into a full-face portrait. Gaston, and the reader, must confront artwork and original in a classic encounter of then and now: the painting shows the poet as he looked twenty years ago, and in his comparison of original and copy, Gaston concludes that Ronsard embodies the face of his generation. 'Haggard', 'wild', 'insane', 'homicidal', and 'nervous' all suggest inner turmoil. As cultivator of the *Flowers of Evil* and recipient of A. C. Swinburne's flowery elegy 'Ave atque Vale', Baudelaire is a contemporary presence in the figure of Ronsard. Clements has pointed out how the features described are those of the aging Baudelaire, known from Étienne Carjat and Félix Nadar's photographs of the mid-1860s (Fig. 7.4); indeed, Ronsard is forty-six years old, the age of Baudelaire when he died, when Gaston visits his Priory.[136] With his Roman garb, his Petrarchesque laurel wreath, and his Baudelairean profile, Pater's Ronsard becomes an allegorical figure of poetry through the ages, with a life span almost as long as that of the *Mona Lisa*, 'the embodiment of the old fancy, the symbol of the modern idea'. The collapsing of the physiognomies of two (potentially three, if we also count Petrarch) of the leading lyrical poets into one brings together the Middle Ages, Renaissance, and modernity, type and individual, while raising the issue of cyclical time. 'The age renews itself', Gaston ponders,[137] echoing Lorenzo il Magnifico's private motto, 'Le Temps Revient', loaded with the symbolism of the return of the Golden Age, of the Laurentian period as itself a Golden Age.[138] The cyclical return of the Golden Age had been a pervasive

[135] *CW* 4:70. [136] Clements, 95. [137] Ibid., 63.
[138] See Jeanet Cox-Rearick, 'Themes of Time and Rule at Poggio a Caiano: The Portico Frieze of Lorenzo il Magnifico', *Mitteilungen des Kunsthistorischen Institutes in Florenz* 26 (1982), 167–210, 183–4.

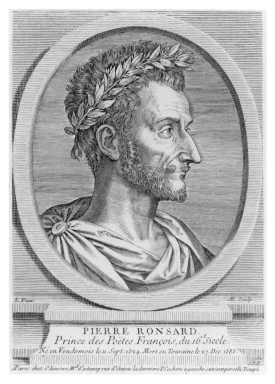

Fig. 7.3. Michel Lasne, *Pierre de Ronsard, Prince des Poëtes* (1585), engraving. Private collection. Photo © Christoffer Rostvad.

theme of 'Denys', and Pater's interest in recurrent phenomena is Vichian, questioning linear time as the only meaningful way of approaching history.[139]

Pater entitled his chapter 'Modernity' and appropriated Baudelaire's definition of modernity from 'La Peintre de la vie moderne' into his own,[140] characterized by 'the latent poetic rights of the transitory, the fugitive, the contingent'.[141] In 1888 the term would most likely have had a French flavour to the readers of *Macmillan's Magazine*. Not until the early twentieth century did 'modernity' become an established term for an 'intellectual tendency or social perspective characterized by a departure from or repudiation of traditional ideas, doctrines, and cultural values in favour of contemporary or radical values and beliefs' (*OED* 1b). By pushing back modernity to the sixteenth century, Pater questioned the very concept as a nineteenth-century phenomenon, suggesting that each era had its modernity:

[139] The 'Euphuism' chapter in *Marius* is another case in point, as Pater applies an Elizabethan literary fashion to the Antonine Flavian's poetry, while indicating that the nineteenth century too had its Euphuists. *Marius the Epicurean*, ch. 6; Østermark-Johansen 2002c.

[140] Cf. Baudelaire, 'Le peintre de la vie moderne': 'La modernité, c'est le transitoire, fugitif, le contingent, la moitié de l'art dont l'autre moitié est l'éternel et immuable', in Charles Baudelaire, *Écrits sur l'art*, ed. Francis Moulinat (Paris: Librairie Générale Française, 1999), 518.

[141] *CW* 4:65.

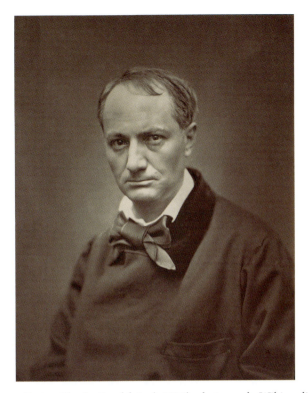

Fig. 7.4. Etienne Carjat, *Charles Baudelaire* (*c.*1863), photograph. Wikimedia Commons.

It was the power of 'modernity,' as renewed in every successive age for génial youth, protesting, defiant of all sanction in these matters, that the true 'classic' must be of the present, the force and patience of present time. He had felt after the thing, and here it was, —the one irresistible poetry there had ever been, with the magic word spoken in due time, transforming his own age and the world about him, presenting its every-day touch, the very trick one knew it by, as an additional grace, asserting the latent poetic rights of the transitory, the fugitive, the contingent. Poetry need no longer mask itself in the habit of a by-gone day: Gaston could but pity the people of by-gone days that they were not above-ground to read. Here was a discovery, a new faculty, a privileged apprehension, to be conveyed in turn to one and another, to be propagated for the imaginative regeneration of the world. It was a manner, a habit of thought, which would invade ordinary life, and mould that to its intention.[142]

Stressing the present, the new, Gaston embraced the notion of the classic as the kind of literature which carries a contemporary appeal. The passage contains the past, the present, and the future, with the youthful protagonist's awareness that those already dead and buried would have enjoyed Ronsard's modernity, while also looking

[142] *CW* 4:65.

356 WALTER PATER'S EUROPEAN IMAGINATION

forward to 'the imaginative regeneration of the world' destined to ensue from the 'new faculty'. He was thus echoing the revolutionary conclusion to 'Diaphaneitè' in which the author hoped for a new type of man who in sheer numbers 'would be the regeneration of the world'.[143] Gaston becomes aware that this new poetry was 'a delightful "fashion" of the time. He almost anticipated our modern idea, or platitude, of the *Zeit-geist*.—Social instinct was involved in the matter, and loyalty to some common intellectual *movement*. As its leader had been himself the first to suggest, the actual authorship belonged not so much to a star as to a constellation'.[144] Pater could have used Hazlitt's term 'spirit of the age', but chose the German *Zeit-geist*, thus bringing Herder, Goethe, and Hegel into the discourse, making the eighteenth and nineteenth centuries interfere with sixteenth-century France.

Most of Pater's portraits have similarities with the *Bildungsroman*: circular plots which revolve around one young individual, tracing his personal, emotional, and intellectual development. Pater's almost obsessive focus on youth cannot merely be explained within the context of Greek love, 'the love that dare not speak its name', as the homoerotic middle-aged writer's painful exploration of a younger self or of an unobtainable young lover, as has been the tendency within the last few decades, after the 'outing' of Pater in the early 1990s. I find Franco Moretti's coupling of the cult of youth with modernity useful, as well as his linking of the French Revolution with the rise of the *Bildungsroman*. If discussing the portraits in relation to the historical novel made us think about time on the larger scale of European history, the *Bildungsroman* takes us into the microcosmic scale of time, into the individual life.

Moretti pointed out that in contrast to the middle-aged heroes of the epic— Ulysses, Aeneas, Achilles, Hector—the *Bildungsroman* cultivates youth as the most meaningful part of life. Youth is, he reminds us, the first gift Mephisto offers Faust in Goethe's play, an act echoed in Wilde's *Picture of Dorian Gray*, and by the end of the eighteenth century Europe plunged, unprepared, into a culture of modernity: 'If youth, therefore, achieves its symbolic centrality, and the "great narrative" of the *Bildungsroman* comes into being, this is because Europe has to attach a meaning, not so much to youth, as to *modernity*'.[145] Moretti characterizes modernity as a permanent revolution that can no longer be represented by maturity and points out that in an age of constant revolutions, the symbolic value of youth is the hope for rebirth, indicative of the dynamic instability of modernity. A risky business, modernity is full of great expectations and lost illusions, as indeed the titles of some of the canonical novels in the genre remind us. 'Youth is, so to speak, modernity's "essence", the sign of a world that seeks its meaning in the *future* rather than in the past'.[146] For the bourgeois writers, readers, and protagonists of the *Bildungsroman*, youth—a field of potentially boundless possibilities—becomes, rather than a preparation for something else, a '*value in itself*, and the individual's greatest desire is to *prolong* it'.[147] Inevitably, youth becomes the age of ideals, with the melancholy awareness that sooner or later, it will come to an end. Youth can only be the age of ideals '*precisely because* it will not last long'. As Moretti argues, 'These novels establish thus an

[143] 'Diaphaneitè', 140. [144] *CW* 4:72. [145] Moretti, 5. [146] Ibid., 5.
[147] Ibid., 177. Italics are Moretti's own.

essential paradigm for modern existence: "maturity" is no longer perceived as an acquisition, but as a loss. We do not become adults by becoming adults, but by ceasing to be young: the process involves primarily a renunciation.'[148]

In Pater's fiction, none of his protagonists (with the exception of Prior Saint-Jean and Gaudioso) ever reaches maturity. Lives are cut short while ideals are still at their height, and within the aesthetic universe of the short portraits, loss of teeth, of memory, and physical abilities is not part of the parcel. In the longer portraits, youth is constantly confronted with maturity, as Marius and Gaston seek out tutorials with a range of middle-aged intellectuals: Marcus Aurelius, Lucian, Ronsard, Montaigne, and Bruno. The juxtaposition of youth and maturity, of impressionable innocence and clear-sighted experience, is an essential part of the process of *Bildung*, as indeed also Rothenstein's *Oxford Characters* suggested. As the products of Pater's own maturity, his long portraits are concerned with the ages of man, allegorically represented by Giorgione and Titian (Figs 7.5 and 7.6) in different ways. The Leonardesque *sfumato* on the faces of the youth and the adult man in Giorgione's painting lends a gentle softness to their mutual engagement with learning, the youth in the centre, while the old man faces the viewer with the expression of the cynic who knows the world. The language of gestures—as the old man's large hand supports the youth's

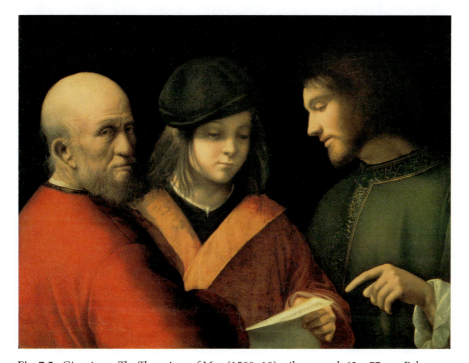

Fig. 7.5. Giorgione, *The Three Ages of Man* (1500–10), oil on panel, 62 × 77 cm. Palazzo Pitti, Florence. Wikimedia Commons.

[148] Ibid., 90.

Fig. 7.6. Titian, *Allegory of Prudence* (1550), oil on canvas, 75.5 × 68.4 cm. National Gallery, London. Presented by Betty and David Koetser 1966 © National Gallery, London.

still boyish hand under the instruction of the mature man's Leonardesque index finger—sums up the relationship, as age moves clockwise, while learning moves anti-clockwise. In Titian's *Allegory of Time*, tightly composed around profile and *en face* heads of men and animals, old age, maturity, and youth, past, present, and future are linked by the Latin inscription above the heads: EX PRÆTE/RITO // PRÆSENS PRVDEN/TER AGIT // NI FVTVRA / ACTIONĒ DE / TVRPET ('from the experience of the past, the present acts prudently, lest it spoil future actions'). The powerful, leonine mature face in the centre lends strength to the need for prudent present action, based on the past. The *Bildungsroman*, and Pater with it, foregrounds the vague, unformed background or profile faces of the youths in the Renaissance

THE POETICS OF TIME 359

allegories and lets their impressionability become the centre of attention, as one school of thought, poetry, or religion after another is consulted, digested, and partially adopted, or dismissed.

Addressing the incompatibility of modernity with maturity, Moretti alerts our attention to the paradox of restlessness and the desire for an ending which is symptomatic of the *Bildungsroman*. Novels have to end, while youth should preferably not, and the challenge of uniting the two lies at the heart of the genre: 'Modern Western society has "invented" youth, mirrored itself in it, chosen it as its most emblematic value—and for these very reasons has become less and less able to form a clear notion of "maturity". The richer the image of youth grew, the more inexorably that of adulthood was drained. The more engaging, we may add, the "novel" of life promised to be—the harder it became to accept its conclusion; to write, with a firm and lasting conviction, the words "The End".'[149] The teleological drive towards marriage or adultery—one being predominantly English, the other French, it is suggested— makes for an ending which may promise more youth to come. Significantly, Pater's portraits are so distinctly neither plot- nor marriage-driven, as youth is framed by the only possible ending, a frequent one in narratives where natural reproduction is not a possibility: that of an early death.

Iser's view of the portraits as studies in failure is rooted in views of a successful *Bildung* as a successful socialization, as the individual becomes a well-functioning and respectable member of a larger community. If the protagonist does not succeed in social integration, the isolation which follows can only lead to an unhappy ending which questions the educational process itself: 'Just as the happy ending implies some kind of "success", which it sublimates into something wider, so the unhappy ending demands the protagonist's death, but it shapes it in a special way. His death must first of all *isolate* the hero: not only from social order in which he never felt completely at ease, but especially from those collective expectations which he has never wholly betrayed, and to which—within himself—he has perhaps entrusted the ultimate meaning of his existence.'[150] The nineteenth century begets a new race of protagonists for whom happiness is not an option, who seem destined for an early and unhappy ending. And fate, as Moretti reminds us, 'only metes out death sentences.'[151] Pater's tubercular heroes, who burn themselves out too soon, are a case in point; others, like Emerald, are haunted by fate from the very beginning, as the narrator toys with which Greek term for Destiny is the more appropriate, 'The common Destinies of men, $Μοῖραι$, *Maerae*,' or '$Κήρ$, the extraordinary Destiny, one's Doom.'[152]

Moretti linked the *Bildungsroman* with the conflicts created by the French Revolution: positioned on the border between the bourgeoisie and the aristocracy, the encounter between the two classes becomes a way 'to heal the rupture that had generated (or so it seemed) the French Revolution, and to imagine a continuity between the old and the new regime.'[153] He concludes that 'in the classical *Bildungsroman* we find the very opposite of what occurred in the summer of 1789: not a secession, but rather a convergence.'[154] As harmony within the ruling classes is

[149] Ibid., 27–8. [150] Ibid., 119. [151] Ibid., 117. [152] *CW* 3:183.
[153] Moretti, viii. [154] Ibid., 64.

360 WALTER PATER'S EUROPEAN IMAGINATION

restored, 'the classical *Bildungsroman* narrates "how the French Revolution could have been avoided."'[155] The real target of the genre is the bourgeois reader 'who must be "educated", convinced of the "absurdity" of his cultural values. It is the bourgeois reader who must be shown the advantages of social reconciliation.'[156] Several of Pater's portraits have bourgeois protagonists, intermingling with the aristocracy: Gaston's sojourn at the court in Paris, Marius's visits to Marcus Aurelius, Watteau as the painter of the Parisian aristocracy, Hippolytus as the son of Theseus, while Duke Carl is decadent aristocracy incarnate, intermarrying with the lower classes. Yet Pater is not depicting the aristocracy in a very positive light: no moral nobility is in sight. Given the absence of a marriage plot, there is no equivalent of a Mr Darcy, but rather an exposure of vain aristocratic immorality which burns itself out. The Paterian ideal of *ascêsis* is incompatible with aristocratic values, and the figure of the fop or the dandy, striving for aristocratic ideals and modes of life—whether in the form of Flavian or Jasmin—is exposed in all his hypocrisy and shallowness.

Was Pater, in effect, more of a revolutionary than most of the authors of the conventional *Bildungsroman*? While we could hardly imagine him on the Parisian barricades, one might suggest that with his particular variation of a genre which, according to Moretti, died out with Flaubert and George Eliot, Pater was taking the *Bildungsroman* out of its socially convergent pattern and into the realm of ideas. For Pater *Bildung* has far less to do with social mobility than with philosophy, and with his background in Platonism, the conventional marriage plot is directed towards the philosophical marriage of body and soul, exemplified in *Marius* in Pater's translation of Apuleius' narrative of Cupid and Psyche from *The Golden Ass*. Allegory and abstraction, rather than bourgeois contracts, provide the protagonist's sentimental education, which is intrinsically tied to ways of perceiving time. As a young man who has lived too much of his youth commemorating the past, Marius eventually reaches the point when he can embrace the present. Pater's account of Marius' ancestral home, Whitenights, a shrine to those already departed, tended with care by his widowed mother, brings back his notion of 'subjective immortality' first aired in the Old Mortality Society:

> Something pensive, spell-bound, and as but half-real, something cloistral or monastic, as we should say, united to that exquisite order, made the whole place seem to Marius, as it were—*sacellum*—the peculiar sanctuary of his mother, who still in real widowhood provided the deceased Marius the elder, with that secondary sort of life which we can give to the dead, in our intensely realized memory of them—the 'subjective immortality', as some now call it, for which many a Roman epitaph cries out plaintively to widow or sister or daughter, still alive in the land of the living.[157]

The ghostly home, to which Marius returns at the end of the novel, must be left behind for the hero to develop into a young man. The strong hold which the dead impose on the living must be broken, albeit through yet another death. Only when his mother has died and Marius has left Whitenights, can he embark on a modern

[155] Ibid., 64. [156] Ibid., 65. [157] *Marius the Epicurean* 2008, 18.

THE POETICS OF TIME 361

life as described in the chapter which served as precursor to the 'Modernity' chapter in *Gaston*. Sent to school to learn Greek and to experience the charm of poetry and the delights of male friendship, Marius steps out of the shadow of the past and into a 'modernness' which reaches into German romanticism:

> Hitherto, all his rearing had tended to the imaginative exaltation of the past; but now the spectacle actually afforded to his untired and freely opened senses, suggested the reflection that the present had, it might be, really advanced beyond the past: and he was ready to boast in its very modernness. If, in a voluntary archaism, the polite world of his day went back to a choicer generation, as it fancied, for the purpose of a fastidious self-correction, in matters of art, of literature, and even, as we have seen, of religion; at least it improved, by a shade or two of scrupulous finish, on the old pattern; and the new era, like the *Neu-zeit* of the German enthusiasts at the beginning of our own century, might perhaps be discerned, awaiting one just but a single step onward, the perfected new manner, in the consummation of time, alike as regards the things of the imagination and the actual conduct of life.[158]

Both 'modernness' and *Neu-zeit* are unusual terms which make us question our modes of measuring and denominating time, while Pater also reminds us of the Ovidian *tempus edax rerum*. Indeed, is time subject or object in Pater's 'consummation of time'? As with Gaston's 'modernity' and *Zeit-geist*, Pater wants us to consider the ways in which the desire to 'make it new' is timeless, part of the human condition, as urgent in the second century A D as in the sixteenth or nineteenth centuries. Culture is born through revolution, and the birth of the new constantly takes place. Consider how in the nineteenth century young writers leapt into the literary world with titles claiming modernity: Mary Shelley, *Frankenstein, or the Modern Prometheus* (1818); Ruskin, *Modern Painters* (1843); Wilkie Collins, *Basil: A Story of Modern Life* (1852); George Meredith, *Modern Love* (1862); George Moore, *Modern Painting* (1893). Many more could be added. John Ruskin, who by the time Pater was writing his portraits was considered sufficiently 'old school' to be killed off in the figure of Prior Saint-Jean in Pater's last portrait, characteristically turned things upside down, making the modern love of the old controversial. Lecturing in 1853 on the new, on 'Pre-Raphaelitism', he attacked the modern fashion for historical fiction, even employing the term 'imaginary portrait' long before Pater. Modernism should be about the contemporary and not about the past, he argued:

> Of all the wastes of time and sense which Modernism has invented—and there are many—none are so ridiculous as this endeavour to represent past history. What do you suppose our descendants will care for our imaginations of the events of former days? Suppose the Greeks, instead of representing their own warriors as they fought at Marathon, had left us nothing but their imaginations of Egyptian battles; and suppose the Italians, in like manner, instead of portraits of Can Grande and Dante, or of Leo the Tenth and Raphael, had left us nothing but imaginary portraits of

[158] Ibid., 34–5.

362 WALTER PATER'S EUROPEAN IMAGINATION

Pericles and Miltiades? What fools we should have thought them! how bitterly we should have been provoked with their folly![159]

Ironically, the Pre-Raphaelite use of the Old Masters as the point of departure for Modern Painters, to borrow shamelessly from the title of Elizabeth Prettejohn's Mellon lectures,[160] is the painterly equivalent of what Pater was trying to do in his imaginary portraits. We should not forget Pater's great admiration of the Pre-Raphaelites: of Rossetti, Solomon, Burne-Jones, artists who all took their starting point in the art of the Renaissance and 'made it new'. No one would mistake a Pre-Raphaelite painting for an Old Master; traces of nineteenth-century modernity, whether in the form of the photograph, a modern face, or modern colouring and technique interfere with and fix the painting solidly within its own century. The historical layering, the interweaving of past and present, make for a visual modernity which embraces the past, indeed, brings out its modernity, while questioning the meaning of conventional periodization. Pater's constant slippage from historical time to the present time, his teasing choice of historical subjects with a contemporary reference (Duke Carl and Ludwig II, Watteau as a Whistler *avant la lettre*, Jasmin as a decadent aesthete, etc) grant a contemporary edge to history. On the surface the portraits may be about youth, but in their topicality they become the mature writer's comment on a range of highly contemporary issues and controversies. Not unlike George Eliot's, often ironic, narrators, the Paterian narrator becomes a character in his own right, with a humour and maturity which stand outside the main narrative. Moretti's comments about the narrator of *Middlemarch* might also apply to a range of Pater's narrators: 'maturity is no longer achieved within the story, but only in the disembodied universe of discourse. And the relationship between the two levels of the text is inversely proportional: the more devastating the characters' failure, the more impressive the narrator's self-mastery. It is the discontinuity between maturity and life that is stressed here, not their amalgam.'[161]

As Pater's mature narrator frames the portrait of youth, he seals it in time, inviting us to reconsider Marcia Pointon's 'slippery and seductive art of portraiture.'[162] There is a tension between Pater's thorough historical contextualization and the narrator's temporal slippage, designed to make us feel that 'then is now and now is then'. Pointon's suggestion that the finest visual portraits offer us a 'an illusion of timelessness, the impression that we can know people other than ourselves and, especially, those among the unnumbered and voiceless dead',[163] makes us consider whether the literary portrait can actually achieve the same collapsing of then and now as the visual portrait? Lessing's distinction between literature as art existing in time and painting as art existing in space would seem to make this difficult, yet Pater's temporal slippage is an attempt to achieve this effect. Pater's portraits provoke our awareness of presence and absence, life and death; we are reminded of our own mortality and

[159] John Ruskin, *Lectures on Architecture*. Lecture IV, 'Pre-Raphaelitism', delivered on 18 Nov. 1853, *CWR* 10:100–22, 115–16.

[160] Elizabeth Prettejohn, *Old Masters, Modern Painters: The Art of Imitation from the Pre-Raphaelites to the First World War* (London and New Haven: Yale University Press, 2017).

[161] Moretti, 222. [162] Pointon, 28. [163] Ibid., 28.

THE POETICS OF TIME 363

the eventual silencing of our own voices as one young person after another is put to rest when the portraits come to an end. Pater's silent protagonists are several steps removed from the real world where speech and noise are tokens of life. The absence of dialogue, of the living voice in the portraits, contributes to our awareness that portraiture is always about absence, no matter whether it is visual or literary. As the monument of the moment, the portrait invites us to consider time aesthetically, historically, and philosophically. The moment captured in the portrait is forever gone, and while the individual life has been extinguished, the moment has been preserved in art. Conditioned through centuries of western literature to contemplate the Hippocratic aphorism *vita brevis, ars longa* ('life is short, art is long'),[164] we accept the artifice of Pater's portraits as a series of significant moments in the lives of relatively insignificant people. Like Eliot's Dorothea Brooke, Pater's protagonists would never have made it into any dictionary of national biography, and the concluding words of *Middlemarch* could be applied to many a Paterian hero, most of whom rest, quite unlike Michelet, in unvisited tombs. Aware that 'the growing good of the world is partly dependent on unhistoric acts' and that 'things are not so ill with you and me as they might have been', in part 'owing to the number who lived faithfully a hidden life, and rest in unvisited tombs',[165] Pater is asking us to consider what makes history and what is our own place in it. The poetics of Pater's time invites us to view our individual lives within the much broader framework of European culture across the centuries, to see the modernity of the past and cultivate the past in the present. Pater's portraits may be imaginary, but their significance has never been more real than now.

[164] For the European reception history of the Hippocratic aphorism, see Harald Weinrich, *On Borrowed Time: The Art and Economy of Living with Deadlines* (Chicago: University of Chicago Press, 2008). Weinrich gives a translation of the aphorism in full, reminding us of Hippocrates' profession as a physician: 'Life is short, art is long, opportunity fleeting, experience deceptive, judgement difficult. For (as a physician) one must not only do the right thing, but also see to it that the patient, the people around him, and the whole context collaborates with him' (2).

[165] George Eliot, *Middlemarch: A Study of Provincial Life*, ed. David Carroll, intr. Felicia Bonaparte, Oxford World's Classics (Oxford: Oxford University Press, 2008), 785.

Bibliography

1. Manuscripts

Houghton Library, Harvard University
Gaston de Latour, Houghton bMS Eng. 1150 (4).
'Tibalt the Albigense', Houghton bMS Eng. 1150 (5).
'Gaudioso the Second', Houghton bMS Eng. 1150 (8).
'Evil in Greek Art', Houghton bMS Eng. 1150 (14).
'Notre Dame de Troyes', Houghton bMS Eng. 1150 (20).
'The Young Romantic', Houghton bMS Eng. 1150 (21).
'Il Sartore', Houghton bMS Eng. 1150 (22) | fol. 12r.
'The Youth of Michelet', Houghton bMS Eng. 1150 (28).
'Thistle', Houghton bMS Eng. 1150 (31).
'An Imaginary Portrait', Houghton bMS Eng. 1150 (32).

Brasenose College Archive, Oxford
PPI B2/1.

King's College Archives, Cambridge
Forster, Edward Morgan, *Talk on Walter Pater* (*c*.1917), MS, The Papers of Edward Morgan Forster EMF/6/32.

2. Printed Primary and Secondary Material

Abdy-Williams, E. M., 'An Enchanted Island', *Time* (Aug. 1886), 214–20.
A Book of Characters, selected from the Writings of Overbury, Earle, and Butler (Edinburgh: n.p., 1865).
Aleksiuk, Natasha, '"A Thousand Angles": Photographic Irony in the Work of Julia Margaret Cameron and Virginia Woolf', *Mosaic* 33:2 (Jun. 2000), 125–42.
Alpers, Svetlana, *The Art of Describing* (Chicago: Chicago University Press, 1983).
Amic, Sykvain and Ségolène Le Men, ed., *Cathédrales 1789–1914: Un Mythe Moderne* (Paris: Somogy éditions, 2014).
Amiel, Henri-Frédéric, *The Journal Intime of Henri-Frédéric Amiel*, tr. and intr. Mrs Humphry Ward, 2 vols (London: Macmillan, 1885).
Amiel, Henri-Frédéric, *Amiel's Journal. The Journal Intime of Henri-Frédéric Amiel*, tr. and intr. Mrs. Humphry Ward, 2nd edn (London: Macmillan & Co., 1898).
Amiel, Henri-Frédéric, *Journal intime*, ed. B. Gagnebin and B. M. Monnier, 12 vols (Lausanne: L'âge de l'Homme, 1976–94).
Anderson, Anne, '"Fearful Consequences . . . of Living Up to One's Teapot": Men, Women and "Cultchah" in the Aesthetic Movement', in ed. Jason Edwards and Imogen Hart, *Rethinking the Interior, c.1867–1896* (Farnham: Ashgate, 2010), 111–29.
Anderson, Anne, 'Harmony in the Home: Fashioning the "Model" Artistic Home or Aesthetic House Beautiful through Color and Form', *Interiors* 5:3 (2014), 341–60.

366 BIBLIOGRAPHY

Anderson, Benedict, *Imagined Communities: Reflections on the Origin and Spread of Nationalism* (London: Verso, 1986).

Andrews, Kit, 'The Figure of Watteau in Walter Pater's "Prince of Court Painters" and Michael Field's *Sight and Song*', *English Literature in Transition, 1880-1920* 53:4 (2010), 451–84.

Andrews, Kit, 'Walter Pater as Oxford Hegelian: Plato and Platonism and T. H. Green's *Prolegomena to Ethics*', *Journal of the History of Ideas* 72:3 (Jul. 2011), 437–59.

Anon., 'Wagner and the Fairy Prince', *London Society: An Illustrated Magazine of Light and Amusing Literature for the Hours of Relaxation* 106 (Oct. 1870), 289–96.

Anon., 'The Old Masters at the Royal Academy', *Saturday Review* 39 (16 Jan. 1875), 82.

Anon., 'The Royal Academy Winter Exhibition', *Athenaeum* 2465 (23 Jan. 1875), 128.

Anon., 'The Pleasures and Drawbacks of Travelling', *Temple Bar* 45 (Nov. 1875), 347–55.

Anon., 'Boys and Schoolboys', *Saturday Review* 46 (3 Aug. 1878), 141.

Anon., 'Magazines and Reviews', *Academy* 328 (17 Aug. 1878), 166.

Anon., 'Foreign Notes' (on Ludwig II's grotto), *Magazine of Music* (Mar. 1886), 278.

Anon., 'Recent Bavarian Kings', *Saturday Review* (19 Jun. 1886), 845–6.

Anon., 'Louis the Second of Bavaria', *Temple Bar, with which is incorporated Bentley's Miscellany* (Aug. 1886), 511–28.

Anon. [Emilia Dilke], '*Imaginary Portraits*. By Walter Pater', *Athenaeum* (25 Jun. 1887), 824–5.

Anon. [Elizabeth Balch], *An Author's Love: Being the Unpublished Letters of Prosper Merimée's 'Inconnue'* (London: Macmillan & Co., 1889).

Anon., *La passion d'un auteur. Réponses à Prosper Merimée* (Paris: Paul Ollendorff, 1889).

Anon., 'Oxford Characters', *Athenaeum* 3617 (20 Feb. 1896), 251.

Anon., 'Oxford Characters', *Saturday Review* 82 (7 Nov. 1896), 504–5.

Anon., 'Rev. Dr. F. W. Bussell, Late Principal of Brasenose', *Times* (1 Mar. 1944), 7.

Aristotle, *On the Art of Poetry* in *Aristotle, Horace, Longinus: Classical Literary Criticism*, tr. and intr. T. S. Dorsch (Harmondsworth: Penguin, 1978), 29–75.

Armstrong, Isobel, *Victorian Glassworlds: Glass Culture and the Imagination 1830–1880* (Oxford: Oxford University Press, 2008).

Arnold, Matthew, 'Obermann', *Academy* (9 Oct. 1869), 1–3.

Arnold, Matthew, 'Amiel', *Macmillan's Magazine* 56 (Sept. 1887), 321–9.

Arnold, Matthew, *The Poems of Matthew Arnold*, ed. Kenneth Allott (London: Longmans, 1965).

Arnold, Matthew, *The Complete Prose Works of Matthew Arnold*, ed. Robert H. Super, 11 vols (Ann Arbor: University of Michigan Press, 1960–77).

Austin, James, *Proust, Pastiche, and the Postmodern, or Why Style Matters* (Lewisburg: Bucknell University Press, 2013).

Bachelard, Gaston, *The Poetics of Space* (1957), intr. Richard Kearney, tr. Maria Jolas, Penguin Classics (New York: Penguin, 2014).

Backscheider, Paula R., *Reflections on Biography* (Oxford: Oxford University Press, 2001).

Baedeker, Karl, *Northern France from Belgium and the English Channel to the Loire, Excluding Paris and its Environs. Handbook for Travellers with 9 Maps and 25 Plans* (London: Dulau & Co., 1889).

Bailey, Suzanne, 'Francis Galton's Face Project: Morphing the Victorian Human', *Photography and Culture* 5:2 (2012), 189–214.

Bakewell, Sarah, *How to Live: A Life of Montaigne in One Question and Twenty Attempts at an Answer* (London: Vintage, 2011).

Bakhtin, M. M., 'Forms of Time and of the Chronotope in the Novel: Notes toward a Historical Poetics', in *The Dialogic Imagination: Four Essays*, tr. Caryl Emerson and Michael Holquist (Austin: University of Texas Press, 1981), 84–258.

Balzac, Honoré de, *The Quest of the Absolute* (1834), tr. Ellen Marriage (London: J. M. Dent, 1908).

BIBLIOGRAPHY 367

Bann, Stephen, *The Clothing of Clio: A Study of the Representation of History in Nineteenth-Century Britain and France* (Cambridge: Cambridge University Press, 1984).

Baring-Gould, Sabine, *Further Reminiscences 1864–1894* (London: John Lane Bodley Head, 1927).

Barolsky, Paul, *Walter Pater's Renaissance* (University Park and London: Pennsylvania State University Press, 1987).

Barthes, Roland, *Michelet*, tr. Richard Howard (New York: Hill & Wang, 1987).

Barthes, Roland, *Camera Lucida*, tr. Richard Howard (London: Vintage Books, 2000).

Baudelaire, Charles, *Écrits sur l'art*, ed. Francis Moulinat (Paris: Librairie Générale Française, 1999).

Beardsley, Aubrey, *The Letters of Aubrey Beardsley*, ed. Henry Maas, J. L. Duncan, and W. G. Good (London: Cassell, 1970).

Beebee, Thomas O., *Epistolary Fiction in Europe 1500–1850* (Cambridge: Cambridge University Press, 1999).

Beer, Gillian, '"The Death of the Sun": Victorian Solar Physics and Solar Myth', in ed. J. B. Bullen, *The Sun is God: Painting, Literature and Mythology in the Nineteenth Century* (Oxford: Oxford University Press, 1989), 159–80.

Beerbohm, Max, *The Works of Max Beerbohm*, with a Bibliography by John Lane (London: John Lane, 1896).

Beerbohm, Max, 'Preface', in *The Portrait Drawings of William Rothenstein 1889–1925. An Iconography by John Rothenstein with a Preface by Max Beerbohm and 101 Collotype Plates* (London: Chapman & Hall, 1926), xii–xiii.

Beerbohm, Max, *Letters to Reggie Turner*, ed. Rupert Hart-Davis (London: Rupert Hart-Davis, 1964).

Benson, A. C., *Walter Pater*, English Men of Letters (London: Macmillan, 1906).

Benson, A. C., *The Thread of Gold* (London: John Murray, 1907).

Bini, Benedetta, '*Genus loci*: il pellegrinaggio di Emerald Uthwart', in ed. Elisa Bizzotto and Franco Marucci, *Walter Pater (1839–1894): Le forme della modernità. The Forms of Modernity* (Milan: Cisalpino, 1996), 187–202.

Bizzotto, Elisa, 'The Imaginary Portrait: Pater's Contribution to a Literary Genre', in ed. Laurel Brake, Lesley Higgins, and Carolyn Williams, *Walter Pater: Transparencies of Desire* (Greensboro: ELT Press, 2002), 213–23.

Black, Charles C., *Catalogue of the Collection of Paintings, Porcelain, Bronzes, Decorative Furniture and Other Works of Art, lent for exhibition in the Bethnal Green Branch of the South Kensington Museum, by Sir Richard Wallace* (London: Eyre and Spottiswoode 1872).

Bloom, Harold, 'Introduction', in *Selected Writings of Walter Pater*, ed. Harold Bloom (New York: Signet Classics, 1974), vii–xxxi.

Bloom, Harold, *Essayists and Prophets* (New York: Chelsea House Publishers, 2005).

Bradford, Gamaliel, *A Naturalist of Souls: Studies in Psychography* (New York: Dodd, Mead, and Company, 1917).

Brake, Laurel, *Walter Pater*, Writers and their Work (Plymouth: Northcote House, 1994).

Brake, Laurel, 'After *Studies*: The Cancelled Book', in Brake, *Print in Transition, 1850–1910: Studies in Media and Book History* (Basingstoke: Palgrave Macmillan, 2001), 213–24.

Brake, Laurel, 'Vernon Lee and the Pater Circle', in ed. Catherine Maxwell and Patricia Pulham, *Vernon Lee: Decadence, Ethics, Aesthetics* (Basingstoke: Palgrave Macmillan, 2006), 40–57.

Brake, Laurel, 'Walter Pater's Circle: The Queer Family Relations of John Rainer McQueen, 1840–1912', *Studies in Walter Pater and Aestheticism* 5 (Summer 2020), 1–30.

Bramly, Serge, *Mona Lisa* (London: Thames & Hudson, 1996).

Brentano-von Arnim, Bettina, *Goethe's Correspondence with a Child*, 3 vols (London: Longman, Orme, Brown, Green, and Longmans, 1837–9).

368 BIBLIOGRAPHY

Bressani, Martin, *Architecture and the Historical Imagination: Eugène-Emmanuel Viollet-le-Duc, 1814–1879* (Farnham: Ashgate, 2014).

Brilliant, Richard, *Portraiture* (London: Reaktion Books, 1991).

Browne, Thomas, *Hydriotaphia: Urne-Burial or, a Brief Discourse of the Sepulchrall Urnes Lately Found in Norfolk* (London: Penguin, 2005).

Bryson, Norman, 'Philostratus and the Imaginary Museum', in ed. Simon Goldhill and Robin Osborne, *Art and Text in Ancient Greek Culture* (Cambridge: Cambridge University Press, 1994), 255–83.

Buckler, William E., 'The Poetics of Pater's Prose: "The Child in the House"', *Victorian Poetry* 23:3 (Autumn 1985), 281–8.

Budziak, Anna, *Text, Body and Indeterminacy: Doppelgänger Selves in Pater and Wilde* (Newcastle: Cambridge Scholars Publishing, 2008).

Bullen, J. B., 'Pater and Ruskin on Michelangelo: Two Contrasting Views', in ed. Philip Dodd, *Walter Pater. An Imaginative Sense of Fact* (London: Cass, 1981), 55–73.

Bullen, J. B., 'Walter Pater's Interpretation of the Mona Lisa as a Symbol of Romanticism', in ed. Karsten Engelberg, *The Romantic Heritage: A Collection of Critical Essays* (Copenhagen: Department of English, University of Copenhagen, 1983), 139–52.

Bullen, J. B., *The Expressive Eye: Fiction and Perception in the Work of Thomas Hardy* (Oxford: Clarendon Press, 1986).

Bullen, J. B., *The Myth of the Renaissance in Nineteenth-Century Writing* (Oxford: Oxford University Press, 1994).

Burdett, Carolyn, 'Walter Pater and Vernon Lee', *Studies in Walter Pater and Aestheticism* 2 (2016), 31–42.

Buzard, James, *The Beaten Track: European Tourism, Literature, and the Ways to Culture, 1800–1918* (Oxford: Clarendon Press, 1993).

Byrne, Katherine, *Tuberculosis and the Victorian Literary Imagination* (Cambridge: Cambridge University Press, 2011).

Camille, Michael, *Gothic Art: Visions and Revelations of the Medieval World* (London: Callmann and King, 1996).

Campo, Roberto E., 'A Poem to a Painter: The Elegie a Janet and Ronsard's Dilemma of Ambivalence', *French Forum* 12:3 (Sept. 1987), 273–87.

Candido, Anne Marie, 'Biography and the Objective Fallacy: Pater's Experiment in "A Prince of Court Painters"', *Biography: An Interdisciplinary Quarterly* 16:2 (Spring 1993), 147–60.

Carlyle, Thomas, 'Memoirs of the Life of Sir Walter Scott, Baronet', *Westminster Review* 27 (Jan. 1838), 154–82.

Carlyle, Thomas, *On Heroes, Hero-Worship, and the Heroic in History* (London: Chapman & Hall, 1840).

Carlyle, Thomas, *Cromwell's Letters and Speeches*, in *The Works of Thomas Carlyle*, ed. Henry Duff Traill, 30 vols (Cambridge: Cambridge University Press, 1897), vol. 6.

Carriera, Rosalba, *Journal de Rosalba Carriera pendant son séjour à Paris en 1720 et 1721*, traduit, annoté et augmenté d'une biographie et des documents inédits sur les artistes et les amateurs du temps par Alfred Sensier (Paris: J. Techener, 1865).

Casanova, Pascale, *The World Republic of Letters*, tr. M. B. Debevoise (Cambridge, MA: Harvard University Press, 2004).

Casey, Edward S., *The Fate of Place: A Philosophical History* (Berkeley: University of California Press, 1997).

Catalogue of Books from the Library of Leonard and Virginia Woolf (Brighton: Holleyman & Treacher, 1975).

Catalogue of the Leigh Court Gallery. The Property of Sir Philip Miles, Bart M.P. will be Sold at Auction by Messrs Christie, Manson & Woods on Saturday 28 June 1884 (London: Christie, Manson & Woods, 1884).

Cecil, David, *Max: A Biography* (London: Constable, 1964).

Chadbourne, Richard M., *Charles-Augustin Sainte-Beuve* (Boston: Twayne Publishers, 1977).

Chambers, D. S., 'Edward Armstrong (1846–1928), Teacher of the Italian Renaissance at Oxford', in ed. John Law and Lene Østermark-Johansen, *Victorian and Edwardian Responses to the Italian Renaissance* (Farnham: Ashgate, 2005), 211–32.

Cheeke, Stephen, 'Walter Pater: Personality and Persons', *Victoriographies* 5.3 (2015), 234–50.

Claiborne, Jay Wood, 'Two Secretaries: The Letters of John Ruskin to Charles Augustus Howell and the Rev. Richard St. John Tyrwhitt', PhD thesis (Univ. of Texas, 1969).

Clayworth, Anya and Ian Small, '"Amiel and Lord Beaconsfield": An Unpublished Review by Oscar Wilde', *English Literature in Transition, 1880–1920* 39:3 (1996), 284–97.

Clements, Patricia, *Baudelaire and the English Tradition* (Princeton: Princeton University Press, 1985).

Coates, Christopher, 'Writing it "Better, Over Again": Walter Pater and Victorian Biography', *Genre* 24:4 (Winter 1991), 381–96.

Coates, Christopher, 'Pater as Polemicist in "Prosper Merimée"', *Modern Language Review* 99:1 (Jan. 2004), 1–16.

Coates, Christopher, 'Pater's Apologia: "The Child in the House"', *Essays in Criticism* 54:2 (Apr. 2004), 144–64.

Colley, Ann, *Victorians in the Mountains: Sinking the Sublime* (Farnham: Ashgate 2010).

Collingwood, W. G., *The Life and Work of John Ruskin*, 2 vols (London: Methuen, 1893).

Collini, Stefan, *Public Moralists: Political Thought and Intellectual Life in Britain 1850–1930* (Oxford and New York: Clarendon Press, 1991).

Collister, Peter, 'Shakespeare for Tourists: Henry James's "The Birthplace"', *Modern Philology* 116:4 (May 2019), 377–400.

Conlon, John, 'Walter Pater's "Diaphaneitè"', *English Language Notes* 17 (1980), 195–7.

Conlon, John, *Walter Pater and the French Tradition* (Lewisburg: Bucknell University Press, 1982).

Cook, Edward T., *A Popular Handbook to the National Gallery, including, by special permission, notes collected from the works of Mr. Ruskin, compiled by Edward T. Cook, with a preface by John Ruskin* (London: Macmillan & Co., 1888).

Costelloe, Timothy, 'Giambattista Vico', *The Stanford Encyclopedia of Philosophy* (Fall 2018 Edition), Edward N. Zalta (ed.), https://plato.stanford.edu/archives/fall2018/entries/vico/ (accessed on 13 Jan. 2021).

Cox-Rearick, Jeanet, 'Themes of Time and Rule at Poggio a Caiano: The Portico Frieze of Lorenzo il Magnifico', *Mitteilungen des Kunsthistorischen Institutes in Florenz* 26 (1982), 167–210.

Creyghton, Camille, 'Commemorating Jules Michelet 1876, 1882, 1898: The Productivity of Banality', *French History* 33:3 (2019), 399–421.

Cruise, Colin, *Love Revealed: Simeon Solomon and the Pre-Raphaelites* (London: Merrell, 2005).

Curtius, Ernst, *The History of Greece*, tr. A. W. Ward, 5 vols (London: R. Bentley, 1868–73).

Daley, Kenneth, *The Rescue of Romanticism: Walter Pater and John Ruskin* (Athens: Ohio University Press, 2001).

Danson, Lawrence, *Max Beerbohm and the Act of Writing* (Oxford: Clarendon Press, 1989).

Delafield, Catherine, *Women's Diaries as Narrative in the Nineteenth-Century Novel* (Farnham: Ashgate, 2009).

Dellamora, Richard, *Masculine Desire: The Sexual Politics of Victorian Aestheticism* (Chapel Hill: University of North Carolina Press, 1990).

Denisoff, Dennis, *Aestheticism and Sexual Parody, 1840–1940* (Cambridge: Cambridge University Press, 2001).

Denisoff, Dennis, 'The Forest Beyond the Frame: Women's Desires in Vernon Lee and Virginia Woolf', in *Sexual Visuality from Literature to Film, 1850–1950* (Basingstoke: Palgrave Macmillan, 2004), 98–120.

370 BIBLIOGRAPHY

de Rinaldis, Maria Luisa, 'The Sacred in Pater's Aesthetic: Ambivalences and Tensions', *English Literature* 2:2 (2015), 383–99.

Desan, Philippe, *Portraits à l'essai: l'iconographie de Montaigne* (Paris: H. Champion, 2007).

Devenish, William Hammon, *Oxford Characters after the Manner of Theophrastus: Or, A Menagerie of Curious Beasts* (Oxford: A. Thos. Shrimpton & Son, 1881).

Dickens, Charles, 'Sands of Life', *All the Year Round* (14 Sept. 1861), 585–9.

Dickens, Charles, 'Nobody Abroad', *All the Year Round* (12 Jun. 1869), 32–7.

Dickens, Charles, *Great Expectations*, ed. Margaret Cardwell, intr. Kate Flint, Oxford World's Classics (Oxford: Oxford University Press, 1998).

Donaldson, Ian, 'National Biography and the Arts of Memory: From Thomas Fuller to Colin Matthew', in ed. Peter France and William St Clair, *Mapping Lives: The Uses of Biography* (Oxford: Oxford University Press, 2002), 67–82.

Donoghue, Denis, *Walter Pater: Lover of Strange Souls* (New York: A. Knopf, 1995).

Dowling, Linda, *Language and Decadence in the Victorian Fin de Siècle* (Princeton: Princeton University Press, 1986).

Dowling, Linda, 'Walter Pater and Archaeology: The Reconciliation with Earth', *Victorian Studies* 31:2 (Winter 1988), 209–31.

Dowling, Linda, *Hellenism and Homosexuality in Victorian Oxford* (Ithaca: Cornell University Press, 1994).

Dyer, Richard, *Pastiche* (London: Routledge, 2007).

Earle, John, *Micro-cosmographie* (London: John Murray 1868).

Earle, John, *Micro-cosmographie: or, A piece of the world discovered; in essayes and characters* (Cambridge: Cambridge University Press, 1903).

Eastham, Andrew, 'Aesthetic Vampirism: The Concept of Irony in the Work of Walter Pater. Oscar Wilde and Vernon Lee', in Eastham, *Aesthetic Afterlives: Irony, Literary Modernity and the Ends of Beauty* (London: Continuum, 2011), 36–60.

Eastlake, Charles, *The Travel Notebooks of Sir Charles Eastlake*, ed. Susanna Avery-Quash, 2 vols (London: The Walpole Society, 2011).

Edwards, Jason and Imogen Hart, ed., *Rethinking the Interior, c.1867–1896* (Farnham: Ashgate, 2010).

Eliot, George, *Adam Bede*, ed. Carol A. Martin (Oxford: Clarendon Press, 2001).

Eliot, George, *Middlemarch: A Study of Provincial Life*, ed. David Carroll, intr. Felicia Bonaparte, Oxford World's Classics (Oxford: Oxford University Press, 2008).

Ellenbogen, Josh, *Reasoned and Unreasoned Images: The Photography of Bertillon, Galton, and Marey* (University Park: Pennsylvania State University Press, 2012).

Ellmann, Richard, *Oscar Wilde* (London: Hamish Hamilton 1987).

Elsner, Jaś, 'Philostratus Visualizes the Tragic: Some Ekphrastic and Pictorial Receptions of Greek Tragedy in the Roman Era', in ed. Chris Kraus, Simon Goldhill, Helene P. Foley, and Jaś Elsner, *Visualizing the Tragic: Drama, Myth, and Ritual in Greek Art and Literature: Essays in Honour of Froma Zeitlin* (Oxford: Oxford University Press, 2007), 309–37.

Emerson, Ralph Waldo, *Selected Essays* (London: Penguin 2003).

Emery, Elizabeth and Laura Morowitz, *Consuming the Past: The Medieval Revival in Fin-de-Siècle France* (Aldershot: Ashgate, 2003).

Erckmann, Émile and Alexandre Chatrian, *Histoire d'un paysan 1789-1815. La Révolution française racontée par un paysan*, 4 vols (Paris: Hetzel & Cie, 1886).

Evangelista, Stefano, 'Swinburne's Galleries', *Yearbook of English Studies* 40:1–2 (2010), 160–79.

Evangelista, Stefano, *Literary Cosmopolitanism in the English Fin de Siècle: Citizens of Nowhere* (Oxford: Oxford University Press, 2021).

Exhibition of the Works of the Old Masters, Associated with a Collection from the Works of Charles Robert Leslie, R. A. and Clarkson Stanfield, R. A. (London: William Clowes & Sons, 1870).

Exhibition of Works by the Old Masters, and by Deceased Masters of the British School, including a Special Selection from the Works of Sir A. W. Callcott, R. A. and D. Maclise, R. A. Winter Exhibition (London: William Clowes & Sons, 1875).

Exhibition of Works by the Old Masters and by Deceased Masters of the British School, including a Special Collection of Works by Holbein and his School. Winter Exhibition 1880 (London: William Clowes & Sons, 1880).

Exposition Universelle de 1862 à Londres. Section française. Catalogue Officiel. Publié par ordre de la Commission Impériale (Paris: Imprimerie Impériale, 1862).

'F', 'In Pater's Rooms', *The Speaker* (26 Aug. 1899), 207–8.

Farnell, L. R., *An Oxonian Looks Back* (London: M. Hopkinson, 1934).

Fellows, Jay, *Tombs, Despoiled and Haunted: 'Under-Textures' and 'After-Thoughts' in Walter Pater*, with a Foreword by J. Hillis Miller (Stanford: Stanford University Press, 1991).

Figlerowicz, Marta, *Flat Protagonists: A Theory of Novel Character* (Oxford: Oxford University Press, 2016).

Ford, Ford Madox, *A Mirror to France* (London: Collins, 1926).

Forster, Edward Morgan, *Aspects of the Novel* (1927 Clark Lectures) (London: Hodder & Stoughton, 1993).

Fossi, Gloria, 'Le vite antiche di Watteau e il ritratto imaginario di Walter Pater', in ed. Elisa Bizzotto and Franco Marucci, *Walter Pater (1839-1894): Le forme della modernità. The Forms of Modernity* (Milan: Cisalpino, 1996), 81–110.

France, Peter and William St Clair, ed., *Mapping Lives: The Uses of Biography* (Oxford: Oxford University Press, 2002).

Frank, Ellen Eve, *Literary Architecture: Essays toward a Tradition: Walter Pater, Gerard Manley Hopkins, Marcel Proust, Henry James* (Berkeley: University of California Press, 1979).

Fraser, Hilary, *The Victorians and Renaissance Italy* (Oxford: Blackwell, 1992).

Fraser, Hilary, 'Walter Pater and Emilia Dilke', *Studies in Walter Pater and Aestheticism* 2 (2016), 21–30.

Freud, Sigmund, *Leonardo da Vinci: A Psychosexual Study of an Infantile Reminiscence*, tr. A. A. Brill (New York: Moffat, Yard, and Company, 1916).

Freud, Sigmund, *The Complete Psychological Works of Sigmund Freud*, tr. James Strachey, 24 vols (New York: W. W. Norton, 1976).

Freud, Sigmund, *The Uncanny*, tr. David McLintorck, intr. Hugh Haughton (London: Penguin, 2003).

Freud, Sigmund and Joseph Breuer, *Studies in Hysteria*, tr. Nicola Luckhurst, intr. Rachel Bowlby (London: Penguin, 2004).

Friedman, David, *Wilde in America: Oscar Wilde and the Invention of Modern Celebrity* (New York: Norton & Co., 2014).

Frow, John, *Character and Person* (Oxford: Oxford University Press, 2016).

Galton, Francis, 'The History of Twins as a Criterion of the Relative Powers of Nature and Nurture', *Journal of the Anthropological Institute* 5 (1 Jan. 1876), 391–406.

Galton, Francis, *Questions on Visualising and Other Allied Faculties* (London: Francis Galton, 1880).

Galton, Francis, 'Photographic Chronicles from Childhood to Age', *Fortnightly Review* 37 (Jan. 1882), 26–31.

Galton, Francis, *Inquiries into Human Faculty and its Development* (London: Macmillan, 1883).

Galton, Francis, *Life History Album* (London: Macmillan, 1884).

Galton, Francis, *Memories of my Life* (London: Methuen, 1908).

Garnett, Richard and Edmund Gosse, *English Literature: An Illustrated Record*, 4 vols (London: Heinemann, 1903).

Gautier, Théophile, 'Artistes contemporains: Meissonier', *Gazette des Beaux-Arts* (May 1862), 419–28.

372 BIBLIOGRAPHY

Geffcken, H., 'Contemporary Life and Thought in Germany', *Contemporary Review* 50 (Aug. 1886), 277–93.

Gere, Charlotte and Lesley Hoskins, *The House Beautiful: Oscar Wilde and the Aesthetic Interior* (London: Lund Humphries, 2000).

Girard, Alain, *Le journal intime* (Paris: Presses universitaires de France, 1963).

Glaser, Stephanie A., ed., *The Idea of the Gothic Cathedral: Interdisciplinary Perspectives on the Meanings of the Medieval Edifice in the Modern Period* (Turnhout: Brepols, 2018).

Goethe, Johann Wolfgang von, 'Philostrats Gemälde', in *Goethes sämmtliche Werke in Vierzig Bänden* (Stuttgart: J. G. Cotta, 1869), 34: 212–44.

Goff, Jacques Le, *The Birth of Europe*, tr. Janet Lloyd (Oxford: Blackwell, 2005).

Goncourt, Edmond de, *La Maison d'un artiste*, 2 vols (Paris: Charpentier, 1881).

Goncourt, Edmond et Jules de, *L'Art du dix-huitième siècle*, deuxième edn, 2 vols (Paris: Rapilly & Marchand, 1873–4).

Goncourt, Edmond et Jules de, *Journal des Goncourt: Mémoires de la vie littéraire*, 9 vols (Paris: Charpentier & Cie, 1888–96).

Goozé, Marjanne E., 'A Language of Her Own: Bettina Brentano-von Arnim's Translation Theory and her English Translation Project', in ed. Elke P. Frederiksen and Katherine R. Goodman, *Bettina Brentano-von Arnim: Gender and Politics* (Detroit: Wayne State University, 1995), 278–303.

Gosse, Edmund, *From Shakespeare to Pope: An Inquiry into the Causes and Phenomena of the Rise of Classical Poetry in England* (Cambridge: Cambridge University Press, 1885).

Gosse, Edmund, 'Walter Pater: A Portrait', *Contemporary Review* 66 (1894), 795–810.

Gosse, Edmund, 'The Custom of Biography', *Anglo-Saxon Review: A Quarterly Miscellany* 8 (Mar. 1901), 195–208.

Goudie, Allison, 'Verso una storia popolare del *Sarto* di Moroni in Gran Bretagna', in *Giovan Battista Moroni Il Sarto*, exhibition catalogue Accademia Carrara (Milan: Silvana Editoriale 2015), 33–9.

Gurney, Edmund, Frederic Myers, and Frank Podmore, *Phantasms of the Living*, 2 vols (London: Trübner & Co., 1886).

Hales, Shelley, 'A Search for Home: The Representation of the Domestic in *Marius the Epicurean*', in *Pater the Classicist: Classical Scholarship, Reception, and Aestheticism*, ed. Charles Martindale, Stefano Evangelista, and Elizabeth Prettejohn (Oxford: Oxford University Press, 2017), 135–48.

Hall, N. John, *Max Beerbohm: A Kind of Life* (New Haven: Yale University Press, 2002).

Hamerton, Philip Gilbert, *Imagination in Landscape Painting* (London: Seeley & Co., 1896).

Hamilton, Walter, *The Aesthetic Movement in England* (London: Reeves & Turner, 1882).

Hamnett, Brian, *The Historical Novel in Nineteenth-Century Europe: Representations of Reality in History and Fiction* (Oxford: Oxford University Press, 2015).

Hannoosh, Michèle, *Jules Michelet: Writing and Art History in Nineteenth-Century France* (University Park: Penn State Press, 2019).

Hardy, Florence Emily, *The Early Life of Thomas Hardy, 1840–1891: compiled largely from contemporary notes, letters, diaries, and biographical memoranda, as well as from oral information in conversations extending over many years* (New York: Macmillan, 1928).

Harris, Wendell V., 'Ruskin and Pater—Hebrew and Hellene—Explore the Renaissance', *Clio* 17:2 (1988), 173–85.

Harrison, J. S., 'Pater, Heine, and the Old Gods of Greece', *PMLA* 39:3 (Sept. 1924), 655–86.

Harvey, Elizabeth D., *Ventriloquized Voices: Feminist Theory and English Renaissance Texts* (London and New York: Routledge, 1992).

Haskell, Francis, *The Ephemeral Museum: Old Master Paintings and the Rise of the Art Exhibition* (New Haven and London: Yale University Press, 2000).

Hatt, Michael, 'Space, Surface, Self: Homosexuality and the Aesthetic Interior', *Visual Culture in Britain* 8:1 (Summer 2007), 105–28.

Haweis, Mary Eliza, *The Art of Decoration* (London: Chatto & Windus, 1881).

Haweis, Mary Eliza, *Beautiful Houses; Being a Description of Certain Well-Known Artistic Houses*, 2nd edn (London: Sampson, Low, Marston, Searle & Rivington, 1882).

Haweis, Mary Eliza, 'Mixed Æsthetes', *Time* 9 (Oct. 1883), 433–8.

Hay, Denys, *Europe: The Emergence of an Idea* (Edinburgh: Edinburgh University Press, 1968).

Heffernan, James A. W., *Museum of Words: The Poetics of Ekphrasis from Homer to Ashbery* (Chicago: Chicago University Press, 1993).

Heine, Heinrich, 'Les Dieux en exil', *Revue des deux mondes* (1 Apr. 1853), 5–38.

Henderson, Peter, 'An Annotated Version of "Emerald Uthwart"' (Canterbury: King's School, 1994).

Henri, V. and C., 'Enquête sur les premiers souvenirs d'enfance', *L'Année psychologique* 3 (1896), 184–98.

Herder, Johann Gottfried, *Ideen zur Philosophie der Geschichte der Menschheit* (Riga und Leipzig: J. F. Hartknoch 1785).

Hext, Kate, *Walter Pater: Individualism and Aesthetic Philosophy*, Edinburgh Critical Studies in Victorian Culture (Edinburgh: Edinburgh University Press, 2013).

Higgins, Lesley, 'But Who Is She? Forms of Subjectivity in Walter Pater's Writings', *Nineteenth-Century Prose* 24:2 (1997), 37–65.

Higgins, Lesley, *The Modernist Cult of Ugliness: Aesthetic and Gender Politics* (New York: Palgrave Macmillan, 2002).

Hochman, Baruch, *Character in Literature* (Ithaca: Cornell University Press, 1985).

Hollyer, Frederick, *Catalogue of Platinotype Reproductions of Pictures etc., Photographed and Sold by Mr. Hollyer* (London: Frederick Hollyer, 1904).

Holmes, C. J., *Self & Partners (Mostly Self): Being the Reminiscences of C. J. Holmes* (London: Constable, 1936).

Hugo, Victor, *Notre Dame of Paris*, tr. John Sturrock (Harmondsworth: Penguin, 1978).

Hugo, Victor, 'Sur Walter Scott: A propos de *Quentin Durward*', in *Œuvres complètes*, ed. Jacques Seebacher and Guy Rosa, 15 vols (Paris: Laffont, 1985), 10:149.

Huysmans, Joris-Karl, *Against Nature*, tr. Margaret Mauldon, Oxford World's Classics (Oxford: Oxford University Press, 1998).

Inman, B. A., '"Sebastian van Storck": Pater's Exploration into Nihilism', *Nineteenth-Century Fiction* 30:4 (Mar. 1976), 457–76.

Inman, B. A., *Walter Pater's Reading: A Bibliography of his Library Borrowings and Literary References, 1858–1873* (New York: Garland Press, 1981).

Inman, B. A., *Walter Pater and his Reading, 1874–1877: With a Bibliography of his Library Borrowings, 1878–1894* (New York: Garland Press, 1990).

Inman, B. A., 'Pater's Letters at the Pierpoint Morgan Library', *English Literature in Transition, 1880–1920* 34:4 (1991), 407–17.

Inman, B. A., 'Estrangement and Connection: Walter Pater, Benjamin Jowett and William M. Hardinge', in ed. Laurel Brake and Ian Small, *Pater in the 1990s* (Greensboro: ELT Presss, 1991), 1–20.

Inman, B. A., 'Tracing the Pater Legacy, Part II: Posthumous Sales, Manuscripts and Copyrights', *Pater Newsletter* 32 (1995), 3–8.

Inman, B. A., 'Reaction to Saintsbury in Pater's Formulation of Ideas of Prose Style', *Nineteenth-Century Prose* 24 (Autumn 1997), 108–26.

Iser, Wolfgang, Walter Pater: *The Aesthetic Moment*, tr. David Henry Wilson (Cambridge: Cambridge University Press, 1987).

Israel, Kali, *Names and Stories: Emilia Dilke and Victorian Culture* (Oxford: Oxford University Press, 1999).

374 BIBLIOGRAPHY

James, Henry, 'The Art of Fiction', *Henry Longman's Magazine* 4 (Sept. 1884), 502–21.

James, Henry, 'In Holland', *Transatlantic Sketches* (Boston: Houghton Mifflin & Co, 1903), 380–90.

James, Henry, *Letters*, ed. Leon Edel, 4 vols (Harvard: Belknap Press, 1980).

Jefferson, Ann, *Biography and the Question of Literature in France* (Oxford: Oxford University Press, 2007).

Johnson, Diane, *The True History of the First Mrs Meredith and Other Lesser Lives* (London: Heinemann, 1973).

Johnson, Samuel, *A Dictionary of the English Language. To which are prefixed, a History of the Language, and an English Grammar* (London: Knapton, Longman et al., 1755).

Jöttkandt, Sigi, 'Effectively Equivalent: Walter Pater, "Sebastian van Storck" and the Ethics of Metaphor', *Nineteenth-Century Literature* 60:2 (Sept. 2005), 163–98.

Joukovsky, Nicholas, 'The Early Meredithian Milieu: New Evidence from Letters of Peter Augustin Daniel', *Studies in Philology* 115:3 (Summer 2018), 615–40.

Jullienne, Jean de, ed., *L'Œuvre d'Antoine Watteau, Peintre du Roy en son Académie Roïale de Peinture et Sculpture, gravé d'après ses tableaux et desseins originaux tirez du cabinet du Roy et des plus curieux de l'Europe par les soins de M. de Jullienne* (Paris: Chez Gersaint, 1735).

Kaiser, Matthew, 'Pater's Mouth', *Journal of Victorian Literature and Culture* 39:1 (Mar. 2011), 47–64.

Kaplan, Louis, 'Where the Paranoid Meets the Paranormal: Speculations on Spirit Photography', *Art Journal* 62:3 (Fall 2003), 18–29.

Kaplan, Louis, *The Strange Case of William Mumler, Spirit Photographer* (Minneapolis: University of Minnesota Press, 2008).

Katz, Tamar, '"In the House and Garden of His Dream": Pater's Domestic Subject', *Modern Language Quarterly* 56:2 (1995), 167–88.

Keates, Jonathan, *The Portable Paradise: Baedeker, Murray, and the Victorian Guidebook* (London: Notting Hill Editions, 2011).

Keefe, Robert, '"Apollo in Picardy": Pater's Monk and Ruskin's Madness', *English Literature in Transition, 1880–1920* 29:4 (1986), 361–70.

Keefe, Robert and Janice A., *Walter Pater and the Gods of Disorder* (Athens: Ohio University Press, 1988).

Kemp, Martin and Giuseppe Pallanti, *Mona Lisa: The People and the Painting* (Oxford: Oxford University Press, 2017).

Kemp, Martin, Robert B. Simon, and Margaret Dallivalle, *Leonardo's Salvator Mundi and the Collecting of Leonardo in the Stuart Courts* (Oxford: Oxford University Press, 2020).

Kerrigan, John, ed., *Motives of Woe: Shakespeare and 'Female Complaint': An Anthology* (Oxford: Oxford University Press, 1991).

Kijinski, John L., 'John Morley's "English Men of Letters" Series and the Politics of Reading', *Victorian Studies* 34:2 (Winter 1991), 205–25.

Klibansky, Raymond, Erwin Panofsky, and Fritz Saxl, *Saturn and Melancholy: Studies in the History of Natural Philosophy, Religion, and Art* (London: Nelson, 1964).

Koerner, Joseph Leo, *The Moment of Self-Portraiture in German Renaissance Art* (Chicago: University of Chicago Press, 1996).

Korsten, F. J. M., 'The "English Men of Letters" Series: A Monument of Late Victorian Literary Criticism', *English Studies* 6 (1992), 503–16.

Kouloris, Theodore, *Hellenism and Loss in the Work of Virginia Woolf* (Farnham: Ashgate, 2011).

Kufferath, Maurice, 'Louis II of Bavaria', *Musical World* (26 Jun. 1886), 403–5.

Lago, Mary M. and Karl Beckson, ed., *Max and Will: Max Beerbohm and William Rothenstein. Their Friendship and Letters 1893–1945* (London: John Murray, 1975).

Lamb, Charles, 'Blakesmoor in H—shire', ed. E. V. Lucas, *Elia and The Last Essays of Elia*, (London: Methuen & Co., 1912), 174–8.

Lambert-Charbonnier, Martine, *Walter Pater et les "Portraits Imaginaires": Miroirs de la culture et images de soi* (Paris: L'Harmattan, 2004).

Landor, Walter Savage, *The Complete Works*, ed. T. Earle Welby, 16 vols (London: Chapman & Hall, 1927–36), Vol. 7: *Imaginary Conversations*, 'Joseph Scaliger and Montaigne'.

Lang, Andrew, 'Literary Chronicle', *Cosmopolis* 1 (Jan. 1896), 70–87.

Lee, Adam, *The Platonism of Walter Pater: Embodied Equity* (Oxford: Oxford University Press, 2020).

Lee, Sidney, *Principles of Biography: The Leslie Stephen Lecture* (Cambridge: Cambridge University Press, 1911).

Lee, Vernon, 'The Portrait Art of the Renaissance', *Cornhill Magazine* 47 (May 1883), 564–81.

Lee, Vernon, *Genius Loci: Notes on Places* (London: Grant Richards, 1899).

Lee, Vernon, 'Dionysus in the Euganean Hills: Walter H. Pater In Memoriam', *Contemporary Review* 120 (1 Jul. 1921), 346–53.

Lee, Vernon, *Vernon Lee's Letters*. With a Preface by her Executor, ed. Irene Cooper Willis (London: privately printed, 1937).

Lee-Morrison, Lila, *Portraits of Automated Facial Recognition: On Machinic Ways of Seeing the Face* (Bielefeld: Transcript Verlag, 2019).

Lefebvre, F.-A., *La Chartreuse de Notre-Dame-des-Prés à Neuville* (Paris: Bray et Retaux, 1881).

Lefebvre, F.-A., *La Célèbre Inconnue de Prosper Merimée. Sa Vie et ses Oeuvres authentiques, avec Documents, Portraits et Dessins inédits*. Préface introduction par Félix Chambon (Paris: E. Sansot & Cie, 1908).

Legros, Alain, *Essais sur poutres. Peintures et inscriptions chez Montaigne*. Preface de Michael Screech (Paris: Klincksieck, 2000).

Legros, Alain, '"Visite à Montaigne" au XIXe siècle: petite histoire d'un genre méconnu', *Montaigne Studies: An Interdisciplinary Forum* 12:1–2 (2000), 185–208.

Leighton, Angela, *On Form: Poetry, Aestheticism, and the Legacy of a Word* (Oxford: Oxford University Press, 2007).

Lepik, Andres and Katrin Bäumler, *The Architecture under King Ludwig II—Palaces and Factories* (Berlin: de Gruyter, 2018).

Lessing, G. E., *Laocoön: An Essay on the Limits of Painting and Poetry*, tr. and ed. E. A. McCormick (Baltimore: Johns Hopkins University Press, 1984).

Levey, Michael, *The Case of Walter Pater* (London: Thames and Hudson, 1978).

Lewes, G. H., *Sea-side Studies at Ilfracombe, Tenby, the Scilly Isles, and Jersey* (Edinburgh: Blackwood, 1860).

Lewis, Ben, *The Last Leonardo: The Secret Lives of the World's Most Expensive Painting* (New York: Ballantine Books, 2019).

Leydi, Silvio, 'Sarti a Bergamo (ed Albino) nel maturo Cinquecento', in *Giovan Battista Moroni Il Sarto*, exhibition catalogue Accademia Carrara (Milan: Silvana Editoriale 2015), 41–57.

Locke, John, *Essay Concerning Human Understanding* (Oxford: Oxford University Press, 1975).

Losey, Jay B., 'Epiphany in Pater's Portraits', *English Literature in Transition, 1880–1920* 29 (1986), 297–308.

Lukács, Georg, *The Historical Novel*, tr. Hannah and Stanley Mitchell (Harmondsworth: Penguin, 1976).

Lyons, Sara, *A. C. Swinburne and Walter Pater: Victorian Aestheticism, Doubt, and Secularisation* (Cambridge: Legenda, 2015).

MacColl, D. S., 'A Batch of Memories: 12 Walter Pater', *Week-end Review* (12 Dec. 1931), 759–60.

'Maitland, Thomas' (pseud. for Robert Buchanan), 'The Fleshly School of Poetry: Mr D. G. Rossetti', *Contemporary Review* 18 (Oct. 1871), 334–50.

376 BIBLIOGRAPHY

Malley, Shawn, 'Disturbing Hellenism: Walter Pater, Charles Newton, and the Myth of Demeter and Persephone', in ed. Laurel Brake, Lesley Higgins, and Carolyn Williams, *Walter Pater: Transparencies of Desire* (Greensboro: ELT Press, 2002), 90–106.

Mallock, W. H., *The New Republic: Culture, Faith and Philosophy in an English Country House*, intr. John Lucas (Leicester: Leicester University Press, 1975).

Marchi, Dudley M., *Montaigne among the Moderns: Receptions of the Essais* (Providence: Berghahn Books, 1994).

Marcus, Laura, *Auto/Biographical Discourses* (Manchester: Manchester University Press, 1994).

Marcus, Laura, 'The Newness of the "New Biography": Biographical Theory and Practice in the Early Twentieth Century', in ed. Peter France and William St Clair, *Mapping Lives: The Uses of Biography* (Oxford: Oxford University Press, 2002), 193–218.

Martens, Lorna, *The Diary Novel* (Cambridge: Cambridge University Press, 1985).

Martindale, Charles, Stefano Evangelista, and Elizabeth Prettejohn, eds, *Pater the Classicist: Classical Scholarship, Reception, and Aestheticism* (Oxford: Oxford University Press, 2017).

Martindale, Charles, Lene Østermark-Johansen, and Elizabeth Prettejohn, eds, *Walter Pater and the Beginnings of English Studies* (Cambridge: Cambridge University Press, 2023).

Maxwell, Catherine, *Second Sight: The Visionary Imagination in Late Victorian Literature* (Manchester: Manchester University Press, 2008).

Maxwell, Catherine, *Scents and Sensibility: Perfume in Victorian Literary Culture* (Oxford: Oxford University Press, 2017).

McCormick, 'The Idea of Europe', in ed. McCormick, *Europeanism* (Oxford: Oxford University Press, 2010), 1–26.

McGrath, F. C., *The Sensible Spirit: Walter Pater and the Modernist Paradigm* (Florida: University Presses of Florida, 1986).

McMullen, Roy, *Mona Lisa: The Picture and the Myth* (London: Macmillan, 1976).

Meijer, D. C., 'The Amsterdam Civic Guard Portraits within and outside the New Rijksmuseum. Pt III. Bartholomeus van der Helst', tr. Tom van der Molen, *Journal of Historians of Netherlandish Art* 6:1 (Winter 2014), 1–24.

Meinhold, Wilhelm, *The Amber Witch: A Romance by Wilhelm Meinhold*, tr. Lady Duff Gordon, intr. Joseph Jacobs and ill. Philip Burne-Jones (London: D. Nutt, 1895).

Meinhold, Wilhelm, *The Amber Witch*, tr. Lady Duff Gordon, intr. and ed. Barbara Burns, MHRA European Translations 4 (London: Modern Humanities Research Association, 2016).

Meisel, Perry, *The Absent Father: Virginia Woolf and Walter Pater* (New Haven: Yale University Press, 1980).

Mentmore. Catalogue of Paintings, Prints and Drawings Sold on Behalf of the Executors of the 6th Earl of Rosebery and his Family, which will be auctioned by Sotheby Parke Bernet & Co. on Wednesday 25 May 1977, 5 vols (London: Sotheby's, 1977).

Merimée, Prosper, *Lettres à une inconnue*, 2 vols (Paris: Michel Lévy, 1874).

Merrington, M. and J. Golden, *A List of the Papers and Correspondence of Sir Francis Galton (1822–1911) held in the Manuscripts Room, The Library, University College, London*, second impression (London: Galton Laboratory, 1978).

Michelet, Jules, *Histoire de France au seizième siècle: Renaissance* (Paris: Chamerot, 1855).

Michelet, Jules, 'Preface' to *The History of France* (1869), tr. Edward K. Kaplan, (Cambridge: Open Book Publishers, 2013), 133–61, https://books.openedition.org/obp/1389?lang=en (accessed on 16 Jan. 2021).

Mirandula, G. F. Pico della, *Here is coteyned the lyfe of Johan Picus erle of Mirandula. With dyuers epystles & other werkes of ye sayd Johan Picus*, tr. Thomas More (London: W. de Worde, *c.*1525).

Mollett, John W., *Meissonier* (London: Sampson Low, Marston, Searle & Rivington, 1882).

Monsman, Gerald, *Pater's Portraits: Mythic Pattern in the Fiction of Walter Pater* (Baltimore: Johns Hopkins University Press, 1967).

Monsman, Gerald, 'Old Mortality at Oxford', *Studies in Philology* 67:3 (Jul. 1970), 359–89.

Monsman, Gerald, 'Pater, Hopkins, and Fichte's Ideal Student', *South Atlantic Quarterly* 70 (1971), 365–76.

Monsman, Gerald, *Walter Pater's Art of Autobiography* (New Haven: Yale University Press, 1980).

Monsman, Gerald, 'Walter Pater, Circe, and the Paths of Darkness', *Nineteenth-Century Prose* 24:2 (Fall 1997), 66–77.

Monsman, Gerald, *Oxford University's Old Mortality Society: A Study in Victorian Romanticism* (Lewiston: Edwin Mellen Press, 1998).

Monsman, Gerald, 'The Platonic Eros of Walter Pater and Oscar Wilde: "Love's Reflected Image" in the 1890s', *English Literature in Transition, 1880–1920* 45:1 (2002), 26–45.

Monsman, Gerald, 'Pater's Portraits: The Aesthetic Hero in 1890 (Part I)', *Expositions* 2:1 (2008), 83–102.

Monsman, Gerald, 'Pater's Portraits: The Aesthetic Hero in 1890 (Part II)', *Expositions*, 3.1 (2009), 23–40.

Montaigne, Michel de, *The Complete Essays by Michel de Montaigne*, tr. and ed. M. A. Screech, Penguin Classics (Harmondsworth: Penguin, 1993).

Moran, Maureen, 'Walter Pater's House Beautiful and the Psychology of Self-Culture', *English Literature in Transition, 1880–1920* 50:3 (2007), 291–312.

Morgan, Benjamin, *The Outward Mind: Materialist Aesthetics in Victorian Science and Literature* (Chicago: University of Chicago Press, 2017).

Morley, John, ed., *Character Writings of the Seventeenth Century* (London: G. Routledge, 1891).

Moretti, Franco, *The Way of the World: The Bildungsroman in European Culture*, new edn, tr. Albert Sbragia (London: Verso, 2000).

Müller, Karl Otfried, *History and Antiquity of the Doric Race*, tr. Henry Tufnell and George C. Lewis, 2 vols (Oxford: John Murray, 1830).

Murray, A. S., 'An Ancient Picture Gallery', *Magazine of Art* 5 (Jan. 1882), 371–6.

Murray, Alex, *Landscapes of Decadence: Literature and Place at the Fin de Siècle* (Cambridge: Cambridge University Press, 2016).

Murray, John, *A Handbook for Travellers in France, being a Guide to Normandy, Brittany; the Rivers Seine, Loire, Rhône, and Garonne; The French Alps, Dauphiné, the Pyrenees, Provence, and Nice, &c, &c, &c. Their Railways and Roads*. With maps and plans. 9th edn, revised and corrected, 2 vols (London: John Murray, 1864).

Murray, John, *A Handbook for Travellers in France, Alsace, and Lorraine: Being a Guide to Normandy, Brittany; the Rivers Seine, Loire, Rhône and Garonne; the French Alps, Dauphiné, the Pyrenees, Provence, and Nice, &c. &c. &c; the Railways and Principal Roads*, 12th edn, entirely revised, with maps and plans of towns (London: John Murray, 1873).

Murray, John, *A Handbook of Travel-Talk: Being A Collection of Questions, Phrases, and Vocabularies in English, German, French, and Italian Intended to Serve as Interpreter to English Travellers Abroad or Foreigners Visiting England*, by the Editors of the Handbooks, new edn, carefully revised (London: John Murray, 1877).

Nardinocchi, Elisabetta and Matilde Casati, eds, *L'immagine e lo sguardo: Ritratti e studi di figura da Raffaello a Constable* (Florence: Museo Horne, 2011).

Newby, Zahra, 'Absorption and erudition in Philostratus' *Imagines*', in ed. Ewen Bowie and Jaś Elsner, *Philostratus* (Cambridge: Cambridge University Press, 2009), 322–42.

Ng, Aimee, Arturo Galassino, and Simone Farrchinetti, *Moroni: The Riches of Renaissance Portraiture* (New York: Scala, 2019).

Nicolson, Harold, *Some People* (Oxford: Oxford University Press, 1983).

Nicolson, Harold, *The Harold Nicolson Diaries 1907–1964*, ed. Nigel Nicolson (London: Phoenix, 2005).

378 BIBLIOGRAPHY

Novarr, David, *The Lines of Life: Theories of Biography, 1880–1970* (West Lafayette: Purdue University Press, 1986).

Orr, Linda, *Headless History: Nineteenth-Century French Historiography of the Revolution* (Ithaca and London: Cornell University Press, 1990).

Østermark-Johansen, Lene, 'Swinburne's Serpentine Delights: The Aesthetic Critic and the Old Master Drawings in Florence', *Nineteenth-Century Contexts* 24:1 (2002a), 49–72.

Østermark-Johansen, Lene, 'Serpentine Rivers and Serpentine Thought: Flux and Movement in Walter Pater's Leonardo Essay', *Victorian Literature and Culture* 30 (2002b), 455–82.

Østermark-Johansen, Lene, 'The Death of Euphues: Euphuism and Decadence in Late Victorian Literature', *English Literature in Transition, 1880–1920* 45:1 (2002c), 4–25.

Østermark-Johansen, Lene, *Walter Pater and the Language of Sculpture* (Farnham: Ashgate, 2011).

Østermark-Johansen, Lene, 'The Book Beautiful: Emilia Dilke's Copy of Walter Pater's *Studies in the History of the Renaissance*', *Brasenose College Library and Archives Blog*, 11 Jun. 2015, https://brasenosecollegelibrary.wordpress.com/2015/06/11/the-book-beautiful-emilia-dilkes-copy-of-walter-paters-studies-in-the-history-of-the-renaissance-by-lene-ostermark-johansen/ (accessed on 9 Nov. 2020).

Østermark-Johansen, Lene, 'From Periphery to Centre: The Female Writer in Walter Pater and Virginia Woolf', in ed. Bénédicte Coste, Catherine Delyfer, and Christine Reynier, *Reconnecting Aestheticism and Modernism: Continuities, Revisions, Speculations* (Abingdon: Routledge, 2016), 56–66.

Østermark-Johansen, Lene, 'Pater's "Hipolytus Veiled": A Study from Euripides?', in ed. Charles Martindale, Stefano Evangelista, and Elizabeth Prettejohn, *Pater the Classicist: Classical Scholarship, Reception, and Aestheticism*, Classical Presences (Oxford: Oxford University Press, 2017), 183–99.

Østermark-Johansen, Lene, '"The Power of an Intimate Presence": Walter Pater's Leonardo Essay (1869) and its Influence at the Fin de Siècle', in ed. Susanna Avery-Quash and Juliana Barone, *Leonardo in Britain: Collections and Historical Reception* (Florence: Olschki, 2019), 303–21.

Østermark-Johansen, Lene, '"This will be a popular picture": Giovanbattista Moroni's Tailor and the Female Gaze', in special issue of '*19*', ed. Susanna Avery-Quash and Hilary Fraser, *Knowing "as much of art as the cat"? Nineteenth-Century Women Writers on the Old Masters* 28 (2019), https://doi.org/10.16995/ntn.822 (accessed on 14 Jan. 2021).

Østermark-Johansen, Lene, 'The Dream of a German Renaissance: Conrad Celtis, Albrecht Dürer, and Apollo in Walter Pater's "Duke Carl of Rosenmold" (1887)' in *Studia Humanitatis: Essays in Honour of Marianne Pade on the Occasion of her Sixty-Fifth Birthday 8 March 2022, Nordic Journal of Renaissance Studies* 18 (2022), https://www.njrs.dk/18_2022/30_Oestermark_Johansen.pdf (accessed on 15 April 2022).

Pagden, Anthony, ed., *The Idea of Europe: From Antiquity to the European Union* (Cambridge: Cambridge University Press, 2002).

Palmieri-Marinoni, Alessio Francesco, et al., 'Aspetti di costume e moda nel *Sarto* di Giovan Battista Moroni', in *Giovan Battista Moroni Il Sarto*, exhibition catalogue Accademia Carrara(Milan: Silvana Editoriale 2015), 59–71.

Palmieri-Marinoni, Alessio Francesco et al., 'L'abito del Sarto: la ricostruzione', in *Giovan Battista Moroni Il Sarto*, exhibition catalogue Accademia Carrara (Milan: Silvana Editoriale 2015), 73–7.

Panofsky, Erwin and Fritz Saxl, *Dürers 'Melencolia I'. Eine Quellen- und typengeschichtliche Untersuchung*, Studien der Bibliothek Warburg 2 (Leipzig: B. G. Teubner, 1923).

Paravicini, Frances de, *Life of St. Edmund of Abingdon, Archbishop of Canterbury* (London: Burns & Oates, 1898).

BIBLIOGRAPHY 379

Pater, Walter, 'Poems by William Morris', *Westminster Review* 34 (Oct. 1868), 300–12.

Pater, Walter, 'Notes on Leonardo da Vinci', *Fortnightly Review* 6 (1 Nov. 1869), 494–508.

Pater, Walter, *Studies in the History of the Renaissance* (London: Macmillan & Co., 1873).

Pater, Walter, 'The Myth of Demeter and Persephone', *Fortnightly Review* 19 (1 Jan. 1876), 82–95 and 19 (1 Feb. 1876), 260–76.

Pater, Walter, 'Romanticism', *Macmillan's Magazine* 35 (Nov. 1876), 64–70.

Pater, Walter, 'A Study of Dionysus: The Spiritual Form of Fire and Dew', *Fortnightly Review* 20 n.s. (1 Dec. 1876), 752–72.

Pater, Walter, 'Imaginary Portraits. I. The Child in the House', *Macmillan's Magazine* 38 (Aug. 1878), 313–21.

Pater, Walter, 'Charles Lamb: The Character of the Humourist', *Fortnightly Review* 24 (1 Oct. 1878), 466–74.

Pater, Walter, *Marius the Epicurean: His Sensations and Ideas*, 2 vols (London: Macmillan, 1885).

Pater, Walter, 'Amiel's "Journal Intime"', *Guardian* (17 Mar. 1886), in *Essays from the Guardian*, 19–37.

Pater, Walter, 'Sir Thomas Browne', *Macmillan's Magazine* 54 (May 1886), 5–18.

Pater, Walter, 'Denys l'Auxerrois', *Macmillan's Magazine* 54 (Oct. 1886), 413–23.

Pater, Walter, 'English at the Universities', *Pall Mall Gazette* 44 (27 Nov. 1886), 1–2.

Pater, Walter, 'M. Feuillet's "La Morte"', *Macmillan's Magazine* 54 (Dec. 1886), 97–105.

Pater, Walter, 'Browning', *Guardian* (9 Nov. 1887), in *Essays from the Guardian*, 39–51.

Pater, Walter, *Imaginary Portraits* (London: Macmillan, 1887).

Pater, Walter, 'The Life and Letters of Flaubert', *Pall Mall Gazette* 48 (25 Aug. 1888), 1–2.

Pater, Walter, 'Style', *Fortnightly Review* 44 (Dec. 1888), 728–43.

Pater, Walter, 'The Bacchanals of Euripides', *Macmillan's Magazine* 60 (May 1889), 63–72.

Pater, Walter, 'Correspondance de Gustave Flaubert', *Athenaeum* 3223 (3 Aug. 1889), 155–6.

Pater, Walter, *Appreciations, with an Essay on Style* (London: Macmillan, 1889).

Pater, Walter, 'Art Notes in North Italy', *New Review* 3 (Nov. 1890), 393–403.

Pater, Walter, 'Prosper Merimée', *Fortnightly Review* 48 (Dec. 1890), 852–64.

Pater, Walter, 'A Novel by Mr. Oscar Wilde', *The Bookman* 1 (Nov. 1891), 59–60.

Pater, Walter, *Plato and Platonism* (London: Macmillan, 1893).

Pater, Walter, 'Some Great Churches in France. 1. Notre Dame d'Amiens', *Nineteenth Century* 35 (Mar. 1894), 481–8.

Pater, Walter, 'Some Great Churches in France. 2. Vézelay', *Nineteenth Century* 35 (Jun. 1894), 963–70.

Pater, Walter, *Greek Studies* (London: Macmillan, 1895).

Pater, Walter, 'Pascal', in *Miscellaneous Studies: A Series of Essays* (London: Macmillan, 1895), 55–84.

Pater, Walter, *Miscellaneous Studies: A Series of Essays* (London: Macmillan, 1895).

Pater, Walter, 'Shadwell's Dante', in Walter Pater, *Uncollected Essays* (Portland: Thomas B. Mosher, 1903), 145–61.

Pater, Walter, 'Robert Elsmere', *Essays from the Guardian* (London: Macmillan, 1910), 53–70.

Pater, Walter, 'Imaginary Portraits 2: An English Poet', *Fortnightly Review* 129 (1 Apr. 1931), 433–48.

Pater, Walter, *Letters*, ed. Lawrence Evans (Oxford: Oxford University Press, 1970).

Pater, Walter, *The Renaissance: Studies in Art and Poetry*, the 1893 text, edited with textual and explanatory notes by Donald L. Hill (Berkeley: University of California Press, 1980).

Pater, Walter, *Gaston de Latour: The Revised Text*, ed. Gerald Monsman (Greensboro: ELT Press, 1995).

Pater, Walter, *Marius the Epicurean*, ed. Gerald Monsman (Kansas City: Valancourt Books, 2008).

380 BIBLIOGRAPHY

Pater, Walter, *Studies in the History of the Renaissance*, ed. Matthew Beaumont, Oxford World's Classics (Oxford: Oxford University Press, 2010).

Pater, Walter, *Imaginary Portraits, The Collected Works of Walter Pater*, vol. 3, ed. Lene Østermark-Johansen (Oxford: Oxford University Press, 2019).

Pater, Walter, *Gaston de Latour, The Collected Works of Walter Pater*, vol. 4, ed. Gerald Monsman (Oxford: Oxford University Press, 2019).

Pater, Walter, *Classical Studies, The Collected Works of Walter Pater*, vol. 8, ed. Matthew Potolsky (Oxford: Oxford University Press, 2020).

Pater, Walter, *Letters, Collected Works of Walter Pater*, vol. 9, ed. R. L. Seiler (Oxford: Oxford University Press, 2022).

Pattison, Emilia, 'Contemporary Literature. Art', *Westminster Review* (Apr. 1873), 638–45.

Peacock, Thomas Love, *The Letters of Thomas Love Peacock*, ed. Nicholas A. Joukovsky, 2 vols (Oxford: Clarendon Press, 2001).

Pearson, Karl, *Life, Letters and Labours of Francis Galton*, 4 vols (Cambridge: Cambridge University Press, 1924).

Philips, Adam, 'Provocation', review of Denis Donoghue, *Walter Pater: Lover of Strange Souls*, *London Review of Books*, vol. 17, no. 16, 24 Aug. 1995, https://www.lrb.co.uk/the-paper/v17/n16/adam-phillips/provocation (accessed on 16 Nov. 2020).

Philips, Adam, *Becoming Freud: The Making of a Psychoanalyst* (New Haven and London: Yale University Press, 2014).

Philips, Adam, 'Against Biography', in Phillips, *In Writing: Essays on Literature* (London: Penguin, 2016), 43–63.

Philostratus the Elder and Philostratus the Younger, *Imagines*, tr. Arthur Fairbanks, Loeb Classical Library (Cambridge, MA: Harvard University Press, 1931).

Pick, Daniel, *Faces of Degeneration: A European Disorder, c.1848–c.1918* (Cambridge: Cambridge University Press, 1993).

Pittock, Matthew, ed., *The Reception of Walter Scott in Europe* (London: Bloomsbury, 2007).

Plutarch, *Plutarch's Lives: Translated from the Greek by Several Hands. To which is Prefixed the Life of Plutarch*, 5 vols (London: J. Tonson, 1683–6).

Plutarch, *Plutarch's Lives. The Translation Called Dryden's. Corrected from the Greek and Revised by A. H. Clough*, 5 vols (London: Sampson Low, 1859).

Pocock, J. G. A., 'Some Europes in their History', in ed. Anthony Pagden, *The Idea of Europe: From Antiquity to the European Union* (Cambridge: Cambridge University Press, 2002), 55–71.

Pointon, Marcia, *Portrayal and the Search for Identity* (London: Reaktion Books, 2013).

Potolsky, Matthew, *The Decadent Republic of Letters: Taste, Politics, and Cosmopolitan Community from Baudelaire to Beardsley* (Philadelphia: University of Pennsylvania Press, 2013).

Potvin, John, *Bachelors of a Different Sort: Queer Aesthetics, Material Culture and the Modern Interior in Britain* (Manchester: Manchester University Press, 2014).

Pound, Ezra, 'The Approach to Paris, II', *The New Age* 13:20 (1913), 577.

Preller, Ludwig, *Griechische Mythologie*, 2 vols (Leipzig: Weidmannsche Buchhandlung, 1854).

Prettejohn, Elizabeth, *The Modernity of Ancient Sculpture: Greek Sculpture and Modern Art from Winckelmann to Picasso* (London: I. B. Tauris, 2012).

Prettejohn, Elizabeth, *Old Masters, Modern Painters: The Art of Imitation from the Pre-Raphaelites to the First World War* (London and New Haven: Yale University Press, 2017).

Prins, Yopie, 'Greek Maenads, Victorian Spinsters', in ed. Richard Dellamora, *Victorian Sexual Dissidence* (Chicago: University of Chicago Press, 1999), 43–82.

Proust, Marcel, *On Reading Ruskin*, tr. and ed. Jean Autret, William Burford and Philip J. Wolfe, intr. Richard Macksey (New Haven: Yale University Press, 1987).

BIBLIOGRAPHY 381

Radford, Andrew and Victoria Reid, ed., *Franco-British Cultural Exchanges, 1880–1940: Channel Packets* (Basingstoke: Palgrave Macmillan, 2012).

Raleigh, John Henry, 'What Scott Meant to the Victorians', in ed. Harry E. Shaw, *Critical Essays on Sir Walter Scott: The Waverley Novels* (New York: G. K. Hall, 1996), 47–69.

Reiset, Frédéric, *Notice des dessins, cartons, pastels, miniatures et émaux, exposés dans les salles du Ier étage au Musée impérial du Louvre. Première partie: Ecoles d'Italie, Ecoles Allemande, Flamande et Hollandaise* (Paris: Charles de Mourgues, 1866).

Renan, Ernest, *Qu'est-ce qu'une nation? Conférence faite en Sorbonne, le 11 Mars 1882* (Paris: Lévy Frères, 1882).

Reynolds, Stephen, 'Autobiografiction', *Speaker*, n.s., 15:66 (1906), 28–30.

Ribeyrol, Charlotte, 'Hellenic Utopias: Pater in the Footsteps of Pausanias', in ed. Charles Martindale, Stefano Evangelista, and Elizabeth Prettejohn, *Pater the Classicist: Classical Scholarship, Reception, and Aestheticism* (Oxford: Oxford University Press, 2017), 201–18.

Ribeyrol, Charlotte, '"The golden stain of time": Remembering the Colours of Amiens Cathedral', *Word & Image* 36:1 (2020), 37–47.

Richards, Bernard, 'Pater and Architecture', in ed. Laurel Brake and Ian Small, *Pater in the 1990s* (Greensboro: ELT Press, 1991), 189–204.

Ricoeur, Paul, 'Life in Quest of Narrative', in *On Paul Ricoeur: Narrative and Interpretation*, ed. David Wood (London and New York: Routledge, 1991), 20–33.

Rigney, Ann, *Imperfect Histories: The Elusive Past and the Legacy of Romantic Historicism* (Ithaca: Cornell University Press, 2001).

Rigney, Ann, 'Abbotsford: Dislocation and Cultural Remembrance', in ed. Harald Hendrix, *Writers' Houses and the Making of Memory* (New York and London: Routledge, 2008), 75–91.

Rigney, Ann, *The Afterlives of Walter Scott: Memory on the Move* (Oxford: Oxford University Press, 2012).

Robinson, Lionel, *J. L. E. Meissonier, Honorary Royal Academician, His Life and Work*, The Art Annual for 1887 (London: J.S. Virtue, 1887).

Roellinger, Francis, 'Intimations of Winckelmann in Pater's Diaphaneité', *English Language Notes* 2 (1965), 277–82.

Ronsard, Pierre de, *Cassandra*, tr. and intr. Clive Lawrence (Manchester: Carcanet Press, 2015).

Rosenthal, Michael, 'Shakespeare's Birthplace: Bardolatry Reconsidered', in ed. Harald Hendrix, *Writers' Houses and the Making of Memory* (New York: Routledge, 2008), 31–44.

Rothenstein, William, *Men and Memories: Recollections of William Rothenstein*, 2 vols (London: Faber & Faber, 1931).

Rothenstein, William and Frederick York Powell, *Oxford Characters: Twenty-Four Lithographs by Will Rothenstein, with Text by F. York Powell, and Others* (London: John Lane, 1896).

Rousseau, George S. and Caroline Warman, 'Writing as Pathology, Poison or Cure: Henri-Frédéric Amiel's *Journal Intime*', *Studies in Gender and Sexuality* 3:3 (2002), 229–62.

Ruskin, John, *The Complete Works of John Ruskin*, 39 vols, ed. E. T. Cook and Alexander Wedderburn (London: George Allen, 1903–12).

Russell, David, *Tact: Aesthetic Liberalism and the Essay Form in Nineteenth-Century Britain* (Princeton: Princeton University Press, 2018).

Sackville-West, Vita and Harold Nicolson, *Vita and Harold: The Letters of Vita Sackville-West and Harold Nicolson 1910–1962*, ed. Nigel Nicolson (London: Phoenix, 1993).

Said, Edward, *Reflections on Exile and Other Essays* (Cambridge, MA: Harvard University Press, 2000).

Said, Edward, *Orientalism*, Penguin Modern Classics (London: Penguin, 2003).

Sainte-Beuve, Charles Augustin, 'Vie, poésies et pensées de Joseph Delorme' in *Poésies complètes de Sainte-Beuve* (Paris: Charpentier, 1840), 5–22.

382 BIBLIOGRAPHY

Sainte-Beuve, Charles Augustin, *Portraits littéraires*, ed. G. Antoine (Paris: Robert Laffont, 1993).

Saunders, Max, *Self Impression: Life-Writing, Autobiografiction, and the Forms of Modern Literature* (Oxford: Oxford University Press, 2010).

Schaffer, Talia, 'Posing Orlando', in ed. Ann Kibbey, Kayann Short, and Abouali Farmanfarmaian, *Sexual Artifice: Persons, Images, Politics, Genders* 19 (New York: New York University Press, 1994), 26–63.

Schivelbusch, Wolfgang, *The Railway Journey: Trains and Travel in the 19th Century*, tr. Anselm Hollo (Oxford: Blackwell, 1977).

Schliemann, Heinrich, *Troy and Its Remains: A Narrative of Researches and Discoveries Made on the Site of Ilium and in the Trojan Plains* (London: John Murray, 1875).

Schliemann, Heinrich, *Mycenae: A Narrative of Researches and Discoveries at Mycenae and Tiryns* (London: John Murray, 1878).

Schuster, Peter-Klaus, *Melencolia I: Dürers Denkbild*, 2 vols (Berlin: Gebr. Mann, 1991).

Schwob, Marcel, *Vies imaginaires* (Paris: Éditions Gérard Lebovivi, 1986).

Schwob, Marcel, 'Preface', *Imaginary Lives*, tr. Chris Clarke (Cambridge, MA: Wakefield Press, 2018).

Seiler, R. M., ed., *Walter Pater: The Critical Heritage* (London: Routledge & Kegan Paul, 1980).

Seiler, R. M., ed., *Walter Pater: A Life Remembered* (Calgary: University of Calgary Press, 1987).

Seiler, R. M., ed., *The Book Beautiful: Walter Pater and the House of Macmillan* (London: Athlone Press, 1999).

Senancour, Étienne Pivert de, *Obermann*, with a Biographical and Critical Introduction by Arthur Edward Waite (London: P. Wellby, 1903).

Shaffer, Elinor S., 'Shaping Victorian Biography: From Anecdote to Bildungsroman', in ed. Peter France and William St Clair, *Mapping Lives: The Uses of Biography* (Oxford: Oxford University Press, 2002), 115–33.

Shuter, William, 'The Arrested Narrative of "Emerald Uthwart"', *Nineteenth-Century Literature* 45:1 (Jun. 1990), 1–25.

Siegel, Jonah, *Desire and Excess: The Nineteenth-Century Culture of Art* (Princeton: Princeton University Press, 2000).

Siegel, Jonah, 'Schooling Leonardo: Collaboration, Desire, and the Challenge of Attribution in Pater', in ed. Laurel Brake, Lesley Higgins, and Carolyn Williams, *Walter Pater: Transparencies of Desire* (Greensboro: ELT Press, 2002), 133–50.

Simpson, Juliet, 'Edmond de Goncourt's *Décors*—Towards the Symbolist *Maison d'Art*', *Romance Studies* 29:1 (2011), 1–18.

Small, I. C., 'The Sources for Pater's Spinoza in "Sebastian van Storck"', *Notes and Queries* 25 (1978), 318–20.

Smeed, J. W., *The Theophrastan 'Character': The History of a Literary Genre* (Oxford: Clarendon Press, 1985).

Sontag, Susan, *Illness as Metaphor* (New York: Farrar, Straus, and Giroux, 1978).

Sontag, Susan, *On Photography* (London: Penguin, 1979).

Spiers, R. Phéné, 'The Palaces of the Late King of Bavaria', *Art Journal* (Jul. 1888), 213–16.

Spirit, Jane, 'Nineteenth-Century Responses to Montaigne and Bruno: A Context for Pater', in ed. Laurel Brake and Ian Small, *Pater in the 1990s* (Greensboro: ELT Press, 1991), 217–27.

St Clair, William, *The Reading Nation in the Romantic Period* (Cambridge: Cambridge University Press, 2004).

St John, Bayle, *Montaigne the Essayist: A Biography, with Illustrations*, 2 vols (London: Chapman and Hall, 1858).

Stephen, Leslie, *The Playground of Europe* (London: Longmans, Green & Co., 1871).

Stephen, Leslie, 'A New "Biographia Britannica"', *Athenaeum* 2878 (23 Dec. 1882), 850.

Sternberger, Dolf, *Panorama of the Nineteenth Century*, tr. Joachim Neugroschel (Oxford: Blackwell, 1977).

Sterne, Laurence, *A Sentimental Journey*, ed. Ian Jack, intr. Tim Parnell (Oxford: Oxford University Press, 2008).

Story, William Wetmore, *Roba di Roma*, 2nd edn, 2 vols (London: Chapman & Hall, 1863).

Strachey, Lytton, *Eminent Victorians* (1918) (London: Chatto & Windus, 1993).

Super, R. H., 'Documents in the Matthew Arnold-Sainte-Beuve Relationship', *Modern Philology* 60:3 (Feb. 1963), 206–10.

Sutton, Peter C. et al., *Love Letters: Dutch Genre Paintings in the Age of Vermeer* (London: Frances Lincoln, 2003) in collaboration with National Gallery of Ireland and the Bruce Museum of Arts and Science.

Swinburne, A. C., 'Notes on Designs of the Old Masters at Florence', *Fortnightly Review* 10 (Jul. 1868), 16–40.

Symonds, John Addington and Margaret Symonds, *Our Life in the Swiss Highlands* (London and Edinburgh: Adam and Charles Black, 1892).

Symonds, John Addington, *Letters of John Addington Symonds*, ed. Herbert Schueller and Robert L. Peters, 3 vols (Detroit: Wayne State University Press, 1967–9).

Symons, Arthur, *An Introduction to the Study of Browning* (London: Cassell, 1886).

Symons, Arthur, 'Walter Pater', *Monthly Review* 24 (Sept. 1906), 14–24.

Symons, Arthur, 'The Magic of Auxerre' (1924), in *Wanderings* (London: J. M. Dent & Sons, 1931), 178–82.

Syson, Luke with Larry Keith, *Leonardo da Vinci: Painter at the Court of Milan* (London: National Gallery, 2011).

Three Hundred French Portraits Representing Personages of the Courts of Francis I, Henry II, and Francis II, by Clouet, Auto-Lithographed from the Originals at Castle Howard, Yorkshire by Lord Ronald Gower, 2 vols (London: Sampson, Low, Marston/Hachette & Cie, 1875).

Tintner, Adeline R., *The Museum World of Henry James* (Ann Arbor: UMI Press, 1986).

Tucker, Paul, '"Reanimate Greek": Pater and Ruskin on Botticelli', in ed. Laurel Brake, Lesley Higgins, and Carolyn Williams, *Walter Pater: Transparencies of Desire* (Greensboro: ELT Press, 2002), 119–32.

Turner, Marion, *Chaucer: A European Life* (Princeton: Princeton University Press, 2019).

Vadillo, Ana Parejo, 'The Crownless A. Mary F. Robinson', *Studies in Walter Pater and Aestheticism* 2 (2016), 71–84.

Varty, Anne, 'The Crystal Man: A Study of "Diaphaneitè"', in ed. Laurel Brake and Ian Small, *Pater in the 1990s* (Greensboro: ELT Press, 1991), 205–15.

Vasari, Giorgio, *The Lives of the Artists*, tr. Julia Conway Bondanella and Peter Bondanella, Oxford World's Classics (Oxford: Oxford University Press, 1998).

Veblen, Thorstein, *The Theory of the Leisure Class: An Economic Study in the Evolution of Institutions* (London: Macmillan, 1899).

Viollet-le-Duc, Eugène, *Dictionnaire raisonné de l'architecture française du Xie au XVIe siècle*, 10 vols (Paris: Bance et Morel, 1854–9).

Ward, Anthony, *Walter Pater: The Idea in Nature* (London: Macgibbon, 1966).

Ward, Hayden, '"The last thing Walter Wrote": Pater's "Pascal"', in ed. Laurel Brake and Ian Small, *Pater in the 1990s* (Greensboro: ELT Press, 1991), 143–53.

Ward, Mary Augusta, 'The Literature of Introspection. Two Recent Journals', *Macmillan's Magazine* 49 (Jan. 1884), 190–201; and 'The Literature of Introspection. Amiel's *Journal Intime*', *Macmillan's Magazine* 49 (Feb. 1884), 268–78.

Ward, Mary Augusta, 'Meissonier', *Macmillan's Magazine* 50 (Jun. 1884), 92–8.

384 BIBLIOGRAPHY

Ward, Mary Augusta, *Robert Elsmere*, ed. Rosemary Ashton (Oxford: Oxford University Press, 1987).

Watson, Nicola, *The Literary Tourist* (Basingstoke: Palgrave Macmillan, 2006).

Wedderburn, Alexander, 'Mr. Ruskin on Cistercian Architecture', *Art Journal* (Feb. 1883), 46–9.

Wedmore, Frederick, 'The Revival of Lithography II', *Art Journal* (Feb. 1896), 41–4.

Weinberg, Gail S., 'Ruskin, Pater and the Rediscovery of Botticelli', *Burlington Magazine* 129 (1987), 25–7.

Weinrich, Harald, *On Borrowed Time: The Art and Economy of Living with Deadlines* (Chicago: University of Chicago Press, 2008).

Welcker, Friedrich, *Griechische Götterlehre*, 3 vols (Göttingen: Verlag der Dieterischer Buchhandlung, 1857–63).

White, Hayden, *Metahistory: The Historical Imagination in Nineteenth-Century Europe*, fortieth-anniversary edn, with a new preface and a foreword by Michael S. Roth (Baltimore: Johns Hopkins University Press, 2014).

White, Hayden, 'Historical Discourse and Literary Writing', in *Tropes for the Past: Hayden White and the History/Literature Debate*, ed. Kuisma Korhonen (Amsterdam: Rodopi, 2006), 25–34.

Whiteley, Giles, *Aestheticism and the Philosophy of Death: Walter Pater and Post-Hegelianism* (Oxford: Legenda, 2010).

Whiteley, Giles, 'Pater's *Parerga*: Framing the Imaginary Portraits', *Victoriographies* 3:2 (2013), 119–35.

Whitridge, Arnold, 'Arnold and Sainte-Beuve', *PMLA* 53:1 (Mar. 1938), 303–13.

Wilde, Oscar, *The Importance of Being Earnest* in *The Works of Oscar Wilde* (London: Collins, 1948), 321–69.

Wilde, Oscar, *Complete Shorter Fiction*, ed. Isobel Murray (Oxford: Oxford University Press, 1980).

Wilde, Oscar, *The Complete Works of Oscar Wilde*, Vol. 3: *The Picture of Dorian Gray. The 1890 and 1891 Texts*, ed. Joseph Bristow (Oxford: Oxford University Press, 2005).

Wilde, Oscar, 'Historical Criticism', in *The Complete Works of Oscar* Wilde, Vol. 4: *Criticism: Historical Criticism, Intentions, The Soul of Man*, ed. Josephine M. Guy (Oxford: Oxford University Press, 2007), 3–67.

Wilde, Oscar, 'The Critic as Artist', in *The Complete Works of Oscar* Wilde, Vol. 4: *Criticism: Historical Criticism, Intentions, The Soul of Man*, ed. Josephine M. Guy (Oxford: Oxford University Press, 2007), 124–206.

Wilde, Oscar, 'The Decay of Lying', in *The Complete Works of Oscar* Wilde, Vol. 4: *Criticism: Historical Criticism, Intentions, The Soul of Man*, ed. Josephine M. Guy (Oxford: Oxford University Press, 2007), 73–103.

Wilde, Oscar, 'The Portrait of Mr W. H.', in *The Complete Works of Oscar Wilde*, Vol. 8: *The Short Fiction*, ed. Ian Small (Oxford: Oxford University Press, 2017), 197–258.

Williams, Carolyn, *Transfigured World: Walter Pater's Aesthetic Historicism* (Ithaca: Cornell University Press, 1989).

Williams, Carolyn, 'Walter Pater, Film Theorist', in ed. Elicia Clements and Lesley Higgins, *Victorian Aesthetic Conditions: Pater across the Arts* (Basingstoke: Palgrave Macmillan, 2010), 135–51.

Witemeyer, Hugh, *George Eliot and the Visual Arts* (New Haven: Yale University Press, 1979).

Wolfgang, Aurora, *Gender and Voice in the French Novel, 1730–1783* (Aldershot: Ashgate, 2004).

Woolf, Virginia, *The Flight of the Mind: The Letters of Virginia Woolf*, ed. N. Nicolson and J. Trautmann, Vol. 1: 1888–1912 (London: Hogarth Press, 1975).

Woolf, Virginia, 'A Sketch of the Past' (1939), in *Moments of Being: Unpublished Autobiographical Writings*, ed. and intr. Jeanne Schulkind (Frogmore: Panther Books, 1978), 74–159.

Woolf, Virginia, *The Diary of Virginia Woolf*, ed. A. O. Bell and A. McNeillie, 6 vols (London: Hogarth Press, 1980).

Woolf, Virginia, *The Complete Shorter Fiction of Virginia Woolf*, ed. S. Dick (London: The Hogarth Press, 1985).

Woolf, Virginia, 'Mr Bennett and Mrs Brown', in *The Essays of Virginia Woolf*, ed. Andrew McNeillie, 6 vols (London: Hogarth Press, 1988), 3:384–9.

Woolf, Virginia, 'Character in Fiction', in *The Essays of Virginia Woolf*, ed. Andrew McNeillie, 6 vols (London: Hogarth Press, 1988), 3:420–38.

Woolf, Virginia, *A Passionate Apprentice: The Early Journals 1897–1909 of Virginia Woolf*, ed. M. A. Leaska (London: Hogarth Press, 1990).

Woolf, Virginia, 'The New Biography', in *The Essays of Virginia Woolf*, ed. Andrew McNeillie, 6 vols (London: Hogarth Press, 1994), 4:473–80.

Woolf, Virginia, 'The Modern Essay', in *The Essays of Virginia Woolf*, ed. Andrew McNeillie, 6 vols (London: Hogarth Press, 1994), 4:216–27.

Woolf, Virginia, 'Montaigne', in *The Essays of Virginia Woolf*, ed. Andrew McNeillie, 6 vols, (London: Hogarth Press, 1994), 4:71–81.

Woolf, Virginia, *Orlando: A Biography*, ed. Suzanne Raitt and Ian Blyth, the Cambridge Edition of the Works of Virginia Woolf (Cambridge: Cambridge University Press, 2018).

Wright, Samuel, *A Bibliography of the Writings of Walter H. Pater* (New York: Garland Publishing, 1975).

Wright, Samuel, *An Informative Index to the Writings of Walter H. Pater* (West Cornwall: Locust Hill Press, 1987).

Wright, Thomas, *The Life of Walter Pater*, 2 vols (London: Everett & Co., 1907).

Wyndham, Violet, *The Sphinx and her Circle: A Biographical Sketch of Ada Leverson 1862–1933* (New York: Vanguard Press, 1963).

Yates, Frances, *The Art of Memory* (London: Routledge and Kegan Paul, 1966).

Yeazell, Ruth Bernard, *Art of the Everyday: Dutch Painting and the Realist Novel* (Princeton: Princeton University Press, 2008).

Young, John, *A Catalogue of the Pictures at Leigh Court, near Bristol; the Seat of Philip John Miles, Esq M.P. with Etchings from the Whole Collection* (London: Bulmer & Nicol, 1822).

Zeitlin, Froma I., 'The Artful Eye: Vision, Ecphrasis and Spectacle in Euripidean Theatre', in ed. Simon Goldhill and Robin Osborne, *Art and Text in Ancient Greek Culture* (Cambridge: Cambridge University Press, 1994), 138–96.

Zemgulys, Andrea, 'Henry James in a Victorian Crowd: "The Birthplace" in Context', *Henry James Review* 29:3 (Fall 2008), 245–56.

Index

Note: Figures are indicated by an italic "*f*", respectively, following the page number.

For the benefit of digital users, indexed terms that span two pages (e.g., 52–53) may, on occasion, appear on only one of those pages.

Abelard, Pierre 128–9, 345–6
Achilles 166–7
Acland, Henry 182
Aeschylus 162–3
Agathon 166–7
Alberti, Leonbattista 147
Alexander the Great 85, 246–8
Alma-Tadema, Lawrence 238–9, 338
Alpers, Svetlana 147–9
Alps, the 98, 235, 264, 279–81, 283–5, 291, 306–7, 309–10
Amiel, Henri-Frédéric 21, 124–5, 152–7
 Journal intime 21, 121, 153–4
Amsterdam 10–11, 24, 144, 280
Amyot, Jacques 85, 285–6
Anderson, Anne 231–3
Angelico, Fra 346–7
Angiolieri, Cecco 105–6
Aphrodite 168, 174, 256–7, 257*f*
Apollo 1–2, 4, 159–60, 168–71, 174–5, 178, 191–3, 200–1, 204–5, 258–61, 279–84, 292–6, 308–9
Apollo Belvedere 176*f*
Apollyon 169–71, 282–3
Apuleius 171, 360
d'Arc, Jeanne 105–6
Ariadne 128–9
Aristophanes 162–3
Aristotle 23–4, 166–7, 169–71, 179, 212–13
 De anima 141
 Physics 23–4, 267–8
 Poesis 166–7
Armstrong, Edward 321–2
Armstrong, Isobel 41–2, 44–5
Arnold, of Brescia 345–6
Arnold, Matthew 65, 98, 100–1, 120–1, 153–5, 196–7, 284–5
Arnold, Thomas 75, 80, 320
Artemis 83–4, 168, 173–4
Aubrey, John 84–5
Austen, Jane 165
Austin, James 136–7
Auxerre 89, 249–52, 262–3, 265–6, 299–304, 306–7, 344–5
Averoldi, Altobello 254, 255*f*

Bachelard, Gaston 23, 212–18, 229, 237–8
Backhuizen, Ludolf 140–1, 143*f*
Backscheider, Paula 102
Baedeker, Karl 288
Bakhtin, Mikhail 24, 268–9
Balch, Elizabeth 122–3
Balder 201, 280, 283–4
Baldinucci, Giovanni 254
Balliol College, Oxford 109, 197, 331
Balzac, Honoré de 144–5, 326–8, 342–3
 The Quest for the Absolute [*La recherche de l'absolu*] 145
Bann, Stephen 24–5, 318–19, 324, 336–7
Barthes, Roland 29–31, 38, 72–3, 342–3
Bassen, Bartholomeus 140–1
Baudelaire, Charles 333, 346–9, 353–4, 355*f*
 'The Painter of Modern Life' 354
Beardsley, Aubrey 188–9, 191–3, 196
Beatrice (Dante's *Divine Comedy*) 43
Beaumont, Francis 106
Becker, Wilhelm Adolf 320, 338
Bede, Venerable 331
Beebee, Thomas 128–9
Beer, Gillian 281–2
Beerbohm, Max 22, 109, 178–81, 188–97, 189*f*, 190*f*, 192*f*, 209
Bell, Angelica 111–12
Bellay, Joachim du 4, 16–17, 99, 221–2, 310–11, 352
Belloc, Hillaire 181
Bennett, Arnold 158
Benson, Arthur Christopher 10, 37–8, 74, 124–5, 198–9, 271
 The Thread of Gold 74–5
 Walter Pater 94–5
Berenson, Bernard 178–9
Bergson, Henri 267
Besant, Walter 165–6
Bildungsroman 24–6, 82, 178, 317–18, 356–60
Blake, William 81–2, 349
Bloom, Harold 114, 125, 161, 177
Boccaccio, Giovanni 311
Boétie, Étienne de la 223
Bonaparte, Napoleon 283–4, 290, 311–12, 335–6
Bonnington, Richard Parkes 264
Borch, Gerhard ter 137–8

388 INDEX

Boreas 279–80, 282–3
Boswell, James 80, 107–8
Botticelli, Sandro 15–16, 35–6, 81–2, 112–13, 177, 333
Boulogne 100–1, 122, 289–91, 298, 312–13
Bourget, Paul 152–3, 290–1
Bradford, Gamaliel 85–6, 102–4
Brake, Laurel 19
Brantôme, Pierre de Bourdelle, Seigneur de 79, 237, 241–2
Brasenose College, Oxford 23, 35–6, 40, 182–3, 191–3, 209, 210f, 250, 258–9, 271–2, 321–2, 329–30
Brera 14–15, 57–9
Bressani, Giovanni 7–8
Brentano-von-Arnim, Bettina 89–90, 125, 131
Brueghel, Pieter 148
Bridges, Robert 39–40
British Museum 15–16, 91–3, 136, 172–3, 276–7
Brontë, Emily 72–3, 110–11, 270, 332–3
 Wuthering Heights 72–3, 199–200, 342
Brooke, S. R. 331–2
Browne, Thomas 23, 94–5, 98, 110–11, 221–2, 229, 245–8, 248f, 250, 294, 338–9
Browning, Oscar 231–3
Browning, Robert 98, 115, 125–6, 131, 214–16, 224–5, 331
Bruno, Giordano 15–16, 120–1, 165, 226, 285–6, 326, 357–9
Bryson, Norman 172
Buchanan, Robert 347–8
Buckler, William 70
Budziak, Anna 5
Buffon, Comte de (Georges-Louis Leclerc) 115, 334–5
Bullen, J. B. 146–7, 342
Bulwer-Lytton, Edward 179–80
Bunyan, John 94–5
Buonarroti, Michelangelo *see* Michelangelo Buonarroti
Burckhardt, Jacob 324
Burges, William 238–9
Burke, William 106
Burne-Jones, Edward 117–19, 200, 201f, 362
Burnet, Gilbert 80, 321
Burney, Fanny 125–6
Burton, John Hill 321
Bussell, F. W. 22, 182–8, 187f
Buzard, James 287, 305
Byron, Lord George Gordon 120, 214–16, 288, 290–1, 334
Bywater, Ingram 39–40, 181

Calais 289–92, 295, 309, 317
Cameron, Julia Margaret 67, 111–12
Cane, Sir Edmund de 61–2

Canterbury 4–5, 40, 250, 258–60, 264, 268, 285–7, 289–90, 299–300
Cantor, William 260–1
Carjat, Étienne 353–4, 355f
Carlyle, Thomas 36, 42–3, 49, 80, 98, 104–5, 325, 329, 331, 336–7
 History of Frederick II of Prussia, Called Frederick the Great 80, 321
 Oliver Cromwell's Letters and Speeches 80, 321, 337
 On Heroes, Hero-Worship and the Heroic in History 42–3
Carriera, Rosalba 133–6, 134f
Carroll, Lewis (Charles Lutwidge Dodgson) 36
Casanova, Pascale 2–3
Casey, Edward 267–9, 315–16
Catullus 256–7
Caylus, Comte de 87–8
Celtis, Conrad 283–4
Chadbourne, Richard 101–2
Chambers, D. S. 321–2
Champagny, F-J-M-T 320
Champion, Pierre 104–5
Chapman, John 98
Charlemagne 283–4, 311–12
Charles II of England 45, 84–5
Charles V of France 201, 283–4, 311–12
Chateaubriand, François-Réné de 121, 284–5
Chatrian, Alexandre 337–8
Chaucer, Geoffrey 286–7
Cheeke, Stephen 1–2
Christ 51–3, 53f, 60–1, 204–5, 216, 255f, 256, 282–3, 308
Christ Church College, Oxford 180, 182
Cicero 179, 199–200, 338–9
Circe 226
Clair, William St 93–4, 327–8
Clare, John 98
Clements, Patricia 347–8, 353–4
Clouet, François 235, 286, 349–52, 351f
Clouet, Jean 235, 286
Clough, Arthur Hugh 84–5
Coates, Christopher 80
Coleridge, Samuel Taylor 95–6, 98, 120, 324
Colley, Ann 284
Collins, Wilkie 361
Colvin, Sidney 81
Constant, Benjamin 153
Cook, Clarence 239–40
Cook. E. T. 137
Cook, Thomas 94–5, 284–5
Corneille, Pierre 102
Costello, Timothy 324
Coulanges, Fustel de 258–9
Cranach, Lucas 106
Crozat, Pierre 133–5
Cruise, Colin 35–6

INDEX 389

Curtius, Ernst 278–9, 320
Cuyp, Albert 139

Dacquin, Jeanne-Françoise 122–3
Daedalus 276–7
Dalou, Jules 290–1
Daniel, Charles Henry Olive 181
Daniel, Peter Augustin 226–7
Danson, Lawrence 196
Dante Alighieri 3–4, 105–6, 310–11, 332
Darwin, Charles 66, 267
Defoe, Daniel 110–11
Delacroix, Eugène 153, 340
Dellamora, Richard 39–40
Delville, Jean 51, 52*f*
Demeter 1–2, 221, 344–5
Denisoff, Dennis 111–12
Dickens, Charles 114–15, 160–1, 295, 328, 336
 Great Expectations 163–4, 164*f*
 Sketches by Boz 179–80
Dictionary of National Biography 19–20, 78–9,
 82–6, 89–90, 362–3
Diderot, Denis 312
Dido 128–9
Didron, Adolphe Napoléon 258–9
Dilke, Emilia (Emilia Pattison) 34, 129–30,
 319–22, 333
Diodorus 279–80
Diogenes 3–4
Dionysus 1–2, 83–4, 89, 159, 244–5, 250–2, 275–6,
 306–7, 332, 344–5
Disraeli, Benjamin, Earl of Beaconsfield 153–4, 288
Donaldson, Ian 84–5
Donoghue, Denis 81, 271
Dow, Gerard 114
Dowling, Linda 40
Drake, Francis 94–5
Dresden 14–15, 200, 279–80, 283–4
Drouet, Juliette 295
Dryden, John 84–5
Dumas, Alexandre 242–4, 313–14
Dürer, Albrecht 57–61, 235–6
 Melencolia I 57–9, 58*f*, 235–6, 309–10, 347
Dyer, Thomas Henry 320
Dyer, Richard 136–7

Earle, John 179–80
Eastlake, Charles 115–17
Edward VII of England 107–8, 194–5
Edwards, Jason 230
'Eliot, George' (Mary Ann Evans) 144–7, 335,
 360, 362
 Adam Bede 145–7
 Impressions of Theophrastus Such 179–80
 Middlemarch 362–3
Eliot, T. S. 4–5

Elisabeth of Austria 350–1, 351*f*
Elizabeth I 285–6
Ellenbogen, Josh 62–3, 67
Elliott & Fry 29–31, 32*f*, 34*f*, 189*f*
Elsner, Jaś 171–3
Emerson, Ralph Waldo 42–4, 49
Empedocles 105
English Channel, the 4, 97–8, 113, 122–3, 258–9,
 264, 285–6, 288, 290–1, 293–4, 309–10,
 314, 337
Erasmus of Rotterdam 106
Erckmann, Émile 337–8
Ernst, Carl Wilhelm 119–20
Euripides 21–2, 90, 167–8, 171–3, 275
 Bacchae 22, 167–8, 276
 Hippolytus 22, 167–8
Europa 274
Evangelista, Stefano 3–4
Evelyn, John 80, 84–5, 125–6

'F' 209
Fabre, Ferdinand 115
Fairbanks, Arthur 173
Fauriel, Claude Charles 320
Feuillet, Octave 96–7, 115, 124
Fielding, Henry 136–7
Flaubert, Gustave 99, 115, 123–4, 335–7, 360
Fletcher, John 106
Ford, Ford Madox 290–1
Forster, E. M. 160–2, 204–5
Forster, John 216
France, Peter 93–4
François I of France 16–17
François, Duke of Anjou 285–6
Frank, Eve Ellen 261–2
Franklin, Alfred 320
Freeman, Edward 320
French Revolution 26, 121, 298, 313, 321, 327–30,
 334–8, 346, 348, 356, 359–60
Freud, Sigmund 19, 36, 49–50, 55–7, 59–61, 67–8,
 81, 129–31
 A Childhood Memoir of Leonardo da Vinci
 49–50, 81
 Family Romances 60–1
 Screen Memories 67–8
 Studies in Hysteria (with Joseph Breuer) 130–1
 The Uncanny 280–1
Froude, James Anthony 94–5, 321, 331
Frow, John 160, 163–4
Fuller, Thomas 84–5

Gallienne, Richard Le 178–9
Galton, Francis 18–19, 45, 61–4, 68–9, 75–6, 82–3
 Composite Portraits 18, 61–4, 67, 72–4, 76*f*, 109,
 165, 324–5
 Inquiries into Human Faculty 62

390 INDEX

Galton, Francis (*cont.*)
 Life History Album 62, 75–6, 82–3
 Questions on Visualising and Other Allied
 Faculties 62, 64–5, 67
Galy, Jean-Baptiste 223–4
Gardine, Samuel Rawson 321
Gautier, Théophile 99, 150–2, 272, 332, 334, 347–8
Geffcken, H. 201–3
Gere, Charlotte 238–9
Gibbon, Edward 312, 320, 322, 331
Gide, André 153
Gilchrist, Alexander 81–2
Giorgione 15–16, 46, 357–9, 357*f*
Gissing, George 37–8
Glass 19, 38–9, 41–3, 46, 49–50, 53–4, 59–60, 64,
 73, 87, 89, 112–13, 152, 182–3, 230, 245,
 250, 261–2, 272, 305–6, 308–9, 344–5
Glaser, Stephanie 258–9
Goethe, Johann Wolfgang von 15–16, 41–5, 49, 59,
 89–90, 131, 139, 167–8, 200, 204–5, 279–80,
 284–5, 324, 332, 334, 355–6
 Poetry and Truth 89–90
 Faust 59, 356–7
 'Philostrats Gemälde' 171
 Sorrows of the Young Werther 120–1, 153
Goethe, Katharina Elisabeth ('Frau Rath') 89–90, 131
Goff, Jacques Le 310–13
Goldilocks 234
Goncourt, Edmond de 23, 180, 220
Goncourt, Edmond and Jules de 87–8, 136
Gordon, George 94–5
Gordon, Lady Duff 117–19
Gosse, Edmund 13–14, 85–8, 94–6, 107–8, 115,
 124, 197–9, 271–3, 280, 314
Gournay, Marie de 226–7
Gower, Lord Ronald 352
Graves, *see* Tombs
Gray, Thomas 94–5, 284–5
Green, John Richard 321
Green, Thomas Hill 39–40, 165, 329–30
Grimm, Jakob 272–3
Grote, Georg 320
Grove, George 14
Guggenheim, Jules 29, 31*f*, 33–6

Haarlem 144, 268–9, 280, 294, 313
Hadley, James 231–3, 233*f*
Halbwachs, Maurice 327–8
Hall, Joseph 179–80
Hallé, Charles 117–19
Hamerton, Philip Gilbert 297–8
Hamilton, Walter 230–3
Hannibal 283–4
Hannoosh, Michèle 347
Hardinge, William Money ('The Balliol
 Bugger') 197–8

Hardy, Thomas 144, 146–7, 167
 Under the Greenwood Tree: A Rural Painting
 of the Dutch School 146–7
Hare, William 106
Hart, Imogen 230
Hatt, Michael 209, 211
Haughton, Hugh 59–61
Haweis, Mary Eliza 237–40, 242
Hawthorne, Nathaniel 98, 306–7, 317–18
Hay, Denys 274–5
Hazlitt, William 179–80, 355–6
Hearn, James 191–3, 195*f*
Heffernan, James 15–16
Hegel, Georg Wilhelm Friedrich 25, 66–7, 154–5,
 267, 277–8, 324, 329–30, 336–7, 355–6
Heidelberg 279–80, 283, 295, 334
Heine, Heinrich 159, 204–5, 280–1, 324
Helmholtz, Hermann 281–2
Héloïse 128–9
Henri d'Orleans 352
Henry II 289–90, 298
Hephaistus 276–7
Heraclitus 66, 286, 318
Hercules 285
Herder, Johann Gottfried 2–3, 312, 324, 334, 355–6
Herkomer, Hubert von 177, 264
Hermes 209–11, 250–2
Herodotus 162–3, 275, 279–80, 320, 331
Herostratus 105
Hesiod 279–80
Heyden, Jan van der 144
Hippocrates 362–3
Hippolytus 171, 359–60
Hitler, Adolf 311–12
Hobbema, Meindert 144–5
Hochmann, Baruch 158
Hoefer, Jean-Chrétien-Ferdinand 79, 99
 Nouvelle biographie générale 99, 105–6
Holbein, Hans 8–10
Hollinghurst, Alan 178
Hollyer, Frederick 35–6
Holmes, C. J. 182–3, 191–3, 193*f*, 194*f*
Holmes, Sherlock 10–11
Homer 91–3, 166–7, 171, 226, 275–80, 334–5
Hopkins, Gerald Manley 39–40
Horace 91–3
Horne, Herbert 35–6
Houdon, Jean-Antoine 140–1
Houghton, Georgiana 72–3
Houssaye, Arsène 80, 347–8
Hudson, Fred 72–3
Hughes, Thomas 178
Hugo, Victor 258, 262–4, 290–1, 295, 313–14,
 333–5
Hume, David 312, 320, 331
Hunt, Leigh 179–80

Huxley, Thomas 95–6, 197
Huysmans, Joris-Karl 2–3, 23, 211, 220, 240–2
Hyacinthus 159, 167–9, 171, 174–6, 282–3, 295
Hyperboreans 279–83

Ibsen, Henrik 167, 280
Inman, Billie Andrew 79, 84–5, 314, 320
Innocent III, Pope 308
Irving, Washington 317–18
Iser, Wolfgang 89–90, 359

'Jacques Bonhomme' 343–4
James, Alice 128
James, Henry 14–15, 123, 128, 143–4, 165–7, 188, 197
 'The Art of Fiction' 165–7, 204–5, 268, 317–18
 Guy Domville 167
 Turn of the Screw 199–200
 'The Birthplace' 214–16
James, William 128, 267
Jeens, Charles Henry 55, 56*f*
Jefferson, Ann 99
Jervis, Henley 320
Johnson, Lionel 178–9
Johnson, Samuel 78, 94–5, 107–8
Jonson, Ben 105–6
Jowett, Benjamin 85, 178–9, 197
Joyce, James 4–5, 328
Jullienne, Jean de 87–8, 136
Jung, Carl 49–50, 59–60

Kant, Immanuel 120, 312–13, 336
Kaplan, Louis 72–3
Kean, Charles 114–15
Kearney, Richard 212–13
Keates, Jonathan 288–9
Keats, John 80, 120, 345
Keyser, Peter de 140–1
Keyser, Thomas de 140–1
Kierkegaard, Søren 32–3, 267
Kingsley, Charles 114–15, 137
King's School, Canterbury 4–5, 40, 179, 258–60, 268, 270, 286–7
Kneller, Sir Godfrey 45
Koerner, Joseph 57–9
Koninck, Philip de 147–8, 148*f*

Lamb, Charles 22, 74, 123–4, 179–80, 196, 221–2
 'Blakesmoor in H–shire' 74, 221–2
 Essays of Elia 221–2
 Last Essays of Elia 221–2
Landor, Walter Savage 160, 223–4, 324–5
Landseer, Edwin 216
Lane, John 180–1, 185–9, 191–3
Lang, Andrew 48, 70
Lapeyre, Léon 223–4

Lasner, Mark Samuel 188–9
Lassus, Jean-Baptiste 258–9
Lee, Sidney 82–3, 85–8, 107–8
'Lee, Vernon' (Violet Paget) 2–3, 21–4, 32–3, 55–7, 74, 125–6, 159–60, 178–9, 197, 269, 290–3, 306–7, 342
 'The Child in the Vatican' 74
 Genius Loci: Notes on Places 23–4, 268, 291
 Miss Brown 159–60
 'The Portrait Art of the Renaissance' 55–7
Lee-Morrison, Lila 61–2, 64
Lefèbvre, A.-F. 299
Legros, Alain 223–4
Legros, Alphonse 181
Leighton, Frederick 238–9
Lely, Sir Peter 45
Leonardo da Vinci 4, 15–17, 19, 46, 49–51, 55, 57–61, 66–7, 75, 80–3, 234–5, 286, 310–11, 326, 333
 Belle Ferronière 55–7
 Cecilia Galerani 55–7
 Drawings 350–1
 Last Supper 51–2
 Mona Lisa 16–17, 49, 53–4, 57–60, 108, 196–8, 240–4, 342, 346–7, 353–4
 Salvator Mundi 52–3, 53*f*
Leonardo, School of 51, 53–4
Lessing, Gotthold Ephraim 2–3, 103–4, 173, 362–3
Leverson, Ada 188
Levey, Michael 271
Lewes, George Henry 41–5
 Life of Goethe 41–3
Leyland, Frederick 239–40
Lingard, John 320
Liotard, Jean-Michel 135, 135*f*
Livy 322, 338–9
Locke, John 141, 213
Lorenzo il Magnifico 353–4
Louis XIV ('The Sun King', *Le Roi Soleil*) 200, 203–4, 283
Louvre, Paris 14–17, 55–9, 242, 276–7, 346–7, 350–1
Loyseleur, Nicolas 105–6
Lucian 120–1, 171, 286, 326, 357–9
Lucretius 109
Ludovico il Moro 55–7
Ludwig II of Bavaria ('The Swan King', 'The Fairy Tale King') 201–4, 362
Luini, Bernardino 51, 67
Lukás, Georg 327–30, 335
Lyncaeus 42–3

Macaulay, Lord 110–11, 320, 327–8
MacColl, D. S. 32–4, 37–8
Macmillan, Alexander 55
Macmillan, George 96–7

392 INDEX

Maeterlinck, Maurice 167
Magdalen College, Oxford 109, 231–3
Magritte, Réné 6–7
Mâle, Émile 263–4
Mallock, W. H. 21–2, 30–1, 34f, 112–13, 159–60,
 197, 203–5, 349
 The New Republic 21–2, 112–13, 159–60,
 178, 197–9
Manet, Édouard 290–1
Manning, Henry Edward Cardinal 250
Manzoni, Alessandro 327–8, 335
Marat, Jean-Paul 336–7
Marchi, Dudley 229
Marcus Aurelius 15–16, 120–1, 184, 199–200, 286,
 326, 357–9
Marcus, Laura 85–6
Marguerite de Navarre 16–17, 99, 226, 229–30,
 234, 240, 242–4, 350–1
Marionneau, Charles 223–4
Marivaux, Pierre de 129–30
 Hannibal 201
 Vie de Marianne 128–9
Marlowe, Christopher 110–11
 Tamburlaine 162–3
Martens, Lorna 152–3
Martin, Henri 320
Marx, Karl 267
Maurice, F. D. 114–15
Maurier, George du 179, 230–1
Maxwell, Catherine 70–1
Mayhew, Henry 179–80
McQueen, John Rainer 114–15, 198–9,
 270, 295
Medea 128–9
Medici, Catherine de 286, 310–11
Medici, Giuliano de 37–8
Medici, Lorenzo de 37–8
Meinhold, Wilhelm
 The Amber Witch 117–19, 131
Meissonier, Jean-Louis Ernest 150–2
Melzi, Francesco 51
Menander 162–3
Meredith, Mary Ellen 226–7
Meredith, George 361
Merimée, Prosper 23, 99, 121–3, 131, 156–7,
 256–8, 262, 327–8, 343
Merivale, Charles 320
Merton College, Oxford 95–6, 178–9, 209
Metsu, Gabriël 147–52, 149f
Meyers, Fredric 68–9
'Michael Field' (Katherine Bradley and Edith
 Cooper) 244–5
Michaud, Louis-Gabriel 99, 105–6
 Biographie universelle ancienne et moderne 99
Michelangelo Buonarroti 7–8, 37, 46, 81–2, 177,
 326, 342

Michelet, Jules 24–6, 153, 313, 320, 322, 324,
 327–8, 336–40, 341f, 342–9
Milnes, Richard Monkton 80
Milton, John 94–5, 174–5, 308
Mino da Fiesole 278–9
Mirandola, Pico della 80
Mirecourt, Eugène de 99
Mollett, John 150–2
Mommsen, Theodor 320
Monsman, Gerald 4–5, 16–17, 40, 331
Montaigne, Michel de 15–16, 22–3, 85, 99, 120–1,
 123–4, 165, 196, 212, 221–30, 285–6, 310,
 326, 339
Montaigne, Pierre Eqyuem de 223
Montreuil-sur-Mer 269, 279–80, 292, 295–9, 300f,
 301f, 302f, 303f, 304f
Moore, George 178–9, 290–1, 361
Mor, Antonis 8–10
 Saint Sebastian 8–10, 9f
More, Thomas 80
Moreau, Gustave 241–4
Moretti, Franco 26, 356–7, 359–60, 362
Moretto da Brescia, Alessandro Bonvicino 256
Morgan, Benjamin 63
Morgenstern, Karl von 79
Morley, John 19–20, 94–7
Moroni, Giovanni Battista 7–8, 7f, 115–17
 The Tailor 115–17, 116f, 119, 137, 309–10
Morris, William 95–6, 117–19, 238–9, 324–5
Motley, John Lothrop 320
'Mr Rose' (caricature of Pater in W. H. Mallock's
 The New Republic) 112–13, 159–60, 178,
 197–200, 203–5, 209, 349
Müller, Karl Ottfried 278–80
Müller, Max 95–6, 181, 272–3, 281–2
Mumler, William 72–3, 72f
Murray, Alex 297–8, 302–4
Murray, James 181
Murray, John 272, 288–92, 295, 309
Myron 183
 Discobolos 169, 170f

Nadar, Félix 353–4
National Gallery 10, 14–15, 115–17, 137–8,
 146–7, 252–3
National Portrait Gallery 36, 46, 83–4, 182–3
Nelson, Horatio 94–5
Neuville *see* Montreuil-sur-Mer
Newman, John Henry 120–1, 338–9
Nicolson, Harold 4–5, 20, 87, 94–5, 103–4,
 107–10, 196
 Some People 20, 87, 94–5
Nietzsche, Friedrich 278
Normand, Clavis 298
North, Thomas 85, 285–6
Norton, Grace 197

Old Mortality Society, Oxford 40, 331–2, 360
Oost, Jacob van 137, 139
Oriel College, Oxford 40, 95–6
Orr, Linda 336–7
Ostade, Isaac van 137–9
Ottley, Canon 96–7
Ottley, May 96–7, 112–13
Overbury, Thomas 179–80
Ovid 90, 361
 Heroides 128–9
 Metamorphoses 169–71, 226
Oxford English Dictionary (*OED*) 42–4, 46, 84–5,
 102–3, 150, 162–3, 220, 268, 270, 297–8,
 315–16, 354

Pagden, Anthony 269, 274, 283–4, 310, 313
Pan 169–71
Panizzi, Antonio 156–7
Panofsky, Ernst 198–9
Paris 71–2, 83, 87–8, 97–8, 120–2, 124–5, 127,
 129, 132, 134–5, 150–2, 180–1, 188–9,
 221–3, 229–30, 234, 236–7, 240–1, 246–8,
 258–9, 262–3, 280–1, 287, 289–91, 295,
 299, 311–14, 320, 335–6, 340, 346, 359–60
Pascal, Blaise de 99, 156–7, 221–2, 224–5
Pater, Albert Dircksz 10
Pater, Clara 12–13, 29–31, 33*f*, 35–6, 39–40, 85–6,
 97–8, 112–13, 128
Pater, Hester 12–13, 35–6, 39–40, 85–6, 96–8,
 112–13, 128
Pater, Jean-Baptiste 81–2, 124, 132, 137
Pater, Marie-Marguerite 124–5, 132, 133*f*, 137
Pater, Walter
 'The Age of Athletic Prizemen' 182–3
 'Amiel's Journal: The *Journal Intime* of
 Henri-Frédéric Amiel' 123–4
 'Apollo in Picardy' 1–2, 4, 159–60, 168–71, 178,
 258–60, 279–83, 292, 295–9
 Appreciations, with an Essay on '*Style*' 95–6,
 322–3, 332
 'Aucassin and Nicolette' 310–11
 'The Bacchanals of Euripides' 167–8, 275–6
 'The Character of the Humourist: Charles
 Lamb' 22, 74–5, 221–2, 332
 'The Child in the House' 4, 14, 47–8, 50–1, 60–1,
 69–75, 77, 82, 199–200, 204–5, 213, 218–21
 'Coleridge' 1–2, 95–6, 332
 'Denys l'Auxerrois' 4, 22–3, 82–4, 89–90, 159,
 167–8, 204–5, 244–5, 249–52, 262–3,
 265–6, 276, 287, 302–7, 330, 344–5
 'Diaphaneitè' 18, 39–41, 43–5, 48–9, 331, 355–6
 'Duke Carl of Rosenmold' 4, 22, 48, 89–90, 131,
 139, 159–60, 200–1, 204–5, 280, 283, 330
 'Emerald Uthwart' 4, 48, 82, 90–4, 172–3,
 219–20, 265–6, 268–9, 293–4, 330, 337, 359
 'Evil in Greek Art' MS 168–71

Gaston de Latour 4, 16–17, 19, 23, 40, 47, 82,
 119–21, 156–7, 159–60, 165, 212, 217–18,
 222–7, 229–30, 234–7, 240–8, 260, 285–6,
 330, 342, 349–56
'Gaudioso the Second' 4, 23, 48, 244–5,
 252–7, 357–9
Greek Studies: A Series of Essays 40, 275
'Hippolytus Veiled: A Study from Euripides' 4,
 83–5, 90, 167–8, 171, 330
'An Idyll of the Cevennes' 115
'Imaginary Portraits 2: An English Poet' 4, 19–20,
 48, 82–3, 96–102, 273, 280, 285, 292–3
'Joachim du Bellay' 16–17, 221–2, 310–11, 352
'The Life and Letters of Flaubert' 115
Marius the Epicurean 1–2, 4, 16, 22, 84–5, 109,
 119–20, 124, 171, 191–3, 199–200, 217–18,
 246–8, 330, 338, 360–1
'M. Feuillet's "La Morte" ' 123–4
Miscellaneous Studies: A Series of Essays 40, 48
'The Myth of Demeter and Persephone' 1–2,
 221, 344–5
'Notes on Leonardo da Vinci' 16–17, 49–53,
 55–62, 75–6, 80, 333, 346–8
'Notre Dame d'Amiens' 230, 242–4, 258–9
'A Novel by Mr. Oscar Wilde' 240
'Pascal' 48, 156–7
Plato and Platonism 66–7
'Poems by William Morris' 222–3, 324–5
'The Poetry of Michelangelo' 126–7, 342
'A Prince of Court Painters' 4, 20–1, 48, 81–4,
 87–8, 97–8, 113, 123–5, 129–31, 286, 330
'Prosper Merimée' 115, 121, 123, 256–7, 262
'Robert Elsmere' 115, 159–60, 165
'Romanticism' 117–19, 121, 332–5
'Il Sartore' MS 14–15, 115–17, 118*f*, 119, 132
'Sebastian van Storck' 4, 10–11, 20–1, 47–8,
 82–5, 88–9, 124–5, 137, 139–44, 146–50,
 153–7, 161–2, 172–3, 294, 330
'Sir Thomas Browne' 123–4, 221–2, 245, 294
Studies in the History of the Renaissance (1873),
 subsequently (1877, 1888, 1893) *The*
 Renaissance: Studies in Art and Poetry 19,
 22, 30–1, 31*f*, 34, 39–40, 45, 49, 55, 56*f*,
 80–2, 178, 194–5, 197–8, 269–70, 310–11,
 315–16, 318–20, 346–8
 'Conclusion' 66, 236–7, 286
 'Preface' 7–8, 65, 81–2
'A Study of Dionysus: The Spiritual Form of Fire
 and Dew' 1–2, 244–5, 250–2, 275–6,
 332, 344–5
'Style' 2–3, 25, 115, 123–4, 258–9, 262, 319–20,
 322–4, 332, 334–5, 338–9
'Thistle' MS 4, 119–21, 123, 336
'Tibalt the Albigense' 4, 48, 307–9, 330
'Toussaint Galabru' 115
'Winckelmann' 123–4, 131, 204–5

394 INDEX

Pattison, Emilia *see* Emilia Dilke
Pattison, Mark 94–5, 197
Pausanias 275–7, 279–80
Peacock, Thomas Love 226–7
Peel, Sir Robert 137–8, 146–7
Penelope 128–9
Pepys, Samuel 80, 84–5, 125–6
Petrarca, Francesco 84–5, 212, 349–50, 353–4
Phaedra 128–9, 168, 174
Philips, Adam 59–60, 81
Philostratus 21–2, 167, 172–3
 Imagines 22, 167, 171–4, 179
 Lives of the Sophists 171
Pindar 279–80
Pinero, Arthur 115
Pissarro, Camille 290–1
Pius, Antoninus 283–4
Plato 38–40, 51, 66–7, 162–3, 184, 197, 278, 338–9
Pléiade 310–11, 349–50, 352
Pliny 279–80, 294
Plutarch 79, 84–6, 106, 225–6, 285–6
 Parallel Lives 84–5, 106
Pocock, J. G. A. 274–5, 312
Poe, Edgar Alan 240
Pointon, Marcia 1, 6–7, 14–15, 63–4, 362–3
Polygnotus 166–7
Pope, Alexander 78, 94–5
Poseidon 168
Potolsky, Matthew 2–3
Pound, Ezra 4–5, 292
Powell, Frederick York 180–2, 185–8
Praz, Mario 220
Preller, Ludwig 279–80
Prettejohn, Elizabeth 362
Prévost, Abbé
 Manon Lescaut 129
Price, Eleanor 161–2
Proserpine 349
Proust, Marcel 264
Pugin, Augustus Welby 258–9

Quincey, Thomas de 110–11, 123–4, 322
Quinet, Edgar 313, 320
Quintilian 179

Racine 167–8
Radford, Andrew 290–1
Raleigh, John Henry 327–8
Ranke, Leopold von 81–2, 201–2, 318–20
Raphael Sanzio 41–3
 Sistine Madonna 200, 283–4
Rask, Rasmus 272–3
Raymond VI of Toulouse 307–8
Reichensperger, August 258–9
Reid, Victoria 290–1
Rejlander, Oscar 72–3

Renan, Ernest 79, 152–3, 314–16, 320
Reynolds, Sir Joshua 81–2
Reynolds, Stephen 37–8
Richardson, Samuel 136–7
 Clarissa 128–9
 Pamela: or, Virtue Rewarded 128–9
Ricketts, Charles 352
Ricoeur, Paul 21–2, 158
Rigney, Ann 25, 325–8
Robbia, Luca della 81–2, 177
Robert, Count of Boulogne and Auvergne 298
Robespierre, Maximilien 336–7
Robinson, A. Mary F. 12–14
Robinson, Henry Peach 72–3
Robinson, Lionel 150–2
Rochester, John Wilmot, Second Earl of 80
Rod, Édouard 153
Romanino, Girolamo 252–3, 256, 309–10
Ronsard, Pierre de 16, 99, 120–1, 135, 165, 222–3,
 326, 333, 349–59, 354f
Röntgen, Wilhelm 47
Roque, Antoine de la 87–8
Rorty, Richard 5
Rossetti, Dante Gabriel 35–6, 95–6, 239,
 291–2, 362
Roth, Michael S. 318–19
Rothenstein, William 22, 35–6, 178–93, 190f,
 290–1, 352
 Oxford Characters 22, 186f, 187f, 357–9
Rothschild, Baron Meyer de 7–8
Rousseau, Jean-Jacques 85, 120–1, 284–5, 334–6
 Julie, ou la Nouvelle Héloïse 128–9
 Reveries of a Solitary Walker 120–1
Royal Academy 7–11, 14–15, 226–7
Rubens, Peter Paul 137–8, 200, 286
Ruskin, John 23, 37–8, 98, 137–40, 174–5, 177,
 182, 197, 227, 230, 258, 260–1, 264–6,
 284–5, 305, 313, 317–18
 Bible of Amiens 264–5
 Modern Painters 137–8, 284, 317, 361
 Praeterita 37–8
'Rutherford, Mark' (William Hale White) 37–8
Ruysdael, Salomon van 145

Sackville-West, Vita 108–12, 229
Said, Edward 269–70, 274–5, 290–1
Sainte-Beuve, Charles Augustin 19–20, 79, 94–5,
 98–103, 113, 120–1, 153–4, 214–16, 332,
 338–9
 Causeries du lundi 98–9
 Portraits contemporains 98–9
 Portraits littéraires 19–20, 100, 124
 Vie, poésies et pensées de Joseph Delorme 100–2
Saintsbury, George 102–3
'Salai, Andrea' (Gian Giacomo Caprotti da
 Oreno) 53–5

'Sand, George' (Amantine Lucile Aurore Dupin) 120–1, 165, 342–3
Sargent, John Singer 290–1
Sartre, Jean-Paul 93–4
Saunders, Max 2–7, 36–8, 70
Sayce, A. H. 179
Scaliger, Joseph 223–4
Schiller, Friedrich von 214–16
Schivelbusch, Wolfgang 305
Schlegel, Friedrich 272–3
Schliemann, Heinrich 275, 278–9
Schopenhauer, Arthur 153
Scott, Sir Walter 25, 110–11, 214–16, 325–35, 342–3
Schwob, Marcel 20, 103–8, 110–11
 Vies imaginaires 20, 104–7, 113
Senancour, Étiènne Pivert de 21, 131
 Obermann 21, 120–1, 131, 153–4
Seneca 167–8, 225–7
Shadwell, Charles Lancelot 2–3, 35–6, 39–40, 47, 85–6
Shaffer, Elinor 82
Shakespeare, William 23, 42–3, 81, 98, 105–8, 110–11, 115, 125–6, 212, 214–16, 221, 224–5, 227, 285–6, 291–2, 328, 332, 334–5
 Hamlet 163–4, 216
 Henry IV, Part I 114–15, 179
 Twelfth Night 162–3
Sharp, William 211, 273
Shaw, George Bernard 167
Shelley, Mary 85, 361
Shelley, Percy Bysshe 94–5, 109, 120, 282–3, 291–2, 345
Shusterman, Richard 5
Sickert, Walter 290–1
Sidgwick, Henry 68–9
Sidney, Sir Philip 94–5, 285–6
Siegel, Jonah 51
Sisley, Alfred 290–1
Sismondi, Simonde de 320
Smeed, John 179
Snow White 90–1, 234, 240–1
Society for Physical Research 68–9
Solomon, Simeon 35–6, 184, 362
 Pencil drawing of Walter Pater 35–6, 35f
Sontag, Susan 30–3, 38–9
Sophocles 332
South Kensington Museum 14–15
Spence, E. F. 189–91
Spenser, Gabriel 105–6
Spinoza, Baruch de 15–16, 43, 88–9, 143–4, 155–7, 326
Stägemann, Elizabeth von 125
Stanfield, James Field 82
Stanley, Arthur Penrhyn 80, 114–15

Stephen, Leslie 19, 78–9, 82–3, 89–90, 94–5, 284–5
Sternberger, Dolf 305
Sterne, Lawrence 110–11, 295–6
Stevenson, Robert Louis 78, 104–5, 264, 290–1
Story, William Wetmore 288
St Bruno 140–1, 298–9
St Cecilia 246–8
St Edmund of Abingdon (Saint Edme) 246–52, 251f, 289–90
St Gaudioso 252–4, 253f
St Germain 250, 251f
St Jerome 265
St John the Baptist 242–4, 243f
St John, Bayle 227
St Sebastian 8–11, 31f, 32f
St Thomas à Becket 289–90, 298
Strachey, Lytton 20, 79, 85–7, 103–4, 107–8, 113
 Eminent Victorians 20, 79
Strindberg, August 167
Sullivan, Arthur
 Patience 179, 239–40
Swift, Jonathan 78, 94–5
Swinburne, Algernon Charles 35–6, 39–40, 53–4, 179, 198–9, 290–2, 347–9, 353–4
Symonds, John Addington 37–40, 85–6, 94–6, 279–80, 306–7
Symons, Arthur 2–3, 32–3, 47, 115–17, 125–6, 150–2, 158–9, 161–2, 178–9, 290–1, 306–7
Syson, Luke 51–2

Tacitus 320, 322, 338–9
Taine, Hippolyte 122–3
Talbot, Henry Fox 32–3
Taunt, W. H. 29, 30f
Tell, Wilhelm 8–10
Tenniel, John 189–91
Tennyson, Lord Alfred 36
Tennyson, Lionel 67, 68f
Terburg, Gerard 150–2
Thackeray, William Makepeace 94–5, 179–80
Theophrastus 22, 48, 179
 Characters 22, 163–4, 179–80
Theseus 85, 168, 174, 359–60
Thirwall, Connop 320
Thomson, William 281–2
Thucydides 320, 331
Tieck, Ludwig 117–19, 334
Titian 35–6, 234–5, 254, 255f, 256, 357–9, 358f
Tombs 23, 71–2, 75–6, 86–7, 89–93, 103–4, 140–1, 142f, 163, 169, 172–3, 204–5, 214–18, 220–1, 223–4, 236–7, 244–8, 250–3, 256, 258, 294, 297, 331–3, 340, 341f, 342, 345, 362–3
Toulouse-Lautrec, Henri 181

396 INDEX

Towers
 Calais tower 317
 Montaigne's tower 23, 222–7, 228*f*, 229
 Prior Saint Jean's tower 296
 Sebastian's tower 147–8
Transparency 18–19, 32–3, 36–9, 41–7, 50–4,
 59–61, 63, 67–8, 74, 101–2, 199–200, 261–2
Trollope, Antony 37–8, 94–5, 179–80
Tryphon (Greek stele in the British Museum)
 91–3, 92*f*
Tuberculosis 47, 62–4, 88–9, 97–101, 124–5,
 152–3, 191–3, 359
Turner, J. M. W. 258, 264, 299–300
Turner, Marion 286–7
Turner, Reggie 188–9

Uccello, Paolo 105
Uffizi 14–15

Valenciennes 124–5, 127, 132, 135, 264, 286–7, 313
van der Helst, Bartholomeus 10, 140–1, 143
 *The Four Archers of the St Sebastian
 Guards* 10, 11*f*
Vasari, Giorgio 19, 49–50, 59–60, 79–81, 105, 326
Veblen, Thorstein 231–3, 239
Velde, Adrian van de 139
Venus *see* Aphrodite
Verlaine, Paul 184, 290–1
Verrocchio, Andrea del 49–51, 57–9, 278–9
Vesalius, Andreas 246, 247*f*
Vico, Giambattista 24–5, 324–5
Vinci, Leonardo da *see* Leonardo da Vinci
Vinci, Piero da 83
Viollet-le-Duc, Eugène 23, 258–9, 263–4, 298
Vitruvius 262
Vliet, Hendrick van 140–1
Voltaire (François-Marie Arouet) 109, 120, 312, 336

Wagner, Richard 167, 201–2, 283–4
Wallace, Richard 150–2
Wallace, William 117–19
Wallis, Henry 214–18, 214*f*, 217*f*, 218*f*, 226–7, 228*f*
Walpole, Horace 284–5
Ward, Mary Augusta 21–2, 150–2
 Amiel's Journal Intime (trans.) 121, 153–4
 Robert Elsmere 21–2, 115, 159–60, 165, 178
Ward, Thomas Humphry 95–7
Warren, T. H. 95–6
Watson, Nicola 216
Watteau, François 140n.117
Watteau, Jean-Antoine 81–2, 87–90, 93–4, 125,
 129–32, 134–7, 134*f*, 135*f*, 140–1, 218–19,
 286, 313–14, 326, 362

Watteau, Louis-Joseph 140n.117
Waugh, Alec 32–3
Waugh, Arthur 32–3
Waugh, Evelyn 32–3, 178
Webster, John 98
Wedmore, Frederick 185–8
Welcker, Friedrich 279–80
Wellington, Arthur Wellesley, First Duke of 290,
 293–4, 337
Whewell, William 43–4
Whistler, J. A. M. 176–7, 180, 237–40, 290–1, 362
White, Hayden 24–5, 318–19, 323–6
Whiteley, Giles 204–5
Wilde, Lady 'Speranza' 117–19
Wilde, Oscar 2–3, 5, 21–3, 32–3, 87, 117–19, 153–5,
 161–2, 167, 172–3, 178–9, 185–202, 231–3,
 239–41, 290–1, 317, 321–2
 'The Decay of Lying' 236–7
 Importance of Being Earnest 127–8, 167
 The Picture of Dorian Gray 21–2, 115, 159–60,
 178, 240, 256, 278–9, 356–7
 'The Portrait of Mr W. H.' 59–60, 352
 Review of *Imaginary Portraits* 161–2, 201–2,
 236–7
Wilhelm of Orange ('Wilhelm the Silent') 124,
 140–1
William of Sens 299–300
Williams, Carolyn 43, 324
Winckelmann, Johann Joachim 4, 80, 275, 279–80,
 311–12, 324–5
Windebank, Francis 337
Witte, Emanuel 140–1, 142*f*
Wodrow, Robert 321
Wolfgang, Aurora 129–30
Wood, Anthony à 84–5, 321
Woodberry, G. E. 161–2
Woolf, Virginia 4–5, 19–20, 25, 78, 87, 103–4,
 107–13, 158, 196, 228–30, 318, 328–9
 Orlando 20, 109–13
Wordsworth, William 74, 96–7, 101, 120, 123–4,
 165, 297–8, 311–12
 'Immortality Ode' 74
 'Tintern Abbey' 258
Wright, Thomas 79, 124–5, 198–9, 209, 210*f*,
 211, 270–1

Yates, Frances 212
Yeats, W. B. 178–9, 217–18, 324

Zamenhof, L. L. 272–3
Zeus 274
Zeuxis 166–7
Zola, Émile 313–14